EDITED BY JAMES MEYER

back cover and spine, Donald Judd
Untitled
1964
Painted steel

page 4, Frank Stella
In his studio working on *Getty Tomb*
(second version)
1959

pages 2–3, Donald Judd
Concrete Works, Chinati Foundation
Marfa, Texas
1992

inside flap, Anne Truitt
Gloucester
1963
Painted wood

cover, Dan Flavin
the nominal three (to William of Ockham)
1964–69
Cool white fluorescent light

Printed in Hong Kong

A CIP catalogue record for this book is available from the British Library.

ISBN 0 7148 4523 X

First published 2000
Reprinted in paperback 2005
© 2000 Phaidon Press Limited

www.phaidon.com

Phaidon Press Inc.
180 Varick Street
New York, NY 10014

Phaidon Press Limited
Regent's Wharf
All Saints Street
London N1 9PA

MINIMALISM

DBS Library
13/14 Aungier Street
Dublin 2
Phone: 01-4177572

1967–79 CANONIZATION/CRITIQUE
page 138

1980–present RECENT WORK page 168

DOCUMENTS page 190

1959–63 FIRST ENCOUNTERS page 193

1964–67 HIGH MINIMALISM page 196

1967–79 CANONIZATION/CRITIQUE page 237

1980–present RECENT WRITINGS page 266

PRE-
BY JAMES MEYER
FACE

This book is a reappraisal, from a contemporary perspective, of one of the signal developments of late twentieth-century art.

Tracing the history of Minimal practice and criticism from the late 1950s until the present, it presents Minimalism not as a defined movement but as a debate that surrounded a new kind of abstraction during the 1960s. The whole or serial geometric works of Carl Andre, Dan Flavin, Donald Judd, Robert Morris, Sol LeWitt and such contemporaries as Anne Truitt, Larry Bell, John McCracken, Ronald Bladen and Robert Smithson, often factory-made and scaled to the viewer's body, established a new paradigm of sculpture. The serial, monochromatic painting of Jo Baer, Ralph Humphrey, Brice Marden, Robert Mangold, Agnes Martin, Paul Mogensen, David Novros, Robert Ryman and Frank Stella evoked comparisons to the Minimal object, and was also characterized as Minimalist to a lesser degree. Beginning with short reviews and statements and culminating in well-known essays by such writers as Clement Greenberg, Barbara Rose, Michael Fried, Mel Bochner, Robert Smithson, Annette Michelson, Rosalind Krauss, Hal Foster and Peter Halley, the discussions around Minimalism developed into one of the most substantial literatures of contemporary art. This volume seeks to acquaint the reader with these fascinating debates.

Chapter One, 'First Encounters', is a survey of early Minimal works and writings. Chapter Two, 'High Minimalism', focuses on the key exhibitions and essays associated with the new art during the mid 1960s, and the establishment of a Minimal 'movement'. The third chapter, 'Canonization/Critique', examines new directions in Minimal practice as artists became exposed to and inspired such developments as post-Minimal and Land art, as well as the critical reception of their work by writers associated with post-Minimalism, Conceptualism and New Left and feminist politics during the late 1960s and 1970s. The final chapter is a survey of recent Minimal work and contemporary analyses of the Minimalist aesthetic.

SUR-

BY JAMES MEYER

VEY

WORK TO HAVE A LOT OF THINGS TO LOOK AT, TO COMPARE, TO ANALYSE ONE BY ONE, TO CONTEMPLATE. THE THING AS A WHOLE, ITS QUALITY AS A WHOLE, IS WHAT IS INTERESTING. THE MAIN THINGS ARE ALONE AND ARE MORE INTENSE, CLEAR AND POWERFUL.

Donald <u>JUDD</u> 'Specific Objects', 1965

The Maze and Snares of Minimalism, shown in a New York gallery in 1993, is a little-known work by Carl Andre.[1] This deceptively simple work consists of three open pedestals butted end to end; six more lean against them at even intervals. Completely filling the tiny storefront gallery, Andre's

work was difficult to view; the protruding pedestals afforded little room for circulation. Indeed, the farther one penetrated the installation, the harder it was to move about: other viewers blocked one's path. A seemingly benign abstract sculpture, the work was a snare, a trap.

The Maze and Snares of Minimalism had a rather pointed reference: 'Minimalism' itself. What was the meaning of Andre's allegory?

Carl **ANDRE** The Maze and Snares of Minimalism, 1993

Although never exactly defined, the term 'Minimalism' (or 'Minimal art') denotes an avant-garde style that emerged in New York and Los Angeles during the 1960s, most often associated with the work of Carl Andre, Dan Flavin, Donald Judd, Sol LeWitt and Robert Morris, and other artists briefly associated with the tendency. Primarily sculpture, Minimal art tends to consist of single or repeated geometric forms. Industrially produced or built by skilled workers following the artist's instructions, it removes any trace of emotion or intuitive decision-making, in stark contrast to the Abstract Expressionist painting and sculpture that preceded it during the 1940s and 1950s. Minimal work does not allude to anything beyond its literal presence, or its existence in the physical world. Materials appear as materials; colour (if used at all) is non-referential. Often placed in walls, in corners, or directly on the floor, it is an installational art that reveals the gallery as an actual place, rendering the viewer conscious of moving through this space.

With its modular, repeated units and gallery scale, *The Maze and Snares of Minimalism* was clearly a parody of Minimal art, a Minimal burlesque. 'JuddMorrisAndre LeWitt stripped bare of their MFAs, even', Andre joked.[2] Even the use of pedestals alluded to a central innovation

of Minimalism (an innovation by no means confined to Minimal art), its rejection of the plinth of classical and Renaissance sculpture. Carl Andre, Donald Judd, Robert Morris, Dan Flavin, Sol LeWitt, and their contemporaries Anne Truitt and John McCracken placed the sculptural object directly upon the wall or ground. In the work of these artists, the cubic solid no longer functions as a pedestal, it has itself become sculpture.

A tongue-in-cheek summary of Minimal style, *The Maze and Snares of Minimalism* looked back at this movement's emergence from the vantage of its 'wake'.[3] It implied that Minimalism is no longer an avant-garde style, having been adopted by the museum and written into the annals of art history. Like other avant-garde developments of the 1960s such as Conceptualism and Pop, Minimalism is now viewed as a significant development of twentieth-century art. Ironically, though, the establishment of Minimalism as a historical movement has given it a new lease on life. In the past decade, younger artists including Felix Gonzalez-Torres, Roni Horn, Charles Ray and Janine Antoni have put the geometries and serial syntax of Minimalism to new use. Presented nearly thirty years after his first show, Andre's *Maze* marks the closing of one chapter and the opening of another, the slippage of historical Minimalism into a contemporary neo-Minimalism.

Now, the artist who organizes Minimalism's funeral is an ambivalent mourner: for one whose work has been designated 'Minimal' by the commercial art magazine and gallery, Minimalism's passing may well be a cause for celebration. All of the artists associated with Minimalism rejected the idea that theirs was a coherent movement; there was never a manifesto, they pointed out, only differing or even opposing points of view. They regarded 'Minimalism' as the catchy label of a fashion-hungry art world in search of new trends. As Judd observed at the time, 'Very few artists receive attention without publicity as a new group. It's another case of the simplicity of criticism and of the public ... One person's work isn't considered sufficiently important historically to be discussed alone.'[4] It is this critical construction of Minimalism – a Minimalism of the art magazine, the press release, and art history – to which Andre alludes. For what is the 'maze of Minimalism' but Minimal criticism, the contentious, at times brilliant discourse that developed around this work, evolving into one of the most substantial literatures of post-war American art?

Detractors of Minimal art have said that the voluminous critical writing around this work compensated for its purported lack of complexity (that is, there is much to say about an art that gives so little). However, the generation of writers that emerged simultaneously

with the development of Minimal art – Mel Bochner, Rosalind Krauss, Lucy R. Lippard, Annette Michelson, Barbara Rose and Robert Smithson, among others – saw the need for a new vocabulary that could contend with this austere abstraction. The work of the so-called Minimalists resisted previous critical understanding, throwing criticism itself into a 'crisis'.[5]

The flourishing of critical art debate during the 1960s resulted from other material factors, such as the development of the commercial art magazine in conjunction with an expanding art market. The commercial success of Abstract Expressionism, Colour Field painting and Pop art fostered a growing interest in contemporary art.[6] Inspired by the example of influential critic Clement Greenberg, a leading champion of Abstract Expressionist painting, whose essays achieved an analytical rigour unsurpassed in American criticism, younger critics published increasingly ambitious articles in such journals as *Arts Magazine* (New York), *Art International* (Lugano), *Studio International* (London) and

Willem DE KOONING Merritt Parkway, 1959
Franz KLINE White Forms, 1955
David SMITH 7 Hours, 1961

Artforum (New York).[7] Many of these writers were academically trained art historians.[8] Emulating the formal precision and serious tone of Greenberg's criticism, Krauss, Lippard, Michelson, Rose and the Modernist critic Michael Fried assessed developments in contemporary art with scrupulous attention.

Arts Magazine and *Artforum* also printed the writings of the Minimal artists themselves (in particular Dan Flavin, Donald Judd, Sol LeWitt and Robert Morris) and certain younger artists, such as Mel Bochner and Robert Smithson, who developed powerful and idiosyncratic readings of this work. Following in the tradition of such New York School artists as Barnett Newman, Ad Reinhardt and Mark Rothko, many of the Minimalists also came from a liberal arts education, and their propensity to theorize bespoke an essentially academic background. (By the late 1950s and 1960s, Newman and Reinhardt stood as exemplary figures for ambitious younger artists, both for their work and their writings.)[9] Robert Morris,

a leading polemicist of the new art, studied at Reed College in Oregon, and completed a Masters Thesis on the Romanian sculptor Constantin Brancusi at Hunter College in New York, where his professors included Ad Reinhardt and the art historian Eugene Goossen.[10] Donald Judd was a paradigmatic figure who, after enrolling in the Art Students League, New York, completed degrees in both philosophy and art history at Columbia University.[11] In 1959 he began to write for *Arts Magazine*, elaborating his aesthetic in a series of compelling reviews and articles. Judd made clear his preference for an art of simple design, clean, unmodulated surfaces and bright colour exemplified by the work of Barnett Newman and Kenneth Noland. In contrast, he attacked the 'relational', gestural painting produced by Willem de Kooning, Franz Kline and younger Abstract Expressionists, and the part-by-part, late-Cubist sculpture of David Smith and Anthony Caro. He praised the former as literal or 'specific', and criticized the latter as illusionistic. The clarity and consistency of Judd's point of view brought him acclaim as a critic – indeed, he was better known in the early 1960s as a writer than as an artist. His argument also helped to reconfigure critical debate so that, when he began to show his own work in 1963, he had prepared its receptive context.

The discursive nature of 'Minimalism' became evident early on, as numerous critics attempted to explain the new work. Short reviews of early shows led to longer articles, which in turn led to elaborate essays. It all happened very quickly. The earliest statement concerned with Minimal art is probably Andre's 1959 homage to painter Frank Stella, 'Preface to Stripe Painting',[12] which praises the artist's reduction of painting to its essential formal components. By the mid 1960s the early phase of Minimal criticism had already reached its peak.[13] In 1968 Gregory Battcock's important book *Minimal Art: A Critical Anthology* launched these debates into broader circulation. It also opened up the analysis of Minimal art to a broader number of potential interpretations, encompassing painting, sculpture and even dance. Eventually the term Minimalist was used to describe a wide variety of pursuits such as Yvonne Rainer's choreography, the music of Philip Glass and Steve Reich, the fiction of Ann Beattie and Raymond Carver, and the design of John Pawson. However, the term remained ill-defined, as these highly individual practices were conducted in a variety of different media and thus resist strict comparison.

The artists Jo Baer, Ralph Humphrey, Robert Mangold, Brice Marden, Agnes Martin, Paul Mogensen, David Novros and Robert Ryman, among others, developed a painting of radically simplified form, evident materiality and obvious construction during the 1960s. A few exhibitions, most notably Lawrence Alloway's 'Systemic Painting' at the Solomon R. Guggenheim Museum, New York, in 1966, focused solely on this work. But Minimalism's repudiation of illusion necessarily led to a disavowal of the painting medium by artists like Flavin and Judd. The publication of Judd's influential essay 'Specific Objects' marked this turn of Minimal criticism away from painting in favour of the three-dimensional object.

The question of painting's relevance – or obsolescence – was only one of a number of controversies that raged within Minimal criticism. Even the proper names surrounding this work were under dispute. Initially the objects of Judd, Morris, Andre and others had been called ABC art, Rejective art, Cool

art and Primary Structures. By 1967 'Minimalism' was in common use. As this plethora of labels suggests, the definition of the new art was never stable. Was it sculpture or painting? Both or neither? A single shape or modular sequence? Was it brightly polychrome, as Judd argued, or sternly 'Black, White, and Gray', as the curator Samuel J. Wagstaff, Jr, suggested in his exhibition of that name in 1964? Or did it reflect the 'cool' sensibility of an entire generation of younger artists – including the Pop artists Andy Warhol and Roy Lichtenstein – whose recourse to serial procedures and hard-edged design cancelled signs of emotion? Artists, curators and critics debated these questions at length, each defining the new development in a particular way: there was no coherent 'Minimalism', but different, overlapping Minimalisms.

1959–63 First Encounters

'Art excludes the unnecessary.'

– Carl Andre, 'Preface to Stripe Painting (Frank Stella)', 1959
What was the meaning of the term 'Minimal' as it emerged in the 1960s? While it was never defined, to its detractors it initially implied two kinds of aesthetic lack: on one hand, it suggested an excessive formal reduction, an appalling simplicity (the work's design was pared down to a 'minimum'); on the other hand, it implied a deficiency of artistic labour, a complaint most often levelled at the work of Flavin, made from standard fluorescent lights, at Andre's industrial construction blocks, and at Judd's factory-produced objects. A basic cube, a pile of bricks or a white monochrome canvas offered too little to look at and seemed too easy to make. Presenting itself as formal art – an art of visual complexity in the Modernist tradition of Constantin Brancusi, Pablo Picasso and Jackson Pollock – Minimal work smacked of the readymade, the factory-produced object transformed into art by Marcel Duchamp. When Duchamp placed a bottlerack in a gallery in 1914 he debunked the

Modernist premise of formal innovation: art could be a declaration, an idea. Dissatisfied with the purely 'retinal' effects achieved by such contemporaries as the Cubists or the Fauves, Duchamp proposed a more 'conceptual' art. The readymade, produced in a factory, bore no trace of the artist's hand; it seemed to lack formal complexity and therefore did not resemble a 'work of art'. Minimal art, however, used factory-made objects to achieve formalist-type reduction. It was thus based on an internal contradiction: presenting itself as 'high', formal art, it was not legible as such; it was not art-enough.[14]

To be sure, the reduction of the artwork to its essential structural components and the use of factory production techniques were hardly new. The Russian avant-garde explored similar concerns, although their historical context – the revolutionary Soviet Union of the 1910s and 1920s – is not comparable to 1960s New York. The Russian Suprematist artist Kasimir Malevich developed a painting of radically

Constantin BRANCUSI Bird, 1940
Pablo PICASSO Three Musicians, 1921
Jackson POLLOCK One (Number 31, 1950), 1950
Marcel DUCHAMP Bottlerack, 1914

simplified means in his *Black Square* (1913–15): the large, centred black square inset in a white ground flattens out Cubism's shallow space of interlocking planes. His monochromatic *White on White* (1917) was even flatter, counterpoising a white figure against a white ground. Malevich simplified pictorial organization as never before (he described the *Black Square* as the 'zero-degree' of painting), yet he still pitted a figure against a ground, suggesting a minimum amount of depth.[15] It was left to the Constructivist Aleksandr Rodchenko to go one step further and rid painting of illusionism or reference of any kind, in an effort to align his art with the materialist values of the new Communist culture. Rodchenko described his monochrome triptych *Pure Colours: Red, Yellow, Blue* (1921) as the 'last painting'. Shown in the famous '5×5 = 25' exhibition (1921),[16] this work demonstrated Rodchenko's criticism of the idealism and illusionism of easel painting (its suggestion of a subjectively arranged order or truth) and his identification of art-making with proletarian

of reception to that of previous Western art. Constructivist theory allied the Romantic notion of the artist of nineteenth-century aesthetics with a bourgeois spectator, who allegedly found in the handmade, expressive work an affirmation of his own subjectivity. Even more, it held that the unique art object evoked a contemplative vision, the aesthetic pleasure or expertise of the wealthy connoisseur. Constructivist art voided the work of affect and uniqueness in order to excite a proletarian viewer. Its machine-made appearance and the fact that the work required one to physically activate it in order to complete it were not aimed at aesthetic admiration, but rather at a more physical, interactive response. Vladimir Tatlin sought precisely this effect in his *Complex Corner Relief* (1915), a metal construction suspended from wires that projected into the gallery space, causing an awareness of the actual corner of the room, the presence of the work in three dimensions and the body of the viewer standing before it. Another of Tatlin's works that engage the spectator's body, his famous

labour. Karl Marx's materialist philosophy, the foundation of Soviet socialism, locates the formation of ideas and beliefs in material and economic facts. Thus the Constructivists explored the premises of *faktura* (facture), a revelation of an object's literal materiality, and *konstruktsiia* (construction), an organization dictated by function and the physical nature of the chosen materials.[17] Rodchenko's canvases exemplified these notions: the thickly applied all-over surface highlighted the painting's objectness, while the primary colours generated the work's tripartite structure. As the 'last paintings', the *Pure Colours* marked the moment of transition from painting to the production of objects, from artistic pursuits to practical applications. In the same year Rodchenko produced preliminary models for industrial design, and his contemporaries Varvara Stepanova and Lyubov Popova, who also participated in '5×5', created geometric designs for textile factories.[18]

The Constructivists' alternative mode of production, dictated by function and *faktura*, implied an alternative mode

Monument to the Third International (1921), was to be a tower of rotating structures, moving at different speeds, with the movement dictated by the cycles of the calendar. Intended as a vehicle to transport its socialist inhabitants into a dynamic new Marxist future, this fantastical design was only ever built in model form. Rodchenko's *Hanging Constructions* (1920–21) were physically activated by the presence of the viewer: suspended from the ceiling, where they were subject to the slightest breeze, these delicate works moved in sync with one's movements.[19] The exhibition designs of El Lissitzky also transformed the neutral, white-walled gallery, or white cube, developed by Modernist architects in the 1920s into an interactive environment. In his *Abstract Cabinet* (1927–28) at the Landesmuseum, Hannover, the walls of the exhibition space, lined with vertical wooden slats painted black, grey and white, shifted in tone as the viewer walked past. Abstract paintings hung on movable racks that the viewer altered in order to select what would be seen.[20] Forty years later the Minimal

artists would also create a dynamic and embodied viewing experience, inspiring writers to explore analogies between Constructivist and Minimalist practice. Constructivism's use of materials for their innate properties, rather than to refer to something else (such as the carving of marble to make it resemble drapery), its depersonalizing of artistic procedure through the use of industrial production and its activation of the beholder were central concerns of Minimalism as well. However, within the context of 1960s New York, these radical innovations no longer carried the revolutionary political meaning they once possessed.

The Minimal artists were not well informed about their avant-garde precursors, largely due to the suppression of Constructivism during the Cold War by both the US and the Soviet Union.[21] The Director of New York's Museum of Modern Art, Alfred Barr, purchased works by Malevich, Rodchenko, Lissitzky and others during a trip to Russia in 1928, thus introducing key examples of Suprematism and

Constructivism into the Museum's collection. Although these works were admired by Andre, Flavin and Stella, they were little understood. It wasn't until the publication of Camilla Gray's *The Great Experiment in Art: 1863–1922* in 1962, the first English-language history of the Russian avant-garde, that the Americans began to understand this history in any depth.[22] Dan Flavin's series of white fluorescent works, *Homages to Vladimir Tatlin* (begun in 1964), Robert Morris' allusions to Tatlin and Rodchenko in his text 'Notes on Sculpture',[23] and later essays by Donald Judd on Malevich and his contemporaries reveal a growing fascination with this avant-garde legacy.[24]

One might imagine that the monochromatic paintings of Ellsworth Kelly and Ad Reinhardt of the 1950s inspired the younger generation of Minimal artists. However, the monochromes Kelly developed in Paris during the early 1950s were largely unknown to the younger artists who only knew his New York work of the late 1950s and early 1960s, which introduced

'organic' shapes and figure/ground play.[25] The subtle illusionism of Reinhardt's 'black' paintings caused his work to have a limited impact on Judd or even Stella.[26] In truth, the work of the neo-Dada artists Jasper Johns and Robert Rauschenberg, and the Abstract Expressionists Barnett Newman and Mark Rothko had a more direct impact, and indeed, individually, the Minimalists developed independent readings of these and other contemporary sources. The path from painting to sculpture in the work of Judd, Flavin, Truitt and others was hardly direct: each artist was motivated by individual concerns, and arrived at a unique destination.

Most accounts of Minimalism rightly begin with Frank Stella's *Black Paintings*. Exhibited in '16 Americans' at The Museum of Modern Art, New York, in 1959,[27] Stella's works announced a turn away from the gestural action painting of the previous generation. Avoiding the rhetorical brushwork of artists such as Willem de Kooning and Franz Kline, which fostered an illusion of spontaneity and individualism, Stella

painted in a methodical manner, filling in regulated patterns with even strokes. Stella's patterns were made up of 6 cm [2.5 in] bands whose width mimicked that of the painting's stretcher bars; the patterns themselves were deduced from the canvas' shape.[28] For example, a vertical rectangle could be divided symmetrically in half (*Arundel Castle* [1959]), (*Marriage of Reason and Squalor* [1959]) or into four quadrants (*Die Fahne Hoch!* [1959]). Simply conceived, the *Black Paintings* aspire to reveal nothing more than the mode of their own organization. As Andre observed in 'Preface to Stripe Painting (Frank Stella)', 'Stella is not interested in expression and sensitivity. He is interested in the necessities of painting.'[29] For Stella, painting stripes on a canvas was a valid enough act in its own right. There was, Andre claimed, 'nothing else' in his work.

Stella did not reject Abstract Expressionism outright. Rather, he and the other Minimalists turned their sights away from the painterly wing of the New York School (de Kooning,

Aleksandr RODCHENKO Hanging construction, 1920–21
El LISSITZKY Sketch for Abstract Cabinet, 1927–28
Ellsworth KELLY White Square, 1953
Ad REINHARDT Black Painting No. 34, 1964

20

SURVEY

Kline) towards the field painters Barnett Newman and Mark Rothko. The *Black Paintings* recalled the mural scale and symmetrical format of a work like Newman's *Onement I* (1948), but rejected Newman's grand allusions. Where Newman sought to produce an art that transcends its object-ness and points to religious and mythical themes, Stella made the experience of materiality concrete: the paint as paint, the canvas as canvas. In Newman's paintings the thin stripes, called 'zips', flicker against the ground. Stella's stripes, executed in mat latex, lie flat on the canvas, pointing not to a Beyond but to their own congealed presence.

Stella's method also bore some relation to Rauschenberg's *White Paintings* (begun 1951), a series of monochromes premised on an additive logic: the first was a single canvas, the second a diptych and so on (the set concludes with the seventh painting). Casually executed in the same hue, one after the next, the *White Paintings* were purged of subject matter: their concern was nothing more than their

Barnett NEWMAN Onement I, 1948
Robert RAUSCHENBERG White Painting, 1951–68
Jasper JOHNS Three Flags, 1958

own making. In this respect, Rauschenberg's works recalled the aesthetics of process developed by John Cage, a composer who had a considerable impact on younger American artists during the 1950s.[30] In Cage's music, the 'finished' work of classical composition is replaced with an arbitrary, self-exhausting scheme. His most notorious piece, *4'33"*, required the composer to sit in front of the piano for the allotted time without striking a chord, dashing the audience's expectation of a well-wrought work; instead, the restless movements, coughs and whispers of the listeners became the work's focus. But most of all Stella was affected by the early work of Jasper Johns, which brought these process concerns specifically to bear on the problem of pictorial organization. Johns' *Flags* (begun 1954) reduced artistic decision making to the reproduction of an iconic image of repeated stars and (most generative for Stella) stripes. In his *Number Paintings* (1958–59), a sequence of counting numbers arranged in a grid dictated the work's design. For Stella, the no-nonsense logic

of Johns' approach presented a strong alternative to the action painters' 'spontaneous' displays of feeling.[31]

Andre claimed that Stella's work was 'not symbolic' and indeed the Minimal aesthetic fervently rejected allusion.[32] However, the *Black Paintings*, as transitional works emerging from Abstract Expressionism, do contain a residue of subject matter, later erased by the Minimalists.[33] The titles in the series refer to various twentieth-century disasters and 'down-beat themes'; their blackness suggests a Motherwellian pathos, as well as a Beatnik posture of negation.[34] *Morro Castle* (1958), a title supplied by Andre, was the name of a sunken ship; *Getty Tomb* (1959) alludes to a famous mausoleum designed by Louis Sullivan; *Die Fahne Hoch!* (1959) and *Arbeit Macht Frei* (1958) were Nazi slogans; *Seven Steps* (1959) and *Club Onyx* (1959) were the names of lesbian and gay bars in Manhattan, extremely marginal places in the intensely homophobic 1950s.[35] It wasn't until he developed the *Aluminum* and *Copper Series* (1959–61) that Stella expunged this tragic subject matter. Metallic stripes were laid down with machine-like precision. Incisions along the edge or in the centre of the canvas stressed the painting's shape and revealed the wall. The Stella canvas was nearly a relief. Judd wrote approvingly in a 1962 review: '*Criticism is pretty much after the fact. Frank Stella's paintings are one of the recent facts. They show the extent of what can be done now … The absence of illusionistic space in Stella, for example, makes Abstract Expressionism seem now an inadequate style, makes it appear a compromise with representational art and its meaning.*'[36]

It is hard to overstate the impact of Stella's early work on the Minimalist generation. Stella's material surfaces, clarification of process and invention of the shaped canvas were signal developments. Though his work elicited immediate attention, Stella was not unique in developing a Minimal-type painting in the late 1950s, when artists like Ralph Humphrey and Robert Ryman had begun to explore monochromatic formats. Humphrey's early work had thick all-over surfaces, using paint as paint to fill out the canvas rather than as a gestural embodiment of emotion. (Admittedly, his brushwork was more random than Stella's stripe patterns.) Based on a

dominant hue, Humphrey's paintings achieved subtle variations of tone through the admixture of a secondary colour, yet their all-overness cancelled any suggestion of illusion. In an early review, Donald Judd praised the '[raw] ... unique immediacy' of Humphrey's work. Where some critics found Humphrey's paintings 'too simple', Judd suggested that the spareness of Humphrey's formats focused attention on the canvas itself and the simple act of perceiving it.[37]

Ryman also began to produce monochromatic works in the late 1950s; like Humphrey, he applied individual strokes of paint within an all-over format (his first acknowledged painting, *Untitled* [*Orange Painting*] [1955–59], has various shades of a single hue). But Ryman soon enlarged his method, exploring the essentials of the medium through other means: inscription of text (the date or artist's signature), variation of brushstrokes in the same work and use of wallpaper, tracing paper or unstretched linen with raw edges, unconventional materials that stressed the literalness of the

vein, producing gestural drawings brimming with sentiment. In his personal testament, ' ... in daylight or cool white' (1964), Flavin describes seeing a postcard of 'a ten-year old painting by Robert Motherwell which looked strikingly like my last week's work'.[38] In 1961 he abandoned this tragic, Motherwellian mode, and began to produce painting-reliefs that incorporated found objects, including crushed cans. Executed in thick paint applied to masonite, *Apollinaire Wounded* (1959–60) and other similar works stress the painting's physical support. It is perhaps not coincidental that Flavin began to use assemblage, or combining formats – developed by Robert Rauschenberg, Jasper Johns, Jim Dine and others – at this time, while working as a guard at The Museum of Modern Art. The Museum's 1961 exhibition 'The Art of Assemblage', curated by William Seitz, featured these artists.[39] A mixture of painting and relief, the combine introduced found objects within a pictorial or sculptural format, such as in Rauschenberg's *Odalisque* (1955–58) which incor-

Robert MOTHERWELL At Five in the Afternoon, 1949
Robert RAUSCHENBERG Odalisque, 1955–58
Jasper JOHNS Target with Four Faces, 1955
Jim DINE Wiring the Unfinished Bathroom, 1962

support. As he began to paint in white exclusively and adopt serial formats (in works like *A painting of twelve strokes measuring 11 1/4" × 11 1/4"* [1961]), Ryman regularized the process of painting to an extraordinary degree. Rather than paint in order to express a content or motif, he demonstrated that the simple task of covering a canvas in repeated brushstrokes could stand as the work's 'subject'.

Where Stella, Humphrey and Ryman developed a pared-down, non-illusionistic abstract painting (as would Jo Baer, Robert Mangold, Brice Marden, Paul Mogensen and David Novros), the Minimal object-makers admired the material presence and organization of the new painting precisely because it seemed to spell the medium's conclusion. Dan Flavin and Donald Judd in particular perceived Stella's works as the 'last' paintings that could be made: because the *Black* and *Aluminum Series* rendered illusion and handmadeness passé, they necessarily pointed to the production of objects.

Dan Flavin initially worked in an Abstract Expressionist

porates a rooster and a flickering light bulb. Flavin's *icon* series (1962) also includes incandescent and fluorescent lights, and was the first of his works using what became his signature material. In *icon V* (*Coran's Broadway Flesh*) (1962), the largest and most realized of the group, clear incandescent 'candle' bulbs surround a square sheet of pink masonite, creating a lambent glow that both highlights the work as an object and lifts it off the wall.[40] The works of unmodified fluorescent tubes he began to produce in 1963, such as *the diagonal of May 25, 1963 (to Robert Rosenblum)*, explore this tension of materiality revealed and disassembled. Exhibited on supporting pans with exposed electrical cords, Flavin's lamps are clearly industrial objects, yet the light they project causes the fixtures to dissolve in a pool of intense colour.

Flavin's friend, Sol LeWitt (the two artists met as co-workers at The Museum of Modern Art, New York) also worked in a relief format in the early 1960s. *Wall Structure, White* (1962) and *Wall Structure, Black* (1962) are seemingly

straightforward constructions of masonite and wood. Perfectly square, with thickly painted oil surfaces, LeWitt's works highlight their organization; yet the attached peepholes at their front confound this literalist effect, inviting the viewer to peer into darkness and occluding his or her vision. Other early works by LeWitt reveal the artist's growing fascination with serial method, prompted by the serial images of human and animal locomotion recorded by the nineteenth-century photographer Eadweard Muybridge. These tentative efforts would lead to a more conscious integration of systemic logic by LeWitt in his Minimalist structures of the later 1960s which, based on complex mathematical calculations, manifest the progressive development of a given shape or idea.

Donald Judd began a remarkable sequence of paintings in Liquitex, oil and sand, and reliefs built of aluminium, masonite and wood in the early 1960s.[41] Arranged in simple combinations – a sheet of plywood placed between two cornices, for example – these works made clear their method

Eadweard MUYBRIDGE The Attitudes of Animals in Motion, 1881
David SMITH Cubi XiX, 1964
Anthony CARO Twenty Four Hours, 1960

of construction. The largest of these, *Untitled* (1962), adopted the mural-sized scale and symmetrical formats explored by Newman and Stella. Judd observed in 1965 that, 'The main thing wrong with painting is that it is a rectangular plane placed flat against the wall ... In work before 1946 the edges of the rectangle are a boundary, the end of a picture.'[42] Easel painting – or 'European' painting, as Judd called it – was structured on a relational balancing of parts, or a compositional hierarchy. In contrast, the most radical recent painting was based on either a non-hierarchical all-over pattern or predetermined symmetrical divisions. The drip paintings of Jackson Pollock or Newman's vast canvases were legible as 'whole' images, 'intense, clear and powerful'.[43] Where European painting depended on illusionistic space, the new American painting was a unified, literal entity.

Judd next abandoned painting altogether for 'real space'.[44] Three dimensions did not alone guarantee the literal quality he sought, and indeed Judd disliked the work of such

prominent sculptors as David Smith and Anthony Caro, premised on a Cubist balancing of parts. For Judd, the tradition of welded sculpture they exemplified, ultimately derived from Cubist collage, was essentially pictorial. He believed that it was necessary for sculpture to assimilate the flat, rich colour, simple design and scale of the new painting. Judd's earliest objects were coloured cadmium red light (for its visual impact) and built by the artist using industrial materials, including Plexiglas, galvanized metal and plywood. His first solo exhibition, held at the Green Gallery, New York, in the fall of 1963, consisted only of these red works, creating a strong impression. It received favourable reviews from such influential critics as Michael Fried and Sidney Tillim, and established Judd as a leading representative of this emerging literalist tendency.

Among the Minimal sculptors, Andre had the closest relationship with Stella. A classmate of Stella's at Phillips Academy, Andover, Andre had been present during the execution of the *Black* and *Aluminum Paintings*, and cut his first sculpture in Stella's studio in 1959.[45] What did Stella represent for Andre? Unlike Judd and Flavin, Andre did not begin as a painter; he identified himself as a sculptor from early on, and thus was not leaving painting behind in some sort of radical departure into 'real space'. As Andre later recalled, 'It was not basically the appearance of Stella's paintings that influenced me, but his practice'.[46] In other words, Stella's canvases suggested a planned, predetermined way of building sculpture by means of methodically repeated forms. Andre's *Ladders* of 1959 were made of wooden beams with a succession of notches carved repeatedly on one side,[47] and his following series, the *Pyramids* of the same year, were built of identical, stacked, notched beams of progressive length.[48] As he simplified his technique he began to lay blocks of wood directly one upon another or upon the floor. In the *Elements Series* (1960/71) the beams in *Pyre* (1960/71) and *Trabum* (1960) are stacked; in *Inverted Tau* (1960) and *Angle* (1960)

they are placed one on top of the other. The most striking of the *Elements* is *Herm* (1960), which, because it consists of only a single block of wood, bypassed the need for joining or stacking altogether. Released from structural necessity, *Herm* stands alone, subject to gravity's pull. The purest demonstration of Andre's materialism, it manifests the sculptor's desire to reveal 'wood as wood and steel as steel, aluminium as aluminium, a bale of hay as a bale of hay'.[49]

In the art of Andre, Flavin, Judd and Stella, a simplification of format and technique implied that the work harboured no meaning beyond its material components and the facts of its construction. Andre wrote there was 'nothing else' in Stella's art apart from the painted stripes; Stella claimed that in his work 'what you see is what you see'. Abstract Expressionists like Newman and Rothko purged their work of extraneous elements in order to develop an art of transcendental immediacy. Rothko, in a famous statement, argued that only enlarged, simple shapes could convey a 'tragic and timeless'

subject matter.[50] The Minimalists, however, rejected the metaphysical claims of the Abstract Expressionists. Admiring the simplicity and scale of Newman and Rothko's work, they studiously avoided the older generation's grandiose themes. Even so, there were some artists associated with Minimalism who did not discount the expressive potential of pared-down abstraction. Artists Agnes Martin and Anne Truitt, included in the key Minimal shows during the 1960s, admitted subjective experience into their work. At a time when firm definitions of 'Minimalism' were hardly clear, Truitt and Martin seemed to share certain formal affinities with the canonical Minimal artists.[51] Truitt developed a sculpture of unbroken geometric shapes resembling columns and barriers, while Martin produced austere canvases of repeated marks arranged in a grid. However, although their work looked like Minimal art, and was selected by curators for Minimal exhibitions, neither had adopted the literalist agenda key to Minimalism and both retained some form of allusion.

Agnes Martin's earliest Minimal-type painting dates from 1960–62. Executed in graphite, watercolour and washes of ink and acrylic, these delicate and idiosyncratic canvases are the antithesis of Stella's bold compositions. In many works, uneven lines trace the web of the cotton support; the brass

nails in *Untitled* (1962) follow a grid matrix, yet their ever-so-slightly off alignment suggests an arbitrariness and handmadeness in complete opposition to literalist method. (In Judd's reliefs of the same year, the nails line up with exacting precision.) Instead of revealing the work's organization as material and evident, the all-over patterns point to a transcendent world order.[52] Though her vision of absolute harmony could not be further removed from Rothko's tragic themes or Newman's sublime terror, Martin also holds fast to the Abstract Expressionists' belief that abstraction must point beyond mere material facts, and in this contrasts with the literalist Minimalists such as Andre, Morris and Judd.

Where Martin posits a notion of abstraction as a universal language, Truitt devised a geometric sculpture rooted in personal memory. Her earliest works include *First* (1961), which recalls the picket fences of her home town of Easton, Maryland, and *Southern Elegy* (1962) which mimics the profiles of local tombstones. Though 'Minimal' in appearance, Truitt's practice holds a unique position within the field of Minimal art. Where much Minimal work renders colour and literal shape congruent, Truitt's sculpture retains a measure of arbitrariness: in many works, the colour planes overlap adjacent shapes. Even more, her work is hand-painted, not factory-made. Truitt's allusive content and intuitive approach thus opposed the literalist impulse of much Minimal art. Judd, assessing her first one-person show in 1963, was not charmed by her allusions to tombstones and her instinctive use of colour, but his opinion wasn't widely shared at the time. Truitt's exhibition at New York's Andre Emmerich Gallery won the support of the influential critics Clement Greenberg and William Rubin (curator at The Museum of Modern Art), and the eminent Abstract Expressionist sculptor David Smith. As the 1960s unfolded, however, and Judd's literalist views predominated, Truitt's expressive aims came to seem retrograde.

Robert Morris also fits uneasily in Minimalism, albeit for different reasons. Where much Minimal work developed in response to painting or sculpture, Morris' objects emerged from his involvement in performance. A member of the Judson Dance Theater in Greenwich Village along with dancer/choreographers Trisha Brown, Lucinda Childs, Simone Forti and Yvonne Rainer, Morris initially built plywood pieces as stage props. *Column* (1961), a work exhibited in his first show at the Green Gallery (1963), was originally meant to be a container

Anne TRUITT First, 1962

for a body.[53] *Box with the Sound of Its own Making* (1961), a wooden cube containing a recording of a pounding hammer, forced the viewer to re-experience the work's construction by the artist. Morris described such works as *Column* and *Box with the Sound of Its own Making* as 'Blank Forms', 'essentially empty' sculptures with nothing to say.[54] Like the *White Paintings* of Robert Rauschenberg or Jasper Johns' *Numbers*, *Box with the Sound of Its own Making* suggests the aesthetic of the composer John Cage, whose performances are emptied of feeling and allusion. For Morris, the Minimal work began as the pretext for a bodily encounter; it is a thing to use more than something to look at, a stage prop rather than the finished work of art favoured by Judd, Stella and Flavin, primarily directed to the viewer's gaze. In the years to come, he explored the nature of this encounter in his essay 'Notes on Sculpture', developing a theory of sculpture that remains influential to the present day.[55]

balance: the artist puts 'something in one corner' and 'something in the other', resulting in a harmonious composition. Non-relational organization – the wholistic method of Stella, Judd and Flavin – dispenses with the necessity for compositional harmony. Stella's *Stripe Paintings* are the result of predetermined patterns, symmetrical divisions and shapes, not elements poised in counterbalance. According to Judd, this apparently more direct way of working implied something beyond a shift in technique. Compositional balance was an objectionable relic of 'European' art and its 'rationalistic' philosophy. European painting and sculpture impose a fiction of total comprehension, suggesting that it is possible to represent the world in a singular, coherent and truthful manner. Renaissance one-point perspective typifies this compositional approach, orchestrating the scene in conformity with the spectator's gaze: in a Leonardo or Poussin, every element is carefully arranged in a receding space. Cubism shallowed out perspectival depth, yet retained a

Yvonne RAINER *Film About a Woman Who ...*, 1974
Piet MONDRIAN *Composition C*, 1920
Pablo PICASSO *Violin and Grapes*, 1912

1964–67 High Minimalism

'There isn't anything to look at.'
– Donald Judd, 'Black, White, and Gray', 1964

During the mid 1960s all of the leading Minimal object-makers – Morris, Andre, Judd, Flavin, LeWitt, Truitt, Bell and McCracken – had one-person shows.[56] Mangold, Baer, Marden and Novros started to exhibit work that they had been developing since the early 1960s. As critics began to review and discuss the impact of these exhibitions, the impressions of the early 1960s consolidated into clearer accounts of this emerging development, and indeed the mid 1960s saw the publication of several essays that helped to clarify what came to be known as Minimal art.

In a radio interview conducted by critic Bruce Glaser with Stella, Judd and Flavin in February 1964, a common point of view linking these artists emerged. All of these artists agreed on the distinction between relational and non-relational method. As Stella explained, relational work is premised on

pictorial coherence: the most abstract Picasso depicts something – a figure or still-life – even as it radicalizes the mode of depiction, fracturing the image into many parts. Even Mondrian's abstract canvases of the 1920s were perfectly balanced arrangements, reflecting the artist's theosophical conviction in an underlying world harmony.

It was Judd's opinion that the new American art was more 'advanced' because it did not posit a rational viewer who can discern an ideal order, only one who perceives simple material facts. Prompted by Greenberg and other critics who touted Abstract Expressionism in chauvinistic terms, Judd dismissed centuries of European culture with arrogant assurance. Yet he and Stella were hardly unique at the time in claiming there was no underlying meaning to things, no truth apart from one's immediate encounter with empirical reality. In the French New Novel developed by such writers as Alain Robbe-Grillet and Nathalie Sarraute during the 1950s, for example, narrative climax is absent; expression is negated;

and the reader discerns 'nothing' beyond the narrator's flat descriptions of situations and events. Stella's famous observation to Glaser, 'what you see is what you see',[57] suggests that his work harbours no meaning apart from the facts of its construction. In *For a New Novel* (1965), a discussion of this new type of fiction, Robbe-Grillet similarly observes, 'If art is something, it is everything, which means that it must be self-sufficient and that there is nothing beyond'.[58]

In her seminal essay 'Against Interpretation' (1964), cultural critic Susan Sontag argues for a criticism responsive to this new aesthetic, which she equates with a variety of practices on either side of the Atlantic: Robbe-Grillet's fiction, the New Wave cinema of Alain Resnais and the neo-Dada/Pop of Warhol and Johns.[59] Artists and writers in both Paris and New York were engaged in developing an art concerned with unmasking metaphysical certitudes. According to Sontag, criticism should describe the work as it is sensually experienced by a reader or viewer rather than attempt to decode its

underlying meaning. Purged of unnecessary detail, the new art had rendered its form transparent; hence it required a purely formal approach.

'Black, White, and Gray', at the Wadsworth Atheneum in Hartford, Connecticut in 1964, was one of the first shows to examine this new aesthetic.[60] According to the curator, Samuel J. Wagstaff, Jr, an 'affinity' bound together this widely diverse group of artists, which included Pop artists such as Andy Warhol and Robert Rauschenberg and Minimal artists such as Dan Flavin, Robert Morris and Frank Stella. Most of the works incorporated simple, hard-edged shapes; all were executed in black, white and grey, a palette allegedly devoid of feeling.[61] As Wagstaff suggests, the new art was informed by two legacies. On the one hand, he cites the Modernist tradition of formal reduction, exemplified in the exhibition by Newman's and Reinhardt's abstract canvases. On the other, he allies the new art – so apparently indifferent to the traditional premise that art emerges from the hand of the artist –

to the Dada heritage of Duchamp and Cage, observing that 'Much of [it] is idea art, as opposed to the retinal or visceral'.[62] As Wagstaff implies, the art in 'Black, White, and Gray' exists on the cusp between the Modernism and Dada, deriving from both the formal and conceptual traditions of twentieth-century art.

Donald Judd found it difficult to accept those works in the show whose drastic simplicity seemed to undermine their status as visual art. Even so, in his review of 'Black, White, and Gray', Judd had to admit that the work does 'exist after all, as meagre as [it is].'[63] Robert Morris and Robert Rauschenberg in particular had developed an art so 'minimal' that it blurred the distinction between Modernism's tendency to formal reduction and Dada's challenge to the definition of art as it had been known. Rauschenberg's *White Paintings* and Morris' bland, grey cubes offered little to 'look at', Judd wrote. In contrast, Judd sought a more deliberate formal complexity in his own work, opting for polychromy, varied materials and highly finished surfaces: there was no question that what he was making was 'fine art'.

Judd elaborated this point of view in 'Specific Objects', commissioned by *Arts Magazine* as a wrap-up of contemporary work in New York in 1965.[64] Though ostensibly a long review, its pronouncements became tremendously influential, and this text is often viewed as Judd's manifesto. He proposes an innovative art that is 'neither painting nor sculpture', combining the intense colour and simple design of recent American painting with the use of brand-new materials, such as Plexiglas, steel, iron and plastic. He also advocates a serial distribution of parts, 'one thing after another', that dictates the work's organization in advance of its production. One could easily surmise that Judd is basically advocating his own work, and to a certain extent he is, but a closer examination reveals that an extraordinary variety of practices enter his discussion. Having worked as a reviewer since 1959, Judd had a wide-ranging knowledge of contemporary art; he

Alain RESNAIS *Last Year in Marienbad*, 1961
Andy WARHOL *Brillo (Boxes)*, 1964
Robert RAUSCHENBERG *Retroactive II*, 1964
Robert RAUSCHENBERG *Almanac*, 1962

discusses the work of Flavin, Newman and Stella in relation to the unlikely and very different practices of John Chamberlain and Claes Oldenburg. Judd does not specify that the Specific Object is necessarily an abstract cube or relief: Oldenburg's soft sculptures resemble real things, such as ice cream cones or hamburgers, but their scale, simplified shapes and synthetic materials relate to Judd's own work. Chamberlain's sculpture made up of crushed metal rejects the part-by-part welding of late Cubist sculpture, such as that of David Smith. Often made from a single sheet of aluminium compressed into a single shape, Chamberlain's works read as whole, distinctive forms. Other practices are less specific. Rauschenberg's work certainly qualifies as 'neither painting nor sculpture', but its relational arrangement of elements is still mired in a collage aesthetic. (When Rauschenberg adopted the photo silkscreen in the early 1960s, his work was all the more pictorial, and therefore objectionable, from Judd's point of view.)

Rose locates these practices within a broader cultural field, citing a *melange* of literary and philosophical sources current in New York intellectual circles, including the widely varying writings of Alain Robbe-Grillet, Samuel Beckett and Ludwig Wittgenstein. The appearance of these citations opened up Minimal criticism to concerns beyond the purely formal or visual. Though loosely applied, Rose's epigraphs are an unusual presence in an art text during a time when close visual analysis, as practised by the Modernist critic Clement Greenberg, reigned supreme. Much Minimal criticism would continue to address formal interpretations of the work, but in the wake of Rose's text, social and philosophical reflection increasingly played a part.

Although Rose declared her support for Minimal work early on, other critics were more equivocal. The reception of early shows associated with the movement was mixed: the work of one artist looked more 'acceptably' Minimal than another's. Robert Morris' installation at the Green Gallery

(New York) in 1964 was praised by Lucy R. Lippard, David Bourdon and others who marvelled at the way he revealed the gallery space with simple, grey shapes.[68]

'Specific Objects' established a common formal vocabulary for discussing the new work. In 'ABC Art' (1965), critic Barbara Rose also identified a variety of art historical sources informing Minimal practice.[65] Like Wagstaff, Rose suggested that Minimal work partakes both of the Modernist impulse of formal reduction – exemplified by Malevich's *Black Square* – and the Duchampian readymade's 'kinship to the world of things'. Rose was less concerned with formal specifics than Judd, however, and instead related the new art to a sensibility of 'reserved impersonality'.[66] Her discussion encompasses a variety of styles and media: the geometric forms of Robert Morris, Donald Judd, Carl Andre, Dan Flavin, Anne Truitt and Ronald Bladen; the optical abstraction of painters Walter Darby Bannard and Larry Zox; Pop art; the real time music of John Cage and La Monte Young; and Andy Warhol's anti-narrative cinema. The dance of Merce Cunningham and Yvonne Rainer, whose repeated movements abrogate narrative focus and climax, is another reference.[67] Furthermore,

In contrast, Dan Flavin's early shows of fluorescent lights, at the Kaymar and Green Galleries (both New York), met with confusion. Lippard acknowledged Flavin's desire to make 'fine art' using commercial lamps, but remained unconvinced that he had succeeded in doing so.[69] Bourdon's review was particularly cruel.[70] It describes how after visiting Flavin's show, he is 'startled by the window display' at a local lighting company which looked like Flavin's show in the gallery across the street. The only difference between Flavin's installation and the store display was that Flavin's tubes had been 'put into an art context'. Like Lippard, Bourdon interpreted Flavin's art as a Duchampian gesture: by placing the readymade lamp in a gallery, Flavin declares its status as art. Poor Flavin! As his statement ' ... in daylight or cool white'[71] suggests, he viewed the fluorescent tube not as a conceptual declaration but as the formal vocabulary of an installational art. Rejecting the pictorial format of his earlier *icons* made of painted canvases and lamps combined, he used the lamp

alone to illuminate and disrupt the gallery's parameters. However, during the early 1960s, even the most open-minded critics doubted whether his arrangements could qualify as 'high art'.

Andre's work was also interpreted as a Dadaist exercise. His first exhibition, of stacked polystyrene beams, at Tibor de Nagy Gallery (New York) in 1965, completely filled the gallery space, eliciting comparisons to architecture. Although Lippard acknowledged the physical impact of Andre's works, however, she characterized the show as a conceptual installation. '[Andre's] exhibition at Tibor de Nagy, in this day of conceptual extremism, was one of the most extreme events.'[72] She felt that Andre's method of stacking the units without building a permanent structure implied that the show was the demonstration of an idea: the actual polystyrene beams were beside the point. For Andre, materials are unique. His practice, though interpreted as Conceptual art, is in fact staunchly materialist; the works he developed at this time expose matter

for its own sake, avoiding sculptural techniques that impose an extraneous conceptual or figurative schema (welding, carving, etc.) Years later, Andre distanced himself 'from any Conceptual art or even with ideas in art', insisting that his work springs from his desire to 'have things in the world'.[73]

Just as some viewers perceived an underlying Conceptualism in Andre's work, there were also doubts about Judd's literalist claims.[74] In his essay 'Donald Judd', commissioned for the catalogue of a show at the Philadelphia Institute for Contemporary art in 1965, fellow artist Robert Smithson noted that, 'It is impossible to tell what is hanging from what or what is supporting what. Ups are downs and downs are ups. An uncanny materiality inherent in the surface engulfs the basic structure.'[75] Judd equates these industrial materials – steel, aluminium and Plexiglas – with material specificity, denying the possibility of illusionism. But Smithson challenges Judd's views. Delighting in the gorgeous reflections of these materials, he implies that Judd's embrace of the factory has resulted in works that undermine their specificity: the meticulously finished surfaces of Judd's metal and Plexiglas boxes make them hard to read. In a 1966 essay,

critic Rosalind Krauss also notes this contradiction, discussing how his work derives its power from 'a heightening of illusion', the antithesis of Judd's stated intention.[76] As critics began to look carefully at Minimal practice during the 1960s, they discerned a disparity between the artists' claims and the perceptual experience of the work itself. At the same time, early understandings of Minimalism were challenged as the field of Minimal art evolved and incorporated new practices.

The art of Larry Bell, for example, transformed the visual effects of the Minimal object in new ways. A member of the circle of artists associated with the Ferus Gallery, a centre for avant-garde activity in Los Angeles, Bell worked in a gestural, Abstract Expressionist manner during the late 1950s. An encounter with the artist Robert Irwin, his professor at the Chouinard Art Institute (now CalArts), altered his course. Dissatisfied with his efforts as an action painter, Bell turned his attention to the production of perceptual effects. Starting in 1960, he developed a series of shaped canvases whose irregular polygons and isometric painted figures mimicked and countered the shape of the support, creating false perspectives and optical conundrums. In some works, inserted panes of glass complicated these visual trickeries. Bell then began to make glass sculpture in which illusionism was no longer a matter of depiction, but a perceptual effect of the materials themselves. His early glass and mirror cubes, like *Bette and the Giant Jewfish* (1963), are decorated with etched geometric figures, checkerboards and stripes; by the mid 1960s, they consist entirely of unadulterated glass panes. Tinted in a vacuum chamber, a mechanism that chemically binds vaporized metal to glass, Bell's cubes induce a range of evanescent perceptual qualities.[77]

Classic examples of the so-called Finish Fetish/Light and Space aesthetic of 1960s Los Angeles – which emphasized the illusionistic qualities of shiny, synthetic materials including fibreglass, cast acrylic and polyester resin, and Harley Davidson lacquer – Bell's work has been mythically linked to a culture of cars, plastics and surfboards, and the streamlined aesthetic of the aerospace and defence industries that flourished in Southern California during this period.[78] (In fact, unlike some of his contemporaries, such as the artist Billy Al Bengston who produced highly finished fibreglass reliefs resembling surfboards, Bell was not interested in automobile and surfer culture.) Critics have often

Robert IRWIN Untitled, 1965–67

distinguished Finish Fetish work from New York Minimalism, opposing the pastel hues and illusionism of the work of Bell and McCracken – organically linked to the light and expansive space of Southern California – to the sober palette and plain materiality of Morris and Andre. Certainly, Bell's tendency to 'dissolve the construction into shimmering harmony', to quote John Coplans, opposed the avowedly literalist aims of East Coast artists. However, comparisons of individual works reveal overlapping formal effects. Judd was just as likely to use Harley Davidson lacquer as the Californians, and he, Morris and Smithson shared Bell's predilection for reflective glass (see Morris' *Mirrored Cubes* [1965], or Smithson's *Enantiomorphic Chambers* [1964] and *Glass Strata* [1966]). The East Coast/West Coast divide was hardly an absolute.[79] Southern Californians were familiar with New York-based work through art magazines. Bell and McCracken began to show in New York in the mid 1960s and established friendships with the New York Minimalists.[80] As McCracken has

Billy Al **BENGSTON** Carburetor 1, 1961
David **ANNESLEY** Orinoco, 1965

observed:

'*I decided to go to Los Angeles first, because things were really happening there ... but I was paying primary attention to the New York art world ... I felt like the main conversation I was in was with people like Don Judd, Bob Morris, Dan Flavin, Carl Andre and so on.*'[81]

McCracken began to produce Minimal-type sculpture in 1965, having first painted, in 1963–64, a series of hard-edged canvases featuring simplified, heraldic figures – arrows, crosses and chevrons – reminiscent of the Suprematist paintings of Kasimir Malevich and the diagrammatic works of Robert Indiana. His first sculptures, a series of reliefs which he exhibited at the Nicholas Wilder Gallery in 1965 (Los Angeles), were brightly polychrome and built of sheets of masonite coated in layers of automotive lacquer. Other early works alluded to ancient architectural forms such as lintels, pyramids and columns derived from ancient Egyptian architecture. Increasingly, McCracken's shapes became simpler,

his surfaces more polished. He began to use fibreglass for its consistent finish, and in 1966 developed his famous untitled series of highly finished wooden planks. Individual sheets of plywood painted a single hue, these works were viewed by many as the final stage in Minimal art's asymptotical process of formal simplification: a final 'minimum'. Like Andre's *Elements* and Flavin's *Nominal Three*, these works may be counted among the boldest examples of Minimalist 'reduction' of the 1960s.[82]

The show 'Primary Structures', curated by Kynaston McShine at the Jewish Museum, New York, in 1966, heralded the Minimal movement to a broader public. In addition to the artists typically associated with Minimalism – Carl Andre, Dan Flavin, Donald Judd, Sol LeWitt and Robert Morris – it also included figures more tangentially associated with the movement, such as Larry Bell, John McCracken, Robert Smithson and Anne Truitt. The presence of British sculptors such as Anthony Caro, David Annesley and Michael Bolus, whose welded, part-by-part works Minimal work opposed, also demonstrated the general vitality of sculpture at this time. 'Primary Structures', considered the most important show of Minimal art of the 1960s, was actually a broad survey of recent sculpture. Judd, in 'Complaints: Part I', recalled his displeasure with the exhibition which 'started out a year earlier with Flavin, Morris, myself, maybe Andre and Bell' and was transformed into a show with forty-odd artists, many of whom 'had become geometric during that year'.[83] Whom did he mean? Perhaps Judy Chicago, whose *Rainbow Pickets*, a row of prismatically coloured planks arranged in descending height order, suggested a recent assimilation of Minimal style, or Ronald Bladen, whose overscaled *Elements*, three 274-cm [9-ft] rhomboids leaning at a 65-degree angle, dominated the gallery in which the works of Judd and Morris were exhibited. Numerous works by other, younger artists crowded the halls of the Jewish Museum; 'Minimal art' was definitely undergoing an expansion, contaminating the severe (if contrasting) restrictions of Judd, Morris *et al*.

As Minimalism grew in notoriety, some critics attempted to create an artistic hierarchy. Artist and critic Mel Bochner, in his essay 'Primary Structures' published in *Arts Magazine*, hailed Andre, Flavin, Judd, LeWitt, Morris and Smithson as the 'best' artists in the show.[84] Others were less impressed. Hilton Kramer, art critic for the *New York Times*, lamented the

absence of feeling in the new sculpture, although he admitted that 'Primary Structures' was a seminal show. Lack of emotive affect was, of course, the point of serial method and factory production, but Kramer found no solace in Minimalism's anti-subjective impulse. As he suggested, the visitor to 'Primary Structures' was 'enlightened, but rarely moved'.[85]

Responding to critics like Kramer, Robert Morris went on the defence. His 'Notes on Sculpture', published in *Artforum* in 1966, makes a rigorous case in favour of the new sculpture, while distinguishing his work from the practices of the other artists with whom he had become associated in shows such as 'Primary Structures'.[86] He particularly targets Judd's theory of the Specific Object. Where Judd proposes an art that exists between painting and sculpture, Morris characterizes the new work as purely sculptural, recalling Clement Greenberg's Modernist insistence, in his 1940 essay 'Towards a Newer Laocoon',[87] that each medium explore its own formal qualities. According to Morris, the Specific Object has not left behind its pictorial origins; a brightly coloured object or relief, it does not exist fully in the viewer's space. Sculpture in Morris' sense is divested of colour and its pictorial associations – he recommends a bland grey – and strictly three-dimensional. Placed in the centre of the gallery, it requires the viewer's active participation:

'*The better new work takes relationships out of the work and makes them a function of space, light and the viewer's field of vision … [The viewer] is more aware than ever before that he himself is establishing relationships as he apprehends the object from various positions and under varying conditions of light and spatial context.*'[88]

Morris theorized the experience of Minimal art in respect to two perceptual models: Gestalt psychology and the phenomenology of Maurice Merleau-Ponty. Gestalt theory, founded by the German psychologists Wolfgang Köhler and Kurt Koffka in the early twentieth century, concerns the isolation and description of discrete perceptual phenomena, or Gestalts. Morris describes a spectator circulating around the Minimal object, comparing his or her perception of its literal shape against the mental image of its form. The goal of the new sculpture is to make this form – the Gestalt – visible to a viewer moving around the work. He then provides a phenomenological explanation of his sculpture inspired by the French philosopher Maurice Merleau-Ponty. Merleau-Ponty, who has been referred to as 'the central philosopher for Minimalist

art',[89] argued that we exist within a constantly unfolding encounter with our surroundings, or being-in-the-world; we come to know ourselves only in relation to what we touch or perceive. 'Our body is in the world as the heart is in the organism. It keeps the visible spectacle constantly alive … and with it forms a system.'[90] Similarly, Morris describes the experience of his work as a perceptual system – an inextricable relation of the body, the work and the gallery – and describes the temporal nature of this encounter. The viewer of the Minimal work takes in the sculpture's Gestalt from a succession of points of view. This integration of time into Morris' theory of sculpture was altogether consistent with his earlier performance aesthetic, and would radicalize subsequent discussions of his work.

As Minimal criticism began to focus on three-dimensional work and the viewer's physical encounter with the object, the question of painting's status became problematic. However, a number of critics, including Lawrence Alloway and Lucy R. Lippard, saw painting as equally relevant in discussions of Minimal art.[91] Lippard suggested that the new monochrome painting was the Primary Structure's closest counterpart, observing that painters Ralph Humphrey, Robert Mangold, Brice Marden, Paul Mogensen, David Novros and Robert Ryman were creating work capable of meeting 'the challenge of the increasing limitations set by the two-dimensional plane'.[92] Painting associated with Minimalism varied in surface and perceptual effects, as artists explored qualities of illusion to varying degrees. According to Lippard, Mangold's shaped monochromes, such as the *Area* paintings of 1965–66, disrupt the convention of the rectangular canvas and the fictive space it suggests. Projecting complementary after-images on the surrounding wall, they are both literal shapes and sources of retinal play. Humphrey's 'frame' paintings of the mid 1960s have thick, all-over surfaces, yet set up an optical tension of close values and hues.

In contrast, Lippard observed that the painters Brice Marden, Paul Mogensen, David Novros and Robert Ryman produced work that is unequivocally literal. Marden's paintings are covered with a luminescent encaustic mixture of oil and wax thick as butter, but retain an empty bottom edge of drips and smears, revealing the bare canvas. Novros developed a series of L-shaped canvases painted in a mixture of acrylic paint and Marano powder, a light interference material that shifts in tone as the viewer moves past. Distributed

across the wall, the Ls fracture the picture plane into multiple units, casting shadows on to interstitial areas of wall. Paul Mogensen also fragmented the mural canvas of Abstract Expressionism into a multi-panelled assemblage of discrete parts. The relative size of each canvas was calculated according to a progressive schema. In *Copperopolis* (1966), the width and length of the units seem to double from right to left, and from bottom to top. *Standard* (1966) is comprised of four progressively thinner rectangular shapes. Executed in such elemental hues as copper and white, Mogensen's works exemplify the literalist fixation on pure materiality; like Andre's metal plates, each canvas is an individual unit. Much like Minimal sculpture, too, Mogensen's installations – like the polyptychs of Novros – expose the gallery itself as an actual place, inscribing the wall (traditionally a 'neutral' background for painting) as a positive term within the work as a whole. Ryman instead focused on exploring the parameters of his own painterly process. In the *Winsor Series* he developed in 1964–65, named after the white Winsor and Newton paint he used to complete the works, execution is entirely manifest; the all-over patterns of uneven stripes trace the descent of the artist's hand filling the canvas. In other works, such as the *Standard Series* of 1967, he arranged a selection of materials (enamel paint, steel, etc.) into various – and by implication infinite – combinations. Transforming painting into a game with no conclusion, Ryman was concerned with nothing more (nor less) than the activity of painting as such.

The Bykert Gallery in New York hosted a series of shows organized by Klaus Kertess in the late 1960s, which focused primarily on this work. Critic Barbara Rose, in a review of an exhibition of paintings by Humphrey, Marden and Novros at the Bykert in the summer of 1967, claimed that 'the reductive solution' had become a dead end.[93] Although the prospect of Minimal painting had seemed novel during the early 1960s, when Stella was working at the forefront of this pursuit, he soon found the literalist agenda extremely limiting. Slowly but surely during the 1960s, Stella restored polychromy and figure/ground play, as in his *Concentric Squares* (1962) and *Irregular Polygons* (1966). To Rose, who was married to Stella, monochrome painting was definitely old news.

In contrast, artist Jo Baer made a passionate defence of monochrome painting in a letter to the editor of *Artforum* in September 1967.[94] Baer developed a Minimal-type abstraction in 1962–63 of white canvases with black and concentric

coloured borders, and had exhibited in 'Systemic Painting' and in group shows alongside Andre, Flavin, Judd, LeWitt and Morris. She argues, contra Judd, that painting is not inherently pictorial: 'Allusion inheres no more now in paint than in wallpaper'. Nor are new materials necessarily less illusionistic than old ones, as her wicked comparison of Flavin's light to a 'fluffy ... Mazda', a mirage, suggests. Nor are they inherently more radical. Ideas and materials share 'a functional relationship, not an identity'. Though provocative, Baer's analysis failed to spark debate: in the mid 1960s, Judd's claim that painting was obsolete held sway. It wasn't until the Minimal object lost its novelty that the discourse around literalist painting could mature. In the elegant 'Opaque Surfaces' (1973), critic Douglas Crimp connects the 'opaque' canvases of Ryman and Marden both to the heritage of late Modernist painting – Kelly, Newman and Stella – and to Minimalist sculpture, observing that monochrome painting has achieved 'the painted equivalent of sculpture's objecthood'.[95] Crimp's account would be followed by other close analyses as the work of Ryman, Marden, Mangold and Novros received considerable attention in the 1970s and 1980s.[96]

During the late 1960s, the debates around Minimalism began to address the 'serial attitude' manifest in the work of Carl Andre, Dan Flavin and Donald Judd, as well as in the practices of Mel Bochner, Dan Graham, Eva Hesse, Sol LeWitt and Robert Smithson, which used the forms and seriality of Minimalism in support of different ends.[97] LeWitt experimented with serial technique as early as 1962 in his *Wall Structures*, a series of concentric open-ended squares projecting into space from the canvas. In 1965–66 he went on to develop his first open modular cubic structures, initially in black, then in white, which were entirely preconceived according to predetermined mathematical formulas. *Serial Project No.1* (*ABCD*) (1966) is a permutation set (a closed, self-exhausting system) consisting of both open and closed cubes arranged on a grid. Constructed for an exhibition at the Dwan Gallery, Los Angeles, in 1967, *Serial Project No.1* (*ABCD*) equally existed in the form of the show's invitation (a plan covered with mathematical formulas) as in three dimensions. In LeWitt's project, Minimalism's distancing of the artist's hand reached a new extreme. Not only did the planning occur ahead of the work's execution, the execution itself had become virtually unnecessary: the idea alone was the artwork. Where other Minimalists repressed the conceptual founda-

tions of their art, LeWitt focused on the concept as such; he rendered the finished object prized by Judd secondary to its generating idea.

Mel Bochner, Dan Graham and Eva Hesse also elaborated upon the conceptual, social and metaphorical implications of seriality. Working at the same time as LeWitt, Bochner explored a seemingly endless variety of mathematical formulas such as permutation sets, Fibonacci progressions, rotations and reversals in drawings and small reliefs. Other projects used photographic and xerographic technologies. *36 Photographs and 12 Diagrams* (1966) records the permutational development of temporary sculptures in paired representational systems; the mathematical schema underlying each 'work' is presented next to its image. *Working Drawings or Other Things on Paper Not Necessarily Meant to be Viewed as Art*, an installation presented at the School of Visual Arts, New York, in 1966, examines the social and conceptual underpinnings of seriality.[98] Consisting of four identical photocopy

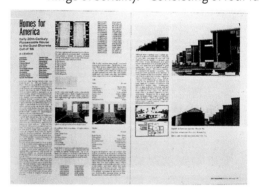

books mounted on white pedestals, it includes photocopies of project drawings by Minimal sculptors shown alongside diagrams from *Scientific American* magazine, architectural plans and the blueprint of the photocopier machine used to reproduce these images. As Bochner suggests, serialism is at once a strategy of avantgarde work and a social logic: the de-subjectivizing techniques of Minimalism have developed in tandem with systematic thinking in mathematics and other disciplines, as well as expanding technologies of reproduction.

Dan Graham's *Homes for America*, a conceptual project originally created for the pages of *Arts Magazine* in 1966–67, also connected serial method to the way in which post-war society had been restructured through new forms of mass production and consumption. A text with photographic documentation, *Homes for America* reveals how the prefabricated housing of the new middle-class suburb had been developed in a systematic manner. For example, a purchaser in Florida's Cape Coral community had to choose between eight housing models and eight exterior colour options. The possible number of combinations of model and colour was predetermined and self-fulfilling: personal choice was confined to a closed set of possibilities. As Director of the short-lived John Daniels Gallery in New York, Graham had exhibited the work of the Minimalists Judd, Flavin and LeWitt. In *Homes for America*, he allies the serial methods favoured by these artists with the production formulas of the most bland tract housing.[99]

Where Dan Graham and Mel Bochner used the tools and techniques of Minimalism in their more Conceptual art, Eva Hesse transmuted the syntax and geometries of Minimalism into a distinctive sculptural language. Handmade from synthetic polymers and fibreglass resins, wires and cords, sculptures such as *Ishtar* (1965) and *Addendum* (1967) transform the modular relief or progression into a sequence of forms reminiscent of breasts and hair. *Accession II* (1967), a metal box threaded with hundreds of rubber tubes, is a Judd gone awry, a Minimal cube rendered uncanny through its conjunction of rigid shape and soft materials. In Hesse's work, Minimalist seriality and wholeness give way to idiosyncratic shape and irregular schemes: the factory-produced, contentless Minimal object is softened and suffused with bodily metaphor.

Robert Smithson also adopted Minimal form to new effect. In his Non-sites, begun in 1966, the Minimal box has become a receptacle for shale culled from quarries; the work is less a thing to be looked at than a reminder of the place from which the material derived. The literal site defined by the work of Morris and Andre has become a non-place, a vector pointing to an elsewhere. In his 1966 essay 'Entropy and the New Monuments',[100] Smithson characterizes the work of Flavin, Judd, Morris and LeWitt as ephemeral and anti-monumental. The once solid Minimal object is on the verge of material breakdown. Flavin's work is exemplary in this respect. His lights are art only when illuminated; after they are turned off, the work no longer exists. Smithson also describes Minimal practice in geological terms, claiming that Judd's untitled pink Plexiglas and steel box with wires of 1965 suggests crystallographical models. He even characterizes Judd as a kind of geologist, citing the older artist's collection of maps and comparing Judd's laconic writing style to the factual descriptions in geology books. Filled with fragmentary observations, 'Entropy and the New Monuments' is an eccentric, brilliant text that speaks more of Smithson's own scientific interests than the stated aims of the Minimalists. The affection was not

Dan GRAHAM Homes for America, 1966–67

always returned: Judd's pithy statement, 'Smithson isn't my spokesman' speaks to a growing frustration with Smithson's imaginative appropriations.[101]

The Modernist critic Clement Greenberg takes a less celebratory view of Minimal practice in 'Recentness of Sculpture' (1967). Greenberg sees Minimalism as a 'Novelty' art, a Dadaist activity whose sole concern is to shock. Where the Modernist work, i.e. a Cézanne or Picasso, has a lasting effect on taste, the novelty item is no more than a momentary surprise. Like Dada, Minimalism blurs the clear distinction between what is art and what is not-art. Preplanned and executed by somebody else, the Minimal work lacks formal complexity and feeling; it is 'too much a feat of ideation', too conceptual. Closer to furniture than to art, it is a kind of Good Design, but nothing more.[102] Where Judd, Flavin, Andre and LeWitt explored factory production to develop an art devoid of feeling, Greenberg held the bias of Abstract Expressionist aesthetics that the 'true' work of art is a handmade expression of the artist's subjectivity.

Critic Michael Fried's 'Art and Objecthood' (1967) also addresses Minimalism's blurring of the border between art and not-art.[103] But where Greenberg equates the Minimal work with Duchamp's readymades, Fried sees Minimalism as an unfortunate outgrowth of Modernism. According to Greenberg, the task of the Modernist work is to explore its medium, whether sculpture, painting or poetry. Painting's salient quality is its flatness, hence it is flatness – the literalness of the support – that Modernist painting should reveal.[104] Fried suggests that Minimal art has brought this investigation too far. Painting's pursuit of flatness has resulted in an unforeseen conclusion: the Specific Object. Judd's coloured relief is neither painting nor sculpture; blurring Modernist distinctions between media, it undermines the Modernist project from within. Where the Modernist canvas points to a beyond (however flat its surface), Minimal art alludes only to itself, to its very objecthood. For Fried, this revelation of objecthood, of literalness for its own sake, has undermined the distinction between art and non-art. A work of art is 'not an object', he writes.[105] In contrast, the Modernist work defeats its objecthood by organizing an ideal aesthetic space. The Modernist paintings of Morris Louis or Barnett Newman construct a purely visual realm of colour. The painted sculptures of Anthony Caro resolve to a pictorial format and transcend their three-dimensionality. Minimal art, instead,

reveals the literal space of the viewer and the viewer's presence in this space. Placed in the centre of the gallery, the Minimal work sets up a 'theatrical' relationship with the spectator, demanding his or her attention, much as an actor does. Theatre in Fried's sense suggests this obtrusive demand for recognition and also the temporal nature of this encounter. It is '[…] as though theatre confronts the beholder, and thereby isolates him, with the endlessness not just of objecthood but of time'.[106] Instead of valuing the crucial role that time plays in the experience of Minimal art – the viewer circulates around the sculpture, perceiving its Gestalt in a sequence of points of view – Fried believed the viewer's important encounter with the Modernist work occurs outside of time. Just as Modernist art exists in an ideal space, its experience is ideal: the spectator sees the work and, like Kant's viewer in the *Critique of Judgement*, is 'forever convinced by it'.[107] Fried describes an exalted moment of recognition – of pure 'presentness' – removed from the mundane encounters of everyday life. The problem with Minimal art is that it destroys this pure recognition, relocating the viewer in real time and space. 'Art and Objecthood' was lambasted by numerous writers for its unapologetic idealism, even though Fried's claim that presentness is only a passing sensation – and one rarely felt – suggests that doubt, not pure conviction, had become the new ground for aesthetic experience in the 1960s.

1967–79 Canonization/Critique

During the late 1960s and mid 1970s, Minimalism acquired an international profile. The Minimal sculptors received one-person shows at such major institutions as the Whitney Museum of American Art, the Solomon R. Guggenheim Museum (both in New York), the Hague Gemeentemuseum and the Tate Gallery, London. Jo Baer, Robert Ryman, Brice Marden and Robert Mangold were also the subject of important mid-career retrospectives at a number of major international museums.[108] The assimilation of Minimal art by the museum and blue-chip gallery marked the passing of its avant-gardist phase.[109] In the process of editing his Minimal Art anthology, which was published in 1968, Battcock lamented that the museum had 'take[n] art away from us' by transforming Minimalism into an art historical movement. Indeed, Eugene Goossen, curator of 'The Art of the Real: USA 1948–1968' which opened at The Museum of Modern Art, New York, and toured to the Grand Palais, Paris, Kunsthalle,

Zurich and the Tate Gallery, London, provided an exalted pedigree for the Minimalists. He juxtaposed works by Carl Andre, Robert Morris and Frank Stella with those of such prominent figures as Georgia O'Keeffe, Ellsworth Kelly, Jackson Pollock and Barnett Newman, thus positioning the younger artists within the narrative of American twentieth-century art history. By so doing he laid claim to an exclusively American artistic phenomenon, observing that the younger artists were the latest avatars of an 'American' impulse to confront 'the experiences and objects we encounter every day'.[110]

Critics had a field day assessing the show. The French writer Marcelin Pleynet, reviewing the installation of 'The Art of the Real' at the Grand Palais, Paris, asked how the notion of the 'real' applied to such diverse practices (O'Keeffe's figuration and Judd's cubes made a strange pair), and why it was that American artists had a greater purchase on the representation of concrete experience.[111] In a biting review of the New York show, Philip Leider, editor of *Artforum*, attacked the

naiveté of Goossen's conception: to present the optical canvases of Noland and Louis side by side with Judd's and Morris' objects was tantamount to a total unawareness of the recent debates between Modernists such as Michael Fried and literalists such as Donald Judd.[112]

Although no longer avant-garde, Minimalism's impact upon subsequent work was considerable. In 1968 the critic Robert Pincus-Witten coined the term 'post-Minimalism' to describe this expanding field of activity that followed in the wake of Minimalism and included Conceptual and process art. As Pincus-Witten suggested, Minimalism's use of factory production and repeated modular forms had led to the serial Conceptualism of Bochner, LeWitt and Graham. But the literalist object was also a springboard for the material process art developed by Eva Hesse, Barry LeVa, Robert Morris, Bruce Nauman, Alan Saret, Richard Serra, Robert Smithson and Keith Sonnier.[113] (Carl Andre's scatter works had destroyed the Gestalt of Minimalism as early as 1966.)

Robert Morris, who went on to become a leading figure of post-Minimalism, argued in 'Anti-Form', published in *Artforum*, New York, in April 1968, that the new sculpture was both an extension and a subversion of the Primary Structure.[114] He notes that the Minimal object jettisoned relational arrangement, making the work's construction explicit. In revealing materials as materials, however, Minimal art did not go far enough. Minimalism's imposition of geometry or serial logic enforced a separation of matter and idea, an order 'operating beyond ... physical things'. Morris argues that the simple act of making is sculpture's concern; the finished object is beside the point. Where LeWitt and Bochner revealed the conceptual underpinnings of Minimal art, Morris proposes a sculpture of pure matter, apparently purged of ideas. He advocates a more bodily relationship to materials – Jackson Pollock and Morris Louis, who dripped and poured paint directly from the tin, are his models – and in this respect 'Anti-Form' marks a return to the process concerns of his *Box*

Ellsworth KELLY Painting for a White Wall, 1952
Kenneth NOLAND And Half, 1959

with the Sound of its Own Making and earlier performances. Morris recommends soft materials – felt, threadwaste, earth, clay and grease – in place of hard metals, casual or chance procedures – piling, throwing, loose stacking, hanging – instead of Minimal preplanning. In his felt works of the late 1960s and early 1970s, evenly spaced incisions in the fabric recall Minimalism's serial methods, yet there is no clear organization as the cloth had been left to tumble arbitrarily to the floor.

Morris' transformation was dramatic but hardly unique. Many of the figures associated with Minimalism moved in new directions or developed concerns implicit in their previous work. Sol LeWitt's development of the wall drawing in 1968 led to a near-complete 'dematerialization of the object', a bare representation of the idea, or concept, marked out in faint pencil. Marden explored lavish, polychromatic combinations in his *Grove Group* (1973–76) and lintel paintings (1979–84), replacing his earlier, sober palette with rich

blues and greens, and vivid reds and yellows. Humphrey abandoned monochrome painting; Novros moved from the shaped canvas to work directly on the wall. Baer produced large, rectangular reliefs decorated with illusionistic geometries before abandoning abstraction altogether. Truitt replaced the bulky forms of her early work with tall, thin columns. Bell, investing in a larger vacuum-coating machine in 1968, developed increasingly elaborate installations of free-standing glass walls. Andre explored a looser distribution of matter in such works as *Joint* (1968), a sequence of bales of hay executed at Windham College in Vermont, as well as a site-specific earthwork, *Stone Field Sculpture* (1977), at Hartford. Flavin expanded his fluorescent syntax, encompassing whole galleries or corridors with intricate arrangements of polychrome lamps. Judd also focused increasingly on the setting of his work, developing site-specific projects (for the 1971 Guggenheim International and the Pulitzer Collection in St Louis) and long-term art installations, begin-


Morris LOUIS Psi, 1960
Richard SERRA One-Ton Prop (House of Cards), 1969
Sit-in at the Metropolitan Museum of Art, New York Art Strike, 22 May 1970


ning with his own loft building in SoHo. As the period of 'High Minimalism' came to a close in the late 1960s and other trends came to the fore – post-Minimal sculpture, Conceptual art, earthworks and site-specific installation – the Minimal artists responded to new developments in distinctive ways, and indeed in some cases were responsible for them (LeWitt was at the forefront of Conceptualism; Andre and Morris of post-Minimalism). Although they still continued to produce Minimal-type work, Andre, Bell, Flavin, Judd and LeWitt were not immune to outside influences. As they explored other avenues during the 1970s, their practices remained innovative and relevant.

The museum acceptance of Minimalism and the emergence of post-Minimalism and Conceptualism coincided with the politicization of the New York art world in the late 1960s. Many of the Minimalists became involved in anti-war and urban politics. Judd, along with his then-wife Julie Finch, was active in the War Resisters' League in 1968 and later in the

Lower-Manhattan Township, an advocacy group that successfully fought the destruction of SoHo by insensitive city planners, leading to the area's designation as a historical and artists' district in 1973. Andre was an original member of the Art Workers Coalition, an activist group founded in 1969 and dedicated to promoting artists' rights, whose protests against the curatorial and financial practices of The Museum of Modern Art and other museums led to a critical analysis of a capital-driven art world. He and LeWitt were among the line-up of presenters at the Speak Out on artists' rights held by the Art Workers Coalition at the School of Visual Arts during the spring of 1969, while Morris, as the group's president, led the 1970 Art Strike on the steps of the Metropolitan Museum of Art, part of a city-wide protest against the war in Vietnam that closed down museums across New York City.

In an interview with critic Jeanne Siegel in 1970, Andre offers a trenchant critique of the contemporary museum.[115] He notes that museum boards in the US consist of wealthy trustees whose taste dictates what is shown (often overlapping with work they themselves collect); that the museum claims to show work on the basis of quality, but this quality is determined by the work's economic value; and that artists (who are rarely trustees) have little say in how the museum is run. Furthermore, Andre questions the supposedly apolitical nature of museums, remarking that they are run by the 'same people' who had devised American foreign policy during the Cold War and Vietnam war era. Siegel challenges Andre's Marxist claims, noting that he sells his works to wealthy collectors and enjoys the support of galleries and museums. Andre, however, makes no apologies for commodifying his work: as an artworker living in a capitalist economy, he is responsible to himself, and must survive through the sale of his labour. Whether or not his work resists the commodity system is not an issue.

In fact, the assimilation of Minimal work into the art and museum establishment was an issue for other observers committed to leftist politics. The political involvement of

Andre, Judd, LeWitt and Morris notwithstanding, the Minimal artists were increasingly associated with the Establishment.[116] As Object art became commodified, younger leftist critics and artists championed ephemeral, 'de-objectified' post-Minimal and Conceptual practices that appeared to resist commodification far better than Judd's elegant boxes or Andre's steel and copper plates.

Although the integration of Minimalism seemed a *fait accompli*, the actual reception of the work during the 1960s and 1970s was more complicated. The most obvious example of the enormous public resistance to Minimal work was the so-called 'Bricks Controversy' that developed around the Tate Gallery's purchase of Andre's sculpture *Equivalent VIII* (1966) in 1976. Seized upon by the British and international press, the acquisition of this work, consisting of 120 identical fire bricks temporarily arranged into a rectangular solid, quickly devolved into a scandal. As critics debated whether Andre's pile of bricks could be considered art, tabloids tweaked the

public's anger over an apparently wasteful use of taxpayer's money.[117] Even today, Minimalism represents a popular conception of an elitist art form inaccessible to the common viewer. The pillorying of works by Robert Ryman and Ellsworth Kelly on episodes of the American television news magazine *60 Minutes*, or the pseudo-aesthetic debates of Yasmina Reza's recent play *Art*, in which three men fight over a white monochrome, point to the anxiety of a public afraid of having the wool pulled over its eyes.

With the emergence of feminism in the early 1970s, a new analysis of Minimalism developed. Artist Judy Chicago's autobiography *Through the Flower: My Struggle as a Woman Artist* (1975) is the *locus classicus* of this turn in Minimalist discourse.[118] Her early sculptures, such as *Ten Part Cylinders* (1966) and *Rainbow Pickets* (1966), were built on Minimal-type systems of geometric shape, progressive dimension or interchangeable arrangements of units. Although she received some acclaim for these works, Chicago was never

comfortable with Minimalism. In her autobiography she presents geometric abstraction as something she had to discard. But her account of her engagement with Minimalism is more complex than it initially seems. On the one hand, she characterized Minimalism as a 'male-oriented form language'. Working in a Finish Fetish mode allowed her to explore her 'masculine' side: her assertiveness, her strength, her ability to use industrial tools (Chicago described being the sole woman enrolled in an autobody class). On the other hand, Minimalism represents an absence of gender. The standard geometries, uninflected surfaces and contentlessness of the new sculpture allowed her to mask her gender. In the chauvinistic art world of the 1960s, this was no small thing. For Chicago, learning to make such work was – at least initially – liberating.

Wielding a spray gun or saw like a man, Chicago was able to transcend fixed gender roles, but at a cost. She observed that the gender 'neutrality' of pure abstraction is hardly genderless. The lingua franca of mid 1960s art, Minimalism is 'male-oriented' precisely because it erases gender. Repressing female subjectivity, or any subject matter whatsoever, it affirms a sexist status quo.

In Chicago's narrative, female identity is rediscovered only through its sublimation; the restoration of a 'female' iconography requires Minimalism's repression in turn. She describes how three apparently abstract acrylic domes of 1968–69 subversively allude to female anatomical parts, as well as the classic nuclear family of mother, father and child. The open-ended pastel octagons of the *Pasadena Lifesavers* series (1964), symmetrically arranged in quadrants, refer to wombs and vaginas, yet still mask their content. During the early 1970s, as a result of her involvement with the Feminist Art Program, University of California at Fresno, as well as with Womanhouse, a co-operative women's art space in Los Angeles, Chicago developed a more explicit 'central core' iconography. In her best-known project, *The Dinner Party* (1974–79), erotic imagery and textual inscription, as well as traditionally 'female' handicrafts such as sewing and ceramics, are in direct opposition to the abstract, geometric, industrial Finish Fetish aesthetic. Chicago arrived at a feminist idiom only after having worked through the precepts of California Minimalism.[119] In this respect, her project reflects a larger tendency of early feminist practice to infuse the Minimal and post-Minimal idioms with marks of female subjectivity during the 1970s.[120]

Carl ANDRE Equivalent VIII, 1966
Judy CHICAGO The Dinner Party, 1974–79

While some writers developed social and feminist readings of Minimalism, others explored its philosophical character. Annette Michelson's important catalogue text for Robert Morris' 1969 retrospective at the Corcoran Gallery of Art in Washington, DC, makes the claim that Morris' work enacts a rupture with Modernist aesthetics.[121] Her analysis focuses on a divide between two modes of perception: the instantaneous, ideal aesthetic encounter described by Fried in 'Art and Objecthood' versus the literal spectatorship outlined by Morris, which transpires in real time and space. Where the Modernist work aspires to transcend its materiality, Morris' sculpture is merely itself, 'apodeictic' (self-evident and demonstrable). What is more, it heightens the viewer's sense of him or herself in the act of perceiving. A literalist thing existing in the same space as the beholder, it fosters awareness of oneself as inextricable from other objects and persons. This sense of co-presence, as Michelson describes it, is a phenomenological notion derived from Merleau-Ponty,

seen or touched. Michelson equates firstness with Modernism's aesthetic of immediacy or pure presentness, while implying that Morris' art produces a secondary awareness, a heightened self-consciousness.

In 1973 Rosalind Krauss traced the after-effects of Minimalism in two strands of recent practice in the essay 'Sense and Sensibility: Reflection on Post '60s Sculpture'.[124] The first strand leads from Minimalism to certain post-Minimal activities such as process art or serial-based Conceptualism, as in the felt works of Morris and the mathematical schemas of LeWitt and Bochner. The second is a clear rupture with Minimalism in the form of a language-based Conceptualism (as in the work of Joseph Kosuth, Douglas Huebler and On Kawara, which consists of a linguistically construed declaration of intent such as Kawara's 'I am still alive'). She explains this divide as an opposition of two models of subjectivity. The declarative acts and concepts of language-based Conceptualism reflect a faith that we truly





mean what we say, and that the words we use to represent our thoughts are able to convey them with perfect transparency. Kosuth's seemingly radical notion of Art-as-Idea-as-Idea restores a sort of Cartesian ontology, the retrograde belief

who argues that we come to know ourselves as sentient beings in relation to our daily surroundings.[122] As a phenomenological practice, Morris' art solicits the viewer into a direct and protracted encounter, undermining the ideal aesthetic realm and transcendental immediacy fostered by the Modernist work. Although Fried deprecates this dissolution of boundaries as theatrical, Michelson values Morris' art precisely because it transgresses Modernist protocols.

'Epistemological firstness', a notion developed by the American pragmatist philosopher Charles Sanders Peirce at the turn of the century,[123] also enters her discussion. According to Peirce, experience is different for each individual, and the knowledge gained from that experience leads to an ever-changing and wholly personal understanding of 'truth'. Experience produces different kinds or degrees of knowledge. 'Firstness' denotes the most immediate sensual impressions – a glance or a touch. 'Secondness' is the recognition that follows this encounter, the awareness that one has

that the artist is capable of clearly expressing his or her 'ideas'.[125] Krauss, citing the late writings of the early twentieth-century philosopher Ludwig Wittgenstein, argues that we are never masters of our intentions, for we can only formulate our thoughts within socially given systems of representation. Minimalism and practices influenced by Minimalism locate the self in the realm of public language and experience. The serial art of Judd and Andre is not generated by a rational, subjective mind, but by pre-given mathematical formulas. Similarly, in Morris' work, perception is a response to the external world, not private and self-determined. In the years to come, this new notion of selfhood described by Michelson and Krauss as public not private, contingent not whole, would be characterized as Postmodern, as would Minimalism as well.

1980–present Recent Minimalism

Towards the close of the twentieth century, as the artists associated with Minimalism pursued their own paths even more

Joseph KOSUTH One and Three Chairs, 1965
Douglas HUEBLER Site Sculpture Project Variable Piece No. 1, New York City, 1968

independently, the differences between their practices became more pronounced. Some remained faithful to the methods they devised during the 1960s; others expanded, or even revised the concerns of their early work. Internationally renowned, with vastly improved financial resources through the support of foundations, museums, galleries and collectors, the most prominent Minimalists gained the freedom to work with an expanding array of materials and techniques, and on a much greater scale.[126] As their work became increasingly monumental, the 1960s notion of Minimalism as a spare, 'reductive' art wore thin.

In the decade and a half before his death in 1977, Dan Flavin designed increasingly complex installations.[127] At the Dia Foundation in Bridgehampton, New York, he installed a line of fluorescent barriers that traversed a long room. Each wall was a densely packed field of vertical lamps arranged according to complementary colour schemes. As the viewer moved from one barrier to the next (from left to right or right to left), a new, dazzling arrangement cancelled the optical impression of the previous one. A second row of barriers stood back to back with the first; their glow penetrated the gaps between each wall. Where Flavin's earliest work focused attention on a few lamps, the Dia show set up complex polychromatic combinations experienced as a sequence of views, each causing a retinal overload.

Sol LeWitt's later work has also grown increasingly elaborate. The irrational, democratizing impulse of his early drawings – works that could be made by anyone – has given way to extensive planning. Trained assistants execute each work with great care. At times during their creation LeWitt will modify the result: the balance of concept and outcome tips in favour of formal resolution. This return of subjective decision making may seem to contradict the aims of his earlier work, but LeWitt has argued that 'one cannot rule anything out. All possibilities include all possibilities.'[128] Where his early projects could exist solely as ideas without having to exist in the world, LeWitt's later works rely on a more bodily impact. The extraordinarily massive, breeze block ziggurats and towers he began to produce in the 1980s suggest a dramatic turn from the 'dematerialized' aesthetic of his 1960s work.

A number of artists, including Carl Andre, Donald Judd, John McCracken, Robert Mangold, Agnes Martin, Robert Ryman and Anne Truitt, further refined their Minimal styles during the 1980s and 1990s. Carl Andre has continued to work with arrangements of repeated identical units, incorporating an expansive selection of materials such as acrylic, plastic, poplar wood, white gas-beton blocks, blue Belgian limestone and red Scottish sandstone. Gathered from local quarries and factories near where the exhibitions are held, these materials have given rise to a remarkably diverse variety of shapes within Andre's characteristic horizontal format which, developed in such works as *Lever* and *Elements I–VIII* in 1966, radically transformed the nature of sculptural syntax. As in those works, identical units lie on the floor in temporary piles which, arranged by the artist, are held in place by gravity alone.

Anne Truitt has continued to explore the columnar format that she developed in earnest in the late 1960s, although her later sculptures are tapered in shape, with even more complex colour arrangements. *Breeze* (1980) is a tall, thin column with stripes of mint and forest green, white and pale blue bracketing a central band of pale yellow. The recent *Elixir* (1997), with different combinations of pink, fuschia, yellow and green on each of the four sides, cannot be seen in one glance, but only in a sequence of views. Her journals, the first of which, *Daybook*, was published in 1982, make clear her belief in the evocative use of colour and shape. Records of daily life, they combine reflections on her art and its reception with more practical meditations.[129]

John McCracken has also sought a lighter touch in his later work. His *Four Part Plank* (1984) divides his weighty planks of the 1960s into several thin beams; reliefs like *Neon* (1989) and *Flame* (1990) hover against the wall. Robert Mangold's *Frame Paintings* (1983–86), *X Series* (1980–82) and *Attic Series* (1990–91) continue to explore the nuanced relations of figure, painted surface, the literal shape of the canvas and the wall developed out of his early paintings. Agnes Martin, in her late eighties, still works in graphite and acrylic washes, producing spare canvases made up of faint horizontal bands. The retrospective of Martin's work at the Whitney Museum of American Art, New York, in 1992, as well as Robert Ryman's one-person show at the Tate Gallery, London and The Museum of Modern Art, New York, in 1993–94, traced the continuity of a pared-down abstraction into the present day. Indeed, it is perhaps Ryman's work that has most come to epitomize a Minimal practice of 'reduction' for contemporary audiences. His work of the 1980s, executed on Lumasite, Plexiglas and aluminium, with exposed bolts and fasteners, reduced painting to its bare bones, removing subjective

marks or excess of any kind. (Ryman's more recent canvases have restored a methodical brushwork.) As Yve-Alain Bois has argued, Ryman's art is an asymptotical reflection on painting's limits, an endgame endlessly deferred.[130] Exploring the monochrome's considerable formal potential, Ryman forestalls indefinitely Judd's conclusion that painting is no longer a viable medium.

The later Judd became involved in a remarkable variety of pursuits. In many ways he remained absolutely consistent, developing objects that were only slight modifications of his early works, or new kinds of boxes and reliefs meticulously executed in European workshops. His interest in installation, which reached an apogee in the 1980s and 1990s, was evident in the careful arrangement of objects in his earliest shows. Now Judd became absorbed in the problem of display as such. Attentive to the detail of materials and production techniques, he was understandably concerned when his works were mishandled during transportation or carelessly

an impressive installation of concrete works developed by Judd during the early 1980s.

As Minimalism evolved during the 1980s, younger artists took an interest in the work of figures like Andre, Flavin and Judd. The so-called Neo-Geo/Cute Commodity artists – Jeff Koons, Haim Steinbach and Peter Halley – infused the vocabularies of Minimalism with 'low' cultural associations. In the work of Koons and Steinbach, the Minimal box was divested of formal complexity and recast as a support for commodity display. Koons stacked vacuum cleaners in transparent cubes lit by fluorescent lights, recontextualizing banal readymades within debased Juddian and Flavinesque forms. Similarly, Steinbach arranged boxes of soap, lampshades and other store-bought items on rectangular reliefs. Equating the repeated geometries of Minimal art with the most mundane commodities, Koons and Steinbach exposed the Dadaist underbelly of Minimalism, its presentation of the readymade unit as fine art. Purely abstract, Minimal work resisted the

Jeff KOONS New Hoover Convertible, 1980
Haim STEINBACH Untitled (walking canes, fireplace sets) No. 2, 1987
Peter HALLEY CUSeeMe, 1995
Frank STELLA River of Ponds, 1968

installed. As he observes in 'On Installation' (1982),[131] most displays of contemporary work are 'unsuitable', and this problem can only be ameliorated by the permanent and semi-permanent installation of works. And this is what he did, beginning with the loft building he purchased in SoHo in 1968. At Marfa, a town in western Texas to which he moved in 1973–74, Judd converted a suite of former aeroplane hangars into his personal domicile and exhibition space. His Chinati Foundation, initially established in conjunction with the Lone Star and Dia Foundations,[132] developed permanent installations devoted to John Chamberlain, Claes Oldenburg, Ilya Kabakov and Dan Flavin, as well as long-term shows of work by Roni Horn, Richard Long and Agnes Martin. Chinati includes a large Judd installation of 100 anodized aluminium boxes in two former artillery sheds. Each building is lined with four-paned, square windows through which the natural light casts a dizzying array of shadows and reflections on the sculpture and surrounding architecture. The adjacent fields house

mass culture that Pop art purportedly embraced, yet Koons and Steinbach explicitly related Minimal practice to the postwar system of production and consumption from which it emerged.

The painter and critic Peter Halley equates Minimalism with the emergence of Postmodernism in 'Frank Stella ... and the Simulacrum'.[133] Followings the writings of the French cultural critics Guy Debord and Jean Baudrillard, among others, he describes the shift into Postmodernism as an evolution in technology and modes of production in the 1960s. Where Koons and Steinbach relate the Minimal object to the mass-produced commodity developed during those years, Halley links Stella's work to 'the informational culture of the computer and electronics, the interstate highway system, the space programme and satellite reconnaissance'.[134] Stella's *Aluminum Paintings* (1959–61) announced this transition into a post-industrial matrix. Where the *Black Paintings* (1958–59) still resonate with Abstract Expressionist

pathos, the *Aluminum* works are 'cool, even, science fictional'; they are thus not 'pure' painting but reflect a more general cultural logic. The jogs on the sides cause the silvery stripes to shimmer and 'circulate' (Halley compares them to motorway lanes). For Halley, Stella's later work is the ultimate expression of Postmodern sensibility. The Day-Glo *Protractors* (1967–69) and illusionistic metal reliefs that Stella developed in the 1970s and 1980s convey the sensation of Hyperspace, the unreal environment described in Baudrillard's writings: the space of the highway and TV screen, of artifice and spectacle. In hyperspace, 'everything is arranged to maximum effect. Here, like at Disneyworld, Las Vegas or the shopping mall, everything is arranged to entice, seduce and amaze.' No doubt Halley is describing the motivation behind his own Day-Glo geometric paintings, whose allusions to computer cells and conduits point to a circulation of information and energy flow. Even so, his analysis remains compelling, for it offers a new interpretation of Stella's readoption of illu-

sionism and abandonment of stripe painting during the 1960s and 1970s. Usually described in purely formal terms, Stella's later career emerges in Halley's account as the progressive embrace of a spectacular Postmodern aesthetic.

In his 1986 essay 'The Crux of Minimalism', Hal Foster also identified Minimalism with the shift into Postmodernism, locating it within a genealogy of 'neo' avant-garde practice from the 1960s until the present day.[135] For Foster, the recuperation of this legacy was an urgent task during the neo-conservative Reagan/Thatcher years, when 'a general trashing of the 1960s is used to justify a return to tradition'. During the 1980s Minimalism had become a focus of this trashing, a 'rule-bound' foil for a new pluralism.[136] But, according to Foster, it is the return of figuration and gestural brushwork in the art of the 1980s that is actually regressive. The new generation of neo-Expressionist artists, revitalizing national and regional figurative painting styles, ignored Minimalism's radical critique of illusionism and subjective

expression in favour of older artistic forms. As other leading art critics like Benjamin Buchloh, Douglas Crimp and Craig Owens also argued, this restoration of traditional painterly formulas fed the expanding art market's demands for time-honoured commodity forms. In the Bright Lights, Big City, affluent ambience of 1980s New York, neo-Expressionist painting was 'hot'. This triumph of unbridled feeling and subject matter – ratified by collectors and museums – suggested that Minimalism's relevance had severely diminished since the late 1960s.

According to Foster, however, Minimalism establishes the framework for another kind of Postmodernism: a critical Postmodernism of 'resistance'. Much Minimal work challenges the Modernist dictum of medium-specificity; it introduces factory production into formalist art, collapsing the distinction between the Modernist and Dada traditions, between a hand-made, high art and everyday objects. Minimalism's reinscription of the readymade is thus not a

'hollow' repetition; rather, it makes the legacy of the pre-war avant-garde conscious for subsequent

practices, disturbing Modernism's repression of this legacy. Even more, Minimalism disrupts the ideal space and temporality of Modernist sculpture, as Michelson also suggests. Revealing the exhibition space as material and actual, it opens up a critical reflection on the museum and gallery system developed by artists like Daniel Buren and Michael Asher during the late 1960s and 1970s. Their work of this time disrupted the very architecture of the gallery, drawing our attention to both the physical and ideological constraints of the exhibition of contemporary art.[137] Finally, Minimalism's critique of the expressive author of Modernism points to the critical Postmodernism of artists such as Barbara Kruger, Sherrie Levine and Cindy Sherman, whose work denies the fiction of a centred self. The recovery of this 'resistant' legacy is complex, necessitating a detailed genealogy of Minimal discourse. Foster surveys the arguments of Michael Fried, Clement Greenberg, Donald Judd, Robert Morris and Rosalind Krauss, clearly elucidating the nature of

Daniel BUREN Within and Beyond the Frame, 1973
Michael ASHER Installation view, 'Exhibition at the Claire Copley Gallery, Los Angeles', 1974
Barbara KRUGER Untitled (We Are Not What We Seem), 1988
Cindy SHERMAN Untitled No. 122, 1983

Minimalism's rupture with Modernist aesthetics and its impact on later artists.

Foster's is a dialectical argument, suggesting that Minimalism's rupture with Modernism is not complete. A crux is a cross, a burden or transition, and in certain respects Minimalism remains tied to what it rejects. Minimalism 'threatens' and 'breaks' with Modernist practice, but it also 'consummates it', Foster observes.[138] Its introduction of the readymade and literal experience into fine art undermined Modernist values, even though artists like Judd and Flavin conceived these departures as formal innovations. Even more, Minimalism's repression of subject matter perpetuated Modernism's formal bias: the pure, phenomenological character of Minimal perception 'treated the perceiver as historically innocent, sexually indifferent'.[139] Foster suggests that Minimalism looks forward to the Postmodernist practices of Levine and Kruger, yet it also remains beholden to the Modernist values it rejects.

Rosalind Krauss, who had been suspicious of Minimal practice during the 1960s, emerged as one of its most thoughtful supporters during the 1970s. She came to see Minimalism and work influenced by Minimalism as advanced because it undermines the fiction of a private self. In her 1990 essay, 'The Cultural Logic of the Late Capitalist Museum', the doubt of her earlier writing has returned.[140] Krauss no longer sees the subject as coming to know itself as embodied in respect to the Minimal work; rather, she discusses how present-day installations of Minimal art have deprived the work of its ability to provide that phenomenological encounter. The contemporary museum has created 'oddly emptied yet grandiloquent' spaces to accommodate Minimal work. Placed in these vast, open interiors, the stolid object of Morris or Judd is now a component of an intensely visual spectacle. Flavin's works, in particular, take on a 'disembodied glow'. In the new installation, space is not 'real' but hyper-real; 'simulacral experience' replaces 'aesthetic immediacy'. The lone phenomenological spectator of the 1970s is reconceived as a Postmodern viewer in search of bedazzling visual entertainment.

Peter Halley had equated the visual glow of Stella's paintings with a Postmodernist culture of spectacle. Krauss connects this emergence of art-as-spectacle with particular individuals and institutions, specifically Giuseppe di Panza, a leading collector of Minimal work, and the Guggenheim Museum, which recently purchased Panza's holdings. As Krauss suggests, it is Panza who realized the spectacular potential of Minimal display in installations at his villa and former stables at Varese, Italy. Isolated in a reflective white room, a single Flavin work loses all semblance of materiality, becoming pure luminosity. The Guggenheim Museum's purchase of Panza's collection is hardly coincidental. As the Guggenheim opens up branches around the globe, becoming a kind of international cultural conglomerate, it has found in Minimalism – in Flavin's lights, Andre's fields of copper and tin, and Judd's gleaming boxes – an art form perfectly suited to the perceptual demands of present-day audiences. Recast within the spaces of the Postmodern museum as visual entertainment, an art that once resisted mass culture and its virtual pleasures has ushered in, or come to exemplify, this experience. Krauss notes how the seeds of this transformation lay dialectically within Minimal practice itself. 'By prizing loose the old ego-centred subject of traditional art, Minimalism unintentionally – albeit logically – prepares for that fragmentation.'[141]

Krauss' text signals the return of a social critique of Minimalism that continued unabated during the 1990s. Perhaps the most controversial of these texts was Anna C. Chave's 'Minimalism and the Rhetoric of Power' (1990).[142] Chave characterizes Minimal art as the very 'face of capital, the face of authority, the face of the father'. Because Minimal art was developed largely by men, it embodies an aggressive masculinity; the 'cold', industrial forms of Judd, Flavin and Andre dominate the viewer, forcing her to submit to patriarchal control. 'The Minimalists perpetrated violence through their work – violence against the conventions of art and against the viewer.'[143] Chave aligns notions of gender and form into binaristic polarities, equating maleness with hard shape, order, factory production and aggression (hence 'femaleness' with soft form, disorder, organicity and passivity). What is more, she compares Minimalism's purportedly masculine geometries with the colonnades of classical and Nazi architecture, even though the serial art of Stella and Judd seeks to avoid hierarchy and rational order. The specific historical and aesthetic contexts that generated these form languages – ancient Paestum, 1930s Berlin and 1960s New York – are subsumed into a continuous narrative of male aggression.

Although problematic in numerous respects, Chave's critique struck a chord during the early 1990s, when younger artists also turned a critical eye on Minimalism's geometric

forms, serial syntax, anti-subjective procedures and revelation of the gallery space. In the work of Charles Ray, Felix Gonzalez-Torres, Roni Horn, Janine Antoni and others, the formal codes of Minimal art have become vehicles of expression and content, much against their original use.

The artist Felix Gonzalez-Torres converted such classic Minimal forms as the corner triangle of Morris, the Andre floor plane or Judd box into piles of sweets to be consumed by a viewer, or a stack of posters to be disseminated and taken home. Supporters of Gonzalez-Torres argued that he had replaced the supposedly cold, unforgiving aesthetic of Minimalism with one of 'generosity and mutual exchange'.[144] Defying Minimalism's anti-symbolic stance, Gonzalez-Torres' works are vaguely allusive; some suggest a quite specific content. His *Untitled* (*21 Days of Bloodwork-Steady Decline*) (1994), a sequence of identical drawings on graph paper in identical frames, is a striking reversal of Minimal technique. Though it mimics the serial grid drawings of

confrontational aspect of Ray's sculpture recalled his earlier performance, which also used the purportedly neutral Minimal Box as a means of unsettling the spectator. In *Clock Man* (1978), the artist's legs were suspended from a box nailed to the wall; his torso and head were hidden behind the clock's face. In another early work, Ray crouched in a wooden box and waved a red flag through a hole in the top.[145] More recently, Janine Antoni used the Minimal cube as a springboard for feminist critique. Her *Gnaw*, exhibited at the 1993 Biennial Exhibition at the Whitney Museum of American Art, New York, were enormous cubes of chocolate and lard. Raw teeth marks indicated that Antoni herself had masticated these blocks of fat; pressing the chocolate into moulds, she exhibited the resulting 'candies' in heart-shaped boxes in vitrines. Antoni's unforgettable piece thematized contemporary female obsessions with overeating and dieting, beauty and thinness, and the masochistic longing for love that propels such obsessions.

Charles RAY Oh! Charley, Charley, Charley ... , 1992
Felix GONZALEZ-TORRES Untitled (Ishia), 1993
Roni HORN When Dickinson Shut Her Eyes, No. 974, 1994
Janine ANTONI Chocolate Gnaw, 1992

Robert Ryman and Sol LeWitt, rather than documenting the process of drawing as such, the installation traces the decline of the artist's immune system during his battle with AIDS.

The impact of the AIDS epidemic may also be seen in a work by Gonzalez-Torres' colleague Roni Horn, *Gold Mats, Paired* (*For Ross and Felix*) (1995). Two paper-thin sheets of gold laid on the floor, Horn's sculpture recalls Andre's horizontal formats and use of elemental materials, yet its memorial dedication to Gonzalez-Torres and his lover, who both died of HIV, transforms the floor plane into a vehicle of mourning. Its allusion to supine bodies contests Minimalism's aversion to resemblance. Where Gonzalez-Torres and Horn changed the sculptural use of Minimal forms, the artists Charles Ray and Janine Antoni used them as props for performance. The Los Angeles-based Ray also produced a number of Minimal-type objects including *Ink Box* (1986), a cube with an open top filled to the brim with black ink, threatening to stain the unsuspecting viewer. The

Gonzalez-Torres, Horn, Ray and Antoni have perverted the forms of historical Minimalism for their own use. As curator Lynn Zelevansky has suggested, the overturning of Minimalist style by younger artists is equally a homage to the movement. Minimalism, she argues:

'*has a place in the second half of the century akin to the one Cubism had in the first half. A high percentage of artists ... have worked with aspects of it ... deliberately violating it and creatively misunderstanding it.*'[146]

Now firmly established as an essential lexicon of late twentieth-century art, Minimalism takes on new significance as subsequent generations of sculptors, painters, installation artists and performers continue to mine its forms. Of compelling interest to artists and critics over four decades, Minimalism continues to generate new controversies and uses; its relevance is unlikely to diminish. Whatever else you want to say about it, Minimalism matters.

1 The show was presented at the Julian Pretto Gallery, New York (1993). For a further discussion of the work, see Eva Meyer-Hermann, *Carl Andre Sculptor 1966–1996* (Krefeld: Kunstmuseen; Wolfsburg: Kunstmuseum, 1996) 282.

2 Tim Marlow, 'Interview with Carl Andre', *Tate Magazine* (Summer 1996) 39.

3 A wake 'as in the wake of a ship or funeral'. [From a telephone conversation with Carl Andre, 12 August 1996.]

4 Donald Judd, 'Complaints: Part I', *Studio International* (April 1969) 166–79; reprinted in *Donald Judd: Complete Writings 1959–1975* (Halifax: Nova Scotia College of Art and Design; New York University Press, 1975) 197–99.

5 Annette Michelson, 'Robert Morris: An Aesthetics of Transgression', *Robert Morris* (Washington, DC: Corcoran Gallery of Art, 1969) 13.

6 On this expansion see Clement Greenberg, 'The Jackson Pollock Market Soars', in *Clement Greenberg: The Collected Essays and Criticism*, IV (Chicago and London: University of Chicago Press, 1993) 107–14; Steven Naifeh, *Culture Making: Money, Success, and the New York Art World* (Princeton University Studies in History, 1976); Jennifer Wells, 'The Sixties: Pop Goes the Market', *Definitive Statements: American Art 1964–65* (Providence: Department of Art, Brown University, 1986).

7 The Lugano-based *Art International*, which published the early writings of Michael Fried, Rosalind Krauss, Lucy R. Lippard and Annette Michelson, was founded in 1956. *Arts Magazine*, established in the 1920s, published early writings by Gregory Battcock, Mel Bochner, Michael Fried, Dan Graham, Donald Judd, Sol LeWitt, Ursula Meyer and Robert Smithson. *Artforum*, founded in Los Angeles in 1962, relocated to New York by 1965 where it quickly established itself as an important venue of contemporary criticism and writings on Minimalism in particular, including texts by Mel Bochner, Dan Flavin, Michael Fried, Rosalind Krauss, Robert Morris and Robert Smithson.

8 Michelson, Rose and Judd studied art history at Columbia University with Meyer Schapiro, while Fried and Krauss completed doctorates in the Fine Arts Department at Harvard University. On the Harvard circle see Caroline Jones, *Modern Art at Harvard* (New York: Abbeville Press, 1985) 80–95; and Barbara Reise, 'Greenberg and the Group: A Retrospective View, Parts I and II', *Studio International* (May–June 1968) 254–57; 314–16.

9 See Reinhardt's collected writings, *Art as Art*, ed. Barbara Rose (Berkeley: University of California Press, 1975); Barnett Newman, *Selected Writings and Interviews*, ed. John P. O'Neill (New York: Knopf, 1990). On the significance of these artists during the 1960s, see Elizabeth Baker, 'Barnett Newman in a New Light', *ARTnews* (February 1969); Lynn Zelevansky, 'Ad Reinhardt and the Younger Artists of the 1960s', *American Art of the 1960s* (New York: The Museum of Modern Art, 1991) 16–38.

10 Sol LeWitt graduated from Syracuse University, New York; Anne Truitt studied at Bryn Mawr College, Pennsylvania; Carl Andre attended Phillips Academy in Andover, Massachusetts. Brice Marden and Robert Mangold, two painters associated with Minimalism, attended graduate school at Yale University in Connecticut.

11 His professor, Meyer Schapiro, introduced the young Judd to Thomas Hess, editor of *ARTnews*, launching Judd's career as an art critic. Donald Judd, unpublished interview with James Meyer (Marfa, Texas, 27 October 1991).

12 Carl Andre, 'Preface to Stripe Painting (Frank Stella)', *16 Americans* (New York: The Museum of Modern Art, 1959) 76. [See in this volume p. 193.]

13 Most of the classic texts of Minimalism were published by the 1960s, such as: Donald Judd's 'Specific Objects', *Arts Yearbook*, 8 (1965); reprinted in Donald Judd, *Complete Writings 1959–1975, op. cit.*, 181–89. [See in this volume pp. 207–10.]; Barbara Rose's 'ABC Art', *Art in America* (October–November 1965) 57–69. [See in this volume pp. 214–17.]; Bruce Glaser's 'New Nihilism or New Art: Interview with Stella, Judd and Flavin', originally broadcast on WBAI-FM, New York (February 1964); revised and published in *ARTnews* (September 1966); reprinted in *Minimal Art: A Critical Anthology*, ed. Gregory Battcock (New York: E.P. Dutton & Co., 1968) 148–64. [See in this volume pp. 197–201.]; Robert Morris' 'Notes on Sculpture: Part I', *Artforum* (February 1966); reprinted in *Minimal Art, op. cit.* [See in this volume pp. 217–18.]; Mel Bochner's 'The Serial Attitude', *Artforum* (December 1967) 73–77. [See in this volume pp. 227–29.]; Robert Smithson's 'Entropy and the New Monuments', *Artforum* (June 1966); reprinted in *The Writings of Robert Smithson*, ed. Nancy Holt (New York University Press, 1979); *Robert Smithson: The Collected Writings*, ed. Jack Flam (Berkeley, Los Angeles and London: University of California Press, 1996) [See in this volume pp. 223–26.]; and Michael Fried's 'Art and Objecthood', *Artforum* (June 1967); reprinted in *Minimal Art, op. cit.*, 116–47. [See in this volume pp. 234–35.]

14 The emergence of the notion of Minimalism during the 1960s is explored in my forthcoming book entitled *Minimalism: Art and Polemics in the 1960s* (New Haven and London: Yale University Press, 2000)

15 For Malevich, the 'zero degree' of painting was a dialectical notion that both implied the medium's demise and heralded its renewal. See Yve-Alain Bois, 'Malevich, le carré, le degré zéro', *Macula*, 1 (1976) 28–49.

16 The exhibition '5 × 5 = 25', held in September 1921 in Moscow, included works by Aleksandr Rodchenko, Varvara Stepanova, Lyubov Popova, Alexandra Exter and Alexander Vesnin. It announced the formation of a Constructivist group committed to the production of three-dimensional objects.

17 The implications of these terms were far more complicated, and in dispute, than my presentation suggests. See Margit Rowell, 'Vladimir Tatlin: Form/Faktura', *October*, 7 (Winter 1978) 83–108; Benjamin H.D. Buchloh, 'From Faktura to Factography', *October*, 30 (Fall 1984) 82–119; Maria Gough, 'In the Laboratory of Constructivism: Karl Logonson's Cold Structures', *October*, 84 (Spring 1998) 91–117.

18 See Christina Lodder, *Russian Constructivism* (New Haven and London: Yale University Press, 1983) 145–55.

19 See Buchloh, 'From Faktura to Factography', *op. cit.*

20 *Ibid.*

21 On the suppression of the Soviet avant-garde in the post-war period, see Benjamin H.D. Buchloh, 'Cold War Constructivism', in *Reconstructing Modernism: Art in New York, Paris, and Montreal 1945–1964*, ed. Serge Guilbaut (Cambridge, Massachusetts and London: MIT Press, 1990) 85–112. The influence of Constructivism on these artists is discussed in Carl Andre and Hollis Frampton, *12 Dialogues 1962–1963*, ed. Benjamin H.D. Buchloh (Halifax: Nova Scotia College of Art and Design, 1980) 23; 34; 37; Maurice Tuchman, 'The Russian Avant-Garde and the Contemporary Artist' in *The Avant-Garde in Russia 1910–1930: New Perspectives* (Los Angeles County Museum of Art, 1980) 118–21; and Hal Foster, 'Some Uses and Abuses of Russian Constructivism', in *Art into Life: Russian Constructivism: 1914–1932* (Seattle: Henry Art Gallery, University of Washington, 1990) 241–53; Hal Foster, 'The Crux of Minimalism', *Individuals: A Selected History of Contemporary Art 1945–1986*, (Los Angeles: The Museum of Contemporary Art; New York: Abbeville Press, 1986) 162–318. [See in this volume pp. 270–75.]

22 See Camilla Gray, *The Great Experiment in Art: 1863–1922* (London: Thames and Hudson, 1962).

23 Robert Morris, 'Notes on Sculpture', *Artforum* (February/October 1966); reprinted in *Minimal Art, op. cit.* 222–35. [See in this volume pp. 217–20.]

24 See Donald Judd, 'Malevich: Independent Form, Colour, Surface' in *Donald Judd: Complete Writings 1959–1975, op. cit.*, 211–15; and Donald Judd, 'On Russian Art and its Relation to My Work', *Donald Judd: Complete Writings 1975–1986* (Eindhoven: Stedelijk Van Abbemuseum, 1987) 14–18.

25 Ellsworth Kelly had solo exhibitions at Betty Parsons Gallery in New York in 1956, 1957, 1959, 1961 and 1963, and participated in such group exhibitions as '16 Americans' at The Museum of Modern Art, New York (1959) and 'Abstract Expressionists and Imagists' at the Solomon R. Guggenheim Museum, New York (1961). One of his monochrome polyptychs, *Gaza* (1952–56), appeared in a group show at the Green Gallery, New York (1963) alongside works by Judd, Morris and Stella. Judd remained unconvinced of its relevance, however, declaring Kelly's painting a 'fluke'. [See Donald Judd, *Complete Writings 1959–1975, op. cit.*, 112]

26 For Judd's views on Reinhardt see 'Specific Objects', *op. cit.* [See in this volume pp. 207–10]. On the distinction between Reinhardt's position and that of the Minimalists, see Yve-Alain Bois, 'The Limit of Almost' in *Ad Reinhardt* (New York: The Museum of Modern Art, 1991).

27 '16 Americans', curated by Dorothy Miller at The Museum of Modern Art, New York (16 December 1959–14 February 1960). The show included J. De Feo, Wally Hedrick, James Jarvaise, Jasper Johns, Ellsworth Kelly, Alred Leslie, Landes Lewitin, Richard Lytle, Robert Mallary, Louise Nevelson, Robert Rauschenberg, Julius Schmitt, Richard Stankiewicz, Albert Urban and Jack Youngerman.

28 For a discussion of Stella's technique, see William Rubin, *Frank Stella* (New York: The Museum of Modern Art, 1971) 113 ff; Michael Fried, *Three American Painters* (Cambridge, Massachusetts: Fogg Museum of Art, 1965).

29 Andre, 'Preface to Stripe Painting (Frank Stella)', *op. cit.*

30 See John Cage, 'On Robert Rauschenberg, Artist, and his Work', *Silence* (Middletown: Wesleyan University Press, 1961) 99.

31 See Rubin, *Frank Stella, op. cit.*, 12–13.

32 Andre, 'Preface to Stripe Painting (Frank Stella)', *op. cit.*

33 Brenda Richardson, *Frank Stella: The Black Paintings* (Baltimore Museum of Art, 1976).

34 On the importance of the colour black in Beatnik culture during the late 1950s, see Todd Gitlin, *The Sixties: Years of Hope, Days of Rage* (New York: Bantam Books, 1987) 52. On the metaphysical implications of black in Abstract Expressionism, see Hubert Damisch, 'Mystery Paintings', *Les années 1950s* (Paris: Musée national d'Art Moderne, Centre Georges Pompidou, 1988).

35 See Richardson, *op. cit.*, 22; 26; 34; 36; 40; 44; 46; John D'Emilio, 'The Bonds of Oppression: Gay Life in the 1950s', *Sexual Politics, Sexual Communities: The Making of a Homosexual Minority in the United States, 1940–1970* (Chicago and London: University of Chicago Press, 1983) 40–56.

36 Donald Judd, 'In the Galleries: Frank Stella', *Arts Magazine* (September 1962). [See in this volume p. 194.]

37 Donald Judd, 'In the Galleries: Ralph Humphrey', *Arts Magazine* (March 1960); reprinted in Donald Judd, *Complete Writings 1959–1975, op. cit.* This review is one of Judd's first to distinguish the 'elder Purism' of earlier abstraction – Malevich, Mondrian, Albers – and the new American painting.

38 Dan Flavin, ' … in daylight or cool white', originally presented as a lecture at the Brooklyn Museum School of Art (18 December 1964); Ohio State University School of Law (26 April 1965); revised and published in *Artforum* (December 1965); revised and reprinted in *Fluorescent light, etc. from Dan Flavin*, ed Brydon Smith (Ottawa: National Gallery of Canada, 1969) 14.

39 'The Art of Assemblage', curated by William Seitz, opened at The Museum of Modern Art, New York (2 October–12 November 1961), and travelled to the Dallas Museum for Contemporary Arts (9 January–11 February 1962); San Francisco Museum of Art (5 March–15 April 1962). This exhibition was a historical survey show and included works by 142 artists from ten countries. See William Seitz, *The Art of Assemblage* (New York: The Museum of Modern Art, 1961).

40 Flavin describes his first fluorescent work, *the diagonal of May 25, 1963* as 'a buoyant and insistent gaseous image which, through brilliance, somewhat betrayed its physical presence'. [Flavin, ' … in daylight or cool white', *op. cit.*, 18.]

41 For a fine discussion of Judd's early work, see Roberta Smith, 'Donald Judd', in *Donald Judd*, ed. Brydon Smith (Ottawa: National Gallery of Canada, 1975) 6–15.

42 Judd, 'Specific Objects', *op. cit.*, 182.

43 *Ibid.*, 187.

44 Ibid., 184.

45 On the interaction of Stella, Andre, and the photographer and film-maker Hollis Frampton at this time, see Caroline Jones, *Machine in the Studio: Constructing the Postwar American Artist* (Chicago and London: University of Chicago Press, 1996).

46 Rhonda Cooper, 'An Interview with Carl Andre', *Carl Andre: Sculpture* (The Fine Arts Gallery, State University of New York at Stony Brook, 1984). Stella's impact was more complicated, as Andre averred in the same context: 'Stella's influence on me was practical and profoundly ethical. What [Stella] demanded from himself and from those for whom he had respect was that an artist must discover between himself and the world that art which is unique to him and then to purge that art of all effects that do not serve its ends.'
In addition to inspiring Andre's anti-compositional method of stacking beams, Stella taught a deeply Modernist lesson: the pursuit of originality (Minimalism's anti-subjective drive did not preclude artistic ambition), and a Minimalist 'purging' of effects extraneous to the medium, a position the Modernist critic Clement Greenberg also advocated.

47 Andre's reading of Stella's method was mediated by another source, the *Endless Column* of Constantin Brancusi (1918), whose repeated, identical shapes particularly inspired the *Ladders*.

48 'My *Pyramid* has the cross section of Brancusi's *Endless Column*, but the method of building it with identical, repeated units ... derives from Stella.' [Cooper, 'An Interview with Carl Andre', *op. cit.*]

49 Phyllis Tuchman, 'An Interview with Carl Andre', *Artforum*, 8: 10 (June 1970) 56.

50 Mark Rothko and Adolph Gottlieb, 'Statement', the *New York Times* (13 June 1943); reprinted in *Theories of Modern Art*, ed. Hirschel Chipp (Berkeley: University of California, 1968) 545.

51 They were included in such key exhibitions of Minimalism as 'Black, White, and Gray' at the Wadsworth Atheneum, Hartford, Connecticut (1964), 'Primary Structures' at the Jewish Museum, New York (1966), and '10' at the Dwan Gallery, New York (1966).

52 Barbara Haskell, 'Agnes Martin: The Awareness of Perfection' in *Agnes Martin* (New York: Whitney Museum of American Art, 1993) 93–117.

53 Morris' intention was to topple the sculpture with the weight of his own body standing inside. However, during a dress rehearsal this proved to be dangerous, hence, during the actual performance he pulled it over with a string.

54 Robert Morris, 'Blank Form', 1960–61, in Barbara Haskell, *Blam! The Explosion of Pop, Minimalism and Performance Art 1958–64* (New York: Whitney Museum of American Art, 1984) 101. Word pieces deleted by the artist from planned anthology, 1964. [See in this volume p. 193]

55 Morris, 'Notes on Sculpture', *op. cit.*

56 Robert Morris had solo exhibitions at Green Gallery, New York (1964; 1965), Dwan Gallery, Los Angeles (1966), Leo Castelli Gallery, New York (1967). Carl Andre had solo exhibitions at Tibor de Nagy Gallery, New York (1965, 1966), Dwan Gallery, New York (1967). Donald Judd had a solo exhibition at Leo Castelli Gallery, New York (1966). Dan Flavin had solo shows at Kaymar and Green Galleries, New York (1964), and Kornblee Gallery, New York (1967). Sol LeWitt had solo shows at John Daniels Gallery, New York (1965), Dwan Gallery, New York (1966) and Los Angeles (1967). Anne Truitt had a second solo exhibition at Andre Emmerich Gallery, New York (1965). Larry Bell had solo exhibitions at Ferus Gallery, Los Angeles (1965), Pace Gallery, New York (1965, 1967), and a retrospective exhibition at the Stedelijk Museum, Amsterdam (1967). John McCracken had solo exhibitions at Nicholas Wilder Gallery, Los Angeles (1965, 1967), Robert Elkon Gallery, New York (1966, 1967).

57 In Bruce Glaser, 'Questions to Stella and Judd', in *Minimal Art*, *op. cit.*, 158.

58 Alain Robbe-Grillet, *For a New Novel*, trans. Richard Howard (New York: Grove Press, 1965) 43.

59 Susan Sontag, 'Against Interpretation', originally published in *Evergreen Review* (1964); reprinted in *Against Interpretation and Other Essays* (New York: Farrar, Straus and Giroux, 1966; New York: Anchor Books/Doubleday, 1990) 3–14.

60 'Black, White, and Gray' was curated by Samuel J. Wagstaff, Jr for the Wadsworth Atheneum, Hartford, Connecticut, in 1964. It included: George Brecht, James Lee Byars, Jim Dine, Dan Flavin, Jean Follett, Robert Indiana, Jasper Johns, Ellsworth Kelly, Alexander Liberman, Roy Lichtenstein, Agnes Martin, Robert Morris, Robert Moskowitz, Barnett Newman, Ray Parker, Robert Rauschenberg, Ad Reinhardt, Tony Smith, Frank Stella, Anne Truitt, Cy Twombly, Andy Warhol.

61 Samuel J. Wagstaff, Jr, 'Paintings to Think About', *ARTnews* (January 1964). [See in this volume pp. 202–203.]

62 Ibid.

63 Donald Judd, review of 'Black, White, and Gray', *Arts Magazine* (March 1964); reprinted in Donald Judd, *Complete Writings 1959-1975*,

64 Judd, 'Specific Objects', *op. cit.*, 181–89.

65 Rose, 'ABC Art', *op. cit.*

66 Ibid.

67 Yvonne Rainer elaborates these connections in 'A Quasi Survey of Some "Minimalist" Tendencies in the Quantitatively Minimal Dance Activity Midst the Plethora, or an Analysis of Trio A', in *Minimal Art*, *op. cit.*, 263–73. [See in this volume pp. 235–36.]

68 Lucy R. Lippard, 'New York Letter: Robert Morris', *Art International*, 46 (March 1965); David Bourdon, 'Robert Morris', *Village Voice* (18 March 1965).

69 Lucy R. Lippard, 'New York: Dan Flavin', *Artforum*, 52–54 (May 1964); and 'New York Letter: Dan Flavin', *Art International*, 37 (February 1965).

70 David Bourdon, 'Dan Flavin', *Village Voice* (26 November 1964). [See in this volume p. 204.]

71 Flavin, ' ... in daylight or cool white', *op. cit.*

72 Lucy R. Lippard, 'New York Letter: Carl Andre', *Art International* (20 September 1965) 58–59. [See in this volume pp. 206–207.]

73 Carl Andre, 'An Interview with Phyllis Tuchman', *Artforum* (June 1970) 60.

74 Lippard was not alone in regarding Andre's work as Conceptual. *Lever*, a line of 137 fire-bricks exhibited in 'Primary Structures', inspired a hostile art professor in Orange, California, to organize a mock-exhibition of projects based on pseudo-serial schemas. See Harold Gregor, *Everyman's Infinite Art* (Orange, California: Purcell Gallery, Chapman College, December 1966). [See in this volume pp. 222–23.]

75 Robert Smithson, 'Donald Judd', *7 Sculptors* (Philadelphia Institute for Contemporary Art, 1965); reprinted in *The Writings of Robert Smithson*, *op. cit.*, 21–23. [See in this volume pp. 210–11.]

76 Rosalind Krauss, 'Allusion and Illusion in Donald Judd', *Artforum* (May 1966) 24–26. [See in this volume pp. 211–14.] For a more recent discussion of this subject see Rosalind Krauss, 'The Material Uncanny', in *Donald Judd: Early Fabricated Works* (New York: PaceWildenstein, 1998) 7–13.

77 John Coplans, 'Larry Bell', *Artforum* (May 1965) 27–29. [See in this volume p. 207.]

78 Other artists associated with this development included Larry Alexander, Billy Al Bengston, Judy Chicago, Ron Davis, Tony DeLap, Frederick Eversley, Robert Irwin, Craig Kauffman, Helen Pashgian, Kenneth Price and DeWain Valentine. See *Finish Fetish: LA's Cool School* (The Fisher Gallery, Los Angeles University, 1991); and *Art in Los Angeles: Seventeen Artists in the 1960s*, ed. Maurice Tuchman (Los Angeles County Museum of Art, 1981).

79 The assumption of an East Coast/West Coast divide in the art of the 1960s is a longstanding cliché perpetuated in the literature. See, for example, the otherwise excellent Peter Frank, 'Larry Bell: Understanding the Percept', *Zones of Experience: The Art of Larry Bell* (New Mexico: The Albuquerque Museum, 1977).

80 Larry Bell's first solo exhibition in New York was held at Pace Gallery (1965), and was soon followed by John McCracken's New York debut at Robert Elkon Gallery (1966).

81 John McCracken, 'Interview with Thomas Kellein', *John McCracken* (Basel: Kunsthalle, 1995) 28.

82 McCracken explained: 'After I'd done all the things I call slabs and blocks, I thought, how could I simplify these even more? They seemed almost as simple as they could get, but then I saw that leaning against the wall were the sheets of plywood that I used to make these blocks – and that led me to the planks. And I remember thinking, "can I really do this? Can I do something this simple, this dumb?" I did, of course.' [Ibid., 30.]

83 Judd, 'Complaints: Part I', *op. cit.*

84 Mel Bochner, 'Primary Structures', *Arts Magazine* (June 1966) 32–35. [See in this volume p. 222.]

85 Hilton Kramer, '"Primary Structures": The New Anonymity', *New York Times* (1 May 1966) 23. [See in this volume p. 220.]

86 Robert Morris, 'Notes on Sculpture: Part I', *Artforum* (February 1966); 'Notes on Sculpture: Part II', *Artforum* (October 1966); reprinted in *Minimal Art*, *op. cit.*, 222–35. [See in this volume pp. 218–20.]

87 Clement Greenberg, 'Towards a Newer Laocoon', *Partisan Review* (July–August 1940); reprinted in John O'Brian (ed.), *Clement Greenberg: The Collected Essays: Criticism*, I (Chicago and London: University of Chicago Press, 1986) 23–37.

88 Morris, 'Notes on Sculpture: Part I', *op. cit.*

89 The remark is by Benjamin Buchloh. See *Discussions in Contemporary Culture*, ed. Hal Foster (New York: Dia Foundation for the Arts, 1987) 72. On the various interpretations of phenomenology in discussions of Minimalism, see James Meyer, 'The Uses of Merleau-Ponty', in *Minimalism* (Ostfildern: Cantz Verlag, 1988) 178–89.

90 Maurice Merleau-Ponty, *Phenomenology of Perception*, trans. Colin Smith (London: Routledge & Kegan Paul, 1962) 203; originally published as *Phénoménologie de la perception* (Paris: Gallimard, 1945).

91 In *Systemic Painting*, Alloway linked the serial canvases of Frank Stella and Kenneth Noland to Minimal sculpture. See Lawrence Alloway, *Systemic Painting* (New York: Solomon R. Guggenheim Museum, 1966).

92 Lucy R. Lippard, 'Silent Art: Robert Mangold', in *Changing: Essays in Art Criticism* (New York: E.P. Dutton & Co., 1971) 13.

93 Barbara Rose, 'Group Show: Bykert Gallery', *Artforum* (November 1967) 59–60. [See in this volume p. 231.]

94 Jo Baer, 'Letter to the Editor', *Artforum* (September 1967) 5–6. [See in this volume pp. 231–33.]

95 Douglas Crimp, 'Opaque Surfaces', *Arte Come Arte* (Milan: Centro Comunitario di Biera, 1973). [See in this volume pp. 257–60.]

96 The analysis of Ryman's work has been especially rigorous. See Barbara Reise, 'Robert Ryman: Unfinished I (Materials)', *Studio International* (February 1974) 76–80; and 'Robert Ryman: Unfinished II (Procedures)', *Studio International* (March 1974) 122–28. See also Jean Clay, 'La peinture en charpie', *Macula*, 3/4 (September 1978) 167–85; Yve-Alain Bois, 'Ryman's Tact', *Painting as Model*, *op. cit.*, 215–26.

97 See Mel Bochner, 'The Serial Attitude', *Artforum* (December 1967) 73–77. [See in this volume pp. 227–29.]

98 See James Meyer, 'The Second Degree: *Working Drawings and Other Visible Things on Paper Not Necessarily Meant to be Viewed as Art*' in *Mel Bochner: Thought Made Visible*, ed. Richard Field (New Haven: Yale University Art Gallery, 1995) 75–106.

99 See Dan Graham, 'My Works for Magazine Pages: A History of Conceptual Art 1965–1969', in *Dan Graham*, ed. Gloria Moure (Barcelona: Fundació Antoni Tàpies, 1998) 61–66.

100 Robert Smithson, 'Entropy and the New Monuments', *Artforum* (June 1966); reprinted in *The Writings of Robert Smithson*, *op. cit.*; *Robert Smithson: The Collected Writings*, *op. cit.* [See in this volume pp. 223–26.]

101 Donald Judd, 'Letter to the Editor', *Arts Magazine* (February 1967); reprinted in *Donald Judd: Complete Writings 1959–1975*, *op. cit.*

102 Clement Greenberg, 'Recentness of Sculpture', 1967, in *Minimal Art*, *op. cit.*, 180–86. [See in this volume pp. 233–34.]

103 Fried, 'Art and Objecthood', *op. cit.*, 116–47.

104 Greenberg, 'Modernist Painting', in *Clement Greenberg: The Collected Essays and Criticism*, *op. cit.*

105 Fried, 'Art and Objecthood', *op. cit.*, 146.

106 Ibid.

107 Ibid.

108 Donald Judd had his first retrospective exhibition at the Whitney

Museum of American Art, New York, in 1968. Dan Flavin had a retrospective at the National Gallery of Canada, Ottawa, in 1969. Carl Andre had solo shows at the Gemeentemuseum, The Hague, in 1969 and at the Solomon R. Guggenheim Museum, New York, in 1970. Sol LeWitt also had a retrospective exhibition at the Gemeentemuseum, The Hague, as well as the Pasadena Art Museum, both in 1970. Robert Morris' work was exhibited at the Corcoran Gallery of Art, Washington, DC, in 1969, the Whitney Museum of American Art in 1970, and at the Tate Gallery, London, in 1971. Anne Truitt had solo exhibitions at the Baltimore Museum of Art in 1969, the Whitney Museum of American Art, New York, in 1973, and the Corcoran Gallery of Art, Washington, DC, in 1974. Jo Baer's first museum retrospective was held at the Whitney Museum of American Art, New York, in 1975. Robert Ryman had solo shows at the Solomon R. Guggenheim Museum, New York, in 1972, and the Stedelijk Museum, Amsterdam, in 1974. Robert Mangold's first major retrospective was held at the Solomon R. Guggenheim Museum, New York, in 1971, and Brice Marden's first retrospective was also held at the Guggenheim in 1975.

109 This is suggested by Gregory Battcock's review of The Museum of Modern Art's exhibition, 'The Art of the Real: The Development of a Style: 1948–1968'. See Gregory Battcock, 'The Art of the Real the Development of a Style: 1948–68', *Arts Magazine* (June 1968) 44–47. [See in this volume pp. 238–39.]

110 Eugene Goossen, *The Art of the Real: USA 1948–1968* (New York: The Museum of Modern Art, 1968) 7.

111 See Marcelin Pleynet, 'Peinture et "réalité"', *l'Enseignement de la peinture* (Paris: Seuil, 1971) 163–85.

112 Philip Leider, '"Art of the Real", The Museum of Modern Art; "Light: Object and Image", Whitney Museum', *Artforum* (September 1968). [See in this volume pp. 237–38.]

113 See Robert Pincus-Witten, 'The Seventies' in *Eye to Eye: Twenty Years of Art Criticism* (Ann Arbor: UMI Research Press, 1984) 123–39.

114 Robert Morris, 'Anti-Form', *Artforum* (April 1968); reprinted in *The New Sculpture 1965–1975: Between Geometry and Gesture* (New York: Whitney Museum of American Art, 1990) 100–101.

115 Jeanne Siegel, 'Interview with Carl Andre: Artworker', *Studio International* (November 1970) 175–79; reprinted in *Artwords: Discourse on the 60s and 70s* (New York: Da Capo Press, 1992). [See in this volume pp. 250–53.]

116 Ursula Meyer, 'De-Objectification of the Object', *Arts Magazine* (Summer 1969) 20–21. [See in this volume pp. 247–50.]

117 Carl Andre, 'The Bricks Abstract', *Art Monthly*, 1 (October 1976) 24. [See in this volume p. 251.]

118 Judy Chicago, *Through the Flower: My Struggle as a Woman Artist*, (Garden City: Doubleday & Company, 1975). [See in this volume pp. 264–65.]

119 For another account of Chicago's early work, see Laura Meyer, 'From Finish Fetish to Feminism: Judy Chicago's Dinner Party' in *Sexual Politics: Judy Chicago's Dinner Party in Feminist Art History*, ed. Amelia Jones (Los Angeles: Armand Hammer Museum, University of California, 1996).

120 See Susan Stoops, *More than Minimal: Feminism and Abstraction in the 1970s* (Waltham, Massachusetts: Rose Art Museum, Brandeis University, 1996).

121 Michelson, *op. cit.*

122 Michelson quotes from lecture notes taken during a course taught by Merleau-Ponty at the Collège de France in Paris in the 1950s. [Michelson, *op. cit.*]

123 Charles Sanders Peirce quoted in Michelson, *op. cit.* For a discussion of 'firstness', see Thomas S. Knight, *Charles Peirce* (New York: Washington Square Press, 1965) 74–75.

124 Rosalind Krauss, 'Sense and Sensibility: Reflection on Post '60s Sculpture', *Artforum* (November 1973) 43–53. [See in this volume pp. 253–57.]

125 Joseph Kosuth, 'Art After Philosophy', Parts I and II, *Studio International* (October–November 1969); reprinted in *Idea Art*, ed. Gregory Battcock (New York: E.P. Dutton & Co., 1973) 70–101.

126 The non-profit Dia Foundation, founded by Philippa de Menil and the dealer Heiner Friedrich, provided important commissions to artists like Flavin, Judd and De Maria.

127 Robert Rosenblum, 'Name in Lights', *Artforum* (March 1997) 11–12. [See in this volume pp. 290–91.]

128 Sol LeWitt and Andrea Miller-Keller, 'Excerpts from a Correspondence, 1981–1983', *Sol LeWitt Wall Drawings 1968–1984* (Amsterdam: Stedelijk Museum, 1984) 19.

129 Truitt, *Daybook, op. cit.*

130 See Bois, 'Ryman's Tact', *op. cit.*

131 Donald Judd, 'On Installation' (Kassel: Documenta 7, 1982) 164–67; reprinted in *Donald Judd: Complete Writings 1975–1986, op. cit.*, 19–24. Originally published under the title, 'The Importance of Permanence', *Journal: A Contemporary Art Magazine*, 32: 4 (Spring 1982) 18–21. [See in this volume pp. 266–68.]

132 On this history see Donald Judd, 'Statement for the Chinati Foundation', in *Donald Judd: Complete Writings 1975–1986, op. cit.*, 110–14.

133 Peter Halley, 'Frank Stella ... and the Simulacrum', *Flash Art* (January 1986); reprinted in *Peter Halley: Collected Essays 1981–1987* (Zurich: Bruno Bischofberger Gallery, 1988) 137–50. [See in this volume pp. 268–70.]

134 *Ibid.*

135 Hal Foster, 'The Crux of Minimalism', *Individuals: A Selected History of Contemporary Art 1945–1986* (Los Angeles: The Museum of Contemporary Art; New York: Abbeville Press, 1986) 162–83. [See in this volume pp. 270–75.]

136 *Ibid.*

137 On the development from Minimalism to Institutional Critique, see the important essay by Benjamin Buchloh, 'Michael Asher and the Conclusion of Modernist Sculpture', *Performance/Text(e)s/ and Documents*, ed. Chantal Pontbriand (Montreal: Parachute, 1981) 55–65.

138 Foster, 'The Crux of Minimalism', *op. cit.*, 162.

139 *Ibid.*, 172.

140 Rosalind Krauss, 'The Cultural Logic of the Late Capitalist Museum', *October*, 54 (Fall 1990) 3–17. [See in this volume pp. 285–89.]

141 *Ibid.*

142 Anna C. Chave, 'Minimalism and the Rhetoric of Power', *Arts Magazine* (January 1990) 51. [See in this volume pp. 276–85.]

143 *Ibid.*, 54.

144 Russell Ferguson, 'The Past Recaptured' in *Felix Gonzalez-Torres* (Los Angeles: Museum of Contemporary Art, 1994) 29.

145 See Paul Schimmel, *Charles Ray* (Los Angeles: Museum of Contemporary Art, 1998) 80.

146 See Lynn Zelevansky, *Sense and Sensibility: Women Artists and Minimalism in the 1990s* (New York: The Museum of Modern Art, 1994) 7. This point of view also appears in Nancy Spector, *Felix Gonzalez-Torres* (New York: Solomon R. Guggenheim Museum, 1995) 16–17. The topic of neo-Minimalism is also the subject of Alexander Alberro, 'Minimalism and its Vicissitudes' in *Minimalisms* (Ostfildern: Cantz, 1998) 197–210.

WORK-
S

CARL ANDRE

JO BAER

LARRY BELL

RONALD BLADEN

MEL BOCHNER

JUDY CHICAGO

WALTER DE MARIA

DAN FLAVIN

EVA HESSE

RALPH HUMPHREY

DONALD JUDD

SOL LEWITT

JOHN MCCRACKEN

ROBERT MANGOLD

BRICE MARDEN

AGNES MARTIN

PAUL MOGENSEN

ROBERT MORRIS

DAVID NOVROS

ROBERT RYMAN

TONY SMITH

ROBERT SMITHSON

FRANK STELLA

ANNE TRUITT

1959–63 FIRST ENCOUNTERS During the late

1950s a new sensibility began to emerge that suggested an alternative to the subjective impulse of Action painting. Using anti-compositional methods of symmetrical division and repetition, and thick, material surfaces, Frank Stella, Ralph Humphrey, Robert Ryman, Robert Mangold and Jo Baer embarked on a radical simplification of painterly process. For Donald Judd, Dan Flavin, Sol LeWitt, Anne Truitt, Larry Bell and John McCracken this reduction led to the production of reliefs and objects that extended the perceptual concerns of painting into three dimensions. Carl Andre developed a materialist sculpture of unadulterated notched and stacked beams, while Robert Morris first created his Minimal works as prop pieces for performances. The influential artist/critic Donald Judd both defined this new literalist tendency in art and began showing his own work during this period.

'16 Americans'
The Museum of Modern Art, New York
16 December 1959–17 February 1960
Installation view
Frank STELLA
Black Paintings
1958-59

This seminal exhibition organized by Dorothy Miller at The Museum of Modern Art, New York, included four of the *Black Paintings* by the then twenty-three year-old artist Frank Stella. Their large scale recalls the size of the Abstract Expressionists' paintings, although their monochromatic palette and symmetry deny the possibility of unexpected chromatic or compositional relationships. Stella used the thickness of the support to dictate the width of the stripes, allowing the material edge of the canvas, rather than spontaneous 'artistic expression', to determine the work's organization. As Carl Andre said of Stella's paintings: 'Art excludes the unnecessary. Frank Stella has found it necessary to paint stripes. There is nothing else in his painting.'
– Carl Andre, *16 Americans* [cat.], 1959

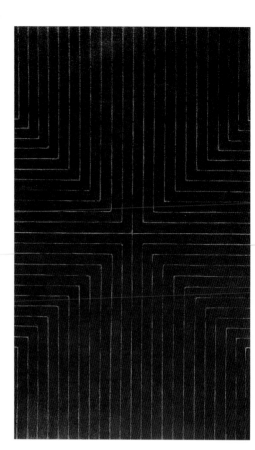

left

Frank STELLA

Die Fahne Hoch!

1959

Enamel on canvas

309 × 185 cm [122 × 73 in]

Collection, Whitney Museum of American Art, New York

Frank Stella, who temporarily worked as a house painter in the late 1950s, began using the house painter's commercial enamels and brushes in his *Black Paintings*. Each black stripe is separated by a thin line of unpainted canvas. The all-over symmetry of the works helps avoid illusionism and pictorial depth. The rectilinear shape of the canvas determines the placement of each hand-painted stripe. The central cruciform lines symmetrically bisect the canvas into quadrants, and each interior stripe reiterates the right angles of the cross. Stella's eschewing of allusions ('What you see is what you see'), however, becomes complicated by his choice of titles. Many of the *Black Paintings* refer to disasters; '*Die Fahne Hoch!*', a refrain from the official marching song of Hitler's stormtroopers, is one of several titles in the series alluding to Nazi subject matter.

Frank <u>STELLA</u>
Aluminum Paintings
1960
Aluminium paint on canvas
Leo Castelli Gallery, New York
Installation view

The *Aluminum Paintings* were first shown at the Leo Castelli Gallery, New York, in 1960. Each of the twelve large, shaped canvases in the series is covered in stripes of metallic aluminium oil paint. The first three paintings are a darker colour, the remainder are a lighter shade.

Frank <u>STELLA</u>
Luis Miguel Dominguin
1960
Aluminium paint on canvas
244 × 183 cm [96 × 72 in]

Whereas the stripes in Stella's *Black Paintings* directly follow the shape of their support, in the *Aluminum Paintings* the stripes break from the rectilinearity of the canvas and shift direction, or 'jog', to form more decorative patterns. This change caused empty spaces, or squares of exposed canvas that did not fit into the configuration. Stella cut these unpainted areas out, thereby forming the shaped canvas. This was an important innovation in the 1960s, and became the subject of the 1965 group exhibition, 'The Shaped Canvas', at the Solomon R. Guggenheim Museum, New York.

opposite
Frank <u>STELLA</u>
Marriage of Reason and Squalor
1959
Enamel on canvas
230 × 334 cm [91 × 131.5 in]
Collection, The Saint Louis Art Museum

Stella's use of uniform repetition in his stripe paintings influenced many younger artists. Both Stella and the younger Minimalists were united in a rejection of the emotionality of Abstract Expressionism. Stella's close friend Carl Andre helped name this bilaterally symmetric painting, referring to a series of pastels Andre completed in 1957. They were both pleased with the title's allusions to both J.D. Salinger ('For Esmé With Love and Squalor') and William Blake ('The Marriage of Heaven and Hell'), as well as its acute description of the experience of being a young and impoverished artist in New York.

Frank <u>STELLA</u>
Portrait Series
1963
Metallic paint on canvas
Leo Castelli Gallery, New York
1964
Installation view

Stella's *Portrait Series* of 1963 is a group of paintings that protrude from the wall and feature various cut-out shapes. In 1964 Stella exhibited eight of these lavender paintings at the Leo Castelli Gallery, New York. Each work is a shaped canvas whose contours are delineated by painted lines and whose centres remain open. He named them after his friends: the sculptor Carl Andre; the painter – and later Stella's biographer – Sidney Guberman; the gallerists Leo Castelli and Ileana Sonnabend; the photographer and filmmaker Hollis Frampton; Charlotte Tokayer, Henry Garden and D, the nickname of director Emile D'Antonio, whose *Painters Painting* (1970) is a well-known film on the New York art scene of the 1960s. Once again he limited himself to one colour, as in the *Black Paintings*, choosing metallic purple paint for this series. The Minimalists admired the cut-out shapes and the thickness of Stella's stretchers for enhancing the painting's three-dimensional materiality and revealing the supporting wall.

Frank STELLA
Valparaiso Green
1963
Metallic paint on canvas
198 × 343 cm [78 × 135 in]

Part of the *Valparaiso Series*, in which the green paintings were often juxtaposed with orange-coloured, mirrored image copies, it was completed soon after Stella's return to New York from a residency at Dartmouth College, Vermont. This work is made up of bands of paint that form three interlocking triangles, placed so that the apex of each triangle touches the base of the neighbouring triangle. Admired by the artist/critic Donald Judd, it was included in the permanent installation of works by contemporary artists in the loft building at the corner of Spring and Mercer Streets that Judd renovated in SoHo, New York, in the early 1970s.

52 Robert <u>RYMAN</u>
Untitled
1959
Oil on linen
84 × 84 cm [33 × 33 in]

Ryman preferred the neutrality of white because it mimicked most closely the
unpainted canvas and carried no dark, emotive associations. The monochrome colour
allows the texture of the canvas' surface to be a prominent feature, whereas with
multiple colours the viewer's focus would shift to colour relations. The seam calls
attention to the edge of the work, shifting focus away from the traditional centre of the
picture plane. With bright lighting, the pronounced seam creates shadows and
variations in tone on the white surface. Ryman continued to use irregular surfaces
and thick, uneven applications of white pigment throughout the 1960s.

Robert <u>RYMAN</u>
Untitled No. 15
1961
Oil on linen
25 × 28 cm [10 × 11 in]

In this painting, Ryman segments the top half of the stretched linen cloth surface into four square sections painted with a flat, uniform brushstroke. The lower half is a field of painterly, thick strokes. Beneath the white surface a layer of blue paint is visible. Ryman uses the blue underpainting not only to contrast with the white, but also as a tool in building a tactile surface.

Robert <u>RYMAN</u>
Untitled
1962
Oil on linen
43 × 43 cm [17 × 17 in]

This work is built up with layers of colour. First Ryman laid a blue-green colour on the linen canvas, and then overpainted it with loose, thick brushstrokes in white. The openness of the brushstrokes allows the underpainting to show through. He then stapled the canvas on to a board so that its irregular edges remain visible. The areas of unpainted canvas appear to form a border around the central painted section, stressing the materiality of both the paint and support.

Ralph <u>HUMPHREY</u>
Untitled
1954
Oil on canvas
81 × 96.5 cm [32 × 38 in]

Ralph Humphrey's monochrome paintings of the 1950s and early 1960s, such as this rich copper-brown work, were admired by such artists as Donald Judd, Mel Bochner, Brice Marden and Robert Mangold. The purity of the single colour, combined with the thickness of the canvas, appealed to the Minimalists' interest in the basic abstract forms and objecthood, or materiality, of an artwork.

Ralph <u>HUMPHREY</u>
Olympia
1959
Oil on canvas
201 × 142 cm [79 × 56 in]

Ralph <u>HUMPHREY</u>

Atlanta

1958

Oil on canvas

168 × 244 cm [66 × 96 in]

In the late 1950s Ralph Humphrey began creating abstract paintings made up of the subtle gradation of a single colour such as ochre, blue or green. Critics originally dismissed this work as offering 'nothing to look at'. The austerity of these paintings, which did not espouse any emotive content (as found in the work of the Abstract Expressionists who still predominated at the time), as well as their opaque surfaces, were admired by younger Minimalist sculptors and painters. Judd, reviewing Humphrey's 1960 show at Tibor de Nagy Gallery, New York, praised the way the textured, painterly surface and all-over organization of Humphrey's monochrome canvases caused an effect of 'unique immediacy', focusing attention on the simple act of perceiving them.

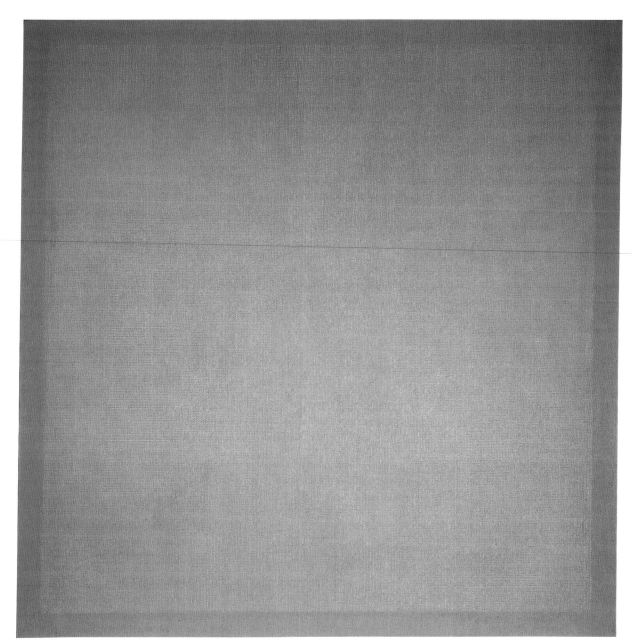

Agnes <u>MARTIN</u>

Graystone II

1961

Oil and gold leaf on canvas

190 × 187 cm [74 × 73 in]

This large, dense and intricate painting is built up of a grid of small rectangular dabs of blue/purple on a gold leaf surface. The colour is limited to the centre of the canvas, allowing a border of pure gold to frame the work. Although the grid is ordered and geometric, the hand-painted surface and the luxurious materials, reminiscent of the gold used in religious icons, suggest the spirituality Martin often associated with her work.

Agnes <u>MARTIN</u>

Song

1962

Watercolour on canvas

61 × 61 cm [24 × 24 in]

Martin uses the arch here to allude to classical forms, which epitomized, for her, the human attempt to reach towards perfection and the sublime. Only abstract, elementary geometry could refer to a transcendental experience; literally representing nature would be too limiting. The work's title reinforces Martin's desire to reflect the sublimity of nature, poetry and music.

FIRST ENCOUNTERS

Jo BAER
Untitled
1961
Oil on canvas
183 × 183 cm [72 × 72 in]

Jo Baer's first paintings were iconic, geometric representations, as in this star. Although this work is not completely abstract, it opposes traditional painting's reliance on multiple parts and complex figure/ground relationships. Her use of so basic and fundamental an image filling up the canvas causes it to become a star, rather than merely its representation. The simple geometry allows for an immediacy of perception, which Baer strove to achieve in her future work.

Jo BAER
Untitled
1963
Oil on canvas
183 × 183 cm [72 × 72 in]

Baer surrounded the large white, seemingly empty centre of the canvas with painted borders: a thin stripe of light blue travels around three sides of the canvas, while a thick black stripe borders the entire painting. A small linear design of blue pigment appears in the upper corners of the black border, a simple pattern which seems almost ornate amidst the stark black and white canvas.

Carl ANDRE
Last Ladder
1959
Wood
214 × 15 × 15 cm [84 × 6 × 6 in]
Collection, Tate Gallery, London

Carl Andre chiselled triangular cuts into one face of the vertical wooden column of his sculpture *Last Ladder*. Its vertical shape and the repeated cuts into the wood relate to the repeated cuts made by Constantin Brancusi in his sculpture *Endless Column* (1938). Andre particularly admired Brancusi's use of cutting into material instead of traditional sculptural techniques such as carving or clay modelling. Eventually Andre abandoned making repeated cuts into solid materials in favour of repeated combinations of identical, discrete units of wood, brick or metal. Of work from this period he said, 'Up to a certain time I was cutting into things. Then I realized that the thing I was cutting was the cut. Rather than cut into the material, I now use the material as the cut in space.'
– Carl Andre, Artist's statement, 1966

214 × 15 × 15 cm [84 × 6 × 6 in]
Collection, Tate Gallery, London

Carl ANDRE

Pyramid (Square Plan)

1959 (destroyed), remade Orleans, Massachusetts, 1970

Eastern pine

74 units, 5 × 10 × 79 cm [2 × 4 × 31 in] each

175 × 79 × 79 cm [69 × 31 × 31 in] overall

Collection, Dallas Museum of Art, Texas

In the *Pyramid Series*, Andre used lengths of wood bought directly from the timber yard, notching each piece with a radial saw and using traditional joinery techniques to connect the units. This work is constructed from seventy-four small beams intersecting at right angles; the beams are progressively longer according to their structural role within the work. Created in Frank Stella's studio at the same time as Stella was working on his *Black Paintings*, the *Pyramids'* serial ordering recalls the stripe patterns of Stella's canvases. Both artists worked with basic geometric units, eschewing ornament and subjective, traditional studio technique.

Carl ANDRE

Herm

1960 (destroyed), remade 1976

Western red cedar

91.5 × 30.5 × 30.5 cm [36 × 12 × 12 in]

Collection, Solomon R. Guggenheim Museum, New York

This work is part of the *Elements Series*, originally proposed in 1960. The most simple of a series of basic geometric shapes, it consists of a single cedar timber 91.5 cm [3 ft] high. The title refers to ancient Greek and Roman columnar markers which were accompanied by a bust of the god Hermes or other important gods and ancestors.

Carl ANDRE

Pyre

proposed New York, 1960, made Minneapolis, 1971

Wood

8 units, 30.5 × 30.5 × 91.5 cm [12 × 12 × 36 in] each

122 × 91.5 × 91.5 cm [48 × 36 × 36 in] overall

This is one of the more complex structures in Andre's *Elements Series*. Eight timber blocks measuring 30.5 × 30.5 × 91.5 cm [12 × 12 × 36 in] form a compact, wall-like structure, with two timbers placed on four levels to form right angles, the centre remaining open.

Donald JUDD
Untitled
1962
Oil on wood, metal pipe
122 × 84 × 56 cm [48 × 33 × 22 in]

This work makes apparent Judd's frustrations with painting early in his career. Where a painting or relief is to be viewed straight on, Judd's object is free-standing and meant to be seen in the round; it exists in actual space rather than pictorial space. The pipe is a found object and the piece made according to its dimensions. Other details stress the work's three-dimensional quality. The pipe articulates the cubic volume between the perpendicular planks; the cadmium red surface unifies the work into a single, whole shape. Yet Judd's aim to produce a 'specific' object, an object that is easy to grasp visually, is compromised by crude execution: the red paint cannot mask the grainy, knotted wood. Dissatisfied with the arbitrary appearance of his early works, Judd sought a more pristine effect, developing factory-made works built of anodized aluminium, Plexiglas and other man-made materials.

Donald JUDD
Untitled
1963
Oil on wood, galvanized iron, aluminium
127 × 107 × 14 cm [50 × 42 × 5.5 in]

Donald Judd began his professional career as a painter in the late 1950s. In 1961–62 he achieved an amalgam of painting and sculpture using industrial materials, creating reliefs that jut into space. In this piece the edges of the metal strips curve away from the supporting wall, and their texture draws attention to their three-dimensionality. The work is seemingly more a relief than a painting, pointing to his development of three-dimensional objects later that same year. This work was first shown at the Green Gallery in New York in 1963–64, then again in Providence, Rhode Island, in 1965, and was included in 'The Art of the Real' at The Museum of Modern Art, New York, in 1968.

Donald JUDD
Untitled
1963
Oil on wood, enamel on aluminium
183.5 × 264 × 124.5 cm [72 × 104
× 49 in]

Donald JUDD
Untitled
1991 (First type 1963)
Painted plywood, aluminium tube
49.5 × 114 × 77.5 cm [19.5 × 45 ×
30.5 in]

This work consists of a wooden box painted cadmium red with a scooped recession in the top into which Judd placed an aluminium tube. He built the box to the dimensions of the tube's circumference, so that the two elements, the wood and the metal, combine in a wholistic, singular shape. The first piece of this type was included in Judd's first show at the Green Gallery, New York, in 1963. All the works in the show were painted cadmium red to unify the ensemble and to highlight the literal contours of the individual shapes.

Donald JUDD
Untitled
1991 (First type 1963)
Painted plywood, aluminium tube
49.5 × 114 × 77.5 cm [19.5 × 45 ×
30.5 in]

Dan <u>FLAVIN</u>
icon V (Coran's Broadway Flesh)
1962
Oil on masonite, clear
incandescent lightbulbs
107 × 107 × 25 cm [42 × 42 × 10 in]

In the *icon series*, Flavin's first experiments with industrial lighting, he combined the solid, rectilinear form reminiscent of a canvas with various types of lightbulbs, tubes and fittings positioned around the edges of the rectangle. He used the term 'icon' to describe not a religious object but a non-hierarchical arrangement of light and shape. The *icons* were designed to accompany one another in the exhibition space; hence Flavin carefully considered how the illuminating lights of each would interact and affect the ensemble as a whole. Thus *icon V* proved to be prescient of Flavin's installations of the later 1960s: the ambient glow of the many lights surrounding the square dematerializes its geometric form, pointing away from singular, discrete objects towards a more environmental art.

Dan <u>FLAVIN</u>
Untitled drawing
1963
Pencil on paper
28 × 36 cm [11 × 14 in]

In this drawing Flavin has sketched some of his *icons* that were to be exhibited at the Kaymar Gallery, New York, 'some light' show in 1964. Flavin also planned a layout of lights for an entire gallery environment, with white, circular lights attached to a strip of dark blue wall on all four sides of the room, a project that was never executed.

Dan <u>FLAVIN</u>
the diagonal of May 25, 1963 (to
Robert Rosenblum)
1963
Cool white fluorescent light
l. 244 cm [8 ft]

This ground-breaking work, originally a single, gold fluorescent tube affixed to the wall at a 45-degree angle, was first exhibited at the Wadsworth Atheneum in Hartford, Connecticut in cool white. The work transformed the traditional gallery-going experience into one where the viewer did not so much view the work as an object as become enveloped by its play of light and shadow. Inspired by the single straight line and repetition suggestive of continuity of Constantin Brancusi's *Endless Column* (this work was initially dedicated to the Romanian artist), Flavin also used a simple linear form that, because of the glow of the fluorescent light, appears to extend beyond the limits of the physical object. 'A common lamp becomes a common industrial fetish, as utterly reproducible as ever but somehow strikingly unfamiliar now.'
– Dan Flavin, ' … in daylight or cool white', 1964

Dan <u>FLAVIN</u>
the nominal three (to William of
Ockham)
1964-69
Cool white fluorescent light
h. 244 cm [96 in]

Dedicated to the fourteenth-century Nominalist philosopher William of Ockham, this work consists of three discrete parts: the first is one lamp, the second, two, the third, three. Limiting the number of elements, Flavin followed the economic mathematics of William of Ockham who stated: 'No more entities should be posited than necessary'. When first installed at the Green Gallery, New York, in 1964 alongside other works, the three elements were arranged closely together. A subsequent installation at the National Gallery of Canada in 1969 demonstrated an increased engagement with the site: the elements were distributed across a large wall, revealing the gallery as a whole.

Robert MORRIS
Column
1961
Painted plywood
244 × 61 × 61 cm [96 × 24 × 24 in]

Column, a simplified form based on ancient Egyptian temple architecture, was used as a prop for a performance at the Living Theater in New York. The artist's original intention was to stand inside the sculpture and allow the weight of his body to topple the column. Although the action was finally produced by means of a small rope, the human scale and dynamism of the column still refer to the body's presence.

left
Robert MORRIS
Untitled (Box for Standing)
1961
Fir
188 × 63.5 × 27 cm
[74 × 25 × 10.5 in]

Box for Standing uses the architectural form of a doorway with a back panel creating a space for enclosure and cover. The work was made to fit the dimensions of Morris' own body, much like other early works by the artist built as props for performances.

Robert MORRIS
Untitled (Knots)
1963
Painted wood, hemp rope
Wooden structure, 14 × 38 × 8 cm
[5 × 15 × 3 in]
This work was one of a series made
between 1962 and 1964 using rope either
attached to or piercing a wooden form. A
painted wooden relief with five
rectangular recesses hangs on the wall.
Five strands of hemp are affixed to the
recesses. The ends of the rope are
knotted together. Morris juxtaposes a
pliable material – rope – with the rigid
wooden structure. This is one of his first
explorations with unstructured forms, a
method he would continue to explore in
his later 'anti-form' works.

left
Robert MORRIS
Untitled (Rope Piece)
1964
Painted wood, rope
Dimensions variable
This work combines a relief and a free-standing structure, united by a thick rope. A
5.5-m [18-ft] rope extends from a circular hole in a triangular box attached to the wall.
The rope coils upon the floor and terminates in a square box that is placed a few feet
away from the gallery wall. Both the wooden forms and the rope are painted grey, like
the plywood structures that dominated Morris' Green Gallery show in December 1964.

Sol <u>LEWITT</u>
Wall Structure, Black
1962
Oil on canvas, painted wood
100 × 100 × 60 cm [39 × 39 × 23.5
in]

In this work the viewer gazes inside the
peephole and sees a metallic silver
square. This sets up a more
contradictory perception than the
literalist canvases of Stella and the early
reliefs of Judd, which are to be seen in
their entirety at once.

Sol <u>LEWITT</u>
Wall Structure
1963
Oil on canvas, painted wood
157.5 × 157.5 × 63.5 cm [62 × 62
× 25 in]

In the early 1960s LeWitt created a
number of wall reliefs, or *Structures*,
protruding out from the wall into the
space of the viewer. They are neither
paintings nor sculptures, but both. This
early work was one of his first
experiments with seriality, although it
lacked the steady progression and
precise measurements he was to use in
later works.

opposite
Anne <u>TRUITT</u>
Southern Elegy
1962
Painted wood
119 × 53 × 18 cm [47 × 21 × 7 in]

Although Truitt was moving into a more
abstract style by 1962, her earliest
sculptures, such as this work or *First*,
still retain allusions to fences,
tombstones and other architectural
details recalled from the artist's
childhood in Easton, Maryland.

opposite

Anne <u>TRUITT</u>

Knight's Heritage

1963

Painted wood

152 × 152 × 30.5 cm

[60 × 60 × 12 in]

Truitt was inspired by Barnett Newman's use of simple divisions and great expanses of saturated colour, as well as his allusions to the sublime. Truitt also imbued her sculpture with allusion, yet hers is to personal memory, rather than to transcendent, grand themes.

White: Five

1962

Painted wood

137 × 59 × 20 cm [54 × 23 × 8 in]

In 1962 Truitt began her first series of abstract sculptures. The title *White: Five* refers to the colour and number of elements that make up this work. She soon abandoned this focus on pure seriality and uniform colour, preferring variations of both colour and shape, and naming her work in such a way as to evoke a highly personal subject matter.

Anne <u>TRUITT</u>

Valley Forge

1963

Painted wood

154 × 152 × 30.5 cm [60.5 × 60 × 12 in]

Truitt constructed this work to approximate human scale, just short enough to allow the viewer to peer over the top. It is segmented into geometric divisions with lines incised into the wood and distinct colour divisions. The title refers to the American Revolutionary battle site at Valley Forge, Pennsylvania, where General George Washington was stationed in 1777–78.

Larry BELL

Ghost Box

1962-63

Paint on canvas and glass

122 × 223.5 × 8 cm [48 × 88 × 3 in]

This mirrored relief combines painting on canvas and three types of glass – mirrored, vacuum-coated and sandblasted – in order to suggest contradictory forms of illusion. The central panel neutralizes the isometric reading of the outer black frame, proposing a shallow, fictitious depth of 'receding' squares. These contradictory impressions of volumetric space make for a work of surpassing visual complexity.

Larry BELL

Untitled No. 7

1961

Mirror, wood, paint

30.5 × 30.5 × 13 cm [12 × 12 × 5 in]

Untitled No. 7 is one of Larry Bell's earliest glass boxes. A rectangular solid, it consists of six mirrored panes inset in a white wooden frame. On the front side, Bell has scraped the mirroring off the glass. This transparent section, a square zone with truncated corners, opens on to the box's interior, revealing a pattern of mirrored stripes on the rear panel that fragments the viewer's reflection.

Larry BELL
Bette and the Giant Jewfish
1963
Vacuum-coated glass, chrome-plated metal
42 × 42 × 42 cm
[16.5 × 16.5 × 16.5 in]

In this sculpture, one of Bell's most arresting works, the surface pattern was applied by silkscreen, then washed off after the glass was vacuum-coated with aluminium. The resulting checkerboard patterns are layered and visually complex. The screened areas are transparent, allowing the viewer to peer inside the cube; the aluminium-coated squares reflect his or her body. Bell eventually jettisoned patterning from his work, yet continued to explore this contradiction of transparency and reflection in his all-glass cubes and installations. The sculpture refers to an old postcard which, bearing the legend 'Bette and Giant Jewfish', was used as the announcement of Bell's second show at the Los Angeles Ferus Gallery in 1963.

John <u>MCCRACKEN</u>
Untitled
1963
Oil on paper
127 × 127 cm [50 × 50 in]

In this painting the pattern of intersecting post and lintel forms refers to ancient
Neolithic architecture, a primary source of McCracken's work. Here McCracken allows
the pattern to comprise the entire painting, negating traditional figure/ground
relationships and suggesting a continuation beyond the limits of the work.

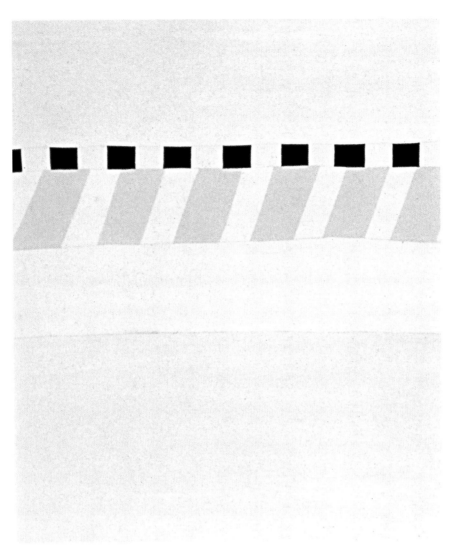

John <u>MCCRACKEN</u>
Horizon
1963
Acrylic on canvas
56 × 51 cm [22 × 20 in]

John McCracken, a native of California, began as a painter before moving to more sculptural forms. In this work McCracken's process of paring painting down to its most basic geometric elements is apparent: the rectangular shapes that proceed in a horizontal line across the painting mimic the shape of the canvas itself, calling attention to the fundamental materials of painting; the colours are limited to black and white.

John <u>MCCRACKEN</u>
Black Cross
1963
Acrylic on canvas
56 × 56 cm [22 × 22 in]

This is one of several paintings completed by McCracken in 1963–64 incorporating such emblems as arrows, crosses and chevrons. Inspired by the diagrammatic works of Ellsworth Kelly, Robert Indiana and Kenneth Noland made during the late 1950s and early 1960s, as well as the Supremacist paintings of Kasimir Malevich, McCracken began to use emblematic formats in order to simplify and strengthen the visual impact of his work. This painting alludes to Malevich's famous *Black Cross* (c. 1913).

1964–67 HIGH MINIMALISM

During the mid 1960s, group shows such as 'Black, White, and Gray' and 'Primary Structures' established Minimal art as a significant new movement. Each of the leading figures associated with Minimalism developed a style of austere, serial or whole geometric forms. Donald Judd began to use factory production, creating boxes and stacks in iron, anodized aluminium and Plexiglas; Robert Morris built all-grey plywood pieces and mirrored cubes; Dan Flavin mounted fluorescent lamps on the wall and floor. Carl Andre's brick pieces and metal planes, Sol LeWitt's open cube lattices, Anne Truitt's asymmetrical metal solids, Larry Bell's glass boxes and John McCracken's lacquered works were also developed during these years. Younger artists including Robert Smithson, Mel Bochner and Eva Hesse transformed the serial logic and geometric forms of the new sculpture into highly distinctive idioms. When Frank Stella, the painter most associated with Minimalism, rejected his stripe format in 1966, it was left to Robert Ryman, Jo Baer, David Novros, Robert Mangold, Ralph Humphrey, Agnes Martin, Paul Mogensen and Brice Marden to breathe new life into the monochrome canvas.

'Black, White, and Gray'
Wadsworth Atheneum, Hartford, Connecticut
9 January–9 February 1964
Tony SMITH
Die
1962
Steel
183 × 183 × 183 cm [6 × 6 × 6 ft]

Tony Smith's *Die* was fabricated by professional steelworkers, thus ensuring that any possibility of a reading of the object as a direct result of the individual artist's touch was completely removed. The title makes reference both to its resemblance to a playing die, and to the imperative tense of the verb 'to die', while its scale makes obvious reference to the human form, thus creating a sense of foreboding. The expressive quality of Smith's colour and allusions distinguished his work from the avowedly contentless, literalist art of the younger Minimalists.

This exhibition, curated by Samuel J. Wagstaff, Jr, sometimes referred to as the 'first' Minimal show, included the work of the Minimal artists Robert Morris, Anne Truitt and Dan Flavin alongside that of the Pop artists Andy Warhol and Roy Lichtenstein as well as their influential predecessors Robert Rauschenberg and Jasper Johns. The black geometric sculpture of Tony Smith was also presented for the first time in a museum. All of the work in the show was extremely limited in colour; only work in black, white and grey was included. Although stylistically diverse, this disparate group of artists was identified as epitomizing an emerging 'cool' sensibility.

'Black, White, and Gray'
Wadsworth Atheneum, Hartford, Connecticut
9 January-9 February 1964
Installation view

'Primary Structures'
Jewish Museum, New York
27 April-12 June 1966
Installation view

Often considered the exhibition that ushered in Minimalism as a movement, 'Primary Structures' actually included a wide range of works by forty-two American and British artists. This exhibition, organized by Kynaston McShine, received extensive publicity in both the specialist and popular press, including *Newsweek* and *Life* magazines. Although they did not necessarily receive the most congratulatory reviews, Andre, Flavin, Judd, LeWitt and Morris, who were all in this show, soon emerged as Minimalism's key figures.

opposite
'Primary Structures'
Jewish Museum, New York
27 April-12 June 1966
Dan FLAVIN
monument 4 those who have been killed in ambush (to P.K. who reminded me about death)
1966
Red fluorescent light
3 units, 244 cm [96 in] each; 345 cm [136 in] overall

First shown at 'Primary Structures', this construction of red fluorescent tubes demarcates a gallery corner. Two tubes are hung on adjacent walls meeting in the corner and a third spans the corner, creating a triangular projection into real space. The red glow from the lights illuminates that entire portion of the gallery, extending beyond the physical boundaries of the tubes themselves, and moreover reveals the corner as a place of display. Both the title and the red colour reflect Flavin's awareness of the growing death toll of the burgeoning Vietnam war. Following the Jewish Museum show, it was then hung in the back room at Max's Kansas City, a famous bar where many New York artists used to congregate during the 1960s and 1970s.

HIGH MINIMALISM

'Primary Structures'
Jewish Museum, New York
27 April–12 June 1966
Walter DE MARIA
Cage
1961–65
Stainless steel
216 × 37 × 37 cm [85 × 14.5 × 14.5 in]

Walter De Maria began constructing geometric sculptures in the early 1960s, including his famous steel *Cage* shown in 'Primary Structures'. Unlike many of the Minimalists, he did not intentionally seek a refinement of the object pared of all metaphorical allusions. *Cage* both refers to the composer John Cage, whose aesthetic of 'meaninglessness' is suggested by the work's simple, repetitive structure, and an actual cage, or a constricting, barred environment. 'By meaningless work I simply mean work which does not make you any money or accomplish a conventional purpose. For instance, putting wooden blocks from one box to another, then putting the blocks back to the original box, back and forth … '
– Walter De Maria, Artist's statement, 1961

above left and right

'Systemic Painting'

Solomon R. Guggenheim Museum, New York

21 September-27 November 1966

Installation in progress

Lawrence Alloway organized 'Systemic Painting' for the Solomon R. Guggenheim Museum in New York, which opened in September 1966. It included works by twenty-eight artists, including Jo Baer, Ralph Humphrey, Ellsworth Kelly, Robert Mangold, Agnes Martin, David Novros, Robert Ryman and Frank Stella. Alloway defines 'systemic' as a type of painting that moves away from expressionism by using single fields of colour, often repeated, or grids and geometric shapes. The systemic painter knows the final result of the work before its completion; the planning occurs conceptually and in preliminary sketches, not on the canvas itself.

'Systemic Painting'

Solomon R. Guggenheim Museum, New York

21 September-27 November 1966

Jo BAER

Primary Light Group: Red, Green, Blue

1964

Oil and synthetic polymer on canvas

Triptych, 153 × 153 cm [60 × 60 in] each

Collection, The Museum of Modern Art, New York

In the catalogue for 'Systemic Painting', Baer states that the three canvases are part of a series of twelve primary-coloured paintings, yet each canvas is a different size and shape: small squares, large squares, vertical rectangles and horizontal rectangles. The canvases in this work are large squares, measuring 153 × 153 cm [5 × 5 ft]. Baer focuses on the variations in the appearance of the canvases when the black border is juxtaposed with a different primary colour, as well as the immense number of permutational possibilities in a series of twelve canvases: the works could be arranged in 831,753,600 different combinations of shapes and primary colours.

HIGH MINIMALISM

'10'
Dwan Gallery, New York
4-29 October 1966
clockwise l. to r.,
Carl ANDRE
Field
1966
Jo BAER
Horizontal Flanking: large scale
1966
Donald JUDD
Untitled
1966
Sol LEWITT
A5
1966
Robert SMITHSON
Alogon
1966
Robert MORRIS
Untitled
1966

In the autumn of 1966 art dealer Virginia Dwan brought together the ten painters and sculptors most associated with the new pared-down geometric style. This important exhibition placed such emerging artists as Andre, Baer, Flavin, Judd, LeWitt, Morris, Smithson and Michael Steiner alongside such established figures as Agnes Martin and Ad Reinhardt.

Robert MORRIS
Green Gallery, New York
1964
Installation view

For this solo exhibition, Robert Morris installed seven grey geometric plywood structures. The massive structures occupied the actual physical space of the gallery, forcing the viewer to be aware of his or her position in space in relation to the artwork as well as in relation to the volume of the room itself. *Untitled (Corner Piece)* fit in to the corner of the gallery. The back and sides of the work disappeared in to the wall. By filling the negative space of the corner, Morris' sculpture made the usually overlooked corner visible as a literal space and altered the room's volume.

Robert MORRIS
Mirrored Cubes
1965
Plexiglas mirrors, wood
21 × 21 × 21 cm [53 × 53 × 53 in]
Installation view

In this second solo exhibition at the Green Gallery, New York, Morris continued to work with structures designed to affect the viewer's experience of the space, this time filling the gallery with a series of his cast lead wall reliefs and four *Mirrored Cubes*. The *Cubes* were arranged in a grid pattern across the gallery floor, creating obstructions. Their mirrored sides caused the cubes to appear to dissolve in to the wooden floors and white walls, and cast the viewer's reflection back upon him or herself.

Robert MORRIS
Dwan Gallery, Los Angeles
1966
Installation view

Morris exhibited six works at the Dwan Gallery, Los Angeles, in 1966, all of which were untitled. They were constructed from wood and fibreglass, rigid materials he used to create familiar, weighty shapes. The one broken circle in the show incorporated a fluorescent light. The two grey hemispheres are placed with a thin gap separating them; the light in between reveals each form as distinct while at the same time dissolving the clear contours of their individual shapes.

Robert MORRIS
Untitled (2 Half-Circles with
Light)
1966
Painted wood, fibreglass,
fluorescent light
61 × 244 cm [2 × 8 ft] each

Robert <u>MORRIS</u>
Untitled (L-Beams)
1965-67
Fibreglass
2 units, 244 × 244 × 61 cm [96 × 96 × 24 in] each
Installation view, Stedelijk Van Abbemuseum, Eindhoven, 1968

Morris originally planned to construct a series of nine *L-Beams*, grey fibreglass structures with a 90-degree angle halfway down their length. Initially only three were built: although the work now exists in different versions, it is always shown with three units. The positioning of the structures causes them to appear to be different forms, although they are identical in every way. The viewer is aware of having contradictory impressions of the scale of each *L-Beam*.

Robert <u>MORRIS</u>
Untitled (Quarter-Round Mesh)
1967
Steel grating
79 × 277 × 277 cm [31 × 109 × 109 in]
Installation view, Stedelijk Van Abbemuseum, Eindhoven, 1968
Collection, Panza Collection, Solomon R. Guggenheim Foundation, New York

By the mid 1960s Morris had begun to move away from making only solid, rigid structures. With *Quarter-Round Mesh* he introduced the use of an open material that would allow the viewer to see inside the structure yet could still retain a solid form. The structure was fabricated at the Lippincott factory in Connecticut from Morris' design. It has a flat, square base, four rounded sides and an open centre. Morris called this form 'toroid'.

Robert <u>MORRIS</u>
Untitled (Stadium)
1967
Steel
8 units, 119 × 122 × 119 cm [47 ×
48 × 47 in] each
Collection, Panza Collection,
Solomon R. Guggenheim Foundation,
New York

In his *Permutation* works of 1967, Morris constructed a number of wedge-shaped units in fibreglass, steel and aluminium. These were intended to be rearranged on a daily basis in a variety of round, linear and rectangular configurations, following a schematic plan. In the first few days of March the units were arranged into a square, in mid March an oval, then into a sphere and eventually a straight line. Although the wedges are geometric and painted a neutral grey as in his earlier structures, the units can no longer be seen as individualized and singular, but as parts of a serial cluster of constantly changing formations.

above
Donald JUDD
Untitled
1964
Red painted wood, brass
55 × 93 × 125.5 cm [21.5 × 36.5 × 49 in]

Judd began fabricating objects in March of 1964, first with the assistance of his father, then by employing professional industrial fabricators. He was frustrated with the lack of precision of his earlier handmade wooden objects. The perfect finish of the industrially fabricated metal focuses the viewer's attention on the work itself rather than the artistic craftsmanship or subjective motivations of the artist. This brass box is mounted on top by six identical wooden struts whose cadmium red enamel finish contrasts with the sheen of its brass support, stressing the difference between the different materials in the work.

opposite top
Donald JUDD
Untitled
1964
Light cadmium red enamel, galvanized iron
39.5 × 236 × 198 cm [15 × 93 × 78 in]

Soon after his December 1963 exhibition of wooden sculptures and reliefs at the Green Gallery, New York, Judd commissioned his first metal objects. At first he designed wooden works covered in a metal skin, then soon fabricated completely iron pieces, such as this 1964 work. He continued to use the cadmium red paint here, but now Judd avoids the graininess and mass of the wooden structures, preferring the even metal surface and the seemingly lightweight hollow form. Using rounded corners, Judd synthesized a rectangular and an oval form. The work is a dual structure, comprised of both the closed ring and the interior negative space which it demarcates.

opposite bottom
Donald JUDD
Untitled
1965
Galvanized iron, lacquer
38 × 203 × 66 cm [15 × 80 × 26 in]
Collection, Walker Art Center, Minneapolis

These objects were industrially made so as to ensure a smooth, uniform surface, allowing the viewer to perceive the object without any visual distractions.

Donald JUDD
Untitled
1990 (First type 1965)
Black anodized aluminium, bronze
Plexiglas
10 units, 15 × 68.5 × 61 cm [6 ×
27 × 24 in] each

Judd created the first vertical 'stack' in 1965, and continued to develop this form throughout his career. They usually consist of ten units placed vertically on the wall in a precisely ordered configuration (fewer units may be used if the given space has a low ceiling height). This form makes evident his intention to eliminate any reference to individual craftsmanship or artistic handiwork. The same form is repeated ten times, with the spaces between the units the same as the space occupied by the unit. It is not a complete composition with clearly limited boundaries, but part of a potentially limitless system based on a singular principle of ordering; it avoids part-to-part and figure/ground relationships by repeating 'one thing after another'. Although these structures are technically sculptural reliefs, since they rely upon the gallery wall for support, Judd refers to them as Specific Objects, three-dimensional works that are 'neither painting nor sculpture'.

Donald JUDD
Untitled
1965
Red fluorescent Plexiglas, steel
51 × 122 × 86 cm [20 × 48 × 34 in]
Judd's earliest Plexiglas boxes are held
stable by tension wires strung inside the
structure, which can be seen through the
translucent Plexiglas. In this work, first
exhibited at the John Daniels Gallery,
New York, in 1965, the top and sides are
made of coloured Plexiglas, the ends are
steel and the bottom is open. The
Plexiglas surface has a mechanized
sheen; the fluorescent colour is an
intrinsic part of the material rather than
an applied coating. The artist and critic
Robert Smithson praised Judd's use of
this transparent material which has the
ability to make both the interior and the
exterior equally visible. However, the
critic Rosalind Krauss accused Judd of
creating a type of optical illusionism that
contradicts his self-proclaimed belief in
a literalist art.

Donald <u>JUDD</u>

Untitled

1965

Perforated 16-gauge cold-rolled steel

20 × 168 × 305 cm [8 × 66 × 120 in]

This work, which exists in several nearly identical versions, was first exhibited at
Donald Judd's solo exhibition at the Leo Castelli Gallery, New York, in 1966. Judd
designed a wedge-shaped plate of unpainted cold-rolled steel perforated throughout
with small holes. The lowest end of the work comes to a narrow point where it meets
the gallery floor, while the tallest end of the triangular form stands 20 cm [8 in] high.
The object is a whole, singular form, although two lines divide the work into three
parts, creating a serial segmentation.

Donald JUDD
Untitled
1966
Stainless steel, amber Plexiglas
4 units, 86 × 86 × 86 cm [34 × 34 × 34 in] each

This work exemplifies Judd's embrace of industrially made materials and factory production in the mid 1960s. It was obvious to Judd that, in order to achieve the high quality he sought, employing specialized workers would produce much better work than he would ever achieve by fabricating it himself. The units project 86 cm [34 in] from the wall, and each of the four identical stainless steel cubes has translucent amber Plexiglas side panels.

Donald JUDD
Untitled
1966
Turquoise enamel on aluminium
8 units, 122 × 305 × 20 cm [48 × 120 × 8 in] each; 122 × 305 × 305 cm [48 × 120 × 120 in] overall; 20 cm [8 in] spaces between

Judd used repeating turquoise enamelled aluminium rectangles in this work shown at the Whitney Museum of American Art 'Annual Exhibition' in 1966–67. It reduces part-to-part relationships to an elemental series: Judd used an additive schema to determine the total length and the distance of the space between each unit. The application of mathematical systems eliminated any seemingly intuitive artistic intent.

Dan FLAVIN
alternate diagonals (to Don Judd)
1963
Daylight and cool white
fluorescent light
l. 366 cm [12 ft]

Dan FLAVIN
'some light'
Kaymar Gallery, New York
5–29 March 1964
Installation view

Six of Flavin's *icons*, chosen from his first series of eight works made using electric lights, lined the wall of his first solo show. Consisting of relief boxes and both incandescent and fluorescent lights, they varied in colour, shape and formal effect. The term 'icon', normally associated with Byzantine religious imagery, has been used by Flavin to name a new abstract art form that stresses perceptual, rather than transcendent, experience.

Dan FLAVIN
'fluorescent light'
Green Gallery, New York
18 November–12 December 1964
Installation view

In his first show made solely with fluorescent lights and their fittings, Flavin carefully planned and sketched the placement of each structure within the gallery space, working with the way the experience of the room could be altered through the placement of the individual lights. The white, pink and multicoloured lights reflected off the shiny wooden floors and white walls, causing the entire gallery to become illuminated with their coloured glow. This show marked a shift from the individual *icons* to the creation of an environment of diffused light, expanding the notion of Minimalist art to include installations of artworks created for a specific location.

Dan <u>FLAVIN</u>
red and green alternatives (to Sonja)
1964
Fluorescent light
l. 244 cm [8 ft]

Flavin experimented with the juxtaposition of differently coloured fluorescent lights, here placing red next to green. This work was dedicated to Sonja Severdija, then his wife, who installed many of his fluorescent light structures at this time. The juxtaposition of complementary hues caused the red to appear a deeper tone than the bulbs would on their own, while the green remained unaffected. It was included in 'fluorescent light', an exhibition at the Green Gallery, New York.

Dan <u>FLAVIN</u>
monument I (to Vladimir Tatlin)
1964
Cool white fluorescent light
h. 244 cm [8 ft]

The first of Flavin's *Monuments to Tatlin* consists of a central, vertically placed fluorescent light flanked on either side by three more fluorescent lights in descending size. This work schematically recalls the Russian artist's famous *Monument to the Third International* (1921), an enormous spiral structure commemorating the Communist Party and intended to serve as an information centre for the new government following the Bolshevik Revolution (it was never built). The dedication to Tatlin in the title and its shape serve as a testament to Flavin's longstanding fascination with Russian Constructivism, an avant-garde art movement associated with the Communist Revolution whose formal innovations anticipated aspects of Minimal practice. Flavin updates the Constructivist emphasis on a simple organization of industrial materials by his use of industrially produced fluorescent lights, yet sublimates the political ambitions of Tatlin's monument in favour of a primarily visual effect.

Carl <u>ANDRE</u>
Redan
1964 (destroyed), remade 1970
Wood
27 units, 30.5 × 30.5 × 91.5 cm [12 × 12 × 36 in] each
Collection, Art Gallery of Ontario, Toronto

Redan, first shown in 'Shape and Structure' at the Tibor de Nagy Gallery, New York, in 1965, is constructed from unaltered pre-cut lengths of timber. Andre built a zigzag wall by interlocking the planks at five separate right angles, allowing the ends of the middle tier to project as if ready for further interlocked units. The result is a sculpture that spreads its weight laterally across the floor, anticipating the development of his horizontal works such as *Lever* and *Equivalents* in 1966.

opposite left to right
Carl <u>ANDRE</u>
Crib
1965
Carl <u>ANDRE</u>
Compound
1965
Carl <u>ANDRE</u>
Coin
1965
Installation view, Tibor de Nagy Gallery, New York

Andre's notion of 'sculpture-as-place', or sculpture that reveals its surroundings, was powerfully demonstrated in his first solo exhibition at the Tibor de Nagy Gallery, New York, in 1965. The works in this show filled the gallery, blocking the viewer's vision and mobility, making it difficult to manoeuvre around the room and impossible to view any single work in its entirety. The installation consisted of three massive forms built of 274-cm [9-ft]-long polystyrene planks stacked one on top of another. The tallest structure, *Coin*, was an open latticework of planks, while the shorter *Compound* was made of planks laid horizontally. *Crib* was placed in the middle of the room, the planks placed at right angles to create an open cubic space in the interior of the sculpture.

front to back
Carl <u>ANDRE</u>
Lever
1966
Carl <u>ANDRE</u>
Well
1964 (destroyed), remade 1970
Carl <u>ANDRE</u>
Pyramid (Square Plan)
1959 (destroyed), remade 1970
Installation view, Solomon R. Guggenheim Museum, New York, 1970

In 1970 Andre exhibited over sixty artworks completed between 1958 and 1970 at the Solomon R. Guggenheim Museum, New York, including sculptures first exhibited in the Jewish Museum's ground-breaking show of Minimal art, 'Primary Structures'. *Lever* was specifically designed for its site. The work, consisting of 137 firebricks laid in a straight line, was originally intended to span the doorway between two galleries, so that each entrance would offer a unique view of the object. Viewers were shocked that the sculpture consisted of nothing more than bricks placed upon the floor. *Well*, originally constructed in 1964 and remade in 1970, consists of twenty-eight lengths of timber, stacked without the use of mortar. Although the interior is hollow, the height makes viewing the interior impossible, and the work appears to be a solid structure. The 1959 sculpture *Pyramid* (*Square Plan*) was also remade for this exhibition. This work is also made of wooden beams, yet the timbers are more narrow, and have slots cut into each so that they hinge together, tapering inward in the centre to form a cross.

Carl <u>ANDRE</u>
Equivalent VIII
1966
120 fire-bricks
13 × 69 × 229 cm [5 × 27 × 90 in]
Collection, Tate Gallery, London

In the spring of 1966, Andre exhibited eight *Equivalents* at the Tibor de Nagy Gallery, New York. A numerical sequence determines four different arrangements of an identical number (120) of bricks placed directly on the floor: 3 × 20, 4 × 15, 5 × 12, 6 × 10. For each equation, Andre produced two configurations, arranging the bricks both along their short ends and their long ends, two layers deep. Distributed according to a grid plan, the low piles revealed the surrounding floor and the gallery's cubic volume.

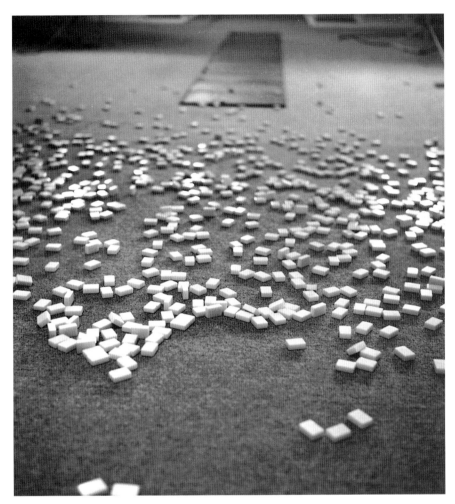

Carl ANDRE
Spill (Scatter Piece)
1966
Plastic, canvas bag
Dimensions variable

In this work, gravity and chance alone determine the placement of the 800 plastic blocks spilled from a canvas bag on to the gallery floor. Thus, each time the work is installed, the blocks will create different patterns. Although each individual unit is a Minimalist geometric solid, the action-based installation disrupts the coherence and serial structure usually associated with Minimalism and points to the post-Minimal decomposition of solid, rigid form associated with the felt works of Robert Morris and the sculpture of Eva Hesse.

left
Carl ANDRE
8 Cuts
1967
Concrete capstone blocks
1472 units, 5 × 20 × 41 cm [2 × 8 × 16 in] each; 5 × 935 × 1300 cm [2 ×
368 × 512 in] overall
Installation view, Dwan Gallery, Los Angeles

At the Dwan Gallery, Los Angeles, in 1967 Andre filled the gallery with a layer of concrete capstone blocks, leaving eight negative spaces in the installation. These spaces corresponded to the configurations of *Equivalents* that he had shown the previous year at Tibor de Nagy Gallery, New York, substituting empty volumes for dense solids. This work overtakes the entire space, forcing the viewer to walk upon the unhinged blocks in order to view the work.

above, foreground
Carl ANDRE
144 Steel Square
1967
Steel
366 × 366 cm [12 × 12 ft]
above, background
Carl ANDRE
144 Aluminum Square
1967
Aluminium
366 × 366 cm [12 × 12 ft]
Installation view, Dwan Gallery, New York

Andre began constructing large metal floor sculptures in 1967. For the first show of those works at the Dwan Gallery, New York, in 1967, he cut the metal plates acquired from the local salvage yard into 366 × 366 cm [12 × 12 ft] units, each unit representing the square root of the overall structure. Arranged in a simple geometric grid directly on the gallery floor, these works invite the viewer to walk upon the sculpture itself, entering into the actual space of the artwork. Andre commented on the unique experience of viewing such a sculpture: 'You can stand in the middle of it and you can look straight out and you can't see that piece of sculpture at all because the limit of your peripheral downward vision is beyond the edge of the sculpture.'
– Carl Andre, 'Interview with Phyllis Tuchman', *Artforum*, June 1970

opposite
Carl ANDRE
5 × 20 Altstadt Rectangle
1967
Hot-rolled steel
100 units, 25 × 25 cm [10 × 10 in] each; 250 × 1,000 cm [98.5 × 394 in] overall

In 1967 Andre made several sculptures composed of steel plates laid directly upon the gallery floor. Andre's first European exhibition, at the Konrad Fischer Gallery, Dusseldorf, in 1967, introduced his work to a European audience. Five plates wide and twenty plates long, it covered the entire expanse of the Fischer Gallery's narrow, rectangular space, perfectly conforming to the gallery's dimensions and defining the contours of the site. In later installations of the work, as pictured here, the sculpture shifted in scale and impact in conformity with the setting.

For her 1965 show at The Andre Emmerich Gallery, Truitt displayed works that broke from the tall rectangular and cubic shapes she had previously exhibited. The sculptures are more sprawling and irregular; asymmetrical and polyhedral rather than elemental. Instead of using hand-painted wooden objects, Truitt commissioned the works to be constructed in metal. She did not continue to work with industrial fabrication, preferring to return to more hand-crafted structures, even destroying the works in this show because of their disconnection from the artistic process.

opposite

Anne TRUITT
Sea Garden
1964
Metal
244 × 84 cm [96 × 33 in]

This work was exhibited at Truitt's 1965 show at the Andre Emmerich Gallery and at the Jewish Museum's 'Primary Structures' exhibition in 1966. It is one of her few industrially fabricated works. *Sea Garden* forms an irregular geometric shape that stretches 244 cm [8 ft] across the gallery floor, with an irregular bend in the middle. It is painted with vertical striations of white, green, yellow and blue. Truitt, who was living in Japan at the time of 'Primary Structures', sent a poem that attests to the importance of both colour and subtle allusions to nature in her work:
'There was a blue sea, and above it was a yellow hill and beside the hill was a green field.
On the other side of the blue sea was a blue sea, and on the other side of the yellow hill was a yellow hill, and on the other side of the green field was a green field.
And that was a sea garden.'
– Anne Truitt, *Primary Structures* [cat.], 1966

Larry BELL
Untitled Cubes
1965
Installation view, Pace Gallery, New York

Bell's early geometric sculptures, exhibited at the Pace Gallery in New York in 1965, are made of glass etched with illusionistic shapes and patterns, or unadulterated sheets of glass tinted in a vacuum-coating machine. Chemically bonded with various metals, Bell's material is gorgeously reflective. The cubes, placed on Plexiglas pedestals, set up complex reflections that incorporate the viewer and the gallery as part of the work.

Larry BELL
15" Glass Cube
1966
Glass
38 × 38 × 38 cm [15 × 15 × 15 in]

John <u>MCCRACKEN</u>

Manchu

1965

Lacquer, fibreglass, plywood

114 × 157.5 × 37 cm [45 × 62 × 14.5 in]

This work was exhibited in McCracken's first one-person show at the Nicholas Wilder Gallery, Los Angeles, in 1965. The show consisted of lacquered wooden reliefs mounted on pedestals or placed directly on the floor. The Wilder series is significant because it announced McCracken's transition from the production of paintings to objects. Although one of the largest and most massive sculptures in the series, *Manchu* still retains a frontal orientation and a bright, complementary painter's palette of red and green. McCracken's later works – including the well-known planks – continued to explore this overlap of painterly and sculptural qualities.

John <u>MCCRACKEN</u>

Blue Post and Lintel

1965

Plywood, fibreglass, lacquer

259 × 81 × 43 cm [102 × 32 × 17 in]

John <u>MCCRACKEN</u>

Yellow Pyramid

1965

Plywood, fibreglass, lacquer

121 × 183 × 183 cm [47.5 × 72 × 72 in]

McCracken gradually simplified his sculpture to the most basic shapes, such as cubes, pyramids and planks. The forms of these works, including ziggurats, door jambs and lintels, indicate McCracken's longstanding fascination with the architecture of ancient Egypt. Although he continued to admire the powerful scale and simplicity of Egyptian models, McCracken ultimately purged his work of specific allusions and developed a purely abstract art.

John <u>MCCRACKEN</u>

Page from sketchbook

1965

Pencil on paper

35.5 × 28 cm [14 × 11 in]

McCracken sketched many hypothetical, geometric forms composed of only one or two free-standing blocks. This page is a proposal for sculptures in yellow, blue and red, primary hues that McCracken deemed appropriate for his pared-down abstraction.

John <u>MCCRACKEN</u>

Blue Plank
1966
Polyester resin, fibreglass,
plywood
244 × 29 × 2.5 cm [96 × 11 × 1 in]

By 1966 McCracken had turned to monochrome planks leaning against the wall. The plank retains ties with the wall – the site of painting – yet it also enters the three-dimensional realm and the physical space of the viewer. Each plank is monochrome and coated in a highly reflective, polished resin surface.

Judy CHICAGO
Rainbow Pickets
1965
Plywood, canvas, latex
320 × 279 × 320 cm [126 × 110 × 126 in]

Rainbow Pickets was first shown at the groundbreaking Minimal art exhibition
'Primary Structures', held at the Jewish Museum in New York. Composed of six
multicoloured planks of increasing height leaning against the wall in the vestibule,
this work integrates the serial methods of New York Minimalism with an allusive
palette of yellow, pink and pale blue.

Judy CHICAGO
Ten Part Cylinders
1966
Fibreglass
305 × 610 × 610 cm [10 × 20 × 20 ft] overall

These cylinders have been compared to the pillars that support the freeways in California. Made of fibreglass and standing as tall as 610 cm [20 ft], the pillars were displayed in a seemingly random configuration a few feet apart from one another. The work was first exhibited at 'American Sculpture of the Sixties' at the Los Angeles County Museum of Art in 1967.

Judy CHICAGO
Cubes and Cylinders (Rearrangeable)
1967
Gold-plated stainless steel
24 units, 5 × 5 × 5 cm [2 × 2 × 2 in] each

Cubes and Cylinders (*Rearrangeable*) is composed of twenty-four gold-plated stainless steel cubes and cylinders that are arranged in various formations, with the cylinders resting on a line with the cubes, or with the cubes resting on top of the cylinders, forming a spherical shape with a hollow centre. The appearance varies depending upon the installation, creating a site-specific arrangement of geometric metal units. Their configuration around a central core was a method the artist continued to use in her later feminist artworks, such as *The Dinner Party* (1974–79). In a re-evaluation of her Minimalist work, Chicago states: 'The hard materials ... perfect finishes and minimal forms in my work in 1966 and 1967 were "containers" for my hidden feelings, which flashed in the polished surfaces, shone in the light reflections and disappeared in the mirrored bases.'
– Judy Chicago, *Through the Flower: My Struggle as a Woman Artist*, 1975

above
Sol LEWITT
John Daniels Gallery, New York
1965
Installation view

LeWitt had his first solo exhibition at Dan Graham's John Daniels Gallery, New York, in 1965. The reliefs and free-standing structures are made of large slabs of plywood that meet at right and oblique angles, forming open cubes. LeWitt used coloured lacquer to disguise the irregular wooden surface, giving the works a more industrial appearance. While the John Daniels Gallery structures are not based on serial systems, they do show his early use of the open cube, the basic modular unit of LeWitt's future work.

left
Sol LEWITT
Standing Open Structure, Black
1964
Paint, wood, steel
244 × 65 × 65 cm [96 × 25.5 × 25.5 in]

LeWitt's first shift from solid objects to the skeletal framework began with this 1964 work. At the 1966 'Art in Process' exhibition at Finch College in New York, he showed this work with its miniature scale model. Sometimes described as the 'telephone booth', this geometric, black wooden structure approximates to the size and stature of the human body.

Sol LEWITT
Floor Structure, Black
1965
Painted wood
47 × 208 × 46 cm [18.5 × 82 × 18 in]

This was one of the last painted wooden structures LeWitt constructed, as he became increasingly frustrated at his inability to disguise the textured surface of wood. Before turning to metal as his primary material (1965–66), he began to experiment with open skeletal forms, emphasizing the shape and form of the structure and diminishing the physical impact of the material.

Sol LEWITT
Modular Wall Piece with Cube
1965
Steel, baked enamel
46 × 46 × 18 cm [18 × 18 × 7 in]

By late 1965 LeWitt began using white paint exclusively. The wall structures completed during this year use the three-dimensional cube form of his earlier reliefs, yet are open skeletal forms rather than solids. *Modular Wall Piece with Cube* is composed of a simple ladder-like form with a projecting three-dimensional cube on one end. LeWitt based the measurements on an arbitrarily established 8.5 to 1 ratio between material and negative space. He continued to use mathematical systems and ratios in his later works, deriving increasingly complex permutations.

Sol LEWITT
Modular Piece (Double Cube)
1966
Baked enamel on steel
274 × 140 × 140 cm [108 × 55 × 55 in]

LeWitt exhibited three white structures in his 1966 solo show at the Dwan Gallery in New York. *Modular Piece (Double Cube)* was the tallest in the show, made from an open cube that he arranged three units in width and three in height. He named it *Double Cube* because the entire work consists of two cubes, comprised of the smaller modular cubes, doubled in height. Thus the overall work, a free-standing structure placed in the central area of the gallery, forms a three-dimensional grid.

Sol LEWITT

Dwan Gallery, Los Angeles

1967

Poster and invitation card

LeWitt's drawing of the floor plan with explanatory notes for *Serial Project No. 1*
(*ABCD*) served as the poster and invitation for his Dwan Gallery, Los Angeles show of
1967. In his notes he explains how the grid system is used to regularize the
measurements of each unit and neutralize any spatial differences. This drawing
serves as both an explanatory guide to the show and as a testimony to the importance
LeWitt placed on the concept, or idea, underlying the completed artwork.

Sol <u>LEWITT</u>
Serial Project No. 1 (ABCD)
1966
Baked enamel on aluminium
51 × 414 × 414 cm [20 × 163 × 163 in]

LeWitt's first serial project is based on a set of permutations, or step-by-step
modifications of open and closed cubes. He used painted aluminium in their
fabrication in order to minimize apparent surface texture, and based each of the
configurations on a grid mapped out on the floor. The project follows a series of four
variations (ABCD), beginning with a flat grid and open cubes and ending with three-
dimensional closed volumes.

opposite
Mel BOCHNER
Untitled (Study for Three-Way
Fibonacci Progression)
1966
Ink on graph paper
21.5 × 28 cm [8.5 × 11 in]
Bochner based his work on the Fibonacci
Progression, a system of mathematical
sequence based on a simple principle of
addition of the preceding numbers: 1, 1,
2, 3, 5, 8 ... He first mapped his schema
on graph paper, joining five interlocking
forms according to mathematical sets
entitled A, B and C. Each set uses the
Fibonacci Progression to determine the
depth, height and width of the solid wall
relief which was to be constructed in
wood and cardboard. For Bochner, the
mathematical process and schematic
plan recorded on the graph paper is
integral to the sculpture, rather than
merely a preliminary sketch.

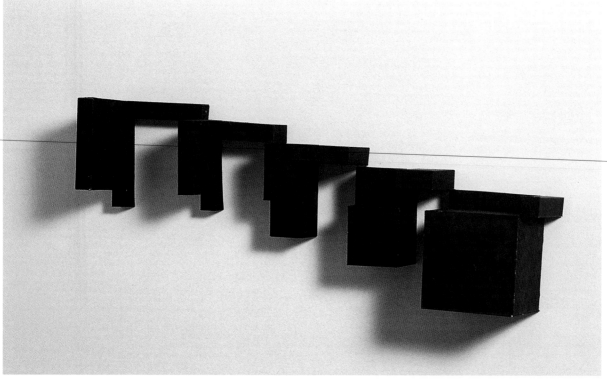

left
Mel BOCHNER
Three-Way Fibonacci Progression
1966
Paint on cardboard, balsa wood
25 × 13 × 69 cm [10 × 5 × 27 in]
In this small work derived from his *Study
for Three-Way Fibonacci Progression*,
Bochner used casually made,
interlocking cubic shapes constructed of
cardboard to represent visually a
conceptual numerical system. In
contrast to the solid, well-made serial
objects of Judd and other Minimalists,
Bochner produced a temporary
construction in order to illuminate a
mathematical idea.

opposite

Mel <u>BOCHNER</u>

Working Drawings and Other Visible Things on Paper Not Necessarily
Meant to be Viewed as Art

1966

4 identical looseleaf notebooks, 100 pages each

4 pedestals

Installation, School of Visual Arts, New York

For his first New York exhibition at the School of Visual Arts in New York, Mel Bochner photocopied 100 pages of studio notes, working drawings and diagrams made by fellow artists including Eva Hesse, Sol Lewitt, Donald Judd and Dan Flavin, pages from *Scientific American*, notations from serial musical compositions, mathematical calculations and other information. These were then bound in four identical looseleaf notebooks and placed on pedestals in the centre of the gallery. By doing this, Bochner allied the systemic techniques of 1960s artists with serial investigations in other disciplines and new forms of reproduction, including photocopying.

Mel <u>BOCHNER</u>

Untitled ('child's play!': Study for Seven-Part Progression)

1966

Ink on paper

14 × 18 cm [5.5 × 7 in]

Bochner, like his friends Sol LeWitt and Eva Hesse, interpreted the number systems underlying Minimal practice as the pretext of a playful – and quite pointless – experimentation with repetition. Where Donald Judd and Dan Flavin used serial formulas to generate definite forms, the title of this drawing makes explicit Bochner's view of seriality as a form of intellectual play. Like a child's game, the work is a temporary arrangement of building blocks that may be constructed and taken apart (and then rearranged once again). It is not a well-made Specific Object, a finished work of art, but a plan for a 'work' that need not be made, an idea.

Mel <u>BOCHNER</u>

Four Sets: Rotations and Reversals

1966

Ink on tracing paper

30.5 × 38 cm [12 × 15 in]

Bochner conceived of this work while experimenting with the type of numbered tracing paper used by schoolchildren. He drew dots on each sheet of paper and stacked the sheets so the full set of dots would be visible. In this image Bochner combines all the dots on one sheet of tracing paper. In each of the four sets of four connected rectangles the pattern of dots in the rectangles connected diagonally are the mirror image of one another.

Eva HESSE

Addendum

1967

Papier mâché, wood, cord

Wood, 12.4 × 303 × 12.4 cm [5 × 119 × 5 in]

Eva Hesse's *Addendum* was exhibited in 'Art in Series', in 1967, Finch College, New York's testament to the predominant 'serial attitude' of 1960s visual art. It consists of a horizontal row of unevenly spaced domes, from which long cords extend to the floor below. Although the forms allude to body parts, Hesse carefully kept these organic referents ambiguous. By combining the seriality found in the work of the Minimal artists with soft and irregular materials, she developed a highly personal sculptural idiom.

opposite

Eva HESSE

Accession II

1967

Galvanized steel, rubber tubing

78 × 78 × 78 cm [30.5 × 30.5 × 30.5 in]

Accession II was one of Eva Hesse's few fabricated works. After the steel cube was constructed, she tied rubber tubing into each of the 30,000 holes in the surface, creating a physical, tactile interior at odds with the pure reductionism usually associated with Minimal art. The first version of this work, made with plastic tubing, was shown at the Milwaukee Art Center in 1968, where it was badly damaged when viewers climbed inside the cube.

Eva HESSE

Washer Table

1967

Wood, rubber washers, metal

21.5 × 126 × 126 cm [8.5 × 49.5 × 49.5 in]

Eva Hesse was given a square white wooden table by Sol LeWitt which she
transformed by methodically covering it with almost 700 black rubber washers and
painting the frame in black. Here as in other works integrating identical units by Hesse.
the organizing impulse of Minimalism is rendered absurd through pointless repetition.

HIGH MINIMALISM

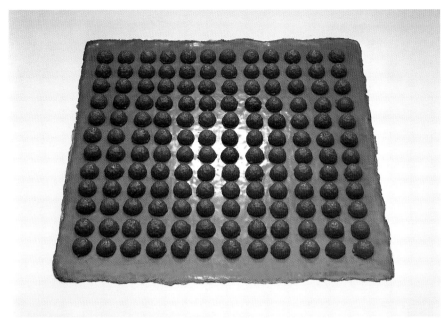

Eva HESSE
Schema
1967
Latex
144 mounds, ø 6 cm [2.5 in] each
107 × 107 cm [42 × 42 in] overall
Collection, Philadelphia Museum
of Art

One of several floor works based upon the Minimal grid, *Schema* consists of 144 small latex mounds which rest upon thin, translucent latex squares. Here again Hesse worked within the 'schema' of the Minimalist format, yet the irregularities of her handmade materials reflect the painstaking process of their production.

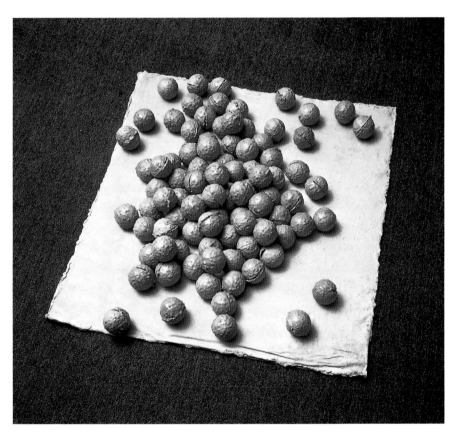

Eva HESSE
Sequel
1967
Latex and powdered white pigment
76 × 81 cm [30 × 32 in]

Sequel follows on from the previous work in latex, *Schema*, in which mounds are arranged on a grid. By adding white pigment powder to the latex, Hesse transformed the rubber from a translucent to an opaque substance. Hesse cast the spheres from a Spaulding rubber ball, leaving an open slit in each unit when she placed the two halves together. By cutting into and altering the round spheres and then arranging them on the latex sheet in a haphazard fashion, she exposed the potential of chaos and breakdown integral to ordered systems.

Robert SMITHSON
Enantiomorphic Chambers
1964
Painted steel and mirrors
2 units, 86 × 86 cm [34 × 34 in] each

The word 'enantiomorphic' refers to crystals whose left and right molecular structure is asymmetrical. The molecules do not directly reflect one another. For the viewer, expecting to see a reflection of the room or himself, expectations of experience are not met. Smithson has made the spectator aware of the act of seeing, an experience he likens to blindness: 'To see one's own sight means visible blindness.'
– Robert Smithson, 'Interpolation of Enantiomorphic Chambers', 1964

Robert SMITHSON
Alogon No. 2
1966
Painted steel
10 units, dimensions variable
Collection, The Museum of Modern Art, New York

This work, intended to resemble the faceted interior of rock crystal, consists of ten units placed approximately a foot apart, arranged in descending height order. The largest is about 91 cm [3 ft] tall, and the shortest is about 30 cm [1 ft] tall. Each of the ten units was built following one mathematical system and arranged in the gallery following another, contradictory mathematical system. By setting up a contradiction between systems, Smithson challenged any notion of a logical ordering. Even the title is meant to suggest the irrationality inherent within serial progression, just as the word *alogos* is the antithesis of *logos*, Greek for reason.

opposite
Robert SMITHSON
Four Sided Vortex
1965
Stainless steel, mirror
89 × 71 × 71 cm [35 × 28 × 28 in]

Four Sided Vortex was made by inserting an inverted mirrored pyramid into an industrially fabricated steel cube. The structure was based on the configuration of crystal planes, reflecting Smithson's longstanding fascination with geological forms; unlike the abstract shapes of Donald Judd and Robert Morris, Smithson's Minimalism alludes to crystallographic sources. The word 'vortex' in the title refers to centrifugal phenomena such as whirlpools or hurricanes, mimicked by the sculpture's rotational structure.

2 units, 86 × 86 cm [34 × 34 in] each

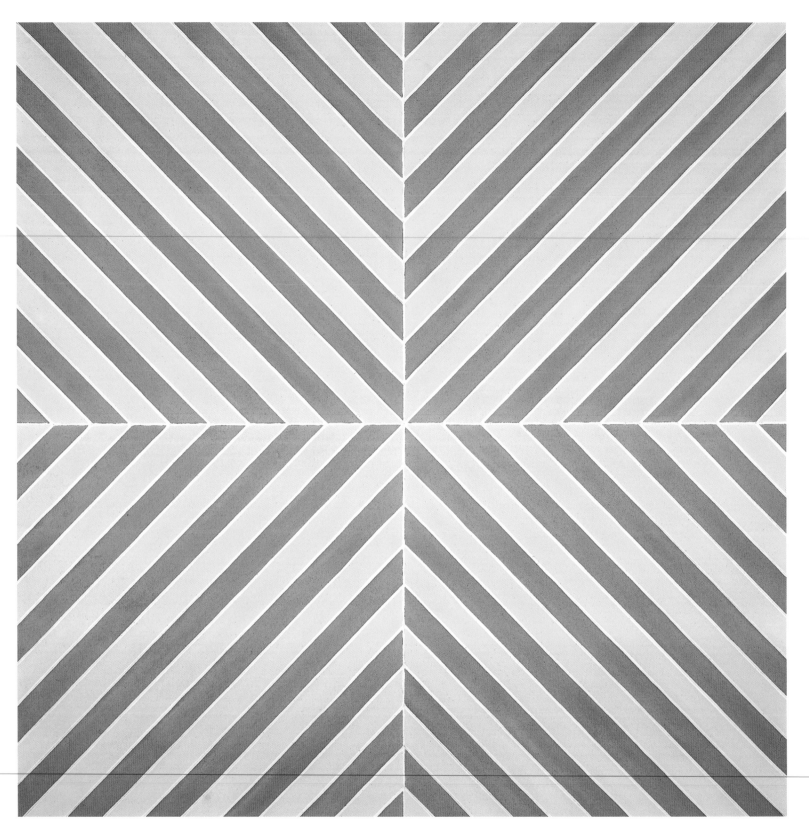

Frank STELLA

Fez

1964

Fluorescent alkyd paint on canvas

198 × 198 cm [77 × 77 in]

Fez is one of a series of twelve paintings that Stella completed between 1964 and 1965, each named after a city in Morocco. These brightly coloured works are divided into symmetrical sections with the stripes in each quadrant going in a different direction, creating a strong optical pattern. They indicate Stella's turn towards optical and illusionistic effects during the mid 1960s as he progressively distanced himself from the austere monochromy of the *Black* and *Aluminum Paintings*.

HIGH MINIMALISM

Frank STELLA
Irregular Polygons
1966
Installation view, Leo Castelli Gallery, New York

In the *Irregular Polygon Series*, exhibited in 1966 at the Leo Castelli Gallery, New York, Stella sought a balanced composition of complex shapes and colours. For each of the eleven works in the series Stella first constructed four copies of each differently shaped canvas. He then experimented with different combinations of colours to create a composition of interpenetrating shapes, exhibiting the most successful version.

Frank STELLA
Empress of India
1965
Metallic powder in polymer emulsion on canvas
198 × 569 cm [77 × 224 in]

The enormous scale of this painting suggests Stella's mounting ambition as he monumentalized his stripe format in 1964–65. *Empress of India*, part of what has become known as the *Notched-V Series*, is made of striped V-shaped canvases attached to one another. This painting stretches almost 569 cm [19 ft] across and is mural-like in scale. Stella used subtle gradations of brown, red and orange to delineate both the individual stripes and the separate quadrants.

HIGH MINIMALISM

opposite
Jo <u>BAER</u>
Untitled (White Square Lavender)
1964-74
Oil on canvas
183 × 183 cm [72 × 72 in]
Baer, like the other Minimal painters, distilled painting to its most essential aspects: form, shape, structure and surface. Throughout her work of the 1960s she emphasized the work's edge with concentric coloured and black bands painted around the perimeter of the canvas; the bands were often painted in secondary hues including red, green, blues or in the case of this work, lavender. Baer used paint economically, ensuring that the surface did not show perceptible painterliness. However, the irregularity of the hand-drawn line distinguishes her working process from that of the Minimal sculptors whose work had an industrially perfected appearance.

right top and bottom
Jo <u>BAER</u>
Untitled (Stacked Horizontal
Diptych - Green)
1966-68
Oil on canvas
Diptych, 132 × 183 cm [52 × 72
in] each
This work consists of two identical canvases, designed to be hung one above the other, separated by several inches. In opposition to traditional painting, where the focus of the work usually appears in the centre of the canvas, Baer pushes the focus to the edges of the work, emphasizing the geometric shape of the canvas.

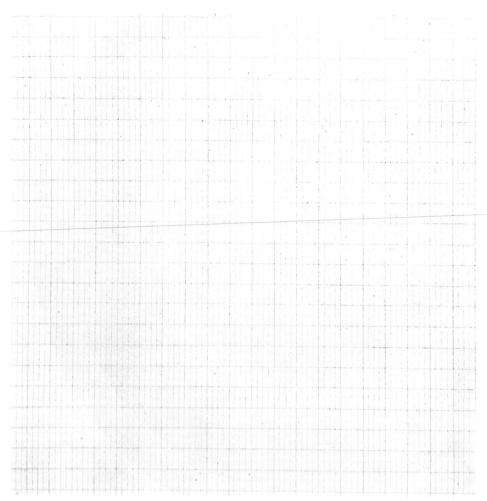

Agnes MARTIN
Leaf
1965
Acrylic on canvas
183 × 183 cm [72 × 72 in]

Both the title and the seemingly endless expanse of the drawn grid in *Leaf* allude to Martin's belief in the grandeur and majesty of nature. The subtly shifting white paint across the surface of the canvas has a number of slight changes in tone, gradually darkening towards the outer edges. This is overlaid with a delicate rectangular grid pattern in faint pencil suggesting a subtle optical effect.

Ralph HUMPHREY
Camden
1965
Oil on canvas
168 × 168 cm [66 × 66 in]

Humphrey responded to the objectness of Minimal painting by referencing both framing devices and physicality in his work of the mid 1960s. Minimal paintings often eschew frames; in this work Humphrey alluded to this convention by painting a framing band around the edges of the canvas. Also, other Minimal paintings were made on extra-thick stretchers, projecting into the viewer's space like a wall relief, while Humphrey's 'frame' canvases are made on thin stretchers and with thin washes of oil paint, declaring their identity *as* paintings.

Ralph <u>HUMPHREY</u>
Rio
1965
Oil on canvas
178 × 152 cm [70 × 60 in]

Robert RYMAN
Untitled
1965
Enamel on linen
29 × 29 cm [11 × 11 in]

In 1965 Ryman completed a series of small square linen canvases that were later exhibited at the Solomon R. Guggenheim Museum, New York, in 1972. In this work, Ryman applied the white enamel paint in thin layers, so that the brushstrokes are indiscernible within the centre of the painting; the smooth surface contrasts with the sliver of brown, textured linen visible at the outermost edges.

opposite
Robert RYMAN
Winsor 34
1966
Oil on linen
159 × 159 cm [63 × 63 in]

The *Winsor Series*, named after the Winsor brand of oil paint, consists of four works whose uneven brushstrokes allow areas of the raw canvas to remain visible. Each painting in the series was a different size and made with a different type of paint. *Winsor 34* was made by loading the brush with white oil paint and painting horizontal bands from left to right, continuing each stroke until the brush was dry. This technique emphasized the alterations in the thickness of paint, from thick on the left to thin on the right.

Robert RYMAN
Untitled
1965
Oil on linen
26 × 26 cm [10 × 10 in]

Robert RYMAN
Standard Series
1967
Installation view, Paul Bianchini Gallery, New York

For this series, exhibited at the artist's first solo exhibition at the Paul Bianchini Gallery in New York in 1967, Ryman painted white enamel on to cold-rolled steel by swabbing the metal with thin coats of enamel that he then treated with chemical solutions in order to adhere the paint to the slick surface. Ironically, none of the works in the show sold, and Ryman was allowed to keep the series intact.

HIGH MINIMALISM

Robert MANGOLD
Red Wall
1965
Oil on masonite
244 × 244 cm [96 × 96 in]

In 1965 Lucy R. Lippard wrote in the catalogue of *Robert Mangold: Walls and Areas* for his exhibition at the Fischbach Gallery, New York: 'The *Walls* refer obliquely to prefabricated building in that their cut-out silhouettes suggest windows, doors or stairwells, and some edges are left raw and unpainted to imply further additions'. Mangold's own statements can be compared with those of another painter associated with Minimalism, Frank Stella, who influenced Mangold's straightforward approach. Mangold: 'I wanted the application of paint to be "matter of fact", to cover the surface. I wanted to paint the surface with the same attitude and care that you would have if you were painting a real wall in a loft or apartment, no more or less artful than this.'
– Robert Mangold, 'Interview with Michael Auping', 1988

Robert MANGOLD
Manila Area
1966
Oil on masonite
122 × 122 cm [48 × 48 in]

Mangold's earliest mature works were a series of *Walls* and *Areas* (1964–65), in part influenced by the visual experience of living in the industrial ambience of New York. Executed in such colours as 'paper bag brown', 'file cabinet grey' and 'manila envelope tan', these works reflected the artist's view of New York as 'an image-rich situation, a material-rich situation. Not [rich] with natural colour … but the scale and colour of industry, of commerce [that] surrounded you.'
– Robert Mangold, 'Interview with David Carrier', 1996

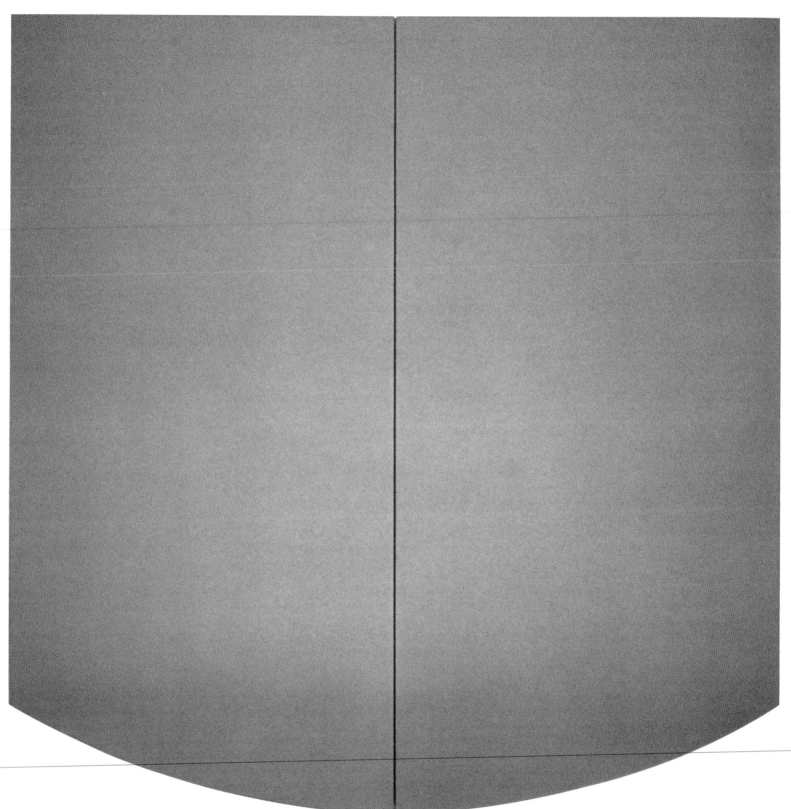

Robert <u>MANGOLD</u>
1/2 Blue-Gray Curved Area (Central Section)
1967
Oil on masonite
183 × 183 cm [72 × 72 in]

Mangold's curved *Areas*, which he started to develop in 1966, marked a shift with respect to the earlier *Areas*. They continued to insist on the essential formal relation of the support and surrounding wall, yet now each work consists of multiple-shaped panels. Foregoing the traditional, Renaissance-derived format of the rectangular canvas as a 'window on to the world', Mangold, in the later *Areas*, secured a multipart arrangement of juxtaposed, shaped panels. The flatness and literalness of the ensemble was stressed, the surrounding wall revealed.

HIGH MINIMALISM

Brice MARDEN
Private Title
1966
Oil and wax on canvas
122 × 244 cm [48 × 96 in]

This work was exhibited at Marden's debut exhibition at the Bykert Gallery, New York, in the autumn of 1966. All of the paintings in the show were rectangular in shape, and referred to a person important to Marden's life in New York, such as his wife Helen Harrington; many of these works have private dedications. Marden often associates individuals and personal memories with particular works, and colour arrangements with powerful sentiments.

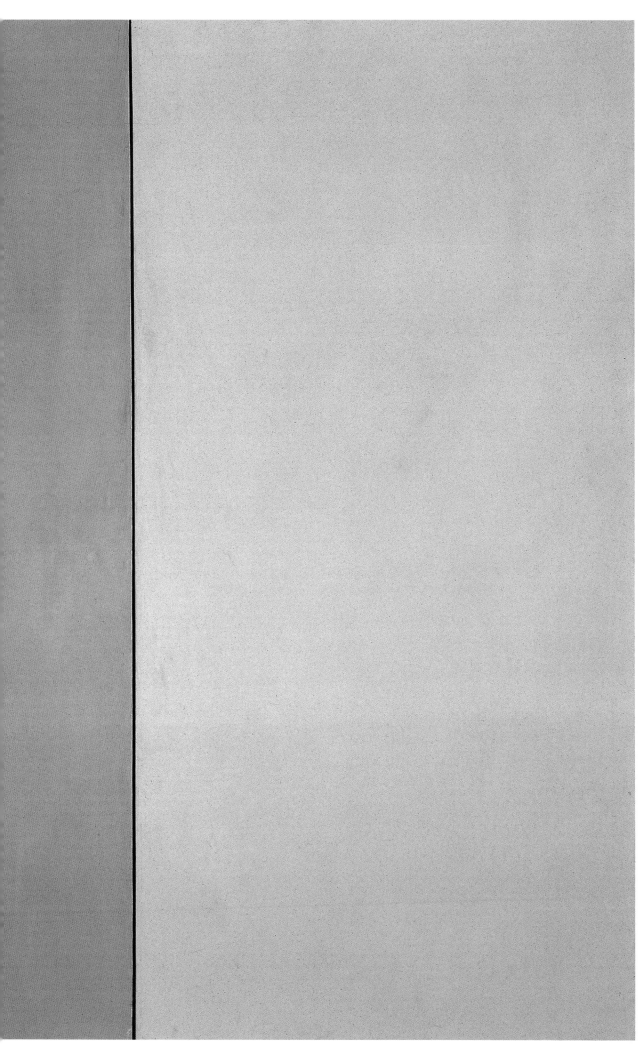

D'après la Marquise de la Solana
1969
Oil and wax on canvas
195.5 × 297 cm [77 × 117 in]
Collection, The Panza Collection,
The Solomon R. Guggenheim Museum,
New York

Marden began to create multi-panel paintings in the late 1960s. In this work, each panel is separated by a few millimetres, with the right panel spaced slightly further away than the left. This decision draws attention to the thickness and materiality of the paint and the support, rendering the muted hues of grey, lavender and pink distinct.

6:59
1966
Vinyl lacquer on canvas
290 × 686 cm [9.5 × 22.5 ft]

Novros arranged rectangular canvases in a ziggurat formation that invites the viewer to experience it horizontally. The canvases were painted in light tints which he then covered with an all-over pearl lacquer. The monochrome lacquer unifies the separate canvases, while the distinctions in hue visible underneath encourage the viewer to experience the work by walking along it laterally, noting the variations in colour and shape.

opposite
David <u>NOVROS</u>
Untitled
1965
Acrylic lacquer on canvas
305 × 366 cm [120 × 144 in]

David Novros became known for working with the shaped canvas which acts as a coloured surface in its own right rather than an illusionistic ground on which images are drawn. Novros' paintings are assemblages of discrete, interlocking units arranged on the wall. This untitled work consists of several separate L-shaped canvases in colours ranging from reds to blues to browns. They are arranged in a square configuration with the long legs of the Ls leading the eye both vertically and horizontally.

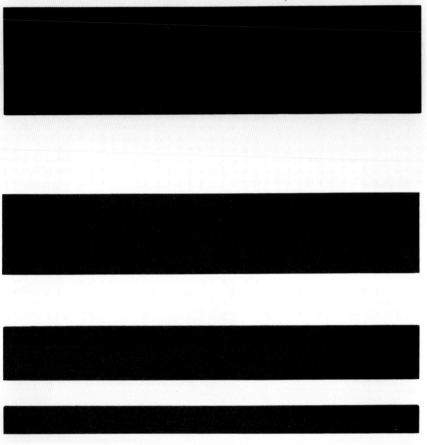

Paul <u>MOGENSEN</u>
Standard
1966
Acrylic lacquer on Dacron
244 × 244 cm [96 × 96 in]

Mogensen demonstrates his interest in mathematics and formulas in this work, where he juxtaposes four black canvases of the same width in an elementary progression: each canvas becomes taller as you progress towards the top of the arrangement, and the intervals between canvases are in a 1:1 ratio with the size of the panels beneath. The use of the title *Standard* suggests that this ratio is fundamental, or the foundation for further experiments with multi-panel, serial configurations.

Paul <u>MOGENSEN</u>
Untitled
1967
Acrylic lacquer on canvas
203 × 330 cm [80 × 130 in]

In this painting, Mogensen combines two schemes – the Golden Section and a rotational format. The Golden Section, a system of proportions that artists have used for centuries, holds that A is to B as B is to the sum of A and B. (Mathematically, the relation is 0.616 is to 1.000 as 1.000 is to 1.616, and so on into infinity.) Here, a tiny rectangle of wall is left bare in the centre of six juxtaposed canvases. Its proportion to the square canvas to the right is the same as that of both areas to the square canvas above. The other canvases become progressively larger, neatly filling out the rectangle in a spiral arrangement. Mogensen exhibited this and other works based on the Golden Section in a show at the Bykert Gallery the following year.

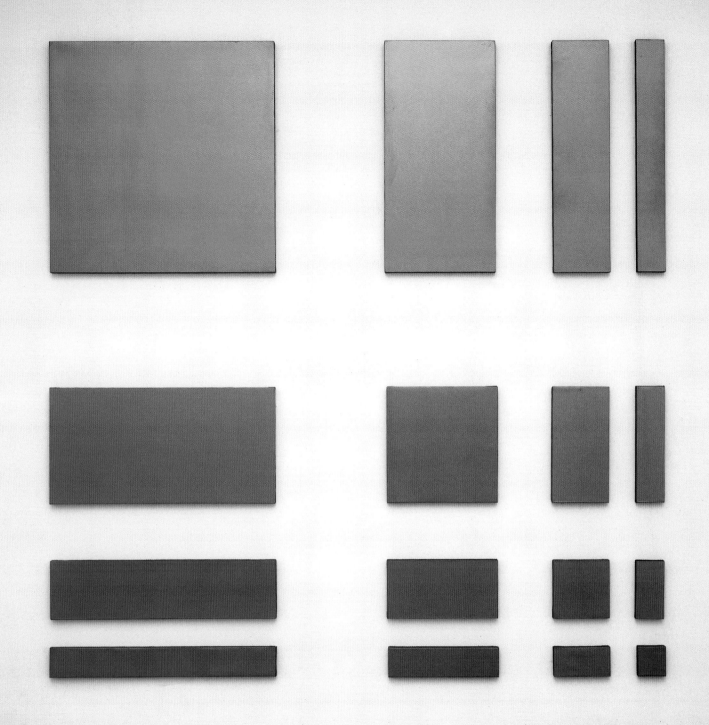

Paul <u>MOGENSEN</u>

Copperopolis

1966

Acrylic lacquer and copper on canvas

335 × 335 cm [132 × 132 in]

Mogensen favoured richly saturated colours, blacks and whites in his paintings of the 1960s and 1970s. The uniform copper surface in this work increases in intensity in juxtaposition with the white gallery wall. Colour is presented in its most essential or fundamental form, unmixed and undiluted. A serial logic of progressive width from right to left and from top to bottom organizes the sequence of monochrome canvases.

1967–79 CANONIZATION/CRITIQUE

During the late 1960s Minimal art received major exhibitions in the United States and Europe, becoming established as a leading contemporary movement, yet artists associated with Minimalism began to transform their work in concert with such developments as post-Minimal sculpture, Conceptualism and Land art. Where the work of Donald Judd became more monumental, and even moved outdoors, Sol LeWitt developed a Conceptual art that stressed idea over execution, reflecting the late 1960s impulse to 'dematerialize' the work of art. Carl Andre produced outdoor works incorporating wood, bales of hay and boulders. Robert Morris made perhaps the most radical departure of all in his 'anti-form' felt and scatter works, which sought to critique the geometrical, factory-made Minimal object of the mid 1960s. Others continued to refine their methods: John McCracken's lacquered planks, Larry Bell's glass partitions and Anne Truitt's columns suggest a continued commitment to whole geometric form. The work of Robert Ryman, Brice Marden and Robert Mangold became increasingly visible in museum exhibitions, consolidating the notion of a Minimal-type painting.

'Scale as Content'
Corcoran Gallery of Art, Washington, DC
1–30 November 1967
left
Tony SMITH
Smoke
1967
opposite
Ronald BLADEN
X
1967

'Scale as Content' announced the emergence of an oversized sculpture of primary forms, bringing the Minimal investigation of environmental scale to a new monumentality. Tony Smith made the enormous *Smoke* to fill the two storeys of the museum's atrium using a tetrahedral plan reminiscent of the molecular configurations found in crystalline forms. Ronald Bladen's *X* also spanned the two-storey gallery; its wooden skeletal structure was constructed off-site and erected *in situ*, finally clad in a black skin. The viewer could easily walk through the sculpture's lower extensions, experiencing the physical impact of its looming presence within the Corcoran's Neoclassical interior.

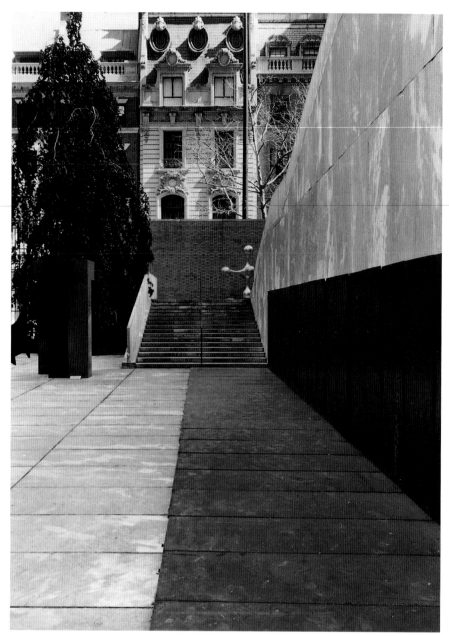

'The Art of the Real'
The Museum of Modern Art, New York
3 July-8 September 1968
Installation view
Carl ANDRE
Fall
1968
Hot rolled steel
21 units, 183 × 71 × 183 cm [72 × 28 × 72 in] each

Eugene C. Goossen curated this exhibition, which included a wide array of artists working between 1948 and 1968, such as Georgia O'Keeffe, Jasper Johns, Ellsworth Kelly, Jackson Pollock and Frank Stella, and the Minimalist sculptors Carl Andre, Donald Judd, Sol LeWitt, John McCracken, Robert Morris, Tony Smith and Robert Smithson, claiming that all of the artists in the show had rejected the depiction of symbolic and metaphysical subject matter in favour of a representation of the 'real'. Carl Andre constructed an installation in the garden of The Museum of Modern Art, lining the path and one exterior wall with plates of hot-rolled steel. The plates meet at the intersection of the ground and the museum wall, creating a dark channel of metal that leads the viewer towards the terrace above.

Ronald BLADEN
Three Elements (originally Untitled)
1965
Painted aluminium
3 units, 284 × 122 × 61 cm [112 × 48 × 24 in] each
Installation view, The Museum of Modern Art, New York, 1968

This series of three highly polished and reflective leaning rhomboid monoliths is held together by a system of internal weights. This causes them to appear to threaten imminent collapse. They were installed in the sculpture garden at The Museum of Modern Art, New York.

Donald JUDD
Untitled
1970
Aluminium
21 × 642.6 × 20.3 cm [8 × 253 × 8 in]

This work consists of a hollow thin tube of aluminium that is attached to the wall. Aluminium boxes arranged according to a progression of decreasing width are hung below the tube with increasing amounts of space between the boxes. This arrangement creates a dynamic progression formed only by the changes in dimension and spatial relationships. Judd's use of materials made by industrial fabrication creates a streamlined work composed of clean, sharp forms.

Donald <u>JUDD</u>
Galvanized Iron Wall
1974
Galvanized iron
h. 152.5 cm [60 in]; distance from wall 20 cm [8 in]

In the 1970s Judd began to design installations for specific locations, such as this
work, first shown at the Leo Castelli Gallery, New York (1970), and then at the
Pasadena Art Museum, California (1971), and the Panza Collection in Varese, Italy
(1974). Rather than creating a wholistic object that has precedence over the
vicissitudes of the site, the rectangular iron panels in the Castelli show partially lined
three walls of the front room, projecting 20 cm [8 in] out from the gallery walls. The
panels are of the same height, yet of different widths so that they perfectly fit the space
of the room and engage the gallery space.

Donald <u>JUDD</u>
Bern Piece No. 3
1976
Plywood
No longer extant, dimensions unknown
Installation view, Kunsthalle, Bern

This work is one of five numbered objects that Judd exhibited at the Kunsthalle, Bern; they are designed to fill an entire room, leaving walking space only around the perimeter. Here Judd expands the scale of his previous Specific Objects, and also experiments with unpainted plywood, rather than the pristine metal surfaces he had used throughout the late 1960s and 1970s. The top is raised a few inches above its base, creating a two-part structure within the rectangular form. Judd designed the works specifically for the gallery space, as a cohesive group: the objects are low enough to allow the viewer to perceive all the works together.

Donald JUDD
Bern Piece No. 3
1976
No longer extant, dimensions unknown
Installation view, Kunsthalle, Bern

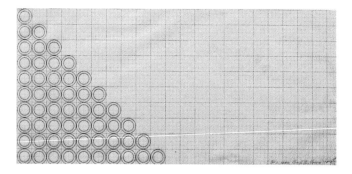

Dan <u>FLAVIN</u>

the final finished diagram of the triangularly massed cool white
fluorescent light dedicated, '(to a man, George McGovern) 1'
1972
Graphite and pencil on vellum
26 × 56 cm [10 × 22 in]

Throughout his career Flavin perceived a reciprocal relationship between his
drawings and sketches for installations and the finished sculptures, carefully
planning the placement of the works within the room and the interaction of their
diffused lights. This drawing is a plan for his installation at the Leo Castelli Gallery,
New York, in the autumn of 1972. Sonja Severdija, Flavin's wife at the time, mapped
the circular tubes on to graph paper, following his rough notebook sketches.

Dan FLAVIN
untitled (to Jan and Ron Greenberg)
1972-73
Fluorescent light
2 views, 244 × 244 cm [96 × 96 in]

In the mid 1970s Flavin designed installations of multiple fluorescent light tubes placed in square configurations. In this work, Flavin used green lights on one side and yellow on the other. The tubes are butted together, forming a type of barrier that both blocks most of the emission of the coloured light from the other side of the configuration and prohibits pedestrian traffic between two spaces of the room. Only a sliver of open space at the side of the wall allows the viewer to glimpse the coloured glow from the other side.

opposite
Dan FLAVIN
untitled (to a man, George McGovern)
1972
Fluorescent light
310 × 310 cm [122 × 122 in]

This work is part of a series of three, each of which uses the same triangular configuration of circular fluorescent tubes, yet differs in hue. Flavin used cool white in one sculpture, warm white in the next and daylight in the third. In this installation, dedicated to the unsuccessful Democratic presidential candidate of 1972, whom Flavin admired, the two legs of the triangle converge at the corner of the gallery space, mimicking the configuration of the room.

Larry BELL
The Iceberg and Its Shadow
1974
Inconel-coated glass
56 units, dimensions variable
Installation view, Massachusetts Institute of Technology, Cambridge

While working in Taos, New Mexico, Bell began designing asymmetrical sculptures with planes that were not parallel to either the floor or the ceiling. For this, the most monumental of these asymmetrical works, Bell created fifty-six planes of glass coated in a layer of quartz deposits that gave the work a bluish sheen. Each of the triangular and trapezoidal plates may be installed differently, creating faceted shapes that reflect light at oblique angles with prismatic transparency: the other viewers and the surroundings visible through the planes are distorted and fragmented.

Larry BELL
Untitled
1977
Inconel-coated glass
4 units, 244 × 152.5 cm [8 × 5 ft] each
Installation view with Andy Warhol, Denver Art Museum

As Bell became more interested in the appearance of the edges of his cubes and the gradations in colour at different points on the panels, he developed new techniques that allowed him to create larger structures without the brass strips to hold the glass panels together, thus creating uninterrupted plays of coloured light and unobstructed transparency. This shot records the artist Andy Warhol's fascination for Bell's glass environments which surround the viewer with multi-panel reflections.

Larry BELL
20" Glass Cube
1968
Vacuum-coated glass
51 × 51 cm [20 × 20 in]

Bell's glass cubes became larger and larger towards the end of the 1960s. This vacuum-coated glass box rests upon a clear pedestal of the same width and depth, clouding the distinction between support and artwork. The sides of the cube are covered in chromium-plated brass, calling attention to the edges of the work and the subtle diminishing of the coloured coating in the perimeter of each glass panel. Bell used the cube as the foundation of his work during this period because the 90-degree angle is one of the most basic forms in our visual vocabulary, a ubiquitous element of our built environment and our architecture.

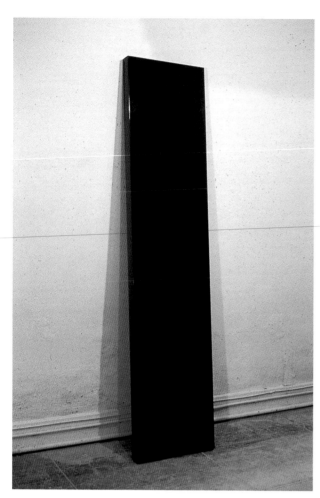

John MCCRACKEN
Untitled (Dk Blue)
1970
Polyester resin, fibreglass,
plywood
244 × 56 × 8 cm [96 × 22 × 3 in]

The plank leaning against the wall became McCracken's prototypical form by the late 1960s. The plank is sculptural, yet it retains ties to the pictorial by physically touching the site of painting, the gallery wall. McCracken's work also refers to that fundamental of architecture, the carpenter's plank. The sculpture's polymer resin surface creates a seamless veneer: the rich blue colour seems indivisible from the form rather than applied, stressing the wholeness and indivisibility of the rectangular shape.

John MCCRACKEN
Untitled
1975
Polyester resin, fibreglass,
plywood
25 × 41 × 41 cm [10 × 16 × 16 in]

In this free-standing sculpture McCracken places a yellow pyramid shape upon a white block of wood, creating a form that mimics an edifice, with the pyramid serving as the uppermost section, or the roof, of the standard square architectural base. Yet the coloration of the work separates the two forms, creating a two-part structure and also referring to the exhibition of traditional sculpture upon neutral pedestals. The emphasis on colour as an intrinsic part of sculpture and as a device to explore human perception characterizes the work of many of the California Minimalists, such as McCracken, Larry Bell and Judy Chicago.

Anne <u>TRUITT</u>
King's Heritage
1973
Painted wood
244 × 48 × 20 cm [96 × 19 × 8 in]

This work, a rectangular shaft with a cruciform top, departs from the standard columnar format of Truitt's later work. Painted bright red and 244 cm [8 ft] tall, it is one of Truitt's boldest sculptures. This is part of a series of three works bearing chivalric or regal titles, including *Knight's Heritage* (1963) and *Queen's Heritage* (1968).

top
Anne <u>TRUITT</u>
Whitney Museum of American Art,
New York
18 December 1973-27 January 1974
Installation view
bottom
Anne <u>TRUITT</u>
Corcoran Gallery of Art,
Washington, DC
21 April-2 June 1974
Installation view

This show, organized by the curator Walter Hopps, was the first retrospective of Truitt's work and established the artist's reputation as a significant figure of Minimal art. The Whitney installation included works from the early 1960s such as *Hardcastle* and *Gloucester*, as well as more recent sculptures, paintings and drawings. An expanded version of the show at the Corcoran Gallery of Art in Washington, DC, featured Truitt's recent columnar sculptures arranged in pairs around the periphery of the gallery space.

Sol LEWITT
Wall Drawing No. 1, Drawing Series II 14 (A&B)
1968
Pencil
No longer extant, dimensions unknown
Installation view, Paula Cooper Gallery, New York

LeWitt returned to working in two dimensions with his series of wall drawings begun in 1968. The first wall drawing was at the Paula Cooper Gallery, New York, and consisted of a four-part grid; each quadrant was further subdivided into four more squares. In each area he alternated vertical, horizontal and diagonal lines of black pencil following the rules of a system he devised which dictated all the possible permutations of lines. This system, which could be completed by anyone, has made the execution a purely 'perfunctory affair'.

Sol LEWITT
Five Modular Structures (Sequential Permutations on the Number Five)
1972
Painted wood
Dimensions variable

In this series of white wooden skeletal structures LeWitt used permutations, or serial modifications of five cubic units, to develop a sequence of related works. Each of the units has exactly the same dimensions, yet the shape and structure of each sculpture varies, with different levels and arrangements of the five connected cubes forming distinct configurations.

opposite
Carl ANDRE
8006 Mönchengladbach Square
1968
Hot-rolled steel
36 units, 300 × 300 cm [118 × 118 in] overall

The title of this work refers to the Mönchengladbach Museum in Germany, an avant-garde exhibition space run by the noted curator Johannes Cladders, for which Andre specifically designed the sculpture. Built of local steel, the work consists of two identical floor pieces, each comprised of thirty-six metal tiles grouped in a square formation; the two parts are separated by an interval of a few feet.

Carl ANDRE
Joint
1968
Baled hay
183 units, approx. 36 × 46 × 91 cm [14 × 18 × 36 in] each
Installation view, Windham College, Putney, Vermont

With the metal floor pieces Andre began including the possibility of a work's gradual disintegration through being walked upon. This notion of gradual change is made more apparent in *Joint*, constructed specifically for an outdoor site at Windham College, Vermont, of bales of hay. The hay was compacted tightly into squares and placed in a 84-m [274.5-ft]-long structure, uncovered, so that with time and the elements the components would eventually decompose. The name refers to the way the work connects, or joins, the different grades of landscape.

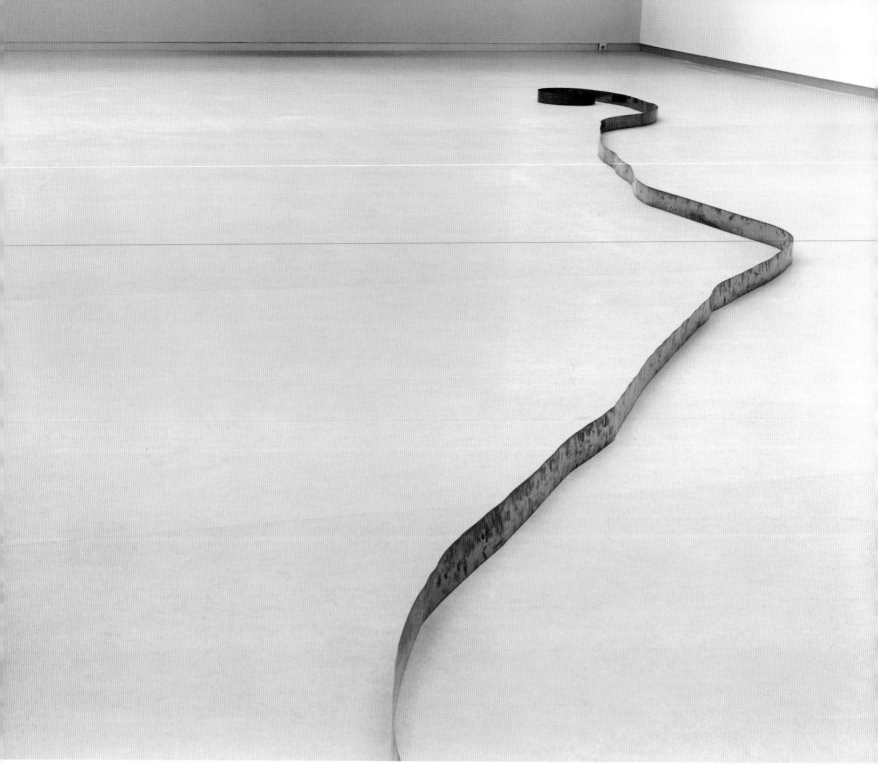

Carl ANDRE

Copper Ribbon

1969

Copper

9 × 1 × 2,100 cm [3.5 × .5 × 827 in]

Collection, Kröller-Müller Museum, Otterlo

Continuing to work with metal, as in his earlier metal floor pieces. Andre has placed a long, thin copper strip on the gallery floor. One end is coiled in the gallery with a long tail stretching out across the expanse of the room. The coiled end can be made larger or smaller depending on the size of the gallery.

Carl ANDRE
Dwan Gallery, New York
3-23 April 1971
Installation view

This exhibition of thirty of Andre's works included his *Runs* and *Rods*, thin strips of various metals and rubber that coil or stretch across the gallery floor. Several metal tile floor works were also included. Andre highlighted the commodification of art objects in this exhibition by calculating the price of his works in accordance with the buyer's income: the purchaser paid 1 per cent of his annual income for each yard of sculpture. Andre also assumed control over the future resale of works by claiming 10 per cent of any profit made on resale.

Carl ANDRE
25 Blocks and Stones
1986 (first version 1973)
Concrete blocks, river stone, geological specimens
25 units, 5 × 30.5 × 30.5 cm [2 × 12 × 12 in] each

This work, exhibited in Dusseldorf in 1986, consists of twenty-five concrete blocks arranged in a grid pattern with 91.5 cm [36 in] intervals between blocks. Each block has one geological specimen centred upon it, but for the central block which supports a river stone. The Dusseldorf work is derived from a larger work exhibited in 1973 at the Portland Center for the Visual Arts, Oregon, in which Andre used 144 blocks, rather than the twenty-five shown here.

Carl ANDRE
Stone Field Sculpture
1977
Glacial boulders
Dimensions variable
Installation view, Hartford, Connecticut

This is Andre's most significant permanent outdoor work, made for a lawn in Hartford, Connecticut, next to an eighteenth-century church. Thirty-six glacial boulders of various sizes and types of stone are placed in eight rows, forming a pyramid pattern suggesting the lines of tombstones in the adjacent cemetery. The number of boulders in each row matches the row's line number in the pattern: one stone in row one, two stones in row two, and so on. Perhaps more than any other work by Andre, it reflects the sculptor's abiding interest in such Neolithic monuments as Stonehenge, Avebury and so on.

Carl ANDRE
Flanders Field
1978
Western red cedar beams
54 beams, 91.5 × 30.5 × 30.5 cm [36 × 12 × 12 in] each

This work was constructed in the Netherlands and first exhibited in Dusseldorf, where the gallery was filled with fifty-four identical cedar beams measuring 30.5 cm [1 ft] square and standing 91.5 cm [3 ft] tall. The distance between each of the beams matches the width of the beams, and is sufficient to allow the viewer room to walk through the field of timbers. Filling up the gallery interior, it exemplifies Andre's attempt to develop a sculpture that defines its site of display.

Robert <u>SMITHSON</u>
Double Non-site, California and
Nevada
1968
Steel, obsidian, lava
30.5 × 180 × 180 cm [12 × 71 × 71 in]

opposite

Robert <u>SMITHSON</u>

Gypsum Non-site, Benton,
California
1968
Gypsum, steel, photograph
Dimensions variable

Smithson's 'Non-sites' are sculptural
installations that remind the viewer of a
location far from the gallery. The actual
place, or site, is represented by the Non-
site. Many of these works used pre-
fabricated Minimal-type forms as
containers for rocks or sand taken from
the particular site. For this work,
Smithson used three different elements
referring to a location in Benton,
California. On the floor is a steel
container filled with gypsum specimens;
on the wall is a photograph super-
imposed on a map of this location.

Jo <u>BAER</u>
Untitled (Double Bar Diptych - Green and Red)
1968
Oil on canvas
Diptych, 91.5 × 100 × 4 cm [36 × 39 × 1.5 in] each

The coloured borders usual to Baer's paintings here are simple vertical bars on the left and right edges of each canvas. The right canvas features a black bar with a red edge, and the left canvas a black bar with a green edge. The vertical borders create a strong pattern of retinal after-images on the white ground that contrasts with the side-by-side placement of the canvases. The bands also contrast with – and highlight – the vertical gap between the paired supports.

Jo <u>BAER</u>
Untitled (Red Wraparound)
1970-74
Oil on canvas
122 × 132 × 8 cm [48 × 52 × 3 in]

Baer restretched the canvas so that the vertical black and red bars at the edges of the canvas literally wrap around the support. The colour and dimensions of the border appear to alter once they reach the sides of the canvas, changing the viewer's perception of the work from that of a frontal orientation.

Jo BAER
H. Arcuata
1971
Oil on canvas
56 × 244 × 10 cm [22 × 96 × 4 in]

Baer titled this work after a species of plant, using the letter H to refer to its horizontal placement on the wall. It was meant to be hung only a few inches from the floor in order both to challenge the traditional eye-level view of painting and to mimic sculpture by calling attention to its width.

opposite

Robert <u>RYMAN</u>

Concord

1976

Oil on linen, steel

259 × 244 cm [102 × 96 in]

Robert <u>RYMAN</u>

Konrad Fischer Gallery, Dusseldorf

1968

Installation view

Ryman exhibited six paintings at the Konrad Fischer Gallery, Dusseldorf, including the *Classico Series*: acrylic paint on several panels of handmade paper hung in a square format. When Ryman shipped the paintings from his studio to Germany for the exhibition, the customs slip listed the contents of the crate as paper, rather than paintings. The customs officials, as Ryman recalls, determined that the paper was expensive, and asked for high tariffs. The owner of the gallery, Konrad Fischer, declared that the paper was indeed expensive, yet used, and thus the crates arrived at the gallery labelled 'Used Paper'.

Robert <u>RYMAN</u>

Prototype No. 2, 3, 5

1969

Oil on fibreglass

46 × 46 cm [18 × 18 in] each

In the *Prototype Series* Ryman attached thin plastic sheets directly to the wall with tape. He then painted the plastic with a white polymer. When the tape was removed, the plastic still stuck to the wall, because the overlaps of paint on the wall held the thin plastic down. Ryman then stretched the plastic, marred by the tears of the tape, on a red underpainting.

Robert <u>RYMAN</u>

General

1970

Enamel on Enamelac on canvas

124.5 × 124.5 cm [49 × 49 in]

This is one of a series of fifteen paintings from the *General Series*, which were shown together at the Fischbach Gallery, New York, in 1971. They are almost identical in appearance and execution, yet vary in size. Each canvas was first painted in Enamelac, a type of shellac used as a primer-scaler. Ryman then applied six coats of white enamel to the canvas, calculating the size of the square centre in relation to the stretcher. Each coat was sanded after it dried, causing the enamel to appear luminous and reflective in contrast to the mat, Enamelac borders. At Fischbach Ryman emphasized such contrasts by illuminating one wall of works, and leaving the other unlit.

Agnes MARTIN
Untitled No. 3
1974
Acrylic, pencil and shiva gesso on canvas
183 × 183 cm [72 × 72 in]

In 1967 Martin declared her temporary retirement from painting, moving from New York City to New Mexico. She began exhibiting again in 1975 with the Pace Gallery, New York. These later works are distinctly different from her earlier work, emphasizing planes of pale colour rather than the previous grids of pencil lines. The pigment washes are so subtle that the variations in colour, such as the three bands of different shades of pink in *Untitled No. 3*, are barely noticeable from a distance.

CANONIZATION/CRITIQUE

below l. to r.,

Robert <u>MANGOLD</u>
W Series Central Diagonal 1 (Orange)
1968
Acrylic on masonite
122 × 183 cm [48 × 72 in]
Robert <u>MANGOLD</u>
W Series Central Diagonal 2
1968
Acrylic on masonite
122 × 244 cm [48 × 96 in]
Robert <u>MANGOLD</u>
1/2 W Series (Orange)
1968
Acrylic on masonite
122 × 244 cm [48 × 96 in]
Collection, The Museum of Modern Art, New York
Installation view, Fischbach Gallery, New York, 1969

Around the time of Mangold's *W, V, X Series*, various permutations based roughly on three letters of the alphabet, Mangold turned to using a roller – rather than a brush – to apply the paint and thus enhance the works' flatness. The *X Series*, moreover, formalized Mangold's method of developing a serial sequence according to a predetermined schema. 'From roughly 1968–70 I worked with a more rigid serial intent, in that I conceived ideas – the *W, V, X Series*, for instance – that attempted to work out all the possibilities of a given idea ... For the *W, V, X Series* I lifted colours – a kind of pumpkin orange, a forest green and a blue – from a fabric store window display on the Lower East Side of New York.'
– Robert Mangold, 'Interview with Sylvia Plimack Mangold', 1999

Robert MANGOLD

Distorted Square/Circle (Blue-Green)

1971

Acrylic and pencil on canvas

161 × 161 cm [63 × 63 in]

During the early 1970s Robert Mangold broadened his experimentation into the possibilities of a 'Flat Art' by examining many combinations of basic, two-dimensional geometric shapes – circles, squares, ellipses, curves and triangles – which he overlapped or distorted in monochromatic, single-panel (later multiple-panel) paintings. Works such as his *Distorted Square Circles* have often been compared with Leonardo's image of Vitruvian man, the Renaissance artist's diagram of a man inscribed within a perfect circle and square.

Robert MANGOLD
Painting for Three Walls (Blue, Yellow, Brown)
1979
Acrylic and pencil on canvas
Triptych, 230 × 323 cm [90.5 × 127 in] each
Installation view, John Weber Gallery, New York

Painting for Three Walls, exhibited at the John Weber Gallery, New York, in 1980, is made up of three paintings of different colours – a central bluish-grey trapezoid with a horizontal rectangle inscribed inside, flanked by an olive-brown rhomboid on the right with a vertical rectangle within. On its left is a warm yellow panel of distorted, roughly rectangular shape with a horizontal rectangle drawn inside. Mangold's exploration of the multiple-panel format and architectural scale can in part be attributed to his travels to Italy in the mid 1970s, where he became interested in early Renaissance polyptychs and frescoes, from which he could draw connections to his 'Flat Art'.

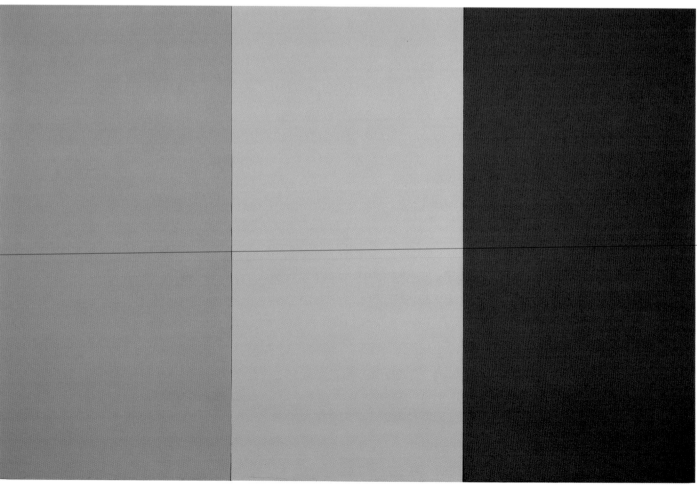

Brice <u>MARDEN</u>
Grove Group I
1972
Oil and wax on canvas
183 × 274 cm [72 × 108 in]
Collection, The Museum of Modern
Art, New York

By the 1970s Marden returned to the
single monochrome format of his early
work in addition to producing multi-
panel diptychs and triptychs. The *Grove
Group* series, named after an olive grove
in his favourite vacation spot on the
Greek island of Hydra, includes both
formats. The encaustic technique used in
those paintings helps to create the thick,
tactile surface which viewers found so
appealing to the senses. Critic Douglas
Crimp commented of Marden's work: 'Its
sense of material *qua* material is so
strong that … I felt compelled to walk up
to a work and smell it.'
– Douglas Crimp, 'Opaque Surfaces',
1973

Brice <u>MARDEN</u>
Grove Group III
1973
Oil and wax on canvas
183 × 274 cm [72 × 108 in]

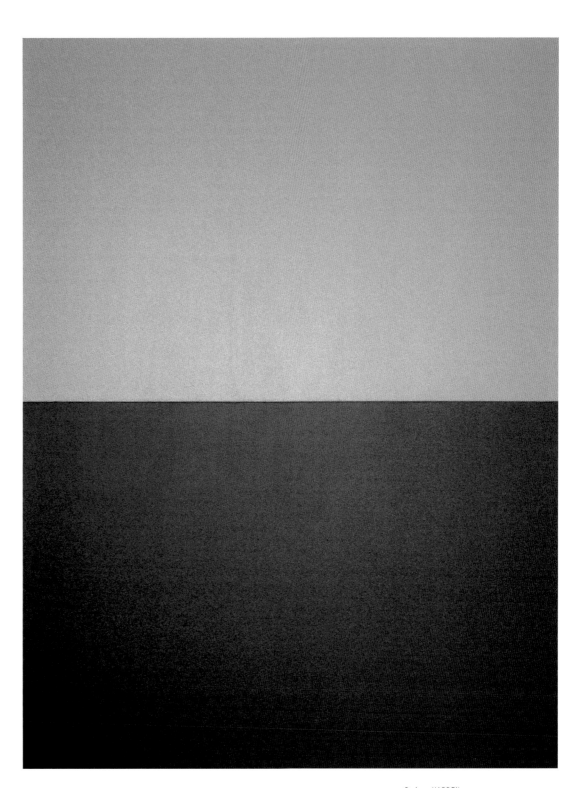

Brice <u>MARDEN</u>
Sea Painting
1973-74
Oil and wax on canvas
183 × 137 cm [72 × 54 in]

David NOVROS
Untitled
1968-69
Lacquer on fibreglass
183 × 366 cm [6 × 12 ft]

Novros began using fibreglass by the late 1960s because it allowed for a perfect, smooth lacquered surface with no surface grain to detract from the undulating variations of colour. Here he displays L-shaped canvases with legs of varying lengths. Novros juxtaposes light-coloured canvases with darker ones and also places them closer together as the configuration proceeds to the right. This arrangement encourages a mobile, protracted vision in the viewer, who must traverse the entire work in order to take in the complex colour and spatial relationships.

David NOVROS
Untitled
1968
Lacquer and dry pigment on fibreglass
366 × 457 cm [12 × 15 ft]
Collection, The Museum of Contemporary Art, Los Angeles

Novros' use of the shaped canvas allows the blank white space of the wall behind the work to become activated by the play of coloured shapes. In this untitled series Novros arranges twelve L-shaped paintings in a two-level composition. The placement of the multicoloured canvases in pairs causes the interior L-shapes to appear as shadows, creating a dynamic interplay of illusionistic depth and literal materiality.

David <u>NOVROS</u>

Untitled

1972 (destroyed)

Fresco

305 × 914 cm [10 × 30 ft]

Installation view, 'Projects', The Museum of Modern Art, New York

In his previous works Novros sought to activate the negative space of the gallery wall through the placement of coloured, shaped canvases. In this fresco, created for a special project at The Museum of Modern Art, New York, this activation of the gallery wall has been perfected by literally making the wall his canvas, indivisible from the coloured areas. Novros continued to use the geometric shapes of his earlier canvases, but the flat, continuous surface allows an overlap of forms, creating a more complex colour scheme and configuration of shapes. The fresco wall transcends the effect of a single painting, creating an environment that encompasses the viewer.

1980-present RECENT WORK

In recent years the artists associated with Minimalism have transformed the austere, geometric style of the 1960s in a number of directions. Whereas figures like Carl Andre, Robert Ryman and Robert Mangold continue to work in characteristic modes, Brice Marden has abandoned the monochrome panel for a gestural, calligraphic manner. Sol LeWitt's ephemeral, pencil wall drawings of the late 1960s and early 1970s have devolved into vast, multi-hued compositions, his simple cubic lattices into ever more intricate structures and polygonal solids. Anne Truitt's sculpture has become flagrantly polychrome, while the later installations of Dan Flavin explored spectacular combinations of colour and shape. Donald Judd's transformation was total, indeed breathtaking: continuing to develop his gallery work in updated materials and colours, he created enormous installations in concrete and aluminium at the Chinati Foundation in Marfa, Texas, extending the premises of wholeness and perspicuity of his early work into the orchestration of a total art environment.

Robert RYMAN
Versions VII
1991
Oil on fibreglass, waxed paper
44 × 41 in [112 × 104 cm]

Between 1991 and 1992 Ryman completed sixteen *Versions* paintings, each of which is a thin membrane bordered with waxed paper. The thinness of the works reacts to the light and space of the surrounding environment, as well as the way the painting reacts with the plane of the wall. Each of the works in the series differs in size and overall appearance. *Versions VII* is a fibreglass panel painted in thick white brushstrokes. The top of the picture plane is bordered with waxed paper, extending the painting visually beyond the fibreglass support.

above

Robert <u>RYMAN</u>

Express

1985

Oil on Enamelac on fibreglass,

steel bolts

274 × 121 cm [108 × 47.5 in]

Ryman coated a fibreglass panel with a thin layer of Enamelac, a green/yellow mat shellac. He then over-painted the top and bottom in a lighter shade of oil paint in the same colour, exposing the middle horizontal band and the large black steel bolts that hold the panel to the wall.

left

Robert <u>RYMAN</u>

Pace

1984

Acrylic on fibreglass, wood,

aluminium

Panel, 66 × 66 × 67 cm [26 × 26 × 26.5 in]

Overall, 151 × 66 × 71 cm [59.5 × 26 × 28 in]

Ryman questions the traditional premise of painting as an object viewed vertically against the wall by butting the thin edge of a painted panel to the wall and supporting it with aluminium rods. The work is thus viewed as a quasi-sculptural form that projects out from the wall into the gallery space at eye level. The viewer sees the red edge of the panel, and the reflection of the gallery lighting bouncing off the top of the work which, painted in reflective enamel, contrasts with the bottom, coated in a mat white varnish.

Robert <u>MANGOLD</u>
X within X (Gray)
1980
Acrylic and pencil on canvas
\, 240 cm [96 in]; /, 203 cm [80 in]

In 1980 Mangold began the *X* and *+ Series* composed of four attached arms forming either an X or a + on the wall. Recalling operations (addition, multiplication) associated with the printed page, these paintings refer to the systems and forms that are part of daily life. They also bear a relationship with Piet Mondrian's *Pier and Ocean Series*, canvases composed of short vertical and horizontal strokes which, similarly, have been described as suggesting mathematical notation, pluses and minuses.

RECENT WORK

Robert <u>MANGOLD</u>
Attic Series XIV
1991
Acrylic and pencil on canvas
293.5 × 213.5 cm [115.5 × 84 in]

In 1990–91 Mangold produced one of his most ambitious group of paintings, the *Attic Series*, the title of which was inspired by a visit he made to the collection of early classical pottery from Attica at The Metropolitan Museum of Art in New York. This series, which eventually reached eighteen full-scale works, has a fresco-like quality resulting from the thin acrylic paint applied with a roller to the boldly coloured, shaped canvases. Each presents an elegant composition of hand-drawn ovals and figure-8s which allude to classical geometrics. The artist's early interest in his immediate urban surroundings gave way in later years to a broadened interest in art-historical affinities.

Robert <u>MANGOLD</u>
Curved Plane/Figure IV (Double Panel)
1995
Acrylic and pencil on canvas
249 × 362.5 cm [98 × 143 in]

The *Curved Plane/Figure Series* from mid 1994 to 1995 involved at least two adjacent panels, later extending up to four (and eventually leading to his wall-length *Zone* paintings, which comprised up to five such panels). These asymmetrical works with mismatched ellipses reaching across unequal, differently coloured panels are especially architectural, recalling the lunettes and irregular arching wall segments of Italian frescoed churches of the Renaissance.

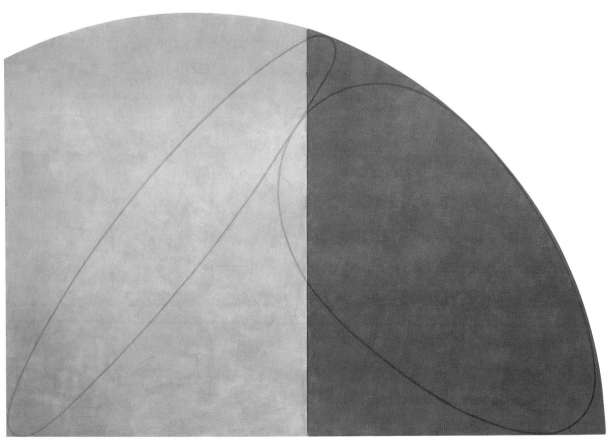

Agnes MARTIN
Untitled No. 4
1984
Acrylic, gesso and graphite on canvas
183 × 183 cm [72 × 72 in]

In her early work Martin often gave her paintings titles meant to be evocative of the natural world. In contrast, her later paintings are identified only by number, expanding the interpretative and associative potential by refusing to give the viewer natural referents. This work, with more than ninety evenly spaced graphite lines, is reminiscent of her 1960s canvases of allover grids with wide margins on either side, exposing the pale white ground.

RECENT WORK

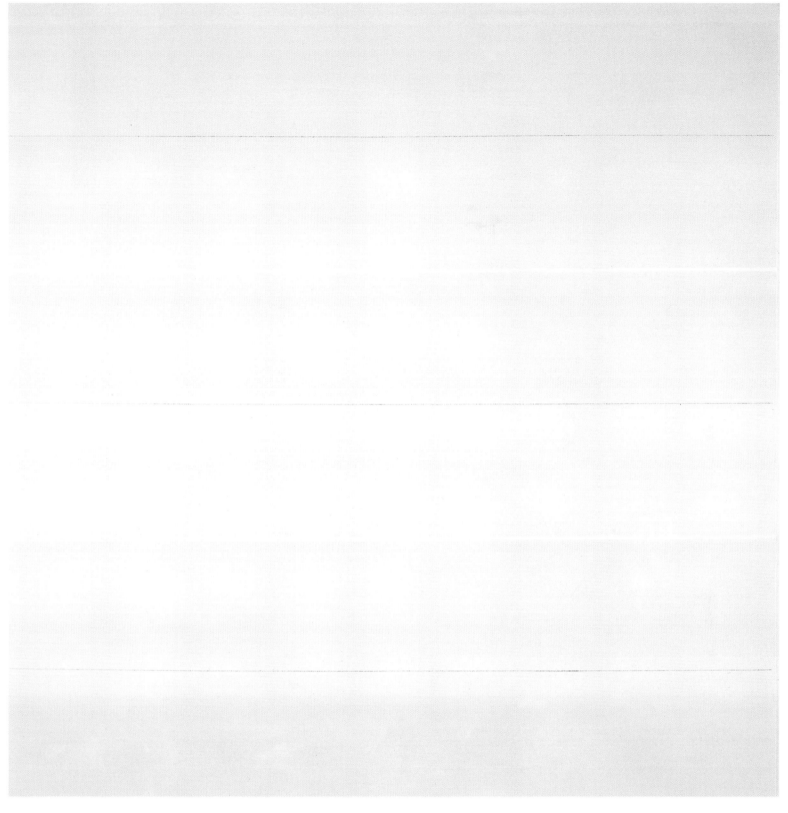

Agnes MARTIN
Untitled No. 1
1988
Acrylic and pencil on canvas
183 × 183 cm [72 × 72 in]

In Martin's recent paintings, the wide horizontal bands are defined through the simplest of techniques. Here the bands are established by alternating lines of white acrylic paint and graphite pencil drawn on a pale ground. The strong value contrast of the acrylic and pencil lines creates the optical illusion that the wide bands beneath the white lines stand out from the canvas, while the bands beneath the black lines appear to recede behind the canvas.

opposite

Anne TRUITT

Breeze

1980

Painted wood

153 × 10 × 14 cm [60 × 4 × 5.5 in]

Truitt's later work is columnar and has a greater emphasis on the effects of colour on a viewer. The tall thin column is painted in blocks and stripes over the entire surface, each patch of colour remaining distinct. The stripes travel the full 360 degrees around the sculpture, eliminating any possibility of a frontal reading and reiterating the three-dimensionality of the column.

Anne TRUITT

Baltimore Museum of Art

14 October–28 November 1992

Installation view

This installation appeared in a group exhibition inaugurating the new wing of the Baltimore Museum of Art in October 1982. It consisted of several columnar sculptures from different phases of Truitt's career, such as *Odeskalki* (1963), *A Wall for Apricots* (1968) and *Nicea* (1977), as well as more recent works. The Baltimore Museum has held several exhibits of Truitt's work over the years, including a show of her *Arundel* paintings in 1975 and a major retrospective in 1992 curated by Brenda Richardson.

Anne TRUITT

Parva XXX

1993

Acrylic on wood

15 × 81 × 10 cm [6 × 32 × 4 in]

Since making her first *Parva* in 1974, Truitt has produced forty-three works in the series. *Parva* is the feminine form of the Latin adjective for small. Works in the series tend to be diminutive in size, in contrast to most of Truitt's sculptures, which are scaled to the human body. Though consistently small, the *Parvas* come in a variety of shapes: this work is one of Truitt's few horizontal sculptures, a group that includes *Sandcastle* (1963), *Milkweed Run* (1974), *Remembered Sea* (1974) and *Grant* (1974). *Parva XXX* has a subtle palette with a thin yellow line dividing the dark bottom from the large pale top.

Carl <u>ANDRE</u>
Cataract
1980
Hot-rolled steel
300 units, 100 × 100 cm [39 × 39 in] each

Andre constructed this work for the Wenkenpark in Riehen/Basel, Switzerland. He placed steel plates upon the ground, as in his earlier metal floor works, but the vicissitudes of the outdoor site are reflected in the work's appearance. The sculpture follows the contours of a slope, and the grass pushes up between the edges of the tiles, disrupting the even surface of the regular grid.

Carl <u>ANDRE</u>
Steel Peneplein
1982
Steel
300 units, 100 × 100 cm [39 × 39 in] each

Part of the international exhibition of contemporary art, Documenta 7, Kassel, Germany, *Steel Peneplein* consisted of 300 steel plates neatly placed on top of a pedestrian walkway in a park surrounded by rows of trees. Leading the viewer from one point to another, the sculpture is no longer a discrete object but a catalyst for movement, sculpture 'as a road'.

Carl <u>ANDRE</u>
Peace of Munster
1984
Gas-beton blocks
408 unit grid
24 × 18 × 50 cm [9.5 × 7 × 19.5 in] each;
50 × 760 × 850 cm [19.5 × 299 × 334.5 in] overall

The title of this work, exhibited at the Westfälischer Gallery in Munster during the Skulptur Projekte in Münster, refers to the peace treaty signed in that city, ending the Thirty Years War. Andre created a horizontal and vertical pattern from 408 white blocks that are arranged in a twenty-three block square configuration.

below l. to r.

Carl ANDRE
Angellipse
1995
Poplar
28 units, 5 × 127 × 25 cm [2 × 50
× 10 in] each
Carl ANDRE
Angelimb
1995
Poplar
65 units, 5 × 25 × 127 cm [2 × 10
× 50 in] each
Installation view, Paula Cooper
Gallery, New York

Carl ANDRE
'Pb Cu'
Galerie Tschudi, Glarus
27 May–2 September 1995
Installation view

The title of this exhibition refers to the chemical symbols for the two materials used in the fifteen sculptures included in the show: lead and copper. One section included works with the word 'None' in the title, derived from the Latin for ninth, which is the number of cubes in each. 'None' also is suggestive of their diminutive size. The sculptures in the other section had the word 'Trianone' in the title, alluding to the shape formed by the placement of three of the 'None' configurations in a larger cube formation.

Carl ANDRE
1Cu8Pb None
1995
Copper, lead
30 × 30 × 10 cm [12 × 12 × 4 in]

Andre stacks one cube of copper between eight cubes of lead in this work, juxtaposing the burnished metal with the dark, mat lead. The colour of the copper is similar to the tiles of the gallery floor and thus seems to create a transparent space within the solid square configuration.

Carl ANDRE
Glarus Copper Galaxy
1995
Copper
20 × .05 × 10,000 cm [8 × .02 × 3,937 in]
ø 225 cm [88.5 in]
Collection, Kunsthaus, Zurich

This work, named for the town of Glarus, Switzerland, where it was shown, marks Andre's return to the use of copper coil. He began using this sheet metal in 1969, when he allowed the raw material to coil naturally on the gallery floor. He has returned to working in this material in a much expanded scale, shaping the single sheet of copper into a spiral reminiscent of a 'galaxy' or other cosmological form.

Sol LEWITT
13/11
1985
Painted wood
152 × 305 × 152 cm [5 × 10 × 5 ft]

LeWitt's white structures of the 1970s and 1980s are reminiscent of his earlier modular objects exhibited in 1966 at the Dwan Gallery, New York. However, these are more visually complex than the early works, due to their smaller lattice openings and intricate, layered designs. This piece is made up of two triangular structures of interlocking open cubes stacked thirteen high and eleven deep. The bright lighting creates shadows, confusing the viewer's ability to differentiate the boundaries between the object and its surrounding space and belying the geometric order of the structure.

Sol LEWITT
Complex Form
1978-80
Painted wood
Dimensions variable

LeWitt's *Complex Forms* mark a departure from his modular works of the 1960s. His earlier structures, however complex, were based on the simplest of forms – the cube – which could be repeated according to a pre-chosen scheme. In contrast, the *Complex Forms* begin as irregular shapes: each is the projected three-dimensional volume of a two-dimensional figure. LeWitt first draws a polygon and then places a dot somewhere inside the figure; lines running from the vertexes of the polygon to the dot become the volume's multiple edges. Though they are consistently executed in wood painted white, each work is unique. The number of possible shapes is endless: the wildly varied forms in the series include ziggurats, irregular pyramids and polygonal solids too complicated for description.

Sol LEWITT
Complex Form No. 8
1988
Painted plywood
305 × 691 × 183 cm [120 × 272 × 72 in]

Complex Form No. 8 consists of five interconnected parts, each of which is a completely different polyhedron structure varying in shape and height from the others. The entire structure resembles an organic, crystalline molecular configuration, with the five forms seeming to 'grow' from each other. It was first exhibited at the 1988 Venice Biennale.

opposite
Sol LEWITT
New Structures
1995
Breeze blocks
Installation view, ACE Gallery,
New York

LeWitt filled the entire gallery with breeze block structures rising from the floor in a pattern of open square forms. At the points where the square bases intersect, towers rise to the ceiling. LeWitt used the same basic form he had chosen in the mid 1960s, the open skeletal cubic shape, yet with an expanded scale. The architectural size contradicts the domestic scale of his earlier geometric forms; the viewer can no longer perceive the works as distinct shapes, but must navigate the crowded gallery space in order to discern a more monumental configuration.

Sol LEWITT
Open Geometric Structure IV
1990
Painted wood
98 × 438 × 98 cm [38 × 172 × 38 in]

In 1990 LeWitt created several of these white wood sculptures, all of which he titled *Open Geometric Structure*. In each he used his signature white cube in a variety of configurations reminiscent of architectural forms, such as stairs. Although the works may allude to architecture, they remain small-scale, measuring only 98 cm [38 in] high.

John <u>MCCRACKEN</u>
Hill
1997
Polyester resin and fibreglass on
plywood
51 × 245 × 18 cm [20 × 96.5 × 7 in]

In this work McCracken again creates a
hybrid between painting and sculpture,
as he had done with his *Planks*. Like a
painting, *Hill* hangs upon the wall, and is
coloured in a rich resin pigment, yet the
thickness of the wooden support, which
creates shadows upon the gallery wall,
and the shaped form testify to the work's
sculptural quality. With the title
McCracken relates *Hill* to nature and the
landscape, yet the work also retains a
machine-made quality, with angular
edges and smooth resin veneer upon
fibreglass.

John <u>MCCRACKEN</u>
One
1997
Polyester resin and fibreglass on
plywood
240 × 119 × 23 cm [94.5 × 47 × 9 in]

This sculpture, a flat triangular relief,
avoids the rectilinearity and heft of
McCracken's classic planks and cubes. It
is one of a number of recent works by
McCracken that are physically light and
idiosyncratically shaped.

Made for Arolsen
1992
Tempered glass
16 units, h. 183 cm [6 ft] each

This work, exhibited at an outdoor site in Arolsen, Germany, consists of sixteen panels of blue and pink glass, all measuring 183 cm [6 ft] high. Eight of the panels are 244 cm [8 ft] long, and the remaining eight are 122 cm [4 ft] long. Bell arranged them in two concentric rectangular structures, with four of the smaller blue panels forming a box that rests in the centre of a large pink box. The other structure reverses the colour: the small glass box is pink and lies within a larger blue cube. The variation in the placement of colours completely alters the appearance of each object, despite the fact that the same two colours are used in each.

Larry BELL
6 × 8 × 4, 1996
1996
Inconel-coated glass
183 × 244 × 122 cm [6 × 8 × 4 ft]
Installation view, Kiyo Higashi Gallery, Los Angeles

The titles of these works are derived from their dimensions. Arranging large sheets of tinted glass in cubic and cruciform configurations, Bell has created a sculpture that borders on installation. The glass is both transparent and opaque; each wall is visible as itself, yet reveals the other glass sheets and the gallery space beyond. The reflective sheen of the glass causes the walls to mirror each other, the floor beneath and the viewer's body. The spectator of Bell's work is made conscious of his or her surroundings and the act of perception itself.

The Guggenheim Museum and the Art of this Century

'The Guggenheim Museum and the Art of This Century: Dan Flavin'
The Solomon R. Guggenheim Museum, New York
22 June–27 August 1992
Dan FLAVIN
untitled (to Tracy, to celebrate the love of a lifetime)
1992
Fluorescent light

Flavin was invited to design an installation for the renovated galleries of the Solomon R. Guggenheim Museum, New York, in 1992. Dedicated to his fiancée, Tracy, this work was an expanded version of his 1971 Guggenheim installation dedicated to the artist Ward Jackson. Each bay of the rotunda was lit by blue, pink, yellow or green fluorescent lights, highlighting the museum's unique architectural design by Frank Lloyd Wright. Flavin also added an immense vertical column of pink fluorescent tubes in the museum's atrium that extended from the floor to the skylight. The colour of the central column changed at different times of day: the daylight caused the lamps to appear off-white, while after dark their pale pink glow became prominent.

Dan FLAVIN
Städtische Galerie im Lenbachhaus, Kunstbau
16 July–6 September 1998
Installation view
In 1998 Flavin designed an installation for an art centre in Munich made from a converted underground station. He replaced the normal utilitarian white fluorescent lights with pink, yellow, blue and green tubes. The lack of natural light in the cavernous space allowed the combination of lamps to flood the entire area with a polychromatic glow, completely transforming the feel of the narrow gallery.

Donald JUDD
Untitled
1985
Enamel on aluminium
30 × 60 × 30 cm [12 × 23.5 × 12 in]

Beginning in 1984 Judd commissioned a factory in Switzerland to produce a new type of aluminium object that could sometimes grow to monumental size; the wall-pieces consist of hollow aluminium boxes bolted together, two high and three deep, with a hollow central core. The boxes were painted a variety of hues – bright orange, yellow, blue, teal, fuschia and red – as well as neutral shades of brown, ochre, black and white, allowing Judd to work with the full spectrum of colours. The aluminium objects are more intuitively conceived than Judd's earlier works. The clear rationale of his classic Minimal objects, which used a few colours at most in order to define a shape, is no longer apparent in these visually complex arrangements.

overleaf and following page
Donald JUDD
North Artillery Shed
1982-86
Installation view, interior

opposite top
Donald JUDD
Untitled
1981
Concrete
15 groups, 2.5 × 2.5 × 5 m [8 × 8 × 16 ft] each unit
1. 1 km [3,281 ft] overall

Donald Judd passed through western Texas while serving in the army as a young man. Attracted to the region's vast open spaces, he settled in the town of Marfa in the early 1970s. The concrete structures that Judd built on land next to the artillery sheds of his Chinati Foundation are arranged in a linear sequence of individual groups, and consist of both open and closed forms. Those with two open sides allow the viewer to see the landscape beyond; those with one open side are more enclosed and shelter-like. Viewing the entire installation, which stretches across a vast field, is a truly temporal experience involving a bodily encounter with each monumental arrangement.

opposite bottom
Donald JUDD
South Artillery Shed
1982-86
Installation view, exterior

Donald Judd relocated his home and studio to Marfa, Texas, in 1971. Following his belief that the gallery system transforms the experience of art into that of a portable commodity, Judd sought a place to permanently install his and others' work. Between 1982 and 1986, Judd installed 100 identical aluminium boxes in two former military artillery sheds. Despite their identical exterior dimensions and materials, each box is unique. One open panel in each box allows the viewer to peer into an interior divided into varying angles by sheets of aluminium. These works are significant because, unlike the Specific Objects of the 1960s – discrete objects impervious to their environment – now the objects literally reflect their surroundings, the changing angles of the sunlight and the weather: the experience of viewing each box is different and dependent on the external world.

DOCU MENTS

CARL ANDRE

JO BAER

GREGORY BATTCOCK

KARL BEVERIDGE

MEL BOCHNER

DAVID BOURDON

IAN BURN

ANNA C. CHAVE

JUDY CHICAGO

JOHN COPLANS

DOUGLAS CRIMP

MARK DI SUVERO

DAN FLAVIN

HAL FOSTER

MICHAEL FRIED

BRUCE GLASER

CLEMENT GREENBERG

HAROLD GREGOR

PETER HALLEY

DONALD JUDD

HILTON KRAMER

ROSALIND KRAUSS

PHILIP LEIDER

SOL LEWITT

LUCY R. LIPPARD

JOHN MCCRACKEN

KYNASTON MCSHINE

ROBERT MANGOLD

MAURICE MERLEAU-PONTY

URSULA MEYER

ANNETTE MICHELSON

ROBERT MORRIS

YVONNE RAINER

BARBARA ROSE

ROBERT ROSENBLUM

RICHARD SERRA

JEANNE SIEGEL

ROBERT SMITHSON

SUSAN SONTAG

FRANK STELLA

SIDNEY TILLIM

SAMUEL J. WAGSTAFF, JR

1. [see page 200]
Yves KLEIN
Monochrome
1962
Oil on canvas
Detail

2. [see page 203]
Roy LICHTENSTEIN
Girl with Hair Ribbon
1965
Oil and magna on canvas
122 × 122 cm [48 × 48 in]

3. [see page 207]
Mark ROTHKO
Untitled
1951-55
Oil on canvas
189 × 101 cm [74.5 × 40 in]

4. [see page 209]
Joseph CORNELL
Untitled
c 1958
Box construction
25.5 × 38 × 10 cm
[10 × 15 × 4 in]

6. [see page 209]
Lee BONTECOU
Untitled
1961
Welded steel, wire,
canvas
204 × 226 × 88 cm
[80 × 89 × 35 in]

5. [see page 209]
Robert RAUSCHENBERG
Monogram
1955-59
Freestanding combine
107 × 162.5 × 164 cm [42
× 64 × 64.5 in]

7. [see page 212]
Barnett NEWMAN
L'Errance
1953
Oil on canvas
218 × 197 cm
[86 × 77.5 in]

8. [see page 214]
Merce CUNNINGHAM
Suite for Five
1956
l. to r.
Carolyn Brown, Merce
Cunningham, Barbara
Dilley
Music, John Cage
Costumes, Robert
Rauschenberg

9. [see page 216]
Andy WARHOL
Sleep
1963
Black and white
Film still

10. [see page 221]
Alberto GIACOMETTI
Man Pointing (Uomo che indica)
1947
Bronze
h. 178 cm [69 in]

11. [see page 243]
Auguste RODIN
The Kiss
1899
Marble
190.5 × 119 × 114 cm
[75 × 47 × 45 in]

12. [see page 249]
Robert MORRIS
Felt Piece
1967-68
Felt
Dimensions variable

13. [see page 279]
The Times Diary
London
February 1979

14. [see page 281]
Walter DE MARIA
Bed of Spikes
1968-69
Stainless steel
6 × 199 × 105 cm
[2.5 × 78.5 × 41.5 in]

15. [see page 290]
Piet MONDRIAN
Composition
1927
Oil on canvas
53 × 38 cm [21 × 15 in]

1959–63 FIRST ENCOUNTERS Before the term

'Minimalism' was coined in the mid 1960s, a series of short statements and reviews hinted at the emergence of a new kind of pared-down abstraction. Carl Andre observed that Frank Stella's *Black Paintings* 'exclude the unnecessary'. Robert Morris proposed an art of 'blank', geometric forms emptied of any meaning. Following solo shows of Donald Judd and Robert Morris in 1963, Sidney Tillim and other critics began to speak of a 'new avant-garde' of younger artists who were using simple geometric shapes and materialist surfaces to critique the subjective, gestural 'action painting' of the previous generation.

Carl ANDRE
Preface to Stripe Painting (Frank Stella) [1959]

Art excludes the unnecessary. Frank Stella has found it necessary to paint stripes.
There is nothing else in his painting.

Frank Stella is not interested in expression or sensitivity. He is interested in the necessities of painting.

Symbols are counters passed among people. Frank Stella's painting is not symbolic. His stripes are the paths of brush on canvas. These paths lead only into painting.

Carl Andre, 'Preface to Stripe Painting (Frank Stella)', *16 Americans* (New York: The Museum of Modern Art, 1959) 76.

Frank STELLA
The Pratt Lecture [1960]

There are two problems in painting. One is to find out what painting is and the other is to find out how to make a painting. The first is learning something and the second is making something.

One learns about painting by looking at and imitating other painters. I can't stress enough how important it is, if you are interested at all in painting, to look, and to look a great deal, at painting. There is no other way to find out about painting. After looking comes imitating. In my own case it was at first largely a technical immersion. How did Kline put down that colour? Brush or knife or both? Why did Guston leave the canvas bare at the edges? Why did Helen Frankenthaler use unsized canvas? And so on. Then, and this was the most dangerous part, I began to try

to imitate the intellectual and emotional processes of the painters I saw. So that rainy winter days in the city would force me to paint Gandy Brodies as a bright clear day at the shore would invariably lead me to De Staels. I would discover rose madder and add orange to make a Hoffman. Fortunately, one can stand only so much of this sort of thing. I got tired of other people's painting and began to make my own paintings. I found, however, that I not only got tired of looking at my own paintings but that I also didn't like painting them at all. The painterly problems of what to put here and there and how to do it to make it go with what was already there, became more and more difficult and the solutions more and more unsatisfactory, until finally it became obvious that there had to be a better way.

There were two problems which had to be faced. One was spatial and the other methodological. In the first case I had to do something about relational painting, i.e., the balancing of the various parts of the painting with and against each other. The obvious answer was symmetry – make it the same all over. The question still remained, though, of how to do this in depth. A symmetrical image or configuration symmetrically placed on an open ground is not balanced out in the illusionistic space. The solution I arrived at, and there are probably quite a few although I only know of one other, colour density, forces illusionistic space out of the painting at constant intervals by using a regulated pattern. The remaining problem was simply to find a method of paint application which followed and complemented the design solution. This was done by using the house painter's technique and tools.

Frank Stella, 'The Pratt Lecture', presented at the Pratt Institute, Brooklyn, New York, January/February 1960; published in *The Black Paintings*, ed. Brenda Richardson (Baltimore Museum of Art, 1979).

Robert MORRIS
Blank Form [1960–61]

From the subjective point of view there is no such thing as nothing – Blank Form shows this, as well as might any other situation of deprivation.

So long as the form (in the broadest possible sense: situation) is not reduced beyond perception, so long as it perpetuates and upholds itself as being an object in the subject's field of perception, the subject reacts to it in many particular ways when I call it art. He reacts in other ways when I do not call it art. Art is primarily a situation in which one assumes an attitude of reacting to some of one's awareness as art.

Blank Form is still in the great tradition of artistic weakness – taste. That is to say I prefer it – especially the content (as opposed to 'antiform' for the attempt to contradict one's taste). Blank Form is like life, essentially empty, allowing plenty of room for disquisitions on its nature and mocking each in its turn.

Blank Form slowly waves a large grey flag and laughs about how close it got to the second law of thermodynamics.

Some examples of Blank Form sculpture:
1. A column with perfectly smooth, rectangular surfaces, $61 \times 61 \times 244$ cm [$2 \times 2 \times 8$ ft], painted grey.
2. A wall, perfectly smooth and painted grey, measuring $61 \times 61 \times 244$ cm [$2 \times 2 \times 8$ ft].
3. A cabinet with simple construction, painted grey and measuring $30.5 \times 61 \times 183$ cm [$1 \times 2 \times 6$ ft] – that is, a cabinet just large enough to enter.

Robert Morris, word pieces written for *An Anthology* (1963), deleted by the author prior to publication.
Robert Morris, 'Blank Form', 1960–61, in John G. Hanhardt and Barbara Haskell, *Blam! The Explosion of Pop, Minimalism,*

and Performance 1958-64 (New York: Whitney Museum of American Art; New York and London: W.W. Norton, 1984) 101.

Donald JUDD

In the Galleries: Frank Stella

[1962]

Criticism is pretty much after the fact. Frank Stella's paintings are one of the recent facts. They show the extent of what can be done now. The further coherence supersedes older forms. It is not only new but better, not necessarily on an onlooker's scale of profundity which can measure Pollock against Stella, but on the scale of making painting and sculpture, of development. The absence of illusionistic space in Stella, for example, makes Abstract Expressionism seem now an inadequate style, makes it appear a compromise with representational art and its meaning. The paintings of Al Jensen and Kenneth Noland are similarly decisive advances. The coherence is philosophical as well as technical, which seems obvious but which apparently is not, and so cannot be ignored. It is, of course, pointless to imitate the appearance of Stella's work or of anyone else's or to consider it as a fixed point to be synthesized, to be passed. This exhibit is of seven large paintings: a U shape, an H, a backward L, etc. The canvas is on stretchers 10 cm [4 in] deep so that the shapes become reliefs – which is an innovation of Stella's. The U, by way of example, has nine narrow concentric lines, bare canvas, following the U shape, some 6 cm [2.5 in] apart, adding up to about 61 cm [2 ft]. The surface is copper paint. At the right angles of the U the distance between the turning lines becomes about 9 cm [3.5 in]. The geometric field initially appears rigid, objective and somewhat oppressive. The successive angles at the two turns align into diagonals. That, the greater distance between the lines and the paint reflecting differently, cause the surface surrounding the angles to borrow the diagonal direction.

The sensation is optical and definite. The diagonals are free and electric in a static field. The paintings are both objective, like geometric work, and truculently subjective, unlike that. To a small degree this show is not as good as the one in 1960. Primarily this is because the copper paint is lighter in weight and less harsh than the aluminium paint of the earlier show. This vitiates the density particular to Stella. Also, while the Us and the Ls are further from the rectangle and more unusual than the notched slabs of the earlier work, they do less to the concentric lines. The notches radiated diagonals which met to shape Vs or diamonds, forms unlike the exterior ones. And Stella neglected to paint the edges this time. That denies the relief and also weakens the density.

Donald Judd, 'In the Galleries: Frank Stella', *Arts Magazine* (September 1962) 57.

Donald JUDD

In the Galleries: Anne Truitt

[1963]

There are a number of boxes and columns, both simple and combined, in this exhibition, and a large slab. The colours are dark reds, browns and greys, very much like Ad Reinhardt's colour. The work looks serious without being so. The partitioning of the colours on the boxes is merely that, and the arrangement of the boxes is as thoughtless as the tombstones which they resemble.

Donald Judd, 'In the Galleries: Anne Truitt', *Arts Magazine*, 37: 8 (April 1963) 61.

Barbara ROSE

New York Letter: Robert Morris [1963]

With his first one-man show at the Green Gallery, Robert Morris is already an important artist. His workmanship is as sophisticated as Latham's or Westermann's but the ideas that animate the work are yet more sophisticated and, I think, of a higher order. Like Westermann's wood sculptures, Morris' constructions, particularly the larger ones like *Platform*, *North South Track* and *Wheel*, transcend the object category to become satisfying sculpture.

Most of the things are painted a colour I am tempted, for want of a more precise adjective, to call Jasper Johns' grey. This immediately causes us to look for links to Johns' work that are in part real and in part coincidence caused by Morris' using Sculp-metal, a clay-like substance Johns has used, that dries to a dull grey finish. But there are also other analogies as well, such as the stencilled lettering, the use of rulers, etc. that cause us finally to say that Morris depends on Johns to about the degree that Johns depends on Duchamp, which is not to impute the originality of either. In any case, Morris seems an artist of such a singular mind that one scarcely fears his becoming an epigone. Like Johns' casts of light bulbs and flash lights and Duchamp's casts of the male and female fig-leaves (from which such a piece as *Golden Arrows* obviously derives) Morris' fetishes, and to an extent they are that, too, depend for part of their aesthetic effect on our apprehension or intuition of some force behind them – some magnetism, mana or charisma that inhabits them to give them their mysterious 'presence'. Thus, an untitled piece with five compartments from which issue the ends of a tangled skein of rope hanging below is more than what a literal description implies.

Morris has been called a Pop artist, but I should like to know what is 'pop' about his works. The ideas they explore visually, and the existential problems with which they are concerned are of a more generalized and universal nature than any considered by the affluent sociology that constitutes the iconography of Pop art. Neither are the cold, neutral grey colouring and the hard, resistant qualities of metal and glass very like the engaging warmth of Pop art, nor do they generate any of its optimistic bravado. On the contrary, Morris' art is speculative, meditative and run through with the ironic pessimism of any existential consideration of the human condition. Primarily it appears concerned with relationships of facade or exterior, which is impersonal, to interior, which is often unknowable or useless if known. Most specifically, it considers *process* a more definitive expression of the nature of a thing than means or ends. To illustrate, I wish to describe one complicated piece in some detail: *Hook* is composed of a shallow, horizontal glass case with a shelf in it. On top of the case is a grey box with two compartments. The left-hand compartment is open, permitting one to read the word 'removed' in raised lettering on the bottom. The right-hand compartment is covered and locked. Inside it is a hook. This hook has been dragged through a long bar of grey Sculp-metal (lying on the shelf in the case below) in order to make a rough, vicious-looking furrow, and it has also been dropped into five plaster squares, later cast in lead, arranged on the bottom of the case. The casts have a shiny, polished surface that contrasts with both the dull granular quality of the dried Sculp-metal and the thumb-printed irregularities of the dull, dark grey box. Here we have most of what Morris is involved in: the relationship of what is inside (the hook, which, because we never see it, we accept on faith as actually being in the locked box), to what is outside (the things in the case) and the reference to the event or action in which the hook was involved. As the box containing the tape with the sound of its own making causes us to witness repeatedly the process of how it came into existence, the mysterious hook was also the agent in the process of the making of the piece. We retrace the artist's actions: the hook is removed from the box, it makes a furrow, then five different impressions of itself, then it is locked into place. But suppose the artist is lying, and the box is, after all, empty? By posing the question of the lady and the tiger, Morris somehow reinforces both our fascination and the magic 'presence' of the hook.

Forced participation on the part of the spectator is what Morris demands: either we must assist the actual making, or we must open doors to learn their secrets if we are at all curious. But Morris asks no riddles, he gives answers: the box answers the question of how it was made, the electroencephalogram records the thought processes of the artist, the 'I' box shows you how the artist looks without his clothes on. So, seemingly, the purpose of these objects is to reveal, to lay bare with candour the total physical and mental make-up of the artist. Yet, what do we learn, really? Absolutely nothing. The artist, behind the pink door of the 'I' box, is happy to expose himself, but his smile is impersonal, and finally, he gives away nothing. The grey colour, too, is impersonal and serves to equalize and neutralize everything to the same level of importance or unimportance. This complete impersonality, a kind of making of equations or equalizing of all that is physical or mental, pretends to give the secret of being and finally yields nothingness. What I like especially about Morris,

aside from the internal consistency of his programme, is his sense of where to stop and his appreciation of visual as well as intellectual subtleties. The middle class may not be shocked, but I am impressed.

Barbara Rose, 'New York Letter: Robert Morris', *Art International*, 7: 9 (5 December 1963) 63-64.

Michael <u>FRIED</u>
New York Letter: Donald Judd [1964]

At the Green Gallery, Donald Judd is showing a number of constructions made, for the most part, out of wood and metal. In all the pieces the wood is painted a bright, mat red and the metal is either left alone or painted blue (though it is possible the blue parts are plastic). As one might expect on the strength of Judd's monthly criticism published in *Arts Magazine*, it is an assured, intelligent show; it also provides a kind of commentary on the criticism and is doubly interesting on that count. In general, I think one can say that Judd, in his art writing, has expressed strong suspicions that easel painting is more or less defunct and has championed artists whose paintings are on the verge of becoming objects, such as Frank Stella and Al Jensen. But what has not clearly emerged in the criticism – at least to my reading of it – is how exactly Judd means to discriminate between the objects he admires and those he does not. Most of my confusion on this point has survived my visit to the present show. On the one hand there are several qualities it is clear enough Judd likes: overall rectilinearity, regularity of structural pulse, play between positive and negative spaces and structural mirroring of all kinds. But on the other it is not at all clear *why* Judd values these qualities: that is, I find myself unable to discover a convincing internal rationale for the particular decisions of style and structure Judd has made. Such judgements as I might make about individual pieces are therefore halting; but it seems to me that, on the whole, the free-standing ones are stronger than the wall-pieces, in which I sense that an uneasy compromise has been made with certain norms of painting. For example, I experience their rectilinearity not as a particular decision on Judd's part but rather as a retention of the most conventional shape of picture-support. Finally, it is worth mentioning that this is Judd's first one-man show as well as one of the best on view in New York this month.

Michael Fried, 'New York Letter: Donald Judd', *Art International*, 8: 1 (15 February 1964) 26.

Sidney <u>TILLIM</u>
The New Avant-Garde: Donald Judd and Frank Stella [1964]

The avant-garde in America has never really got off the ground – at least not for long. The Armory Show, designed to publicize it in 1913, instead set it back twenty-five years because it showed how far ahead of Americans the Europeans were. The Depression delayed its public debut further by creating a climate more favourable to Social Realism, and though finally 'arriving' after the Second World War, its principal force was spent by the mid 1950s, since which time it has been gliding on sheer momentum, arousing only artistically backward areas at home and abroad. Now all the signs point to still another effort to revive it: we have hard-edge painting, assemblage, Pop art, Happenings, etc. The ironic and important thing is that, cultivating the Modern artist's talent for bickering and dispute, the new avant-garde derives its momentum from a strong reaction to the old one, and not to some alien style […]

Judd's first one-man exhibition, at the Green Gallery (17 December–11 January), does not show a premeditated leap into the new wave. His wall reliefs, one of which is huge, are obviously related to late abstract painting with their banded patterns, the significant difference being that the outside bands are made of sheet metal and, in the middle, spaced strips of moulding, in addition to which the top and bottom edges are scooped, creating a moderate concavity. ('Painting is the art of hollowing a surface', said Seurat.) The central band of two of these reliefs is painted red, but the raised wood makes it seem less like paint, while in a third relief the upper and lower layers are painted black and the midsection is metal, evenly perforated and unpainted. The underlying passivity of such construction is relieved by the materials, but they are not enough. Judd seems to have recognized their fundamentally retrograde character, though the conceptual link between the reliefs and the constructions is not clear.

The constructions are mostly wood, painted red, with slight additions of coloured plastic (purple) and, in two instances, lengths of pipes. They have vague Cubist overtones and resemble storage units of an unidentifiable kind, steps and things the reader may guess from reproductions. There is one that for identification purposes is referred to as the 'record cabinet'. It is a big crate with a groove in which can be seen unevenly spaced shelving. Another unit has a slanted roof that holds an upright purple slotted plane of, possibly, masonite. In still another a pipe is half-embedded in a groove. The cutting, grooving and notching are further addenda to a style whose physical deportment is otherwise immaculate. The contrast of the orifice to a plane is a basic one and suggests that the work is a bit oversimplified and somewhat tense because of it. But it is necessary in order to avoid a completely monolithic passivity – which it only delays until the paradoxical vigour of the objects wears off.

Stella's show at the Leo Castelli Gallery (4–30 January), which I take to be about his third, resembles a hall of mathematically heraldic symbols. For this group, Stella has chosen common geometric forms – the triangle, the square, the hexagon, the trapezoid, etc. – and all are hollow in the centre and stretched over wide strips. As has been his general custom, though there was a period when

he used pure colour in concentric bands that followed the shape of regulation canvases, Stella has covered the shaped surfaces with concentric bands of a metallic lavender, leaving a thin pin-stripe of unpainted canvas to show through. There is little to add in the way of further description unless it is Judd's own description – very interesting – of the work. He wrote, again in *Arts Magazine*, 'It is something of an object, not a field with something in it, and it has almost no space'.

By the standards implied in that favourable description, Judd's work fails and Stella's succeeds. One reason is that Stella's objects remain entirely artificial. They hug the wall as if it were a security blanket. The frame has disappeared into the image and is an aspect of it. Judd's work has no comparable link to the past. Stella's pictorial parts, though minimal, are consistent with the overall effect. There is something right about the anonymous pin-stripes. They increase an awareness of contour by aping it and set up a rippling vibration that draws the plane out of its passive state. The work is quietly aggressive, if monotonously so when seen in numbers. Stella also manages to keep paint in its place (optical subtlety replacing the function of touch) by using an unconventional medium that, though unpalatable, is luridly decorative. Also, showing no brush strokes, it emphasizes the linear values. Judd seeks a more radical context for the problem of painterliness, but his monochrome exists apart from structure. It is not consanguine with either the wood or metal. It is Louise Nevelson's idea and is incongruously tasteful.

But it strikes me that there is something awry when painters try so hard not to seem like painters. The suspicion that Judd and Stella cannot deal with any painterly effects at all simply won't leave, though I recognize that there is more than one way to skin a cat. So it is with a certain lack of enthusiasm that I cast my ballot for Stella, even though Judd is the more powerful personality. In addition to the reasons I have given, I prefer his quiet dignity, obtained despite an aesthetic in which a 'morality' of progress continues to reduce the human factor.

Sidney Tillim, 'The New Avant-Garde', *Arts Magazine* (February 1964) 18-21.

1964–67 HIGH MINIMALISM Minimal art became

an established art movement in the mid 1960s through group shows such as 'Black, White, and Gray' and 'Primary Structures'. At the same time, solo exhibitions of Anne Truitt, Carl Andre, Dan Flavin, Donald Judd, John McCracken, Larry Bell, Robert Morris and Sol LeWitt, and the painters Brice Marden, David Novros, Jo Baer, Ralph Humphrey, Robert Mangold and Robert Ryman suggested considerable differences in approach. Barbara Rose, who coined the term 'ABC art', saw this new work not as a style of sculpture or painting, but a 'sensibility' made manifest in a variety of media. Donald Judd described an art that is 'neither painting nor sculpture' in his seminal essay 'Specific Objects', while Robert Morris characterized his work as a new kind of sculpture in 'Notes on Sculpture'. In 1967 Michael Fried wrote his famous 'Art and Objecthood' rejecting what he saw as Minimalism's 'theatrical' effect of 'presence'.

Maurice MERLEAU-PONTY
The Theory of the Body is Already a Theory of Perception [1945]

Our own body is in the world as the heart is in the organism: it keeps the visible spectacle constantly alive, it breathes life into it and sustains it inwardly, and with it forms a system. When I walk round my flat, the various aspects in which it presents itself to me could not possibly appear as views of one and the same thing if I did not know that each of them represents the flat seen from one spot or another, and if I were unaware of my own movements and of my body as retaining its identity through the stages of those movements. I can of course take a mental 'bird's eye view' of the flat, visualize it or draw a plan of it on paper, but in that case too I could not grasp the unity of the object without the mediation of bodily experience, for what I call a plan is only a more comprehensive perspective: it is the flat 'seen from above', and the fact that I am able to draw together in it all habitual perspectives is dependent on my knowing that one and the same embodied subject can

view successively *from* various positions. It will perhaps be objected that my restoring the object to bodily experience as one of the poles of that experience will deprive it of precisely that which constitutes its objectivity. From the point of view of my body I never see as equal the six sides of the cube, even if it is made of glass, and yet the word 'cube' has a meaning; the cube itself, the cube in reality, beyond its sensible appearances, has *its* six equal sides. As I move round it, I see the front face, hitherto a square, change its shape, then disappear, while the other sides come into view and one by one become squares. But the successive stages of this experience are for me merely the opportunity of conceiving the whole cube with its six equal and simultaneous faces, the intelligible structure which provides the explanation of it. And it is even necessary, for my tour of inspection of the cube to warrant the judgement 'here is a cube', that my movements themselves be located in objective space and, far from its being the case that the experience of my own movement conditions the position of an object, it is, on the contrary, by conceiving my body itself as a mobile object that I am able to interpret perceptual appearance and construct the cube as it truly is. The experience of my own movement would therefore appear to be no more than a psychological circumstance of perception and to make no contribution to determining the significance of the object. The object and my body would certainly form a system, but we would then have a nexus of objective correlations and not, as we

were saying earlier, a collection of lived-through correspondences. The unity of the object would thus be conceived, not experienced as the correlate of our body's unity.

But can the object be thus detached from the actual conditions under which it is presented to us? One can bring together discursively the notion of the number six, the notion of 'side' and that of equality, and link them together in a formula which is the definition of the cube. But this definition rather puts a question to us than offers us something to conceive. One emerges from blind, symbolic thought only by perceiving the particular spatial entity which bears these predicates all together. It is a question of tracing in thought that particular form which encloses a fragment of space between six equal faces. Now, if the words 'enclose' and 'between' have a meaning for us, it is because they derive it from our experience as embodied subjects. In space *itself* independently of the presence of a psycho-physical subject, there is no direction, no inside and no outside. A space is 'enclosed' between the sides of a cube as we are enclosed between the walls of our room. In order to be able to conceive the cube, we take up a position in space, now on its surface, now in it, now outside it, and from that moment we see it in perspective. The cube with six equal sides is not only invisible, but inconceivable; it is the cube as it would be for itself; but the cube is not for itself, since it is an object. There is a first-order dogmatism, of which analytical

reflection rids us, and which consists in asserting that the object is in itself, or absolutely, without wondering what it is. But there is another, which consists in affirming the ostensible significance of the object, without wondering how it enters into our experience. Analytical reflection puts forward, instead of the absolute existence of the object, the thought of an absolute object, and, through trying to dominate the object and think of it from no point of view, it destroys the object's internal structure. If there is, for me, a cube with six equal sides, and if I can link up with the object, this is not because I constitute it from the inside: it is because I delve into the thickness of the world by perceptual experience. The cube with six equal sides is the limiting idea whereby I express the material presence of the cube which is there before my eyes, under my hands, in its perceptual self-evidence. The sides of the cube are not projections of it, but precisely sides. When I perceive them successively, with the appearance they present in different perspectives, I do not construct the idea of the geometrized projection which accounts for these perspectives: the cube is already there in front of me and reveals itself through them. I do not need to take an objective view of my own movement, or take it into account, in order to reconstitute the true form of the object behind its appearing: the account is already taken, and already the new appearance has compounded itself with the lived-through movement and presented itself as an appearance of a cube. The thing, and the world, are given to me along with the parts of my body, not by any 'natural geometry', but in a living connection comparable, or rather identical, with that existing between the parts of my body itself.

External perception and the perception of one's own body vary in conjunction because they are the two facets of one and the same act. The attempt has long been made to explain Aristotle's celebrated illusion by allowing that the unaccustomed position of the fingers makes the synthesis of the perceptions impossible: the right side of the middle finger and the left side of the index do not ordinarily 'work' together, and if both are touched at once, then there must be two marbles. In reality, the perceptions of the two fingers are not only disjoined, they are inverted: the subject attributes to the index what is touched by the middle finger and *vice versa* […]

There is an immediate equivalence between the orientation of the visual field and the awareness of one's own body as the potentiality of that field, so that any upheaval experimentally brought about can appear indifferently either as the inversion of phenomenal objects or as a redistribution of sensory functions in the body. If a subject focuses for long-distance vision, he has a double image of his own finger as indeed of all objects near to him. If he is touched or pricked, he is aware of being touched or pricked in two places.' Diplopia is thus extended into a bodily duplication. Every external perception is immediately synonymous with a certain perception of my body, just as every perception of my body is made explicit in the language of external perception. If, then, as we have seen to be the case, the body is not a transparent object, and is not presented to us in virtue of the law of its constitution, as the circle is to the geometer, if it is an expressive unity which we can learn to know only by

actively taking it up, this structure will be passed on to the sensible world. The theory of the body schema is, implicitly, a theory of perception. We have relearned to feel our body; we have found underneath the objective and detached knowledge of the body that other knowledge which we have of it in virtue of its always being with us and of the fact that we are our body. In the same way we shall need to reawaken our experience of the world as it appears to us in so far as we are in the world through our body, and in so far as we perceived the world with our body. But by thus remaking contact with the body and with the world, we shall also rediscover ourself, since, perceiving as we do with our body, the body is a natural self and, as it were, the subject of perception.

1 Jean Lhermitte, *L'Image de notre Corps* (Paris: Nouvelle Revue Critique) 39.

Maurice Merleau-Ponty, *Phenomenology of Perception*, trans. Colin Smith (London: Routledge & Kegan Paul, 1962) 203–5; originally published as *Phénoménologie de la perception* (Paris: Gallimard, 1945).

Dan FLAVIN, Donald JUDD, Frank STELLA
New Nihilism or New Art?
Interview with Bruce GLASER [1964]

Bruce Glaser There are characteristics in your work that bring to mind styles from the early part of this century. Is it fair to say that the relative simplicity of Malevich, the Constructivists, Mondrian, the neo-Plasticists and the purists is a precedent for your painting and sculpture, or are you really departing from these earlier movements?

Frank Stella There's always been a trend towards simpler painting and it was bound to happen one way or another. Whenever painting gets complicated, like Abstract Expressionism or Surrealism, there's going to be someone who's not painting complicated paintings, someone who's trying to simplify.

Glaser But all through the twentieth century this simple approach has paralleled more complicated styles.

Stella That's right, but it's not continuous. When I first showed, Coates in the *New Yorker* said how sad it was to find somebody so young right back where Mondrian was thirty years ago. And I really didn't feel that way.

Glaser You feel there's no connection between you and Mondrian?

Stella There are obvious connections. You're always related to something. I'm related to the more geometric, or simpler, painting, but the motivation doesn't have anything to do with that kind of European geometric painting. I think the obvious comparison with my work would be Vasarely, and I can't think of anything I like less.

Glaser Vasarely?

Stella Well, mine has less illusionism than Vasarely's, but the Groupe de Recherche d'Art Visuel actually painted all

the patterns before I did – all the basic designs that are in my painting – not the way I did it, but you can find the schemes of the sketches I made for my own paintings in work by Vasarely and that group in France over the last seven or eight years. I didn't even know about it, and in spite of the fact that they used those ideas, those basic schemes, it still doesn't have anything to do with my painting. I find all that European geometric painting – sort of post-Max Bill school – a kind of curiosity – very dreary.

Donald Judd There's an enormous break between that work and other present work in the US, despite similarity in patterns or anything. The scale itself is just one thing to pin down. Vasarely's work has a smaller scale and a great deal of composition and qualities that European geometric painting of the 1920s and 1930s had. He is part of a continuous development from the 1930s, and he was doing it himself then.

Stella The other thing is that the European geometric painters really strive for what I call relational painting. The basis of their whole idea is balance. You do something in one corner and you balance it with something in the other corner. Now the 'new painting' is being characterized as symmetrical. Ken Noland has put things in the centre and I'll use a symmetrical pattern, but we use symmetry in a different way. It's non-relational. In the newer American painting we strive to get the thing in the middle, and symmetrical, but just to get a kind of force, just to get the thing on the canvas. The balance factor isn't important. We're not trying to jockey everything around.

Glaser What is the 'thing' you're getting on the canvas?

Stella I guess you'd have to describe it as the image, either the image or the scheme. Ken Noland would use concentric circles; he'd want to get them in the middle because it's the easiest way to get them there, and he wants them there in the front, on the surface of the canvas. If you're that much involved with the surface of anything, you're bound to find symmetry the most natural means. As soon as you use any kind of relational placement for symmetry, you get into a terrible kind of fussiness, which is the one thing that most of the painters now want to avoid. When you're always making these delicate balances, it seems to present too many problems; it becomes sort of arch.

Glaser An artist who works in your vein has said he finds symmetry extraordinarily sensuous; on the other hand, I've heard the comment that symmetry is very austere. Are you trying to create a sensuous or an austere effect? Is this relevant to your surfaces?

Judd No, I don't think my work is either one. I'm interested in spareness, but I don't think it has any connection to symmetry.

Stella Actually, your work is really symmetrical. How can you avoid it when you take a box situation? The only piece I can think of that deals with any kind of symmetry is one box with a plane cut out.

Judd But I don't have any ideas as to symmetry. My things are symmetrical because, as you said, I wanted to get rid of any compositional effects, and the obvious way to do it is to be symmetrical.

Glaser Why do you want to avoid compositional effects?

Judd Well, those effects tend to carry with them all the

structures, values, feelings of the whole European tradition. It suits me fine if that's all down the drain. When Vasarely has optical effects within the squares, they're never enough, and he has to have at least three or four squares, slanted, tilted inside each other and all arranged. That is about five times more composition and juggling than he needs.

Glaser It's too busy?

Judd It is in terms of somebody like Larry Poons. Vasarely's composition has the effect of order and quality that traditional European painting had, which I find pretty objectionable ... The objection is not that Vasarely's busy, but that in his multiplicity there's a certain structure that has qualities I don't like.

Glaser What qualities?

Judd The qualities of European art so far. They're innumerable and complex, but the main way of saying it is that they're linked up with a philosophy — rationalism, rationalistic philosophy.

Glaser Descartes?

Judd Yes.

Glaser And you mean to say that your work is apart from rationalism?

Judd Yes. All that art is based on systems built beforehand, *a priori* systems; they express a certain type of thinking and logic that is pretty much discredited now as a way of finding out what the world's like.

Glaser Discredited by whom? By empiricists?

Judd Scientists, both philosophers and scientists.

Glaser What is the alternative to a rationalistic system in your method? It's often said that your work is preconceived, that you plan it out before you do it. Isn't that a rationalistic method?

Judd Not necessarily. That's much smaller. When you think it out as you work on it, or you think it out beforehand, it's a much smaller problem than the nature of the work. *What* you want to express is a much bigger thing than *how* you may go at it. Larry Poons works out the dots somewhat as he goes along; he figures out a scheme beforehand and also makes changes as he goes along. Obviously I can't make many changes, though I do what I can when I get stuck.

Glaser In other words, you might be referring to an antirationalist position before you actually start making the work of art.

Judd I'm making it for a quality that I think is interesting and more or less true. And the quality involved in Vasarely's kind of composition isn't true to me.

Glaser Could you be specific about how your own work reflects an antirationalistic point of view?

Judd The parts are unrelational.

Glaser If there's nothing to relate, then you can't be rational about it because it's just there?

Judd Yes.

Glaser Then it's almost an abdication of logical thinking.

Judd I don't have anything against using some sort of logic. That's simple. But when you start relating parts, in the first place, you're assuming you have a vague whole — the rectangle of the canvas — and definite parts, which is all screwed up, because you should have a definite *whole* and maybe no parts, or very few. The parts are always more important than the whole.

Glaser And you want the whole to be more important than the parts?

Judd Yes. The whole's it. The big problem is to maintain the sense of the whole thing.

Glaser Isn't it that there's gestation, that there's just an idea?

Judd I do think about it, I'll change it if I can. I just want it to exist as a whole thing. And that's not especially unusual. Painting's been going towards that for a long time. A lot of people, like Oldenburg for instance, have a 'whole' effect to their work [...]

Dan Flavin I wanted to say two things. First of all, my work becomes more and more an industrial object the way I accept the fluorescent light for itself. It *is* an industrial object; it's just a reiteration of it or disorientation of it. The other thing I think it's important to talk about — I think Don has a good sense of this — is the painting as object, as a physical object. I think Frank is the farthest away from this ... I've been noticing [this] difference between Frank's attitude and mine. Bob Rosenblum said to me recently that I had destroyed painting for him. Well, I'm just getting a real sense of this. I don't communicate that much with Frank, and I can see I've done it for myself unconsciously. I don't think in the terms in which he's thinking at all, and it's [laugh] a surprise to me that I had considered myself a painter in a sense. But I can see the difference. That's good.

Stella What are some of the differences?

Flavin You know, consciousness of the way paint works, what you don't want to do with it, what you've seen done with it. I don't even think about it in a sense; I don't think about that at all now. I think more of an arrangement of sticks, of colour sticks that are luminous, if that. The thing is more and more an object for me [...]

Stella But we're all still left with structural or compositional elements. The problems aren't any different. I still have to compose a picture, and if you make an object you have to organize the structure. I don't think our work is that radical in any sense because you don't find any really new compositional or structural element. I don't know if that exists. It's like the idea of a colour you haven't seen before. Does something exist that's as radical as a diagonal that's not a diagonal? Or a straight line or a compositional element that you can't describe?

Glaser So even your efforts, Don, to get away from European art and its traditional compositional effects, are somewhat limited because you're still going to be using the same basic elements that they used.

Judd No, I don't think so. I'm totally uninterested in European art and I think it's over with. It's not so much the elements we use that are new as their context. For example, they might have used a diagonal, but no one there ever used as direct a diagonal as Morris Louis did.

Stella Look at all the Kandinskys, even the mechanical ones. They're sort of awful, but they have some pretty radical diagonals and stuff. Of course, they're always balanced.

Judd When you make a diagonal clear across the whole surface, it's a very different thing.

Stella But none the less, the idea of the diagonal has been around for a long time.

Judd That's true; there's always going to be something in one's work that's been around for a long time, but the fact that compositional arrangement isn't important is rather new. Composition is obviously very important to Vasarely, but all I'm interested in is having a work interesting to me as a whole. I don't think there's any way you can juggle a composition that would make it more interesting in terms of the parts [...]

Stella On the one hand I think that the paintings or what we're trying to do is a little bit different. But on the other hand it seems to me they're still dealing basically with the problems that painting or making art always has. They're pretty much the same old problems. I don't see why everyone feels so desperately in need of a new terminology. And I don't see what there is in our work — I hope I can speak for the other two — that really needs a new terminology to explain it or evaluate it. It seems to me it's art or it wants to be art or it asks to be considered as art and the terms that we have for discussing art are good enough. I don't see that it necessarily needs new ones — nothing specifically in our work that asks for new terms.

Flavin One thing I've always felt in my own work is a physical element, a distinct physical element. Don and I mentioned this up to four in the morning, if I remember. I think it concerns him very much, even more than me. We were discussing the weight of Frank's canvases, the cut-out part: this is all to call attention to that quality, I think.

Stella You two make objects. It's that simple — they're either objects, sculpture, something like that. But the reason I made the canvas deeper than ordinarily — I didn't do it for any reason; it began accidentally, if you want to call it that.

I turned one-by-threes on edge to make a quick frame to butt end them when I first started stretching canvases. And then I liked what that did. When you stand directly in front of the painting, it gives just enough depth to sort of hold it off the wall, you're just conscious of a sort of shadow, just enough depth, so actually it *emphasizes* the surface so in other words to make it *more* like a painting and *less* like an object. It simply emphasizes the surface quality.

Glaser That's very curious. I've heard several artists refer to your paintings as sculptural in form because of that thickness. It's very interesting that you say it's an accidental feature.

Judd I always thought of the aluminium ones of Frank's as slabs in a way, they seemed almost objects to me.

Flavin You can think of the difference from Rothko. He hinted that he was going to add a certain weight to the stretcher — I get that feeling, that the painting goes around the corner.

Stella Yes, right, well I think he did paint around the edge [...] Well, I don't. I *don't* paint around the edge. A lot of people — Sven Lukin in the show at Janis, for example — paint around the edge too. In fact, he's much more object than painting than I am.

Judd I think your [Stella's] flat surface made it seem *more* like an object. And that was pretty rare. I think it was a first [...]

Glaser You obviously have an awareness of Constructivist

work, like Gabo and Pevsner. What about the Bauhaus? You keep talking about spareness and austerity. Is that only in relation to the idea that you want your work 'whole', or do you think there was something in Mies' Bauhaus dictum that 'less is more'?

Judd Not necessarily. In the first place, I'm more interested in neo-Plasticism and Constructivism than I was before, perhaps, but I was never influenced by it, and I'm certainly influenced by what happens in the US rather than by anything like that. So my admiration for someone like Pevsner or Gabo is in retrospect. I consider the Bauhaus too long ago to think about, and I never thought about it much.

Glaser What makes the space you use different from neo-plastic sculpture? What are you after in the way of a new space?

Judd In the first place, I don't know a heck of a lot about neo-plastic sculpture, outside of vaguely liking it. I'm using actual space because when I was doing paintings I couldn't see any way out of having a certain amount of illusionism in the paintings. I thought that also was a quality of the Western tradition and I didn't want it.

Glaser When you did the horizontal with the five verticals coming down from it, you said you thought of it as a whole; you weren't being compositional in any way or opposing the elements. But, after all, you are opposing them because vertical and horizontal are opposed by nature; and the perpendicular *is* an opposition. And if you have space in between each one, then it makes them parts.

Judd Yes, it does, somewhat. You see, the big problem is that anything that is not absolutely plain begins to have parts in some way. The thing is to be able to work and do different things and yet not break up the wholeness that a piece has. To me the piece with the brass and the five verticals is above all *that shape*. I don't think of the brass being opposed to the five things, as Gabo or Pevsner might have an angle and then another one supporting it or relating on a diagonal. Also the verticals below the brass both support the brass and suspend from it, and the length is just enough so it seems that they hang, as well as support it, so they're caught there. I didn't think they came loose as independent parts. If they were longer and the brass obviously sat on them, then I wouldn't like it.

Glaser You've written about the predominance of chance in Robert Morris' work. Is this element in your pieces too?

Judd Yes. Pollock and those people represent actual chance; by now it's better to make that a foregone conclusion — you don't have to mimic chance. You use a simple form that doesn't look like either order or disorder. We recognize that the world is 90 per cent chance and accident. Earlier painting was saying that there's more order in the scheme of things than we admit now, like Poussin saying order underlies nature. Poussin's order is anthropomorphic. Now there are no preconceived notions. Take a simple form — say a box — and it does have an order, but it's not so ordered that that's the dominant quality. The more parts a thing has, the more important order becomes, and finally order becomes more important than anything else.

Glaser There are several other characteristics that accompany the prevalence of symmetry and simplicity in the new work. There's a very finished look to it, a complete negation of the painterly approach. Twentieth-century painting has been concerned mainly with emphasizing the artist's presence in the work, often with an unfinished quality by which one can participate in the experience of the artist, the process of painting the picture. You deny all this, too; your work has an industrial look, a non-man-made look.

Stella The artist's tools or the traditional artist's brush and maybe even oil paint are all disappearing very quickly. We use mostly commercial paint, and we generally tend towards larger brushes. In a way, Abstract Expressionism started all this. De Kooning used house painters' brushes and house painters' techniques.

Glaser Pollock used commercial paint.

Stella Yes, the aluminium paint. What happened, at least for me, is that when I first started painting I would see Pollock, de Kooning, and the one thing they all had that I didn't have was an art school background. They were brought up on drawing and they all ended up painting or drawing with the brush. They got away from the smaller brushes and, in an attempt to free themselves, they got involved in commercial paint and house painting brushes. Still it was basically drawing with paint, which has characterized almost all twentieth-century painting. The way my own painting was going, drawing was less and less necessary. It was the one thing I wasn't going to do. I wasn't going to draw with the brush.

Glaser What induced this conclusion that drawing wasn't necessary any more?

Stella Well, you have a brush and you've got paint on the brush, and you ask yourself why you're doing whatever it is you're doing, what inflection you're actually going to make with the brush and with the paint that's on the end of the brush. It's like handwriting. And I found out that I just didn't have anything to say in those terms. I didn't want to make variations; I didn't want to record a path. I wanted to get the paint out of the can and on to the canvas. I knew a wise guy who used to make fun of my painting, but he didn't like the Abstract Expressionists either. He said they would be good painters if they could only keep the paint as good as it is in the can. And that's what I tried to do. I tried to keep the paint as good as it was in the can.

Glaser Are you implying that you are trying to destroy painting?

Stella It's just that you can't go back. It's not a question of destroying anything. If something's used up, something's done, something's over with, what's the point of getting involved with it?

Judd Root, hog or die.

Glaser Are you suggesting that there are no more solutions to, or no more problems that exist in painting?

Stella Well, it seems to me we have problems. When Morris Louis showed in 1958, everybody dismissed his work as thin, merely decorative. They still do. Louis is the really interesting case. In every sense his instincts were Abstract Expressionist, and he was terribly involved with all of that, but he felt he had to move, too. I always get into arguments with people who want to retain the old values in painting — the humanistic values that they always find on the canvas. If you pin them down, they always end up asserting that there is something there besides the paint on the canvas. My painting is based on the fact that only what can be seen there *is* there. It really is an object. Any painting is an object and anyone who gets involved enough in this finally has to face up to the objectness of whatever it is that he's doing. He is making a thing. All that should be taken for granted. If the painting were lean enough, accurate enough or right enough, you would just be able to look at it. All I want anyone to get out of my paintings, and all I ever get out of them, is the fact that you can see the whole idea without any confusion ... What you see is what you see.

Glaser That doesn't leave too much afterwards, does it?

Stella I don't know what else there is. It's really something if you can get a visual sensation that is pleasurable, or worth looking at, or enjoyable, if you can just make something worth looking at.

Glaser But some would claim that the visual effect is minimal, that you're just giving us one colour or a symmetrical grouping of lines. A nineteenth-century landscape painting would presumably offer more pleasure, simply because it's more complicated.

Judd I don't think it's more complicated.

Stella No, because what you're saying essentially is that a nineteenth-century landscape is more complicated because there are two things working — deep space and the way it's painted. You can see how it's done and read the figures in the space. Then take Ken Noland's painting, for example, which is just a few stains on the ground. If you want to look at the depths, there are just as many problematic spaces. And some of them are extremely complicated technically; you can worry and wonder how he painted the way he did.

Judd Old Master painting has a great reputation for being profound, universal and all that, and it isn't necessarily.

Stella But I don't know how to get around the part that they just wanted to make something pleasurable to look at, because even if that's what I want, I also want my painting to be so you can't *avoid* the fact that it's supposed to be entirely visual.

Glaser You've been quoted, Frank, as saying that you want to get sentimentality out of painting.

Stella I hope I didn't say that. I think what I said is that sentiment wasn't necessary. I didn't think then, and I don't now, that it's necessary to make paintings that will interest people in the sense that they can keep going back to explore painterly detail. One could stand in front of any Abstract Expressionist work for a long time, and walk back and forth, and inspect the depths of the pigment and the inflection and all the painterly brushwork for hours. But I wouldn't particularly want to do that and also I wouldn't ask anyone to do that in front of my paintings. To go further, I would like to prohibit them from doing that in front of my paintings. That's why I make the paintings the way they are, more or less.

Glaser Why would you like to prohibit someone from doing such a thing?

Stella I feel that you should know after a while that you're just sort of mutilating the paint. If you have some feeling about either colour or direction of line or something, I think you can state it. You don't have to knead the material

and grind it up. That seems destructive to me; it makes me very nervous. I want to find an attitude basically constructive rather than destructive.

Glaser You seem to be after an economy of means, rather than trying to avoid sentimentality. Is that nearer it?

Stella Yes, but there's something awful about that 'economy of means'. I don't know why, but I resent that immediately. I don't go out of my way to be economical. It's hard to explain what exactly it is I'm motivated by, but I don't think people are motivated by reduction. It would be nice if we were, but actually, I'm motivated by the desire to make something, and I go about it in the way that seems best.

Judd You're getting rid of the things that people used to think were essential to art. But that reduction is only incidental. I object to the whole reduction idea, because it's only reduction of those things someone doesn't want. If my work is reductionist it's because it doesn't have the elements that people thought should be there. But it has other elements that I like. Take Noland again. You can think of the things he doesn't have in his paintings, but there's a whole list of things that he *does* have that painting didn't have before. Why is it necessarily a reduction?

Stella You want to get rid of things that get you into trouble. As you keep painting you find things are getting in your way a lot and those are the things that you try to get out of the way. You might be spilling a lot of blue paint and because there's something wrong with that particular paint, you don't use it any more, or you find a better thinner or better nails. There's a lot of striving for better materials, I'm afraid. I don't know how good that is.

Judd There's nothing sacrosanct about materials.

Stella I lose sight of the fact that my paintings are on canvas, even though I know I'm painting on canvas, and I just see my paintings. I don't get terribly hung up over the canvas itself. If the visual act taking place on the canvas is strong enough, I don't get a very strong sense of the material quality of the canvas. It sort of disappears. I don't like things that stress the material qualities. I get so I don't even like Ken Noland's paintings (even though I like them a lot). Sometimes all that bare canvas gets me down, just because there's so much of it; the physical quality of the cotton duck gets in the way.

Glaser Another problem. If you make so many canvases alike, how much can the eye be stimulated by so much repetition?

Stella That really is a relative problem because obviously it strikes different people different ways. I find, say, Milton Resnick as repetitive as I am, if not more so. The change in any given artist's work from picture to picture isn't that great. Take a Pollock show. You may have a span of ten years, but you could break it down to three or four things he's done. In any given period of an artist, when he's working on a particular interest or problem, the paintings tend to be a lot alike. It's hard to find anyone who isn't like that. It seems to be the natural situation. And everyone finds some things more boring to look at than others.

Glaser Don, would it be fair to say that your approach is a nihilistic one, in view of your wish to get rid of various elements?

Judd No, I don't consider it nihilistic or negative or cool or anything else. Also I don't think my objection to the Western tradition is a positive quality of my work. It's just something I don't want to do, that's all. I want to do something else.

Glaser Some years ago we talked about what art will be, an art of the future. Do you have a vision of that?

Judd No, I was just talking about what my art will be and what I imagine a few other people's art that I like might be.

Glaser Don't you see art as kind of evolutionary? You talk about what art was and then you say it's old hat, it's all over now.

Judd It's old hat because it involves all those beliefs you really can't accept in life. You don't want to work with it any more. It's not that any of that work has suddenly become mad in itself. If I get hold of a Piero della Francesca, that's fine.

I wanted to say something about this painterly thing. It certainly involves a relationship between what's outside – nature or a figure or something – and the artist's actually painting that thing, his particular feeling at the time. This is just one area of feeling and I, for one, am not interested in it for my own work. I can't do anything with it. It's been fully exploited and I don't see why the painterly relationship exclusively should stand for art.

Glaser Are you suggesting an art without feeling?

Judd No, you're reading me wrong. Because I say that is just one kind of feeling – painterly feeling.

Stella Let's take painterly simply to mean Abstract Expressionism, to make it easier. Those painters were obviously involved in what they were doing as they were doing it, and now in what Don does, and I guess in what I do, a lot of the effort is directed towards the end. We believe that we can find the end, and that a painting can be finished. The Abstract Expressionists always felt the painting's being finished was very problematical. We'd more readily say that our paintings were finished and say, well, it's either a failure or it's not, instead of saying, well, maybe it's not really finished.

Glaser You're saying that the painting is almost completely conceptualized before it's made, that you can devise a diagram in your mind and put it on canvas. Maybe it would be adequate to simply verbalize this image and give it to the public rather than giving them your painting?

Stella A diagram is not a painting; it's as simple as that. I can make a painting from a diagram, but can you? Can the public? It can just remain a diagram if that's all I do, or if it's a verbalization it can just remain a verbalization. Clement Greenberg talked about the ideas or possibilities of painting in, I think, the 'After Abstract Expressionism' article,[2] and he allows a blank canvas to be an idea for a painting. It might not be a *good* idea, but it's certainly valid. Yves Klein did the empty gallery. He sold air, and that was a conceptualized art, I guess.[3]

Glaser Reductio ad absurdum.

Stella Not absurd enough, though.

Judd Even if you can plan the thing completely ahead of time, you still don't know what it looks like until it's right there. You may turn out to be totally wrong once you have gone to all the trouble of building this thing.

Stella Yes, and also that's what you want to do. You actually want to see the thing. That's what motivates you to do it in the first place, to see what it's going to look like.

Judd You can think about it forever in all sorts of versions, but it's nothing until it is made visible […]

Glaser Do you think the frequent use of the word 'presence' in critical writing about your kind of work has something to do with the nature of the objects you make, as if to suggest there is something more enigmatic about them than previous works of art?

Stella You can't say that your work has more of this or that than somebody else's. It's a matter of terminology. De Kooning or Al Held paint 'tough' paintings and we would have to paint with 'presence', I guess. It's just another way of describing.

Glaser Nobody's really attempted to develop some new terminology to deal with the problems of these paintings […] Meyer Schapiro once suggested that there might be an analogy between, say, a Barnett Newman with a field of one colour and one simple stripe down the middle and a mosaic field of some Byzantine church, where there was a completely gold field and then a simple vertical form of the Madonna.

Judd A lot of things look alike, but they're not necessarily very much alike.

Stella Like the whole idea of the field. What you mean by a field in a painting is a pretty difficult idea. A mosaic field can never have anything to do with a Morris Louis field.

Judd You don't feel the same about a Newman and a gold field because Newman's doing something with his field.

Stella Newman's is in the canvas and it really does work differently. With so-called advanced painting, for example, you should drop composition. That would be terrifically avant-garde; that would be a really good idea. But the question is, how do you do it? The best article I ever read about pure painting and all that was Elaine de Kooning's 'Pure Paints a Picture'.[4] Pure was very pure and he lived in a bare, square white loft. He was very meticulous and he gave up painting with brushes and all that and he had a syringe loaded with a colourless fluid, which he injected into his colourless, odourless foam rubber. That was how he created his art objects – by injecting colourless fluid into a colourless material.

Judd Radical artist.

Stella Well, Yves Klein was no doubt a radical artist, or he didn't do anything very interesting.

Judd I think Yves Klein to some extent was outside of European painting, but why is he still not actually radical?

Stella I don't know. I have one of his paintings, which I like in a way, but there's something about him … I mean what's not radical about the idea of selling air? Still, it doesn't seem very interesting.

Judd Not to me either. One thing I want is to be able to see what I've done, as you said. Art is something you look at.

Glaser You have made the point that you definitely want to induce some effective enjoyment in your work, Frank. But the fact is that right now the majority of people confronted by it seem to have trouble in this regard. They don't get this enjoyment that you seem to be very simply presenting to them. That is, they are still stunned and taken aback by its simplicity. Is this because they are not ready for these works, because they simply haven't caught up to the artist, again?

1. Yves Klein

Stella Maybe that's the quality of simplicity. When Mantle hits the ball out of the park, everybody is sort of stunned for a minute because it's so simple. He knocks it right out of the park, and that usually does it [...]

1 Tom Hess, review of Morris Louis, *ARTnews* (1958).

2 Clement Greenberg, 'After Abstract Expressionism', *Art International*, 7: 8 (1962).

3 Yves Klein's exhibition at the Iris Clert Gallery, Paris, April 1958, consisted of an empty, white-walled room.

4 Elaine de Kooning, 'Pure Paints a Picture', *ARTnews*, 56: 4 (Summer 1957) 57; 86-87.

Bruce Glaser, 'New Nihilism or New Art? Interview with Stella, Judd and Flavin', originally broadcast on WBAI-FM, New York, February 1964. Revised and published as 'Questions to Stella and Judd', *ARTnews*, ed. Lucy R. Lippard (September 1966); reprinted in *Minimal Art: A Critical Anthology*, ed. Gregory Battcock (New York: E.P. Dutton & Co., 1968) 148-64. Additional remarks transcribed from the WBAI recording, Pacifica Radio Archive No. BB3394.

Susan SONTAG
Against Interpretation [1964]

The earliest *experience* of art must have been that it was incantatory, magical; art was an instrument of ritual (the paintings in the caves at Lascaux, Altamira, Niaux, La Pasiega, etc.). The earliest *theory* of art, that of the Greek philosophers, proposed that art was mimesis, imitation of reality.

It is at this point that the peculiar question of the *value* of art arose. For the mimetic theory, by its very term, challenges art to justify itself.

Plato, who proposed the theory, seems to have done so in order to rule that the value of art is dubious. Since he considered ordinary material things as themselves mimetic objects, imitations of transcendent forms or structures, even the best painting of a bed would be only an 'imitation of an imitation'. For Plato, art is neither particularly useful (the painting of a bed is no good to sleep on), nor, in the strict sense, true. And Aristotle's arguments in defense of art do not really challenge Plato's view that all art is an elaborate *trompe l'oeil*, and therefore a lie. But he does dispute Plato's idea that art is useless. Lie or no, art has a certain value according to Aristotle because it is a form of therapy. Art is useful, after all, Aristotle counters, medicinally useful in that it arouses and purges dangerous emotions.

In Plato and Aristotle, the mimetic theory of art goes hand in hand with the assumption that art is always figurative. But advocates of the mimetic theory need not close their eyes to decorative and abstract art. The fallacy that art is necessarily a 'realism' can be modified or scrapped without ever moving outside the problems delimited by the mimetic theory.

The fact is, all Western consciousness of and reflection upon art have remained within the confines staked out by the Greek theory of art as mimesis or representation. It is through this theory that art as such – above and beyond given works of art – becomes problematic, in need of defence. And it is the defence of art which gives birth to the odd vision by which something we have learned to call 'form' is separated off from something we have learned to call 'content', and to the well-intentioned move which makes content essential and form accessory.

Even in modern times, when most artists and critics have discarded the theory of art as representation of an outer reality in favour of the theory of art as subjective expression, the main feature of the mimetic theory persists. Whether we conceive of the work of art on the model of a picture (art as a picture of reality) or on the model of a statement (art as the statement of the artist), content still comes first. The content may have changed. It may now be less figurative, less lucidly realistic. But it is still assumed that a work of art *is* its content. Or, as it's usually put today, that a work of art by definition *says* something. ('What X is saying is ... ', 'What X is trying to say is ... ', 'What X said is ... ', etc., etc.)

None of us can ever retrieve that innocence before all theory when art knew no need to justify itself, when one did not ask of a work of art what it *said* because one knew (or thought one knew) what it *did*. From now to the end of consciousness, we are stuck with the task of defending art. We can only quarrel with one or another means of defence. Indeed, we have an obligation to overthrow any means of defending and justifying art which becomes particularly obtuse or onerous or insensitive to contemporary needs and practice.

This is the case, today, with the very idea of content itself. Whatever it may have been in the past, the idea of content is today mainly a hindrance, a nuisance, a subtle or not so subtle philistinism.

Though the actual developments in many arts may seem to be leading us away from the idea that a work of art is primarily its content, the idea still exerts an extraordinary hegemony. I want to suggest that this is because the idea is now perpetuated in the guise of a certain way of encountering works of art thoroughly ingrained among most people who take any of the arts seriously. What the overemphasis on the idea of content entails is the perennial, never consummated project of *interpretation*. And, conversely, it is the habit of approaching works of art in order to *interpret* them that sustains the fancy that there really is such a thing as the content of a work of art [...]

Today is such a time, when the project of interpretation is largely reactionary, stifling. Like the fumes of the automobile and of heavy industry which befoul the urban atmosphere, the effusion of interpretations of art today poisons our sensibilities. In a culture whose already classical dilemma is the hypertrophy of the intellect at the expense of energy and sensual capability, interpretation is the revenge of the intellect upon art.

Even more. It is the revenge of the intellect upon the world. To interpret is to impoverish, to deplete the world – in order to set up a shadow world of 'meanings'. It is to turn *the* world into *this* world. ('This world'! As if there were any other.)

The world, our world, is depleted, impoverished enough. Away with all duplicates of it, until we again experience more immediately what we have [...]

It doesn't matter whether artists intend, or don't intend, for their works to be interpreted. Perhaps Tennessee Williams thinks *Streetcar* is about what Kazan thinks it to be about. It may be that Cocteau in *The Blood of a Poet* and in *Orpheus* wanted the elaborate readings which have been given these films, in terms of Freudian symbolism and social critique. But the merit of these works certainly lies elsewhere than in their 'meanings'. Indeed, it is precisely to the extent that Williams' plays and Cocteau's films do suggest these portentous meanings that they are defective, false, contrived, lacking in conviction.

From interviews, it appears that Resnais and Robbe-Grillet consciously designed *Last Year at Marienbad* to accommodate a multiplicity of equally plausible interpretations. But the temptation to interpret *Marienbad* should be resisted. What matters in *Marienbad* is the pure, untranslatable, sensuous immediacy of some of its images, and its rigorous if narrow solutions to certain problems of cinematic form.

Again, Ingmar Bergman may have meant the tank rumbling down the empty night street in *The Silence* as a phallic symbol. But if he did, it was a foolish thought. ('Never trust the teller, trust the tale', said Lawrence.) Taken as a brute object, as an immediate sensory equivalent for the mysterious abrupt armoured happenings going on inside the hotel, that sequence with the tank is the most striking moment in the film. Those who reach for a Freudian interpretation of the tank are only expressing their lack of response to what is there on the screen.

It is always the case that interpretation of this type indicates a dissatisfaction (conscious or unconscious) with the work, a wish to replace it by something else.

Interpretation, based on the highly dubious theory that a work of art is composed of items of content, violates art. It makes art into an article for use, for arrangement into a mental scheme of categories.

Interpretation does not, of course, always prevail. In fact, a great deal of today's art may be understood as motivated by a flight from interpretation. To avoid interpretation, art may become parody. Or it may become abstract. Or it may become ('merely') decorative. Or it may become non-art.

The flight from interpretation seems particularly a feature of modern painting. Abstract painting is the attempt to have, in the ordinary sense, no content; since there is no content, there can be no interpretation. Pop art works by the opposite means to the same result; using a content so blatant, so 'what it is', it, too, ends by being uninterpretable.

A great deal of modern poetry as well, starting from the great experiments of French poetry (including the movement that is misleadingly called Symbolism) to put silence into poems and to reinstate the *magic* of the word, has escaped from the rough grip of interpretation. The most recent revolution in contemporary taste in poetry – the revolution that has deposed Eliot and elevated Pound – represents a turning away from content in poetry in the old sense, an impatience with what made modern poetry

prey to the zeal of interpreters [...]

It is possible to elude the interpreters in another way, by making works of art whose surface is so unified and clean, whose momentum is so rapid, whose address is so direct that the work can be ... just what it is. Is this possible now? It does happen in films, I believe. This is why cinema is the most alive, the most exciting, the most important of all art forms right now. Perhaps the way one tells how alive a particular art form is, is by the latitude it gives for making mistakes in it, and still being good. For example, a few of the films of Bergman – though crammed with lame messages about the modern spirit, thereby inviting interpretations – still triumph over the pretentious intentions of their director. In *Winter Light* and *The Silence*, the beauty and visual sophistication of the images subvert before our eyes the callow pseudo-intellectuality of the story and some of the dialogue. (The most remarkable instance of this sort of discrepancy is the work of D.W. Griffith.) In good films, there is always a directness that entirely frees us from the itch to interpret. Many old Hollywood films, like those of Cukor, Walsh, Hawks and countless other directors have this liberating anti-symbolic quality, no less than the best work of the new European directors, like Truffaut's *Shoot the Piano Player* and *Jules and Jim*, Godard's *Breathless* and *Vivre Sa Vie*, Antonioni's *L'Avventura* and Olmi's *The Fiancés*.

The fact that films have not been overrun by interpreters is in part due simply to the newness of cinema as an art. It also owes to the happy accident that films for such a long time were just movies; in other words, that they were understood to be part of mass, as opposed to high, culture and were left alone by most people with minds. Then, too, there is always something other than content in the cinema to grab hold of, for those who want to analyse. For the cinema, unlike the novel, possesses a vocabulary of forms – the explicit, complex and discussable technology of camera movements, cutting and composition of the frame that goes into the making of a film.

What kind of criticism, of commentary on the arts, is desirable today? For I am not saying that works of art are ineffable, that they cannot be described or paraphrased. They can be. The question is how. What would criticism look like that would serve the work of art, not usurp its place?

What is needed, first, is more attention to form in art. If excessive stress on *content* provokes the arrogance of interpretation, more extended and more thorough descriptions of *form* would silence. What is needed is a vocabulary – a descriptive, rather than prescriptive, vocabulary – for forms.[1] The best criticism, and it is uncommon, is of this sort that dissolves considerations of content into those of form. On film, drama and painting respectively, I can think of Erwin Panofsky's essay 'Style and Medium in the Motion Pictures', Northrop Frye's essay 'A Conspectus of Dramatic Genres', Pierre Francastel's essay 'The Destruction of a Plastic Space'. Roland Barthes' book *On Racine* and his two essays on Robbe-Grillet are examples of formal analysis applied to the work of a single author. (The best essays in Erich Auerbach's *Mimesis*, like 'The Scar of Odysseus', are also

of this type.) An example of formal analysis applied simultaneously to genre and author is Walter Benjamin's essay, 'The Story Teller: Reflections on the Works of Nicolai Leskov'.

Equally valuable would be acts of criticism which would supply a really accurate, sharp, loving description of the appearance of a work of art. This seems even harder to do than formal analysis. Some of Manny Farber's film criticism, Dorothy Van Ghent's essay 'The Dickens World: A View from Todgers', Randall Jarrell's essay on Walt Whitman are among the rare examples of what I mean. These are essays which reveal the sensuous surface of art without mucking about in it.

Transparence is the highest, most liberating value in art – and in criticism – today. Transparence means experiencing the luminousness of the thing in itself, of things being what they are. This is the greatness of, for example, the films of Bresson and Ozu and Renoir's *The Rules of the Game*.

Once upon a time (say, for Dante), it must have been a revolutionary and creative move to design works of art so that they might be experienced on several levels. Now it is not. It reinforces the principle of redundancy that is the principal affliction of modern life.

Once upon a time (a time when high art was scarce), it must have been a revolutionary and creative move to interpret works of art. Now it is not. What we decidedly do not need now is further to assimilate Art into Thought, or (worse yet) Art into Culture.

Interpretation takes the sensory experience of the work of art for granted, and proceeds from there. This cannot be taken for granted now. Think of the sheer multiplication of works of art available to every one of us, superadded to the conflicting tastes and odours and sights of the urban environment that bombard our senses. Ours is a culture based on excess, on overproduction; the result is a steady loss of sharpness in our sensory experience. All the conditions of modern life – its material plenitude, its sheer crowdedness – conjoin to dull our sensory faculties. And it is in the light of the condition of our senses, our capacities (rather than those of another age), that the task of the critic must be assessed.

What is important now is to recover our senses. We must learn to *see* more, to *hear* more, to *feel* more.

Our task is not to find the maximum amount of content in a work of art, much less to squeeze more content out of the work than is already there. Our task is to cut back content so that we can see the thing at all.

The aim of all commentary on art now should be to make works of art – and, by analogy, our own experience – more, rather than less, real to us. The function of criticism should be to show *how it is what it is*, even *that it is what it is*, rather than to show *what it means*.

In place of hermeneutics we need an erotics of art.

1 One of the difficulties is that our idea of form is spatial (the Greek metaphors for form are all derived from notions of space). This is why we have a more ready vocabulary of forms for the spatial than for the temporal arts. The exception among the temporal arts, of course, is the drama; perhaps this is because the drama is a narrative (i.e. temporal) form that extends itself

visually and pictorially upon a stage … What we don't have yet is a poetics of the novel, any clear notion of the forms of narration. Perhaps film criticism will be the occasion of a breakthrough here, since films are primarily a visual form, yet they are also a sub-division of literature.

Susan Sontag, 'Against Interpretation', 1964, in *Against interpretation and other essays* (New York: Farrar, Straus, Giroux, 1966).

Samuel J. WAGSTAFF, Jr
Paintings to Think About
[1964]

For a number of contemporary American artists, whose works tend away from Expressionism in a more austere direction, the composer John Cage has been an intellectual guide. Whether his influence has been direct, as in the case of Johns, Rauschenberg, Warhol, etc., or whether it was just a parallel affinity, Cage seems to be a spiritual leader with an aggressive following. In alphabetical order, Marcel Duchamp, Barnett Newman and Ad Reinhardt are equally influential with many of these younger moderns. Cage's remarks about music, 'there is too much there there', and 'there is not enough of nothing in it', might represent a binding philosophy of many painters and sculptors for the visual arts as well.

Much of this art seems strongly anti-tradition, even recent tradition. Much of it seems sparse, pared down to a minimum; much of it is conceptual, idea art as opposed to the retinal or visceral. In this respect one thinks of Cage's 'music to be seen'. In front of some of this art, 'one is left thinking rather than seeing and the only choice is to believe', or as Rauschenberg has said of one of his early all-white paintings, 'If you don't take it seriously, there is nothing to take'. Painting and sculpture of this nature often seems to be an idea made manifest. Almost all of this work is planned first and then filled in rather than conceived on the canvas (Ad Reinhardt: 'Only a standardized, prescribed form can be image-less ... ') In other words, aesthetic decisions take place outside the picture. There is an attempt to suggest the presence of paint rather than the presence of the painter. The artist seldom seems to meet you even halfway.

The exhibition 'Black, White, and Gray' at the Wadsworth Atheneum, Hartford, tries to show the degree of similarity and difference of twenty or so such painters and sculptors – among others, James Byars, Moskowitz, Lichtenstein, Rauschenberg, Reinhardt, Anne Truitt, Tony Smith, Jasper Johns, Ellsworth Kelly, Cy Twombly, Agnes Martin, Robert Morris, George Brecht, Frank Stella, Gary Indiana, Alexander Liberman, Ray Parker, Jean Follett, Jim Dine and Andy Warhol. These artists seem to fit into this overlapping aesthetic in varying degrees.

Quite arbitrarily, all the works selected are black, white or grey, so chosen in an attempt to keep the viewer from being distracted by the emotionalism of colour. In this way the degree of severity between artists, which varies greatly,

should be easier to see as well as the degree of difference within the work of each artist himself. There are two pictures as well as prints and drawings from most of the painters and three pieces by the majority of the sculptors.

If no single aesthetic blankets all of these artists, a tendency, an affinity does give them a nodding rapport. A large, grey form in white space of a Ray Parker, though simple and somewhat flat, is still lyrical; Abstract Expressionism where the confines of the canvas bound an ideal space. At the opposite end of the group is Frank Stella, whose paintings may be the most 'difficult' in the show. They are objects, walls with opaque, thick surfaces to block the sight, hardly places for private reverie. You cannot get into the canvas, nor can you read anything into it. Stella seems to have backed out leaving no trace of personal handwriting. He believes that too much nineteenth-century Romanticism still prevails and that sloppy looking around in canvases by the sentimental viewer should come to an end. Stella's impersonal, self-conscious institutional look is shared by other painters shown here, notably Roy Lichtenstein, who deals in simulated mechanical processes. This reality of process involves a number of artists today. Lichtenstein's thought-out lines are also a condemnation of the emotional, and his statement, 'I think the meaning of my work is that it's industrial', explains much of the anonymous feeling of this non-illusionistic art.

Among the sculptors, Tony Smith, also an architect, moves in a parallel path with the 1961 work of Robert Morris, where human scale, proportion, symmetry, order, restraint, clarity and the flat surface, neutral black or indifferent grey, produce a similar effect of noble and hierarchic presence. Such instant transformation of an idea or a decision into painted plywood seems to push sculpture a little further than before. One is left uneasy in front of it, as in front of much of this painting, with an embarrassing freedom.

Samuel J. Wagstaff, Jr, 'Paintings to Think About', *ARTnews* (January 1964) 33; 62.

Donald JUDD
Nationwide Reports: Black, White, and Gray [1964]

Black, white and grey, like black and white, is meagre as a theme. Unlike the Jewish Museum's show, which was diverse – and that's all right, of course – the Wadsworth Atheneum's exhibition in Hartford was chosen, though not entirely, to display an attitude common to a number of artists. The attitude is new and has never been the subject of a museum show before. Since the large majority of the artists are involved in this one attitude, it would have been better to exclude the others and to name the show – and this wouldn't have been easy – after its main concern. This isn't too important though. Samuel J. Wagstaff, Jr, curator of paintings, prints and drawings, selected the work. In 1962 he organized 'Continuity and Change', which was an exhibition of the early and recent work of forty-five artists.

He is trying to have a contemporary museum.

The boxes in the 'Black, White, and Gray' exhibition are scattered around *Venus Attended by a Nymph and a Satyr*, by Pietro Francavilla, a large sculpture above a shallow pool centred in the court of the Avery Memorial. The court has two wide, solid balconies. It was designed in 1932 in a German Modern style. The paintings are hung along the walls of the ground floor of the court, and some drawings are in a room to one side.

The boxes on the floor are by Robert Morris, Tony Smith, Anne Truitt and James Byars. Morris' *Portal* and an untitled piece, an open square, both about 30.5 × 30.5 cm [1 × 1 ft] all around, were shown at Gordon's, *Column* and *Slab* were shown at Green. They are all painted light grey, are large and are only rectangular. These and Rauschenberg's early white painting, made of four panels, are the extreme of the most inclusive attitude of the show. They are next to nothing; you wonder why anyone would build something only barely present. There isn't anything to look at. Rauschenberg said of one of his white paintings, 'If you don't take it seriously, there is nothing to take'. Morris' pieces exist, after all, as meagre as they are. Things that exist exist, and everything is on their side. They're here, which is pretty puzzling. Nothing can be said of things that don't exist. Things exist in the same way if that is all that is considered – which may be because we feel that or because that is what the word means or both. Everything is equal, just existing, and the values and interests they have are only adventitious.

Morris' objects seem to express this flat, unevaluating view. Western art has always asserted very hierarchical values. Morris' work and that of others in this show, in different ways, seems to deny this kind of assertion. This attitude has quite a few precedents in this century, but this work is the most forceful and the barest expression of it so far. This is all good, but these facts of existence are as simple as they are obdurate – as are Morris' objects. I need more to think about and look at. *Slab* is the only one interesting to see. It is about 244 × 244 cm [8 × 8 ft] across and a foot thick and is supported a few inches off the floor. The space below it, its expanse – you are displaced from 59,536 cm² [64 ft²], which you look down upon – and this position flat on the floor are more interesting than the vaguely sculptural and monumental upright positions of the other three pieces. Most of the things in Morris' recent show were more specific and complex as ideas. This made their scant appearance more relevant.

I have nearly the same interest and disinterest in Tony Smith's 122 × 122 × 244 cm [4 × 4 × 8 ft] black boxes, which are a set comprising a cube, as I have in Morris' three pieces. The boxes are plywood, mock-ups for welded metal ones. This is the first I've seen of Smith's work. The boxes can be arranged in any way. Two are stacked parallel to the other two, separated by a narrow aisle. The black, compared to Morris' grey, is indeterminate in space and mysterious. There are three pieces by Anne Truitt, which were shown before at Emmerich – a column, an upright slab partitioned by three grooves into four columns and a piece that looks like an interlocking stack of three boxes. They all have dark colours – brown, maroon, dark green and blue – which is too near Reinhardt. There is a colour to

each section of the grooved piece. This makes sense. The others are coloured regardless of their shape – which doesn't work. Truitt probably wants the dark boxes to change and divide when they are looked at closely, as Reinhardt's paintings do. There are two paintings by Reinhardt here. Their initial appearance of black nothingness is of course a precedent for a work of art really being nothing. There is a set, grouped into a square, of sixteen 61 × 61 cm [2 × 2 ft] boxes, each with a simple wash-drawing on top, by James Byars. So far they aren't interesting. Neither is Byars' large scroll, which has a heretical orange border.

Morris' work implies that everything exists in the same way through existing in the most minimal way, but by clearly being art, purposefully built, useless and unidentifiable. It sets a lowest common denominator; it is art, which is supposed to exist most clearly and importantly, but it barely exists. Everything is caught in between and flattened. A lot of the other work in the show suggests the equal existence of things, but it does this in a different way. A work is a familiar object or a depiction of one, often familiar too. It doesn't appear to be art. Its only claim to be is that it is being exhibited. It is shown as art and becomes the equal of things that are obviously art. The importance of art is extended to everything, most of which is slight, ordinary and unconsidered. You are forced to consider the ordinary things and to question whatever was thought important in art. *Table and Chair Event*, by George Brecht, is the most extreme instance of this in the exhibition. There is a white kitchen chair at either end of a small, white kitchen table. There is a white tablecloth on the table. A white plate, a fork, knife and spoon and a clear wine glass are at one end. *The Daily News*, open to the Hialeah Charts, is at the other end. There is, of course, an attitude shown in this, and you wonder why people have these things. Another of Brecht's tables was shown at Cordier-Ekstrom. It and the various articles were simultaneously modern and early American. This is a prevalent taste [...]

Dan Flavin's fluorescent light and Frank Stella's black painting and aluminium one have some connection to the exhibition's flat and unhierarchical view of things, but are not related to Morris' or Brecht's expression of this. The work of both is more complex. Although they exclude painterly art, their work is decidedly art and is visible art. Stella's aluminium painting is very good. Flavin has been using lights for about four years. He has thought more about them and done more with them than anyone else. A single daylight-white tube has been placed at a diagonal on an approximately 335.5 × 335.5 cm [11 × 11 ft] wall at the end of a short corridor just off the court. It makes an intelligible area of the whole wall. There is some relation to the diagonals of Morris Louis. The tube is a very different white, in colour and nature, from the painted white of the box which supports it. The box casts a definite shadow along its length. The light is cast widely on the wall. The light is an industrial object, and familiar; it is a means new to art. Art could be made of any number of new objects, materials and techniques [...]

Donald Judd, 'Black, White, and Gray', first published as 'Nationwide Reports: Hartford', *Arts Magazine*, 38 (March

2. Roy Lichtenstein

1964); reprinted in *Donald Judd: Complete Writings 1959-1975* (Halifax: Nova Scotia College of Art and Design; New York University Press, 1975) 117-19.

Barbara ROSE
New York Letter: Dan Flavin
[1964]

Downtown at the Kaymar Gallery, Dan Flavin showed constructions made with fluorescent light tubes. The earlier ones were boxes, painted various dark, light-absorbing colours. Sometimes they were square, but more often corners were cut off obliquely and electric light bulbs (sometimes coloured, sometimes white) were set into them. Never was work ever simpler, consisting only of associations of fluorescent tubes of different lengths and colours. Flavin's use of standard, reproducible, machine-made items is a variation on Duchamp's readymades, but in the direction of their possibilities as pure sculpture rather than as vehicles for extra-visual ideas. (The glow of the electric light, however, that ties the work so concretely to the moment of apprehension – since we can conceive of a past or future moment when the light will be out – lends itself to interpretation.) Flavin's work, like Judd's, has a concrete boxiness; it too is both three-dimensional and painted. As things, not related to images, they combine real objects in such a way as to obscure or deny their functional value. One sees about the galleries these days many such objects, most of them not as interesting as Flavin's, and there is every indication that one will be seeing even more. Flavin manages to imbue his objects with a bland impersonality and starkness that seems particularly appropriate to such work.

Barbara Rose, 'New York Letter: Dan Flavin', *Art International*, VIII: 5/6 (Summer 1964) 80.

David BOURDON
Tenth Street: Dan Flavin [1964]

[...] I want to go see those New Zealand caves now that I have seen Dan Flavin's eerie show of fluorescent light. At the Green Gallery long fluorescent tubes hang not from the ceiling but on the wall – diagonally, vertically, horizontally – or they lie on the floor. Some of the tubes are coloured: they are commercially available in red, pink, yellow, green, two shades of blue and several shades of white. (The only white Flavin has used is cool-white.)

ONLY TUBES
Flavin has been working with light for about four years. Until recently he constructed boxes, blocky wall-hangings about 61 cm [2 ft] square, around the edges and bevelled corners of which he added coloured incandescent bulbs or fluorescent tubes. He has exhausted his interest in that kind of construction and now works only with unadorned fluorescent tubes in his quest for a more rarefied purity of concept and means.

One of the earliest works in this direction, *the diagonal of May 25, 1963 (to Robert Rosenblum)*, is still one of his best. A single 244 cm [8 ft], cool-white tube placed on a diagonal includes the wall as a work of art by casting light on it. Another amazing work is the one-two-three arrangement of vertically paralleled white tubes. One is a gold, blue, red, red-gold rectangle. On the floor lies a parallel arrangement of a 61 cm [2 ft] yellow tube, a 122 cm [4 ft] pink, a 183 cm [6 ft] red and a 244 cm [8 ft] red.

This art takes on a kind of biological luminescence. The works literally radiate energy, the emission of light becoming a major part of the art. (Turned off, they would not be interesting.) The light has an intangible fluidity that contrasts sharply with the rigid contours of the tubes themselves. The coloured lights affect each other. Looked at long enough, there are subtle changes of colour and after-images. Adjacent tubes of contrasting colour cast peculiar blends of colour light. This art has instant turn-on.

These tubes probably owe as much to electrified marquees as they do to tiers of votive lights. They derive ultimately, I suppose, from Duchamp's first purchase in a hardware store. Flavin refrains from gimmicky or elaborate arrangements. His compositions are spare and purist. It would be hard to do less.

ON THE AVENUE
After leaving the gallery, John Quinn and I walked over to a Greek cafeteria on West 47th Street off Eighth Avenue. Coming out of the cafeteria, we were startled by the window display across the street of the Samicraft Lighting Company (300 West 47th Street). A shop dealing in coloured and fluorescent tubes, it looked like the Flavin show in the process of being dismantled. We crossed the street to study the windows. There was remarkable similarity. A white tube leaned at a diagonal against one wall. A pink tube stood in the corner. In contrast to the bare austerity of the Green Gallery, the Samicraft windows were cluttered with bulbs and tubes. The Samicraft people, after all, do not have their windows done by Dick Bellamy, nor do they think of their wares as art. The only thing that makes Flavin's tubes art is that they have been arranged and put into an art context.

It is easy to see things in an art context after an artist has pointed it out. Now anybody can put an 244 cm [8 ft] pink fluorescent tube in the corner of his living room and claim to have an artwork, if he is oblivious to the fact that it is only a stylish forgery.

David Bourdon, 'Tenth Street: Dan Flavin', *Village Voice* (26 November 1964).

Dan FLAVIN
... in daylight or cool white
[1964]

(to Frank Lloyd Wright who once advised Boston's 'city fathers' to try a dozen good funerals as urban renewal) ' ... we might, if like the things outside us, we let the great storm over-ride us, grow spacious and anonymous.'
– Rainer Maria Rilke

'It looks like painting is finished.'
– Donald Judd

'Dan Flavin has destroyed electric lights for me. I'm going back to candles.'
– Tom Doyle

My name is Dan Flavin. I am thirty-two years old, overweight and underprivileged, a Caucasian in a Negro year.

I was born (screaming) a fraternal twin twenty-four minutes before my brother, David, in Mary Immaculate Hospital, Jamaica, New York, at about seven in the morning on a wet Saturday, April Fool's Day, 1933, of an ascetic, remotely male, Irish Catholic truant officer whose junior I am, and a stupid, fleshly tyrant of a woman who had descended from German royalty without a trace of nobility.

Early I was the victim of a part-time substitute mother, an English 'nanny', fraught with punctilious schedules, who tried to toilet train me at two weeks of age. When she failed or I failed, she slapped me. Before becoming seven, I attempted to run away from home but was apprehended by a fear of the unknown in sunlight just two blocks from our house.

While a young boy, I began drawing by myself. (My mother has reported that I had made a vivid, if naive record of hurricane damage on Long Island in 1938 which, subsequently, she destroyed along with almost every other drawing from my childhood.)

'Uncle Artie' Schnabel, the vice-president of my father's East River boat club, became my first instructor on art. He was a portly, ebullient, red-faced old World War veteran, whose battered left leg bore a brace and pained him gravely when it was about to rain. Also, he had been gassed. I saw his Purple Heart.

On a certain sunny Sunday afternoon, dockside on the river, 'Uncle Artie' set aside a stein of beer, adjusted his glasses for close observation, and showed me how to put down pencil water around a ship by lightly dappling just some of the surrounding space with the tiniest 'half moons'. His cosmic touch for space is in my drawings even now.

Soon religion was forced upon me to nullify whatever expressive childish optimism I may have had left. Rank suppression at seven in the name of God the Father or any other of the 'heavenly host' did not deter me from devising fantasies in secret. I heard the altar boys' whispered responses in distant Latin as the wonderful soprano of angels concealed above and behind the high altar.

In time I grew curiously fond of the solemn high funeral mass which was so consummately rich in candlelight, music, chant, vestments, processions and incense – and besides that, I got fifteen cents a corpse serving as an acolyte.

I also dwelled in serious fantasies of war – digging in with little lead soldiers under the Japanese yews of my father's rock garden, and changing pencil sketches of

supposed World War bombing devastation as it worsened, these disintegrating depictions mutually drawn with an older boy friend, who, while serving as an aerial gunner, was killed over Guam in the next real war.

By ten I had filled a corrugated cardboard carton with hundreds of pencil and pen-and-ink drawings after the 'Horrors of War' picture cards of Gum, Incorporated, and sundry other wartime illustrations.

In parochial school I was compelled to become the good student and a model child. The sisters diverted me from some of my war-torn tendencies and trained my hand in the peaceful uses of watercolour, but they did not permit much freedom for thought about what was to be drawn and washed.

My class work – dutifully done drawings and watercolours on prescribed themes – was preserved in folders by the nuns as good example for the students of following years until, when in 8A, I defied one of the good sisters by putting a single handle on a vase of flowers instead of two as she demanded. I recall that that 'black' lady began to scold me as a heretic or at least a sinner, but second looks at my plump innocence checked her incipient anger and restored her to modest nunliness.

At fourteen, after Dave and I graduated from St. 'Jokes's' (the Saints Joachim and Anne Parochial School) with honours, my father committed us to a junior seminary in Brooklyn in order that we might doubly fulfil his own lost vocation for priesthood. No one had examined me as to whether or not I wanted to go there, but that seemed hardly to matter since I had not been permitted to consider much else since consciousness.

I continued to draw, to doodle somewhat privately in class, in the margins of my textbooks. Now there were battered profiles of bloodied boxers with broken noses and Dido's pyre on a wall in Carthage, its passionate smoke piercing 'pious' Aeneas' faithless heart outbound in the harbour below.

Young Father Fogarty, my second year Latin professor, was unimpressed with such demonstrations of talent, especially as they evolved in his class against the daily lesson plan. He often censured, even ridiculed me. Nevertheless, I acquired a certain personal power with him. When he chastened me, I noticed that he blushed redder than I did.

My grades failed so evidently by once-repeated senior year that I felt compelled to flee seminary failure for the terrifying profanity of life outside 1914 Gothic walls which, importantly, I had never experienced.

Somehow, at eighteen, I began to think about art – Roman Catholic diversions of it, of course.

I read art, looked for it and listened about it. In an army anti-aircraft battalion library near Osan-ni, Korea, I found only Jacques Maritain's *Art and Poetry*. It was confounding to try to master. After buying a pair of Georges Rouault's prints from *Miserere et Guerre*, I wrote an American 'fan letter' to the aged artist. He responded effectively with a poem. Later, during a Saturday afternoon in the office of the Hansa Gallery, where new generations of New York art were being introduced, co-directors Dick Bellamy and Ivan Karp and artists George Segal and Allan Kaprow engaged in a 'bull session' before me. Frustrated, I

understood little of what I strove to hear.

Since leaving high school I had attempted few drawings and no painting until, in 1955, while loitering in Korea with an army of occupation as an Air Weather Service Observer, I became so restless that I sought out another reluctant soldier, an army private from Special Services, who had studied painting in Oberlin College and would not bathe for four successive days as some sort of most personal aesthetic assertion. I assisted this 'raunchy' G.I. in establishing regular class sessions in figure drawing. Within a few weeks, the programme was suspended by an army major who presumed the probability of a possibility of an unmanly, immoral disclosure in the posing of fellow G.I.'s stripped to the waist while leaning on brooms.

Fortunately, I eluded further formal instructions in art after four inconclusive (and disenchanting) sessions in the Hans Hofmann School of New York's Eighth Street in 1956. Following that discouragement, my drawing had the personally concerned criticism of a new 'American' painter, Albert Urban, a gentle, unreconstructed 'pariah', who, as a young man, had his work acclaimed in Hitler's museum for 'degenerate' art. I never studied in his studio, which Albert maintained as barred sanctuary daily from nine to five, but on several evenings, weeks apart, we sat for hours with his wife, Reva, in their spacious West Tenth Street apartment examining my papers.

After scanning a first batch of divers expression, Albert sighed, settled back into his easy chair, lighted the tobacco in a pipe and, for a while, distractedly puffed smoke through his wiry black moustache. When he finally spoke, he plainly suggested that I might better become a scholar – a religious art historian. I was secretly shocked and grieved by Albert's lack of recognition. In the months that followed, I fervently produced more hundreds of poor drawings and a few horrid aspirations in oil on canvas paper and similar board which I supposed must be what paintings were like. Albert, with comprehensive tolerance, kept watching and talking but he could not be encouraging.

Of a sudden, dear Albert suffered a heart attack and died on his living-room floor. But I had not been with him for quite a while and then I was completely off on my own again. This was April 1959.

At about this time, I studied additional survey courses of art history and participated in Ralph Mayer's drawing and painting Tools and Materials programme for two semesters in Columbia University.

These sessions with Mr Mayer permitted contact with a variety of antique artistic modes of 'permanent painting' which few persons will ever use again. In the second semester, I scumbled a fruited still life too intensely and achieved the effect of a thin 'B' for the effort.

In February 1959, despondent about a failed personal relationship (after an attempt at irrelevant suicide), I burst from Columbia University into a belated full-time affair with art. At first, I was with everybody else's work – Guston's, Motherwell's, Kline's, Gorky's, Pollock's, Rothko's, Jasper Johns' and 'What have you seen in the new *ARTnews*?'

A painter-friend, Ward Jackson, sent inspirational

postcards bearing reproductions such as one of a ten-year-old painting by Robert Motherwell which looked strikingly like my last week's work, but nevertheless, I persisted because, by then, I knew no other way to live. Considerations of much more work were constantly in mind.

For a year or more, I celebrated just about anything: crude Cézanne's self-portrait mask ennobled in a whirl of charcoal; drab tenements on the waterfront silhouetted in oil – sienna, umber, ochre, black and white; freight trains through the rain, indicated by fingered smears of black ink; misspent 'ejaculations' of watercolour and ink out by themselves; words of the 'Song of Songs' in my script, embraced by tenderly rendered washes which sustained sentiments such as giving breasts in the field in morning light; a Luis Lozano Pure Superfine Olive Oil tin found flattened in the gutter disclosed as itself fastened to a busily textured golden box marked *mira, mira*.

By 1960 I had well-established my first complete 'studio', a small, sunny railroad flat on Washington Street in the midst of the old wholesale meat market on Manhattan's West Side below Fourteenth Street, and near the Hudson River waterfront. (I have usually chosen to live by broad expanses of water. I prefer to sense that breadth in continuous flux.)

This place quickly became chock-full of curiosities – a rhythm of carefully distributed objects – arranged like a strange, dirty, cumulative composition but with a random appearance. Most materials deposited there were found during wanderings near piers.

When Dick Bellamy first visited me, he paced from room to room delightedly for some time, and then announced that he wished he could transport the entire apartment into his new Green Gallery. It had never occurred to me that the way in which I wanted to live could become an art commodity.

By 1961 I was tired of my three-year-old romance with art mainly as tragic practice. I had found that all of my small constructions, with the exception of *mira, mira*, were like memorial plaques and that the numerous pages and several folding books of watercolour and poetry which I had completed were dominated by black ink.

The four-room flat felt shrunk to a mental closet. Too many things of old emotion and consideration were accumulated there (an insistent history which seemed bound to restrict further use). It had to be abandoned. My new wife, Sonja, and I pooled our earnings so that we might rent a large loft away in Williamsburg, Brooklyn, where I could begin again to change from so many small derived 'celebrations' to more appreciable efforts – much more intelligent and personal work.

While walking floors as a guard in the American Museum of Natural History, I crammed my uniform pockets with notes for an electric light art. 'Flavin, we don't pay you to be an artist', warned the custodian in charge. I agreed and quit him.

These notes of spring were put to structure in the fall. My wife and I were elated at seeing light and paint posted together on the wall before us. Then, for the next three years, I was off at work on the series of electric light 'icons'.'

Some previously sympathetic friends were alienated by such a simple deployment of typical electric lights against usual, plainly painted square-fronted constructions. 'You have lost your little magic', I was admonished. Yes, for that appreciable achievement, difficult work, blunt in bright repose.

Somewhat in my mind at this time, were quietly rebellious thoughts about proposing a plain physical factual painting of firm plasticity in opposition to the loose, vacuous and overwrought tactile fantasies spread about yards of cotton duck (my friend, Victor Caglioti, has characterized these paintings as 'dreaming on a brush') which inevitably overwhelmed and stifled the invention of their practitioner-victims — a declining generation of artists whom I could easily locate in prosperous commercial galleries. (I do not mean to be misleading. Plastic polemics did not persuade me to initiate work. Most often, I simply thought about what I would plan to build next.)

Work that was somewhat new to my attention and comprehension such as the homely objective paint play about objects of Jasper Johns, the 'easy' separative brushed on vertical bar play in relatively grand scale by Barnett Newman or the restrained multi-striped consecutive bare primed canvas-pencil-paint frontal expanse play from Frank Stella did not hold an appropriate clue for me about this beginning. I had to start from that blank, almost featureless, square-fronted construction with obvious electric light which could become my standard yet variable emblem — the 'icon'.

During spring 1963 I felt sufficiently founded in my new work to discontinue it. From a recent diagram, I declared *the diagonal of personal ecstasy* (*the diagonal of May 25, 1963*), a common 244 cm [8 ft] strip with fluorescent light of any commercially available colour. At first, I chose 'gold'.

The radiant tube and the shadow cast by its supporting pan seemed ironic enough to hold alone. There was literally no need to compose this system definitively; it seemed to sustain itself directly, dynamically, dramatically in my workroom wall — a buoyant and insistent gaseous image which, through brilliance, somewhat betrayed its physical presence into approximate invisibility.

(I put the paired lamp and pan in position at an angle 45 degrees above the horizontal because that seemed to be a suitable situation of resolved equilibrium but any other positioning could have been just as engaging.)

It occurred to me then to compare the new *diagonal* with Constantin Brancusi's past masterpiece, the *Endless Column*. That artificial *Column* was disposed as a regular formal consequence of numerous similar wood wedge-cut segments extended vertically — a hewn sculpture (at its inception). The *diagonal* in its overt formal simplicity was only the installation of a dimensional or distended luminous line of a standard industrial device. Little artistic craft could be possible.

Both structures had a uniform elementary visual nature, but they were intended to excel their obvious visible limitations of length and their apparent lack of complication. The *Endless Column* was like some imposing archaic mythologic totem risen directly skyward. The *diagonal*, in the possible extent of its dissemination as

common light repeated effulgently across anybody's wall, had potential for becoming a modern technological fetish. But who could be sure how it would be understood?

In time, I came to these conclusions about what I had found with fluorescent light, and about what might be accomplished plastically: now the entire interior spatial container and its components — wall, floor and ceiling, could support a strip of light but would not restrict its act of light except to enfold it. Regard the light and you are fascinated — practically inhibited from grasping its limits at each end. While the tube itself has an actual length of 244 cm [8 ft], its shadow, cast from the supporting pan, has but illusively dissolving ends. This waning cannot really be measured without resisting consummate visual effects.

Realizing this, I knew that the actual space of a room could be disrupted and played with by careful, thorough composition of the illuminating equipment. For example, if a 244-cm [8-ft] fluorescent lamp be pressed into a vertical corner, it can completely eliminate that definite juncture by physical structure, glare and doubled shadow. A section of wall can be visually disintegrated into a separate triangle by placing a diagonal of light from edge to edge on the wall; that is, side to floor, for instance.

These conclusions from completed propositions (in the Kaymar Gallery during March 1964 and in the Green Gallery during November 1964 and December 1964) left me at play on the structure that bounded a room but not yet so involved in the volume of space which is so much more extensive than the room's box.

Since December 1964 I have made attempts at this (in the Institute of Contemporary Art from March 1965 through May 1965 and again at the Ohio State University during April 1965 and May 1965) through bringing the lamp as image back in balance with it as object by putting it diagonally from the wall out on to the floor in Philadelphia; by extending it horizontally from an entry arch into the room in Philadelphia and, in Columbus, by placing a complementary pattern of lamps parallel to the diagonal of a flight of stairs and then letting a sole 61-cm [2-ft], cool white fluorescent lamp act as a partial horizontal visual and physical bar across the staircase.

What has art been for me?

In the past, I have known it (basically) as a sequence of implicit decisions to combine traditions of painting and sculpture in architecture with acts of electric light defining space and, recently, as more progressive structural proposals about these vibrant instruments which have severalized past recognitions and increased them into almost effortless yet insistent mental patterns which I may not neglect. I want to reckon with more lamps on occasion — at least for the time being.

1 I used the word 'icon' as descriptive, not of a strictly
 religious object, but of one that is based on a
 hierarchical relationship of electric light over,
 under, against and with a square-fronted structure full
 of paint 'light'.

Dan Flavin, ' … in daylight or cool white', originally pre-
sented as a lecture at the Brooklyn Museum School of Art, New
York (18 December 1964); Ohio State University School of Law
(26 April 1965); revised and published in *Artforum* (December

1965); *fluorescent light, etc. from Dan Flavin*, ed. Brydon
Smith (Ottawa: National Gallery of Canada, 1969) 13-20.

Lucy R. LIPPARD
New York Letter: Carl Andre
[1965]

Carl Andre has added an altogether different dimension to the post-geometric structure concept. His exhibition at Tibor de Nagy Gallery, in this day of conceptual extremism, was one of the most extreme events. The floor space, and much of the cubic space of the room, was literally filled by three immense greyish-white structures made of polystyrene bars, or logs: a broad-angled 'fence', a low solid 'pen' and a high openwork 'crib' which could be looked into but not entered. No attempt had been made to make them look like 'art', or in fact to make them visible at all, since there was only room for the determined viewer to edge around the forms and vantage points were denied. Consequently, the three pieces were seen as one effect, but they were not connected in any way except visually. It was important that they were separate conceptions. The unifying factor was the actual filling of space by their mammoth components. Even more architectural than the work of the other structurists, Andre's exhibits its negative-positive use of interior space but bars the way to experiencing it sensuously. The polystyrene logs are not attached, only laid on top of each other, so that the structures are dismantled after the show, ceasing to exist as anything but ideas — which is their prime role in any case. The form is impermanent but the materials remain — somewhere — as keys back to the intellectual domain in which these pieces exist. Such an extraordinarily cerebral approach to visual art has counterparts in those of Frank Stella or Robert Morris; it differs from those of Duchamp or Warhol in that the ironic or indifferent gesture is not the point. The idea is a plastic one — the displacement of space — and not necessarily negative, although the confined space that is filled does seem more important than what is filling it. The three pieces would have to be seen separately, or outdoors, or in a space for which they were not designed, for a definite opinion to be formed of their specific plastic merits.

Andre had previously used huge raw wooden beams, but they proved too heavy for the second-floor gallery. The polystyrene logs are an improvement: dirty, dented and manhandled, they do not evoke nature by rough wooden surfaces nor industry by pristine mechanical surfaces. They are neutral, and therefore suited to an art in which the idea is central. In addition, they are essential to Andre's second theme: weight. Their very size and bulk is contradicted by their buoyancy, which in turn adds to their space-filling capacities, for they seem to expand. In several much smaller pieces, he further explores the propensities of materials for mass or anti-mass, such as two heavy iron bars set across each other for a single statement of physical character, or a tower of magnets that can be manipulated, or a wooden crib with a heavy chain down

the central well. They too were only fastened together when construction precluded balance. It would be particularly interesting to see how these smaller, more practicable objects would look in grandiose scale.

Lucy R. Lippard, 'New York Letter: Carl Andre', *Art International*, 9: 6 (September 1965) 58-59.

John COPLANS
Larry Bell [1965]

The formative background of Larry Bell's art has been the unique quality of achievement of the major Abstract Expressionist painters. Ranging in style from Pollock's fluid efflorescences to Barnett Newman's passionate spatial declarations, pervasively idiosyncratic and subjective in character, this new art has created a climate emancipated from the absolutes of the past. Like many younger American artists, Bell first absorbed the style and then intuitively extrapolated his own implications from the expressive range of ideas contained within this new approach to painting. As a result, very early on in his career, he deployed acute spatial ideas within a highly formal framework. Thus his work neither refers to, nor draws inspiration from Constructivist principles or theories.

Bell's first one-man exhibition in 1962 (of paintings completed during the previous two years) revealed not only an exceptional assurance, but, in addition, sharp inferences of the sensate yet logical modality of structure that now characterizes his three-dimensional work. Generally, these paintings consisted of very large non-rectilinear-shaped canvases with the two opposing corners diagonally cut away. The implication of this configuration is a crystallographic form or an isometric projection of a three-dimensional solid. An essentially flat canvas surface was maintained with a highly redundant, bilaterally symmetrical imagery. The rigidity of the format was dissolved and thrown into ambiguity not by the deployment of optical flux or colouristic bounce, but by the interaction of the shaped canvas and the internal image, which induced an acute turning movement. In this manner, very early in his development, Bell introduced a tautly reduced schema, carried step by step to a high degree of fulfilment.

A similar organizational principle characterizes Bell's constructions, excepting that this more recent work is the product of technology. However, despite the switch from the hand to the machine, this work is on an extremely sensual and deceptive plane. Bell transforms a complex geometry of hard, intractable and brittle glass enclosed within a framework of sleekly machined and chromed metal into an intimate, luminous and fragile object. Within the limits of these very rigid components he compresses an extraordinary range of form, first by the purity of definition of the overall configuration (a cube), second by framing within this setting a complex range of well defined shapes (ellipses, parallelograms, checkers and hexagonal arrangements) and finally by tracing an extraordinary variety of transitory overtones and embellishments of highly reflective materials, sometimes with transparent coloration. These final touches induce a whole range of changing, evanescent perceptual qualities that enrich the whole harmony, yet act at the same time to dissolve the construction into shimmering intangibility.

An additional quality of Bell's constructions is the manner in which the physiological and psychological interpenetrate within the eye and the mind of the observer. Close viewing, especially of the interior, sets into motion a series of endlessly multiplying and constantly shifting images of the observer and the observed. This phantasmagoria, in turn, creates a spatial continuum which magnifies the scale to an indeterminate degree.

There is a remarkable degree of finish to Bell's work; he does not permit imperfections of technique to detract from the sensuousness of surface. His approach to the advantages of technology is uniquely clear and level-headed; he is interested in a subtle extension of expression that derives, not from the exoticness of the material, but from the refinement of surface, an inhuman perfection of polishing and coating that technology has to offer. Integral to each construction is a transparent stand, fabricated either of glass or clear plastic. Its function (quite apart from that of positioning the work at a suitable level for viewing) is to permit the entry of light through the bottom surface. Thus, although the construction is a physical object, weighty and bound by gravity in terms of light, it is free in space.

John Coplans, 'Larry Bell', *Artforum* (May 1965) 27-29.

Donald JUDD
Specific Objects [1965]

Half or more of the best new work in the last few years has been neither painting nor sculpture. Usually it has been related, closely or distantly, to one or the other. The work is diverse, and much in it that is not in painting and sculpture is also diverse. But there are some things that occur nearly in common.

The new three-dimensional work doesn't constitute a movement, school or style. The common aspects are too general and too little common to define a movement. The differences are greater than the similarities. The similarities are selected from the work; they aren't a movement's first principles or delimiting rules. Three-dimensionality is not as near being simply a container as painting and sculpture have seemed to be, but it tends to that. But now painting and sculpture are less neutral, less containers, more defined, not undeniable and unavoidable. They are particular forms circumscribed after all, producing fairly definite qualities. Much of the motivation in the new work is to get clear of these forms. The use of three dimensions is an obvious alternative. It opens to anything. Many of the reasons for this use are negative, points against painting and sculpture, and since both are common sources, the negative reasons are those nearest common usage. 'The motive to change is always some uneasiness: nothing setting us upon the change of state, or upon any new action, but some uneasiness.' The positive reasons are more particular. Another reason for listing the insufficiencies of painting and sculpture first is that both are familiar and their elements and qualities more easily located.

The objections to painting and sculpture are going to sound more intolerant than they are. There are qualifications. The disinterest in painting and sculpture is a disinterest in doing it again, not in it as it is being done by those who developed the least advanced versions. New work always involves objections to the old, but these objections are really relevant only to the new. They are part of it. If the earlier work is first-rate it is complete. New inconsistencies and limitations aren't retroactive; they concern only work that is being developed. Obviously, three-dimensional work will not cleanly succeed painting and sculpture. It's not like a movement; anyway, movements no longer work; also, linear history has unravelled somewhat. The new work exceeds painting in plain power, but power isn't the only consideration, though the difference between it and expression can't be too great either. There are other ways than power and form in which one kind of art can be more or less than another. Finally, a flat and rectangular surface is too handy to give up. Some things can be done only on a flat surface. Lichtenstein's representation of a representation is a good instance. But this work which is neither painting nor sculpture challenges both. It will have to be taken into account by new artists. It will probably change painting and sculpture.

The main thing wrong with painting is that it is a rectangular plane placed flat against the wall. A rectangle is a shape itself; it is obviously the whole shape; it determines and limits the arrangement of whatever is on or inside of it. In work before 1946 the edges of the rectangle are boundary, the end of the picture. The composition must react to the edges and the rectangle must be unified, but the shape of the rectangle is not stressed; the parts are more important, and the relationships of colour and form occur among them. In the paintings of Pollock, Rothko, Still and Newman, and more recently of Reinhardt and Noland, the rectangle is emphasized. The elements inside the rectangle are broad and simple and correspond closely to the rectangle. The shapes and surface are only those which can occur plausibly within and on a rectangular plane. The parts are few and so subordinate to the unity as not to be parts in an ordinary sense. A painting is nearly an entity, one thing, and not the indefinable sum of a group of entities and references. The one thing overpowers the earlier painting. It also establishes the rectangle as a definite form; it is no longer a fairly neutral limit. A form can be used only in so many ways. The rectangular plane is given a life span. The simplicity required to emphasize the rectangle limits the arrangements possible within it. The sense of singleness also has a duration, but it is only beginning and has a better future outside of painting. Its occurrence in painting now looks like a beginning, in which new forms are often made from earlier schemes and materials.

The plane is also emphasized and nearly single. It is clearly a plane 2.5 or 5 cm [1 or 2 in] in front of another plane, the wall, and parallel to it. The relationship of the

3. Mark Rothko

THE MAIN THING WRONG WITH PAINTING
IS THAT IT IS A RECTANGULAR PLANE PLACED FLAT AGAINST THE WALL.
A RECTANGLE IS A SHAPE ITSELF;
IT IS OBVIOUSLY THE WHOLE SHAPE;
IT DETERMINES AND LIMITS THE ARRANGEMENT OF WHATEVER IS ON OR INSIDE OF IT.

Donald JUDD 'Specific Objects', 1965

two planes is specific; it is a form. Everything on or slightly in the plane of the painting must be arranged laterally.

Almost all paintings are spatial in one way or another. Yves Klein's blue paintings are the only ones that are unspatial, and there is little that is nearly unspatial, mainly Stella's work. It's possible that not much can be done with both an upright rectangular plane and an absence of space. Anything on a surface has space behind it. Two colours on the same surface almost always lie on different depths. An even colour, especially in oil paint, covering all or much of a painting is almost always both flat and infinitely spatial. The space is shallow in all of the work in which the rectangular plane is stressed. Rothko's space is shallow and the soft rectangles are parallel to the plane, but the space is almost traditionally illusionistic. In Reinhardt's paintings, just back from the plane of the canvas, there is a flat plane and this seems in turn indefinitely deep. Pollock's paint is obviously on the canvas, and the space is mainly that made by any marks on a surface, so that it is not very descriptive and illusionistic. Noland's concentric bands are not as specifically paint-on-a-surface as Pollock's paint, but the bands flatten the literal space more. As flat and unillusionistic as Noland's paintings are, the bands do advance and recede. Even a single circle will warp the surface to it, will have a little space behind it.

Except for a complete and unvaried field of colour or marks, anything spaced in a rectangle and on a plane suggests something in and on something else, something in its surround, which suggests an object or figure in its space, in which these are clearer instances of a similar world – that's the main purpose of painting. The recent paintings aren't completely single. There are a few dominant areas, Rothko's rectangles or Noland's circles, and there is the area around them. There is a gap between the main forms, the most expressive parts, and the rest of the canvas, the plane and the rectangle. The central forms still occur in a wider and indefinite context, although the singleness of the paintings abridges the general and solipsistic quality of earlier work. Fields are also usually not limited, and they give the appearance of sections cut from something indefinitely larger.

Oil paint and canvas aren't as strong as commercial paints and as the colours and surfaces of materials, especially if the materials are used in three dimensions. Oil and canvas are familiar and, like the rectangular plane, have a certain quality and have limits. The quality is especially identified with art.

The new work obviously resembles sculpture more than it does painting, but it is nearer to painting. Most sculpture is like the painting which preceded Pollock, Rothko, Still and Newman. The newest thing about it is its broad scale. Its materials are somewhat more emphasized than before. The imagery involves a couple of salient resemblances to other visible things and a number of more oblique references, everything generalized to compatibility. The parts and the space are allusive, descriptive and somewhat naturalistic. Higgins' sculpture is an example, and, dissimilarly, Di Suvero's. Higgins' sculpture mainly suggests machines and truncated bodies. Its combination of plaster and metal is more

specific. Di Suvero uses beams as if they are brush strokes, imitating movement, as Kline did. The material never has its own movement. A beam thrusts, a piece of iron follows a gesture; together they form a naturalistic and anthropomorphic image. The space corresponds.

Most sculpture is made part by part, by addition, composed. The main parts remain fairly discrete. They and the small parts are a collection of variations, slight through great. There are hierarchies of clarity and strength and of proximity to one or two main ideas. Wood and metal are the usual materials, either alone or together, and if together it is without much of a contrast. There is seldom any colour. The middling contrast and the natural monochrome are general and help to unify the parts.

There is little of any of this in the new three-dimensional work. So far the most obvious difference within this diverse work is between that which is something of an object, a single thing, and that which is open and extended, more or less environmental. There isn't as great a difference in their nature as in their appearance, though. Oldenburg and others have done both. There are precedents for some of the characteristics of the new work. The parts are usually subordinate and not separate in Arp's sculpture and often in Brancusi's. Duchamp's readymades and other Dada objects are also seen at once and not part by part. Cornell's boxes have too many parts to seem at first to be structured. Part-by-part structure can't be too simple or too complicated. It has to seem orderly. The degree of Arp's abstraction, the moderate extent of his reference to the human body, neither imitative nor very oblique, is unlike the imagery of most of the new three-dimensional work. Duchamp's bottle-drying rack is close to some of it. The work of Johns and Rauschenberg, and assemblage and low-relief generally, Ortman's reliefs for example, are preliminaries. Johns' few cast objects and a few of Rauschenberg's works, such as the goat with the tyre, are beginnings.

Some European paintings are related to objects, Klein's for instance, and Castellani's, which have unvaried fields of low-relief elements. Arman and a few others work in three dimensions. Dick Smith did some large pieces in London with canvas stretched over cockeyed parallelepiped frames and with the surfaces painted as if the pieces were paintings. Philip King, also in London, seems to be making objects. Some of the work on the West Coast seems to be along this line, that of Larry Bell, Kenneth Price, Tony Delap, Sven Lukin, Bruce Conner, Keinholz of course, and others. Some of the work in New York having some or most of the characteristics is that by John Anderson, Arakawa, Richard Artschwager, Ronald Bladen, Lee Bontecou, George Brecht, John Chamberlain, Dan Flavin, Paul Harris, Aaron Kuriloff, Yayoi Kusama, Barry McDowell, Robert Morris, Richard Navin, Claes Oldenburg, Ralph Ortiz, Nathan Raisen, Lucas Samaras, Salvatore Scarpitta, George Segal, Tony Smith, Michael Snow, Harry Soviak, Frank Stella, Robert Tanner, Anne Truitt, Robert Watts, H.C. Westermann, Robert Whitman, John Willenbecher, Neil Williams and Yoshimura. Some of these artists do both three-dimensional work and paintings. A small amount of the work of others, Andy Warhol and James Rosenquist for instance, is three-

dimensional.

The composition and imagery of Chamberlain's work is primarily the same as that of earlier painting, but these are secondary to an appearance of disorder and are at first concealed by the material. The crumpled tin tends to stay that way. It is neutral at first, not artistic, and later seems objective. When the structure and imagery become apparent, there seems to be too much tin and space, more chance and casualness than order. The aspects of neutrality, redundancy and form and imagery could not be co-extensive without three dimensions and without the particular material. The colour is also both neutral and sensitive and, unlike oil colours, has a wide range. Most colour that is integral, other than in painting, has been used in three-dimensional work. Colour is never unimportant, as it usually is in sculpture.

Stella's shaped paintings involve several important characteristics of three-dimensional work. The periphery of a piece and the lines inside correspond. The stripes are nowhere near being discrete parts. The surface is farther from the wall than usual, though it remains parallel to it. Since the surface is exceptionally unified and involves little or no space, the parallel plane is unusually distinct. The order is not rationalistic and underlying but is simply order, like that of continuity, one thing after another. A painting isn't an image. The shapes, the unity, projection, order and colour are specific, aggressive and powerful.

Painting and sculpture have become set forms. A fair amount of their meaning isn't credible. The use of three dimensions isn't the use of a given form. There hasn't been enough time and work to see limits. So far, considered most widely, three dimensions are mostly a space to move into. The characteristics of three dimensions are those of only a small amount of work, little compared to painting and sculpture. A few of the more general aspects may persist, such as the work's being like an object or being specific, but other characteristics are bound to develop. Since its range is so wide, three-dimensional work will probably divide into a number of forms. At any rate, it will be larger than painting and much larger than sculpture, which, compared to painting, is fairly particular, much nearer to what is usually called a form, having a certain kind of form. Because the nature of three dimensions isn't set, given beforehand, something credible can be made, almost anything. Of course, something can be done within a given form, such as painting, but with some narrowness and less strength and variation. Since sculpture isn't so general a form, it can probably be only what it is now – which means that if it changes a great deal it will be something else; so it is finished.

Three dimensions are real space. That gets rid of the problem of illusionism and of literal space, space in and around marks and colours – which is riddance of one of the salient and most objectionable relics of European art. The several limits of painting are no longer present. A work can be as powerful as it can be thought to be. Actual space is intrinsically more powerful and specific than paint on a flat surface. Obviously, anything in three dimensions can be any shape, regular or irregular, and can have any relation to the wall, floor, ceiling, room, rooms or exterior

4. Joseph Cornel

5. Robert Rauschenberg

6. Lee Bontecou

or none at all. Any material can be used, as is or painted.

A work needs only to be interesting. Most works finally have one quality. In earlier art the complexity was displayed and built the quality. In recent painting the complexity was in the format and the few main shapes, which had been made according to various interests and problems. A painting by Newman is finally no simpler than one by Cézanne. In the three-dimensional work the whole thing is made according to complex purposes, and these are not scattered but asserted by one form. It isn't necessary for a work to have a lot of things to look at, to compare, to analyse one by one, to contemplate. The thing as a whole, its quality as a whole, is what is interesting. The main things are alone and are more intense, clear and powerful. They are not diluted by an inherited format, variations of a form, mild contrasts and connecting parts and areas. European art had to represent a space and its contents as well as have sufficient unity and aesthetic interest. Abstract painting before 1946 and most subsequent painting kept the representational subordination of the whole to its parts. Sculpture still does. In the new work the shape, image, colour and surface are single and not partial and scattered. There aren't any neutral or moderate areas or parts, any connections or transitional areas. The difference between the new work and earlier painting and present sculpture is like that between one of Brunelleschi's windows in the Badia di Fiesole and the facade of the Palazzo Rucellai, which is only an undeveloped rectangle as a whole and is mainly a collection of highly ordered parts.

The use of three dimensions makes it possible to use all sorts of materials and colours. Most of the work involves new materials, either recent inventions or things not used before in art. Little was done until lately with the wide range of industrial products. Almost nothing has been done with industrial techniques and, because of the cost, probably won't be for some time. Art could be mass-produced, and possibilities otherwise unavailable, such as stamping, could be used. Dan Flavin, who uses fluorescent lights, has appropriated the results of industrial production. Materials vary greatly and are simply materials — Formica, aluminium, cold-rolled steel, Plexiglas, red and common brass and so forth. They are specific. If they are used directly they are more specific. Also, they are usually aggressive. There is an objectivity to the obdurate identity of a material. Also, of course, the qualities of materials — hard mass, soft mass, thickness of .08, .15, .3 cm [.03, .06, .12 in], pliability, slickness, translucency, dullness — have unobjective uses. The vinyl of Oldenburg's soft objects looks the same as ever, slick, flaccid and a little disagreeable, and is objective, but it is pliable and can be sewn and stuffed with air and kapok and hung or set down, sagging or collapsing. Most of the new materials are not as accessible as oil on canvas and are hard to relate to one another. They aren't obviously art. The form of a work and its materials are closely related. In earlier work the structure and the imagery were executed in some neutral and homogeneous material. Since not many things are lumps, there are problems in combining the different surfaces and colours and in relating the parts so as not to weaken the unity.

Three-dimensional work usually doesn't involve ordinary anthropomorphic imagery. If there is a reference it is single and explicit. In any case, the chief interests are obvious. Each of Bontecou's reliefs is an image. The image, all of the parts and the whole shape are co-extensive. The parts are either part of the hole or part of the mound which forms the hole. The hole and the mound are only two things, which, after all, are the same thing. The parts and divisions are either radial or concentric in regard to the hole, leading in and out and enclosing. The radial and concentric parts meet more or less at right angles and in detail are structure in the old sense, but collectively are subordinate to the single form. Most of the new work has no structure in the usual sense, especially the work of Oldenburg and Stella. Chamberlain's work does involve composition. The nature of Bontecou's single image is not so different from that of images which occurred in a small way in semi-abstract painting. The image is primarily a single emotive one, which alone wouldn't resemble the old imagery so much, but to which internal and external references, such as violence and war, have been added. The additions are somewhat pictorial, but the image is essentially new and surprising; an image has never before been the whole work, been so large, been so explicit and aggressive. The abatized orifice is like a strange and dangerous object. The quality is intense and narrow and obsessive. The boat and the furniture that Kusama covered with white protuberances have a related intensity and obsessiveness and are also strange objects. Kusama is interested in obsessive repetition, which is a single interest. Yves Klein's blue paintings are also narrow and intense.

The trees, figures, food or furniture in a painting have a shape or contain shapes that are emotive. Oldenburg has taken this anthropomorphism to an extreme and made the emotive form, with him basic and biopsychological, the same as the shape of an object, and by blatancy subverted the idea of the natural presence of human qualities in all things. And further, Oldenburg avoids trees and people. All of Oldenburg's grossly anthropomorphized objects are man-made — which right away is an empirical matter. Someone or many made these things and incorporated their preferences. As practical as an ice-cream cone is, a lot of people made a choice, and more agreed, as to its appearance and existence. This interest shows more in the recent appliances and fixtures from the home and especially in the bedroom suite, where the choice is flagrant. Oldenburg exaggerates the accepted or chosen form and turns it into one of his own. Nothing made is completely objective, purely practical or merely present. Oldenburg gets along very well without anything that would ordinarily be called structure. The ball and cone of the large ice-cream cone are enough. The whole thing is a profound form, such as sometimes occurs in primitive art. Three fat layers with a small one on top are enough. So is a flaccid flamingo switch draped from two points. Simple form and one or two colours are considered less by old standards. If changes in art are compared backwards, there always seems to be a reduction, since only old attributes are counted and these are always fewer. But obviously new things are more, such as Oldenburg's

techniques and materials. Oldenburg needs three dimensions in order to simulate and enlarge a real object and to equate it and an emotive form. If a hamburger were painted it would retain something of the traditional anthropomorphism. George Brecht and Robert Morris use real objects and depend on the viewer's knowledge of these objects.

Donald Judd, 'Specific Objects', *Arts Yearbook*, 8 (1965); reprinted in *Donald Judd: Complete Writings 1959-1975* (Halifax: Nova Scotia College of Art and Design; New York University Press, 1975) 181-89.

Robert SMITHSON
Donald Judd [1965]

Donald Judd has set up a 'company' that extends the technique of abstract art into unheard-of places. He may go to Long Island City and have the Bernstein Brothers, Tinsmiths, put 'Pittsburgh' seams into some (Bethcon) iron boxes, or he might go to Allied Plastics in Lower Manhattan and have cut to size some Rohm-Haas 'glowing' pink Plexiglas. Judd is always on the lookout for new finishes, like Lavax Wrinkle Finish, which a company pamphlet says, 'combines beauty and great durability'. Judd likes that combination, and so he might 'self' spray one of his fabricated 'boxes' with it. Or maybe he will travel to Hackensack, New Jersey, to investigate a lead he got on a new kind of zinc-based paint called Galvanox, which is comparable to 'hot-dip' galvanizing. These procedures tend to baffle art-lovers. They either wonder where the 'art' went or where the 'work' went, or both. It is hard for them to comprehend that Judd is busy extending art into new media. This new approach to technique has nothing to do with sentimental notions about 'labour'. There is no subjective craftsmanship. Judd is not a specialist in a certain kind of labour, but a whole artist engaged in a multiplicity of techniques.

In Judd's first exhibition in 1963, his plywood and aluminium structures disclosed an awareness of physical 'mass' in the form of regular intervals of bulk. The intrinsic virtue of 'primary matter' was very much in evidence. Each work offered a different solution for the dislocation of space. One wooden box, for example, contained a series of recessed slats, exposed only by a slight concave opening on top of the box. This opening took up only about 20 per cent of the top surface. The slats were more closely spaced at one end than the other; as a result, the space seemed squeezed out. Inertia appeared to be subdivided into remote areas of force. A black pipe-like axis, in another work, was polarized between two massive plywood squares, yet no rotation seemed possible because the black pipe was flanked by six polarizing square beams that were bolted into the wooded squares. This non-rotation aspect breaks the suggestion of dynamic space. Matter, not motion, had become Judd's prime concern. Each of Judd's structures brought into question the very *form* of matter. This is contrary to the abstract notion that movement is the direct result of space. All 'created nature' seems to have been abstracted out of Judd's concept of

physical mass. Just as the Mannerist artists of the sixteenth century permuted the facts of the Classic Renaissance, so has Judd permuted the facts of modern reality. By such means, Judd discovered a new kind of 'architecture', yet his contrary methods make his 'architecture' look like it is built of 'anti-matter'. Perhaps 'primary matter' and 'anti-matter' are the same thing.

A lack of consciousness of mass seems to have caused the demise of 'action-painting', and that might explain also the dissolution of assemblage and the Happening. If action, energy, motion and other kinetics are the main motives of an artist, his art is quick to atrophy.

While he was making his aluminium and wood structures, Judd developed an idea for a 'space-lattice'. This was made out of pipe with 'ball fittings', that stood 122 cm [4 ft] high and about 183 cm [6 ft] long. Constructed with the help of a plumber, Judd put together this rectangular parallelepiped with a quartet of pipes conjoining in the centre of the work in the shape of a cross.

In the work of Frank Stella and Barnett Newman, the 'framing support' is both hinted at and parodied. Clement Greenberg recognized an element of 'parody', perhaps unconscious, in Barnett Newman's 'field' paintings, which called attention to the 'frame'. This element becomes less of a parody, and more of a conscious fact, in Frank Stella's 'shaped canvases'. Judd's symmetric, free-standing structure eliminated all doubts about the importance of the framework by asserting its formal presence beyond any reference to flat painting. All surfaces vanish in this important work, but return later in his fabricated works with startling new implications.

With Judd there is no confusion between the anthropomorphic and the abstract. This makes for an increased consciousness of structure, which maintains a remote distance from the organic. The 'unconscious' has no place in his art. His crystalline state of mind is far removed from the organic floods of 'action painting'. He translates his concepts into artifices of fact, without any illusionistic representations.

Space in Judd's art seems to belong to an order of increasing hardness, not unlike geological formations. He has put space down in the form of deposits. Such deposits come from his mind rather than nature. Instead of bringing Christ down from the cross, the way the painters of the Renaissance, Baroque and Mannerist periods did in their many versions of the deposition, Judd has brought space down into an abstract world of mineral forms. He is involved in what could be called 'The Deposition of Infinite Space'. Time has many anthropomorphic representations, such as Father Time, but space has none. There is no Father Space or Mother Space. Space is *nothing*, yet we all have a kind of vague faith in it. What seems so solid and final in Judd's work is at the same time elusive and brittle.

The formal logic of crystallography, apart from any preconceived scientific content, relates to Judd's art in an abstract way. If we define an abstract crystal as a solid bounded by symmetrically grouped surfaces, which have definite relationships to a set of imaginary lines called axes, then we have a clue to the structure of Judd's 'pink Plexiglas box'. Inside the box five wires are strung in a way that resembles very strongly the crystallographic idea of

axes. Yet Judd's axes don't correspond with any natural crystal. The entire box would collapse without the tension of the axes. The five axes are polarized between two stainless steel sides. The inside surfaces of the steel sides are visible through the transparent Plexiglas. Every surface is within full view, which makes the inside and outside equally important. Like many of Judd's works, the separate parts of the box are held together by tension and balance, both of which add to its static existence.

A reversible up and down quality was an important feature of the work which Judd showed in the VIII International Biennial of São Paulo. It is impossible to tell what is hanging from what or what is supporting what. Ups are downs and downs are ups. An uncanny materiality inherent in the surface engulfs the basic structure. Both surface and structure exist simultaneously in a suspended condition. What is outside vanishes to meet the inside, while what is inside vanishes to meet the outside. The concept of 'anti-matter' overruns and fills everything, making these very definite works verge on the notion of disappearance. The important phenomenon is always the basic lack of substance at the core of the 'facts'. The more one tries to grasp the surface structure, the more baffling it becomes. The work seems to have no natural equivalent to anything physical, yet all it brings to mind is physicality.

Robert Smithson, 'Donald Judd', *7 Sculptors* (Philadelphia: Institute of Contemporary Art, 1965); reprinted in *The Writings of Robert Smithson*, ed. Nancy Holt (New York University Press, 1979) 21-23.

Rosalind KRAUSS
Allusion and Illusion in Donald Judd [1966]

For some time, Donald Judd has been a major spokesman for works of art which seek, as their highest attainment, total identity as objects. Last year in praise of a fellow-sculptor's work, Judd wrote:
'*Rather than inducing idealization and generalization and being allusive, it excludes. The work asserts its own existence, form and power. It becomes an object in its own right.*'
Thus object-art would seem to proscribe both allusion and illusion: any reference to experiences or ideas beyond the work's brute physical presence is excluded, as is any manipulation (through the prescribed observation of that presence) of apparent as opposed to literal space. With this presumptive reduction of art from the realm of illusion — and through illusionism, of meaning — to the sphere of transparently real objects, the art with which Judd is associated is characterized as intentionally blank and empty: 'Obviously a negative art of denial and renunciation ... '

Approaching Judd's latest work from within this frame of reference, one is totally unprepared for the extraordinary beauty of the sculptures themselves, a beauty and authority which is nowhere described or accounted for in the polemics of object-art and which leads

one to feel all the more acutely the inadequacy of the theoretical line, its failure to measure up (at least in Judd's case) to the power of the sculptural statement.

In a recent article dealing with the phenomenon of object-art, Barbara Rose emphatically recognized the positive qualities, as opposed to the apparent blankness and denial, of this art, and suggested that these could be located in a mystical experience:
' ... *the blankness, the emptiness and vacuum of content is as easily construed as an occasion for spiritual contemplation as it is a nihilistic denial of the world*'.[2]
One cannot here examine this notion as it applies to other sculptors mentioned by Miss Rose, but at least in the case of Judd's work, which both compels and gratifies immediate sensuous confrontation, the suggestion that his sculpture is the occasion for an experience which completely transcends the physical object does not seem tenable. Nor does it seem that a description of Judd's art as meaning something only in so far as it embodies a negation of meaning (' ... the simple denial of content can in itself constitute the content of such a work')[3] arrives at the richness and plenitude of the works which are somehow not shorn and dumb, but, rather, insistently meaningful.
'*It is easy to strip language and actions of all meaning and to make them seem absurd, if only one looks at them from far enough away ... But that other miracle, the fact that in an absurd world, language and behaviour do have meaning for those who speak and act, remains to be understood.*'[4]

To get meaning in Donald Judd's recent work necessarily involves brute description of the objects themselves, but significantly such a description cannot simply rest at an inventory of characteristics, even though many of the sculptors persuaded by object-art maintain that such an inventory does indeed describe all that the works contain. Miss Rose reports that the artists she deals with ask that their sculpture be taken as 'nothing more than the total of the series of assertions that it is this or that shape and takes up so much space and is painted such a colour and made of such a material'. But it would seem that in Judd's case the strength of the sculptures derives from the fact that grasping the works by means of a list of their physical properties, no matter how complete, is both possible and impossible. They both insist upon and deny the adequacy of such a definition of themselves, because they are not developed from 'assertions' about materials or shapes, assertions, that is, which are given a priori and convert the objects into examples of a theorem or a more general case, but are obviously meant as objects or perception, objects that are to be grasped in the experience of looking at them. As such they suggest certain compelling issues.

One of the most beautiful of the sculptures in Judd's recent Leo Castelli Gallery show was a wall-hung work (now in the Whitney Museum's collection) which is made of a long (approximately 20 ft [61 m]) brushed aluminium bar, from which, at varying intervals, hangs a series of shorter bars enamelled a deep, translucent violet. Or so it appears from the front. The assumption that the apparently more dense metallic bar relates to the

startlingly sensuous, almost voluptuous lower bars as a support, from which they are suspended, is an architectural one, a notion taken from one's previous encounters with constructed objects and applied to this case. This reading is, however, denied from the side view of the object which reveals that the aluminium bar is hollow (and open at both ends) while the purple boxes below it, which had appeared luminous and relatively weightless, are in fact enclosed, and furthermore function as the supports for the continuous aluminium member. It is they that are attached to the wall and into which the square profile of the aluminium bar fits (flush with their top and front sides) completing their own L-shaped profile to form an 20 × 20 cm [8 × 8 in] box in section. A view raking along the facade of the sculpture, then, reveals one's initial reading as being in some way an illusion; the earlier sense of the purple bars' impalpability and luminosity is reversed and a clearer perception of the work can be obtained; but it is still one that is startlingly adumbrated and misleading. For now one sees the work in extension; that is, looking along its length one sees it in perspective. That one is tempted to read it as in perspective follows from the familiar repetitive rhythms of the verticals of the violet boxes which are reminiscent of the colonnades of classical architecture or of the occurrence at equal intervals of the vertical supporting members of any modular structure. Once again, then, Judd's work makes a reference to architecture, or to a situation one knows from previous experience – knowledge gained prior to the confrontation with the object. In this way, it seems to me, Judd brings a reference to a prior experience to bear on the present perception of the work. Or, to put it another way, the work itself exploits and at the same time confounds previous knowledge to project its own meaning. In Renaissance architecture, the even spacing of the colonnade is used to establish harmonious relationships as seen in perspective. The Renaissance mind seized on the realization that the same theorems of plane geometry unite proportion and perspective, and therefore assumed that a series of subjective viewpoints of a building (say, the sequence seen as one travels down the colonnaded nave of Brunelleschi's 'San Lorenzo') would not invalidate an awareness of absolute measurement.[5] It was thus an optical space of measurable quantities that was involved in the Renaissance rationalization of space through perspective.

As was noted before, Judd's sculpture, unless it is seen directly from the front, which is difficult because of its extreme length, demands to be seen in perspective. Yet the work confounds that perspective reading which will guarantee a sense of absolute measurement through proportion, because of the obviously unequal lengths of the violet bars and the unequal distances which separate them. The work cannot be seen rationally, in terms of a given sense of geometrical laws of theorems evolved prior to the experience of the object. Instead, the sculpture can be sensed only in terms of its present coming into being as an object given 'in the imperious unity, the presence, the insurpassable plenitude which is for us the definition of the real'.[6] In those terms the French philosopher Merleau-Ponty describes perception which 'does not give me truths

like geometry, but presences'. The 'lived perspective' of which Merleau-Ponty speaks is very different from the rational perspective of geometrical laws.
'*What prohibits me from treating my perception as an intellectual act is that an intellectual act would grasp the object either as possible or as necessary. But in perception it is "real", it is given as the infinite sum of an indefinite series of perspectival views in each of which the object is given but in none of which is it given exhaustively.*'[7]

It was noted at the beginning of this discussion that Judd's own criticism would seem to accept only that art which eschews both allusion and illusion. In the case described above the work plays off the illusory quality of the thing itself as it presents itself to vision alone – which it does persuasively from a front view, in seeming to be a series of flat, luminous shapes, and from a raking view, in the optical disappearance created by its orthogonal recession – as against the sensation of being able to grasp it and therefore to know it through touch. The sculpture becomes then an irritant for, and a heightening of, the awareness in the viewer that he approaches objects to make meaning of them, that when he grasps real structures he does so as meaningful, whole presences.

In constructing what is undoubtedly the most serious and fruitful description of the development of modern (as opposed to simply contemporary) art, Clement Greenberg and Michael Fried have insisted on the importance of that aspect of the artist's endeavour which involves a critical confrontation with the most vital work of the recent past. Judd's present sculpture can be situated, in this sense, in a critical relationship to the work with which David Smith was involved just before his death in 1965. This is of course not to say that the works contain some kind of veiled allusion to Smith or are only meaningful as seen in relation to his work; they are on the contrary entirely meaningful on their own terms. Judd seems rather to have sensed in Smith certain sculptural possibilities which were as yet unrealized.

In Smith's late *Cubi* pieces, especially *Cubi XXIV* and *Cubi XXVIII*, the works consist of large stainless steel cylinders and beams, which make up enormous rectangular 'frames'. Some of these frames are empty; others contain rectilinear volumes which are set with one broad side parallel to the viewer's plane of vision and are rendered further weightless and immaterial by the finish on the steel: a kind of calligraphic sanding of the metal so that the surfaces appear as a flickering, evanescent denial of the mass that supports them. The works wed a purely optical sensation of openness (the view through the frame) that is the presumed subject of the work with an increased sense of the palpability and substance of the frame. Smith in this way embraced the modality of illusionism within pictorial space from painting, and used this to powerful sculptural advantage. Yet, to Judd, Smith's suspension of planes within the frame, one balanced off against the other, or even the composition of the frame itself of almost arbitrarily combined geometrical segments must have seemed to rob the work of necessary lucidity. Smith's worrying of relationships between parts must have appeared to have clouded over the experience of the object with a kind of artiness which to Judd's eyes, at least,

was irrelevant. In his work of the past few years, as in the pieces in this show, Judd arrives at sculptural forms which do not depend on the balance and adjustment of one part to another for their meaning.

That this departure from traditional modes of composition is also true of the work of Kenneth Noland has been demonstrated by Michael Fried in his various essays on that painter.[8] In Noland's case composition is discarded from what Mr Fried has called 'deductive structure': the derivation of boundaries within the pictorial field from the one absolute boundary given by the physical fact of the picture itself – its framing edge. The importance of Noland's decision to let the shape of the support serve as the major determinant of the divisions within the painting rests in part on its avoidance of an explicit affirmation of the flatness of the canvas, which would dilute the experience of the colour by rendering it tactile (or merely the attribute of sculptural entities) rather than a sheerly visual or optical medium. Mr Fried points to the large works of Barnett Newman from the early 1950s as establishing a precedent for a wholly optical statement conjoined with, or dependent upon, deductive structure.

In Noland's most recent exhibition at the Andre Emmerich Gallery, a type of painting emerged which seemed to me to come from decisions by the painter which in part question the import of his earlier work. This type, found in *Across Center*, a 122-cm [4-ft]-long canvas divided into four horizontal, evenly painted bands, has far greater affinities with Newman than anything else Noland had done until now. In *Across Center* colour becomes more exclusively the basis of the experience than it had been in the diamond-shaped chevron paintings of the past year or so, for in those paintings the bounding shape itself had a limiting and closing effect on the colour. Moving to a 6.1-m [20-ft]-long expanse of colour points to a desire to combat the limits imposed by the shape itself and to promote an experience of the painting, either face-on, in fragment (from a vantage point far enough away to see the painting frontally and whole, the intensity of the colours would be somewhat reduced) or at an angle and therefore in perspective – a sensation promoted by the horizontal bands which seem to increase the work's apparent diminution in size at the far end of one's vision. The sensation thus produced, that one cannot know absolutely the nature of the shape of the painting, that one's view is always adumbrated, that the work in its entirety is highly allusive, throws one more surely and more persuasively on to an immediate experience with colour alone.

It it interesting that both Noland and Judd have arrived at formats which involve the viewer in an experience which is on the one hand more illusive than that of either a normal easel painting or an easily cohesive sculptural form, and on the other more immediate than both. But more important, from within this context of an increased sensuosity neither artist will desert meaning.

1 Barbara Rose, 'ABC Art', *Art in America*, 53: 5 (October–November 1965) 57–69. [See in this volume pp. 214–17.]

2 *Ibid*.

3 *Ibid*.

4 Maurice Merleau-Ponty, 'Metaphysics and the Novel',

7. Barnett Newman

The simple denial of content can in itself constitute the content of such a work. That these young artists attempt to suppress or withdraw content from their works is undeniable. That they wish to make art that is as bland and neutral and as redundant as possible also seems clear.

Rosalind KRAUSS 'Allusion and Illusion in Donald Judd', 1966

Sense and Nonsense (Evanston, Illinois: Northwestern University, 1964).

5 Rudolph Wittkower, 'Brunelleschi and Proportion in Perspective', *Journal of the Warburg and Courtauld Institutes*, 16 (1953) 275-91. In this connection Panofsky writes, ' … from the point of view of the Renaissance, mathematical perspective was not only a guarantee of correctness but also and perhaps even more so, a guarantee of aesthetic perfection'.

6 Merleau-Ponty, 'Cézanne's Doubt', *op. cit.*

7 Merleau-Ponty, 'The Primacy of Perception', *op. cit.*

8 See Michael Fried, *Three American Painters* (Cambridge, Massachusetts: Fogg Art Museum, Harvard University, 1965); and 'Nolan and Caro', *Lugano Review* (1965).

Rosalind Krauss, 'Allusion and Illusion in Donald Judd', *Artforum*, 4: 9 (May 1966) 24-26.

Barbara ROSE
ABC Art [1965]

'I am curious to know what would happen if art were suddenly seen for what it is, namely, exact information of how to rearrange one's psyche in order to anticipate the next blow from our own extended faculties … At any rate, in experimental art men are given the exact specifications of coming violence to their own psyches from their own counter-irritants or technology … But the counter-irritant usually proves a greater plague than the initial irritant, like a drug habit.'
– Marshall McLuhan, 'Understanding Media', 1964

'How do you like what you have. This is a question that anybody can ask anybody. Ask it.'
– Gertrude Stein, 'Lectures in America', 1935

On the eve of the First World War, two artists, one in Moscow, the other in Paris, made decisions which radically altered the course of art history. Today we are feeling the impact of their decisions in an art whose blank, neutral, mechanical impersonality contrasts so violently with the romantic, biographical Abstract Expressionist style which preceded it that spectators are chilled by its apparent lack of feeling or content. Critics, attempting to describe this new sensibility, call it 'cool art' or 'idiot art' or 'know-nothing nihilism'.

That a new sensibility has announced itself is clear, although just what it consists of is not. This is what I hope to establish here. But before taking up specific examples of the new art, not only in painting and sculpture, but in other arts as well, I would like briefly to trace its genealogy.

In 1913 Kasimir Malevich, placing a black square on a white ground which he identified as the 'void', created the first Suprematist composition. A year later Marcel Duchamp exhibited, as an original work of art, a standard metal bottle rack, which he called a 'readymade'. For half a century these two works marked the limits of visual art. Now, however, it appears that a new generation of artists, who seem not so much inspired as impressed by Malevich and Duchamp (to the extent that they venerate them) are

examining in a new context the implications of their radical decisions. Often the results are a curious synthesis of the two men's work. That such a synthesis should be not only possible but likely is clear in retrospect. For, although superficially Malevich and Duchamp may appear to represent the polarities of twentieth-century art – that is, on one hand, the search for the transcendent, universal, absolute and in the other, the blanket denial of the existence of absolute values – the two have more in common than one might suppose at first.

To begin with, both men were precocious geniuses who appreciated the revolutionary element in post-Impressionist art, particularly Cézanne's, and both were urban Modernists who rejected the possibility of turning back to a naive primitivism in disgusted reaction to the excesses of civilization. Alike, too, was their immediate adoption and equally rapid disenchantment with the mainstream modern style, Cubism. Turning from figurative manners, by 1911 both were doing Cubist paintings, although the provincial Malevich's were less advanced and 'analytic' than Duchamp's; by 1913 both had exhausted Cubism's possibilities as far as their art was concerned. Moreover, both were unwilling to resolve some of the ambiguities and contradictions inherent in Analytic Cubism in terms of the more ordered and logical framework of Synthetic Cubism, the next mainstream style. I say unwilling rather than unable, because I do not agree with critic Michael Fried's view that Duchamp, at any rate, was a failed Cubist. Rather, the inevitability of a logical evolution towards a reductive art was obvious to them already. For Malevich, the poetic Slav, this realization forced a turning inward towards an inspirational mysticism, whereas for Duchamp, the rational Frenchman, it meant a fatigue so ennervating that finally the wish to paint at all was killed. Both the yearnings of Malevich's Slavic soul and the deductions of Duchamp's rationalist mind led both men ultimately to reject and exclude from their work many of the most cherished premises of Western art in favour of an art stripped to its bare, irreducible minimum.

It is important to keep in mind that both Duchamp's and Malevich's decisions were renunciations – on Duchamp's part, of the notion of the uniqueness of the art object and its differentiation from common objects, and on Malevich's part, a renunciation of the notion that art must be complex. That the art of our youngest artists resembles theirs in its severe, reduced simplicity, or in its frequent kinship to the world of things, must be taken as some sort of validation of the Russian's and the Frenchman's prophetic reactions.

MORE IS LESS
The concept of 'Minimal art', which is surely applicable to the empty, repetitious, uninflected art of many young painters, sculptors, dancers and composers working now, was recently discussed as an aesthetic problem by Richard Wollheim.' It is Professor Wollheim's contention that the art content of such works as Duchamp's found objects (that is, the 'unassisted readymades' to which nothing is done) or Ad Reinhardt's nearly invisible 'black' paintings is intentionally low, and that resistance to this kind of art

comes mainly from the spectator's sense that the artist has not worked hard enough or put enough effort into his art. But, as Professor Wollheim points out, a decision can represent work. Considering as 'Minimal art' either art made from common objects that are not unique but mass-produced or art that is not much differentiated from ordinary things, he says that Western artists have aided us to focus on 'specific objects' by setting them apart as the 'unique possessors of certain general characteristics'. Although they are increasingly being abandoned, working it a lot, making it hard to do and differentiating it as much as possible from the world of common objects formerly were ways of ensuring the uniqueness and identity of an art object.

Similarly, critic John Ashbery has asked if art can be excellent if anybody can do it. He concludes that:
'*What matters is the artist's will to discover, rather than the manual skills he may share with hundreds of other artists. Anybody could have discovered America, but only Columbus did.*'
Such a downgrading of talent, facility, virtuosity and technique, with its concomitant elevation of conceptual power, coincides precisely with the attitude of the artists I am discussing (although it could also apply to the 'conceptual' paintings of Kenneth Noland, Ellsworth Kelly and others).

Now I should make it clear that the works I have singled out to discuss here have only one common characteristic: they may be described as Minimal art. Some of the artists, such as Darby Bannard, Larry Zox, Robert Huot, Lyman Kipp, Richard Tuttle, Jan Evans, Ronald Bladen and Anne Truitt, obviously are closer to Malevich than they are to Duchamp, whereas others, such as Richard Artschwager and Andy Warhol, are clearly the reverse. The dancers and composers are all, to a greater or lesser degree, indebted to John Cage, who is himself an admirer of Duchamp. Several of the artists – Robert Morris, Donald Judd, Carl Andre and Dan Flavin – occupy to my eye some kind of intermediate position. One of the issues these artists are attacking is the applicability of generalizations to specific cases. In fact, they are opposed to the very notion that the general and the universal are related. Thus, I want to reserve exceptions to all of the following remarks about their work; in other words, some of the things I will say apply only in some cases and not in others.

Though Duchamp and Malevich jumped the gun, so to speak, the avenue towards what Clement Greenberg has called the 'Modernist reduction', that is, towards an art that is simple, clear, direct and immediate, was travelled at a steadier pace by others. Michael Fried points out that there is:
'*A superficial similarity between Modernist painting and Dada in one important respect: namely that just as Modernist painting has enabled one to see a blank canvas, a sequence of random spatters or a length of coloured fabric as a picture, Dada and neo-Dada have equipped one to treat virtually any object as a work of art*'.²
The result is that 'there is an apparent expansion of the realm of the *artistic* corresponding – ironically, as it were – to the expansion of the *pictorial* achieved by Modernist

painting'. I quote this formulation because it demonstrates not only how Yves Klein's monochrome blue paintings are art, but because it ought finally to make clear the difference in the manner and kind of reductions and simplifications he effected from those made by Noland and Jules Olitski, thus dispelling permanently any notions that Noland's and Olitski's art are in any way, either in spirit or in intention, linked to the Dada outlook.

Although the work of the painters I am discussing is more blatant, less lyrical and more resistant – in terms of surface, at any rate, in so far as the canvas is not stained or left with unpainted areas – it has something important in common with that of Noland, Olitski and others who work with simple shapes and large colour areas. Like their work, this work is critical of Abstract Expressionist paint-handling and rejects the brushed record of gesture and drawing along with loose painterliness. Similarly, the sculpture I am talking about appears critical of open, welded sculpture.

That the artist is critic not only of his own work but of art in general and specifically of art of the immediate past is one of the basic tenets of formalist criticism, the context in which Michael Fried and Clement Greenberg have considered reductive tendencies in Modern art. But in this strict sense, to be critical means to be critical only of the formal premises of a style, in this case Abstract Expressionism. Such an explanation of a critical reaction in the purely formal terms of colour, composition, scale, format and execution seems to me adequate to explain the evolution of Noland's and Olitski's work, but it does not fully suffice to describe the reaction of the younger people I am considering, just as an explanation of the rise of neo-Classicism which considered only that the forms of the rococo were worn out would hardly give one much of a basis for understanding the complexity of David's style.

It seems clear that the group of young artists I am speaking of were reacting to more than merely formal chaos when they opted not to fulfil Ad Reinhardt's prescription for 'divine madness' in 'third-generation Abstract Expressionists'. In another light, one might as easily construe the new, reserved impersonality and self-effacing anonymity as a reaction against the self-indulgence of an unbridled subjectivity, just as one might see it in terms of a formal reaction to the excesses of painterliness. One has the sense that the question of whether or not an emotional state can be communicated (particularly in an abstract work) or worse still, to what degree it can be simulated or staged, must have struck some serious-minded young artists as disturbing. That the spontaneous splashes and drips could be manufactured was demonstrated by Robert Rauschenberg in his identical action paintings, *Factum I* and *Factum II*. In fact, it was almost as if, towards the *Götterdämmerung* of the late 1950s, the trumpets blared with such an apocalyptic and Wagnerian intensity that each moment was a crisis and each 'act' a climax. Obviously, such a crisis climate could hardly be sustained; just to be able to hear at all again, the volume had to be turned down, and the pitch, if not the instrument, changed.

Choreographer Merce Cunningham, whose work has been of the utmost importance to young choreographers,

may have been the first to put this reaction into words:[3] '*Now I can't see that crisis any longer means a climax, unless we are willing to grant that every breath of wind has a climax (which I am), but then that obliterates climax, being a surfeit of such. And since our lives, both by nature and by the newspapers, are so full of crisis that one is no longer aware of it, then it is clear that life goes on regardless, and further that each thing can be and is separate from each and every other, viz: the continuity of the newspaper headlines. Climax is for those who are swept by New Year's Eve.*'

In a dance called *Crises*, Cunningham eliminated any fixed focus or climax in much the way the young artists I am discussing here have banished them from their works as well. Thus, Cunningham's activity, too, must be considered as having helped to shape the new sensibility of the post-Abstract Expressionist generation.

It goes without saying that sensibility is not transformed overnight. At this point I want to talk about sensibility rather than style, because the artists I'm discussing, who are all roughly thirty, are more related in terms of a common sensibility than in terms of a common style. Also, their attitudes, interests, experiences and stance are much like those of their contemporaries, the Pop artists, although stylistically the work is not very similar.

Mainly this shift towards a new sensibility came, as I've suggested, in the 1950s, a time of convulsive transition not only for the art world, but for society at large as well. In these years, for some reasons I've touched on, many young artists found action painting unconvincing. Instead they turned to the static emptiness of Barnett Newman's eloquent chromatic abstractions or to the sharp visual punning of Jasper Johns' object-like flags and targets.

Obviously, the new sensibility that preferred Newman and Johns to Willem de Kooning or his epigoni was going to produce art that was different, not only in form but in content as well, from the art that it spurned, because it rejected not only the premises, but the emotional content of Abstract Expressionism. I think we cannot treat the revolt of these young artists as we would that of artists of the age of the second generation, that is, artists now roughly forty. For the art of that generation, the assumption that form and content are identical, the fundamental assumption of formalist criticism, seems adequate to describe the work. But in the work of the younger people, one has the sense that form and content do not coincide, that, in fact, a bland, neutral-looking form is the vehicle for a hostile, aggressive content. Even in instances such as the work of Bannard or Zox, where perhaps a purist reading might appear justifiable, there remains something that jars and sets the teeth just slightly on edge. Why, for example, are the pastel tints so unpleasant? Why is surface tension stretched to the breaking point? Why do we feel, in the end, vaguely deprived or frustrated? That such matters crop up, and that they are ultimately unanswerable, is part of the elusiveness and ambiguity that seem to be prime qualities of the new art. Of the sculptors one might ask similar questions: why is it so big, so blunt, so graceless, so inert? And why are the films and dances and music so boring, so

repetitious, so gratuitously long or short? In the art of these young people, form and content no longer mesh, with the result that the customer gets more or less than he bargained for.

The problem of the subversive content of these works is complicated, though it has to be approached, even if only to define why it is peculiar or corrosive. Often, because they appear to belong to the category of ordinary objects rather than art objects, these works look altogether devoid of Art content. This, as it has been pointed out in criticism of the so-called content-less novels of Alain Robbe-Grillet, is quite impossible for a work of art to achieve. The simple denial of content can in itself constitute the content of such a work. That these young artists attempt to suppress or withdraw content from their works is undeniable. That they wish to make art that is as bland, neutral and as redundant as possible also seems clear. The content, then, if we are to take the work at face value, should be nothing more than the total of the series of assertions that it is this or that shape and takes up so much space and is painted such a colour and made of such a material. Statements from the artists involved are frequently couched in these equally factual, matter-of-fact descriptive terms; the work is described but not interpreted and statements with regard to content or meaning or intention are prominent only by their omission.

For the spectator this is often all very bewildering. In the face of so much nothing, he is still experiencing something, and usually a rather unhappy something at that. I have often thought one had a sense of loss looking at these big, blank, empty things, so anxious to cloak their art identity that they were masquerading as objects. Perhaps what one senses is that, as opposed to the florid baroque fullness of the *angst*-ridden older generation, the hollow barrenness of the void has a certain poignant, if strangled, expressiveness. (Such subjectivity would of course be rejected by the artists in question with the notion of Boss Tweed: 'Balderdash is twaddle at any speed'.)

So, for the present, I prefer to confine myself mostly to describing the new sensibility rather than attempting to interpret an art that, by the terms of its own definition, resists interpretation. However, that there *is* a collective new sensibility among the young by now is self-evident. Looking around for examples, I was struck by the number of coincidences I discovered. For example, I found five painters who quite independently arrived at the identical composition of a large white or light-coloured rectangle in a coloured border. True, in some ways these were recapitulations of Malevich's *Black Square on White* (or to get closer to home, of Ellsworth Kelly's 1952 pair of a white square on black and black square on white); but there was an element in each example that finally frustrated a purist reading. In some cases (Ralph Humphrey's, for example) a Magritte-like sense of space behind a window-frame was what came across; other times there seemed to be a play on picture (blank) and frame (coloured), though again, it was nearly impossible to pin down a specific image or sensation, except for the reaction that they weren't quite what they seemed to be. In the same way, three of the

8. Merce Cunningham

sculptors I'm considering (Carl Andre, Robert Morris and Dan Flavin) have all used standard units interchangeably. Again, the reference is back to the Russians – particularly to Rodchenko in Andre's case – but still, another element has insinuated itself, preventing any real equations with Constructivist sculpture.

It is hard to make more specific remarks without incurring Boss Tweed's criticism. So rather than guess at intentions or look for meanings I prefer to try to surround the new sensibility, not to pin-point it. As T.E. Hulme put it, the problem is to keep from discussing the new art with a vocabulary derived from the old position. Though my end is simply the isolation of the old-fashioned *Zeitgeist*, I want to go about it impressionistically rather than methodically. I will take up notions now in the air which strike me as relevant to the work. As often as possible I will quote directly from texts that I feel have helped to shape the new sensibility. But I do not want to give the impression that everything I mention applies indiscriminately to all the artists under consideration. Where I do feel a specific cause and effect relationship exists between influences of the past and these artists' work, I will illustrate with examples [...]

A ROSE IS A ROSE IS A ROSE: REPETITION AS RHYTHMIC STRUCTURING

' ... the kind of invention that is necessary to make a general scheme is limited in everybody's experience, every time one of the hundreds of times a newspaper man makes fun of my writing and of my repetition he always has the same theme, that is, if you like, repetition, that as if you like the repeating that is the same thing, but once started expressing this thing, expressing any thing, there can be no repetition because the essence of that expression is insistence, and if you insist you must each time use emphasis and if you use emphasis it is not possible while anybody is alive that they should use exactly the same emphasis.'
– Gertrude Stein, *Portraits and Repetition, Lectures in America*, 1935

'Form ceases to be an ordering in time like ABA and reduces to a single, brief image, an instantaneous whole both fixed and moving. Satie's form can be extended only by reiteration or "endurance". Satie frequently scrutinizes a very simple musical object; a short unchanging ostinato accompaniment plus a fragmentary melody. Out of this sameness comes subtle variety.'
– Roger Shattuck, 'The Banquet Years', 1955

In painting, the repetition of a single motif (such as Larry Poons' dots or Gene Davis' stripes) over a surface usually means an involvement with Jackson Pollock's all-over paintings. In sculpture, the repetition of standard units may derive partly from practical considerations. But in the case of Judd's, Morris', Andre's and Flavin's pieces it seems to have more to do with setting up a measured, rhythmic beat in the work. Judd's latest sculptures, for example, are all reliefs made of a transverse metal rod from which are suspended, at even intervals, identical bar or box units. For some artists – for example, the West

Coast painter Billy Al Bengston, who puts sergeants' stripes in all his paintings – a repeated motif may take on the character of a personal insignia. Morris' four identical mirrored boxes, which were so elusive that they appeared literally transparent, and his recent L-shape plywood pieces were demonstrations of both variability and interchangeability in the use of standard units. To find variety in repetition where only the nuance alters seems more and more to interest artists, perhaps in reaction to the increasing uniformity of the environment and repetitiveness of a circumscribed experience. Andy Warhol's Brillo boxes, silk-screen paintings of the same image repeated countless times and films in which people or things hardly move are illustrations of the kind of life situations many ordinary people will face or face already. In their insistence on repetition both Satie and Gertrude Stein have influenced the young dancers who perform at the Judson Memorial Church Dance Theater in New York. Yvonne Rainer, the most gifted choreographer of the group (which formed as a result of a course in dance composition taught by the composer Robert Dunn at Merce Cunningham's New York dance studio) has said that repetition was her first idea of form:

'*I remember thinking that dance was at a disadvantage in relation to sculpture in that the spectator could spend as much time as he required to examine a sculpture, walk around it and so forth – but a dance movement – because it happened in time – vanished as soon as it was executed. So in a solo called* The Bells *performed at the Living Theater in 1961, I repeated the same seven movements for eight minutes. It was not exact repetition, as the sequence of the movements kept changing. They also underwent changes through being repeated in different parts of the space and faced in different directions – in a sense allowing the spectator to "walk around it".'*

For these dancers, and for composers like La Monte Young (who conceives of time as an endless continuum in which the performance of his *Dream Music* is a single, continuous experience interrupted by intervals during which it is not being performed) durations of time much longer than those we are accustomed to are acceptable. Thus, for example, an ordinary movement like walking across a stage may be performed in slow motion, and concerts of the *Dream Music* have lasted several days, just as Andy Warhol's first film, *Sleep*, was an 8-hour-long movie of a man sleeping. Again, Satie is at least a partial source. It is not surprising that the only performance of his piano piece, *Vexations*, in which the same fragment is ritualistically repeated 840 times, took place two years ago in New York. The performance lasted 18 hours, 40 minutes and required the participation in shifts of a dozen or so pianists, of whom John Cage was one. Shattuck's statement that 'Satie seems to combine experiment and inertia' seems applicable to a certain amount of avant-garde activity of the moment.

ART AS A DEMONSTRATION: THE FACTUAL, THE CONCRETE, THE SELF-EVIDENT

'But what does it mean to say that we cannot define (that is, describe) these elements, but only name them? This might mean, for instance, that when in a limiting case a complex consists of only one square, its description is simply the name of the coloured square.

'There are, of course, what can be called "characteristic experiences" of painting to (e.g.) the shape. For example, following the outline with one's finger or with one's eyes as one points – But this does not happen in all cases in which I "mean the shape", and no more does any other one characteristic process occur in all these cases.'
– Ludwig Wittgenstein, 'Philosophical Investigations', 1953

If Jasper Johns' notebooks seem a parody of Wittgenstein, then Judd's and Morris' sculptures often look like illustrations of that philosopher's propositions. Both sculptors use elementary, geometrical forms which depend for their art quality on some sort of presence or concrete thereness, which in turn often seems no more than a literal and emphatic assertion of their existence. There is no wish to transcend the physical for either the metaphysical or the metaphoric. The thing, thus, is presumably not supposed to 'mean' other than what it is; that is, it is not supposed to be suggestive of anything other than itself. Morris' early plywood pieces are all of elementary structures: a door, a window-frame, a platform. He even did a wheel, the most rudimentary structure of all. In a dance he made called *Site*, he mimed what were obviously basic concepts about structure. Dressed as a construction worker, he manipulated flat plywood sheets ('planes', one assumes) until finally he pulled the last one away to reveal behind it a nude girl posed as Manet's *Olympia*. As I've intimated, Morris' dances seem to function more as *explications du texte* of his sculptures than as independent dances or theatrical events. Even their deliberately enigmatic tone is like his sculpture, although he denies that they are related. Rauschenberg, too, has done dances which, not surprisingly, are like three-dimensional, moving equivalents of his combined constructions and are equally littered with objects. But his dance trio called *Pelican* for two men on roller-skates and a girl in toe-shoes has that degree of innovation and surprise which characterizes his best paintings.

ART AS CONCRETE OBJECT

'Now the world is neither meaningful nor absurd. It simply is ... In place of this universe of "meanings" (psychological, social, functional), one should try to construct a more solid, more immediate world. So that first of all it will be through their presence that objects and gestures will impose themselves, and so that this presence continues thereafter to dominate, beyond any theory of explication that might attempt to enclose them in any sort of a sentimental, sociological, Freudian, metaphysical or any other system of reference.'
– Alain Robbe-Grillet, 'Une voie pour le roman futur', *Pour un Nouveau Roman*, 1956

Curiously, it is perhaps in the theory of the French objective novel that one most closely approaches the attitude of many of the artists I've been talking about. I am convinced that this is sheer coincidence, since I have no reason to believe there has been any specific point of contact. This is quite the contrary to their knowledge of

9. Andy Warhol

Wittgenstein, whom I know a number of them have read. But none the less the rejection of the personal, the subjective, the tragic and the narrative in favour of the world of things seems remarkable, even if or even because it is coincidental.

But neither in the new novels nor in the new art is the repudiation of content convincing. The elimination of the narrative element in dance (or at least its suppression to an absolute minimum) has been one of Merce Cunningham's most extraordinary achievements, and in this the best of the young choreographers have followed his lead. Although now, having made dance more abstract than it has ever been, they all (including Cunningham in *Story*) appear to be reintroducing the narrative element precisely in the form of the objects, which they carry, pass around, manipulate and so forth […]

That all this new art is so low-key, and so often concerned with little more than nuances of differentiation and executed in the *pianissmo* we associate with, for example, Morton Feldman's music, makes it rather out of step with the screeching, blaring, spangled carnival of American life. But if Pop art is the reflection of our environment, perhaps the art I have been describing is its antidote, even if it is a hard one to swallow. In its oversized, awkward, uncompromising, sometimes brutal directness, and in its refusal to participate, either as entertainment or as whimsical, ingratiating commodity (being simply too big or too graceless or too empty or too boring to appeal) this new art is surely hard to assimilate with ease. And it is almost as hard to talk about as it is to have around, because of the art that is being made now, it is clearly the most ambivalent and the most elusive. For the moment one has made a statement, or more hopeless still, attempted a generality, the precise opposite then appears to be true, sometimes simultaneously with the original thought one had. As Roger Shattuck says of Satie's music: '*The simplest pieces, some of the humoristic works and children's pieces built out of a handful of notes and rhythms are the most enigmatic for this very reason: they have no beginning, middle and end. They exist simultaneously*'.

So with the multiple levels of an art not so simple as it looks.

1 Richard Wollheim, *Arts Magazine* (January 1965).

2 Michael Fried, *Three American Painters* (Cambridge, Massachusetts: Fogg Art Museum, Harvard University, 1965).

3 Merce Cunningham, *trans/formation*, 1 (1952).

Barbara Rose, 'ABC Art', *Art in America*, 53: 5 (October-November 1965) 57-69; reprinted in *Minimal Art: A Critical Anthology*, ed. Gregory Battcock (New York: E.P. Dutton & Co., 1968).

Robert MORRIS
Notes on Sculpture: Part I
[1966]

'What comes into appearance must segregate in order to appear.'
– Johann Wolfgang von Goethe

There has been little definitive writing on present-day sculpture. When it is discussed it is often called in to support a broad iconographic or iconological point of view – after the supporting examples of painting have been exhausted. Kubler has raised the objection that iconological assertions presuppose that experiences so different as those of space and time must somehow be interchangeable.' It is perhaps more accurate to say, as Barbara Rose has recently written, that specific elements are held in common among the various arts today – an iconographic rather than an iconological point of view. The distinction is helpful, for the iconographer who locates shared elements and themes has a different ambition than the iconologist, who, according to Panofsky, locates a common meaning. There may indeed be a general sensibility in the arts at this time. Yet the histories and problems of each, as well as the experiences offered by each art, indicate involvement in very separate concerns. At most, the assertions of common sensibilities are generalizations that minimize differences. The climactic incident is absent in the work of John Cage and Barnett Newman. Yet it is also true that Cage has consistently supported a methodology of collage that is not present in Newman. A question to be asked of common sensibilities is to what degree they give one a purchase on the experience of the various arts from which they are drawn. Of course this is an irrelevant question for one who approaches the arts in order to find identities of elements or meanings.

In the interest of differences it seems time that some of the distinctions sculpture has managed for itself be articulated. To begin in the broadest possible way it should be stated that the concerns of sculpture have been for some time not only distinct from but hostile to those of painting. The clearer the nature of the values of sculpture become the stronger the opposition appears. Certainly the continuing realization of its nature has had nothing to do with any dialectical evolution that painting has enunciated for itself. The primary problematic concerns with which advanced painting has been occupied for about half a century have been structural. The structural element has been gradually revealed to be located within the nature of the literal qualities of the support.[2] It has been a long dialogue with a limit. Sculpture, on the other hand, never having been involved with illusionism could not possibly have based the efforts of fifty years upon the rather pious, if somewhat contradictory, act of giving up this illusionism and approaching the object. Save for replication, which is not to be confused with illusionism, the sculptural facts of space, light and materials have always functioned concretely and literally. Its allusions or references have not been commensurate with the indicating sensibilities of painting. If painting has sought to approach the object, it has sought equally hard to dematerialize itself on the way. Clearer distinctions between sculpture's essentially tactile nature and the optical sensibilities involved in painting need to be made.

Vladimir Tatlin was perhaps the first to free sculpture from representation and establish it as an autonomous form both by the kind of image, or rather non-image, he employed and by his literal use of materials. He, Aleksandr Rodchenko and other Constructivists refuted Guillaume Apollinaire's observation that 'a structure becomes architecture, and not sculpture, when its elements no longer have their justification in nature'. At least the earlier works of Tatlin and other Constructivists made references to neither the figure nor architecture. In subsequent years Naum Gabo, and to a lesser extent Maurice Pevsner and Georges Vantongerloo, perpetuated the constructivist ideal of a non-imagistic sculpture that was independent of architecture. This autonomy was not sustained in the work of the greatest American sculptor, the late David Smith. Today there is a reassertion of the non-imagistic as an essential condition. Although, in passing, it should be noted that this condition has been weakened by a variety of works that, while maintaining the non-imagistic, focus themselves in terms of the highly decorative, the precious or the gigantic. There is nothing inherently wrong with these qualities; each offers a concrete experience. But they happen not to be relevant experiences for sculpture, for they unbalance complex plastic relationships just to that degree that one focuses on these qualities in otherwise non-imagistic works.

The relief has always been accepted as a viable mode. However, it cannot be accepted today as legitimate. The autonomous and literal nature of sculpture demands that it have its own, equally literal space – not a surface shared with painting. Furthermore, an object hung on the wall does not confront gravity; it timidly resists it. One of the conditions of knowing an object is supplied by the sensing of the gravitational force acting upon it in actual space. That is, space with three, not two, coordinates. The ground plane, not the wall, is the necessary support for the maximum awareness of the object. One more objection to the relief is the limitation of the number of possible views the wall imposes, together with the constant of up, down, right, left.

Colour as it has been established in painting, notably by Jules Olitski and Morris Louis, is a quality not at all bound to stable forms. Michael Fried has pointed out that one of their major efforts has been, in fact, to free colour of drawn shape. They have done all this by either enervating drawing (Louis) or eliminating it totally (recent Olitski), thereby establishing an autonomy for colour that was only indicated by Jackson Pollock. This transcendence of colour over shape in painting is cited here because it demonstrates that it is the most optical element in an optical medium. It is this essentially optical, immaterial, non-containable, non-tactile nature of colour that is inconsistent with the physical nature of sculpture. The qualities of scale, proportion, shape, mass, are physical. Each of these qualities is made visible by the adjustment of an obdurate, literal mass. Colour does not have this characteristic. It is additive. Obviously things exist as coloured. The objection is raised against the use of colour that emphasizes the optical and in so doing subverts the physical. The more neutral hues, which do not call attention to themselves, allow for the maximum focus on those essential physical decisions that inform sculptural works. Ultimately the consideration of the nature of

sculptural surfaces is the consideration of light, the least physical element, but one that is as actual as the space itself. For unlike paintings, which are always lit in an optimum way, sculpture undergoes changes by the incidence of light. David Smith in the *Cubi* works has been one of the few to confront sculptural surfaces in terms of light. Piet Mondrian went so far as to claim that: '*Sensations are not transmissible, or rather, their purely qualitative properties are not transmissible. The same, however, does not apply to relations between sensations ... Consequently only relations between can have an objective value ...* '

This may be ambiguous in terms of perceptual facts, but in terms of looking at art it is descriptive of the condition that obtains. It obtains because art objects have clearly divisible parts that set up the relationships. Such a condition suggests the alternative question: could a work exist that has only one property? Obviously not, since nothing exists that has only one property. A single, pure sensation cannot be transmissible precisely because one perceives simultaneously more than one property as parts in any given situation: if colour, then also dimension; if flatness, then texture, etc. However, certain forms do exist that, if they do not negate the numerous relative sensations of colour to texture, scale to mass, etc., do not present clearly separated parts for these kinds of relations to be established in terms of shapes. Such are the simpler forms that create strong Gestalt sensations. Their parts are bound together in such a way that they offer a maximum resistance to perceptual separation. In terms of solids, or forms applicable to sculpture, these Gestalts are the simpler polyhedrons. It is necessary to consider for a moment the nature of three-dimensional Gestalts as they occur in the apprehension of the various types of polyhedrons. In the simpler regular polyhedrons, such as cubes and pyramids, one need not move around the object for the sense of the whole, the Gestalt, to occur. One sees and immediately 'believes' that the pattern within one's mind corresponds to the existential fact of the object. Belief in this sense is both a kind of faith in spatial extension and a visualization of that extension. In other words, it is those aspects of apprehension that are not co-existent with the visual field but rather the result of the experience of the visual field. The more specific nature of this belief and how it is formed involve perceptual theories of 'constancy of shape', 'tendencies towards simplicity', kinesthetic clues, memory traces and physiological factors regarding the nature of binocular parallax vision and the structure of the retina and brain. Neither the theories nor the experiences of Gestalt effects relating to three-dimensional bodies are as simple and clear as they are for two dimensions. But experience of solids establishes the fact that, as in flat forms, some configurations are dominated by wholeness, others tend to separate into parts. This becomes clear if the other types of polyhedrons are considered. In the complex regular type there is a weakening of visualization as the number of sides increases. A sixty-four-sided figure is difficult to visualize, yet because of its regularity one senses the whole, even if seen from a single viewpoint. Simple irregular polyhedrons, such as beams, inclined planes, truncated

pyramids, are relatively more easy to visualize and sense as wholes. The fact that some are less familiar than the regular geometric forms does not affect the formation of a Gestalt. Rather, the irregularity becomes a particularizing quality. Complex irregular polyhedrons (for example, crystal formations), if they are complex and irregular enough, can frustrate visualization almost completely, in which case it is difficult to maintain one is experiencing a Gestalt. Complex irregular polyhedrons allow for divisibility of parts in so far as they create weak Gestalts. They would seems to return one to the conditions of works that, in Mondrian's terms, transmit relations easily in that their parts separate. Complex regular polyhedrons are more ambiguous in this respect. The simpler regular and irregular ones maintain the maximum resistance to being confronted as objects with separate parts. They seem to fail to present lines of fracture by which they could divide for easy part-to-part relationships to be established. I term these simple regular and irregular polyhedrons 'unitary' forms. Sculpture involving unitary forms, being bound together as it is with a kind of energy provided by the Gestalt, often elicits the complaint among critics that such works are beyond analysis.

Characteristic of a Gestalt is that once it is established all the information about it, *qua* Gestalt, is exhausted. (One does not, for example, seek the Gestalt of a Gestalt.) Furthermore, once it is established it does not disintegrate. One is then both free of the shape and bound to it. Free or released because of the exhaustion of information about it, as shape, and bound to it because it remains constant and indivisible.

Simplicity of shape does not necessarily equate with simplicity of experience. Unitary forms do not reduce relationships. They order them. If the predominant, hieratic nature of the unitary form functions as a constant, all those particularizing relations of scale, proportion, etc., are not thereby cancelled. Rather they are bound more cohesively and indivisibly together. The magnification of this single most important sculptural value – shape – together with greater unification and integration of every other essential sculptural value makes, on the one hand, the multipart, inflected formats of past sculpture extraneous, and on the other, establishes both a new limit and a new freedom for sculpture.

1 'Thus *Strukturforschung* presupposes that the poets and artists of one place and time are the joint bearers of a central pattern of sensibility from which their various efforts all flow like radial expressions. This position agrees with the iconologist's, to whom literature and art seem approximately interchangeable.' George Kubler, *The Shape of Time* (New Haven: Yale University Press, 1962) 27.

2 Both Clement Greenberg and Michael Fried have dealt with this evolution. Fried's discussion of 'deductive structure' in his catalogue *Three American Painters* (Cambridge, Massachusetts: Fogg Art Museum, Harvard University, 1965) deals explicitly with the role of the support in painting.

Robert Morris, 'Notes on Sculpture: Part I', *Artforum*, 4: 6 (February 1966); reprinted in *Minimal Art: A Critical Anthology*, ed. Gregory Battcock (New York: E.P. Dutton &

Co., 1968) 222–28.

Robert MORRIS
Notes on Sculpture: Part II
[1966]

'Q. Why didn't you make it larger so that it would loom over the observer?
A. I was not making a monument.
Q. Then why didn't you make it smaller so that the observer could see over the top?
A. I was not making an object.'
– Tony Smith's replies to questions about his 183-cm [6-ft] steel cube

The size range of useless three-dimensional things is a continuum between the monument and the ornament. Sculpture has generally been thought of as those objects not at the polarities but falling between. The new work being done today falls between the extremes of this size continuum. Because much of it presents an image of neither figurative nor architectonic reference, the works have been described as 'structures' or 'objects'. The word *structure* applies either to anything or to how a thing is put together. Every rigid body is an object. A particular term for the new work is not as important as knowing what its values and standards are.

In the perception of relative size the human body enters into the total continuum of sizes and establishes itself as a constant on that scale. One knows immediately what is smaller and what is larger than himself. It is obvious, yet important, to take note of the fact that things smaller than ourselves are seen differently than things larger. The quality of intimacy is attached to an object in a fairly direct proportion as its size diminishes in relation to oneself. The quality of publicness is attached in proportion as the size increases in relation to oneself. This holds true so long as one is regarding the whole of a large thing and not a part. The qualities of publicness or privateness are imposed on things. This is because of our experience in dealing with objects that move away from the constant of our own size in increasing or decreasing dimension. Most ornaments from the past, Egyptian glassware, Romanesque ivories, etc., consciously exploit the intimate mode by highly resolved surface incident. The awareness that surface incident is always attended to in small objects allows for the elaboration of fine detail to sustain itself. Large sculptures from the past that exist now only in small fragments invite our vision to perform a kind of magnification (sometimes literally performed by the photograph) that gives surface variation on these fragments the quality of detail it never had in the original whole work. The intimate mode is essentially closed, spaceless, compressed and exclusive.

While specific size is a condition that structures one's response in terms of the more or less public or intimate, enormous objects in the class of monuments elicit a far more specific response to size *qua* size. That is, besides

providing the condition for a set of responses, large-sized objects exhibit size more specifically as an element. It is the more conscious appraisal of size in monuments that makes for the quality of 'scale'. The awareness of scale is a function of the comparison made between that constant, one's body size and the object. Space between the subject and the object is implied in such a comparison. In this sense space does not exist for intimate objects. A larger object includes more of the space around itself than does a smaller one. It is necessary literally to keep one's distance from large objects in order to take the whole of any one view into one's field of vision. The smaller the object the closer one approaches it and, therefore, it has correspondingly less of a spatial field in which to exist for the viewer. It is this necessary greater distance of the object in space from our bodies, in order that it be seen at all, that structures the non-personal or public mode. However, it is just this distance between object and subject that creates a more extended situation, for physical participation becomes necessary. Just as there is no exclusion of literal space in large objects, neither is there an exclusion of the existing light.

Things of the monumental scale, then, include more terms necessary for their apprehension than objects smaller than the body, namely, the literal space in which they exist and the kinesthetic demands placed upon the body.

A simple form like a cube will necessarily be seen in a more public way as its size increases from that of our own. It accelerates the valence of intimacy as its size decreases from that of one's own body. This is true even if the surface, material and colour are held constant. In fact it is just these properties of surface, colour, material, that get magnified into details as size is reduced. Properties that are not read as detail in large works become detail in small works. Structural divisions in work of any size are another form of detail. (I have discussed the use of a strong Gestalt or of unitary-type forms to avoid divisiveness and set the work beyond *retardataire* Cubist aesthetics in 'Notes on Sculpture: Part I', above.) There is an assumption here of different kinds of things becoming equivalent. The term 'detail' is used here in a special and negative sense and should be understood to refer to all factors in a work that pull it towards intimacy by allowing specific elements to separate from the whole, thus setting up relationships within the work. Objections to the emphasis on colour as a medium foreign to the physicality of sculpture have also been raised previously, but in terms of its function as a detail a further objection can be raised. That is, intense colour, being a specific element, detaches itself from the whole of the work to become one more internal relationship. The same can be said of emphasis on specific, sensuous material or impressively high finishes. A certain number of these intimacy-producing relations have been gotten rid of in the new sculpture. Such things as process showing through traces of the artist's hand have obviously been done away with. But one of the worst and most pretentious of these intimacy-making situations in some of the new work is the scientistic element that shows up generally in the application of mathematical or engineering concerns to generate or inflect images. This

may have worked brilliantly for Jasper Johns (and he is the prototype for this kind of thinking) in his number and alphabet paintings, in which the exhaustion of a logical system closes out and ends the image and produces the picture. But appeals to binary mathematics, tensegrity techniques, mathematically derived modules, progressions, etc., within a work are only another application of the Cubist aesthetic of having reasonableness or logic for the relating parts. The better new work takes relationships out of the work and makes them a function of space, light and the viewer's field of vision. The object is but one of the terms in the newer aesthetic. It is in some way more reflexive because one's awareness of oneself existing in the same space as the work is stronger than in previous work, with its many internal relationships. One is more aware than before that he himself is establishing relationships as he apprehends the object from various positions and under varying conditions of light and spatial context. Every internal relationship, whether it be set up by a structural division, a rich surface or what have you, reduces the public, external quality of the object and tends to eliminate the viewer to the degree that these details pull him into an intimate relation with the work and out of the space in which the object exists.

Much of the new sculpture makes a positive value of large size. It is one of the necessary conditions of avoiding intimacy. Larger than body size has been exploited in two specific ways: either in terms of length or of volume. The objection to current work of large volume as monolith is a false issue. It is false not because identifiable hollow material is used – this can become a focused detail and an objection in its own right – but because no one is dealing with obdurate solid masses and everyone knows this. If larger than body size is necessary to the establishment of the more public mode, nevertheless it does not follow that the larger the object the better it does this. Beyond a certain size the object can overwhelm and the gigantic space of the room itself is a structuring factor both in its cubic shape and in terms of the kinds of compression different sized and proportioned rooms can affect upon the object-subject terms. That the space of the room becomes of such importance does not mean that an environmental situation is being established. The total space is hopefully altered in certain desired ways by the presence of the object. It is not controlled in the sense of being ordered by an aggregate of objects or by some shaping of the space surrounding the viewer. These considerations raise an obvious question. Why not put the work outside and further change the terms? A real need exists to allow this next step to become practical. Architecturally designed sculpture courts are not the answer nor is the placement of work outside cubic architectural forms. Ideally, it is a space without architecture as background and reference that would give different terms to work with.

While all the aesthetic properties of work that exists in a more public mode have not yet been articulated, those which have been dealt with here seem to have a more variable nature than the corresponding aesthetic terms of intimate works. Some of the best of the new work, being

more open and neutral in terms of surface incident, is more sensitive to the varying contexts of space and light in which it exists. It reflects more acutely these two properties and is more noticeably changed by them. In some sense it takes these two things into itself as its variation is a function of their variation. Even its most patently unalterable property – shape – does not remain constant. For it is the viewer who changes the shape constantly by his change in position relative to the work. Oddly, it is the strength of the constant, known shape, the Gestalt, that allows this awareness to become so much more emphatic in these works than in previous sculpture. A baroque figurative bronze is different from every side. So is a 183-cm [6-ft] cube. The constant shape of the cube held in the mind but which the viewer never literally experiences, is an actuality against which the literal changing, perspective views are related. There are two distinct terms: the known constant and the experienced variable. Such a division does not occur in the experience of the bronze.

While the work must be autonomous in the sense of being a self-contained unit for the formation of the Gestalt, the indivisible and undissolvable whole, the major aesthetic terms are not in but dependent upon this autonomous object and exist as unfixed variables that find their specific definition in the particular space and light and physical viewpoint of the spectator. Only one aspect of the work is immediate: the apprehension of the Gestalt. The experience of the work necessarily exists in time. *The intention is diametrically opposed to Cubism with its concern for simultaneous views in one plane.* Some of the new work has expanded the terms of sculpture by a more emphatic focusing on the very conditions under which certain kinds of objects are seen. The object itself is carefully placed in these new conditions to be but one of the terms. The sensuous object, resplendent with compressed internal relations, has had to be rejected. That many considerations must be taken into account in order that the work keep its place as a term in the expanded situation hardly indicates a lack of interest in the object itself. But the concerns now are for more control of and/or co-operation of the entire situation. Control is necessary if the variables of object, light, space, body are to function. The object itself has not become less important. It has merely become less *self*-important. By taking its place as a term among others the object does not fade off into some bland, neutral, generalized or otherwise retiring shape. At least most of the new works do not. Some, which generate images so readily by innumerably repetitive modular units, do perhaps bog down in a form of neutrality. Such work becomes dominated by its own means through the overbearing visibility of the modular unit. So much of what is positive in giving to shapes the necessary but non-dominating, non-compressed presence has not yet been articulated. Yet much of the judging of these works seems based on the sensing of the rightness of the specific, non-neutral weight of the presence of a particular shape as it bears on the other necessary terms.

The particular shaping, proportions, size, surface of the specific object in question are still critical sources for the particular quality the work generates. But it is now not

possible to separate these decisions, which are relevant to the object as a thing in itself, from those decisions external to its physical presence. For example, in much of the new work in which the forms have been held unitary, placement becomes critical as it never was before in establishing the particular quality of the work. A beam on its end is not the same as the same beam on its side.

It is not surprising that some of the new sculpture that avoids varying parts, polychrome, etc., has been called negative, boring, nihilistic. These judgements arise from confronting the work with expectations structured by a Cubist aesthetic in which what is to be had from the work is located strictly within the specific object. The situation is now more complex and expanded.

Robert Morris, 'Notes on Sculpture: Part II', *Artforum*, 5: 2 (October 1966); reprinted in *Minimal Art: A Critical Anthology*, ed. Gregory Battcock (New York: E.P. Dutton & Co., 1968) 228-35.

Hilton KRAMER
'Primary Structures': The New Anonymity [1966]

Certain exhibitions usher us into the present in easy stages, educating our sensibilities to new and unexpected alternatives by means of a careful expository logic that adjusts our expectations to each of the aesthetic and historical shocks that awaits us. This is not the case with the new show called 'Primary Structures', which opened this week at the Jewish Museum, Fifth Avenue at 92nd Street. Here the transition from past – even the very recent past – to present is abrupt and precipitous. Confronting the multitude of objects that comprise this exhibition, there is no mistaking the fact that we are in a realm of feeling and of ideas utterly removed from the pieties and assumptions that have governed a good deal of Modern art. Everything about the works of art included here – their scale, their materials, their radical renunciations – is a reminder that a new aesthetic era is upon us.

In calling the exhibition 'Primary Structures', the museum's Curator of Painting and Sculpture, Kynaston McShine, who organized the show, discreetly refuses to identify it as a survey of sculpture. And there is good reason for this discretion: so much of the work has such marked affinities with painting and architecture that, at first glance anyway, its strict sculptural identity seems blurred. But only at first glance, I think. This is, for better or worse, an exhibition of new sculpture, and its interest lies in the way it defines the new sculptural aesthetics.

Fundamental to this new aesthetics is an attitude of detachment and impersonality – an attitude that finds its proper expression in forms and materials that do not require the intervention of the artist's hand; that may, in fact, be best executed by mechanical means that do not permit the artist's hand to play any role whatever. Many of the artists included in the exhibition actually do construct and paint or otherwise finish their work themselves, but the sculptural imagery they aspire to does not require

them to do so. Their aims can be carried out so much better by workers professionally trained for the task. As Mr McShine observes in his introduction to the catalogue, the sculptor can 'now conceive his work, and entrust its execution to a manufacturer whose precision and skill convey the standardized "impersonality" that the artist may seek'.

In order to realize sculpture on this order, form must adhere to an extreme simplicity and regularity: geometricity will naturally be favoured. The materials employed must be of an extreme anonymity: painted flat wood surfaces are widely used, and sheet metal too, but the new industrially produced plastics, being even more impersonal than even the most slickly painted surface, are clearly superior for the end in view. For what these new sculptors desire above all is to have their conceptions embodied in a physical object that will function as an expressive visual statement while remaining completely barren of all subjective involvement.

There are forty-two American and British sculptors included in the 'Primary Structures' exhibition – most of them young and little known to the general public – and not all of them succeed in adhering to this impersonal ideal.

What remains important – what, indeed, assumes the greatest importance – are the logistics of form itself. There are sculptural precedents for what the new sculptors are doing – precedents to be found in the work of Naum Gabo and Georges Vantongerloo and Max Bill, in Alexander Calder and David Smith and Louise Nevelson – but these are less immediately relevant than the inspiration that has been drawn from recent painting. In particular, hard-edge and Colour Field painting quite dominates both the way colour is used and the physical scale of the structures themselves. One might say that the new sculpture is, in effect, a species of abstract painting aspiring to the condition of architecture: it is sculpture only because the sculptural medium is the sole means by which this aspiration can be realized.

If one turns from the overall aesthetics of the 'Primary Structures' show to the individual works that make it up, one cannot help feeling that this is an exhibition stronger and more interesting in its general principles than in its specific accomplishments. A good many works engage one's interest as demonstrations of theoretical possibilities, but then fail to sustain one's attention as expressive entities in their own right. I cannot recall another exhibition of contemporary art that has, to the same extent, left me feeling so completely that I had not so much encountered works of art as taken a course in them. One is enlightened, but rarely moved [...]

Hilton Kramer, '"Primary Structures": The New Anonymity', *New York Times* (1 May 1966) 23.

Mark DI SUVERO, Donald JUDD, Kynaston MCSHINE, Robert MORRIS, Barbara ROSE
The New Sculpture [1966]

Barbara Rose [...] I wanted to explain the appropriateness of the participation of Robert Morris, Donald Judd and Mark di Suvero in this symposium. They were among the first to establish and make explicit new positions in sculpture which made possible some of the developments this show has focused upon. In di Suvero's work there is a kind of dynamic tension of structural relationships and a directness of impact that have influenced many young sculptors, particularly those in the Park Place group. Morris was one of, if not the first, to use simple unitary volumes rather than to make sculpture that depended on a relationship of parts. Several works in the show by other artists derive directly from prototypes he executed in plywood from 1961–65 which were exhibited at the Green Gallery, and widely reproduced in photographs. In these works he used the room as a general environment for works which related to floor, wall and ceiling in unprecedented ways. Judd was among the first to use identical or repeated elements and to work with mathematical sequences, particularly those extendible to infinity. Like Morris, he too used simple volumes and non-relational composition. I think it is important to point out how these three artists developed precedents which prepared the way for the kind of work we're seeing now. Di Suvero's work, although more romantic than the sculpture in the show, must be counted as part of the general context in which it developed. And on that score, I want to ask Mark whether he agrees with Hilton Kramer that the new sculpture is anonymous and impersonal, and whether he finds this objectionable, since it is an aesthetic position opposed to his work.

Mark di Suvero I think 'Primary Structures' is the key show of the 1960s, and that it has introduced a new generation of artists. As for whether the work is anonymous, all work is anonymous that doesn't have any name. Some of it is beautiful. The Ron Bladen, for example, is a great piece. It expands our idea of scale and really changes our knowledge of space. Some of the work presents itself as manufactured object, and the very sense of objectness eliminates it from what I think is the most crucial part of modern sculpture. I think that my friend Don Judd can't qualify as an artist because he doesn't do the work. And there is more and more of this kind of thing, which to my mind is the negation of the object by making an object. But this is not grappling with the essential fact that a man has to make a thing in order to be an artist. As far as I'm concerned, those works which give me that sense of radiance which I find I need in a work are those that have been actually worked over by an artist. I think that all those pointed-up bronzes, the pointed-up marbles,

the expanded bronzes from the casts, are meaningless.

Donald Judd Now wait a minute. The point is not whether one makes a work oneself or not. The point is that it's all a case of technique that makes the thing visible, so that I don't see in the long run why one technique is any more essentially art than another technique. And there are presumably an infinite number of techniques. I don't see why someone shouldn't go out and find the one that suits him, whether or not it conforms to the manipulatory technique that's been going on for some time or to a new one.

Rose Here is the crucial question: whether an abstract aesthetic conception which may be manufactured or fabricated is as much art as the personal manipulation of materials. I think the heart of most of the objections to the new work is that people feel that since they can't see the artist's fingerprints, it's not a personal statement.

Robert Morris I think that's a ridiculous issue, and I don't think whether you fabricate it yourself or have somebody fabricate it for you has anything to do with making art. My interest is in having the work as well executed as possible […]

Judd Mark is defining space as something that is moved by the forms. If it isn't moved, if it's static, then, according to his definition, it isn't really space. But that space that is shifted around or activated in one way or another is not what interests me.

Di Suvero The people who change space through a new sense of scale are the ones I dig the most. Giacometti certainly does it, although he has to use the figure. But he actually changes the size of the space.

Judd I hate that kind of space and purposely avoid it, because it's an anthropomorphic kind of space […]

Rose To go on to another point, Hilton Kramer listed what he believes were the precedents for the new sculpture in the works of the Constructivists, Naum Gabo, Georges Vantongerloo, Alexander Calder, David Smith and Louise Nevelson. I don't agree that their work has any kind of direct relationship to the new sculpture, except perhaps in the scale of Calder's and Smith's works or in their relative simplicity. The roots of the new work, it seems to me, lie more specifically in painting, in that it grows out of a dissatisfaction with the limitations of painting. I know, for example, that Don and Bob were both originally painters. Let me ask you then, why did you stop painting and start making sculpture?

Morris I couldn't say. I stopped painting and I didn't do anything for two years and then I started making sculpture. So I don't feel that there's any connection between the two.

Judd I became very tired of several major aspects of painting and felt that I couldn't do anything I would ever like with any of them. In the first place, I was tired of the fact that it's a rectangle, and in the second, that it's so many inches from the wall, and that no matter what you do you have to put something within the shape of the canvas. For example, if you put a series of circles within the canvas, that leaves all that border around the circles. On the other hand, if you decide you want to emphasize the rectangularity of the canvas, then you have to use elements that enforce it, that is, correspond to the edges in

some way. That really leaves you no choice. And also, paintings are invariably canvas. And I'm very tired of that particular surface, and of oil paint too. So it seemed a good thing to give up. Painting seemed very restricted. No matter what you did you couldn't make it strong enough and clear enough. So there was nothing to do but quit on it. Apropos of sculpture, I never took sculpture as a model, although I was impressed, not influenced exactly, but pushed somewhat by quite a few people, for example by Lee Bontecou and John Chamberlain, who at one time I thought did stronger work than I could possibly do. And one of the reasons I stopped painting at the same time was that Oldenburg's work was much stronger than anything I could possibly make in a painting. So the new developments in sculpture don't exactly amount to a revolution. It didn't come overnight, I think it's had a pretty normal development. And you don't want to get saddled with a lot of people who are supposed to have influenced you who didn't influence you. For example, even though I admired Smith's work, I never seriously considered it as an influence. But Kramer mentions that Smith's last show was an influence. Now chronologically that's impossible, because it was last year, and everybody was pretty well along in what they were doing by then, so Smith's late pieces could not have been an influence. In fact, sculpture always looked archaic to me. It always had the kind of space Mark talked about, and it always had related forms and a certain hierarchy of parts – the major part, the minor part and so forth. These were things I wasn't interested in and which I certainly was trying to get away from in painting.

Rose But that's what I mean about painting being a primary source for a number of the ideas in the new sculpture. For example, the elimination of internal compositional relationships was accomplished in painting by Pollock and Newman. That is why I feel the antecedents for the new sculpture can be found in painting rather than in sculpture.

Judd Yes, but I'd say at least for myself that those antecedents are extremely general, and that they mostly concern scale. Almost everybody assumes that broad scale is desirable now. Nearly all the best works have it.

Kynaston McShine How about the Russian Constructivists. Were you interested in their work?

Morris No, I never paid any attention to it. The first sculptures I made were a portal and a column. I copied both forms directly out of the Zoser complex in Egypt.

Judd I think everybody considered Constructivism, neo-Plasticism and Cubism past history by the time Bob and I were developing our work. Piet Mondrian was dead and gone and an Old Master when I thought about painting. Recent American painting seemed much more actual.

McShine In the new work, repetition is a very strong element. Why do you think this is so?

Rose Repetition is a method of structuring; rhythm is important to art. The three repeated diagonals in Ron Bladen's piece give a particular kind of emphasis and the impressive sense of monumentality or static majesty, if you like.

McShine But it's not really static because part of the experience consists of just walking around it.

Rose Let's put it this way ... the viewer moves but the forms don't leap or jump around. They remain, at least in comparison with open welded or assembled work, relatively static. They really stand still. That's one of the big differences between Mark's position and the new aesthetic. And the content of the new work is quite different from the more emotional and romantic content of earlier work.

Judd Mark states that sculpture imitates movement in a way. You know, the gist of it is that a certain anthropomorphic attitude runs through his work. One finds it not only in his work, but in the general history of art for the last several hundred years. Although I like his work very much, I would object to this quality if I were doing it. Smith, too, I think does a great deal of alluding to other things. The general structure even in the last pieces is rather figurative. He has a box there and a box there, which is very relational and allusive. And that particular quality I find pretty unbelievable philosophically and pretty uninteresting. I'd like work that didn't allude to other things and was a specific thing in itself which derived a specific quality from its form. But I think that my work and Bob's work is art in the same sense that work has always been art. It intends to have a certain quality which deals with what you think about the world, and whatever art is, and I don't think it is essentially any different than art has always been in that respect. And it's certainly not impersonal, anonymous and all that sort of stuff. I'd rather stay clear of the word spiritual since I don't like its old meaning. I think that a given thing creates an interesting space but that you don't need to set up a certain amount of motion to make it interesting, that a surface in itself is interesting. You don't have to set a form at an angle and relate something else to it. If you have a rectangle of a certain size and certain surface and material, and it has the quality you want, then it's sufficiently interesting and you don't have to work it into some other context to make it interesting.

Di Suvero You talk about your art in a purely rational fashion while the formation of values, as you know excellently well, is not based upon this rational cognizant sense. And when you talk about space, you're ignoring the mathematical perception of space. That space which we perceive is untrue. We've learned it, yet you're still operating in its terms. When you talk about my space and say that it's suggestive, that is right. But that shows a weakness on my part because I think that space should be *warped*. And the mere idea that man could not find one side of its infinite surface until the eighteenth century is incredible. This is knowledge we must have like a part of our fingertips.

Judd Those kinds of things are very tricky in application to art. Art is not science, and whether it is behind science or not is a very complicated question. If it's dealing with a specific scientific problem, certainly it's following, but on the whole it is not doing that. Usually science is just a mine for technique. Nothing much else.

Di Suvero They used to talk about the interchange between art and science. I think that it meant something then and it still means something now. It's a special kind of approach to a problem which is explorative. I mean in a

10. Alberto Giacometti

true sense art does explore as opposed to the tools which you use. You use a man as a tool. And I object to that because I think that we should use everything we have in the communicative world.

Judd I think there's a big gap between the discussion of Euclidian and non-Euclidian geometry and art, and that the two should be left in the different areas in which they are. The sort of connection you're making is exactly the kind of analogy-making that I object to.

Rose Do you feel your work has expressive quality?

Judd Yes, of course. I don't exactly like talking about spirit, mysticism and that sort of thing because those words have old meanings, and I think they may as well be dumped because their old meanings are stronger than their new meanings.

Di Suvero It's true that what I do really like in a piece of sculpture is to feel from it that sense in which it is not an object, in which it possesses that thing which is not visible to our eyes, which you may call mystical or spiritual. For example, the rock at the Met isn't a rock, it's truly an archaic Apollo. I find that this object art, this 'ABC Art', is often a special kind of commercial acceptance of the technological world that disavows all of the joy and the tragedy and accepts regimentation, which is what you mean by repetition.

McShine Don't you think it's a criticism of the regimentation, though?

Di Suvero I think it's as much a criticism as anybody who wears a grey flannel suit.

Mark di Suvero, Donald Judd, Kynaston McShine, Robert Morris, Barbara Rose, 'Symposium on "The New Sculpture"', New York, 2 May 1966 (unpublished manuscript from the Archives of American Art, Smithsonian Institution, Washington, DC).

Mel BOCHNER
Primary Structures [1966]

' ... there is nothing behind these surfaces, no inside, no secret, no hidden motive.'
– Alain Robbe-Grillet, *For a New Novel*

'Primary Structures' is a misnomer for an important exhibition at the Jewish Museum (29 April–12 June). A qualifying addition to the title is 'Sculpture by Younger British and American Sculptors'. This subtitle reveals most strikingly the extent of misunderstanding about the new art.

The best work in this exhibition is not *sculpture*. In this exhibition the best work is by Carl Andre, Dan Flavin, Sol LeWitt, Don Judd, Robert Morris, Robert Smithson. The addition of 'dilutants' and mannerists to this exhibition (in the name, no doubt, of a 'good show') does not dissolve the issues the best work raises. In this exhibition, sculptors such as the Park Place group, the Richard Feigen group and the Pace Gallery group are seen to be manipulating streamlined versions of outmoded forms. They may be dismissed in a discussion of new art.

The work of the six artists named above demands a new critical vocabulary. The common criticism of their art is in a language without pertinence. Its only accomplishment is to separate the viewer from the object of his sight. Such words as form-content, tradition, classic, romantic, expressive, experiment, psychology, analogy, depth, purity, feeling, space, avant-garde, lyric, individual, composition, life and death, sexuality, biomorphic, biographic – the entire language of botany in art – can now be regarded as suspect. These words are not tools for probing out aspects of a system of moralistic restriction. The anchor of this system is dread. The result of this system is the condemnation of the most intense art of the present as 'cool', 'minimal', 'reduced'.

When Robert Smithson writes about his piece *The Cryosphere* for the catalogue, he lists the number of elements, their modular sequence and the chemical composition of his spray paint can. He strips away the romance about making a work of art. 'Art-mystics' find this particularly offensive. Carl Andre's *Lever* is a 915 cm [360 in] row of firebricks laid side to side on the floor. He ordered them and placed them. He de-mythologizes the artists' function. Don Judd's two *Untitled* (1966) 102 × 483 × 102 cm [40 × 190 × 40 in] galvanized iron and aluminium pieces are exactly alike. One hangs on the wall. The aluminium bar across the top front edge is not sprayed. The second piece sits on the floor directly in front of the first. The aluminium bar across the top front edge is sprayed blue. Their only enigma is their existence. 'Art-existentialists' find this particularly distressing. Dan Flavin's *monument 4 those who have been killed in ambush (to P.K. who reminded me about death)* is an arrangement of four red fluorescent lights 488 cm [192 in] wide, set in the corner at a height of 168 cm [66 in]. Sol LeWitt's 183 × 183 × 183 cm [72 × 72 × 72 in] painted-wood grid cube is anaxial, symmetrical, open and closed. Robert Morris' two large identical L-shaped pieces neither organize, divide nor articulate 'space'. 'Space-artists' find this particularly disappointing.

It will not do good to call this work 'anti-art'. Don Judd says in his catalogue statement, 'If someone says his work is art, it's art'. The definitions are phenomenological. Even the definitions are phenomena.

What these artists hold in common is the attitude that art – from the root *artificial* – is unreal, constructed, invented, predetermined, intellectual, make-believe objective, contrived, useless. Their work is dumb in the sense that it does not 'speak to you', yet subversive in that it points to the probable end of all Renaissance values. It is against comfortable aesthetic experience. It is a provocative art as distant from the humanistic stammering of Abstract Expressionism, Happenings and Pop art as it is from the decorative subterfuges of the Louis Noland school. But what is ultimately most difficult for the art viewer of good faith to accept is the non-visuality – a concept at odds with all previous ideas of the art experience. Old art attempted to make the non-visible (energy, feelings) visual (marks). The new art is attempting to make the non-visual (mathematics) visible (concrete). Invisibility is an element.

For Judd and Smithson, there is no dichotomy between art and science. They are aware of the artistic potentialities of new math, are knowledgeable in mineralogy and crystal structure, concerned with advances in paint chemistry and capable of adapting aspects of modern technology to their ends. All these artists are concerned with standardization. The components of a piece are usually all the same. An art of units. Judd uses set theory in the complex sequences of his modules. Divisions are solidified. LeWitt accomplishes something similar. The areas between Smithson's units are invisible modules. The sequence is 010010010010010010. Invisibility is an object.

There is no work or craftsmanship. Flavin's lights or Andre's bricks can be duplicated by anyone in his own home. The more complicated structures conceived by the artists are executed by metal shops. This further objectifies the result by placing an intermediary between the artist and the work. The artist is an object.

The new art of Carl Andre, Dan Flavin, Sol LeWitt, Don Judd, Robert Morris, Robert Smithson deals with the surface of matter and avoids its 'heart'. It is un-lifelike, not spontaneous, exclusive. It does not move. This is not an 'art-style'. It will not 'wither' with the passing season and go away. It is not engineering. It is not appliances. It is not faceless and impersonal. It will not become academic. It offers no outline or formula. It denies everything it asserts. The implications are astounding. Art no longer need pretend to be about life. Inhibitions, dogmas and anxieties of nineteenth-century romance disappear. Art is, after all, nothing.

Mel Bochner, 'Primary Structures', *Arts Magazine*, 40: 8 (June 1966) 32-35.

Harold GREGOR
Everyman's Infinite Art [1966]

Last spring, in the Jewish Museum's 'Primary Structures' show, Carl Andre exhibited a work entitled *Lever* – a single line of 139 unjoined firebricks laid horizontally on the floor, large side to large side. The line extended at right angles from a wall and terminated in the middle of the floor. The work was not signed.

Andre's work is an art (or non-art) form that seems to rest on the edge of whatever line there is that divides art from non-art. It satisfies any definition of sculpture, yet defies acceptance as such. It cannot be sold for a profit because any buyer could purchase a similar set of bricks and make an identical work. The work is not contained, since the subtraction or addition of a dozen bricks would in no way change its form. It is visually predictable and therefore boringly minimal in content.

Visual randomness is a prerequisite of tension and artistic 'life' but this work affords no opposition of forces. As a primary object it offers an essential facet of the artistic heart, but extracting the essence kills the body.

The literary character of this kind of art is emphasized by the fact that it need not be seen but can be described in words. Thus, the art faculty at Chapman College decided to extend the line that sculptor Andre has marked by packaging an exhibit of this type of work.

THE ULTIMATE IN ARTISTIC COMMUNICATION – WE DESCRIBE OUR EXHIBIT TO YOU

The objects chosen had to meet the following specifications:

a. They could not be organic because natural objects are unique.

b. They had to be visually simple in shape (cube, sphere, cylinder, cone).

c. They had to be easily available in any hardware or department store.

d. They needed to be as free as possible from an individual mark, brand name, design or connotation.

e. The arrangement had to suggest an infinite continuum.

f. The units had to be used unaltered.

THE OBJECTS

1. Two 5-cm [2-in]-wide rolls of masking tape with the two free ends stuck together and rolled out in opposite directions.

2. Fourteen boxes, each containing 500 unmarked envelopes, box-lids removed to reveal the contents. The boxes are laid end to end across the floor.

3. An arc comprised of fifty ping-pong balls, labels down.

4. A 7.5-cm [3-in]-wide red stripe painted from the floor to an open window. The brush and can of paint sit beside the terminus of the stripe.

5. A stack of twenty-four white polystyrene coffee cups, open end down.

6. Twenty-five upright soup cans, labels removed, arranged to form a right angle with twelve cans comprising each leg and one can at the apex.

7. Twelve 340-g [46-ounce] juice cans, labels removed, stacked vertically one on top of the other.

8. Four 15-cm [6-in] galvanized-steel, circular-sectioned, 90 degree elbow stovepipes, ends joined to form an oval link. Four of these links lie on the floor separated by a 25.5 cm [10 in] gap. (See Sears catalogue, p. 835.)

9. Ten yardsticks lined end to end.

10. Thirty overlapping 51×76-cm [20×30-in] sheets of black construction paper. Each sheet overlaps the next by 61 cm [24 in].

11. A row of thirty unmarked, disposable soda-fountain cone inserts displayed pointed-end up.

12. Thirty $2.5 \times 116 \times 1.25$ cm [$1 \times 45 \times .5$ in] flat-headed, hot-dipped, galvanized, barbed roofing nails, points up, aligned 5 cm [2 in] apart.

13. Ten 1.5×91.5 cm [$.5 \times 36$ in] wooden dowel rods leaning against the wall, 15.5 cm [6 in] apart, with the floor ends 18 cm [7 in] from the wall.

– Exhibits donated by Mr Glen Johnson of Double J. Lumber Co., 1600 N. Glassell St., Orange, California

EVERYMAN'S INFINITE ART

Minimizes the gallery function.
The works need not be viewed; they can be described in words.
The works are unsigned and need not be bought; the patron can make his own.
Minimizes the artist's function.
No skill is required to make the works; anyone can repeat the arrangements.
Minimizes the critic's function.
The presentation is practically devoid of content – any interpretation seems appropriate.
Defies categorization.

The works lie on the edge between art and non-art. In conclusion:

This kind of work promotes a literary and cerebral art form knowable through verbal or written description.

It permits instant packaged exhibitions and immediate comprehension.

It entails minimal spectator involvement and minimum artistic skill and discipline. In short ...

EVERYMAN'S INFINITE ART

Harold Gregor, *Everyman's Infinite Art* (Orange, California: Purcell Gallery, Chapman College, December 1966).

Robert SMITHSON
Entropy and the New Monuments [1966]

'On rising to my feet, and peering across the green glow of the Desert, I perceived that the monument against which I had slept was but one of thousands. Before me stretched long parallel avenues, clear to the far horizon of similar broad, low pillars.'
– John Taine (Eric Temple Bell), 'The Time Stream'

Many architectural concepts found in science fiction have nothing to do with science or fiction, instead they suggest a new kind of monumentality which has much in common with the aims of some of today's artists. I am thinking in particular of Donald Judd, Robert Morris, Sol LeWitt, Dan Flavin and of certain artists in the 'Park Place Group'. The artists who build structured canvases and 'wall-size' paintings, such as Will Insley, Peter Hutchinson and Frank Stella, are more indirectly related. The chrome and plastic fabricators such as Paul Thek, Craig Kauffman and Larry Bell are also relevant. The works of many of these artists celebrate what Flavin calls 'inactive history' or what the physicists calls 'entropy' or 'energy-drain'. They bring to mind the Ice Age rather than the Golden Age, and would most likely confirm Vladimir Nabokov's observation that, 'The future is but the obsolete in reverse'. In a rather roundabout way, many of the artists have provided a visible analogue for the Second Law of Thermodynamics, which extrapolates the range of entropy by telling us energy is more easily lost than obtained, and that in the ultimate future the whole universe will burn out and be transformed into an all-encompassing sameness. The 'blackout' that covered the Northeastern states recently may be seen as a preview of such a future. Far from creating a mood of dread, the power failure created a mood of euphoria. An almost cosmic joy swept over all the darkened cities. Why people felt that way may never be answered.

Instead of causing us to remember the past like the old monuments, the new monuments seem to cause us to forget the future. Instead of being made of natural materials, such as marble, granite or other kinds of rock, the new monuments are made of artificial materials, plastic, chrome and electric light. They are not built for the ages, but rather against the ages. They are involved in a systematic reduction of time down to fractions of seconds, rather than in representing the long spaces of centuries. Both past and future are placed into an objective present. This kind of time has little or no space; it is stationary and without movement, it is going nowhere, it is anti-Newtonian, as well as being instant, and is against the wheels of the time-clock. Flavin makes 'instant-monuments'; parts for *Monument 7 for V. Tatlin* were purchased at the Radar Fluorescent Company. The 'instant' makes Flavin's work a part of time rather than space. Time becomes a place minus motion. If time is a place, then innumerable places are possible. Flavin turns gallery space into gallery time. Time breaks down into many times. Rather than saying, 'What time is it?' we should say, 'Where is the time?' 'Where is Flavin's *Monument*?' The objective present at times seems missing. A million years is contained in a second, yet we tend to forget the second as soon as it happens. Flavin's destruction of classical time and space is based on an entirely new notion of the structure of matter.

Time as decay or biological evolution is eliminated by many of these artists; this displacement allows the eye to see time as an infinity of surfaces or structures, or both combined, without the burden of what Roland Barthes calls the 'undifferentiated mass of organic sensation'. The concealed surfaces in some of Judd's works are hideouts for time. His art vanishes into a series of motionless intervals based on an order of solids. Robert Grosvenor's suspended structural surfaces cancel out the notion of weight, and reverse the orientation of matter within the solid-state of inorganic time. This reduction of time all but annihilates the value of the notion of 'action' in art.

Mistakes and dead-ends often mean more to these artists than any proven problem. Questions about form seem as hopelessly inadequate as questions about content. Problems are unnecessary because problems represent values that create the illusion of purpose. The problem of 'form versus content', for example, leads to illusionistic dialectics that become, at best, formalist reactions against content. Reaction follows action, till finally the artist gets 'tired' and settles for a monumental inaction. The action-reaction syndrome is merely the leftovers of what Marshall McLuhan calls the hypnotic state of mechanism. According to him, an electrical numbing or torpor has replaced the mechanical breakdown. The awareness of the ultimate collapse of both mechanical and electrical technology has motivated these artists to build their monuments to or against entropy. As LeWitt points out, 'I am not interested in idealizing technology'. LeWitt might prefer the word 'sub-monumental', especially if we consider his proposal to put a piece of Cellini's jewellery into a block of cement. An almost alchemic fascination with inert properties is his concern here, but LeWitt prefers to turn gold into cement.

The much denigrated architecture of Park Avenue, known as 'cold glass boxes', along with the Manneristic

modernity of Philip Johnson, have helped to foster the entropic mood. The Union Carbide building best typifies such architectural entropy. In its vast lobby one may see an exhibition called 'The Future'. It offers the purposeless 'educational' displays of Will Burtin, 'internationally acclaimed for his three-dimensional designs', which portray 'Atomic Energy in Action'. If ever there was an example of action in entropy, this is it. The action is frozen into an array of plastic and neon, and enhanced by the sound of Muzak faintly playing in the background. At a certain time of day, you may also see a movie called *The Petrified River*. A 274 cm [9 ft] vacuum-formed blue Plexiglas globe is a model of a uranium atom – 'ten million trillion trillion times the size of the actual atom'. Lights on the ends of flexible steel rods are whipped about in the globe. Parts of the 'underground' movie, *The Queen of Sheba Meets the Atom Man*, were filmed in this exhibition hall. Taylor Mead creeps around in the film like a loony sleepwalker and licks the plastic models depicting 'chain-reaction'. The sleek walls and high ceilings give the place an uncanny tomb-like atmosphere. There is something irresistible about such a place, something grand and empty.

This kind of architecture without 'value of qualities', is, if anything, a fact. From this 'undistinguished' run of architecture, as Flavin calls it, we gain a clear perception of physical reality free from the general claims of 'purity and idealism'. Only commodities can afford such illusionistic values; for instance, soap is 99.44 per cent pure, beer has more spirit in it and dog food is ideal; all and all this means such values are worthless. As the cloying effect of such 'values' wears off, one perceives the 'facts' of the outer edge, the flat surface, the banal, the empty, the cool, blank after blank; in other words, that infinitesimal condition known as entropy.

The slurbs, urban sprawl and the infinite number of housing developments of the post-war boom have contributed to the architecture of entropy. Judd, in a review of a show by Roy Lichtenstein, speaks of 'a lot of visible things' that are 'bland and empty', such as 'most modern commercial buildings, new Colonial stores, lobbies, most houses, most clothing, sheet aluminium and plastic with leather texture, the Formica-like wood, the cute and modern patterns inside jets and drugstores'. Near the superhighways surrounding the city, we find the discount centres and cut-rate stores with their sterile facades. On the inside of such places are maze-like counters with piles of neatly stacked merchandise; rank on rank it goes into a consumer oblivion. The lugubrious complexity of these interiors has brought to art a new consciousness of the vapid and the dull. But this very vapidity and dullness is what inspires many of the more gifted artists. Morris has distilled many such dull facts and made them into monumental artifices of 'idea'. In such a way, Morris has restored the idea of immortality by accepting it as a fact of emptiness. His work conveys a mood of vast immobility; he has even gone so far as to fashion a bra out of lead. (This he has made for his dance partner, Yvonne Rainer, to help stop the motion in her dances.)

This kind of nullification has re-created Kasimir Malevich's 'non-objective world', where there are no more 'likenesses of reality, no idealistic images, nothing but a desert!' But for many of today's artists this 'desert' is a 'City of the Future' made of null structures and surfaces. This 'City' performs no natural function, it simply exists between mind and matter, detached from both, representing neither. It is, in fact, devoid of all classical ideals of space and process. It is brought into focus by a strict condition of perception, rather than by any expressive or emotive means. Perception as a deprivation of action and reaction brings to the mind the desolate, but exquisite, surface-structures of the empty 'box' or 'lattice'. As action decreases, the clarity of such surface-structures increases. This is evident in art when all representations of action pass into oblivion. At this stage, lethargy is elevated to the most glorious magnitude. In Damon Knight's scientific novel, *Beyond the Barrier*, he describes in a phenomenological manner just such surface-structures: '*Part of the scene before them seemed to expand. Where one of the flotation machines had been, there was a dim lattice of crystals, growing more shadowy and insubstantial as it swelled; then darkness; then a dazzle of faint prismatic light – tiny complexes in a vast three-dimensional array, growing steadily bigger.*' This description has none of the 'values' of the naturalistic 'literary' novel, it is crystalline and of the mind by virtue of being outside of unconscious action. This very well could be an inchoate concept for a work by Judd, LeWitt, Flavin or Insley.

It seems that beyond the barrier, there are only more barriers. Insley's *Night Wall* is both a grid and a blockade; it offers no escape. Flavin's fluorescent lights all but prevent prolonged viewing; ultimately, there is nothing to see. Judd turns the logic of set theory into block-like facades. These facades hide nothing but the wall they hang on.

LeWitt's first one-man show at the now defunct John Daniel's Gallery presented a rather uncompromising group of monumental 'obstructions'. Many people were 'left cold' by them, or found their finish 'too dreary'. These obstructions stood as visible clues of the future. A future of humdrum practicality in the shape of standardized office buildings modelled after Emery Roth; in other words, a jerry-built future, a feigned future, an ersatz future very much like the one depicted in the movie *The Tenth Victim*. LeWitt's show has helped to neutralize the myth of progress. It has also corroborated Wylie Sypher's insight that, 'Entropy is evolution in reverse'. LeWitt's work carries with it the brainwashed mood of Jasper Johns' *Tennyson*, Flavin's *Coran's Broadway Flesh* and Stella's *The Marriage of Reason and Squalor*.

Morris also discloses this backward looking future with 'erections' and 'vaginas' embedded in lead. They tend to illustrate fossilized sexuality by mixing the time states or ideas of *1984* with *One Million BC*. Claes Oldenburg achieves a similar conjunction of time with his prehistoric 'ray-guns'. This sense of extreme past and future has its partial origin with the Museum of Natural History; there the 'cave-man' and the 'space-man' may be seen under one roof. In this museum all 'nature' is stuffed and interchangeable.

'This City (I thought) is so horrible that its mere existence and perdurance, though in the midst of a secret desert, contaminates the past and future and in some way even jeopardizes the stars.'
– Jorge Luis Borges, *The Immortal*

'Tromaderians consider anything blue extremely pornographic.'
– Peter Hutchinson, *Extraterrestrial Art*

'*Lust for Life* is the story of the great sensualist painter Vincent Van Gogh, who bounds through the pages and passions of Irving Stone's perennial bestseller. And this is the Van Gogh overwhelmingly brought before us by Kirk Douglas in MGM's film version, shot in Cinemascope and a sun-burst of colour on the actual sites of Van Gogh's struggles to feel feelings never felt before.'
– Promotional copy, John Mulligan, *Vincent Van Gogh: The Big Picture*

Unlike the hyper-prosaism of Morris, Flavin, LeWitt and Judd, the works of Thek, Kauffman and Bell convey a hyper-opulence. Thek's sadistic geometry is made out of simulated hunks of torn flesh. Bloody meat in the shape of a birthday cake is contained under a pyramidal chrome framework – it has stainless steel candies in it. Tubes for drinking 'blood cocktails' are inserted into some of his painful objects. Thek achieves a putrid finesse, not unlike that disclosed in William S. Burroughs' *Nova Express*: 'Flesh juice in festering spines of terminal sewage – Run down of Spain and 42nd Street to the fish city of marble flesh grafts'. The vacuum-formed plastic reliefs by Kauffman have a pale lustrous surface presence. A lumpy sexuality is implicit in the transparent forms he employs. Something of the primal nightmare exists in both Thek and Kauffman. The slippery bubbling ooze from the movie *The Blob* creeps into one's mind. Both Thek and Kauffman have arrested the movement of blob-type matter. The mirrored reflections in Bell's work are contaminations of a more elusive order. His chrome-plated lattices contain a Pythagorean chaos. Reflections reflect reflections in an excessive but pristine manner.

Some artists see an infinite number of movies. Hutchinson, for instance, instead of going to the country to study nature, will go to see a movie on 42nd Street, like *Horror at Party Beach*, two or three times, and contemplate it for weeks on end. The movies give a ritual pattern to the lives of many artists, and this induces a kind of 'low-budget' mysticism, which keeps them in a perpetual trance. The 'blood and guts' of horror movies provides for their 'organic needs', while the 'cold steel' of Sci-fi movies provides for their 'inorganic needs'. Serious movies are too heavy on 'values', and so are dismissed by the more perceptive artists. Such artists have X-ray eyes, and can see through all of that cloddish substance that passes for 'the deep and profound' these days.

Some landmarks of Sci-fi are: *Creation of the Humanoids* (Andy Warhol's favourite movie), *The Planet of the Vampires* (movie about entropy), *The Thing*, *The Day the Earth Stood Still*, *The Time Machine*, *Village of the Giants* (first teen-science film), *War of the Worlds*

(interesting metallic machines). Some landmarks of Horror are: *Creature from the Black Lagoon*, *I Was A Teenage Werewolf*, *Horror Chamber of Dr. Faustus* (very sickening), *Abbott and Costello Meet Frankenstein*. Artists that like Horror tend towards the emotive, while artists who like Sci-fi tend towards the perceptive.

Even more of a mental conditioner than the movies is the actual movie house. Especially the 'moderne' interior architecture of the new 'art-houses' like Cinema I and II, 57th Street Lincoln Art Theatre, the Coronet, Cinema Rendezvous, the Cinema Village, the Baronet, the Festival and the Murray Hill. Instead of the crummy baroque and rococo of the 42nd Street theatres, we get the 'padded cell' look, the 'stripped down' look or the 'good-taste' look. The physical confinement of the dark box-like room indirectly conditions the mind. Even the place where you buy your ticket is called a 'box-office'. The lobbies are usually full of box-type fixtures like the soda-machine, the candy counter and telephone booths. Time is compressed or stopped inside the movie house, and this in turn provides the viewer with an entropic condition. To spend time in a movie house is to make a 'hole' in one's life.

Recently, there has been an attempt to formulate an analogue between 'communication theory' and the ideas of physics in terms of entropy. As A.J. Ayer has pointed out, not only do we communicate what is true, but also what is false. Often the false has a greater 'reality' than the true. Therefore, it seems that all information, and that includes anything that is visible, has its entropic side. Falseness, as an ultimate, is inextricably a part of entropy, and this falseness is devoid of moral implications.

Like the movies and the movie-houses, 'printed-matter' plays an entropic role. Maps, charts, advertisements, art books, science books, money, architectural plans, maths books, graphs, diagrams, newspapers, comics, booklets and pamphlets from industrial companies are all treated the same. Judd has a labyrinthine collection of 'printed-matter', some of which he 'looks' at rather than reads. By this means he might take a maths equation and, by sight, translate it into a metal progression of structured intervals. In this context, it is best to think of 'printed-matter' the way Borges thinks of it, as 'The universe (which others call the library)', or like McLuhan's 'Gutenberg Galaxy', in other words as an unending 'library of Babel'. This condition is reflected in Henry Geldzahler's remark, 'I'm doing a book on European painting since 1900 – a drugstore book. Dell is printing 100,000 copies.' Too bad Dell isn't printing 100,000,000,000.

Judd's sensibility encompasses geology and mineralogy. He has an excellent collection of geological maps, which he scans from time to time, not for their intended content, but for their exquisite structural precision. His own writing style has much in common with the terse, factual descriptions one finds in his collection of geology books. Compare this passage from one of his books, *The Geology of Jackson County, Missouri*, to his own criticism:

'*The interval between the Cement City and the Raytown limestones varies from 305 cm [10 ft] to 702 cm [23 ft]. The lower three-quarters is an irregularly coloured green, blue,*

red and yellow shale which at some places contains calcareous concretions.'

And now an excerpt from Judd's review of Dan Flavin's first one-man show:

'*The light is bluntly and awkwardly stuck on the square block; it protrudes awkwardly. The red in the green attached to a lighter green is odd as colour and as a sequence*'.

'I like particularly the way in which he (Robert Morris) subverts the "purist" reading one would normally give to such geometric arrangements.'
– Barbara Rose, 'Looking at American Sculpture', *Artforum*, February 1965

'"Point Triangle Gray" Faith sang, waving at an intersection ahead. "That's the medical section. Tests and diseases, injuries and ... " she giggled naughtily " ... Supply depot for the Body Bank".'
– J. Williamson and F. Pohl, *The Reefs of Space*

'Make a
sick
picture
or a sick
Readymade'
– Marcel Duchamp, *Green Box*

Many of Morris' wall structures are direct homages to Duchamp; they deploy facsimiles of readymades within high Manneristic frames of reference. Extensions of the Cartesian mind are carried to the most attenuated points of no return by a systematic annulment of movement. Descartes' cosmology is brought to a standstill. Movement in Morris' work is engulfed by many types of stillness: delayed action, inadequate energy, general slowness, an all-over sluggishness. The readymades are, in fact, puns on the Bergsonian concept of 'creative evolution' with its idea of 'ready made categories'. Says Bergson:

'*The history of philosophy is there, however, and shows us the eternal conflict of systems, the impossibility of satisfactorily getting the real into the readymade garments of our readymade concepts, the necessity of making to measure.*'

But it is just such an 'impossibility' that appeals to Duchamp and Morris. With this in mind, Morris' monstrous 'ideal' structures are inconsequential or uncertain readymades, which are definitely outside of Bergson's concept of creative evolution. If anything, they are uncreative in the manner of the sixteenth-century alchemist-philosopher-artist. C.G. Jung's writing on 'The Materia Prima' offers many clues in this direction. Alchemy, it seems, is a concrete way of dealing with sameness. In this context, Duchamp and Morris may be seen as artificers of the uncreative or decreators of the Real. They are like the sixteenth-century artist Parmigianino, who 'gave up painting to become an alchemist'. This might help us to understand both Judd's and Morris' interest in geology. It is also well to remember that Parmigianino and Duchamp both painted 'Virgins',

when they did paint. Sydney Freedberg observed in the work of Parmigianino 'an assembly of surfaces, nothing is contained within these surfaces'. Such an observation might also be applied to Duchamp's hollow *Virgins*, with their insidious almost lewd associations. The 'purist' surfaces of certain artists have a 'contamination' in them that relates to Duchamp and Parmigianino, if not in fact, at least in idea.

The impure-purist surface is very much in evidence in the new abstract art, but I think Stella was the first to employ it. The iridescent purple, green and silver surfaces that followed Stella's all-black works conveyed a rather lurid presence through their symmetries. An exacerbated, gorgeous colour gives a chilling bite to the purist context. Immaculate beginnings are subsumed by glittering ends. Like Mallarmé's *Hérodiade*, these surfaces disclose a 'cold scintillation'; they seem to 'love the horror of being virgin'. These inaccessible surfaces deny any definite meaning in the most definite way. Here beauty is allied with the repulsive in accordance with highly rigid rules. One's sight is mentally abolished by Stella's hermetic kingdom of surfaces.

Stella's immaculate but sparkling symmetries are reflected in John Chamberlain's 'Kandy-Kolored' reliefs. 'They are extreme, snazzy, elegant in the wrong way, immoderate', says Judd. 'It is also interesting that the surfaces of the reliefs are definitely surfaces.' Chamberlain's use of chrome and metalflake brings to mind the surfaces in *Scorpio Rising*, Kenneth Anger's many-faceted horoscopic film about constellated motorcyclists. Both Chamberlain and Anger have developed what could be called California surfaces. In a review of the film, Ken Kelman speaks of 'the ultimate reduction of ultimate experience to brilliant chromatic surface; Thanatos in Chrome – artificial death' in a way that evokes Chamberlain's giddy reliefs.

Judd bought a purple Florite crystal at the World's Fair. He likes the 'uncremated' look of it and its impenetrable colour. John Chamberlain, upon learning of Judd's interest in such a colour, suggested he go to the Harley Davidson Motorcycle Company and get some 'Hi-Fi' lacquer. Judd did this and 'self-sprayed' some of his works with it. This transparent lacquer allows the 'star-spangled' marking on the iron sheet to come through, making the surfaces look mineral hard. His standard crystallographic boxes come in a variety of surfaces from Saturnian orchid-plus to wrinkle-textured blues and greens – alchemy from the year 2000.

'But I think nevertheless, we do not feel altogether comfortable at being forced to say that the crystal is the seat of greater disorder than the parent liquid.'
– P.W. Bridgeman, *The Nature of Thermodynamics*

The formal logic of crystallography, apart from any preconceived scientific content, relates to Judd's art in an abstract way. If we define an abstract crystal as a solid bounded by symmetrically grouped surfaced, which have definite relationships to a set of imaginary lines called axes, then we have a clue to the structure of Judd's 'pink Plexiglas box'. Inside the box five wires are strung in a way

DOCUMENTS

that resembles very strongly the crystallographic idea of axes. Yet, Judd's axes don't correspond with any natural crystal. The entire box would collapse without the tension of the axes. The five axes polarize between two stainless steel sides. The inside surfaces of the steel sides are visible through the transparent Plexiglas. Every surface is within full view, which makes the inside and outside equally important. Like many of Judd's works, the separate parts of the box are held together by tension and balance, both of which add to its static existence.

'Like energy, entropy is in the first instance a measure of something that happens when one state is transformed into another.'
– P.W. Bridgeman, *The Nature of Thermodynamics*

The Park Place Group (Mark di Suvero, Dean Fleming, Peter Forakis, Robert Grosvenor, Anthony Magar, Tamara Melcher, Forrest Myers, Ed Ruda and Leo Valledor) exists in a space-time monastic order, where they research a cosmos modelled after Einstein. They have also permuted the 'models' of Buckminster Fuller's 'vectoral' geometry in the most astounding manner.

Fuller was told by certain scientists that the fourth dimension was 'ha-ha', in other words, that it is laughter. Perhaps it is. It is well to remember that the seemingly topsy-turvy world revealed by Lewis Carroll did spring from a well-ordered mathematical mind. Martin Gardner, in his *The Annotated Alice*, notes that in a science-fiction story *Mimsy Were the Borogroves*, the author Lewis Padgett presents the Jabberwocky as a secret language from the future, and that if rightly understood it would explain a way of entering the fourth dimension. The highly ordered nonsense of Carroll suggests that there might be a similar way to treat laughter. Laughter is in a sense a kind of entropic 'verbalization'. How could artists translate this verbal entropy, that is 'ha-ha', into 'solid-models'? Some of the Park Place artists seem to be researching this 'curious' condition. The order and disorder of the fourth dimension could be set between laughter and crystal-structure, as a device for unlimited speculation.

Let us now define the different types of Generalized Laughter, according to the six main crystal systems: the ordinary laugh is cubic or square (Isometric), the chuckle is a triangle or pyramid (Tetragonal), the giggle is a hexagon or rhomboid (Hexagonal), the titter is prismatic (Orthorhombic), the snicker is oblique (Monoclinic), the guffaw is asymmetric (Triclinic). To be sure this definition only scratches the surface, but I think it will do for the present. If we apply this 'ha-ha-crystal' concept to the monumental models being produced by some of the artists in the Park Place group, we might begin to understand the fourth-dimensional nature of their work. From here on in, we must not think of Laughter as a laughing matter, but rather as the 'matter-of-laughs'.

Solid-state hilarity, as manifest through the 'ha-ha-crystal' concept, appears in a patently anthropomorphic way in *Alice in Wonderland*, as the Cheshire Cat. Says Alice to the Cat, 'you make one quite giddy!' This anthropomorphic element has much in common with impure-purist art. The 'grin without a cat' indicates 'laugh-matter and/or

anti-matter', not to mention something approaching a solid giddiness. Giddiness of this sort is reflected in Myers' plastic contraptions. Myers sets hard titter against soft snickers, and puts hard guffaws on to soft giggles. A fit of silliness becomes a rhomboid, a high-pitched discharge of mirth becomes prismatic, a happy outburst becomes a cube and so forth.

'You observed them at work in null time. From your description of what they were about, it seems apparent that they were erecting a transfer portal linking the null level with its corresponding aspect of normal entropy – in other words, with the normal continuum.'
– Keith Laumer, *The Other Side of Time*

Through direct observation, rather than explanation, many of these artists have developed ways to treat the theory of sets, vectoral geometry, topology and crystal structure. The diagrammatic methods of the 'new maths' have led to a curious phenomenon. Namely, a more visible maths that is unconcerned with size or shape in any metrical sense. The 'paper and pencil operations' that deal with the invisible structure of nature have found new models, and have been combined with some of the more fragile states of mind. Maths is dislocated by the artists in a personal way, so that it becomes 'Manneristic' or separated from its original meaning. This dislocation of meaning provides the artist with what could be called 'synthetic maths'. Charles Peirce (1839–1914), the American philosopher, speaks of 'graphs' that would 'put before us moving pictures of thought'. (See Martin Gardner's *Logic Machines and Diagrams*.) This synthetic math is reflected in Duchamp's 'measured' pieces of fallen threads, *Three Standard Stoppages*, Judd's sequential structured surfaces, Valledor's 'fourth dimensional' colour vectors, Grosvenor's hypervolumes in hyperspace and di Suvero's demolitions of space-time. These artists face the possibility of other dimensions with a new kind of sight.

Robert Smithson, 'Entropy and the New Monuments', *Artforum*, 4: 10 (June 1966) 26-31; reprinted in *The Writings of Robert Smithson*, ed. Nancy Holt (New York University Press, 1979); *Robert Smithson: The Collected Writings*, ed. Jack Flam (Berkeley, Los Angeles and London: University of California Press, 1996).

Donald JUDD
Letter to the Editor [1967]

To the Editor:
Smithson isn't my spokesman.
Don Judd
New York City

Donald Judd, 'Letter to the Editor', *Arts Magazine* (February 1967); reprinted in *Donald Judd: Complete Writings 1959-1975* (Halifax: Nova Scotia College of Art and Design; New York University Press, 1975).

Mel BOCHNER
Sol LeWitt [1966]

Grid. Cube. White. Wood. Intersection. Joint. Obstruction. White wood grid cubes and other structures which are not cubes. On the floor. In corners. Against walls. Floor to wall. Wall to wall. Ceiling to floor. Their presence prevails over description. Sol LeWitt's white wood grid multiple structures are computations of interstices, joints, lines, corners, angles. They constantly permute. Binocular vision destroys regularity. Vision unlocks within impassable areas. There is no invitation. Formality is a guise. Space tenses: past, present-future, plural-present. Perceptual phenomena: indeterminate sequence, infinite invention, coordinate disorder. Everything is still. Everything is repeated. Everything is obvious. The accumulation of facts collapses perception. The indicated sum of these simple series is irreducible complexity. And impenetrable chaos. They astound.

Mel Bochner, 'Sol LeWitt, Dwan Gallery,' *Arts Magazine*, 40: 9 (September-October 1966) 61.

Sol LEWITT
Serial Project No. 1 (ABCD) [1966]

Serial compositions are multi-part pieces with regulated changes. The differences between the parts are the subject of the composition. If some parts remain constant it is to punctuate the changes. The entire work would contain sub-divisions that could be autonomous but that comprise the whole. The autonomous parts are units, rows, sets or any logical division that would be read as a complete thought. The series would be read by the viewer in a linear or narrative manner even though in its final form many of these sets would be operating simultaneously, making comprehension difficult. The aim of the artist would not be to instruct the viewer but to give him information. Whether the viewer understands this information is incidental to the artist; one cannot foresee the understanding of all one's viewers. One would follow one's predetermined premise to its conclusion, avoiding subjectivity. Chance, taste or unconsciously remembered forms would play no part in the outcome. The serial artist does not attempt to produce a beautiful or mysterious object but functions merely as a clerk cataloguing the results of the premise.

The premise governing this series is to place one form within another and include all major variations in two and three dimensions. This is to be done in the most succinct manner, using the fewest measurements. It would be a finite series using the square and cube as its syntax. A more complex form would be too interesting in itself and obstruct the meaning of the whole. There is no need to invent new forms. The square and cube are efficient and symmetrical. In order to free a square within a larger

square, the larger square is divided into nine equal parts. The centre square would be equally distant from the outer square and exactly centred. A single measurement is used as the basis for the series.

The set contains nine pieces. They are all of the variations within the scope of the first premise. The first variation is a square within a square. The other variations follow: a cube within a square; a square within a cube; an outer form raised to the height of the inner cube; the inner cube raised to the height of the outer, larger cube; a cube within a cube, and all cross matchings of these forms. The first set contains nine pieces. These pieces are laid out on a grid. The grid equalizes the spacing and makes all of the pieces and spaces between of equal importance. The individual pieces are arranged in three rows of three forms each. In each row there are three different parts and three parts that are the same. The inner forms of one row of three are read in sequence, as are the outer forms.

The sets of nine are placed in four groups. Each group comprises variations on open or closed forms.

In cases in which the same plane is occupied by both the inside and outside forms, the inside plane takes precedence. This is done so that there is more information given the viewer. If it were otherwise more forms would be invisible, impeding the viewer's understanding of the whole set. When the larger form is closed and the top of the smaller form is not on the same plane as the larger – but lower – the smaller form is placed inside. If the viewer cannot see the interior form, one may believe it is there or not but one knows which form one believes is there or not there. The evidence given him or her by the other pieces in the set, and by reference to the other sets will inform the viewer as to what should be there. The sets are grouped in the most symmetrical way possible. Each set mirrors the others, with the higher pieces concentrated in the centre.

Sol LeWitt, 'Serial Project No. 1 (ABCD)', Aspen Magazine, 5-6 (1966); reprinted in Sol LeWitt (New York: The Museum of Modern Art, 1978) 170-71.

Mel BOCHNER
The Serial Attitude [1967]

'What order-type is universally present wherever there is any order in the world? The answer is serial order. What is a series? Any row, array, rank order of precedence, numerical or quantitative set of values, any straight line, any geometrical figure employing straight lines, and yes, all space and all time.'
– Josiah Royce, Principles of Logic

Serial order is a method, not a style. The results of this method are surprising and diverse: Eadweard Muybridge's photographs; Thomas Eakins' perspective studies; Jasper Johns' numerals; Alfred Jensen's polyptychs; Larry Poons' circles, dots and ellipsoids; Donald Judd's painted wall pieces; Sol LeWitt's orthogonal multi-part floor structures, all are works employing serial logics. This is not a stylistic phenomenon. Variousness of the above kind is sufficient grounds for suggesting that

rather than a style we are dealing with an attitude. The serial attitude is a concern with how order of a specific type is manifest.

Many artists work 'in series'. That is, they make different versions of a basic theme; Giorgio Morandi's bottles or Willem de Kooning's women, for example. This falls outside the area of concern here. Three basic operating assumptions separate serially ordered works from multiple variants:

1. The derivation of the terms or interior divisions of the work is by means of a numerical or otherwise systematically predetermined process (permutation, progression, rotation, reversal).

2. The order takes precedence over the execution.

3. The completed work is fundamentally parsimonious and systematically self-exhausting.

Serial ideas have occurred in numerous places and in various forms. Muybridge's photographs are an instance of the serialization of time through the systematic subtraction of duration from event. Muybridge simultaneously photographed the same activity from 180 degrees, 90 degrees and 45 degrees and printed the three sets of photographs parallel horizontally. By setting up alternative reading logics within a visually discontinuous sequence he completely fragmented perception into what Stockhausen called, in another context, a 'directionless time-field'.

Robert Rauschenberg's Seven White Panels and Ellsworth Kelly's orthogonal 244 cm² [8 ft²] Sixty-Four are anomalous works of the early 1950s. Both paintings fall within a generalized concept of arrays, which is serial, although their concerns were primarily modular. Modular ideas differ considerably from serial ideas although both are types of order. Modular works are based on the repetition of a standard unit. The unit, which may be anything (Carl Andre's bricks, Robert Morris' truncated volumes, Andy Warhol's soup cans) does not alter its basic form, although it may appear to vary by the way in which units are adjoined. While the addition of identical units may modify simple Gestalt viewing, this is a relatively uncomplex order form. Modularity has a history in the 'cultural methods of forming' and architectural practice. Frank Stella has often worked within a modular set although in his concentric square paintings he appears to have serialized colour arrangement with the addition of random blank spaces. Some of the early Black Paintings, like Die Fahne Hoch!, employed rotational procedures in the organization of quadrants.

Logics which precede the work may be absurdly simple and available. In Jasper Johns' number and alphabet paintings the prime set is either the letters A–Z or the numbers 0–9. Johns chose to utilize convention. The convention happened to be serial. Without deviating from the accustomed order of precedence he painted all the numbers or letters, in turn, beginning again at the end of each sequence until all the available spaces on the canvas were filled. The procedure was self-exhausting and solipsistic. Other works of Johns' are noteworthy in this context, especially his Three Flags which is based on size diminution and, of course, the map paintings. His drawings in which all the integers 0–9 are superimposed

are examples of a straightforward use of simultaneity.

An earlier example of simultaneity appears in Marcel Duchamp's Nude Descending a Staircase. Using the technique of superimposition and transparency, he divided the assigned canvas into a succession of time intervals. Due to the slight variation in density, it is impossible to visualize specific changes as such. Alternations are levelled to a single information which subverts experiential time. Duchamp has said the idea was suggested to him by the experiments of Doctor Etienne Jules Marey (1830–1904). Marey, a French physiologist, began with ideas derived from the work of Muybridge, but made a number of significant conceptual and mechanical changes. He invented an ingenious optical device based on principles of revolution similar to Gatling's machine-gun. This device enabled him to photograph multiple points of view on one plate. In 1890 he invented his 'chrono-photograph' which was capable of recording, in succession, 120 separate photos per second. He attempted to visualize the passage of time by placing a clock within camera range, obtaining by this method a remarkable 'dissociation of time and image'.

Types of order are forms of thoughts. They can be studied apart from whatever physical form they may assume. Before observing some further usages of seriality in the visual arts, it will be helpful to survey several other areas where parallel ideas and approaches also exist. In doing this I wish to imply neither metaphor nor analogy.

'My desire was for a conscious control over the new means and forms that arise in every artist's mind.'
– Arnold Schoenberg

Music has been consistently engaged with serial ideas. Although the term 'serial music' is relatively contemporary, it could be easily applied to Bach or even Beethoven. In a serial or Dodecaphonic (twelve-tone) composition, the order of the notes throughout the piece is a consequence of an initially chosen and ordered set (the semi-tonal scale arranged in a definite linear order). Note distribution is then arrived at by permuting this prime set. Any series of notes (or numbers) can be subjected to permutation as follows: two numbers have only two permutations (1, 2: 2, 1); three numbers have six (1, 2, 3; 1, 3, 2; 2, 1, 3; 2, 3, 1; 3, 1, 2; 3, 2, 1); four numbers have twenty-four; ... twelve numbers have 479,001,600. Other similarly produced numerical sequences and a group of pre-established procedures give the exact place in time for each sound, the coincidence of sounds, their duration, timbre and pitch.

The American serial composer Milton Babbit's Three Compositions for Piano can be used as a simplified example of this method (see George Perle's Serial Composition and Atonality for a more detailed analysis). The prime set is represented by these integers: $P = 5, 1, 2, 4$. By subtracting each number in turn from a constant of such value that the resulting series introduces no numbers not already given, an inversion results (in this case the constant is 6): $I = 1, 5, 4, 2$. A rotational procedure applied to P and I yields the third and fourth set forms: $Rp = 2, 4, 5, 1; RI = 4, 2, 1, 5$.

'Mathematics — or more correctly arithmetic — is used as a compositional device, resulting in the most literal sort of "programme music", but one whose course is determined by a numerical rather than a narrative or descriptive "Programme".'
— Milton Babbit

The composer is freed from individual note-to-note decisions which are self-generating within the system he devises. The music thus attains a high degree of conceptual coherence, even if it sometimes sounds 'aimless and fragmentary'.

'The adaptation of the serial concept of composition by incorporating the more general notion of permutation into structural organization — a permutation the limits of which are rigorously defined in terms of the restrictions placed on its self-determination constitutes a logical and fully justified development, since both morphology and rhetoric are governed by one and the same principle.'
— Pierre Boulez

'The form itself is of very limited importance, it becomes the grammar for the total work.'
— Sol LeWitt

'Language can be approached in either of two ways, as a set of culturally transmitted behaviour patterns shared by a group or as a system conforming to the rules which constitute its grammar.'
— Joseph Greenberg, *Essays in Linguistics*

In linguistic analysis, language is often considered as a system of elements without assigned meanings ('uninterpreted systems'). Such systems are completely permutational, having grammatical but not semantic rules. Since there can be no system without rules of arrangement, this amounts to the handling of language as a set of probabilities. Many interesting observations have been made about uninterpreted systems which are directly applicable to the investigation of any array of elements obeying fixed rules of combination. Studies of isomorphic (correspondence) relationships are especially interesting.

Practically all systems can be rendered isomorphic with a system containing only one serial relation. For instance, elements can be reordered into a single line, i.e., single serial relation by arranging them according to their coordinates. In the following two-dimensional array, the coordinates of C are (1, 3), of T (3, 2):

R P D
L B T
C U O

Isomorphs could be written as: R, L, C, P, B, U, D, T, O or R, P, D, L, B, T, C, U, O. An example of this in language is the ordering in time of speech to correspond to the ordering of direction in writing. All the forms of cryptography from crossword puzzles to highly sophisticated codes depend on systematic relationships of this kind.

'The limits of my language are the limits of my world.'

— Ludwig Wittgenstein

Certain terms, not common in an art context, are necessary for a discussion of serial art. As yet these terms, often abused, have remained undefined. Some of the following definitions are standard, some are derived from the above investigations, the rest are tailored to specific problems of the work itself:
Abstract System.
1. A system in which the physical units that are to function as objects have not been specified.
Binary.
2. Consisting of two elements.
Definite Transition.
3. A rule that requires some definite interval, before or after a given unit, some other unit is required or excluded.
Grammar.
4. That aspect of the system that governs the permitted combinations of elements belonging to that system.
Isomorphism.
5. A relation between systems so that by rules of transformation each unit of one system can be made to correspond to one unit of the other.
Orthogonal.
6. Right angled.
Permutation.
7. Any of the total number of changes in order which are possible within a set of elements.
Probability.
8. The ratio of the number of ways in which an event can occur in a specified form to the total number of ways in which the event can occur.
Progression.
9. A discrete series that has a first but not necessarily a last element in which every intermediate element is related by a uniform law to the others.
(a) *Arithmetic Progression.*
10. A series of numbers in which succeeding terms are derived by the addition of a constant number (2, 4, 6, 8, 10 ...)
(b) *Geometric Progression.*
11. A series of numbers in which succeeding terms are derived by the multiplication, by a constant factor (2, 4, 8, 16, 32 ...)
Rotation.
12. An operation consisting of an axial turn within a series.
Reversal.
13. An operation consisting of an inversion or upside down turn within a series.
Set.
14. The totality of points, numbers or other elements which satisfy a given condition.
Sequence.
15. State of being in successive order.
Series.
16. A set of sequentially ordered elements, each related to the preceding in a specifiable way by the logical conditions of a finite progression, i.e., there is a first and last member, every member except the first has a single immediate predecessor from which it is derived and every member except the last a single immediate successor.

Simultaneity.
17. A correspondence of time or place in the occurrence of multiple events.

An odd 'free' utilization of series was Allan Kaprow's *18 Happenings in 6 Parts*. His initial set was capriciously chosen: seven smiles, three crumpled papers and nineteen lunch box sounds. The nineteen lunch box sounds were snapping noises made by purchasing many kinds of lunch boxes or recording a few and then altering them until nineteen variations were obtained. The arrangement of sounds will be 3, 12, 7, 8, 10, 2, 15, 6, 1, 13, 5, 18, 4, 19, 17, 9, 14. While being a completely arbitrary use of row technique it does present an interesting possibility for the routinization of spatio-temporal events. Sports, such as football, are based on similar concepts of sequentially-fixed probabilities of random movement.

Alfred Jensen's involvement would appear to be with an unorthodox appreciation of 'Numbers', judging from such titles as *Square Root 5 Figurations*, *Twice Six* and *Nine*, and the recent *Timaeus (Plato's dialogue on aesthetics)*. For Plato, as well as Pythagoras, 'Number' had an ideal existence and was viewed as paradigmatic (a concept which has been reintroduced into mathematical logic by Russell and Whitehead's concept of number as a 'class of classes'). Whatever the derivation, order in Jensen's paintings is defined in terms of progressional enlargement and diminishment of adjacent rectangular spaces. Although his colour choices seem arbitrary, their placement is not, being arranged in bilateral symmetries or systematic rotations. The checkerboard pattern which he adheres to is one of the oldest binary orders.

'The structure of an artificial optic array may, but need not, specify a source. A wholly invented structure need not specify anything. This would be a case of structure as such. It contains information, but not information about, and it affords perception but not perception of.
— James J. Gibson, *The Senses Considered as Perceptual Systems*

Perspective, almost universally dismissed as a concern in recent art, is a fascinating example of the application of prefabricated systems. In the work of artists like Paolo Uccello, Albrecht Durer, Piero della Francesca, Pieter Saendredam, Thomas Eakins (especially their drawings), it can be seen to exist entirely as methodology. It demonstrates not how things appear but rather the workings of its own strict postulates. As it is, these postulates are serial.

Perspective has had an oddly circular history. Girard Desargues (1593–1662) based his non-Euclidean geometry on an intuition derived directly from perspective. Instead of beginning with the unverifiable Euclidean axiom that parallel lines never meet, he accepted instead the visual evidence that they do meet at the point where they intersect on the horizon line (the 'vanishing point' or 'infinity' of perspective). Out of his investigations of 'visual' (as opposed to 'tactile') geometry came the field of projective geometry. Projective geometry investigates such problems as the means of projecting figures from the surface of three-dimensional objects to two-dimensional

planes. It has led to the solution of some of the problems in mapmaking. Maps are highly abstract systems, but since distortion of some sort must occur in the transformation from three to two dimensions, maps are never completely accurate. To compensate for distortion, various systems have been devised. On a topographical map, for example, the lines indicating levels (contour lines) run through points which represent physical points on the surface mapped so that an isomorphic relation can be established. Parallels of latitude, isolates, isothermal lines and other grid coordinate denotations, all serialized, are further cases of the application of external structure systems to order the unordered.

Another serial aspect of mapmaking is a hypothesis in topology about colour. It states that with only four colours all the countries on any map can be differentiated without any colour having to appear adjacent to itself. (One wonders what the results might look like if all the paintings in the history of art were repainted to conform to the conditions of this hypothesis.)

In the early paintings of Larry Poons it was not difficult to discern the use of serialization. The rules of order varied, sometimes they appeared to be based on probabilities of position and/or direction and/or shape (dot or ellipsoid). Definite transitions or replacements occurred in some paintings. *Inforcer* appeared to be based on a system of quadrant reversal and rotation.

Although Donald Judd's chief concerns seem to be 'Specific Objects', he has utilized various modular and serial order types. One of Judd's untitled galvanized iron pieces, consisting of four hemi-cylindrical sections projecting from the front face of a long, rectangular volume, is based on the progression 3, 4, 3.5, 3.5, 4, 3, 4.5. The first, third, fifth and seventh numbers are the ascending proportions of the widths of the metal protrusions. The second, fourth and sixth numbers are the widths of the spaces between. The numbers are not measurements but proportional divisions of whatever length the work is decided to be. Fascinating progressions of the above kind can be found listed in Jolly's *Compilation of Series*.

Sol LeWitt orders his floor pieces by permuting linear dimension and binary volumetric possibilities. Parts of his eighteen-piece Dwan Gallery (Los Angeles) exhibition could have appeared at one of three height variables, in one of two volumetric variables (in this case all were open) and in one of two positional variables, on a constant 3 × 3 square grid. The complexity and visual intricacy of this work seems almost a direct refutation of Whitehead's dictum that the higher the degree of abstraction the lower the degree of complexity. LeWitt's two-dimensional orthogonal grid placement system is related to the principles of order in mapmaking.

Other artists are currently exploiting aspects of seriality. Dan Flavin's *nominal three (to William of Ockham)* (author of the law of parsimony) is based on an arithmetic progression. Jo Baer's paintings, Hanne Darboven's complicated drawings, Dan Graham's concrete poetry, Eva Hesse's constructions, William Kolakoski's programmed asterisks, Bernard Kirschenbaum's crystallographic sculpture, Robert

Smithson's pyramidal glass stacks all suggest future possibilities of serial methodology.

Mel Bochner, 'The Serial Attitude', *Artforum*, VI: 4 (December 1967) 73–77.

Lucy R. LIPPARD
The Silent Art [1967]

The art for art's sake, or formalist strain, of non-objective painting has an apparently suicidal tendency to narrow itself down, to zero in on specific problems to the exclusion of all others. Each time this happens, and it has happened periodically since 1912, it looks as though the much heralded End of Art has finally arrived. The doomsayers delight in predicting an imminent decease for any rejective trend. While Dada, assemblage and Pop art have come in for their share of ridicule and rage, the most venomous volleys have been reserved for those works or styles that seem 'empty' rather than 'ordinary' or 'sloppy'. The message of the Emperor's New Clothes has made a deep impression on the American art public. 'Empty' art is more wounding to the mass ego than 'sloppy' art because the latter, no matter how drastic, is part of the aesthetic that attempts to reconcile art and life, and thus can always be understood in terms of life. There is nothing lifelike about monotonal paintings. They cannot be dismissed as anecdote or joke; their detachment and presence raise questions about what there is to be seen in an 'empty' surface [...]

Instances of single-colour, single-surface paintings during the past fifty years are few. The first and best-known monochrome painter was of course Kasimir Malevich. His *White on White* series, executed as Supremacist studies around 1918, was paralleled by Aleksandr Rodchenko's black-on-black canvas, also sent to Moscow's Tenth State Exhibition in that year, apparently as a reply to Malevich's white works. Rodchenko's manifesto at that time consisted, coincidentally, of a list of quotations: a device used thirty years later by Ad Reinhardt: 'As a basis for my work I put nothing'; 'colours drop out, everything is mixed in black'. Malevich, who was something of a mystic, equated white with extra-art associations: 'I have broken the blue boundary of colour limits and come out into white ... I have beaten the lining of the coloured sky ... The free white sea, infinity lies before you.' Actually, the square in The Museum of Modern Art's *White on White* is diagonally placed to activate the surface by compositional means. This concern with dynamism separates Malevich from later monotone developments, although a series of absolutely symmetrical drawings from 1913 predicted the non-relational premise of Ad Reinhardt and the younger artists of the 1960s. He also emphasized, like today's painters, the art of painting as painting alone, a medium sharing none of its particular properties (two-dimensionality, rectangularity, painted surface) with other media: 'The nearer one gets to the phenomenon of painting, the more the sources lose their system and are broken, setting up another order according to the laws of painting' [...]

Reinhardt, Barnett Newman, Mark Rothko and, to a lesser extent, Clyfford Still are the major American precedents for the current monotonal art. All four, in virtually opposing manners and degrees, stress the experience of the painting above all surface incidents, and all, since around 1951, have more or less consistently dealt with nearly monochromatic or nearly monotonal art that is, in fact, an offshoot of the all-over principle of much New York School painting in the late 1940s. But monotone is all-over painting par excellence, offering no accents, no calligraphy, no inflection. Around 1950, Newman, a strong influence on the younger generation now concerned with monotone painting, made several only slightly modulated, single-colour, single-surface canvases, such as the tall, vertical *Day One* and an all-white painting of 1951–52. His *Stations of the Cross* series (1958–66) concludes with a precise, pure, white-on-white work that was unavoidably interpreted as representing transfiguration. Newman's titles indicate that he welcomes such symbolic or associative interpretation; most of the younger artists, on the contrary, are vehemently opposed to any interpretation and deny the religious or mystical content often read into their work as a result of Newman's better-known attitude, and as a result of the breadth and calm inherent in the monotonal theme itself [...]

The nature of post-war art in Europe has led monotonal painting there in quite a different direction from the increasingly formal orientation of the American concept. The epitome of gesture artists, and one of the most interesting figures to emerge from Paris in the last decade, was the late Yves Klein – 'Yves *le monochrome*', as he called himself. He began experimenting with the concept in 1946, exhibited his first monochromes in 1955 and showed his best-known works, from the *époque bleue*, in May 1957. Klein has little in common with most of the artists discussed here. His work, his statement and his general extravagance were more allied to the Duchampian paradox, and he is an acknowledged founder of the Duchamp-inspired *nouveaux réalistes* [...]

Klein sought detachment in the philosophy of the Far East, where he once lived, though his was a theatrical, Westernized orientalism concerned with a 'trace of sentimentality', 'cosmic phenomena', 'pictorial sensitivity' and 'The Immaterial', which have proved unsympathetic to most American artists [...]

The type of monotone painting that most concerns us in the mid 1960s is the rejective, formally oriented strain. The painters involved share few stylistic traits but are mutually occupied with a further progression of painting, despite the contention of some critics and artists that painting is obsolete. Any discussion of Modernist monotone painting must emphasize the central role of Ad Reinhardt, whose square, black, symmetrically and almost invisibly trisected paintings are, according to him, 'the last paintings that anyone can paint' [...]

By denying colour in his black paintings from 1960 on (though some of them still retain traces of the extremely close-valued red, blue and green and which they began), Reinhardt has simply taken his steadfastly art-for-art's sake aesthetic to its logical end. 'The one work for a fine artist now', he says, 'the one thing in painting to do, is to

repeat the one-size canvas — the single-scheme, one colour monochrome, one linear-division in each direction, one symmetry, one texture, one formal device, one free-hand-brushing, one rhythm ... painting everything into one over-all uniformity and non-regularity'. After two decades of art that screamed for attention (from the Abstract Expressionists through the hard- or soft-edged colourists), Reinhardt's work is finally becoming visible to more than a handful of admirers. The public eye is becoming more accustomed to forced contemplation. Recent events have also proved that the fuzzy-edged, often pretty colour used by the 'colour painters' or 'stain painters' has less attraction for the younger generation than Reinhardt's rigorous abstention [...]

Monotone painting can be said to exist in time as well as in space, for it demands much more time and concentration than most viewers are accustomed or, in most cases, are willing to give. Among the most extreme examples are the recent white paintings of Robert Irwin. After an interval of time the patient viewer begins to perceive in Irwin's 'blank' surfaces tiny dots of colour which form a haloed, roughly circular form. The square canvases are ever so slightly bowed so that the surface slips away into the surrounding space, and they stress the atmospheric central area rather than the traditional properties of the rectangular support. But the atmospheric effect is no more permanent than the initial whiteness; the colour dots in the centre are more and more obvious and, when seen up close, become as uninteresting as Signae's pallid colour bricks. Irwin does not — with good reason — allow his paintings to be reproduced. Instead, he insists on a directly 'hypnotic involvement' between painting and viewer. By reintroducing energy and illusionism and by de-emphasizing the picture support, he deliberately breaks the rules of the formalist academy. But since distance from the canvas is necessary for maximum enjoyment, and since the viewer's optical experience is finally one of amorphous light-energy, Irwin's effects might be better achieved by the use of actual light.

Robert Mangold's work also induces near monotonal atmospheric effects, but it forgoes the impression of glimmering depths that make one query the necessity of Irwin's work being painted instead of projected upon by some outside light source. Mangold's faint gradations, consisting of two pale, closely valued colours, are sprayed on smooth Masonite; the formats are shaped, though only at one corner or edge, sliced or curved to destroy any concrete object effect. At the same time such a particular shape emphasizes the surface, further avoiding its destruction by light. Mangold's colours are hard to pin down. They fade and intensify into and away from monotone as they are watched. His earlier *Walls* were monochromatic but radically silhouetted and relief-like. When he rejected the apparently inevitable move into freestanding structures, Mangold's entire attention returned to the surface. The lightly atmospheric *Areas* reach a successful equilibrium between the shape of support and the strong assertion of flat, elusively coloured plane, presenting the notion of a partially contained space which 'continues' unseen, but which also operates within a structural and eminently *seen* framework [...]

The shaped canvas, even if two-dimensional, is usually an imperfect vehicle for monotone painting. Rather than altering the rectangle and continuing to stress the surface, as Mangold does, most adherents of the shaped canvas (such as Peter Tangen, Ron Davis and David Novros) depart more radically towards a relief or sculptural concept. They do not go beyond painting so much as they ignore painting and establish a 'third-stream' idiom. While obviously irrelevant to the quality of the work, the whole point of a large monotone surface is denied by the use of exaggerated shapes, which de-emphasize surface in favour of contour. When the expanse of an uninflected single surface gives way to the silhouette, the wall becomes the ground, or field, and the canvas itself becomes an image, a three-dimensional version of the hard-edge painted image. Similarly, works like Ellsworth Kelly's monotone (but differently coloured) canvases hung together as one become a three-colour painting, not a monotonal unity. Paul Mogensen's spaced modular panels — of the same height and same iridescent blue but of different widths — also approach sculpture rather than retaining the single surface of true monotone.

An absolutely monotonal and monochromatic art is by nature concerned with the establishment and retention of the picture plane. Three New York artists, Ralph Humphrey, Robert Ryman and Brice Marden, have been working with surfaces that do not relinquish the controlled but improvisational possibilities of the paint itself. They have stripped the impasto of its gestural, emotional connotations. Their canvases emphasize the fact of painting as painting, surface as surface, paint as paint, in an inactive, unequivocal manner. Humphrey has had three monotone exhibitions at the Tibor de Nagy Gallery in New York (1959, 1960 and 1961), in which a dark, heavily worked surface avoided virtuoso expressionism as well as a mechanical or delicately mannered effect. Humphrey's 1965 exhibition was no longer monotonal, but added a contrasting framing band, which also indicated the non-emptiness of a 'blank' centre. Marden's palette is related to Humphrey's, consisting of neutral, rich greys and browns. A flat but rather waxy surface with random, underplayed process-markings covers the canvas except for a narrow band at the bottom, where drips and smears and the effects of execution are allowed to accumulate. He seems to exclude emotion entirely, whereas Humphrey claims neither an Expressionist nor an anti-Expressionist point of view.

Ryman's concern, on the other hand, is entirely with paint; he has gradually rejected colour since 1958, and his square, irregular but all-over white paintings of that period have since become regular, monotonal white paintings in a logical sequence of exclusion. In 1965 he made a series of totally flat, square white canvases (some in oil, some in acrylic, some in enamel) which were still subject to variation, in that even the enamel had a quality of its own, no matter how flatly it was applied. In 1966 Ryman evolved a system of monotone based on an almost imperceptible, impassive, horizontal stroke (made with a 33 cm [13 in] brush) on a 'solid' white surface, the only irregularity being a faintly uneven outer edge.

It should be clear by now that monotonal painting has

no nihilistic intent. Only in individual cases, none of which is mentioned here, is it intentionally boring or hostile to the viewer. Nevertheless, it demands that the viewer be entirely involved in the work of art, and in a period where easy culture, instant culture, has become so accessible, such a difficult proposition is likely to be construed as nihilist. The experience of looking at and perceiving an 'empty' or 'colourless' surface usually progresses through boredom. The spectator may find the work dull, then impossibly dull; then, surprisingly, he breaks out of the other side of boredom into an area that can be called contemplation or simply aesthetic enjoyment, and the work becomes increasingly interesting. An exhibition of all-black paintings ranging from Rodchenko to Humphrey to Corbett to Reinhardt, or an exhibition of all-white paintings from Malevich to Klein, Kusama, Newman, Francis, Corbett, Martin, Irwin, Ryman and Rauschenberg, would be a lesson to those who consider such art 'empty'. As the eye of the beholder catches up with the eye of the creator, 'empty', like 'ugly', will become an obsolete aesthetic criterion.

Lucy R. Lippard, 'The Silent Art', *Art in America* (January-February 1967) 58-63.

Robert MANGOLD
Flat Art [1967]

[...] 'Painting extends to include flat shapes and planes of all sorts.'
— George Kubler, 'The Shape of Time'

'Neither the theories nor the experience of Gestalt effects relating to three-dimensional bodies are as simple and clear as they are for two-dimensions.'
— Robert Morris, 'Notes on Sculpture: Part I', 1966

'I call our world Flatland, not because we call it so, but to make its nature clearer to you my happy readers, who are privileged to life in Space.'
— Edwin A. Abbott, 'Flatland'

To be referred to as a painter or to have my work referred to as paintings is an annoyance, since it presumes a certain importance of one element of a work, and projects that element as the key visual or conceptual factor in those works.

Painting has been criticized for, among other things, its material limitations. Limitations preventing painting from making use of newer techniques, methods and materials. This is a good example of how the word-category, Painting, conceptually becomes a 'stumbling block'. Flat, two-dimensional art can be made out of as wide a range of materials as three-dimensional art.

Some artists, while working in an area which is the historical extension of Painting or Sculpture, find little or no connection with the traditional skills, attitudes, etc. associated with the terms.

Another objection to the use of the term Painting as an all-encompassing category is that it has set up a

hierarchical relationship to other types of flat art, the photograph, drawing, print, etc. It would be more desirable to have all of these forms equally considered under one category.

One thing that is true of flat, two-dimensional art is that flat art can be seen instantly, totally. This could be called its natural advantage. Flat art has only one view, the frontal view, all the visual information which the piece contains is available to the eye or camera from that position [...]

Flat art is all surface, the edges are simply edges of a surface. The thickness is the thickness of the material chosen to work upon, and in some cases the additional thickness of the support needed. When the edge is treated as a side and is painted in some way that suggests it is to be seen in relation to the surface, it is of course no longer a flat work that has but one viewpoint, rather it is a three-dimensional or multi-view work.

Robert Mangold, 'Flat Art' (unpublished artist's statement, New York, 1967).

Barbara ROSE
Group Show: Bykert Gallery [1967]

[...] There is no question that the paintings by Brice Marden, David Novros, Paul Mogensen, Ralph Humphrey and Peter Gourfain at the Bykert aspire to be radical art. All are more or less 'minimal' in that they are monochromatic or close to it. The ambition ranges from Marden's modest small-scale panels to Goufain's expansive 549-cm [18-ft] plum Colour Field painting and Novros' angular, shaped canvas constructions which use the wall as negative space in their Gestalt interplay. Common to all the work, however, is a curious listlessness and homogeneity that often accompanies derivative work. For not one idea in the show is original. Marden's dense rectangles with their dripped lower margins look like the backgrounds of Johns' large paintings; Mogensen's and Novros' modular art fill the gap between Stella and Judd. Only Ralph Humphrey's tense, sensitive abstraction of three narrow, parallel bands on a pale grey field is sufficiently distinctive to be remembered.

A show like this only goes to prove that the reductive solution is a narrow one which leaves little play for the imagination or room for variety. Only master craftsmen like Larry Bell or Robert Irwin seem able to create a reductive art of any complexity or considerable aesthetic impact. For the rest, there appears no exception to the rule that for a few people less is more, but for the vast uninspired majority, less is just simply less. The exhibition at the Bykert is a depressing reminder of the poverty of the current scene. It is quite representative of the work being turned out by young artists, work whose major virtue is competence and whose range of ambition is entirely within the possible.

Obviously, the younger generation see the present cultural situation as calling for an art of introspective contemplation rather than one of emphatic catharsis. Their art rejects 'engagement', self-expression, high-flown rhetoric, metaphor and symbolism. It is a truism that every gain represents a loss; the question now is whether what has been won is worth what has been sacrificed. The vulgarity and tastelessness that have characterized American art until the present have at least been vanquished; but in general they have been replaced by a tepid professionalism [...]

In retrospect, every historical period appears less rich than it did to the artist's own contemporaries. The decades 1910–20 in Paris and 1940–50 in New York are the exceptional years of our century. Like the late 1950s, the late 1960s is basically an academic period. Most artists are still cannibalizing ideas generated by a handful of painters and sculptors in the early years of the decade. Now, Jules Olitski's spray-paintings promise to be the point of departure for a back-to-painterliness bandwagon. Second-generation hard-edge painting and its 'minimal' offshoot, neo-shaped canvases, the various forms of stained painting which derive from Kenneth Noland and Helen Frankenthaler are as dull, repetitive, mannered and predictable as anything one saw on Tenth Street. But they are not as tasteless or as vulgar, and in that, one supposes, one sees progress in American art [...]

Barbara Rose, 'Group Show: Bykert Gallery', *Artforum*, 6: 3 (November 1967) 59-60.

Jo BAER
Letter to the Editor [1967]

Sirs:

Bob Morris writes a paragraph in 'Notes on Sculpture: Part 3', which designates the art of painting an 'antique mode'. The contention parallels Judd's polemic in 'Specific Objects', and taken together, warrant rebuttal.

Morris alleges an 'inescapable, inherent illusionism' in painting, and derives the rest of the indictment from this fallacy. The misconception has at bottom two focusing points: illusion, which is technical, and allusion, which is either mundane or ubiquitous. Morris restricts his critique to mundane allusion: he believes a painting is necessarily a picture of something. This 'duality of thing (the painting) and allusion (the picture)' he finds 'divisive', 'ambiguous', 'elusive', 'non-actual', 'unconvincing', 'indeterminate', 'unpragmatic' and 'non-empirical'. I never much liked it myself. He may be confusing 'inherent' and 'inherit'. It is true we inherit a pictorial convention, but painting has challenged and reduced this inheritance, decade by decade, so that pictorial allusion inheres no more now in paint than in wallpaper. Some recent paintings exist which are not pictures. To de-specify, and in regard to ubiquitous allusion: all art always alludes to something else. Here are some allusions which 'advanced sculptors' may be said to illustrate: a molecular code in the brain which enjoys aesthetic principles of symmetry, unity, good Gestalt; geometry, a fabricated schema which surveys and measures solids, surfaces, lines and angles, space and figures in space; logic, a catalogue of canons and criteria of

validity; other art forms: painting, the theatre; other objects: boxes, tables, benches, statues; and the psychological projections of the artists themselves, object as 'surrogate'. If not, all sculptures are statues, and not all cubical 'specific objects' boxes, then not all paintings are pictures.

Two of Donald Judd's three specific objections to painting specify limits: they clearly objectify Judd's limits, not the art's. Here is his first objection:
'The main thing wrong with the painting is that it is a rectangular plane placed flat against the wall. A rectangle is a shape itself; it is obviously the whole shape; it determines and limits the arrangements of whatever is on or inside it ... A form can be used only in so many ways. The rectangular plane is given a life span. The simplicity required to emphasize the rectangle limits the arrangement possible within it.'

The arrangement of shapes which Judd states, and reiterates, is a specious objective to assign to painting of the mid 1960s. Radical painting completed this specific endeavour in the 1930s. It began it in 1908. Judd's own specific objective has been the arrangement of cubes and other parallelepipeds in or on a shallow space (a 15 to 122 cm [6 to 48 in] projection from the wall, a 15 to 122 cm [6 to 48 in] projection from the floor); and though he specifies arrangements which emphasize unity and wholeness of the objects, paintings or sculpture, this latter qualification was also invented by painters, and is also much prior to any art or paper by Judd (1958–63: Jasper Johns, Frank Stella, Kenneth Noland). As the exhaustion of Cubist concerns in painting is hardly news, their translation now, into 'specific objects', is at best a minor sport. For about one hundred years painting has demonstrated the precursive, radical ideas in art. Painting is best suited for this pursuit, and the best painters are still about it. It is no surprise, however, that an academic, sculptural sensibility is not able to anticipate these new ideas. Arrangements which 'emphasize the rectangle' are not one of them.

Judd's second objection: 'Oil and canvas are familiar, and like the rectangular plane, have a certain quality and have limits. The quality is especially identified with art.'

Oil and canvas are no more or less identified with art than tempera and board, flux and porcelain, ink or watercolour and paper, coloured earths and granite, coloured glass and mullions, pigments and sandstone, lacquer and metal, acrylic and Plexi. We paint a house with oil and shade its windows with canvas. Auto paint (lacquer) sprayed on sheer metal does not innovate, either towards or away from that which 'identifies art'. Any kind of articulated colour film on any kind of flat, frontal surface may be a painting. The only limits to the materials of painting are those of technology and of the eye's discrimination in seeing reflected light. Humans can distinguish 15,000–17,000 colours: envenomed monkey, rat colour and elephant's breath are some of the 7,000 documented varieties. A computer differentiates about two million. Judd has tacitly confused the novel with the radical. He implies that any vacuformed Plexi-bas-relief is automatically superior to any contemporary ideated marks on a flat surface. But ideas are ideas. Techniques and materials are not ideas. Ideas and materials have a

Carl ANDRE 'Dense Review Paul Mogensen Paintings', 1967

functional relationship, not an identity. If oil and canvas did confer a familiar quality 'especially identified with art', there are those who would count this an especial virtue of the materials; there is no new, aesthetic value served in an arrangement of lamps anywhere but the ceiling, or in mirrored cubes confounded with modern tables; Duchamp's early question put and answered what is art, and his catachresis is still sufficient. 'Non-art' settings, sites and positions *per se*, like new materials and techniques *per se*, are not innovations in art. Those works which do depend on the 'unfamiliar' require intensive propaganda to establish and maintain the small art quality in their amalgam; the printer then provides 'that familiar quality especially identified with art'.

Judd's only technical objection to painting has two parts. He first speaks about spatial illusion: *'Almost all paintings are spatial in one way or another. Yves Klein's blue paintings are the only ones that are unspatial … It's possible that not much can be done with both an upright rectangular plane and an absence of space. Anything on a surface has space behind it. Two colours on the same surface almost always lie on different depths. An even colour, especially in oil paint, covering all or much of a painting is almost always both flat and infinitely spatial … '*

A hard look at this expert critique shows it is wrong on all counts. One: not all paintings are spatial, and Yves Klein's blue panels are not even paintings, since their surfaces lack articulation. They are the artefacts of an intellectual position. Two: it is apparent that anything done with both an upright rectangular plane and an absence of space is more than may be seen by the retrograde eye. Three: anything on a surface becomes that surface; it has no space behind it, unless it is so designated; it has its support (canvas, board, steel) behind it. If the painting surface is continuous, border to border and throughout, that shallow space between surface and support (so enjoyed by painters from Albrecht Durer to Paul Cézanne, Henri Matisse through Frank Stella and Kenneth Noland), no longer exists. Some recent paintings look as if their colours might be continuous right through the object to the wall. Some recent wall boxes look hollow. Four: two colours on the same surface can always be made to lie on the same depth. The ability to accomplish, and apparently to see this, distinguishes the painter from the sculptor or whatever. Some recent paintings redefine colour as luminance (reflected light), and use this new colour spectrum so that no illusion of depth is possible at all. Some recent sculptures light lamps deep in their interiors to make them seem less hollow. Five: an even colour, especially in a rich oil-paint, covering all or much of a painting, is always flat and finite if the covering and colour are even, or if the colour has been put on vertically. A surface is almost always infinitely spatial if it is scumbled or the paint is applied horizontally. It is also infinitely spatial if it is mostly painted blue, in any manner, and its frame sides are not. Some recent oil paintings have large flat, vertically painted areas where light reflection is controlled to where the painted canvas is discernible as a finite, painted event, and reflectiveness is still a bounded surface. Some recent lamp arrangements diffuse their light in a fluffy likeness of an Infinite Mazda.

Judd now continues to allusion: *'Except for a complete and unvaried field of colour or marks, anything placed in a rectangle and on a plane suggests something in and on something else, something in its surround, which suggests an object or figure in its space, in which these are clearer instances of a similar world – that's the main purpose of painting.'*

This thought on allusion makes a full circle back to Morris' sister-allegation: the main purpose of painting is to make pictures in the very everyday sense of the word. And only Renaissance pictures, at that. The purpose includes no Oriental journeys ascending the plane, no Grecian narratives gracing a horizon, no Muslim proliferations weaving a surface: only the figure in its perspective ground may be a clearer instance of a 'similar world'. The last radical paintings to attend figure-ground problems were Noland's circle paintings of about 1960. Painters discarded the teleology of distance and pictorial depth when they discarded ground altogether, and paintings became objects altogether. This happened some time before they were inflated into wall objects, up-to-ceiling objects and out-in-floor objects.

An 'inescapable' delusion moves the above critics. It is objectionable.

Jo Baer, New York City

Jo Baer, 'Letter to the Editor', *Artforum* (September 1967) 5–6.

Clement GREENBERG
Recentness of Sculpture
[1967]

Advanced sculpture has had more than its share of ups and downs over the last twenty-five years. This is especially true of abstract and near-abstract sculpture. Having gathered a certain momentum in the late 1930s and early 1940s, it was slowed down in the later 1940s and in the 1950s by the fear that, if it became markedly clean-drawn and geometrical, it would look too much like machinery. Abstract Expressionist painting, with its aversion to sharp definitions, inspired this fear, which for a time swayed even the late and great David Smith, a son of the 'clean-contoured' 1930s if there ever was one. Not that 'painterly' abstract sculpture was necessarily bad; it worked out as badly as it did in the 1940s and 1950s because it was too negatively motivated, because too much of it was done in the way it was done out of the fear of not looking enough like art.

Painting in that period was much more self-confident, and in the early 1950s one or two painters did directly confront the question of when painting stopped looking enough like art. I remember that my first reaction to the almost monochromatic pictures shown by Rollin Crampton in 1951 (at the Peridot Gallery) was derision mixed with exasperation. It took renewed acquaintance with these pictures (which had a decisive influence on Philip Guston at that time) to teach me better. The next monochromatic paintings I saw were completely so – the all-white and all-black paintings in Robert Rauschenberg's 1953 show (at the Stable). I was surprised by how easy they were to 'get', how familiar-looking and even slick. It was no different afterwards when I first saw Ad Reinhardt's, Sally Hazlett's and Yves Klein's monochromatic or near-monochromatic pictures. These, too, looked familiar and slick. What was so challenging in Crampton's art had become almost overnight another taming convention. (Jackson Pollock's and Mark Tobey's 'all-overness' probably helped bring this about too.) The look of accident was not the only 'wild' thing that Abstract Expressionism first acclimatized and then domesticated in painting; it did the same to emptiness, to the look of the 'void'. A monochromatic flatness that could be seen as limited in extension and different from a wall henceforth automatically declared itself to be a picture, to be art.

But this took another ten years to sink in as far as most artists and critics in New York were concerned. In spite of all the journalism about the erased difference between art and non-art, the look of both the accidental and the empty continued to be regarded as an art-denying look. It is only in the very last years, really, that Pollock's achievement has ceased being controversial on the New York scene. Maybe he had 'broken the ice', but his all-over paintings continued to be taken for arbitrary, aesthetically unintelligible phenomena, while the look of art as identifiable in the painter like Willem de Kooning remained the cherished look. Today, Pollock is still seen for the most part as essentially arbitrary, 'accidental', but a new generation of artists has arisen that considers this an asset rather than a liability. By now we have all become aware that the far-out is what has paid off best in avant-garde art in the long run – and what could be further out than the arbitrary? Barnett Newman's reputation has likewise benefited recently from this new awareness and from a similar failure of comprehension – not to mention Reinhardt and his present flourishing.

In the 1960s, it has been as though art – at least the kind that gets the most attention – set itself as a problem the task of extricating the far-out 'in itself' from the merely odd, the incongruous and the socially shocking. Assemblage, Pop, environment, Op, kinetic, erotic and all the other varieties of 'Novelty Art' look like so many logical moments in the working out of this problem, whose solution now seems to have arrived in the form of what is called 'Primary Structures', 'ABC' or 'Minimal art'. The Minimalists appear to have realized, finally, that the far-out in itself has to be the far-out as end in itself, and that this means the furthest-out and nothing short of that. They appear also to have realized that the most original and furthest-out art of the last hundred years always arrived looking at first as though it had parted company with everything previously known as art. In other words, the furthest-out usually lay on the borderline between art and non-art. The Minimalists have not really discovered anything new through this realization, but they have drawn conclusions from it with a new consistency that owes some of its newness to the shrinking of the area in which things can now safely be non-art. Given that the initial look of non-art was no longer available to painting, since even an unpainted canvas now stated itself as a

picture, the borderline between art and non-art had to be sought in the three-dimensional, where sculpture was, and where everything material that was not art also was. Painting had lost the lead because it was so ineluctably art, and it now devolved on sculpture or something like it to head art's advance. (I don't pretend to be giving the actual train of thought by which Minimal art was arrived at, but I think this is the essential logic of it.)

Proto-Pop (Jasper Johns and Robert Rauschenberg) and Pop did a lot of flirting with the third dimension. Assemblage did more than that, but seldom escaped a stubbornly pictorial context. The shaped-canvas school has used the third dimension mainly in order to hold on to light-and-dark or 'profiled' drawing: painters whose canvases depart from the rectangle or tondo emphasize that kind of drawing in determining just what other enclosing shapes or frames their pictures are to have. In idea, mixing the mediums, straddling the line between painting and sculpture, seemed the far-out thing to do; in actual aesthetic experience it has proven almost the opposite – at least in the context of painting, where even literal references to the third dimension seem inevitably, nowadays if not twenty-five years ago, to invoke traditional sculptural drawing.

Whether or not the Minimalists themselves have really escaped the pictorial context can be left aside for the moment. What seems definite is that they commit themselves to the third dimension because it is, among other things, a coordinate that art has to share with non-art (as Dada, Duchamp and others already saw). The ostensible aim of the Minimalists is to 'project' objects and ensembles of objects that are just nudgeable into art. Everything is rigorously rectilinear or spherical. Development within the given piece is usually by repetition of the same modular shape, which may or may not be varied in size. The look of machinery is shunned now because it does not go far enough towards the look of non-art, which is presumably an 'inert' look that offers the eye a minimum of 'interesting' incident – unlike the machine look, which is arty by comparison (and when I think of Jean Tinguely I would agree with this). Still, no matter how simple the object may be, there remain the relations and interrelations of surface, contour and spatial interval. Minimal works are readable as art, as almost anything is today – including a door, a table or a blank sheet of paper. (That almost any nonfigurative object can approach the condition of architecture or of an architectural member is, on the other hand, beside the point; so is the fact that some works of Minimal art are mounted on the wall in the attitude of bas-relief. Likeness of condition or attitude is not necessary in order to experience a seemingly arbitrary object as art.) Yet it would seem that a kind of art nearer the condition of non-art could not be envisaged or ideated at this moment.

That, precisely, is the trouble. Minimal art remains too much a feat of ideation, and not enough anything else. Its idea remains an idea, something deduced instead of felt and discovered. The geometrical and modular simplicity may announce and signify the artistically furthest-out, but the fact that the signals are understood for what they want to mean betrays them artistically. There is hardly any

aesthetic surprise in Minimal art, only a phenomenal one of the same order as in Novelty art, which is a one-time surprise. Aesthetic surprise hangs on forever – it is still there in Raphael as it is in Pollock – and ideas alone cannot achieve it. Aesthetic surprise comes from inspiration and sensibility as well as from being abreast of the artistic times. Behind the expected, self-cancelling emblems of the furthest-out, almost every work of Minimal art I have seen reveals in experience a more or less conventional sensibility. The artistic substance and reality, as distinct from the programme, turns out to be in good safe taste. I find myself back in the realm of Good Design, where Pop, Op, assemblage and the rest of Novelty art live. By being employed as tokens, the 'primary structures' are converted into mannerisms. The third dimension itself is converted into a mannerism. Nor have most of the Minimalists escaped the familiar, reassuring context of the pictorial: wraiths of the picture rectangle and the Cubist grid haunt their works, asking to be filled out – and filled out they are, with light-and-dark drawing.

All of which might have puzzled me more had I not already had the experience of Rauschenberg's blank canvases, and of Yves Klein's all-blue ones. And had I not seen another notable token of far-outness, Reinhardt's shadowy monochrome, part like a veil to reveal a delicate and very timid sensibility. (Reinhardt has a genuine if small gift for colour, but none at all for design or placing. I can see why he let Barnett Newman, Mark Rothko and Clyfford Still influence him towards close and dark values, but he lost more than he gained by the desperate extreme to which he went, changing from a nice into a trite artist.) I had also learned that works whose ingredients were notionally 'tough' could be very soft as wholes, and vice versa. I remember hearing Abstract Expressionist painters ten years ago talking about how you had to make it ugly, and deliberately dirtying their colour, only to render what they did still more stereotyped. The best of Claude Monet's lily-pad paintings – or the best of Morris Louis' and Jules Olitski's paintings – are not made any the less challenging and arduous, on the other hand, by their nominally sweet colour. Equations like these cannot be thought out in advance, they can only be felt and discovered.

In any case, the far-out as end in itself was already caught sight of, in the area of sculpture by Anthony Caro in England back in 1960. But it came to him as a matter of experience and inspiration, not of ratiocination, and he converted it immediately from an end into a means – a means of pursuing a vision that required sculpture to be more integrally abstract than it had ever been before. The far-out as end in itself was already used up and compromised by the time the notion of it reached the Minimalists: used up by Caro and the other English sculptors for whom he was an example; compromised by Novelty art.

Still another artist who anticipated the Minimalists is Anne Truitt. And she anticipated them more literally and therefore, as it seems to me, more embarrassingly than Caro did. The surprise of the boxlike pieces in her first show in New York, early in 1963 (at Emmerich's), was much like that which Minimal art aims at. Despite their being covered with rectilinear zones of colour, I was stopped by their deadpan 'primariness', and I had to look

again and again, and I had to return again, to discover the power of these 'boxes' to move and affect. Far-outness here was stated rather than merely announced and signalled. It was hard to tell whether the success of Truitt's best works was primarily sculptural or pictorial, but part of their success consisted precisely in making that question irrelevant.

Truitt's art did flirt with the look of non-art, and her 1963 show was the first occasion on which I noticed how this look could confer an effect of *presence*. That presence as achieved through size was aesthetically extraneous, I already knew. That presence as achieved through the look of non-art was likewise aesthetically extraneous, I did not yet know. Truitt's sculpture has this kind of presence but did not *hide* behind it. That sculpture could hide behind it – just as painting did – I found out only after repeated acquaintance with Minimal works of art: Judd's, Morris', Andre's, Steiner's, some but not all of Smithson's, some but not all of LeWitt's. Minimal art can also hide behind presence as size: I think of Bladen (though I am not sure whether he is a certified Minimalist) as well as of some of the artists just mentioned. What puzzles me, if I am puzzled, is how sheer size can produce an effect so soft and ingratiating, and at the same time so superfluous. Here again the question of the phenomenal as opposed to the aesthetic or artistic comes in.

Having said all this, I won't deny that Minimal art has brought a certain negative gain. It makes clear as never before how fussy a lot of earlier abstract sculpture is, especially that influenced by Abstract Expressionism. But the price may still not be worth it. The continuing infiltration of Good Design into what purports to be advanced and highbrow art now depresses sculpture as it does painting. Minimal follows too much where Pop, Op, assemblage and the rest have led (as Darby Bannard, once again, has already pointed out). Nevertheless, I take Minimal art more seriously than I do these other forms of Novelty. I retain hope for certain of its exponents. Maybe they will take still more pointers from artists like Truitt, Caro, Ellsworth Kelly and Kenneth Noland, and learn from their example how to rise above Good Design.

1 Darby Bannard, writing in *Artforum* (December 1966), has already said it, 'As with Pop and Op, the "meaning" of a Minimal work exists outside of the work itself. It is a part of the nature of these works to act as triggers for thought and emotion pre-existing in the viewer … It may be fair to say that these styles have been nourished by the ubiquitous question: "but what does it mean?"'

Clement Greenberg, 'Recentness of Sculpture', *American Sculpture of the Sixties*, ed. Maurice Tuchman (Los Angeles County Museum of Art, 1967); reprinted in *Minimal Art: A Critical Anthology*, ed. Gregory Battcock (New York: E.P. Dutton & Co., 1968) 180–86.

Michael FRIED
Art and Objecthood [1967]

[…] What is it about objecthood as projected and hypostatized by the literalists that makes it, if only from the

perspective of recent Modernist painting, antithetical to art? The answer I want to propose is this: the literalist espousal of objecthood amounts to nothing other than a plea for a new genre of theatre; and theatre is now the negation of art. Literalist sensibility is theatrical because, to begin with, it is concerned with the actual circumstances in which the beholder encounters literalist work. Morris makes this explicit. Whereas in previous art 'what is to be had from the work is located strictly within [it]', the experience of literalist art is of an object in a situation – one that, virtually by definition, includes the beholder […]

The theatricality of Morris' notion of the 'nonpersonal or public mode' seems obvious: the largeness of the piece, in conjunction with its nonrelational, unitary character, distances the beholder – not just physically but psychically. It is, one might say, precisely this distancing that makes the beholder a subject and the piece in question … an object […]

Furthermore, the presence of literalist art, which Greenberg was the first to analyse, is basically a theatrical effect or quality – a kind of stage presence. It is a function, not just of the obtrusiveness and, often, even aggressiveness of literalist work, but of the special complicity that that work extorts from the beholder. Something is said to have presence when it demands that the beholder take it into account, that he take it seriously – and when the fulfilment of that demand consists simply in being aware of it and, so to speak, in acting accordingly […]

What has compelled Modernist painting to defeat or suspend its own objecthood is not just developments internal to itself, but the same general, enveloping, infectious theatricality that corrupted literalist sensibility in the first place and in the grip of which the developments in question – and Modernist painting in general – are seen as nothing more than an uncompelling and presenceless kind of theatre. It was the need to break the fingers of this grip that made objecthood an issue for Modernist painting.

Objecthood has also become an issue for Modernist sculpture. This is true despite the fact that sculpture, being three-dimensional, resembles both ordinary objects and literalist work in a way that painting does not […]

It may seem paradoxical to claim both that literalist sensibility aspires to an ideal of 'something everyone can understand' (Smith) and that literalist art addresses itself to the beholder alone, but the paradox is only apparent. Someone has merely to enter the room in which a literalist work has been placed to become that beholder, that audience of one – almost as though the work in question has been waiting for him. And in as much as literalist work depends on the beholder, is incomplete without him, it has been waiting for him. And once he is in the room the work refuses, obstinately, to let him alone – which is to say, it refuses to stop confronting him, distancing him, isolating him […]

It is, I think, significant that in their various statements the literalists have largely avoided the issue of value or quality at the same time as they have shown considerable uncertainty as to whether or not what they are making is art. To describe their enterprise as an attempt to establish a new art does not remove the uncertainty; at most it

points to its source. Judd himself has as much as acknowledged the problematic character of the literalist enterprise by his claim, 'A work needs only to be interesting' […]

The literalist preoccupation with time – more precisely, with the duration of the experience – is, I suggest, paradigmatically theatrical: as though theatre confronts the beholder, and thereby isolates him, with the endlessness not just of objecthood but of time; or as though the sense which, at bottom, theatre addresses is a sense of temporality, of time both passing and to come, simultaneously approaching and receding, as if apprehended in an infinite perspective … ' This preoccupation marks a profound difference between literalist work and Modernist painting and sculpture. It is as though one's experience of the latter has no duration – not because one in fact experiences a picture by Kenneth Noland or Jules Olitski or a sculpture by David Smith or Anthony Caro in no time at all, but because at every moment the work itself is wholly manifest […]

1 The connection between spatial recession and some such
 experience of temporality - almost as if the first were a
 kind of natural metaphor for the second - is present in
 much Surrealist painting (e.g., de Chirico, Dali,
 Tanguy, Magritte …) Moreover, temporality - manifested,
 for example, as expectation, dread, anxiety,
 presentiment, memory, nostalgia, stasis - is often the
 explicit subject of their paintings. There is, in fact,
 a deep affinity between literalists and Surrealist
 sensibility (at any rate, as the latter makes itself
 felt in the work of the above painters), which ought to
 be noted. Both employ imagery that is at once wholistic
 and, in a sense, fragmentary, incomplete; both resort to
 a similar anthropomorphizing of objects or
 conglomerations of objects (in Surrealism the use of
 dolls and mannequins makes this explicit); both are
 capable of achieving remarkable effects of 'presence';
 and both tend to deploy and isolate objects and persons
 in *situations* - the closed room and the abandoned
 artificial landscape are as important to Surrealism as to
 literalism. (Tony Smith, it will be recalled, described
 the airstrips, etc. as 'Surrealist landscapes'.) This
 affinity can be summed up by saying that Surrealist
 sensibility, as manifested in the work of certain
 artists, and literalist sensibility are both
 theatrical. I do not wish, however, to be understood as
 saying that because they are theatrical, all Surrealist
 works that share the above characteristics fail as art;
 a conspicuous example of major work that can be
 described as theatrical is Giacometti's Surrealist
 sculpture. On the other hand, it is perhaps not without
 significance that Smith's supreme example of a Surrealist
 landscape was the parade ground at Nuremberg.
Michael Fried, 'Art and Objecthood', *Artforum* (June 1967);
reprinted in *Minimal Art: A Critical Anthology*, ed. Gregory
Battcock (New York: E.P. Dutton & Co., 1968) 116-47.

Yvonne **RAINER**
A Quasi Survey of Some 'Minimalist' Tendencies in the Quantitatively Minimal Dance Activity Midst the Plethora, or an Analysis of Trio A [1968]

OBJECTS	DANCES
Eliminate or Minimize	
1. role of artist's hand	phrasing
2. hierarchical relationship of part	development and climax
3. texture	variation: rhythm, shape, dynamics
4. figure reference	character
5. illusionism	performance
6. complexity and detail	variety: phrases and the spatial field
7. monumentality	the virtuosic movement feat and the fully extended body
Substitute	
1. factory fabrication	energy equality and 'found' movement
2. unitary forms, modules	equality of parts
3. uninterrupted surface	repetition or discrete events
4. nonreferential forms	neutral performance
5. literalness	task or task-like activity
6. simplicity	singular action, event or tone
7. human scale	human scale

Although the benefit to be derived from making a one-to-one relationship between aspects of so-called Minimal sculpture and recent dancing is questionable, I have drawn up a chart that does exactly that […] It should not be thought that the two groups of elements are mutually exclusive […] Neither should it be thought that the type of dance I shall discuss has been influenced exclusively by art. The changes in theatre and dance reflect changes in ideas about man and his environment that have affected all the arts. That dance should reflect these changes at all is of interest, since for obvious reasons it has always been the most isolated and inbred of the arts. What is perhaps unprecedented in the short history of the Modern Dance is the close correspondence between concurrent developments in dance and the plastic arts […]

Within the realm of movement invention – and I am talking for the time being about movement generated by means other than accomplishment of a task or dealing

with an object – the most impressive change has been in the attitude to phrasing, which can be defined as the way in which energy is distributed in the execution of a movement or series of movements. What makes one kind of movement different from another is not so much variations in arrangements of parts of the body as differences in energy investment [...]

Much of the western dancing we are familiar with can be characterized by a particular distribution of energy: maximal output or 'attack' at the beginning of a phrase,¹ followed by abatement and recovery at the end, with energy often arrested somewhere in the middle. This means that one part of the phrase – usually the part that is the most still – becomes the focus of attention, registering like a photograph or suspended moment of climax [...]

The term 'phrase' can also serve as a metaphor for a longer or total duration containing beginning, middle and end. Whatever the implications of a continuity that contains high points or focal climaxes, such an approach now seems to be excessively dramatic and, more simply, unnecessary.

Energy has also been used to implement heroic more-than-human technical feats and to maintain a more-than-human look of physical extension, which is familiar as the dancer's muscular 'set'. In the early days of the Judson Dance Theatre someone wrote an article and asked, 'Why are they so intent on just being themselves?' It is not accurate to say that everyone at that time had this in mind. (I certainly didn't; I was more involved in experiencing a lion's share of ecstasy and madness than in 'being myself' or doing a job.) But where the question applies, it might be answered on two levels:

1. The artifice of performance has been re-evaluated in that action, or what one does, is more interesting and important than the exhibition of character and attitude, and that action can best be focused on through the submerging of the personality; so ideally one is not even oneself, one is a neutral 'doer'.

2. The display of technical virtuosity and the display of the dancer's specialized body no longer make any sense. Dancers have been driven to search for an alternative context that allows for a more matter-of-fact, more concrete, more banal quality of physical being in performance, a context wherein people are engaged in actions and movements making a less spectacular demand on the body and in which skill is hard to locate.

It is easy to see why the *grand jeté* (along with its ilk) had to be abandoned. One cannot 'do' a *grand jeté*; one must 'dance' it to get it done at all, i.e., invest it with all the necessary nuances of energy distribution that will produce the look of climax together with a still, suspended extension in the middle of the movement. Like a romantic, overblown plot this particular kind of display – with its emphasis on nuance and skilled accomplishment, its accessibility to comparison and interpretation, its involvement with connoisseurship, its introversion, narcissism and self-congratulatoriness – has finally in this decade exhausted itself, closed back on itself, and perpetuates itself solely by consuming its own tail [...]

Which brings me to *The Mind is a Muscle, Trio A*. Without giving an account of the drawn-out process

through which this 4.5 minute movement series (performed simultaneously by three people) was made, let me talk about its implications in the direction of movement-as-task or movement-as-object.

One of the most singular elements in it is that there are no pauses between phrases. The phrases themselves often consist of separate parts, such as consecutive limb articulations – 'right leg, left leg, arms, jump, etc.' – but the end of each phrase merges immediately into the beginning of the next with no observable accent. The limbs are never in a fixed, still relationship and they are stretched to their fullest extension only in transit, creating the impression that the body is constantly engaged in transitions.

Another factor contributing to the smoothness of the continuity is that no one part of the series is made any more important than any other. For 4.5 minutes a great variety of movement shapes occur, but they are of equal weight and are equally emphasized. This is probably attributable both to the sameness of physical 'tone' that colours all the movements and to the attention to the pacing. I can't talk about one without talking about the other.

The execution of each movement conveys a sense of unhurried control. The body is weighty without being completely relaxed. What is seen is a control that seems geared to the *actual* time it takes the *actual* weight of the body to go through the prescribed motions, rather than an adherence to an imposed ordering of time. In other words, the demands made on the body's (actual) energy resources *appear* to be commensurate with the task – be it getting up from the floor, raising an arm, tilting the pelvis, etc. – much as one would get out of a chair, reach for a high shelf or walk down stairs when one is not in a hurry.² The movements are not mimetic, so they do not remind one of such actions, but I like to think that in their manner of execution they have the factual quality of such actions [...]

So much for phrasing. My *Trio A* contained other elements mentioned in the chart that have been touched on in passing, not being central to my concerns of the moment. For example, the 'problem' of performance was dealt with by never permitting the performers to confront the audience. Either the gaze was averted or the head was engaged in movement. The desired effect was a work-like rather than exhibition-like presentation.

I shall deal briefly with the remaining categories on the chart as they relate to *Trio A*. Variation was not a method of development. No one of the individual movements in the series was made by varying a quality of any other one. Each is intact and separate with respect to its nature. In a strict sense neither is there any repetition (with the exception of occasional consecutive travelling steps). The series progresses by the fact of one discrete thing following another [...]

There is at least one circumstance that the chart does not include (because it does not relate to 'minimization'), viz., the static singular object versus the object with interchangeable parts. The dance equivalent is the indeterminate performance that produces variations ranging from small details to a total image. Usually indeterminacy has been used to change the sequentialness – either phrases or larger sections – of a

work, or to permute the details of a work. It has also been used with respect to timing. Where the duration of separate, simultaneous events is not prescribed exactly, variations in the relationship of these events will occur. Such is the case with the trio I have been speaking about, in which small discrepancies in the tempo of individually executed phrases result in the three simultaneous performances constantly moving in and out of phase and in and out of synchronization. The overall look of it is constant from one performance to another, but the distribution of bodies in space at any given instant changes.

I am almost done. *Trio A* is the first section of *The Mind Is a Muscle*. There are six people involved and four more sections. *Trio B* might be described as a VARIATION of *Trio A* in its use of unison with three people; they move in exact unison throughout. *Trio A* is about the EFFORTS of two men and a woman in getting each other aloft in VARIOUS ways while REPEATING the same diagonal SPACE pattern throughout. In *Horses* the group travels about as a unit, recurrently REPEATING six different ACTIONS. *Lecture* is a solo that REPEATS the MOVEMENT series of *Trio A*. There will be at least three more sections.

There are many concerns in this dance. The concerns may appear to fall on my tidy chart as randomly dropped toothpicks might. However, I think there is sufficient separating out in my work as well as that of certain of my contemporaries to justify an attempt at organizing those points of departure from previous work. Comparing the dance to Minimal art provided a convenient method of organization. Omissions and overstatements are a hazard of any systematizing in art. I hope that some degree of redress will be offered by whatever clarification results from this essay.

1 The term 'phrase' must be distinguished from 'phrasing'.
 A phrase is simply two or more consecutive movements,
 while phrasing, as noted previously, refers to the
 manner of execution.

2 I do not mean to imply that the demand of musical or
 metric phrasing makes dancing look effortless. What it
 produces is a different kind of effort, where the body
 looks more extended, 'pulled up', highly energized,
 ready to go, etc. The dancer's 'set' again.

Yvonne Rainer, 'A Quasi Survey of Some "Minimalist"
Tendencies in the Quantitatively Minimal Dance Activity
Midst the Plethora, or an Analysis of Trio A', in *Minimal
Art: A Critical Anthology*, ed. Gregory Battcock (New York:
E.P. Dutton & Co., 1968) 263–73.

1967–79 CANONIZATION/CRITIQUE

During the late 1960s Minimal art was established as an important development of recent art. Flavin, Judd, LeWitt and Morris had major exhibitions in museums in the US and Europe. The publication of Gregory Battcock's *Minimal Art: A Critical Anthology* in 1968 helped to codify the idea of a Minimal movement. Concurrent with the formation of a Minimal canon, the avant-garde became increasingly dissatisfied with Minimalism's alleged acceptance of the aesthetic, commercial and patriarchal values of the 'Establishment'. The emergence of developments such as post-Minimalism, Conceptualism, feminist art and Earth art indicated a general dissatisfaction with the factory-made Minimal object.

Philip LEIDER
'Art of the Real', The Museum of Modern Art; 'Light: Object and Image', Whitney Museum of American Art [1968]

Some months ago, The Museum of Modern Art opened its new 'study centre'; students and professionals using its facilities will have a pretty problem in deciding whether last summer's 'Art of the Sixties' or this summer's 'Art of the Real' best represents the Museum's own indifference to the entire matter of a responsible attitude towards the art of this decade.

We must assume that at some point Mr E.C. Goossen informed the museum that he wished to present an exhibition entitled 'The Art of the Real', and that the point of the exhibition, as stated in the catalogue, would be that, 'Today's "real" ... makes no direct appeal to the emotions, nor is it involved in uplift. Indeed, it seems to have no desire to justify itself, but instead offers itself for whatever its uniqueness is worth – in the form of the simple, irreducible, irrefutable object.' (As opposed, one takes it, to yesterday's 'real', which made a direct appeal to the emotions, was inextricably involved in 'uplift', strenuously desired to 'justify itself', and offered itself for fifty cents more on the dollar than its uniqueness was worth in the form of complex, reducible, refutable non-objects.) Mr Goossen must also have explained that, since this was to be a theme show, it had to begin, like all theme shows, with

a stately presentation of Jackson Pollock, Mark Rothko, Clyfford Still and Barnett Newman; last month's 'Heritage' of the *Sur*-real would be this month's precursor of the *real*-real. Undoubtedly, Mr Goossen also explained why artists like Larry Bell, Ronald Davis, Dan Flavin, Jules Olitski or Robert Irwin are un-real, or at least not as real as, say, Sanford Wurmfeld, Robert Swain and Antoni Milkowski, and to all this we must assume that The Museum of Modern Art, study centre or no study centre, said, 'Fine, just the ticket'.

We must further assume that Mr Goossen informed the museum that he proposed to include a huge painting by Patricia Johanson, and about which he would write: '*In a minimal painting by Patricia Johanson ... we are expected to grasp a single narrow strip of colour extending as much as 853 cm [28 ft] along the middle of an empty field of raw canvas*'.
The catalogue bibliography would note Mr Sidney Tillim's extensive discussion of what 'we are expected to grasp' in Miss Johanson's paintings, but the catalogue essay by Mr Goossen would be altogether remarkable for being written as if not a single item of criticism in the entire bibliography had ever been *read* by Mr Goossen, much less raised issues with which a responsible exhibition might be expected to deal. The realest of the real, for example, are the so-called Minimalists, and the claims for the simple, irreducible, irrefutable objectness of their work, which 'has nothing to do with metaphor, symbolism or any kind of metaphysics' are advanced as if Michael Fried's formidable essay, 'Art and Objecthood', had never been written, was not cited in the bibliography, and as if his argument, 'I am suggesting, then, that a kind of latent, or hidden naturalism, indeed anthropomorphism, lies at the core of literalist theory and practice ... ', had no need at all

to be considered, much less confronted. Similarly, with several years of critical literature on John McCracken by, among others, Barbara Rose and John Coplans behind him, Mr Goossen's sole contribution consists of the following: 'As for John McCracken's slabs of sheer colour, it is hard to tell whether one is confronting a painting or a sculpture'. There is less of a problem with Tony Smith, however, who, if he is not concerned with 'any kind of metaphysics', has made up for the loss with epistemological discoveries of a soaring order: 'To confront one of these works is to know the cube on a scale that allows us to experience it fully without being handed ideas about it'. We must assume that some group of people or some single person at The Museum of Modern Art said – *must* have said – 'Oh, yes, that's very good, that part about knowing the cube so deeply but not even beginning to know whether a slab of plastic painted blue is a painting or a sculpture'.

Colour, we are told, is pretty real too, but one would never guess from this exhibition or from this catalogue that colour might mean considerably different things to Darby Bannard, Ellsworth Kelly, Morris Louis, Agnes Martin, Ken Noland, Larry Poons and Frank Stella. As far as this exhibition is concerned, everyone is using colour to make objects, 'space-occupying objects', to be exact. Morris Louis, for example, running a little late, didn't get to this until the 'unfurleds', when he finally found out how to make a picture which 'adds to our perception of their physical existence as space-occupying objects'.

Ray Parker is having his troubles too: he 'seems to have been torn between lyrical passion and the need to find a way to make his art as palpably real as possible'. And Kenneth Noland is included in the exhibition, is, in fact, the show's *pièce de résistance*, although it would be

difficult to imagine an artist who stands in more searching opposition to each and all of the show's assumptions: 'No systems, no modules, no grids, no thingness and, above all, no objectness'. One could also suggest that Noland's work, and most especially his new work, far from having 'nothing to do with metaphor, symbolism or any kind of metaphysics' (not to mention 'uplift'), is deeply involved with all three. But for the articulation of the complex and difficult new terms in which this involvement might be taking place, we will have to look elsewhere than The Museum of Modern Art [...]

1 Michael Fried, 'Art and Objecthood', *Artforum* (June
 1967); reprinted in *Minimal Art: A Critical Anthology*,
 ed. Gregory Battcock (New York: E.P. Dutton & Co., 1968)
 116-47. [See in this volume pp. 234-35.]
Philip Leider, '"Art of the Real", The Museum of Modern Art;
"Light: Object and Image", Whitney Museum', *Artforum*, 7: 1
(September 1968) 65.

Gregory BATTCOCK
The Art of the Real: The Development of a Style: 1948–68 [1968]

The institutionalism of the art museum today is only slightly less evident than the academicism of the way the art is displayed. One illustration of this can be found in the Preface to the catalogue of the 'Summer Exhibition' at The Museum of Modern Art. The director of the exhibition, Professor E.C. Goossen, has felt compelled to publicly thank the curator of the museum for lending some paintings from the collection of the museum for the museum's summer exhibition. No doubt one of the targets of the protesting students at Columbia University was just this type of bureaucratic excess that is developed within modern institutions in order that they may become free from real responsibility and significant action.

The revolution on the campus is only one of many revolutions that are directed against the obsolete institutions found in the modern world. The museum was relatively safe from this type of dramatic confrontation because it was thought that art itself contained built-in revolution. That art IS revolution – and especially that Modern art is never Establishment – has been taken for granted. However, one thing is clear from the new exhibition at The Museum of Modern Art. It is that art presented in this particular way is not revolution. It is, or rather becomes, establishment. It is academic. (Curiously, the supporters of this type of academicism will label it *anti-academic*.) What we have is art for the art historians. The museum has become a laboratory for the university and its Department of Art History. Thus, the exhibition and the museum both become identified with the University itself. The art that was thought to be so provocative and considered a positive challenge (in so many ways) to the prevailing and inadequate value structure is now seen in quite a different light.

It may well turn out that 'The Art of the Real' will be a landmark in the development of Modern art. The modern trend that Professor Goossen was one of the first to recognize – his word was 'distillation' – may have a purpose that had not been obvious. It is conceivable that the artist was persuaded to remove reference to objects from art and concentrate on art as its own object because such an approach was necessary in order to prepare the way for a real break with artistic tradition. Otherwise, art itself would never become a meaningful arena for significant modern speculation. In this vein it is possible to conclude that this exhibition will be the last that can be logically connected to the period in Western history that begins with the Renaissance. 'The Art of the Real' is thus seen as homage to the past and tribute to a tradition that has had the grace to kill itself off.

One characteristic of the works identified by Goossen as 'Art of the Real' is an extravagant playing with formal components such as colour and space (which allows us to consider the style as 'mannered'). Goossen has perceptively acknowledged the urgency of the special excess inherent in many of the works and has seen to it that, at least in The Modern's version of the show, works are placed in such a way as to prevent people from getting too far back from a painting. This is a normal tendency and one result is that the scale is reduced to a smaller size and the extravagant and excessive spatial manoeuvre is denied. Goossen has not given us the opportunity to reduce many of the art statements to realistic size in his exhibition. Therefore, we are forced to experience the full impact of the style; we must respond to the confidence, assurance and dynamism of the art itself.

The special problem of colour in Minimalist sculpture is also recognized by Goossen. Minimalist sculpture is frequently coloured even if the colour is only black. True, in some instances – especially pieces by Donald Judd and Robert Morris – the works appear in the natural hue of the material used. In his catalogue introduction Goossen remarks: 'The problem of colour in sculpture may never be resolved satisfactorily since painted sculpture tends to become pictorial ... ' and, 'As for John McCracken's slabs of sheer colour, it is hard to tell whether one is confronting a painting or a sculpture'. One might ask, why does it matter? Probably because this important distinction – that of colour alone becoming pictorial – appears to be the single major premise of the works by some Minimalists including Ellsworth Kelly as well as McCracken.

In tracing the development of the style, the director of the exhibition leaves few of the stones unturned among those found on the official path through the jungle of human failures and wasted efforts. He observes the development with a thoroughness that is both precise and academic.

In the exhibition catalogue he goes on to note: 'A number of painters during the late 1950s and early 1960s contributed to the reduction of imagery and incident without quite abandoning Expressionism'. Goossen refers to Parker and Morris Louis particularly. About Louis' late painting (the *Unfurleds*), Goossen observes that the artist: ' ... *pushed the central space between the ribbons of colour more widely apart, thereby increasing the distance over*

which the eye must travel to pull the image together, or, if one's gaze is fixed on the empty centre, calling peripheral vision into action. These two ways of seeing such pictures add to our perception of their physical existence as space-occupying objects.'

Fine. So where does that leave us? This information, while helpful, is not very shattering. Is that *all* there is to Louis? Again, Goossen has avoided risking a conclusion. Why so safe? So what if history will prove that a more conclusive interpretation turns out to be false? But Goossen is hardly the only historian today who finds a retreat to the cosy security of the Academic preferable to the risk of historical censure.

In his notes for the catalogue as well as in the presentation and selection of the pictures themselves, Goossen has avoided the type of interpretation that relates the art to the human condition. His attitude is prevalent in art criticism today. I am not suggesting that our views towards interpretation should be governed by the pragmatic, but instead suggest that there should be some reduction of emphasis on the exclusively intellectual and descriptive aspects. Art is not simply polemic – even Minimal art. No doubt this is what Goossen had in mind when he conceived of the exhibition and certainly why he entitled it 'The Art of the Real'. However, in this way the exhibition ends up contradicting itself, without leaving the viewer much, if anything, of human or artistic interest to take home.

Of course, there are many ways of looking at and criticizing art. The logical positivist will be satisfied to simply experience the work itself. His empirical method leaves little room for any further conclusion. Then there is the historical approach in which art is seen exclusively in historical terms, even new art. Another view greets new art with enthusiasm simply, or perhaps mostly, because it's new. One cannot explain the art because one isn't really sure what art is anyway. In this last instance the critic will be faced with the choice of either making mistakes constantly or playing it safe.

It would seem that now is the time for taking chances and making mistakes. We are pretty much fed up with the order, precision and sterility so characteristic of modern institutions. What The Museum of Modern Art does is to take art away from us by putting it into a historical perspective. The dream and mystery of art is erased. The museum insists on teaching us and we have been taught enough. However, it is not the didactic approach that we resent, but rather the pedantic one. When Modern art was new, a little bit of pedantry did not hurt at all. The academic approach had something to offer. Now that the modern is accepted, we find that the best way to ruin it is to academicize it. The art of the real has been put into history. It has been made unreal. The museum must not consider itself immune from the protests and challenges suffered today by the Institutions of Higher Learning. The objections directed towards the obsolete learning process at Berlin, Paris, Nanterre, Columbia and Rome should be warning enough for the trustees and curators at the Louvre, Tate, Modern and Metropolitan.

A regard for the judgement of history is a major concern that dictates the scope and content of modern

museum exhibitions. It is essential that history judge favourably. In his book *Manet and His Critics*, George Heard Hamilton illustrates the modern fear. We snicker in amazement as we read the carefully documented and picturesquely presented verbiage of Manet's contemporary critics who, for the most part, didn't give a damn for history. Because of this appalling lack of historical perspective on their part, they have been made to appear very foolish indeed. (Of course many of them may actually have been fools.)

It is difficult to imagine any artist or critic today producing anything of interest if he does not possess a good grasp of the history of Western art. But, because of our belief that unilateral concern for the contemporary condition will almost inevitably be followed by the censure of history, we respond with a devotion to historical principles and a slavish preoccupation with historical precedent and licence. As a result, the denouement rarely clarifies, or contributes anything to, the contemporary reality.

I do not mean to imply there is anything wrong (i.e. incorrect) with Goossen's view of the Minimalist tradition in modern American art. Though he follows the official line, he has discovered significant connections that can only help clarify our view of twentieth-century American art. He relates the work of Georgia O'Keeffe (*Lake George Window* [1929]) as well as Jasper Johns to the most recent pictorial and dimensional developments in art. While most of the works in the show were made after 1965, Goossen has turned up an early Carl Andre that is not well known in New York and that was last exhibited publicly in 1964 at the Hudson River Museum.' Among other unexpected works in the new exhibition we find Ellsworth Kelly's important *Window* (Museum of Modern Art, Paris), which was made in 1949. Clearly, it is a prophetic work and a brilliant choice for this exhibition. Another early, significant piece in the show is Barnett Newman's statue *Here* of 1950.

Clearly this is a major exhibition. Besides being just the right sort of thing for the summer – brightness, openness and spaciousness – it is several notches above the usual run of summer exhibitions. It offers plenty of opportunity for thought. It cannot be missed by anybody interested in the art of our time.

By awarding Minimal art the imprimatur of History, Goossen has taken it away from us. Perhaps this was inevitable, perhaps premature. The Minimal artist has not been able to save his work from becoming maximalized.

1 I should like to point out, before anybody else does, that I have not seen this exhibition. I have met with Goossen at the museum, and he has shown me floor plans for the show. I have read the galleys for the catalogue and have them in front of me. I have a final list of the works in the show – all fifty-seven of them. I have been told that, as far as anybody could tell, the listing is complete. I have seen many of the works. Others I have not seen. I have reviewed exhibitions by most of the artists included in the show. Photographs of works by many of the artists have been made available to me.
Gregory Battcock, 'The Art of the Real: The Development of a Style: 1948-68', *Arts Magazine*, 42: 8 (June 1968) 44-47.

Robert SMITHSON

A Museum of Language in the Vicinity of Art [1968]

'She took one or two of them down and turned the pages over, trying to persuade herself she was reading them. But the meanings of words seemed to dart away from her like a shoal of minnows as she advanced upon them, and she felt more uneasy still.'
– Michael Frayn, *Against Entropy*
– Ad Reinhardt, 'The Four Museums are the Four Mirrors'

In the illusory babels of language, an artist might advance specifically to get lost, and to intoxicate himself in dizzying syntaxes, seeking odd intersections of meaning, strange corridors of history, unexpected echoes, unknown humours or voids of knowledge ... but this quest is risky, full of bottomless fictions and endless architectures and counter-architectures ... at the end, if there is an end, are perhaps only meaningless reverberations. The following is a mirror structure built of macro- and micro-orders, reflections, critical Laputas and dangerous stairways of words, a shaky edifice of fictions that hangs over inverse syntactical arrangements ... coherences that vanish into quasi-exactitudes and sublunary and translunary principles. Here language 'covers' rather than 'discovers' its sites and situations. Here language 'closes' rather than 'discloses' doors to utilitarian interpretations and explanations. The language of the artists and critics referred to in this article becomes paradigmatic reflections in a looking-glass babel that is fabricated according to Pascal's remark, 'Nature is an infinite sphere, whose centre is everywhere and whose circumference is nowhere'. The entire article may be viewed as a variation on that much misused remark; or as a monstrous 'museum' constructed out of multi-faceted surfaces that refer, not to one subject but to many subjects within a single building of works: a brick = a word, a sentence = a room, a paragraph = a floor of rooms, etc. Or, *language becomes an infinite museum, whose centre is everywhere and whose limits are nowhere.*

MARGINALIA AT THE CENTRE: INFRA-CRITICISM
Dan Flavin deploys writing as a pure spectacle of attenuation. Flavin's autobiographic method is mutated into a synthetic reconstitution of memories that brings to mind a vestigial history.
'*Now there were battered profiles of boxers with broken noses and Dido's pyre on a wall in Carthage, its passionate smoke piercing pious Aeneas' faithless heart outbound in the harbour below*'.'
Flavin's Carthage is an arsenal of expired metaphor and fevered reverie. His grandiloquent remembrances play on one's poetic sense with a mournful giddiness. In his sentence we find a disarming uselessness that echoes the outrages of Salammbo.
'*The walls were covered with bronze scales; and in the*

midst, on a granite pedestal, stood the statue of the Kabiri called Aletes, the discoverer of the mines in Celtiberia. On the ground, at its base, and arranged in the form of a cross, lay broad gold shields and monstrous silver vases with closed necks, of extravagant shape and of no possible use ... '
Flavin's writings, like Flaubert's 'vases', are of 'no possible use'. Here we have a chronic case of mental immobilization that results in leaded lyrics. Language falls towards its final dissolution like the sullen electricities of Flavin's 'lights'. His slapstick 'letters to the editor' also call forth the assorted humours of Flaubert's *Bouvard et Pécuchet* – the quixotic autodidacts.

Carl Andre's writings bury the mind under rigorous incantatory arrangements. Such a method smothers any reference to anything other than the words. Thoughts are crushed into a rubble of syncopated syllables. Reason becomes a powder of vowels and consonants. His words hold together without any sonority. Andre doesn't practise a 'dialectical materialism', but rather a 'metaphorical materialism'. The apparent sameness and toneless ordering of Andre's poems conceals a radical disorientation of grammar. Paradoxically his 'words' are charged with all the complication of oxymoron and hyperbole. Each poem is a 'grave', so to speak, for his metaphors. Semantics are driven out of his language in order to avoid meaning.

Robert Morris enjoys putting sham 'mistakes' into his language systems. His dummy *File*, for example, contains a special category called 'mistakes'. At times, the artist admits it is difficult to tell a real mistake from a false mistake. Nevertheless, Morris likes to track down the 'irrelevant' and then forget it as quickly as possible. Actually, he can hardly remember doing the *File*. Yet he must have derived some kind of pleasure from preserving those tedious moments, those minute events, that others call 'living'. He works from memory, which is strange when you consider he has nothing to remember. Unlike the elephant, the artist is one who always forgets.

Donald Judd at one time wrote a descriptive criticism that described 'specific objects'. When he wrote about Lee Bontecou, his descriptions became a language full of holes. 'The black hole does not allude to a black hole', says Judd, 'it is one'.² In that article, Judd brings into focus the structure of his own notion of 'the general and the specific' by defining the 'central hole' and periphery of her 'conic scheme'. Let us equate *central* with *specific*, and *general* with *periphery*. Although Judd is 'no longer interested in voids', he does seem interested in blank surfaces, which are in effect the opposite of voids. Judd brings an 'abyss' into the very material of the thing he describes when he says, 'The image is an object, a grim, abyssal one'.³ The paradox between the specific and the general is also abyssal. Judd's syntax is abyssal – it is a language that ebbs from the mind into an ocean of words. A brooding depth of gleaming surfaces – placid but dismal.

Sol LeWitt is very much aware of the traps and pitfalls of language, and as a result is also concerned with ennervating 'concepts' of paradox. Everything LeWitt thinks, writes or has made is inconsistent and contradictory. The 'original idea' of his art is 'lost in a mess of drawings, figurings and other ideas'. Nothing is where it

seems to be. His concepts are prisons devoid of reason. The information on his announcement for his show (Dwan Gallery, Los Angeles, April 1967) is an indication of a self-destroying logic. He submerges the 'grid plan' of his show under a deluge of simulated handwritten data. The grid fades under the oppressive weight of 'sepia' handwriting. It's like getting words caught in your eyes.

Ad Reinhardt's *Chronology*[4] is sombre substitute for a loss of confidence in wisdom – it is a register of laughter without motive, as well as being a history of nonsense. Behind the 'facts' of his life run the ludicrous events of hazard and destruction. A series of fixed incidents in the dumps of time. '1936 Civil War in Spain'. '1961 Bay of Pigs fiasco'. '1964 China explodes atomic bomb'. Along with the inchoate, calamitous remains of those dead headlines, runs a dry humour that breaks into hilarious personal memories. Everything in this *Chronology* is transparent and intangible, and moves from semblance to semblance, in order to disclose the final nullity. '1966 One hundred twenty paintings at Jewish Museum'. Reinhardt's *Chronology* follows a chain of non-happenings – its order appears to be born of a doleful tedium that originates in the unfathomable ground of farce. This dualistic history records itself on the tautologies of the private and the public. Here is a negative knowledge that enshrouds itself in the remote regions of that intricate language – the joke.

Peter Hutchinson, author of 'Is There Life on Earth?'[5], uses the discards of last year's future in order to define today's present. His method is highly artificial and is composed of paralysed quotes, listless theories and blank irony. His abandoned planets maintain unthinkable 'cultures', and have tasteless 'tastes'. In 'Mannerism in the Abstract'[6], Hutchinson lets us know about 'probabilities, contingencies, chances and cosmic breakdown'. 'Scientism' is shown to be actually a kind of Mannerist science full of obvious disguises and false bottoms. 'Topology surely mocks plane geometry', says Hutchinson. But actually his language usage deliberately mocks his own meaning, so that nothing is left but a gratuitous syntactical *device*. His writing is marvellously 'inauthentic'. The complexity and richness of Hutchinson's method starts with science fiction clichés, and scientist conservations and ends in an extraordinary aesthetic structure. To paraphrase Nathalie Sarraute on Flaubert, 'Here Hutchinson's defects become virtues'.

'The attraction of the world outside awakens so energetically in me the expansive force that I dilate without limit ... absorbed, lost in multiple curiosity, in the infinity of erudition and the inexhaustible detail of a peripheral world.'
– Henri-Frédéric Amiel, *Journal*, 1854

Dan Graham is also very much aware of the fringes of communication. And it is not surprising that one of his favourite authors is Robert Pinget. Graham responds to language as though he lived in it. He has a way of isolating segments of unreliable information into compact masses of fugitive meaning. One such mass of meanings he has disinterred from the tombic art of Carl Andre. Some segments from *Carl Andre* (unpublished list) are as

follows: 'frothing at the mouth and from watertaps'; 'misconceptions and canned laughter'; 'difficulty in grasping'. This is the kind of depraved metaphor that Andre tries to bury in his 'blocks of words'. Graham discloses the metaphors that everyone wants to escape.

Like some of the other artists Graham can 'read' the language of buildings.[7] The 'block houses' of the post-war suburbs communicate their '"dead" land areas' or 'sites' in the manner of a linguistic permutation. Andre Martinet writes, 'Buildings are intended to serve as a protection ...' – the same is true of artists' writings. Each syntax is a 'lightly constructed "shell"' or set of linguistic surfaces that surround the artist's unknown motives. The reading of both buildings and grammars enables the artist to avoid out of date appeals to 'function' or 'utilitarianism'.

Andy Warhol allows himself to be 'interrogated'; he seems too tired to actually grip a pencil or punch a typewriter. He allows himself to be *beaten* with 'questions' by his poet-friend Gerard Malanga. Words for Warhol become something like surrogate torture devices. His language syntax is infused with a fake sadomasochism. In an interview he is lashed by Malanga's questions:[8]
'*Q. Are all the people degenerates in the movie?*
A. Not all the people – 99.9 per cent of them.'

Serge Garvronsky writing in *Cahier du Cinéma*,[9] points out that Warhol employs a kind of self-inventing dialogue in his films, that resembles the sub-dialogue of Nathalie Sarraute. Garvronsky points out the 'dis-synchronized talk', 'monosyllabic English', and other 'tropistic' effects. The language has no force, it's not very convincing – all the pornographic preoccupations collapse into verbal deposits, or what is called in communication theory – 'degenerative information'. Warhol's syntax forces an artifice of sado-masochism that mimics its supposed 'reality'. Even his surfaces destroy themselves. In *Conversation and Sub-conversation 1956* by Nathalie Sarraute we find out something about 'pointless remarks', and dialogue masses, that shape our experience – 'the slightest intonations and inflections of voice', that become maps of meaning or antimeaning. Said Bosley Crowther in a review of *My Hustler*, ' ... I would say that *The Endless Conversations* would be a better title for this fetid beach-boy film'.[10]

Edward Ruscha (alias Eddie Russia) collaborated with Mason Williams and Patrick Blackwell on a book, *Royal Road Test*, that appears to be about the sad fate of a Royal (Model 'X') typewriter. Here is no Warholian sloth, but rather a kind of dispassionate fury. The book begins on a note of counterfeit Russian nihilism, 'It was too directly bound to its own anguish to be anything other than a cry of negation; carrying within itself the seeds of its own destruction'. A record of the deed is as follows:
Date: Sunday, 21 August 1966
Time: 5:07 PM
Place: US Highway 91 (Interstate Highway 15), travelling south-southwest approximately 196 km [122 miles] southwest of Las Vegas, Nevada
Weather: Perfect
Speed: 145 kph [90 mph]

The typewriter was thrown from a 1963 Buick window by 'thrower' Mason Williams. The 'strewn wreckage' was

labelled and photographed for the book.

INVERSE MEANINGS – THE PARADOXES OF CRITICAL UNDERSTANDING

'Modern art, like modern science, can establish complementary relations with discredited fictional systems; as Newtonian mechanics is to quantum mechanics, so *King Lear* is to *Endgame*.'
– Frank Kermode, *The Sense of Ending*

'How can anyone believe that a given work is an *object* independent of the psyche and personal history of the critic studying it, with regard to which he enjoys a sort of extraterritorial status?'
– Roland Barthes, *Criticism as Language*

'Materialism. Utter the word with horror, stressing each syllable.'
– Gustave Flaubert, *The Dictionary of Accepted Ideas*

When the word 'fiction' is used, most of us think of literature and practically never of fictions in a general sense. The rational notion of 'realism', it seems, has prevented aesthetics from coming to terms with the place of fiction in all the arts. Realism does not draw from the direct evidence of the mind, but rather refers back to 'naturalistic expressiveness' or 'slices of life'. This happens when art competes with life and aesthetics is replaced by rational imperatives. The fictional betrays its privileged position when it abdicates to a mindless 'realism'. The status of fiction has vanished into the myth of the fact. It is thought that facts have a greater reality than fiction – that 'science fiction' through the myth of progress becomes 'science fact'. Fiction is not believed to be a part of the world. Rationalism confines fiction to literary categories in order to protect its own interests or systems of knowledge. The rationalist, in order to maintain his realistic systems, only ascribes 'primary qualities' to the world.

The 'materialist' Carl Andre calls his work 'a flight from the mind'. Andre says that his 'poems' and 'sculpture' have no mental or secondary qualities, they are to him solidly 'material'. Yet, paradoxically, Lucy R. Lippard writing in the *New York Times*, suggests that Andre's sculpture in a show at the Bykert Gallery is 'rebelliously romantic' because of 'nuance' and 'surface effects'.[11] One person's 'materialism' becomes another person's 'romanticism'. I would venture to assert at this point that both Miss Lippard's 'romanticism' and Andre's 'materialism' are the same thing. Both views refer to private states of consciousness that are interchangeable.

Romanticism is an older philosophical fiction than materialism. Its artifices are to a greater degree more decadent than the inventions of materialism, yet at the same time it is more familiar and not as threatening to the myths of fact as materialism. For some people the mere mention of the word 'materialism' evokes hordes of demonic forces. Romanticism and materialism are viewed with two-dimensional clarity and have a transparence and directness about them that is highly fictive. Peter Brook

recognized this aesthetic in Robbe-Grillet. Says Brook: '*If Robbe-Grillet has sought to destroy the "romantic heart of things", there is a sense in which he is constantly fascinated by the romanticism of surfaces, a preoccupation especially noticeable in the films* Marienbad *and* L'Immortelle, *and quite explicit in his new novel,* La Maison de rendezvous.'[12]

The same is true of 'materialism' when it becomes the aesthetic motive of the artist. The reality of materialism is no more real than that of romanticism. In a sense, it becomes evident that today's materialism and romanticism share similar 'surfaces'. The romanticism of the 1960s is a concern for the surfaces of materialism, and both are fictions in the chance minds of the people who perceive them. If scientism isn't being used or misused, then what I will call 'philosophism' is. Philosophism confuses realism with aesthetics and defines art apart from any understanding of the artifices of the mind and things.

Much Modern art is trapped in temporality, because it is unconscious of *time* as a 'mental structure' or abstract support. The temporality of time began to be imposed on art in the eighteenth and nineteenth centuries with the rise of realism in painting and novel writing. Novels cease being fictions, criticism condemns 'humoral' categories, and 'nature' acts as the prevailing panacea. The time consciousness of that period gave rise to thinking in terms of Renaissance history. Says Everett Ellin in a fascinating article 'Museums as Media', 'The museum, a creation of the nineteenth century, quite naturally adopted the popular mode of the Renaissance for its content'.[13] Time had yet to extend into the distant future (post-history) or into the distant past (pre-history) — nobody much thought about 'flying saucers' or an Age of Dinosaurs. Both pre- and post-history are part of the same time consciousness, and they exist without any reference to Renaissance history. I had slight awareness of the sameness of pre- and post-history, when I wrote in 'Entropy and the New Monuments', 'This sense of extreme past and future has its partial origin in the Museum of Natural History; there the "cave man" and the "space man" may be seen under one roof'.[14] It didn't occur to me then, that the 'meanings' in the Museum of Natural History avoided any reference to the Renaissance, yet it does show 'art' from the Aztec and American Indian periods — are those periods any more or less 'natural' than the Renaissance? I think not — because there is nothing 'natural' about the Museum of Natural History. 'Nature' is simply another eighteenth- and nineteenth-century fiction. Says e.e. cummings, 'Natural history museums are made by fools unlike me. But only God can stuff a tree ...'[15] The 'past-nature' of the Renaissance finds its 'future-nature' in Modernism — both are founded on realism.

RESTORATIONS OF PREHISTORY

The prehistory one finds in the Museum of Natural History is fugitive and uncertain. It is reconstructed from 'Epochs' and 'Periods', that no man has ever witnessed, and based on the remains of 'animated beings' from the Trilobites to Triceratops. We vaguely know about them through Walt Disney and Sinclair Oil — they are the dinosaurs. One of

the best 'recreators' of this 'dinosaurism' is Charles R. Knight. In many ways he excels the Pop artists, but he comes closest to Claes Oldenburg, at least in terms of scale. Sinclair Oil ought to commission Oldenburg to make 'the mating habits of the Brontosaurus' for children's sex education. Knight's art is never seen in museums outside of the M.N.H., because it doesn't fit in with the contrived 'art-histories' of Modernism or the Renaissance.

Knight is also an artist who writes. In *Life Through the Ages*, a book of twenty-eight prehistoric 'time' restorations, Knight can be seen as a combination Edouard Manet and Eric Temple Bell (the professor of Mathematics who wrote science fiction for *Wonder Stories Magazine*). Bell in 'The Greatest Adventure' describes 'brutes' that are 'like no prehistoric monster known to science'. These monsters are 'piled five and six deep' on a frozen beach in Antarctica.
'*They are like bad copies, botched imitations, if you like of those huge brutes whose bones we chisel out of the rocks from Wyoming to Patagonia. Nature must have been drunk, drugged or asleep when she allowed these aborted beasts to mature. Every last one of them is a freak.*'
It is hard to say Knight's monsters are 'bad copies', yet there is something odd and displaced about both his writings and art. He refers to his writings as 'captions', and to his art as 'the more striking forms of Prehistoric times'. The following quote is from Knight's 'The Carboniferous or Coal Period':
'*Great sprawling salamander-like creatures such as Eryops are typical of the period. No doubt these and many other species still passed their earlier life stages in the water. They were stupid, smooth-skinned monsters some 183 cm* [6 ft] *long, with wide tooth-filled jaws and an enormous gape which enabled them to swallow their food at a single gulp.*'
He also has a way of evoking the prehistoric landscape — 'Rancho La Brea — California Pitch Pools', 'Peaceful as the place looks now, tragedy, both dark and terrible, long hung about its gloomy depths'. The corollary of Knight's artifice is immobilization. This heavy prehistoric time extends to the landscape — 'slime-covered morasses' and 'it was an era of swamps ... ' Death is suggested in the ever present petrifaction of forests and creatures; a predilection for the oppressive and grim marks everything he writes and draws. One senses an enormous amorphous struggle between the stable and the unstable; a fusion of action and inertia symbolizing a kind of cartoon vision of the cosmos. Violence and destruction are intimately associated with this type of carnivorous evolutionism. Nothing seems to escape annihilation — for the Brontosaurus, 'starvation is their greatest bugaboo'. A kind of goofiness haunts these 'big bulked and small-brained' saurians. Tyrannosaurus Rex is considered by Knight to be 'just an enormous eating machine'. These 'sinister beings' seem like reformulated symbols of total or original Evil. The battle between the Tyrannosaurus and Stegosaurus in Walt Disney's *Fantasia* set to the music of *The Rite of Spring* evoked a two-dimensional spectacular death-struggle, quite in keeping with the entire cast of preposterous reptilian 'machines'. No doubt Disney at some point copied his dinosaurs from Knight, just as Sinclair Oil must have copied directly from

Disney for their 'Dino-the-Dinosaur'.

TERATOLOGICAL SYSTEMS
'The Art World was created in 4 Days in 4 Sections, 40 years ago, and originally 4004 BC. Today, minor artists have 400 Disciples and more favoured mediocre Artists have 44,000 Devotees approximately.'
— Ad Reinhardt, *A Portend of the Artist as a Young Mandala*

'The immensity of geologic time is so great that it is difficult for human minds to grasp readily the reality of its extent. It is almost as if one were to try to understand infinity.'
— Edwin H. Colbert, *The Dinosaur Book*

The word 'teratology' or 'teratoid' when not being used by biology and medicine in an 'organic' way has a meaning that has to do with marvels, portends, monsters, mutations and prodigious things (Greek: teras, teratos = a wonder). The word teratoid like the word dinosaur suggests extraordinary scale, immense regions and infinite quantity. If we accept Ad Reinhardt's 'portend', the Art World is both a monster and a marvel, and if we extend the meaning of the word: a dinosaur (terrible lizard) — *a lizard with its tail in its mouth.* Perhaps that is not 'abstract' enough for some of the 'devotees'. Perhaps they would prefer the 'circular earth mound' by Robert Morris or even 'a target' by Kenneth Noland. Organic word meanings, when applied to abstract or mental structures, have a way of returning art to the biological condition of naturalism and realism. Science has claimed the word teratology and related it to disease. The 'marvellous' meaning of that word has to be brought to consciousness again.

Let us now examine Reinhardt's 'Portend', and take this 'Joke' seriously. In a sense Reinhardt's teratological Portend seems to approach some kind of pure classicism, except that where the classicist sees the necessary and true concept of pure cosmic order, Reinhardt sees it as a grotesque decoy. Near a label NATURALIST-EXPRESSIONIST-CLASSICISM we see 'an angel' and 'a devil' — and a prehistoric Pterodactyl; Knight calls it 'another kind of flying mechanism'. Reinhardt treats the Pterodactyl as an atemporal creature belonging to the same order as devils and angels. The concrete reptile-bird of the Jurassic Period is displaced from its place in the 'Synoptic Table of the Amphibia and Reptilia' of the 'subclass Diapsida', and transformed by Reinhardt into a demon or possibly an Aeon. The rim of Reinhardt's Portend becomes an ill-defined set of schemes, entities half abstract, half concrete, half impersonal fragments of time or de-spatialized oddities and monsters, a Renaissance dinosaurism hypostatized by a fictional ring of time — something half way between the real and the symbolic. This part of the portend is dominated by a humorous nostalgia for a past that never existed — past history becomes a comic hell. Atemporal monsters or teratoids are mixed in a precise, yet totally inorganic way. Reinhardt isn't doing what so many 'natural expressive' artists do — he doesn't pretend to be honest. History

breaks down into fabulous lies, that reveal nothing but copies of copies. There is no order outside of the mandala itself.

THE CENTRE AND THE CIRCUMFERENCE

The centre of Reinhardt's Joke is empty of monsters, a circle contains four sets of three squares that descend towards the middle vortex. It is an inversion of Pascal's statement, that 'nature is an infinite sphere, whose centre is everywhere and whose circumference is nowhere': instead with Reinhardt we get an Art World that is an infinite sphere, whose circumference is everywhere but whose centre is nowhere. The teratological fringe or circumference alludes to a tumultuous circle of teeming memories from the Past – from that historical past one sees 'nothing' at the middle. The finite present of the centre annihilates itself in the presence of the infinite fringes. An appalling distance is established between past and present, but the mandala always engulfs the present order of things – ART AND GOVERNMENT/ART AND EDUCATION/ART AND NATURE/ART AND BUSINESS – are lost in a freakish grandeur that empties one's central gaze. Everything made and grotesque on the outer edges encompasses the present Art World in an abysmal concatenation of Baals, Banshees, Beelzebobs, Zealots, Wrenches, Toadics, all of which are transformed into horrors of more recent origin. From the central vortex, that looks like prophetic parody of Op art – I can't think of anything more meaningless that that – to the rectangular margin of parodic wisdom – 'Everybuddie understands the Songs of Birds and Picasso', one is aware of a conflict between centre and perimeter. The excluded middle of this Joke plunges the mind into a simulated past and present without a future. The original and historical nightmare bordering the 'void' destroys its own sanctuary. At the bottom of this well we see 'nothing'. The Human centre is encompassed by 'The Human Vegetable, The Human Machine, The Human Eye, The Human Animal' – a human 'prison house of grandeur and glory', not unlike Edgar Allan Poe's *House of Usher*, or even more precisely his *A Descent into the Maelstrom* – 'Upon the interior surface of a funnel vast in circumference, prodigious in depth … ' Poe's 'Pit' (centre) is defined by the swing of the 'Pendulum' from side to side, thus defining the circumference. Reinhardt's 'dark humour' resembles Poe's 'sheeted memories of the past'. Reinhardt maintains the same haunted mind that Poe did; 'a dim-remembered story of the old time entombed'.

THE MOVIES OF ROGER CORMAN AND NEGATIVE ETERNITIES

The films of Roger Corman are structured by an aesthetic of atemporality that relates to Reinhardt and Poe more than most visual artists working at this time. The grammar of Corman's films avoids the 'organic substances' and life-forcing rationalism that fill so many realistic films with naturalistic meanings. His actors always appear vacant and transparent, more like robots than people – they simply move through a series of settings and places and define where they are by the artifice that surrounds them. This artifice is always signalled by a 'tomb' or another

mise-en-scène of deathlessness. For instance, the Great Pyramid at the beginning of *The Secret Invasion*, or the Funeral at the end of *The Wild Angels*. Duration is drained, and the networks of an infinite mind take over, turning the 'location' of the film into ' … immeasurable but still definite distances' (Poe). Corman brings the infinite into the finite things and minds that he directs. The suburban sites in *The Wild Angels* appear with a 'gleaming and ghastly radiance' (Poe) and seem not to exist at all except as spectral cinematic artifices. The menacing fictions of the terrain engulf the creatures that pass as actors. 'Things' in a Corman movie seem to negate the very condition they are presented in. A parodic pattern is established by the conventionalized structure or plot-line. The actors as 'characters' are not developed but rather buried under countless disguises. This is especially true of *The Secret Invasion*, where nobody seems to be anybody. Corman uses actors as though they were 'angels' or 'monsters' in a cosmos of dissimulation, and it is in that way that they relate to Reinhardt's world or cosmic view. Corman's sense of dissimulation shows us the peripheral shell of appearances in terms of some invisible set of rules, rather than by any 'natural' or 'realistic' inner motivation – his actors reflect the empty centre.

SPECTRAL SUBURBS

'Where have all the people gone today? Well, there's no need for you to be worried about all those people. You never see those people anyway.'
– The Grateful Dead, *Morning Dew* (Dobson-Rose)

' … dead streets of the inner suburbs, yellow under the sodium lights.'
– Michael Frayn, *Against Entropy*

'In 1954, when they announced the H-Bomb, only the kids were ready for it.'
– Kurt von Meier, quoted in *Open City*

'A dry wind blows hot and cold down from Chimborazo a soiled postcard in the prop blue sky. Crab men peer out of abandoned quarries and slag heaps … '
– William S. Burroughs, *The Soft Machine*

It seems that 'the war babies', those born after 1937–38 were 'Born Dead' – to use a motto favoured by the Hell's Angels. The philosophism of 'reality' ended some time after the bombs were dropped on Hiroshima and Nagasaki and the ovens cooled down. Cinematic 'appearance' took over completely sometime in the late 1950s. 'Nature' falls into an *infinite series* of movie 'stills' and we get what Marshall McLuhan calls 'The Reel World'.

Suburbia encompasses the large cities and dislocates the 'country'. Suburbia literally means a 'city below'; it is a circular gulf between city and country – a place where buildings seem to sink away from one's vision – buildings fall back into sprawling babels or limbos. Every site glides away towards absence. An immense negative entity of formlessness displaces the centre which is the city and swamps the country. From the worn down mountains of North New Jersey to postcard skylines of Manhattan, the

prodigious variety of 'housing projects' radiate into a vaporized world of cubes. The landscape is effaced into sidereal expanses and contradictions. Los Angeles is all suburb, a pointless phenomenon which seems uninhabitable, and a place swarming with dematerialized distances. A pale copy of a bad movie. Edward Ruscha records this pointlessness in his *Every Building on Sunset Strip*. All the buildings expire along a horizon broken at intervals by vacant lots, luminous avenues and modernistic perspectives. The outdoor immateriality of such photographs contrasts with the pale but lurid indoors of Andy Warhol's movies. Dan Graham gains this 'non-presence' and serial sense of distance in his suburban photos of forbidding sites. Exterior space gives way to the total vacuity of time. Time as a concrete aspect of mind mixed with things is attenuated into ever greater distances, that leaves one fixed in a certain spot. Reality dissolves into leaden and incessant lattices of solid diminution. An effacement of the country and city abolishes space, but establishes enormous mental distances. What the artist seeks is coherence and order – not 'truth', correct statements or proofs. He seeks the fiction that reality will sooner or later imitate.

MAPSCAPES OR CARTOGRAPHIC SITES

'In the deserts of the West some mangled Ruins of the Map lasted on, inhabited by Animals and Beggars; in the whole Country there are no other relics of the Disciplines of Geography.'
– *Suarez Miranda: Viajes de Varones Prudentes*, Book Four, Chapter XLV, Lérida, 1658

' … all the maps you have are of no use, all this work of discovery and surveying; you have to start off at random, like the first men on earth; you risk dying of hunger a few miles from the richest stores … '
– Michel Butor, *Degrees*

From *Theatrum Orbis Terrarum* of Orrelius (1570) to the 'paint'-clogged maps of Jasper Johns, the map has exercised a fascination over the minds of artists. A cartography of uninhabitable places seems to be developing – complete with decoy diagrams, abstract grid systems made of stone and tape (Carl Andre and Sol LeWitt), and electronic 'mosaic' photomaps from NASA. Gallery floors are being turned into collections of parallels and meridians. Andre in a show in the Spring of 1967 at Dwan Gallery in California covered an entire floor with a 'map' that people walked on – rectangular sunken 'islands' were arranged in a regular order. Maps are becoming immense, heavy quadrangles, topographic limits that are emblems of perpetuity, interminable grid coordinates without Equators and Tropic Zones.

Lewis Carroll refers to this kind of abstract cartography in his *The Hunting of the Snark* (where a map contains 'nothing') and in *Sylvie and Bruno Concluded* (where a map contains 'everything'). The Bellman's map in the *Snark* reminds one of Jo Baer's paintings.
He had bought a large map representing the sea,
Without least vestige of land:
And the crew were much pleased when they found it to be

A map they could all understand.'

Jo Baer's surfaces are certainly in keeping with the Captain's map which is not a 'void', but 'A perfect and absolute blank!'. The opposite is the case, with the map in Carroll's *Sylvie*. In Chapter 11, a German Professor tells how his country's cartographers experimented with larger and larger maps until they finally made one with a scale of a mile to a mile. One could very well see the Professor's explanation as a parable on the fate of painting since the 1950s. Perhaps museums and galleries should start planning square mile interiors. The Professor said: '*It has never been spread out, yet. The farmers objected: they said it would cover the whole country, and shut out the sunlight! So now we use the country itself, as its own map, and I assure you it does nearly as well.*'

The *Bound Sphere Minus Lune*, by Ruth Vollmer, may be seen as a globe with a cut away Northern region. Three arcs in the shape of crescents intersect at the 'bound' equator. The 'lune' triangulation in this orb detaches itself and becomes secondary 'sculpture'.

'There are approximately 50 Panama Canals to a cubic mile and there are 317 MILLION cubic miles of ocean.'
– Richard Buckminster Fuller, *Nine Chains to the Moon*

Richard Buckminster Fuller has developed a type of writing and original cartography, that not only is pragmatic and practical but also astonishing and teratological. His *Dymaxion Projection* and *World Energy Map* is a *Cosmographia* that proves Ptolemy's remark that, 'no one presents it rightly unless he is an artist'. Each dot in the *World Energy Map* refers to '1 per cent of World's harnessed energy slave population (inaminate power serving man) in terms of human equivalents … ' says Fuller. The use Fuller makes of the 'dot' is in a sense a concentration or dilation of an infinite expanse of spheres of energy. The 'dot' has its rim and middle, and could be related to Reinhardt's mandala, Judd's 'device' of the specific and general, or Pascal's universe of centre and circumference.

Yet, the dot evades our capacity to find its centre. Where is the central point, axis, pole, dominant interest, fixed position, absolute structure, or decided goal? The mind is always being hurled towards the outer edge into intractable trajectories that lead to vertigo.

1 Dan Flavin, ' … in daylight or cool white', originally presented as a lecture at the Brooklyn Museum School of Art (18 December 1964); Ohio State University School of Law (26 April 1965); revised and published in *Artforum* (December 1965); revised and reprinted in *fluorescent light, etc. from Dan Flavin*, ed. Brydon Smith (Ottawa: National Gallery of Canada, 1969) 13-20. [See in this volume pp. 204-206.]
2 Donald Judd, 'Lee Bontecou', *Arts Magazine* (April 1965).
3 Recently, drama critic Michael Fried has been enveloped by this 'literal' abyss. Michael Fried, 'Art and Objecthood', *Artforum* (June 1967); reprinted in *Minimal Art: A Critical Anthology*, ed. Gregory Battcock (New York: E.P. Dutton & Co., 1968) 116-47. [See in this volume pp. 234-35.]
4 Lucy R. Lippard, *Ad Reinhardt: Paintings* (New York:
Harry Abrams, 1981).
5 Peter Hutchinson, 'Is There Life on Earth?', *Art in America* (Fall 1966).
6 Peter Hutchinson, 'Mannerism in the Abstract', *Art and Artists* (September 1966).
7 Dan Graham, 'Homes for America', *Arts Magazine* (December 1966-January 1967).
8 Gerard Malanga, 'Interview with Andy Warhol', *Arts Magazine*, 41: 4 (1967).
9 Serge Garvronsky, *Cahier du Cinéma*, 10 (1967).
10 Bosley Crowther, 'Review of *My Hustler*', *New York Times* (11 July 1967).
11 Lucy R. Lippard, 'Recent Openings: Carl Andre', *New York Times* (4 June 1967).
12 Peter Brook, writing on Alain Robbe-Grillet, *Partisan Review* (Winter 1967).
13 Everett Ellin, 'Museums as Media', *ICA Bulletin* (May 1967).
14 Robert Smithson, 'Entropy and the New Monuments', *Artforum* (June 1966); reprinted in *The Writings of Robert Smithson*, ed. Nancy Holt (New York University Press, 1979); *Robert Smithson: The Collected Writings*, ed. Jack Flam (Berkeley, Los Angeles and London: University of California Press, 1996). [See in this volume pp. 223-26.]
15 e.e. cummings, 'Letter to Ezra Pound', *Paris Review* (Fall 1966).
Robert Smithson, 'A Museum of Language in the Vicinity of Art', *Art International* (March 1968) 67-78; reprinted in *The Writings of Robert Smithson*, ed. Nancy Holt (New York University Press, 1979); *Robert Smithson: The Collected Writings*, ed. Jack Flam (Berkeley, Los Angeles and London: University of California Press, 1996).

Robert MORRIS
Anti-Form [1968]

In recent object-type art the invention of new forms is not an issue. A morphology of geometric, predominantly rectangular forms has been accepted as a given premise. The engagement of the work becomes focused on the particularization of these general forms by means of varying scale, material, proportion, placement. Because of the flexibility as well as the passive, unemphasized nature of the object-type shape it is a useful means. The use of the rectangular has a long history. The right angle has been in use since the first post and lintel construction. Its efficiency is unparalleled in building with rigid materials, stretching a piece of canvas, etc. This generalized usefulness has moved the rectangle through architecture, painting, sculpture, objects. But only in the case of object-type art have the forms of the cubic and the rectangular been brought so far forward into the final definition of the work. That is, it stands as a self-sufficient whole shape rather than as a relational element. To achieve a cubic or rectangular form is to build in the simplest, most reasonable way, but it is also to build well.

This imperative for the well-built thing solved certain problems. It got rid of asymmetrical placing and composition, for one thing. The solution also threw out all non-rigid materials. This is not the whole story of so-called Minimal or object art. Obviously it does not account for the use of purely decorative schemes of repetitive and progressive ordering of multiple unit work. But the broad rationality of such schemes is related to the reasonableness of the well-built. What remains problematic about these schemes is the fact that any order for multiple units is an imposed one which has no inherent relation to the physicality of the existing units. Permuted, progressive, symmetrical organizations have a dualistic character in relation to the matter they distribute. This is not to imply that these simple orderings do not work. They simply separate, more or less, from what is physical by making relationships themselves another order of facts. The relationships such themes establish are not critical from point to point as in European art. The duality is established by the fact that an order, any order, is operating beyond the physical things. Probably no art can completely resolve this. Some art, such as Pollock's, comes close.

The process of 'making itself' has hardly been examined. It has only received attention in terms of some kind of mythical, romanticized polarity: the so-called action of the Abstract Expressionists and the so-called conceptualizations of the Minimalists. This does not locate any differences between the two types of work. The actual work particularizes general assumptions about forms in both cases. There are some exceptions. Both ways of working continue the European tradition of aestheticizing general forms that has gone on for half a century. European art since Cubism has been a history of permuting relationships around the general premise that relationships should remain critical. American art has developed by uncovering successive alternative premises for making itself.

Of the Abstract Expressionists only Jackson Pollock was able to recover process and hold on to it as part of the end form of the work. Pollock's recovery of the process involved a profound rethinking of the role of both material and tools in making. The stick which drips paint is a tool which acknowledges the nature of the fluidity of paint. Like any other tool it is still one that controls and transforms matter. But unlike the brush, it is in far greater sympathy with matter because it acknowledges the inherent tendencies and properties of that matter. In some ways Louis was even closer to matter in his use of the container itself to pour the fluid.

To think that painting has some inherent optical nature is ridiculous. It is equally silly to define its 'thingness' as acts of logic that acknowledge the edges of the support. The optical and the physical are both there. Both Pollock and Morris Louis were aware of both. Both used directly the physical, fluid properties of paint. Their 'optical' forms resulted from dealing with the properties of fluidity and the conditions of a more or less absorptive ground. The forms and the order of their work were not a priori to the means.

The visibility of process in art occurred with the saving of sketches and unfinished work in the High Renaissance. In the nineteenth century both Rodin and Rosso left traces of touch in finished work. Like the Abstract Expressionists

11. Auguste Rodin

after them, they registered the plasticity of material in autobiographical terms. It remained for Pollock and Morris Louis to go beyond the personalism of the hand to a more direct revelation of matter itself. How Pollock broke the domination of Cubist form is tied to his investigation of means: tools, methods of making, nature of material. Form is not perpetuated by means but by preservation of separable, idealized ends. This is an anti-entropic and conservative enterprise. It accounts for Greek architecture changing from wood to marble and looking the same, or for the look of Cubist bronzes with their fragmented, faceted planes. The perpetuation of form is functioning Idealism.

In object-type art process is not visible. Materials often are. When they are, their reasonableness is usually apparent. Rigid industrial materials go together at right angles with great ease. But it is the a priori valuation of the well-built that dictates the materials. The well-built form of objects preceded any consideration of means. Materials themselves have been limited to those which efficiently make the general object form.

Recently, materials other than rigid industrial ones have begun to show up. Oldenburg was one of the first to use such materials. A direct investigation of the properties of these materials is in progress. This involves a reconsideration of the use of tools in relation to material. In some cases these investigations move from the making of things to the making of material itself. Sometimes a direct manipulation of a given material without the use of any tool is made. In these cases considerations of gravity become as important as those of space. The focus on matter and gravity as means results in forms which were not projected in advance. Considerations of ordering are not necessarily casual and imprecise and unemphasized. Random piling, loose stacking, hanging, give passing form to material. Chance is accepted and indeterminacy is implied since replacing will result in another configuration. Disengagement with preconceived enduring forms and orders for things is a positive assertion. It is part of the work's refusal to continue aestheticizing form by dealing with it as a prescribed end.

Robert Morris, 'Anti-Form', *Artforum*, 6: 8 (April 1968); reprinted in *The New Sculpture 1965–75: Between Geometry and Gesture* (New York: Whitney Museum of American Art, 1990) 100–101.

Ursula MEYER
De-Objectification of the Object [1969]

Coinciding with contemporary art, progressive industry is intensely concerned with reduction and abstraction. In a recent interview, the French economist and author Servan-Schreiber expressed his boredom with the hardware industries. He discussed a 61 × 61 cm [2 × 2 ft] micro-circuit which powered a large TV screen: 'The more abstract, the more interesting'.

The recent crop of oeuvres suggests that the notion of abstraction is substantially changing. Abstraction no longer refers to reduction of form only, but to abstraction for its own sake. 'Hardware sculptures' are giving way to something much more subtle and much more abstract. Engineering and construction devices are either disappearing or altogether absent. The object, deprived of its third dimension and apparent weightiness, loses power and presence. Denied its upright stance, it falls to the ground prone and spineless. The *objet d'art* looks more like a configuration of sorts than like an object. Is the metamorphosis of the object indicative of the end of the minimal-hardware art-package?

The change from the cool structural principle to the hot line of human expressionism seems to be the message of the Castelli Warehouse exhibition (December 1968). Materials were anti-industrial, unclean and unsolid. Suggestive of the human condition – or the brand-new scene and scenery – these works cowered helplessly on the ground, prostrate, accessible to the next blow. Anthropomorphic allusions, psychological gesturing, the arch defects of yesteryear's structural art, are in. The impeccable slickness of industrial art gives way to the vision of human frailty. A leaf in the wind, a speck of dust in the universe. Man is expendable. While structural concepts affirmed man's object mastery, the drooping materials acknowledge the collapse of the great illusion. The let-it-fall material flexibility demonstrates the transitory and impermanent. The new work is possibly also a protest, a reaction against some of the pat intellectual solutions of recent Minimal art. Yet – a merely psychological interpretation – or an aesthetic one, for that matter – does not suffice. To me, the new trend is indicative of the *loss of power* not only over the object but of the object itself. There is no rigidity which is associated with objecthood. The object is de-objectified. The air is out of the balloon. No longer does the compulsive need for object-control prevail, but a much more relaxed attitude of letting it be. A less forceful statement of the Cartesian Gap. The subject – the perceiver – is less alienated from the understated object.

Minimal artists did Minimal art with non-minimal means. Using pliable instead of rigid materials, their oeuvres convey an expressionism of sorts. It has been called 'Funk-Minimal'. The pendulum is swinging back from the Apollonian to the Dionysian principle, from the *universal* to the *particular*, from the *Absolute* to the *relative*. At this stage of *relative Minimalism* one should beware of discrediting the awesome machine-made perfection of structural art as cold and 'inhuman'. It is precisely that flawless perfection which allows for omission of all unnecessary particulars reducing the object to its essence. Thus, at its best, it becomes a *universal*: the *idea* of object. This lofty goal cannot be reached without the flawless co-operation of the machine. One tends to forget that *idea* is as human as emotion – and that the machine is but an extension of the human hand. In his discussion of Surrealism, Mondrian stated the issue succinctly: ' ... we must recognize that it deepens feeling and thought, but since this deepening is limited by individualism, it cannot reach the foundation, the universal'. Non-figurative art, he feels, 'frees art from all particulars' – obviously the new configurations enjoy an abundance of particulars.

During the last few years several art forms and artists challenged the autonomy of the object. The Destructionists directed their ire mainly against ready-made commodities. Minimalists displaced the authority of objecthood with less obvious and dramatic means than those espoused by either Destructionists or Funk Minimalists. To name but a few: Dan Flavin's light works destroyed the object's objective boundaries. Sol LeWitt's 3-D drawings outline the Gestalt of the non-existent object. Tony Smith's *Die* caused the object to crumble under the weight of its own Gestalt. The multiple subunits of Carl Andre's prefabricated modules usurped the authority of the total Gestalt. Al Brunelle's network of modules destroyed the homogeneity of the Gestalt. As early as 1963 Ellsworth Kelly and David Lee dealt with the possibilities of the divided object. At that time, my own work anticipated the decadence of the geometric object with the use of caved-in areas and uneven edges.

I mention Happenings briefly as an art form concerned with the downgrading of the object. The scenery was usually neither preconceived nor constructed. A loosely assembled environment was filled with humble objects – dirty boxes, discarded tyres, torn paper and old burlap bags. Happenings exist only in the present, when they happen. They are blatantly temporal and ephemeral. No patrons, no collectors, for there is nothing to collect. Man is as unprestigious as the surrounding object and often purposefully equated by being enclosed in a box or being wrapped up in a paper shroud. There is no manifest conflict between the subject and the object, but a playful interaction. Happenings are putting the 'precious' object in its place. A Happening is an *object leveller*. Unfortunately. Happenings moved to a commercial destiny, and thus to an early demise. Department stores' and finally supermarkets' staging gave Happenings the *coup de grace*.

Multimedia and *radical abstraction* are the scene of the non-existent object. Multimedia, in contrast to radical abstraction, exposes the viewer to a superabundance of sensory stimuli. Both art forms convey the fascination of *all-at-onceness* which is achieved either with an excess or a lack of stimuli. Minimal art is the only art form *with* object, which allows for immediate recognition.

The younger generation of painters and sculptors, having been weaned on multi-perspective media, film and TV, isn't 'turned on' by traditional art – and I am using that term for all art concerned with objects. The young want to create powerful emotional experiences which, for them, neither traditional literature nor art provide. Through theatrical and projector art, the drug-induced experience of the extended consciousness is emulated and sublimated. An overload of stimuli reacts as a repressant of ordinary critical faculties. The discriminating capacities recede under the onslaught of Rocks and Rolls, beeps and boops, combined with the onrush of images simultaneously projected on multiple screens. The perceiver's mind becomes threadbare and a raw nerve is exposed. With his rational defences gone he now becomes accessible to subliminal perception. This is mind-blowing,

and in their art the young won't settle for anything less. Voracious emotional appetites crave that which will stimulate more hunger, more craving.

In contradistinction to the theatricality of multimedia, *radical abstraction* – like much Minimal art – favours introspection and contemplation. Rather than discussing here earthworks, waterworks and fireworks, I am concerned with the essential laboratory example of art without form or aesthetics without art – that is the dust concept of Bill Bollinger, shown at the Bykert Gallery (January 1969), which is neither sculpture nor painting. It is a revolutionary statement leading into Sartre's 'Nothingness'. Bollinger's work is philosophy which has become real. And as such, it is easily misinterpreted. Personal projections become interpretations reminiscent of H.C. Anderson's story of the pile of coals – a housewife sees only the mess, a young couple anticipates warmth in winter, and a businessman translates the coals into gold. Fear can obstruct authentic perception. Dust becomes disturbing. This most humble of materials spells a most radical orientation. Brunelle called it Bollinger's most dangerous work in *ARTnews* (January 1969). There is neither object nor systemic formation, but a confrontation with the very non-existence of the object.

Art has become objectless abstraction no longer weighted down by extraneous hardware. Creativity is conceptual thinking – and the criterion of art is the expansion of consciousness. If we accept this premise, and *in this sense only*, almost all ulterior manifestations could be dispensed with. Bollinger's oeuvre forces us to think through to the inevitable conclusion. The result of this mental exertion could be devastating. The pursuit of pure abstraction vitiates manifest object-art. Artists might follow in the footsteps of that famous dropout, Marcel Duchamp, though for altogether different reasons. The contradiction between object and idea is obvious. 'Where do we go from here?' Bollinger told me that he likes objects and intends to continue making them. He refuses to be categorized, even though the category is of his own making.

Douglas Huebler exhibited 'beyond direct perception' at the Seth Siegelaub Gallery (February 1969). He photographed the disintegration of a rectangle of dust placed in front of the gallery, and this photographic documentation then became the oeuvre itself. In the catalogue, Huebler states: 'The world is full of objects, more or less interesting. I do not wish to add to it any more.'

An essentially revolutionary event in contemporary art is the cessation of the object, the thing-in-itself, which, according to Kant, man had no way of knowing. It is irrelevant whether artists are driven to radical abstraction by inner anguish, or whether they are taking an egocentric intellectual trip. The issue is the idea. Has Art with a capital 'A' as we have traditionally known it – and as practised by a professional elite and patronage – ceased to exist? Nietzsche's *Umwertung Aller Werte* (*Re-evaluation of All Values* in the sense of *Reversal of All Values*) is becoming a 'bloody truth'. Continuous upheavals in art, the multitude of stylistic expressions, the de-objectification and annihilation of the object are all part of

the total disorientation of values. Art does not merely reflect culture. It *is* it. It is the decaying city culture, the deteriorated human condition. Yet art is much more than the immediate societal environment. Above and beyond, it is conceptual. Art forms are manifestations of thought, and radical abstraction – iconoclastic and revolutionary – opens unknown avenues of thinking. In ceasing to be an object, art has become *idea*. On this level, criteria of aesthetics no longer apply. The full and final meaning is philosophical: it is abstraction *per se*, and not abstraction *from* […]

According to Guillaume Apollinaire, art's great potential is surprise. The significant aspect of contemporary art is the enormously accelerated speed of change. The work is Here and Now. Today eliminates yesterday, yesterday's work becomes a *déjà vu* experience. Tomorrow is already encroaching on today. All of a sudden, prominent Minimalists have become conservatives; entrepreneurs of the new establishment, but establishment none the less. The art of the object is a merchandisable commodity. An artist like Judd refers to his time-consuming managerial tasks. The objectless artists are not burdened with such problems. How do you merchandise dust? Apparently, the profit motive is woefully missing. Alas, capitalism! Alas, establishment! 'Dust thou art and unto dust shalt thou return.' Radical abstraction is against the very fibre of our acquisitive society. The objective reality is the absence of the object. Not a solid investment, but a handful of dust. The handwriting is on the wall or, rather, on the floor […]

Ursula Meyer, 'De-Objectification of the Object', *Arts Magazine* (Summer 1969) 20-21.

Donald JUDD
Complaints: Part I [1969]

I haven't written anything in quite a while; I have a lot of complaints. Most of these are about attempts to close the fairly open situation of contemporary art. There are a lot of arguments for closure: a whole aesthetic or style; a half-aesthetic or movement; a way of working, history or development; seniority, juniority, money and galleries; sociology, politics, nationalism. Most discussion of these aspects is absolute; something is the only true art and something else has got to go. Usually little is said about particular works and artists and nothing about the actual differences and similarities between artists. I've read very little about the present kind of large scale and it is common to almost everyone. It's very definite and will someday be an obvious aspect of the time. That's true of colour also, and of wholeness, which has been discussed some.

Everything on the list should be considered but almost never should any argument result in the destructive conclusion that is the usual ending, or apparent ending, since often it's the premise. Obviously everyone is going to prefer kinds of art. I prefer art that isn't associated with anything and am tired of the various kinds of Dada, and don't think, for example, that the work of Jasper Johns and Robert Rauschenberg is so momentous. But it's good and

I'm not at all inclined to rank them below every last abstract artist. And I know that their work has connections to so-called abstract work. (I don't like the word 'abstract'.) Or, I think American art is far better than that anywhere else but I don't think that situation is desirable. Actually, it's international art in America and the best thing that could happen would be equal international art elsewhere.

In 1964 I wrote an article on the difference between the years just before and after 1960. Most of the artists, the followers by definition of a majority, and the galleries were fixed upon Abstract Expressionism. It was a style and the only legitimate one. Every little debaser was praised as a great artist by Irving Sandler and Max Kozloff and painted a painting in *ARTnews*. But Ad Reinhardt and Rauschenberg, for example, were irrelevant flukes. It was an unpleasant situation and somewhat like the extremely warped one that existed in the US before the late 1940s. By 1960 it became evident that the best work wasn't among the so-called Abstract Expressionists, except for some of the original ones, Mark Rothko, Barnett Newman and Clyfford Still, and one later one, Helen Frankenthaler. There were Reinhardt and Rauschenberg, Morris Louis, Kenneth Noland, Johns and then John Chamberlain, Mark di Suvero, Lee Bontecou, Frank Stella, Claus Oldenburg, James Rosenquist and Roy Lichtenstein.

In the last three years or so I've thought that Clement Greenberg and his followers have been trying to form a similar closed situation. I've expected a lot of stupid things to reoccur – movements, labels – but I didn't think there would be another attempt to impose a universal style. It's naive and it's directly opposed to the nature of contemporary art, including that of the artists they support. Their opinions are the same as those of the critics and followers of the late 1950s: there is only one way of working – one kind of form, one medium; everything else is irrelevant and trivial; history is on our side; preserve the true art; preserve the true criticism. This means that Grace Hartigan and Michael Goldberg were better than Reinhardt and Rauschenberg and that Jack Bush and Edward Avedisian are better than Oldenburg and Flavin. Both groups, by these attitudes, slowly destroy the work they're protecting. The followers of the Abstract Expressionists and some of the leaders went backwards towards representational painterliness. The Greenbergers, except Noland, steadily become either atmospheric or Cubistic. I think Noland is the only first-rate artist involved – Louis is dead – and I like Noland's circles better than I like anything of his since. Caro is a conventional, competent second-generation artist. I don't understand the link between Noland and Caro, since wholeness is basic to Noland's work and cubist fragmentation is basic to Caro's. I think Caro had his first show in New York in December 1964. Di Suvero first showed his somewhat similar but far better sculpture in October 1960; by 1964 di Suvero had a tiresome number of followers and Caro's work looked like that of just another of them. 'Anthony Caro is a major artist – the best sculptor to come up since David Smith.' – C.G. That's only misjudgement, though. I expect that; I don't expect the little league fascism.

Barbara Reise's article on Greenberg was good serious

opposition.' It's surprising that it wasn't done until now. Greenberg's and Michael Fried's articles and the absence of opposition make one of the numerous instances of the incompetence of art criticism. Barbara Rose did rise up in a recent article in *Artforum*,[2] but she concedes Greenberg a separate history as against that of everyone else. I'm harder on Greenberg than Barbara Reise is and don't take him so seriously. By now he's ignorant and hysterical. One instance is a laughable article in *Vogue* last May, ostensibly on Ann Truitt but mainly on the failings of 'Minimal art', including me. This is the nadir of the failures:

'*And with the help of monochrome the artist would have been able to dissemble her feminine sensibility behind a more aggressively far-out, non-art look, as so many masculine Minimalists have their rather feminine sensibilities*'. (*Greenberg's italics.*)

Greenberg made a garbled attempt to give the invention of 'Minimal art', though it was not worth inventing, to Ann Truitt:

'*But if any one artist started or anticipated Minimal art, it was she, in the fence-like and then box-like objects of wood or aluminium she began making, the former in 1961 and the latter in 1962.*'

'*Truitt's first New York show, at the André Emmerich Gallery in February 1963, met incomprehension (from, among others, Donald Judd, today a Minimalist leader, who reviewed the show for Arts Magazine.*[3])

'*Had they been monochrome, the "objects" in Truitt's 1963 show would have qualified as first examples of orthodox Minimal art.*'

The last sentence is in the category of 'if the queen had balls, she would be king'. An opening sentence is:

'*It is hardly two years since Minimal art first appeared as a coherent movement, and it is already more the rage among artists than Pop or Op ever was.*'

That chronology is either intentional falsification or ignorance. The statement about my derogatory review of Truitt's show is also shady. Regardless of work never shown, Flavin, Morris and I were in a group show at Green Gallery in January 1963 and later that year. One of Greenberg's worst statements, attributing everything to money, was in *Studio International* in January 1968:

'*The last such phase, Minimal art, has swept the museums and the magazines and the art buffs, but it doesn't sell commensurately because it's too hard to install. And with Novelty art, sales decide things; Pop, Op, assemblage, erotic, neo-figurative and the rest don't persist in the face of economic adversity — just as second-generation Abstract Expressionism didn't ...*'

It's surprising and despicable.

Greenberg was right of course in supporting Pollock and the others, but mainly his writing then was only approval and disapproval. He didn't write much about Jackson Pollock and didn't add anything to the thinking about his work. He did little for David Smith. He did less for everyone else, including Noland, Louis and Caro. (I consider Jules Olitski's work chronically unresolved and beyond thought.) I didn't think about Greenberg much in the early 1960s and he didn't write much. I suppose Fried and Philip Leider, the editor of *Artforum*, kept him going. When *Artforum* moved to New York it revived the roster of New York hacks.

I gave up on Michael Fried when I heard him say during a symposium that he couldn't see how anyone who liked Noland and Olitski or Stella could also like Oldenburg and Rauschenberg or Lichtenstein, whichever. He was very passionate about it. (Apparently, Fried likes Stella but Greenberg doesn't.) I've never liked Kozloff's ornate platitudes, but during this symposium he actually gave a theory for always writing about things three or four years too late. Fried's opinions narrowed a few years ago. I remember enthusiasm for John Chamberlain's work; I've heard this disappeared because of Greenberg's disapproval. Fried's article 'Art and Objecthood'[4] in the 1967 summer issue of *Artforum* was stupid. He cross-referenced Bob Morris, Tony Smith and myself and argued against the mess. Smith's statements and his work are contradictory to my own. Bob Morris' Dada interests are very alien to me and there's a lot in his dogmatic articles that I don't like. I was especially irked by Fried's ignorant misinterpretation of my use of the word 'interesting'. I obviously use it in a particular way but Fried reduces it to the cliché 'merely interesting': '*Judd himself has as much as acknowledged the problematic character of the literalist enterprise by his claim, "A work needs only to be interesting"*'.

Fried is not careful and informed. His pedantic pseudo-philosophical analysis is the equivalent of *ARTnews'* purple poetic prose of the late 1950s.

That prose was only emotional recreation and Fried's thinking is just formal analysis and both methods used exclusively are shit.

Artforum, since it came to New York, has seemed like *ARTnews* in the late 1950s. There's serious high art and then there's everybody else, all equally low. Dan Flavin plays Ad Reinhardt, entertaining but not worth an article on his work; Larry Bell and Robert Irwin hardly exist; Greenbergers such as Rosalind Krauss review all the shows; Darby Bannard paints a picture, *Hélion relived*; and articles come steadily out of the Fogg. I once complained to Leider that the magazine was dominated by Michael Fried and the third string and he said that he didn't think it was biased, that he published Robert Smithson too. That's balanced mediocrity. *Artforum* is probably the best art magazine still, but it's depressing that it's gotten so bad and so close to the others. I don't know much about *Studio International*. *Artforum's* failure to evaluate artists and to think about their work is characteristic of the whole situation of current art. Art gets quite a bit of attention but the quality of that is depressing.

Greenberg and Fried are of course wrong about mainstream history or development. It's too simple and, as Barbara Reise said, it's nineteenth-century philosophy. Most ideas of history are simplistic, archaic and destructive. One of *Artforum's* numerous vague mediocre articles was by Jack Wesley Burnham, maybe kin to the preacher but none to the painter. Burnham wrote a book, *Beyond Modern Sculpture*. Never mind the present. It's a pastiche of art survey information and misinformation. His idea of history, such as it is, is deterministic. Everyone has his hindsighted place and history rolls on. One cliché: '*It is the peculiarly blind quality of historical change that*

we only grasp the nature of a political or cultural era after it has reached and passed its apogee of influence.'

For whom? For the people who won't think now about particular things like scale? A good example of baloney and of silly futurism is this:

'*The shifting psychology of sculpture invention closely parallels the inversion taking place between technics and man: As the craftsman slowly withdraws his personal feelings from the constructed object, the object gradually gains its independence from its human maker; in time it seeks a life of its own through self-reproduction.*' (Burnham's italics.)

I dislike very much this sort of sloppy correlation of such highly different activities as science and art, the careless and general history and the mystical projection of the future. 'Sculpture can choose one of two courses: it can be fashioned as a reaction against technology or as an extension of technical methodology.'

That's the choice? That's Max Kozloff's or Hilton Kramer's choice.

Originally I agreed to write this to keep *Studio International* from calling me a Minimalist. Very few artists receive attention without publicity as a new group. It's another case of the simplicity of criticism and of the public. It seems as if magazines are unwilling to give a new artist space by himself. *Artforum* has had some discussion of single new artists, mostly by John Coplans. One person's work isn't considered sufficiently important historically to be discussed alone. But most of the so-called movements are only one person or maybe two remotely related. That's obvious by the work, by the initial development, by the fact that in two or three years the followers follow elsewhere. I hated the 'Primary Structures' show at the Jewish Museum in 1966, both itself and its title – 'Primary' sounds Platonic. The show started out a year earlier with Flavin, Morris, myself, maybe Andre and Bell and maybe a couple of others. Forty-odd artists, I think, were in the show and a lot of them, most of Park Place, had become geometric during that year. Barbara Rose's ABC article[5] was just publicity. Theme shows and movements are still produced. Discussion, such as Greenberg's in the Truitt article, is still by groups.

A few months ago *Artforum* ran another manifesto by Bob Morris entitled 'Anti-Form'.[6] It was illustrated with photographs of work by several very diverse new artists, suggesting by the layout that they were a group and that they were following Morris' work in felt, begun a year and a half ago. Leider recently wrote an article in the *New York Times* entitled, I think, 'In the Shadow of Bob Morris'. This was about a show by several of these artists – Saret, Hesse, Serra, Sonnier, Nauman and others – organized by Morris. The show was all right but the suggestion of similarity is bad and the impression that they're fathered by Morris is terrible. Nauman's floppy pieces actually precede Morris' by a couple of years. He and Hesse were in a group show at Fischbach around two years ago. It's not likely that anyone as good as Serra developed his work from someone else's in a year and a half. The suggestion is like Greenberg's that Morris and I picked up on Truitt's work. It's impossible chronologically. Neither do good artists develop substantially from other artists' work.

12. Robert Morris

1 Barbara Reise, 'Greenberg and The Group: A retrospective
 view', *Studio International*, I (May 1968), II (June 1968).

2 Barbara Rose, 'The Politics of Art: Part I', *Artforum*
 (February 1968).

3 Donald Judd, 'In the Galleries: Anne Truitt', *Arts
 Magazine* (April 1963). [See in this volume p. 194.]

4 Michael Fried, 'Art and Objecthood', *Artforum* (June
 1967); reprinted in *Minimal Art: A Critical Anthology*,
 ed. Gregory Battcock (New York: E.P. Dutton & Co., 1968)
 116-47. [See in this volume pp. 234-35.]

5 Barbara Rose, 'ABC Art', *Art in America* (October-November
 1965) 57-69. [See in this volume pp. 214-17.]

6 Robert Morris, 'Anti-Form', *Artforum* (April 1968);
 reprinted in *The New Sculpture 1965-75: Between Geometry
 and Gesture* (New York: Whitney Museum of American Art,
 1990) 100-101. [See in this volume pp. 243-44.]

Donald Judd, 'Complaints: Part I', *Studio International*
(April 1969) 166-79; reprinted in *Donald Judd: Complete
Writings 1959-1975* (Halifax: Nova Scotia College of Art and
Design; New York University Press, 1975) 197-99.

Annette MICHELSON

Robert Morris: An Aesthetics of Transgression [1969]

'There is, however, nothing more wholesome for us than to find problems that quite transcend our powers and I must say, too, that it imparts a delicious sense of being cradled in the waters of the deep – a feeling I always have at sea.'
– Charles Sanders Peirce

Robert Morris has moved, in a decade, from the making of objects to modification of temperature and terrain, passing through a series of parallel strategies, from the scenic space of theatre into that of landscape as Theatre of Operations. The central interest and importance of these movements – in several senses and at most points transgressive – is assured by the manner in which their departures, shifts of emphasis and direction, extensions and contractions of scale, have sharpened and revised the categories of sculptural process, thereby redefining and extending the arena of aesthetic discourse. Developing, sustaining a focus upon the irreducibly concrete qualities of sensory experience, they renew the terms in which we understand and reflect upon the modalities of making and perceiving.

An enterprise of this kind is critical in each sense we commonly attach to the word, and in one other; its fullest comprehension commands recognition of the singular resolution with which a sculptor has assumed the philosophical task which, in a culture not committed on the whole to speculative thought, devolves with a particular stringency upon its artists.

Saying so much as this, one confronts again, if ever so tentatively, the tension between notions of art and ideation as preserved in the contradictions of our critical language. Historical and critical tradition have most generally assumed the existence of philosophical

constructs at work 'behind' the art work, and never more persistently than in this century, when the radical transformation of a pictorial space through which the figure has been articulated has relaxed the iconographer's hold upon painting and sculpture alike.

The Modernist aspiration to autonomy and immediacy working through a pervasive abstraction has elicited a critical literature of considerable refinement, uniquely proficient in its readings of pictorial and sculptural form. That proficiency is, however, largely though subtly subverted by an ancient and tenacious Idealism [...]

'*Whenever we use the notion of form – if only in order to criticize another concept of form – we are forced to resort to the assumption of a source of meaning. And the source or medium of this assumption is necessarily the language of metaphysics*'.'
That language has been, as well, the language of our art criticism, and its presuppositions the source of its proliferating claims for art as 'saying', 'expressing', 'embodying', 'bodying forth', 'incarnating', 'hypostasizing', 'symbolizing', 'dramatizing', when it is not 'figuring', 'presenting' or 'representing'. It was in order to dispel or to attenuate the persistent implication of the 'referent', the reality assumed as prior to the created reality of the work of art, that the term of 'formal statement', so constantly in use throughout the American criticism of the 1940s and 1950s, was devised. Assuming somewhat less than had been assumed by such a term as 'significant form', it was the invention of a generation dedicated to the proposition that the burden of discourse and reference had been lifted from the artist, as from the writer.

Actually, it had been shifted. The formal 'statement', speaking of art alone, confronts us once again with the shadow of the 'subject'. We have proceeded through a hall of mirrors, towards the aesthetic Utopia of a self-referring system of signs, constructed on a single level of articulation, looking backwards all the while through our language to the 'subject'.

The work of Robert Morris came to maturity and into some general public recognition as immediately problematic in this regard. That is to say, it posed certain critical problems in a fresh manner and with a particular sharpness and urgency. Eluding the critical grasp, the descriptive and analytic techniques, the readings of sympathetic and sophisticated critics, it united, for one moment and in one common cause at least, others long established as different, indeed antithetical, in their methods, aims, allegiances. This sculpture – and that of certain of his contemporaries – began, from roughly 1964 on, to present in its unity of contour and innocence of textural and structural accident a resistance to prevailing critical techniques, founded on notions of aesthetic metaphor, gesture or statement. If you asked yourself, 'What is the "statement" made by or in or through a form, a sculpture, such as *Cloud*', you were led to the conclusion that it was saying, as in a celebrated phrase and if anything at all, 'itself'. Now, a 'statement' of this sort appears modest when compared with the claims made for the expressive and formal 'statements' of the 1950s. It was also, apparently, overwhelmingly intimidating in its effect. Sculptures such as *Slab*, which seemed to declare, as it

were, with John Cage, 'I have nothing to say and I am saying it', were 'saying' at the very least, 'I am that I am'. 'Statements' of this sort, which brook neither denial nor debate, we term 'apodiction'.
Criticism's response to this apodicticity was a crisis. The symptoms were roughly the following:
1. A general and immediate proliferation of new epithets.
2. Attempts to find historical, formal precedents which might facilitate analysis.
3. A growing literature about the problematic nature of available critical vocabulary, procedure, standards.
Artists responded with:
1. A growing personal concern and active involvement with critical practice.
2. Serious attempts to redefine the limits of criticism.
3. A correlative attempt to reform critical language and descriptive terms [...]

Consider the following adjectives: 'non-relational', 'unanalysable', 'indescribable', 'undifferentiated', 'incomparable' and 'unintellectual'. They are culled from the critical literature of the time, used by critics from 1966 on. Their source lies in statements made by artists. Thus Donald Judd, on the manner in which his work reflects an 'anti-rationalistic' point of view: 'The parts are unrelational'. This has been preceded by a statement made by Stella:
'*The other thing is that the European geometric painters really strive for what I call relational painting. The basis of their whole idea is balance. You do something in one corner and you balance it with something in the other corner. Now the new painting is being characterized as symmetrical. Ken Noland has put things in the centre and I'll use a symmetrical pattern, but we use symmetry in a different way. It's non-relational. In the newer American painting we strive to get the thing in the middle, and symmetrical, but just to get a kind of force, just to get the thing on the canvas. The balance factor isn't important. We're not trying to jockey everything around.*'
Judd:
'*You see, the big problem is that nothing that is not absolutely plain begins to have parts in some way. The thing is to be able to work and do different things, and yet not break up the wholeness that a piece has.*'[2]

Consider now the following statements, descriptive of a state of consciousness:
'*About (it) little can be affirmed; many of the predicates we can attach to it are negative. It is incomparable, non-relational, undifferentiated, indescribable and unintellectual.*'
That description is extracted, not from the art-critical literature of the 1960s, but from an account of the notion of 'epistemological firstness' as defined by the first among our philosophers, Charles Sanders Peirce.[3] It continues in the following manner:
'*Firstness is somehow absolutely present. It is a purely monadic state of feeling and somehow immediate, without its immediacy being derived by reflection from what is not immediate. It is fresh, free, vivid, original, spontaneous.*'

This quality of immediate, concrete, simple apprehension Peirce proposed as the first focus of an investigation of the most general conditions of experience,

of knowing and perceiving, as he set about marking off the limits of his phenomenology.

'*Imagine, if you please, a consciousness in which there is no comparison, no relation, no recognized multiplicity (since parts would be other than the whole), no change, no imagination of any modification of what is positively there, no reflection – nothing but a simple positive character.*

'*Such a consciousness might be just an odour, say a smell of attar; or it might be one infinite dead ache; it might be the hearing of a piercing eternal whistle. In short, any simple and positive quality would be something which our description fits that it is such as it is quite regardless of anything else.*

'*If we imagine that feeling retains its positive character but absolutely loses all relation (and thereby all vividness, which is only the sense of shock), it no longer is exactly what we call feeling. It is a mere sense of quality ... An idea of a feeling is such as it is within itself, without any elements or relations. One shade of red does not in itself resemble another shade of red. Indeed, when we speak of a shade of red, it is already not the idea of the feeling of which we are speaking but of a cluster of such ideas.*'[4]

Firstness, then, is 'a sense of quality rather than a perception'. Non-cognitive, it is 'absolutely present', as painting and sculpture, Modernist and of 'quality', properly apprehended, are said to be. Consider, now, the notion of the work of art as:

'*Continuous and entire presentness, amounting, as it were, to the perpetual creation of itself, that one experiences as a kind of instantaneousness: as though if only one were infinitely more acute, a single, infinitely brief instant would be long enough to see everything, to experience the work in all its depth and fullness, to be forever convinced by it*'[5] [...]

That which leaps to the eye is the manner in which both 'firstness' as epistemological category and 'presentness' as aesthetic value preserve, for a secular age, the attributes of that logically pre-existent, absolute and timeless, real Presence called into question by Modernism. 'Examine the mutations of things', says St. Augustine, 'and thou wilt everywhere find "has been" and "will be". Think on God and thou wilt find "is" where "has been" and "will be" cannot be.' Absolute presentness being the attribute of Divinity, to experience 'the work in all its depth and fullness' as within 'a single, infinitely brief instant' is to dwell in Presence, in 'conviction' as in Revelation. Modernism seen thus assumes the aspect of a Reformation, bequeathing, in its prescriptiveness, its preoccupation with a canon, its identification of aesthetic decisions with moral choices, a repertory of Calvinist themes of sin and redemption for our contemporary rehearsal.

It is, I think, a prime quality of Morris' work that it offers, through a series of exploratory enterprises, the terms of a sharpened definition of the nature of the sculptural experience, and that it does so in a manner wholly consistent with a commitment to the secularist impulse and thrust of Modernism. I mean by this to suggest its mixture of modesty and ambition. Staking out areas of intensive exploration of the qualities of shape, scale, size, placing, weight, mass, opacity and transparency, visibility and obscurity, this work urges

reflection on the present, concrete options of sculpture, as on the general terms and conditions of its perception. Cognitive in its fullest effect, then, rather than 'meaningful', its comprehension not only demands time; it elicits the acknowledgment of temporality as the condition or medium of human cognition and aesthetic experience [...]

In 1965 Morris exhibited a group of sculptures at the Green Gallery in New York. They constituted a threshold in the development of his work, initiating a radical re-evaluation of the presuppositions and aspirations which had informed much of the best sculpture – and criticism – of the recent past. Among the pieces on view was a group of four cubes measuring 91.5 × 91.5 × 91.5 cm [3 × 3 × 3 ft] and set 183 cm [6 ft] apart. Their surfaces were entirely mirrored. To describe, to account for that which they presented to view, is to relate the terms of a contradiction; each object was dissolved even as it was defined, through reflection.

Somewhere in the oscillation between the terms of the contradiction, during the reflective movement of its apprehension, within the space of equivocation, a fact was posited, a form was located. Real cubes were described by the virtual, inaccessible, intangible space of their mirrored surfaces. Those surfaces, in describing forms, posited facts as problematic, elicited Reflection. The physical space of a perception was perceived as the mental space of paradox, a location issuing in Speculation.

This catoptric strategy assumes a central place in our consideration of Morris' enterprise for the following reasons:

1. It takes account of, uses, renders visible the manner in which the reflective process is grounded in, inseparable from, the radically engaging physicality of the work, a structure which in this instance visibly (virtually) absorbs the spectator.

2. It constitutes a particularly brilliant instance of the manner in which Morris undertook to question the aesthetic convention, the distinction obtaining, in traditional aesthetics and criticism of sculpture, between a 'real' or operational space – that of the beholder – and a 'virtual' space, self-enclosed, optical, assumed to be that of sculpture.

3. It is a strategy. That is to say, it is a work conceived as part of a continuum, initiating in a particularly engaging manner the exploration of an area of sculptural enterprise, a mode of sculptural thinking. It is designed as part of a continuing developing action and experience. To see it as such means accepting the consequences of that solidly established contemporary tradition in which the artist's work defines, in its development, a field of investigation, a range of sculptural options and modes.

The strict morphology and the continually cross-referring variational quality of Morris' early sculpture are to be seen not as embodying or essentialising sculptural ideas or categories, but as proposing a patient investigation, profoundly innovative in its sharpness and intensity of focus, of the conditions for a reconsideration of sculptural processes, a redefinition of its parameters. They resulted from a questioning of assumptions which, determining a contemporary sculptural style, had acquired

the status of a sculptural ontology.

Recognizing this, one understands the nature of and reasons for the critical crisis induced by his work, the asperity of criticism it elicited, the character of the rhetoric revived in debate. Questioning the distinction, the boundary instituted by traditional aesthetics between virtual and real space, the work was in reality – the reality of this particular aesthetic context – transgressive. Demanding an attentiveness in time for its apprehension, it impelled, as well, a shift of emphasis in notions of value, as of gratification. It is the consistency and clarity of its logic, the variety and amplitude of its development, the intellectual trajectory described by that development which gives pleasure. That clarity and consistency, the steadiness and assurance of that trajectory, and, above all, the manner in which our notion of what sculpture may be, is extended – these are the gauge of a 'quality', defined as 'concrete reasonableness' [...]

Consider the *Corner Piece*. Perceived as a plane, it is the broadest side of a triangle, obtruding ultimately into a primary sense of available space. The plane stands in the way of, on our way to, the corner. Subverting and intruding upon the angle, it forces recognition of that angle.

Now, the space enveloping and sustaining the apprehension of these structures is a space common to object and beholder. The corner of the *Corner Piece* is the corner of the gallery space in which we stand, in which we are enclosed. That space subtracted from us by a slab is real; one might stand in it. It hovers over an area of floor on which one might stand. The space absorbed, reflected by the mirrored cubes, is that of the gallery in which we now stand, perceiving ourselves as standing – and as perceiving. In these instances, then, the central focus of attention is the manner of the solicitation – through placing, scale, unity of shape, volume, the nature of materials and of the spectator's sensed relationship of the self as a perceiving, corporeal presence, to the object in question: the sense of co-presence.

The convention or fiction sustaining the sculpture and criticism of a preceding generation had been the notion of a space that was the medium of a predominantly visual and synthetic perception, which is to say, it posited a sculpture which, addressing itself to the eye, elicited a reading, a synthetic recomposing, creating, projecting a synthesized virtual space, distinct from that of non-aesthetic experience, the development and maintaining of this distinction (whose value, like that of all conventions or fictions of its kind, is to be measured by the interest of the art for which it served as a working hypothesis, by its usefulness within a given historical framework) seems, indeed, to have animated the development of the very finest of post-Cubist sculpture. It is, however, in the nature of aesthetic assumptions and of working hypotheses to be limited and particular in value, and the evolution of Morris' work from approximately 1963 on points to an awareness of this [...]

It is the nature of virtual space to be entirely distinct from the space in which we live and act.[6] It is, then, not an operational space, nor the space of experience, but of vision. The sculptor conceives of the work and the world of his imagination as spatial in terms of three-dimensional

volumes; the actual existence of a sculpture is conditioned by its relation to its surrounding space. But 'space' in that sense must not be understood as a physical, geometrical or philosophical concept. Neither the geometrical concept of three-dimensional space nor the physicist's theory of four-dimensional unity of space-time is applicable. These are derived from abstract thought. 'Virtual space is self-contained, a total system, entirely independent, not a local area in actual space. Sculptural form is a powerful abstraction from actual objects, and the three-dimensional space which we construe by means of them through touch and sight. It makes its own construction in three dimensions, namely the semblance of kinetic sight'.[7] Sculpture creates 'the primary illusion', a visual space which is 'not a space of direct vision, for volume is really given originally to touch, both haptic touch and contact limited to bodily movement, and the business of sculpture is to translate its data into entirely visual terms, i.e. to make tactual space visible'.[8]

Confronting sculptures such as those by Robert Morris, the beholder perceives an object whose mass and volume, whose scale and structure are, in their compactness and clarity, perceived as providing not a focus for a synthetic reading, but as being co-present with himself. Attention to the simplicity of its structure, to its qualities, directs him back, as it were, upon the quality of his perception. The inner rehearsal of its modes, of the aspects and parameters of that perception, conduces to an experience of a reflective nature. Every aspect of that experience – the 'reduction' on which it is posited, its reflexiveness, the manner in which it illuminates the nature of our feeling and knowing through an object, a spatial situation, suggests an aesthetic analogy to the posture and method of phenomenological inquiry, as it is familiar to us in the tradition of contemporary philosophy. It is the commitment to the exact particularity of experience, to the experience of a sculptural object as inextricably involved with the sense of self and of that space which is their common dwelling, which characterizes these strategies as radical. Morris' questioning of a self-contained system of virtual space is impelled by a recognition of the most profound and general sense in which our seeing is linked to our sense of ourselves as being bodies in space, knowing space through the body. Acknowledging sight as more and other than seeing, he proposes that we take serious account of the fact that 'to perceive is to render one's self present to something through the body',[9] suggesting that we recognize that 'if it seems absurd to say that the world is understood by the body because to understand is to subsume a particular set of impressions under a general concept, then in the face of the evidence we must either re-examine our notion of "understand" or of "the body". Knowing, then, is the body's functioning in a given environment.'[10]

The consequences of the acknowledgement was a deflection of the direction taken by sculpture in the 1950s. That direction and the lineaments of its sculptural style had been described by Clement Greenberg in an essay entitled 'The New Sculpture'. Published in 1948 and reprinted in 1958, it spans a decade of sculptural

expectations which were, apart from the work of David Smith (and the mature work of Anthony Caro done somewhat later), to be deceived. Claiming first that Brancusi had exhausted the monolithic sculptural form, returning sculpture to the arms of architecture, Greenberg set forth an account of the developments, reversals and paradoxes of the sculptural situation as it now appeared to him.

'Under the Modernist "reduction" sculpture has turned out to be almost as exclusively visual in its essence as painting itself. It has been "liberated" from the monolithic as much because of the latter's excessive tactile associations, which now partake of illusion, as because of the hampering conventions that cling to it [...] The human body is no longer postulated as the agent of space in either pictorial or sculptural art; now it is eyesight alone, and eyesight has more freedom of movement and invention within three dimensions than two. It is significant, moreover, that Modernist sensibility, though it rejects sculptural painting of any kind, allows sculpture to be as pictorial as it pleases'' [...]

The desire for 'purity' works as I have indicated, to put an even higher premium on sheer visibility and an even lower one on the tactile and its associations, which include that of weight as well as of impermeability. One of the most fundamental and unifying emphases of the new common style is on the continuity and neutrality of a space that light alone inflects, without regard to the laws of gravity [...]

Morris' work appears almost as a point-by-point contestation of these claims, challenging the assertion that Constantin Brancusi had exhausted the monolith as sculptural form, challenging, as well, the statement as to 'the ever higher premium of sheer visibility and lower one of the tactile' and 'the growing disregard of laws of gravity'. Affirming these, affirming, above all, the specificity of the medium, contesting the pictorially derived nature of its direction, he proceeded to propose, in sculptural form, the terms of a renewal.

Morris had painted until 1959, when that aspiration to a seamless identity of process and work began to raise questions, heightening a sense of the contradiction at the core of a medium that converts process into static object. It is the contradiction which haunts contemporary art and philosophy alike. By 1961 he had, however, begun making sculpture. The first two pieces known to me are a Column and the Box With Sound of its Own Making, exhibited in 1963.

The shift from painting to sculpture gained momentum through an involvement in theatre work, in a directly temporal medium in which the articulation of process was naturally less fundamentally problematic. The Column in question was, in fact, designed for a performance with La Monte Young at The Living Theatre, and intended to be placed vertically for three-and-a-half minutes, horizontally for three. These placements, changes of direction over specified amounts of time, provided, as it were, a first source of elementary information about conditions for modification of a given space. The L-shaped pieces exhibited in 1965 at the Green Gallery (originally designed as a group of nine, reduced to

seven and subsequently to three) would appear to have evolved out of this first sculptural work. Later work in dance provided occasions for focus on specific problems of body and objects displaced in time. Morris was, from this point on, to be involved in a multiple effort; I wish to isolate two or three aspects.

The first involves the preoccupation with Process, as rendered throughout an extraordinary abundance of relatively small sculptures. The results of this work pursued over the next several years were redirected, through other materials and on quite another scale, transported, extending into the present. This work is, in fact, so abundant and varied that, in isolating aspects of it, one has a feeling of unintentionally scanting its variety. Of the 'process' works, the Box With Sound of its Own Making was the first. And its juxtaposition with Column, on the very threshold of Morris' sculptural career, plainly indicates the double path of his development. The Box, was eventually followed by Card File, a work whose elements are composed of the notations inscribed on filing cards and detailing the steps taken in its composition. Seamlessness involved, then, circularity, the elaboration of formal modes of tautology.

Process is articulated as well, however, within the context of self-presentation, self-exposure, through the visible trace, the 'indexical' sign, that of the body's involvement in the making of a work. Thus one can contrast the use of an 'iconic' presentation of the self in I-Box, an I-shaped box which opens to reveal a photograph of the artist, nude, with the 'indexical' presentation of the body in imprint, such as Hand and Toe-Hold, or the cast which fuses both, as in an untitled piece of 1963 involving the artist's fist and a glove [...]

Scanting the abundance of this work, one scants the richness of the iconography, the precise articulation of the relation to the work of Marcel Duchamp and Jasper Johns – a task which, one is certain, will engage the art historians of the very near future. I am, for the moment, concerned with setting forth a few of the most general terms for thinking about his work and with indicating the manner in which the formal and conceptual character of these objects provided Morris with a field for an early personal achievement. Passing from the elaboration of an iconography of paradox and of process into another sculptural mode and dimension, he retains, as a prime concern, the engagement with, the awareness of the body's presence.

The threshold of this passage, marking the change from the figuring, recording, tracing of bodily presence to the more radical conception of structural space and a sculptural form which would evoke the bodily sense, is marked by a change of scale and a new morphology, by the elaboration of the forms that came to be known as 'minimalist'. It is in sculptures such as Portal (1961), Barrier, the 'L-shaped pieces', Cloud and Corner Piece, among others, that this passage is effected. It was facilitated, as we have seen, by work in theatre and by two or three other factors as well:

1. A growing interest in the nature of materials and forming processes as presenting new sculptural potential.
2. A growing awareness of certain historical

achievements and precedents.

3. Contingent upon these two factors, a developing intuition of the manner in which preoccupation with process and bodily awareness could be shifted and redirected in a renewal of contact with the idiom of contemporary abstraction [...]

I have suggested that Morris' experience of theatre had facilitated the transition to his first strong sculptural work. I wish now to deal, somewhat generally, with the manner in which it is likely to have influenced his sense of materials, of movement, of placement, of process.

The general context of this work was the activity of a group of artists, mostly young, engaged, during the mid 1960s, in a process analogous to that underlying Morris' early sculptural effort. They were involved in a reassessment of the dance aesthetics and dance style of the West. That reassessment turned on considerations which parallel those obtaining for the distinction between virtual and real space in the sculptural situation. Balletic style – indeed, almost all dance style – was predicated on the distinction between a time one might call virtual as against a time that is operational, the time of experience, of our actions in the world.

This questioning was initiated by Merce Cunningham and radicalized through the work of Yvonne Rainer, Simone Whitman, Steve Paxton, Deborah Hay and others, working and performing in New York in the mid 1960s. Their common aim was the establishment of a radically new economy of movement. This required a systematic critique of the rhetoric, the conventions, the aesthetic hierarchies imposed by traditional or classical balletic forms. That rhetoric was, in fact, reversed, destroyed, in what has come to be known as the 'dance of ordinary language' and of 'task performance' [...]

The New Dance set out in much the same manner as the New Sculpture of the 1960s to contest point for point this aesthetic, these conventions which had acquired, as it were, an ontological status, by rehabilitating, installing within the dance texture, the task, the operational movement whose quality is determined by the specific practicality of its character. Instituting games – and rules for games – within the dance fabric, it engendered a specific logic of movement – and, of course, the possibility of that logic's reversal. Using found materials and the principle of found materials transposed into terms of movement, using techniques of disjunction, setting movement against sound, sound against music and against speech, operational movement against recorded movement (film), it distended the arena of organized movement, installing within the dance situation a real or operational time, redefining it as situation within which an action may take the time it takes to perform that action. Neither self-contained, nor engendered by pre-determined rhythmic or rhetorical patterns, it was not 'synthetic'. The time of the New Dance brought into play, through an apparent process of ascesis, a multiplicity of new possibilities, revising the vocabulary of movement through a rethinking of the problem of energy release, its syntax through structural disjunctions.

The nature of Morris' engagement in the dance was complex. Certain concerns already visible in his sculpture

were explored. One would suppose, however, that a primary and general interest of this work – quite apart from the particular insights it provided – lay in the total coincidence of work and process which could resolve that initial malaise engendered by the contradiction at the heart of painting. Neither icon (such as the *I-Box*) nor index (electrode-encephalogram) could afford that totality of fusion. Nor could they quite exhaust the dialectic of masking and self-presentation, attain the immediacy of a devouring temporality nor did they offer what was, perhaps, the ultimate temptation of reconverting pure process into something palpable, dance into object.

Paralleling the critique Morris had initiated through his sculpture, questioning the virtual time of dance as he had questioned the virtual space of sculpture, the New Dance, evolving in a more marginal, less structured, more precarious social situation, affords thereby a particularly privileged instance of an ascesis performed upon an art form by its artists, an ascesis of a profoundly philosophic character. The New Dance and sculpture (emerging in a culture whose literature of the last two decades has been regressive) converges with the New Novel of France (emerging in a culture whose dance and sculpture have been retrogressive) in the systematic focusing upon the ways of organizing and apprehending the movement of bodies in space, a central focus for modern epistemological inquiry. Sculpture, dance and narrative are joined in a contemporary style whose common origin is the intensified awareness of that apprehension, 'that exquisite satisfaction that it is just this thing, very concrete and very much there, that is what is happening'.

This confirms Peirce's declaration that 'the artist's observational power is what is most wanted in the study of phenomenology, his faculty of seeing what stares one in the face, just as it presents itself, unreplaced by an interpretation, unsophisticated by an allowance for this or for that supposed, modifying circumstance ... A resolute discrimination which fastens itself like a bulldog upon the particular feature that we are studying, follows it wherever it may lurk, and detects it beneath all its disguises.'[12]

1 Jacques Derrida, 'La Forme et le Vouloir-Dire: Note Sur la Phénoménologie du Language', *La Revue Internationale De Philosophie* (1967) 278. Derrida's brilliant and tenacious investigation of the assumptions underlying contemporary aesthetic and critical discourse are set forth in *L'Ecriture et la Différence* (Paris: Editions du Seuil, 1967); and *De la Grammatologie* (Paris: Les Editions de Minuit, 1967). The text cited here forms a kind of footnote to these two volumes.

2 See Bruce Glaser, 'New Nihilism or New Art? Interview with Stella, Judd and Flavin', originally broadcast on WBAI-FM, New York, February 1964, revised and published in *ARTnews* (September 1966); reprinted in *Minimal Art: A Critical Anthology*, ed. Gregory Battcock (New York: E.P. Dutton & Co., 1968) 148-64. [See in this volume pp. 197-201.]

3 Thomas S. Knight, *Charles Peirce* (New York: Washington Square Press, 1965) 74.

4 *Ibid.*, 75.

5 Michael Fried, 'Art and Objecthood', *Artforum* (June 1967); reprinted in *Minimal Art: A Critical Anthology*, ed. Gregory Battcock (New York: E.P. Dutton & Co., 1968) 146. [See in this volume pp. 234-35.]

6 The notion of 'virtual' space is discussed at length in chapter six of Susanne Langer's *Feeling and Form* (New York: Charles Scribners Sons, 1953). For a fuller comprehension of its sources the reader is referred to Bruno Adriani's *Problem of the Sculptor* (New York: Nierendorf Gallery, 1943); and, most particularly, to Adolf Hildebrand's *The Problem of Form in Painting and Sculpture* (translated and revised with the author's co-operation by Max Meyer and Robert Morris Ogden, Leipzig, London and New York: G.E. Stechert & Co., 1907). The underlying assumptions, basically idealist in character, of Suzanne Langer's aesthetic deserve fuller consideration than is possible within the context of this exhibition catalogue, because they are perpetuated in contemporary criticism.

7 Langer, *ibid.*, 60.

8 *Ibid.*

9 Maurice Merleau-Ponty. This statement is transcribed from notes taken during lectures delivered during the 1950s at the Collège de France. It is developed in *Le Visible et L'Invisible, suivi de Notes de Travail*, ed. Claude Lefort (Paris: Editions Gallimard, 1964).

10 *Ibid.*

11 Clement Greenberg, 'The New Sculpture', 1948; reprinted in *Art and Culture: Critical Essays* (Boston: Beacon Press, 1961) 142-43; 144-45.

12 Charles Sanders Peirce, in Knight, *op. cit.*, 71.

Annette Michelson, 'Robert Morris: An Aesthetics of Transgression', *Robert Morris* (Washington, DC: Corcoran Gallery of Art, 1969) 7-75.

Carl <u>ANDRE</u>
Artworker: Interview with Jeanne Siegel [1970]

Jeanne Siegel It seems to be a moment in history when the artist, after twenty-five years of withdrawal, is once again thinking about himself in close relationship to society with the same demands and desires as other human beings.

Carl Andre I don't meet too many artists who have the kind of social pretensions of the good solid bourgeoisie or who lead neat Cadillac-driven lives, and most of the artists that I've met have had great social concerns. I remember talking to David Smith and he said that he considered himself redder than Mao, for that matter. He had a very intense social and political concern. The art was considered hermetic in a sense, and withdrawn from society. It was placed aside from the concerns of society not so much by the artist but by the critics and the curators and the art establishment. They made a big thing out of the ordinary man in the street not being able to understand and probably disliking it because of having had no exposure to it, and he used this in a kind of elitist way.

Siegel Certainly the artist is taking a more active public role today; for instance, your participation in the Art Workers Coalition.' Why do you feel the need for that?

The Bricks Abstract
A compilation by Carl Andre

Payne, Attendant Arthur 18 Feb 76
(The Journal, Newcastle-upon-Tyne)

Attendant Arthur Payne, aged 66, said: "Normally we are very quiet here, but these bricks have really brought the public in. They can't make head or tail of them. Nothing has attracted as much attention as they have in the seven years I've been at the Tate."

Tackling, Andrea Mrs. 18 Feb 76
(The Star, Sheffield)

Mrs. Andrea Tackling, aged 29, of Waltham Forest, East London, who was in charge of a party of girls, said: "Quite frankly I don't really know what the fuss was about. They just seem a lot of ordinary bricks to me."

Lucie-Smith, Edward 18 Feb 76
(Evening Standard)

The Tate's dealings with Carl Andre show that money is still a necessary medium of exchange, even when the work itself seems designed to make a monetary transaction impossible.

Jenkins, Arts Minister Hugh 18 Feb 76
(Daily Mail)

Mr. Jenkins said: "The trustees of the Tate have every right to spend a little on experimental art. I do not question their judgment. I am happy with the situation."

Stevas, Norman St. John 18 Feb 76
(Daily Mail)

Also at the preview was Mr. Norman St. John Stevas, Opposition arts spokesman, who said: "The trustees were absolutely right. They have a judgment to exercise and they exercised it."

Healey, Chancellor Denis 18 Feb 76
(Daily Mail)

Chancellor Denis Healey said:
"I didn't see the bricks
or talk about them.
I went to see the Constables."

Casson, Sir Hugh (The Guardian) 18 Feb 76

"My personal view is that once you've had the idea, assembled the bricks, photographed it, you can do it again. You don't have to store it. You can throw the whole bloody lot away."

Levin, Bernard (The Times) 18 Feb 76

Well, I have never been averse to knowing better, or for that matter to saying I do, and I say now that I not only know better than the Daily Mirror and the Daily Mail, but I know better than the people at the Tate who bought a pile of bricks and called it art. I call it a pile of bricks; and that is what it is.

(Liverpool Daily Post) 18 Feb 76

. . . Mind you Hockney isn't quite as bad as Andy Warhol with his paintings of tins of Campbell's Soups and other curiosities, though in my view they are all on the same stupid bandwagon as Carl Andre and his load of firebricks.

(Cambridge Evening News) 18 Feb 76

We do not know much about art, perhaps, but we know what we do not like. We do not like £30 piles of bricks which cost £4,000 or even £2,000, or even £60, taking into account labour, postage and packing across the Atlantic.

(Banstead Advertiser) 19 Feb 76

One final thought:
if there is any
money available to
buy more bricks,
let's turn them
into homes.

Rees, Director Jeremy (Arnolfini Gallery)
(Western Daily Press) 19 Feb 76

"Where the thing does become invalidated is when someone just builds a pile of bricks and says, 'Well, how about that for comparison'."

Waterhouse, Keith (Daily Mirror) 19 Feb 76

Bricks are not works of art. Bricks are bricks. You can build walls with them or chuck them through jewellers' windows, but you cannot stack them two deep and call it sculpture.

Waterhouse, Keith (Daily Mirror) 19 Feb 76

In this cul-de-sac I would place all the piles of bricks, twisted girders, heaps of sand and sheets of blank cardboard to which the avant-garde has been reduced. In the centre there would be a large placard, signed by the Director. It would read: "WE WERE ALL CONNED." (And it would be regarded, by suckers, as a work of art.)

(Shropshire Star) 20 Feb 76

When the Tate Gallery gets a £500,000 government handout every year and when cultural fanatics are prepared to spend no end of time encouraging the masses to enjoy and appreciate art, how could the gallery expect anything but a mass stare of disbelief as they displayed a pile of bricks and called it low sculpture.

Merry, Elspeth 20 Feb 76
(Northern Echo)

It isn't as though the pile in question is interesting — that it was made uneven in some way. Oh, no. The artist, a Mr. Carl Andre, has gone to great lengths to ensure that his masterpiece is perfectly symmetrical; a very rectangular oblong, in fact — made up of very rectangular firebricks.

(Oldham Evening Chronicle) 20 Feb 76

Following the pile of bricks at the Tate Gallery, a fellow at Hull has just had his creation accepted — about 20 logs, sawn in a local timber yard, and laid out in a straight line.

Mullaly, Terence 21 Feb 76
(Daily Telegraph)

Bricks become a work
of art at the point
at which they satisfy
an emotional or
intellectual end.

Mullaly, Terence (Daily Telegraph) 21 Feb 76

I would like to suggest an alternative to the purchase of objects of this sort. Surely the Tate and similar institutions would do well to set aside a room in which photographs of such objects are displayed. In this way they would fulfil their obligation of recording all trends, without using the taxpayers' money to confer on trivia the status of art.

(The Economist) 21 Feb 76

Capital expenditure on the arts
is to take a
dramatic plunge from
£12.7m in the current year
to £4m in year five
(National Theatre finished).

Lindsay, Sculptress Ann 28 Feb 76
(South London Press)

Ann, who spent four years at South Lambeth Institute, potting and sculpting, before quitting her job in market research, said, "I was very angry when I read about that artist's bricks."

Carl ANDRE 'The Bricks Abstract: A Compilation by Carl Andre' (October 1976)

Andre I think the Art Workers Coalition has been the most significant art movement in New York in the last two years. It's the first time that artists have gotten together in my experience without any art problems. Art simply is not discussed at these meetings. The trouble is, artists I've been involved with before have always had a more or less tacit assumption that we approved of each other's art, but the Art Workers Coalition has nothing to do with what your art is like, but it has a great deal to do with keeping the springs and origins of art, which I think are essentially the same for everybody, open and as fertile and as productive as possible. And this is done by artists being able to get together, talk about the common social, economic and political problems and having the right to get up and speak your mind because you consider yourself an artist. Actually an artworker, I should say, because, as you know, I like the term artworker, not because it's any kind of camp Marxism, but it includes everybody who has a contribution to make in the art world. A collector can consider himself an artworker, in fact, anybody connected with art would be considered an artworker if he makes a productive contribution to art. I make artworks by doing artwork but I think the work itself is never truly completed until somebody comes along and does artwork himself with that artwork. In other words, the perceptive viewer or museum-goer who's got some kind of stimulus from the work is also doing artwork, so that broadens the term out to a ridiculous extent; but I think it should be as broad as possible because I never liked the idea of an art political, economic, social organization which is limited to artists, because that's just returning to another kind of elitism.

Siegel What issues or demands made by the Coalition have especially concerned you?

Andre This immediate thing that concerns the museum has to do with what we've come to call the 'dictatorship of the bourgeoisie', which in a sense must end. The museums of the country are run by boards of trustees which are self-perpetuating, and they're there strictly because they're wealthy, and I mean that is a dictatorship by a very small minority of the country over the rest of the country, and this is anti-democratic (of course, it reflects exactly the kind of corporate structure of the country). The Museum of Modern Art states very firmly that they will never have an artist on the board of trustees unless an artist was immensely wealthy. Mr Hightower[2] has said, quite generously, that he considers everyone an artist, so that he has a board of directors of artists, essentially. That's a lot of hokum, of course, because not everyone is a banker just because they have money in their pockets.

It also has to be quite clear that I think the economic and political interests of artists are very much in contradiction to those of Nelson Rockefeller.[3] So it's very bad having his man, Hightower, trying to represent artists, because we have different class interests. One of the reasons, I suppose, that I like to be in Art Workers Coalition is because I consciously do not identify with an owning bourgeois class. I much more identify with a producing, literally working class. I remember when I worked on the railroad, it amused me because on the switching locomotives we used to work with there'd be a plate riveted on to the side of the engine saying, 'This engine is

the property of the Chase Manhattan Bank' or 'The Manufacturers Trust Co.', which was socially absolutely untrue. That locomotive belonged to the people who used it while they were working, and when nobody was using it, nobody owned it, literally.

And what I've seen of the people who buy art is that I'd rather not spend a great deal of time with them. There was a woman who evidently had bought the meteor crater of Arizona and wanted me to do some great scheme defacing it, and I refused to do it because I once wrote a twenty-five word novel and the twenty-five words went: 'Manuel corrupted money. He bought the Leaning Tower of Pisa and straightened it.' So somebody buys the meteor crater of Arizona and puts an amusement park in it. That's what we're in the grip of in the world today.

Siegel But you have no objection to your sculpture being purchased by these same people?

Andre I've never minded people buying works at all. My social position really, in the classic Marxist analysis, is, I'm an artisan. That is, a worker who employs himself essentially as his own tool to produce goods that he exchanges for other people's goods. This is different from a worker who is employed by somebody else. So technically, the artist's position in our society is that of an artisan and so to exchange my goods that I produce for other people for their goods is my economic function. So this business about the art object being corrupt or uncorrupt is just simply not an issue.

Siegel And your personal relationships with museums and galleries have been good, haven't they?

Andre I am represented by a gallery and I've had a good relationship to galleries, the Tibor De Nagy Gallery which I was with formerly and the Dwan Gallery which I am with now. I have never received any aesthetic, political, economic pressure at all. I have not had much to do with museums in America, but what I've had to do with as an artist has not been unsatisfactory. So I could not say that I would be opposed to museums or galleries as such, but I think we need much greater resources to be used. An artist should not be required to go to a gallery to be able to sustain himself as an artist. There should be, for instance, a social welfare system to which they can turn. I would like to see a system for medical and dental and pension insurance for artists and also an artists' registry and perhaps even a royalties bureau to collect royalties on reproductions of artworks, or uses of essential art motifs which now is an enormous area of potential income for artists. I think the motifs of artists are used or stolen outright by commercial artists, and without paying any royalties to us whatsoever, and I think royalties should be paid for work, where it can be shown to be a plain derivation from a 'fine artist's' work.

Museums should be far more open to artists than they are now. There is not in New York, for instance, a Kunsthalle, a kind of museum which is very common in Europe and every town in Germany has one, which is a museum with no permanent collection and where a show of art may be up for two weeks and another will replace it quickly, so that in the course of the year you can have hundreds of artists showing their work without the pre-conditioning thought that they all must have this, what I

consider fascist, lie of quality. I've always found this is utterly distasteful to me because museums and galleries to my mind are not full of splendid art. Most of the art that I see of every period that's in the museums and galleries is of no interest to me whatsoever. I'm not trying to say that the art that I'm interested in has quality. I'm just saying that only a small number of artworks move me deeply. But that's not quality, that's a statement about myself. It reflects my own experience in the world. So the idea that galleries and museums show art because of the quality of the art is not true. Once a work has been shown in a gallery or museum, it has a quality that was conveyed to the work by the splendour of the museum, or the prestige of the gallery. What the museum is really interested in is not quality but commodity — Ma Bell's princess telephone and Carl Andre's sculpture are now in the permanent collection of The Museum of Modern Art because they have reached the level of a commodity.

Siegel Why did you and other members of the New York Art Strike[4] decide to sit-in and close the Metropolitan Museum of Art? Wasn't that a self-defeating act?

Andre Well, it is the pretence of the museum that they are an apolitical organization. And yet the people who run them, the people who are responsible for their operation and decide their policies, the boards of trustees, are exactly the same people who devised the American foreign policy over the last twenty-five years — man for man they are the same. Actually, I think the boards of trustees of these museums favour the [Vietnam] war, they devised the war in the first place and wish to see the war continued, indefinitely. The war in Vietnam is not a war for resources, it is a demonstration to the people of the world that they had better not wish to change things radically because if they do the US will send an occupying punishing force. It is a war of punitive oppression. And they wish to run these quiet, apolitical institutions like museums and universities suppressing politics among artists, among students, among professors. They don't wish people to have broader and more general considerations. They'd rather have artists who do nothing but art, musicians who do nothing but music and athletes who do nothing but their sport.

What's coming now, I think, in the world in every respect you might say, is the crisis of freedom. If freedom has to be at the expense of other people's lives, it isn't worth having at all. In China the artist is not free to do as he likes but the Chinese aren't the people who are killing people in Vietnam to maintain that oppression — we are killing people ostensibly to maintain the rationale of artistic freedom.

Siegel Didn't Mr Hightower suggest to the artists that if The Museum of Modern Art was to politicize itself, the artists should politicize their art?

Andre The artists made it clear to Mr Hightower that they were not politicizing the art but themselves. One suggestion was that artists serve as docents and give tours in the museum to talk about the works of the museum collection — what the artists were most deeply moved by and most influenced them and at the same time they could explain the connection between politics and their art and between the art of the artist and their view of the world and their objections to the war in Vietnam, sexism and racism.

(The art world itself is one of the most thoroughly segregated communities in New York. Unconscious racism even exists within the Art Workers Coalition. For a long time there have been requests that we meet up in Harlem, for instance, and people won't go. They would rather leave the Art Workers Coalition than go up on a Sunday afternoon.) I have felt for a long time that museums should use artists this way. I wouldn't put the artist in front of the works of art to explain them but to explain his position in the society. What I'm thinking of is not so much integrating the artwork itself into the sensibility of the people, but integrating artists in the sociology, which is a much more important problem.

Siegel What do you think is the relationship between the artist's position in society and the work of art?

Andre I've proposed a model which describes the making of any artwork, not accurately but metaphorically, and I call this the three-vector model, the vector merely being a geometrical representation of a line of force having length and slope. The first vector would be the subjective vector which represents one's personal history, one's talents, one's skills, the accidents of one's life – genetic and environmental influences – the whole thing that composes the individual human being. The second vector I would call the objective vector, that is the properties and qualities of the materials of the world. The third is the economic vector which is a kind of intermediary or compromise between the subjective and the objective. It's the availability of the materials of the world at one time to do a work. Now, if these vectors have three points of intersection, there's a contained triangle in the centre – there I would say was where the work of art came about.

It's been my experience that the vector that seems most vexing is the economic one. Between 1959 and 1964, I could never get together the $250 necessary to make the works which would have made a complete gallery show, and I asked dealers and people for the money and they couldn't put the money together either. So at the time I despaired. But now I am in a position where I can command quite generous resources. But the point is that I've also come to the realization that commanding resources shouldn't be what makes possible the work of art. You must be able to make a work of art even if you have no money. But now I cannot say to a person who has no money, you don't need money to do work. That would be sinful. I mean, that's like a rich man saying to a poor man, 'Don't you see, you don't need money to be happy'. The only thing I can do is to confront the problem myself and say, 'Look, make work with a zero-zero vector, that is, make work as if you were poor'. The recent small wire pieces, nail, rusting steel pieces that were picked up in the streets have to do with trying to make a zero-zero economic vector. And I think it's good to have an aspect of one's art that is not so super-precious – kind of ephemeral works. I don't intend them to be ephemeral, but I think it's good to always make works which are not so precious they can just almost literally blow away.

Siegel Do you feel that your political attitudes are reflected in your sculpture?

Andre I have been subject to politics as long as I've been alive, thirty-five years, starting with the New Deal, going into the Second World War, the Cold War, Korea, the whole thing. So I've often been affected by it and hence, since I've made my art, my art must reflect my political experience. I could not possibly separate them, I mean, art for art's sake is ridiculous. Art is for the sake of one's needs and I don't think one has a distinct art need, rather art is an intersection of many human needs. My art will reflect not necessarily conscious politics but the unanalysed politics of my life. Matter as matter other than matter as symbol is a conscious political position, I think, essentially Marxist [...]

1 The Art Workers Coalition, an amorphous, fluctuating group with a steady membership of about 100, came into being when Takis made his gesture of removing his *Telesculpture* from the 'Machine Show' at The Museum of Modern Art, New York, on 3 January 1969. Although it belonged to the Museum, he had forbidden them to use it because he thought the work was no longer representative, and to include it in the show would misrepresent his contribution to machine art. About a dozen artists, critics and writers joined him.

2 John Hightower, formerly Executive Director of the New York Council on the Arts, who on 1 May 1970, replaced Bates Lowry as Director of The Museum of Modern Art, has been conducting negotiations with the Art Workers Coalition and the New York Art Strike.

3 Nelson Rockefeller is a trustee of The Museum of Modern Art.

4 The New York Art Strike constitutes a larger group, made up of former Art Workers Coalition, museum and gallery people who don't want to be identified with AWC, more militant groups such as the Guerrilla Art Action and Art Workers United. It was originally formed as a result of a suggestion by the faculty of the School of Visual Arts to strike on May 22 1970, to protest against war, racism and repression. About 500 artists, students, teachers, dealers and critics sat in on the steps of the Metropolitan Museum of Art for ten hours.

5 Barbara Rose, 'Problems of Criticism V: The Politics of Art, Part II', *Artforum* (January 1969) 45.

Jeanne Siegel, 'Interview with Carl Andre: Artworker', *Studio International* (November 1970) 175-79; reprinted in *Artwords: Discourse on the 60s and 70s* (New York: Da Capo Press, 1992).

Rosalind KRAUSS
Sense and Sensibility:
Reflection on Post '60s
Sculpture [1973]

'Memories.
Every scenario and every *mise-en-scène* have always been constructed by or on memories. One must change that – start from affection and new sounds.'
– Jean-Luc Godard

I am thinking of the terms 'post-Minimalism' and 'dematerialization' – of how they have become entrenched within the lexicon of contemporary criticism. I am thinking of the extreme disjunction between the strategic value of those terms and their capacity to signify. For, while I understand the politics of their usage, their meaning eludes me in so far as it attaches itself to the art they label.

Operationally, post-Minimalism acts to drive a historical wedge between the Minimalist art of Donald Judd, Robert Morris, Dan Flavin, Frank Stella and Carl Andre, and the work of a younger generation which began to achieve prominence by the end of the 1960s.' Post-Minimalism, by insisting upon the temporal divide between these two generations of artists, signals that it is acting as a conceptual marker as well: asserting a separation of meaning between the two groups, a separation in which the gears of sensibility mesh with the supposed shift in historical time. 'Dematerialization' functions similarly as a chronological counter, by scripting as a new act in the historical drama the flight of certain work from the material, concrete arena of the object. The assumption behind the use of both these terms seems to be that the demarcations of historical time carry within themselves the profile of *meaning* – that in themselves they are adequate to characterize or define the deep import of works of art. The same assumption operates when, in answer to a question like, 'What does this painting by Stella mean?' the reply comes, 'It's about his relationship to Johns and Newman'. The question asked was about meaning; the answer that is inevitably given is about historical context. The assumption is that they are synonymous. But they are not.

The special irony of that ingrained use of history as meaning is that it is applied to a tradition which prides itself on an originating act of historical demolition. For sooner or later every account of Modern art feels compelled to turn to Manet and tell of his attack on history painting. With a certain relish those tales relive that moment of subversion, when the very models of academic value – history, classicism – were turned upside-down to become the empty vessels into which could be poured the perceptions of a modern consciousness. Using a strategy of historical reference, the *Olympia* and the *Déjeuner* were erected on Old Master groundplans, structures completely given over to the forms and meanings of the present. And the force of this construction was its power to topple history as the foundation itself of value.

It is a recounting of singular emptiness. For it points to a moment when history was revoked, as the prologue of a story in which history lives on with a particular tenacity. If history *has* been rejected as a source of value, it has certainly been retained within the annals of Modern art as a source of meaning, and therefore of explanation. Each art act in its turn is accounted for in so far as it deepens the logic of a particular formal convention, or as it supplants one convention with another, or as it attempts to transgress the notion of convention altogether. No matter what the stance of a given art towards the acts that preceded it, the description of its meaning is generally entrenched within the hermetic logic of paternity – of the sets of aesthetic lineage that make up the history of Modern art. Meaning in the present becomes a coefficient

of the past; explanation is circumscribed by the profile of a historicist model.

By continuing to operate within this model, the terms post-Minimalism and dematerialization are constructions that trap meaning itself within an infinite regress of negation. Neither label really conceives in positive terms the content of the works they characterize. Neither really describes the particular modality of consciousness, or of reality, which is generated by the works they designate. Yet the interesting thing is that cognizance of that modality begins to tear apart the neatness of the historical packaging. For, if one considers the paradigm of meaning out of which the art that is called post-Minimal operates, one discovers the deep level at which it is antithetical to the content of a dematerialized form of Conceptualism. And further, one begins to see the absolute continuities of meaning that connect post-Minimalism to Minimal art.[2]

From the outside, of course, a claim for the continuity between Minimalism and post-Minimalism will seem rather obvious. For to the uninitiated observer the strategies of the one have an obdurate similarity to the strategies of the other. Which is to say that from the outside, Mel Bochner's use of the series of cardinal numbers in order to achieve extension, or Richard Serra's method of building a form by splashing lead into a corner, pulling the hardened remains away, splashing again, pulling away again ... might not appear all that different from Judd's construction of a row of boxes, or Andre's placement of bricks in a line, or for that matter Stella's repetition of stripes across a canvas surface. They all partake of a similar kind of relentlessness; just as they all share in vouching for the utter seriousness of this putting, to use Judd's words, 'one thing after another'. Given this sameness of tone in the mode of construction, it may look from the outside like something of a fine point to say that Stella's stripes are on a canvas support while Bochner or Dorothea Rockburne mark directly on the wall, and it may seem like an oversubtle distinction that Judd's and Morris' and Andre's constructions involve rational geometric forms while Serra's are generated through the process of making. The naive observer, feeling this continuity, may not quite see why one group is set off from the other by this prefix 'post' on the historical label. And the naive observer has common sense on his side. He is pointing to something that in fact exists – only what he points to is a procedural similarity, rather than to the more crucial one which is also present: a shared notion about the prerequisites for a model of meaning.

It is only a kind of criticism addicted to the pendular logic of a history of alternations that turns away from the objections of the naive observer. Insisting upon the importance of the fact that numbers of pencil-marks on the wall involve a rejection of the concrete object, that criticism finds itself embracing the notion of dematerialization as the operative tool of distinction. And then it is faced with the problem that the cutting edge, rather than appearing too fine, seems too blunt. Because dematerialization is a category incapable of distinguishing the work of, say, Sol LeWitt, Mel Bochner, Dorothea Rockburne and Richard Tuttle from other types of objectless art – Bob Barry's for example, or Joseph Kosuth's or Douglas Huebler's. It therefore encourages one to overlook the way in which the meaning of the work in the first group is deeply opposed to the kind of content – to the models of how meaning itself is formulated – proposed by the work in the second. For the type of Conceptualism evinced by the art of the second group grows from the seeds of a deeply planted traditionalism with respect to meaning.

In connection with the exhibition 'Prospect '69', Robert Barry was interviewed. 'What is your piece for Prospect '69?' he was asked. 'The piece', he replied, 'consists of the ideas that people will have from reading this interview ... The piece in its entirety is unknowable because it exists in the minds of so many people. Each person can really know that part which is in his own mind.'

Barry's answer stands as a verbal equivalent to the *Inert Gas Series* which he did in the same year. The photographs of sites over which released amounts of invisible gas are presumably expanding, demand the same kind of residence within the minds of each of their separate viewers. For the work must be completed by the addition of a mental image of the (invisible) gas to the concrete image of the landscape. Since each of these mental images is private, 'each person can *really know that part which is in his own mind*'.

This notion of privacy, and of meaning tied to the private confines of a mental space, permeates Huebler's thinking as well. Deepening Barry's view of the separateness of experience, Huebler proceeds to deny to time and space their status as the grounds of a transpersonal reality. 'I think', Huebler declares, 'it's perfectly fair to say that time is what each of us says it is at any given moment'. Or take, for another example, On Kawara's 'I got up' postcards and 'I am alive' telegrams, about which Lucy R. Lippard writes:
'*The fascination exerted by Kawara's obsessive and precise notations of his place in the world (time and location) imply a kind of self-reassurance that the artist does in fact exist. At the same time, they are totally without pathos, their objectivity establishing the self-imposed isolation which marks his way of life as well as his art.*'

'Objectivity' is a strange predicate to attach to the utter subjectivism of the notion that we can only know someone is alive (or awake) because he tells us so. Joining conceptual hands with Barry and Huebler, Kawara places art within the confines of what Logical Positivism has called the protocol language – the language of sense-impression, mental images and private sensations. It is a language implying that no outside verification is possible of the meanings of words we use to point to our private experience – that meaning itself is hostage to that separate video of impressions registered across the screen of each individual's monitor. In the terms of the protocol language, my 'green' and my 'headache' point to what I see and feel, just as your 'green' and your 'headache' point to something you possess. The separateness of our 'greens' arises from the separateness of our retinas, and thus neither of us has any way of verifying the separate data to which our words point. In the grip of this argument we may feel that we therefore have no way of verifying the meaning of those words – and that 'time' or 'green' do indeed mean 'what each of us says it is at any given moment'.

Because it is over the notion of privacy or private languages that the division between these artists and Minimal/post-Minimal art arises, it is important to explore the various forms private language takes (and has taken), just as it is important to understand the implications of those forms. One of the forms involves the notion of intention.

If sense-impressions are thought of as necessarily private, intention must be thought of that way also. Thus, it is no surprise that artists who immerse themselves in questions of the protocol language are particularly concerned with intention. One thinks of Kosuth in this connection, of his saying that:
'*Works of art are analytic propositions. That is, if viewed within their context – as art – they provide no information whatsoever about any matter of fact. A work of art is a tautology in that it is a presentation of the artist's intention, that is, he is saying that that particular work of art is art, which means, is a definition of art. Thus, that it is art is true a priori.*'

The construction of the work of art purely around the notion of intention points directly inward: to the privacy of a mental space. 'This is a portrait of Iris Clert', Rauschenberg telegraphed, 'if I say it is'. And this idea of the art act as circumscribed and defined by intention generally claims its paternity in a particular reading of Duchamp – of *The Fountain* for example, the urinal he placed on a pedestal and signed 'R. Mutt/1917'. This reading, addressing itself to the question of intention, goes roughly like this.

The finished work of art is the result of a process of forming or making or creating. It is in a sense the proof that such a process has gone, just as the footprint in soft ground is proof that someone has passed by. The work of art is thus the index of an act of creation which has at its roots the intention to make the work. Intention here is understood as some kind of prior mental event which we cannot see but for which the work now serves as testimony that it occurred. It is a common enough reading of the readymades that they represent or hypostatize pure intention: that since the objects in question were not fabricated by the artist but merely chosen by him, the arthood of the object is seen as residing solely in its capacity to register that decision, to render it up as it were into the physical world. Through this reading, *The Fountain* operates as an *expression* of Duchamp's intention to make a work.

It seems very logical to say 'Art is an expression of something', and if asked, 'An expression of what?' to answer, 'An expression of the artist, of what he had in mind – or an expression of the way *he* saw something'. In the case of Abstract Expressionism this answer seemed particularly compelling; and it largely constituted the initial interpretations of Pollock's painting as well as de Kooning's, although it was subsequently withdrawn from formulations about Pollock's art. The early views of their work proceeded from the very logic of 'expression', seeing every mark on their canvases as asking to be read in the context of a private self from which the intention to make

that mark has been directed. In that sense, the public surface of the work seemed to demand that one see it as a map from which the intention to make that mark has been directed. In that sense, the public surface of the work seemed to demand that one see it as a map from which could be read the privately held crosscurrents of personality – of the artist's inviolable Self.

And this is where that sense of traditionalism which I imputed to certain forms of Conceptual art begins to appear. For a connection might begin to be made at this point between the way in which intention/expression functions as a model in time for the same kind of things for which illusionism in painting serves as a spatial model.

We can think of various kinds of illusionistic spaces: the orthogonal grid of classical perspective; the more nebulous continuum of atmospheric landscape; the undesignated, infinite depth of geometric abstraction. And in each of these pictures of the world, space itself operates as a precondition for the visibility of the pictorial events – the figures, the depicted objects – which appear within it. We consider that the ground (or background) in a painting exists somehow before the figures, and even after the figures are placed on the ground, we understand that the ground 'continues' behind them, serving as their support. In illusionistic painting, 'space' functions as a category which exists prior to the knowledge of things within it. It is in that sense a model of a consciousness which is the ground against which objects are constituted. On its most abstract level, traditional picture making is an argument about the nature of appearance – suggesting that its very possibility depends on a consciousness that is the ground for all relatedness, for all differentiation, for the constitution of perceptual wholes – and that that consciousness operates within the priorness of a mental space. The ground of Western illusionism is an entrenched Cartesianism.

Thus, just as intention can be understood as a necessarily private, internal mental event, which externalizes itself through the selection of objects, the objects which appear within pictorial space can be seen as issuing from an internalized, prearranged set of coordinates. As one moved within the history of painting to post-war American art – that is, to Abstract Expressionism – these two aspects of priorness fuse and become more nakedly the subject of the pictures themselves.

And clearly, the *meaning* of an attempt to undermine illusionism cannot be dissociated from the baggage that Western picture making carried along with it. It is a rejection that inherently implies the disavowal of the notion of a constitutional consciousness and the protocol language of a private Self. It is a rejection of a space that exists prior to experience, passively waiting to be filled; and of a psychological model in which a self exists replete with its meanings, prior to contact with its world. So if we wish to speak of the anti-illusionism of the art of the 1960s, we cannot limit our discourse to an ideology of form.

It is common enough to say of Stella's painting that it is structured deductively – that all internal differentiations of its surfaces derive from the literal aspects of the canvas edge.[3] Thus in the early *Black Paintings*, like *Die Fahne Hoch!*, we point to the way Stella begins with the midpoints of the vertical and horizontal sides and forces the stripes into a repetitive, unbroken declaration of the expanse of the painting's four quadrants in a double set of mirror reversals. Or in the later *Aluminum Paintings* where the canvases begin to be shaped, we note that the stripes perform a more self-evident reverberation inward from the shape of the support, and thereby seem even more nakedly dependent upon the literal features of that support. It seems easy enough to say this, and further to add that the effect of this surface, flashed continuously with the sign of its edge, has purged itself of illusionistic space, has achieved flatness. And that flatness, we think, is the flatness of an object – of a nonlinguistic thing. Yet we would be wrong, in the way that half-truths are wrong; for we would not have said enough.

The signs that haunt Stella's early stripe paintings are more than signifiers of their literal shapes. *Die Fahne Hoch!* is deductively structured, so is *Luis Miguel Dominguin*. But both paintings arrive at a particular configuration, which is the configuration of a cross. We could call this accidental, of course. Just as we could conceive it as accidental that the cross itself relates to that most primitive sign of an object in space: the vertical of the figure projected against the horizon line of a nascent ground. But the three-way relationship that fuses along the striped surface of these pictures is a kind of argument for the logical connection between the cruciform of all pictoriality, of all intention to locate a thing within its world, and the way in which the conventional sign – in this case the cross – arises naturally from a referent in the world. In canvas after canvas one finds oneself in the presence of a particular emblem, drawn from the common repertory of signs – stars, crosses, ring-interlocks, etc. – part of a language that belongs, so to speak, to the world, rather than to the private, originating capacity of Stella to invent shapes. But what Stella convinces us of is an account of the initial genesis of those signs. Because in these paintings we see how they are given birth through a series of natural and logical operations.

The logic of the deductive structure is therefore shown to be inseparable from the logic of the sign. Both seem to sponsor one another and in so doing to ask one to grasp the natural history of pictorial language as such. The real achievement of these paintings is to have fully immersed themselves in meaning, but to have made meaning itself a function of surface – *of the external, the public or a space that is in no way a signifier of the a priori, or of the privacy of intention*.

The *meaning* of Stella's expurgation of illusionism is unintelligible apart from a will to lodge all meanings within the (semiological) conventions of a public space. And to expose illusionistic space as a model of privacy – of the Self conceived as constituted prior to its contact with the space of the world.[4]

That conception of the Self had by the late 1950s already become an aspect of the literary experience of Beckett and of the *nouveau roman*. And it had emerged as the particularly urgent claim of the late philosophy of Wittgenstein, in which the language game was a therapy aimed at severing the connection (the logical connection) between meaning and mind. In the *Blue Book*, for example, Wittgenstein asks what it means to make the claim that we know a tune: does it mean that before we sing it we have quickly whistled it to ourselves silently; or that we have a picture of the score in our heads – a mental image of the tune – from which we read off the notes as we sing them? Is claiming to know the tune dependent upon having it stored up someplace inside us, like beads already positioned on a string and ready to be pulled out of our mouths? Or is it simply singing the tune, or perhaps hearing many tunes and saying, 'that one just there is the right tune'. The tune, and the question of just where it is stored when we claim to know it, widens out in *The Philosophical Investigations* to memory images and to the bases for all claims to know. Again and again Wittgenstein tried to sever the certainty of these claims from a picture of a mental space in which definitions and rules are stored, awaiting application. His work became an attempt to confound our picture of the necessity that there be a private mental space (a space available only to the single self) in which meanings and intentions have to exist *before* they could issue into the space of the world.[5] The model of meaning that Wittgenstein implores us to accept is a model severed from the legitimizing claims of a private self.

The significance of the art which emerged in this country in the early 1960s is that it staked everything on the truth of that model. Therefore, if we read the work of Stella or Morris, or Judd or Andre, merely as part of a text of formal reordering, we miss the meaning that is most central to that work. Further, we may miss or misconceive the way in which that very notion of meaning persists in certain art of the present.

Bochner's work, for example, has been a consistent attempt to map the linguistic fact on to the perceptual one – not to show the insubstantiality of the one as opposed to the materiality of the other, but to demonstrate the necessity in experience of their mutual fruition. In *Measurements, Group B, 1967*, the walls of the room are printed with the notation of their dimensions, so that the space appears against the image of its own blueprint. But one has no sense of the priorness of the one to the other, of either serving as ground to the other as figure. Illusionism is erased in the experience of the extended object (the wall) as the basis for the very notion of arithmetic extension, and of an abstract geometry being indistinct from those oblique directions through which dimension projects itself into the world.

In *Axiom of Indifference*, a group of linguistic propositions are set up in relation to a group of physical facts, each corroborating the other. A wall running down the centre of the work splits the eight integers of the work into two groups of four, and makes the total configuration of physical shape and verbal proposition invisible from either side. Wholeness of shape, as well as wholeness of the propositional entity becomes a matter of reconstruction, which is to say memory. And memory is shown to be a function of language, as language is a coefficient of that which is completely external – a presence that is forever possible. 'Immediate experience', Bochner has written, 'will not cohere as an independent

domain. Memories tend to be remains, not of past sensations, but past verbalizations.' Further, *Axiom of Indifference*, like *7 Properties of Between*, functions as a composite entity in which verbal proposition and physical fact appear within a single act of perception. Verification is therefore immediate, and the work acts as a kind of model for the public assignment of truth-value to a given statement. But aesthetically these works lodge themselves within a broader aspect of the notion of a model, for what is central to them is their insistence upon the externality, the publicness of the space in which verification and meaning reside. They are, one would say, visualizations of a linguistic space that is fully non-psychological – the attempt to picture a world unmediated by the idea of a protocol language, a kind of necessary purging of the fantasy of privacy from his art.

With Rockburne's work, particularly the series *Drawing Which Makes Itself*, one finds this notion of publicness carried critically into the realm of process. For in so far as process art can be understood as the generation of a work from a set of rules or procedures instituted prior to the implementation of the work, process is not logically distinct from the arbitrariness of the private language. Part of the effort of *Drawing Which Makes Itself* is to generate the work from qualities inherent in the materials used: the dimensions of the edges of the paper and its diagonal folds; the double-sidedness natural to paper that makes flipping or reversing it possible, etc. And the effect of this insistence is that one feels the creation of a logical distinction between the grammar of this work and the intention-laden grammar of process.

What I am claiming, then, as continuous over the last decade is the need of certain artists to explore the externality of language and therefore of meaning. During the same time period, this need has a parallel project in the work of other sculptors: the discovery of the body as a complete externalization of the Self.

That aspect of the self comes to light in what is termed the paradox of the alter ego – the way in which the picture of the Self as a contained whole (transparent only to itself and the truths which it is capable of constituting), crumbles before the act of connecting with other selves – with other minds. Merleau-Ponty describes this paradox as the separation of two perspectives, as the fact that for each of us – he and I – there are two perspectives: I for myself and he for himself; and each of us for the other. '*Of course these two perspectives, in each one of us, cannot be simply juxtaposed, for in that case it is not I that the other would see, nor he that I should see. I must be the exterior that I present to others and the body of the other must be the other himself.*'[16] The revelation of this leads away from any notion of consciousness as unified within itself. For the Self is understood as completed only after it has surfaced into the world – and the very existence and meaning of the 'I' is thus dependent upon its manifestation to the 'other'.[7]

Part of the meaning of much of Minimal sculpture issues from the way in which it becomes a metaphorical statement of the Self understood only in experience. Morris' three *L-Beams* from 1965, for example, serve as a certain kind of cognate for this naked dependence of

intention and meaning upon the body as it surfaces into the world in every external particular of its movements and gestures. For no matter how clearly we understand that the three Ls are identical, it is impossible to really perceive them – the one upended, the second lying on its side and the third poised on its two ends – as the same. The *experienced* shape of the individual sections depends, obviously, upon the orientation of the Ls to the space they share with our bodies – thus, the size of the Ls shifts according to the object's specific relation to the ground, both in terms of the overall scale and in terms of an internal comparison between the two arms of a given L.

The *L-Beams* have been described as suggesting: '*A child's manipulation of forms, as though they were huge building blocks. The urge to alter, to see many possibilities inherent in a single shape, is typical of a child's syncretistic vision, whereby learning of one specific form can be transferred to any variations of that form.*'[18] But that account seems exactly to violate one's actual experience of the work, to superimpose a mental construct of 'sameness' on a world of unlikes. In a sense, it is to fall for what Morris refers to as 'the known constant' – that ideal Cartesian unity – which the piece holds out as a kind of nostalgic remnant of past forms of explanation. It is to ignore the way this 'constant' recedes into the ground of the sculpture as a kind of fiction, crowded out by the emergence of absolute difference within the particularity of the actual space. Situating themselves within the space of experience, the space in which one's own body appears, if it is to appear at all, the *L-Beams* suspend the axiomatic coordinates of an ideal space. We explain space in terms of these coordinates when we think of it as an absolute grid which seems, however, to converge in depth because we are badly placed to see it. We imagine clarity to come from thinking ourselves suspended above it in order to defray the distortions of our perspective, in order to recapture the absoluteness of its total parallelism. But the *meaning* of depth is nowhere to be found in the diagrammatic assumptions of this suspension.[9]

The project of Morris' sculpture has consistently been to defeat the diagrammatic. In the sectional fibreglass pieces of 1967–68, for example, the specific configuration of the work is not allowed to become a figure seen against the 'ground' of the object's 'real' structure. The notion of a fixed, internal armature that could mirror the viewer's own self, fully formed prior to experience, that founders on the capacity of those separable parts to shift or to have shifted, to formulate a notion of the self which exists only at that moment of externality within *that* experience.[10]

Morris has persistently written about the conceptual context of his own work and that of fellow artists. In one of the earliest of these essays, 'Notes on Sculpture', Morris speaks of his preoccupation with strong three-dimensional Gestalts. 'Characteristic of a Gestalt', he wrote, 'is that once it is established, all the information about it, *qua* Gestalt, is exhausted. (One does not, for example, seek the Gestalt of a Gestalt.)' The body of criticism that has grown up around Minimal art over the past five or six years has, strangely enough, understood the meaning of that statement, and indeed the meaning of the Gestalt itself, to be about a latent kind of Cartesianism.

The Gestalt seems to be interpreted as an immutable, ideal unit that persists beyond the particularities of experience, becoming through its very persistence the *ground* for all experience. Yet this is to ignore the most rudimentary notions of Gestalt theory, in which the properties of the 'good Gestalt' are demonstrated to be entirely context-dependent. The meaning of a trapezoid, for example, and therefore its Gestalt formations, changes depending upon whether it must be seen as a two-dimensional figure or as a square oriented in depth – a meaning that can in no way precede experience. Morris himself pointed to this when he said, 'It is those aspects of apprehension that are not coexistent with the visual field but rather the result of the experience of the visual field'.

With different forms and varying strategies, Judd's and Andre's and Flavin's works are similarly involved in discrediting the persistence of Cartesianism and in positing meaning itself as a function of external space.

That sense of coalescing in experience and of a realization of the Self as it achieves externality is evident in the *Prop Pieces* that Serra began to make in 1969. By means of a metaphor of striking abstractness, these works suggested a continual coming into coherence of the body, in the guise of a form that was constantly seen *in the act* of cohering. The special precariousness of their parts was not *about* imminent collapse or dissolution. Rather, it was directed at evoking the tension between a conceptual unity of certain simple shapes and the actual conditions of their physical union. The *One Ton Prop* (*House of Cards*), for example, is a cube (therefore an 'ideal' shape) perceived as perpetually dependent upon these conditions. As well, *House of Cards* deals specifically with internal space as something constantly available to external vision, and as something entirely defined by the perpetual act of balance by which its exterior is constituted. Thus, interiority (the 'I for myself') is clearly made a function of exteriority (the 'I for others').

In assigning to this work and to the rest of the *Prop Pieces* the problematic of the double-perspective, I am obviously not speaking of any specific text for which the works serve as some kind of sign. Rather, I hope to locate a certain ground from which to grasp the meaning of Serra's need to achieve verticality without permanently adhering separate parts of sculpture. And this meaning, reaching beyond the domain of the purely formal, connects to the sensibility I have been trying to define within this essay – a sensibility which bridges the boundaries of historical labels.

In the past several years Serra's works have tended to adopt a special form of drawing to define the modality of one's experience of them. In this using of material ever more in terms of line, linear vectors and types of boundaries, Serra shares in the way that recent abstract art in general has posited the importance of line, or of drawing *per se*. This was true of Robert Smithson's and Michael Heizer's art which related to the landscape as a linear unfolding, and in a different way it is clearly true of Bochner and Rockburne.

One explanation for the interest in line – which is at this point quite widespread – might be the inherent closeness between line and language: the formulation of

signs both simple and complex, and the assignment of meaning. And line fully externalized is part of a larger strategy. As I have argued, it functions within that metaphorical expression of the Self that has been the concern of a completely post-Expressionist art.

Godard once said that he thought most films turned out to be a form of remembering, that almost all of them seemed peculiarly to inhabit the past tense. He did not, he said, want that for his own work. For that reason, he explained, he did not prewrite his films. He would wait until the night before shooting a given scene to block it out, and during the shooting itself he would force the actors to improvise their lines. He courted the disarray, the mistakes even, of a lived present. In describing this, he was outlining a sensibility to which history, in the form of a narrative past seemed simply not to apply.

This essay began with another example of history rejected – that of Manet. I realize now that it was a bad example. For his was a procedure that was intensely historical; it was a disavowal of the content of a particular history, but not of history's form. Because in order to criticize or outmode or even outdistance the past, Manet had to incorporate it within a given work. The Old Master prototype had to serve as a ground against which the forms of the present could stand in relief. Couched within that juxtaposition was history itself, like an outworn garment used to line the folds of a new cloak. The meaning of the present was articulated against the included residue of the past.

If I have tried to account for anything in this essay, it is something about why that very procedure has become unacceptable to certain artists of the past ten years. Some of these artists I have named; there are of course many others. For all of them there is no longer any question of proceeding by holding out an alternative to a past position. For to make art out of a reply to a formulation from the historical past is to immure oneself within the solipsistic space of memory itself. So they are not, for example, offering a new account of intention, because to do so would leave them trapped within the privacy of a mental space which the old one entailed. The space in which they exist, and for which they must vouch, is precisely one in which meaning is present as it maps itself on to reality, and in which the art they create must do the same.

1 The composition of this group fluctuates in the various accounts of the period. Among the names generally included are Mel Bochner, Michael Heizer, Eva Hesse, Bruce Nauman, Dorothea Rockburne, Richard Serra, Robert Smithson and Keith Sonnier. For some writers Sol LeWitt belongs properly to post-Minimalism, even though the generation through which his art emerged was that of Minimalism.

2 I hope it is clear that my intention is not to draw up specific lines of influence, but rather to circumscribe a sensibility and a determination that seems to characterize certain art of the last ten years.

3 See Michael Fried, Three American Painters (Cambridge, Massachusetts: Fogg Art Museum, Harvard University, 1965); and Fried's subsequent essays on Stella.

4 If we consider that Stella's painting was involved, early on, in the work of Johns, then Johns'

interpretation of Duchamp and the readymade - an interpretation diametrically opposed to that of the Conceptualist group outlined above - has some relevance in this connection. For Johns clearly saw the readymade as pointing to the fact that there need be no connection between the final art object and the psychological matrix from which it issued, since in the case of the readymade this possibility is precluded from the start. The Fountain was not made (fabricated) by Duchamp, only selected by him. Therefore, there is no way in which the urinal can 'express' the artist. It is like a sentence which is put into the world unsanctioned by the voice of a speaker standing behind it. Because maker and artist are evidently separate, there is no way for the urinal to serve as the externalization of the state or states of mind of the artist as he made it. And by not functioning within the grammar of the aesthetic personality, the Fountain can be seen as putting distance between itself and the notion of personality per se. The relationship between Johns' American Flag and his reading of the Fountain is just this: the arthood of the Fountain is not legitimized by its having issued stroke by stroke from the private psyche of the artist; indeed it could not. So it is like a man absentmindedly humming and being dumbfounded if asked if he had meant that tune rather than another. That is a case in which it is not clear how the grammar of intention might apply.

5 In an important recent article, Kenneth Baker discusses sculptural space - mainly that of Caro - in relation to issues defined by Wittgenstein. See Arts Magazine (September 1973).

6 Maurice Merleau-Ponty, Phenomenology of Perception, tr. Colin Smith (London: Routledge & Kegan Paul, 1962) xii, originally published as Phénoménologie de la perception (Paris: Gallimard, 1945). [See in this volume pp. 196-97.]

7 'At the very moment', writes Merleau-Ponty, 'when I experience my existence … I fall short of the ultimate density which would place me outside time, and I discover within myself a kind of internal weakness standing in the way of by being totally individualized: a weakness which exposes me to the gaze of others as a man among men.' Ibid.

8 Marcia Tucker, Robert Morris (New York: Whitney Museum of American Art, 1970) 25.

9 Describing the meaning of depth, Merleau-Ponty writes: 'When I look at a road which sweeps before me towards the horizon, I must not say either that the sides of the road are given to me as convergent or that they are given to me as parallel: they are parallel in depth. The perspective appearance is not posited, but neither is the parallelism. I am engrossed in the road itself and I cling to it through its virtual distortion, and depth is this intention itself which posits neither the perspective projection of the road nor the 'real road'. Merleau-Ponty, op. cit.

10 When these pieces were first exhibited in 1967, they were rearranged every day by the artist into different configurations.

Rosalind Krauss, 'Sense and Sensibility: Reflection on Post '60s Sculpture', Artforum (November 1973) 43-53.

Douglas CRIMP
Opaque Surfaces [1973]

American painting came to fruition after the Second World War as the result of the confluence of disparate circumstances and aspirations, among them an innocence in the US of the extent to which aesthetic enterprises in general had begun to grow acutely self-critical, even so far as to question the foundations of their very existence. In large measure, the maturing process of this painting has been determined by the loss of that innocence, a loss which almost no one is willing to embrace wholeheartedly; but it is perhaps the unspoken thread in the discourse which New York paintings and its criticism have constituted.

'I'm just making the last paintings which anyone can make.'
– Ad Reinhardt

While it might seem in retrospect to have been thoroughly reckless, there were nevertheless cogent reasons by about 1965 for various artists and critics to proclaim painting dead, or at least momentarily not viable, as a medium of aesthetic enterprise. That is not to say that no important painting was being produced, but it did seem that the extraordinary energies of New York painting between 1945 and 1965 had severely ebbed. Indeed, something of a crisis for painting was perceived by anyone seriously committed to that art, anyone who could simultaneously witness the greatly renewed energies of sculpture – in fact, with Minimalism, American sculpture had finally achieved a status equal to that attained by Abstract Expressionist painting in the 1950s.

Furthermore, around 1968, one began to perceive the extent and import of a 'dematerialization' of art, where iconoclasm itself was the strategy of greatest urgency among artists. With anti-form, earthworks and particularly Conceptualism the entire structure of the art world was assailed – not only the forms of painting and sculpture themselves, but also the system for marketing and exhibiting works and the terms of the critical dialogue elicited by them – although this was not carried out systematically and without contradictions.

The problem for painting's survival in the mid 1960s was the perennial problem of illusionism. In fact, a major impetus to Minimal sculpture was the feeling among its practitioners (some of whom had previously been painters) that painting could never be successfully anti-illusionistic. Thus, Donald Judd said, 'I finally thought that all painting was spatially illusionistic'. In a sense, the very success of Minimal sculpture depended on its ability to define itself specifically as mute object, i.e., as an object which bespeaks only itself. This, it was thought, was something which painting as an inherently opposed medium could not do; a painting will always evoke, if nothing else, a virtual space apart from that real space which it actually inhabits. However, it was precisely those moves made by Minimal sculpture and its dematerialized

offshoots which invested painting with both a renewed aspiration for anti-illusionism and the strategies with which to pursue it.

If the ascendancy of Minimal sculpture and Conceptual art was one barometer for a crisis in painting, another was the disturbing spate of two superficially dissimilar types of painting – new realism and painterly formalism – which converged at the point of their betrayal of Modernism's fundamentally radical aspiration, an aspiration inseparable from anti-illusionism.[2] It is easy to see betrayal in the various new forms of realist painting; what is somewhat more difficult is how illusionism might be perceived in recent formalist painting, represented by the work of such painters as Larry Poons and Jules Olitsky and the hundreds of artists who are working within the general parameters of that style.

While I am not directly concerned here with the failures of recent formalist painting, I think it necessary to understand at least how it might have been perceived by those painters of the late 1960s who wanted to maintain an allegiance to a radical aesthetic. Apart from the theoretical problem where formalism is seen as rooted in a fictive historical narrative of Modernism and bases itself on the illusion of quality whose terms are determined by that narrative,[3] formalist painting was also seen as illusionist in a traditional spatial sense. The canvases exhibiting a large expanse of pure colour tended to get atmospheric, associative or both. One was no longer looking *into* the specified space through the rectangle (now often too large to see as a frame); rather one was absorbed mentally in the ambiguous space of the colour field. I think it makes sense to speak of an efficacy of Giotto's invention of pictorial space, an invention which is fairly embedded in the consciousness of anyone who is used to looking at paintings, or rather looking *into* paintings, which is our habit. 'I describe a rectangle of whatever size I please, which I imagine to be an open window through which I view whatever is depicted there.' Alberti's description of painting in the fifteenth century is a description of our visual habit when confronted by painted rectangles. Although nothing clearly recognizable, nothing nameable, has been depicted there for some time, our consciousness is still drawn towards that fictive space through the framing edge, and flatness, as such, is not necessarily a hindrance. What the mural-size canvas of Abstract Expressionism and Colour Field painting does is to obliterate our sense of the frame in order to propel us directly into fictive space.

'The next revolution in art will be the same old revolution.' – Ad Reinhardt

As I mentioned above, what lies at the roots of recent radical painting is the very doomsaying of painting by those artists who abandoned the canvas to make the 'specific objects' of Minimal sculpture. One knew, of course, that a painting could not achieve objecthood in the specific sense of asserting its third dimension without relinquishing its claim to be called painting (often, though certainly not always, the shaped canvas fell into that trap). And while the hybridization of painting and sculpture

offered viable alternatives, notably in the work of Eva Hesse, it cannot be painting properly so called. The problem, then, was to achieve the painted *equivalent* of sculpture's objecthood, i.e., surfaceness, if you will – to give to the painted surface an equivalent literalness to that which Minimalism had imparted to the sculptural object. The specificity of a 'specific surface' is inherent in the quality of opacity, a quality that had been banished from painting when burnished gold surfaces gave way to pictorial spaces in the fourteenth century. For this reason I intend, for present purposes, to call recent painting of a radical nature 'Opaque painting'. Its leading progenitors are Robert Ryman, Brice Marden, Robert Mangold and David Novros, among others.

Apart from its parallel aspirations, Opaque painting shares with Minimal sculpture a generally programmatic strategy based on a commitment to the conceptual, the critical and the autonomous nature of a work of art. Also cued by Minimalism (as well as by earlier painting, to which I shall return), these painters set themselves very circumscribed areas of concern and usually work serially (or systematically) within those confines. One's involvement with any single painting is therefore tied to the recognition that its meaning is contingent upon other paintings in that group or series; that is to say, rather than looking for meaning within the rectangle, we are enjoined to participate in the conception of the entire group and to recognize in what way a particular painting is part of a larger intellective enterprise. This is in direct contradistinction to thematic variation, in which we are given the enrichment of a single meaning rather than a unit of an expanded discourse. What is intended is that no painting, no image, can exhibit an autonomy of meaning; its reflexivity situates it within the broad cognitive context from which it derives. It is, paradoxically, the very muteness, immediacy and autonomy of these works of art (proceeding from their own given conditions and bespeaking, as I said of Minimal sculpture, only themselves) which throws us back into the reflection on the structure of consciousness itself. The problem with any form of illusionism is that consciousness is absorbed by it; we are not compelled to reflect, only to experience, and at that, to experience what we already 'know'.

This muteness or blankness obtains in Opaque painting as the result of various strategies. These I want to ennumerate tentatively under the terms of a narrow definition of painting as a surface exhibiting a particular *format*, *size*, *scale*, *colour*, *line* and *texture*, all of these contingent on the *materials* used and the *manner* in which they are employed. Although we are concerned here with a group of painters of quite disparate tendencies, bound together almost exclusively by their commitment to anti-illusionism, I shall limit myself to Ryman and Marden, each of whom I consider to be exemplary and each of whom is separate enough from the other to give some idea of the complexity of the entire enterprise.

Format. One senses immediately that shape has been brought under control by these artists. It is not arbitrary, but instead exists in a fixed relation to the strategies at work. One can easily imagine the Abstract Expressionist delighted by the prospect of each new rectangle,

regardless of its exact proportions, as a new arena in which to record his activity; by the same token, one can picture the formalist painter, canvas on the floor, staining, pouring, pushing his paint and cropping his product wherever it seems appropriate at the time. But for Opaque painting, the format is predetermined by the necessities of opacity and how best to achieve it.

Thus, Ryman's format is always a square because its lack of horizontal or vertical emphasis prevents readings of a fictive extendibility. Of all rectangles, the square is undoubtedly the least allusive, the most neutral. In the case of Marden, who does use both vertical and horizontal rectangles, the possibility of extendibility of surface is vitiated by the use of polyptychs whose panels refer only to one another, and by the emphasis on layering up to the surface which is revealed in the 'incomplete' lower edge. (Marden is difficult to speak of in terms of his strategies because his ability to insist on surface is intuitive; he can easily fail because he has a less programmatic means to success; his success is therefore based on his ability to be extremely critical of his own inactivity.)

Size. Almost without exception the size of Opaque painting is midway between the easel picture and the mural-size canvas; it is less easy, therefore, to see these surfaces in the terms of Alberti's 'open window' or the engulfing ambiguous space of recent formalism. (Leo Steinberg has likened the experience of this painting to an imaginative penetration of outer space.)[4] Because of Opaque painting's inherent suspicion of painting itself, it constantly attempts to situate itself outside the expected conditions of traditional painting, whether that tradition be considered in terms of the Renaissance or the early 1960s.

Scale. Traditionally, scale has functioned aesthetically in both real and illusionist senses. The actual large scale of formalist painting is figured in terms of its proportion to the viewer and his actual space; this, in turn, increases the fictive scale where an illusion of infinity is provided by the proportion of surface size to surface particle or incident. In Opaque painting there is no fictive scale because one cannot enter into a relationship of imaginative proportion with the painting. Staying on the surface, one is aware only of real scale, the proportion of the painting to one's self; and it is precisely this appropriately one-to-one ratio which Opaque painting exploits by limiting itself to the size of the human figure. It should be emphasized that this relationship does not lead to a latent illusion of anthropomorphism; rather it functions to make the viewer aware of his own cognitive activity, to make him apprehend himself in the act of apprehension.

In the case of Ryman's recent *Surface Veils*, which are 366 × 366 cm [12 × 12 ft], the emphasis is still on the real scale in as much as the approximate doubling of the artist's size is employed strategically to provide an area beyond the reach of a single brush stroke: the surface is visibly constructed of strokes which exhaust that reach.

Colour. The formalist painters sought to exclude every perceptible element from painting but colour, thereby insisting upon the purely optical nature of painting. Because it had been recognized early on in that enterprise that separate colour values abutting one another tend to

create almost definable shifts in depth, a conscious attempt was made to even out those values either by limiting them essentially to one, or by giving them equal play all over the surface in minute particles. But the result was, as I have noted, to increase the ambiguity of optical space to the point where one's imagination is engaged to invent one's own spatial fiction associatively. Consequently, those painters who wanted to oppose illusionism absolutely grew more and more suspicious of colour.

In Opaque painting colour is kept as neutral as possible. Ryman has limited his palette entirely to white. Where colour is used, as with Marden, it is usually extremely muted, kept non-specific and entirely even; it eludes both description and association. Furthermore, it is never used to assert an optical effect; rather it is dictated by the necessities of opacity. Marden's use of colour is exemplary. He uses both close and far values and hues but manages to make them read with equivalent weight through the qualities of total saturation and lack of lustre.

Line. In almost all traditional painting, line functioned either to delineate an object in space or to delineate space itself; that is to say, in almost every case, line was the exclusive prerogative of representation. Abstract Expressionist painting gave a breadth to that line while using it to represent an active gesture. Line was either expunged entirely from formalist painting (although it does creep surreptitiously back in as is the case with Poons' recent painting), or it was conceived of as the basis of delineating 'deductive structure', particularly in what came to be abstract illusionism.

Line is employed in Opaque painting, if at all, as the edge of shape or as equal and logically referent to that edge. Both of these uses of line occur in Marden's polyptychs and the second occurs in the 'unfinished' edge in the single panel paintings. With Ryman, line figures only to reveal the edge layers, the length and width of strokes and the disjunction of the paint and support. In the cases of both Ryman and Marden, line is the result of abutment of panels, of painted areas or of the separation between levels of surface. It is not drawn but rather is the result of painting only.

Texture. Texture, like scale, has both actual and virtual readings. The problem with much of so-called flat painting, which sought to expunge texture, is that in equalizing the structure of the surface, the viewer apprehended the 'texture' of atmosphere.

In revealing a specific texture of paint *qua* paint or stroke *qua* stroke, as Ryman does, or layer *qua* layer, as Marden does, the viewer apprehends the structure of the surface as being actually on that surface. For this reason it does not matter whether the texture is smooth (Marden) or relatively rough (Ryman; but Ryman's textures vary from series to series as they form an integral part of his overall schema). What matters is that texture is apprehended as an actual characteristic of the material used to create the surface.

Materials. Material is, of course, paramount in an art which depends on its substance being apprehended as actual. Ryman has best demonstrated this in his ever varying supporting surfaces – cotton, linen, corrugated

paper, cold-rolled steel, fibreglass on featherboard – and of types of paint – oil, enamel and Enamelac. It is the properties of the materials used as materials that Ryman exploits in order that the viewer keep his attention fixed on what, specifically, he is seeing (and *that* he is seeing).

Marden's material is a complex but fixed one derived from Jasper Johns' encaustic, a mixture of oil and wax. The precise characteristic of this material is opacity, of an extremely dense, mat surface; its sense of material *qua* material is so strong that on last seeing an exhibition of Marden's paintings, I felt compelled to walk up to a work and smell it.

Manner. It is particularly within the realm of manner or style that Opaque painting has taken its cues from Minimal sculpture. Thus, this painting employs non-relational parts, if any; logical procedures of applying material or 'skin' to supporting surface; a straightforward and simple approach to the act of painting; a self-critical responsibility for the surface which accrues. One senses the artist's presence in these works as one sees Godard at work in a Godard film, not, that is, in terms of the artist's sensibility or personality, but in the more inclusive sense that we are shown how this surface is *made* explicitly. The viewer might not know that Marden uses an oil and wax medium, but he does know that Marden applies it layer upon layer; by the same token, the viewer might not know that Ryman uses oil on linen, for example, but he knows by simple examination that a painting from the *Winsor Series* consists of one layer of fairly short horizontal strokes painted end to end across the canvas from its top edge to its bottom edge.

By contrast, one would be hard pressed to say how it was that Van Eyck painted Chancellor Rolin's robe or how Jules Olitsky painted the airy space of one of his paintings; one also realizes that the question is meant to be beside the point because illusionism of any kind depends on the artist's ability to make the viewer suspend such questions, just as, in Andre Bazin's view, the style of narrative and editing in 'deep focus' cinema makes us suspend our questions regarding the director's role in the fictive reality on the screen.

'Every revolution in art turns over art from Art-as-also-something-else into Art-as-only-itself.'
– Ad Reinhardt

An integral aspect of Opaque painting is the extent to which it requires our reconsideration of what has preceded it. In effect, the new radical work results in relegating its predecessors to past history and suggests that we call into question the order we had imposed on that history. Opaque painting is engaged in a dialectical relationship to its precursors, questioning the very enterprise that it initially emulated. This is not a destructive act but rather a constructive one which enjoins one's consciousness to keep leaping into the present.

In as much as Opaque painting seeks to find a parallel anti-illusionism with that of Minimal sculpture, it finds its sources in the same painting to which Minimalism finally grew hostile, particularly that of Frank Stella. Leaving aside the problematic question of recent art's relationship to

early twentieth-century art, particularly Russian Constructivism, I want to outline the lineage of Opaque painting.

As has often been pointed out, Barnett Newman is the painter who, in the 1950s, began to assert the greatest influence on a younger generation, who admired what was apprehended at the time as a thoroughgoing purge from painting of every element but structure and colour. Where even colour was expunged in the white paintings of the early 1950s, the resulting image seemed to predict a new kind of painting entirely.

On the other hand, Newman's increasing use of strong primary colour, a non-tactile surface and hugely expanded horizontal formats, while then seen as 'empty' canvases, are now seen to be quite assuredly illusionistic. They are a representation, so to speak, of 'spatial infinity', which Robert Rosenblum has characterized as the 'Abstract Sublime'. Rosenblum said of Newman:
'*He has spoken of a strong desire to visit the tundra, so that he might have the sensation of being surrounded by four horizons in a total surrender to spatial infinity. In abstract terms, at least, some of his paintings of the 1950s already approached this sublime goal … Newman bravely abandons the securities of familiar pictorial geometries in favour of the risks of untested pictorial intuitions; and … he produces awesomely simple mysteries that evoke the primeval moment of creation. His very titles* (Onement, The Beginning, Pagan Void, Death of Euclid, Adam, Day One) *attest to this sublime intention. Indeed, a quartet of the largest canvases by Newman, Still, Rothko and Pollock might well be interpreted as a post-World War II myth of Genesis.*'[5]

In the later 1950s, the American painting sensibility was turning squarely away from the latent representational qualities of Abstract Expressionism, including even the work of the more reductivist early Colour Field painters like Newman. Prior to 1959, when Frank Stella produced a reverberating shock with his black striped paintings, there were already strong hints of a firmer anti-illusionist approach. Among the artists who would strongly affect Opaque painting in the later 1960s, foremost are Jasper Johns and Ellsworth Kelly. Johns is, not unlike Jackson Pollock, a difficult painter to get at critically because he has been taken as the leading spirit behind a number of quite separate styles of art; among these are Pop art, Stella, much of the ideational work in and around Conceptual art and, most recently and primarily for reasons of technique and sensibility, Brice Marden. Probably it is Johns' relationship to Marcel Duchamp that places him so squarely at the centre of activity in the 1960s. However, this is a separate issue because Duchamp's role for recent painting is surely tangential. What, I think, made Johns so compelling, and this is equally true for Andy Warhol and Roy Lichtenstein, is that he was able to use representation as a form of anti-illusionism. At the same time, Johns managed to take responsibility for his painting, never allowing himself to be innocent of what led to illusionism. Another aspect of his importance for Opaque painting is Johns' limited palette; in many paintings he used only white or shades of grey – the 'value colours' – to paint representations of patently

flat images.

Within the European tradition of geometric abstraction, Ellsworth Kelly programmatically attacked the problem of colour by nailing it squarely to shape. As such, he managed much more successfully than the formalist painters, who were also theoretically intent upon an intransigent flatness, to block entry into the rectangle. The absolute removal of surface incident in Kelly's colour panels made for a fixed identification of colour and format. Nevertheless, there are persistent illusionist references in the latent anthropomorphic readings possible in Kelly's shapes. There is, moreover, a tendency for his colour relationships to become optically illusionistic because his colours are often primary and secondary and their extreme value contrast — including even black and white — makes the shapes appear to pop back and forth and leave after-images. I think also that when 'true' colours are used, one's tendency is to *identify* that colour, which, in a sense, makes the colour a 'representation' of itself; that is to say, a red shape 'represents' the colour red.

The crucial pivotal juncture in American painting came in 1959 with Frank Stella's *Black Paintings*; these, the black paintings of Ad Reinhardt, the square grid paintings of Agnes Martin and Jo Baer's 'edge only' paintings (the earliest direct alignment with the basic strategies of Minimalism) are the clearest antecedents of Opaque painting. An important element of Stella's early black and monochromatic paintings was the interstice of raw canvas between stripes. These 'lines' pointed to a disjunction between the painted surface and its canvas support which made the viewer aware of the double nature of a painting's actual surface (this disjunction is not dissimilar from the separation of the vellum of a medieval illuminated manuscript and the burnished gold surface laid on to it). Stella provided a number of other cues to opacity: the use of monochromy; of paint taken directly from the can and applied so as to retain the physicality of its substance; the logical relationship of surface structure to shape of support; the square format; the serial relationship of one painting to another.

However, Stella himself perceived illusionism in his paintings and ultimately decided to move in the direction of that illusionism rather than attempt to resist it further. He apprehended the 'speed' with which the eye is propelled across a striped surface and the slight space created by the shimmer of the aluminium paintings of 1960: 'You know it's on the surface, but it catches just enough light to have a shimmer. That shimmering surface has very much its own kind of surface illusionism, its own self-contained space.'[6] When Stella moved to the irregular polygons in 1966, he inexorably committed himself to abstract illusionism. One critic said of these:
'*The variety of acute and obtuse angles wrenches out of the flat colour planes strange perspective effects of oblique foreshortenings, of concave-convex ambiguities, all closely related to that new investigation of fictive depth on a plane surface*'.[7]

Throughout the 1950s, Ad Reinhardt worked to expunge expressionism from his painting, limiting himself to monochromatic colour and a flat application of paint. By 1960 he expelled colour also, arriving at his final black

palette and square format. However, these paintings, consisting of arrangements of rectangles painted in various 'hues' of black, retained a subtly Cubist or Constructivist space. He said, 'Space should be empty, should not project, and should not be flat. "The painting should be behind the picture frame".'[8] As might be assumed from the various quotations from Reinhardt in this text, one cannot take what he says entirely at face value. However, these terse statements are often appropriate descriptions of his own work and they do, at times, read as prophetic of recent radical painting. In any case, the strength of the iconoclastic side of Reinhardt's sensibility is clearly felt in present art.

Like Reinhardt, Agnes Martin is an artist closer in spirit to her own generation (Abstract Expressionism) than her paintings might indicate at first. Perhaps it is a constructive misreading of Martin that makes her so nearly paradigmatic for Opaque painting. Her systems of vertical and horizontal coordinates consisting of graphite lines, her standard 183 cm² [6 ft²] format, and her expunging of colour can easily be taken as exemplary of conceptual structure, neutral shape and material surface. One cannot deny the potential of her grids to keep the viewer engaged with the actual surface.

However, both the title references to unitary elements of nature — *Tundra*, *Beach*, *Milk River*, *Gray Stone* — and her statements regarding her 'representations' of moments of perfection are a clue to a more complicated and ambiguous stance on illusionism, 'When I draw horizontals you see this big plane and you have certain feelings like you're expanding over the plane'.[9] Martin's work is very much at the centre of that juncture where American painting abandoned the spiritual for the logical; they are, as it were, suspended there, which accounts for their extraordinary tension and for the fact that they seem to contain within them a totality of the aspirations of two generations of American painting.

'The end of art is not the end.'
— Ad Reinhardt

Although it has often been said to be irrelevant whether a work of art is considered painting or sculpture or neither, this seems to me to be too easy a dismissal of a central issue. I think that the allegiance to painting of artists like Robert Ryman is not a matter of sensibility but rather that the questions of painting are seen to be contained within painting itself: not *whether* to paint but *how* to paint. To paint has become a precarious enterprise which makes this question an urgent one.

On the other hand, certain artists whose work has not been called painting with any ease seem to me to be committed to similar issues as Opaque painting, the work of Dorothea Rockburne and Richard Tuttle, for example. As long as an artist's investigations are concerned with two-dimensional surfaces and how we apprehend those surfaces visually, they are working within the general confines of painting. Finally, the question is how far away from the conventions of a given form can an artist go before he relinquishes his relevance to that form. Does Conceptual art, for example, address itself to the problem

of how painting might still be possible or does it seek to displace it entirely?

1 Donald Judd, *ARTnews* (October 1971) 60.
2 For the terms of this identification of radical aspiration and anti-illusionism, one may go to various sources: Eisenstein's theories of montage, for example, or Robbe-Grillet's theories of a new narrative.
3 This problem has been approached by various critics. See, for example, Rosalind Krauss, 'A View of Modernism', *Artforum* (September 1972) 48-51; Bruce Boice, 'The Quality Problem', *Artforum* (October 1972) 68-70; Leo Steinberg, 'Reflections on the State of Criticism', *Artforum* (March 1972) 37-49.
4 Steinberg, *ibid.*, 40.
5 Robert Rosenblum, 'The Abstract Sublime', *ARTnews* (February 1961); reprinted in *New York Painting and Sculpture: 1940-1970* (New York: E.P. Dutton & Co, 1969) 358.
6 Quoted in William S. Rubin, *Frank Stella* (New York: The Museum of Modern Art, 1970) 60.
7 Robert Rosenblum, *Frank Stella* (Harmondsworth: Penguin, 1971) 44.
8 'Writings', *The New Art*, ed. Gregory Battcock (New York: E.P. Dutton & Co., 1966) 201.
9 Agnes Martin, 'The Untroubled Mind' (recounted by Ann Wilson), *Agnes Martin* (Philadelphia: Institute of Contemporary Art, University of Pennsylvania, 1973).
Douglas Crimp, 'Opaque Surfaces', *Arte Come Arte* (Milan: Centro Comunitario di Brera, 1973).

Karl BEVERIDGE, Ian BURN

Donald Judd [1975]

Don Judd, is it possible to talk? What must we each do to construct a relationship which is not merely institutionally-mediated? Can we cut through the public mythology of 'Don Judd'? How do we deal with an almost sacrosanct figure, a reputation seemingly above ordinary criticism, a powerful reference point for so much during the 1960s and apparently still 'fundamental' to a lot of the high art produced today?

What do we know of you? You 'exist' in Castelli, in The Modern, in the Stedelijk, on Philip Johnson's front lawn. For a while, you wrote criticism to earn a living; now you exhibit and sell to earn a living, to be able to make more work. You like John Chamberlain's work, you don't like Robert Morris', Tony Smith's even less. Barbara Rose says your work is 'pragmatic'; Michael Fried says it is 'theatrical'. Is this what we are addressing? By addressing this are we addressing *you*?

Should we accept your admonition that a 'thorough discussion' of an artist should involve 'the primary information [which] should be the nature of his work', and 'almost all other information should be based on what is there'?' What does that leave for us to say?

More to the point, can we ask what sort of relation *your* writing has to your work? Your writing does function

differently to the writings of other artists, say Kasimir Malevich's, or even Barnett Newman's. Maybe the easiest way to summarize the function of your writing is to say it operates almost like a manual for the sculptures or objects you make. For a lot of artists, particularly Morris, but also Robert Smithson, Mel Bochner and Joseph Kosuth, this became a model for 'controlling' the public image of their work in the art magazines.[2] Emphatically enough, you've insisted on the *terminology* you want your work *experienced* in relation to … 'specificness', 'wholeness', 'objectivity', 'facticity', 'large scale', 'simplicity', 'non-associative', 'non-anthropomorphic', 'anti-hierarchical', 'non-relational' and so on. These intermesh to provide a more or less linguistically defined context. The language which constructs this context reflects a collection of assumptions about a particular form of art — what sorts of assumptions are these? In other words, what can we say about the *form of art* this context presupposes?

By your own reiteration, specificity seems to be the key concept. It is not always easy to understand what you intend by 'specific'. In one sense, you often use it to set up a comparative value; for example, 'I'd like my work to be somewhat more specific than art has been … '[3] But doesn't this hold the implication that your work is specific only within a history of art objects, and so the value 'specific' depends on the acceptance of that history as unproblematic? Doesn't the specificity of your work hold in a 'world' categorically limited to what counts as 'art', and thus it is a tacit claim for immunity to 'anything to do with society, the institutions and grand theories'?

But you have used 'specific' in another sense: '*materials vary greatly and are simply materials — formica, aluminium, cold-rolled steel, Plexiglas, red and common brass and so forth. They are specific. If they are used directly, they are more specific. Also they are usually aggressive.*'[4]
Doesn't this suggest that the materials (and techniques) you use are 'specific' to an advanced industrial society? In as much as we know America is technologically the most advanced nation, wouldn't that locate 'specific' in what are generally held as *American* ways of doing things?

Of course, you would claim this has nothing to do with your work, that people who associate your work with advanced industrial materials and American life are being simple-minded.[5]

On the other hand, you have said that the structure of your work is 'barely order at all'.[6] You dismiss technology and mathematics, 'the scale … is pragmatic, immediate and exclusive … the work asserts its own existence, form and power'.[7] Finally, we are left with 'whatever the boxes are made of'.[8] That is, we are left with materials.

In this light, the use of 'practical' industrial materials appears almost as an end-in-itself. Put this with a disavowal of transcendental qualities and it suggests that the identity of the art object is embodied *in* the materials (— that is, if we understand what you said about the bottlerack as an interesting *object*, and ignore the Dadaist gesture of it).[9] Would you perhaps want to add that the identity lies also in the *arrangement* of the materials, and in the physical context of that arrangement? Or doesn't it matter? If you take the identity for granted, you must also

take its function for granted and presuppose the whole context of art as given. Do you?

You have also asserted 'there is an objectivity to the obdurate identity of materials' and that 'most of the new materials … aren't obviously art'. You are saying that materials which don't 'belong' to art are more objective. But you are *also* saying that, by appropriating these materials 'for' art purposes, they *lose* their extra-art associations.[10] They become materials 'without histories'. That is the explicit claim, but what is implicit in it? Isn't it an implicit appeal to a notion of art history in which that history is totally divorced from social history? Doesn't your assertion rest on the assumption of *autonomy* for art history? Without that assumption, can we understand your claims at all? And given what we know about the political and ideological appropriation of the function of art, is the autonomy of art history an assumption we can abide any longer?

If you assume an autonomous art history, you are assuming autonomy for the category of art — at least, so long as it continues to be assumed that art is historical, and not social. Even if 'specific' has nothing to do with materials, this presupposition of art still underwrites so much you've done. You stated it succinctly when you said 'an activity shouldn't be used for a foreign purpose except when the purpose is extremely important and when nothing else can be done'.[11] But, in the same article, you said, 'I've thought that the situation was pretty bad and that my work was all I could do' — which means things would have to be much worse than 'pretty bad' before you would use your art for a 'foreign' (or extra-art) purpose. That is an indication of the degree of autonomy you associate with the form of art you presuppose.

This has ramifications for many of your other concepts. When saying you 'prefer art that isn't associated with anything … '[12], aren't you saying you want the 'associations' to be restricted or localized to the object or its immediate (i.e. architectural) environment?[13] Along with an autonomous form of art, you wanted a *more autonomous art object*, what you would call 'more objective'. Let's look at that. Traditionally art objects are associated with other art and art history by way of their materials and by being a conventional *type* of art object. Such associations would, I suppose, in your words, be specific. But this was the last thing you wanted. The 'autonomy' you developed for your objects had to function in respect to your presuppositions of an art (historical) context, and hence you still needed a means of associating the object with that context. Since the object itself denied any associations, *the physical situation* became a more important vehicle. That is to say, the object had to be *circumstantially* associated with its art context.

The ramifications of this are plain. You've said that works of this sort, what you've called three dimensional work, are 'real space'.[14] But this 'real space' ends up being not a neutral space but a particularly *loaded* space.[15] It is this which provides the circumstantial association. Which is an indirect way of saying that the sense of art and art history being appealed to is an *institutional* sense. It means that the more 'objective' you make your work, *the more necessarily dependent the work is on a culturally*

institutionalized situation. It also exposes — and perhaps this isn't so surprising — the interdependence of the autonomy of art and art history with their institutionalization.

I'm not sure — are we stretching the point too much to suggest that, putting this in the context of your rejection of the European tradition, it throws all of that increased dependence on to the institutionalized forms of *American* culture? And, if we accept that, in as much as your form of art is influential on other artists, American and non-American alike, doesn't it force these artists to reproduce an equal dependence on the institutionalized forms of American culture?

Let's look a bit more closely at what you rejected as 'European tradition'. You characterized it as 'relational'.[16] Any work which had a lot of parts which invited 'visual play' was entrenched in that relationalism. To escape that, you made something which didn't *readily* break up into parts, so that the number and functional role of the parts were reduced (or subordinated). For what parts there were, their power lay 'in a polarization of elements and qualities, or at least in a combination of dissimilar ones'.[17] This was characteristic of a number of artists' work you liked. The effect was to *force the constituent materials to assume a significance they hadn't assumed before*. Moreover, 'new' materials had no obvious (a priori) cultural or historical relations, this was their 'objectivity'. As we all well know, subsequent history of avant-garde art can be seen as an elucidation of that significance … the 'trek through materials', aesthetic investigations of a particular material's range of presentation, the identification of particular artists with certain materials, to the extent of standing as a 'signature', and so on. The 'new art' was identified by the significance and the newness of the materials. (It is largely in this respect that we understand your important and enduring influence).

It is the central role of materials which coalesce your concepts of 'specific', 'objective' and 'factual'. At times, for you, these seemed synonymous. To your thinking, specific is stronger than general, objectivity is stronger than subjectivity, facts are stronger than fiction — and the factualness of the materials you used was the justification for your attack on the illusionism of painting. You saw illusionism as retrogressive:
'*A new form of art usually appears more logical, expressive, free and strong than the form it succeeds. There is a kind of necessity and coherent, progressive continuity to changes in art*'.[18]
But do you really think that the 'objectivity' or 'facticity' of your work is independent of a viewer and his or her system of beliefs? Do you really think that something might be seen as objective or factual without first having met a socially accepted rule of procedure? Do you think *you* can see something as objective, independent of *your beliefs*? You obviously did at one time; do you still? And what is this objectivity — isn't it the sort of 'objectivity' popularly held in American society, the middle-class materialist sense, the supposed 'objectivity' of science, and so on? By asserting the 'objectivity' of your sculptures, weren't you claiming their character as 'real objects', the matter of their *existence* and *identity* being independent of a viewer? It is

the attempt to establish *a more autonomous* art objective. This *was* the point, wasn't it?

There are a couple of curious questions left over. The 'autonomy' of the art object for us is its objectivity for you. So, for you, is the autonomy of art history also *its* 'objectivity'? And then, would the autonomy of art be ground for claiming a possible 'objectivity' for art.[19]

What does 'a more autonomous artwork' mean from the viewpoint of the artist who produces it, or the person who looks at it? More autonomous translates into *more alienable*, in personal terms. The object itself (but not its context) is aggressive to the viewer, to his or her cultural expectations. Isn't the viewer then forced to treat the object as more alienable?

How *does* a viewer relate to what you do? You've stressed the importance of the viewer *seeing* the works ... 'Art is something you look at.'[20] You've also stressed the importance *for yourself* of seeing the works ... 'you can think about it forever in all sorts of versions, but it's nothing until it is made visible.'[21] But what kind of 'seeing' did you mean? As you've stated, you wanted works which couldn't be contemplated.[22] What kinds of things do we see but not contemplate? Did you mean we should try to see them in an 'ordinary' sense — say, like bits of furniture in a room? Obviously, that was out of the question, the presuppositions of your art wouldn't allow it: its specialized mode of marketing and the prices demanded removed the work from the realm of objects seeable in an ordinary sense, and the institutionalized forms on which the work depends have emerged from assumptions which deny such viewing.

Contemplation was seen as a problem, and a number of artists of your time were able to induce some shift in the traditional habits of perception. For instance, Robert Morris theorized and rhapsodized about how we see the object in a field, the immediacy of the space in which it is placed. What you and others achieved was a break with the Modernist hardline of formal and exclusively 'optical' (their word) qualities. This made a precedent for a less exclusively visually mediated relation between the viewer and the object. You were right in so far as we *didn't* contemplate (in the standard sense of the word) the objects, rather we experienced them *within a particular situation*, a situation which is, of necessity, culturally loaded ... as we have already pointed out.

But that didn't change the *passivity of a contemplative mode that the work imposed on the viewer*. If anything, it heightened that passivity. It was just contemplation under a faintly different and more hierarchic guise. I remember looking at your work and feeling that my 'looking' was almost 'programmed'; I remember walking around your series of boxes and thinking my reactions were in some way 'choreographed'. Contemplation isn't the problem, the cultural *passivity* it reinforces *is*. It is this passivity which makes us powerless in face of our cultural institutions, and which constrains us to reproduce our own powerlessness.

So why did it seem so radical in the mid 1960s? Why did it generate so much other work, not only of your own generation, but of those who followed, *ourselves* included? The traditional European art object was very deterministic

about the condition of subject, the historical conventions determined the role of viewer (me-as-subject). Your work and that of some others made the role of viewer more 'open-ended' — at least it made me more self-conscious, more aware of my own presence alongside your sculpture. Perhaps this was a function of the sculpture's alienating effect; the art object, being (as it were) exclusive of me, forced me self-reflectively to deal with my own presence. This focused attention anew on the subject-object relation, it made the relation explicit, it made it *conscious* again. This became important for a lot of us. It encouraged me to view myself as object-and-subject. For a moment, this seemed radical, even revolutionary. It *was* radical. It touched the very alienating structure of Modern art. *But what was its relation to your work, your aims?* The possibility of a dialectical relation between object and subject didn't exist in your work. The possibility was inherent in your work only in a *negative* sense. The changes you (and others) wrought made us self-conscious *only in reaction to* what you did: your form of art precluded the very options it made us aware of. Your work remained immutable, passive, disengaged, its heightened alienability denying the possible transformations of subject-object relations. Your work's fundamental dependence on loaded contexts made us too aware of the institutionalized forms of our culture [...]

You have sometimes been referred to as the first really American sculptor. What does that mean? America is powerful, aggressive. It's hard not to embody that, and even harder not to reproduce it. But why shouldn't you, you are American? After all, in your attitude towards art there is a constant equation of 'American' with 'most powerful' and 'best work'. Did making your art 'more American' mean it was 'more powerful'? Was Abstract Expressionism 'American' and Minimal art 'more American'? Was this reflecting the fact that America, as the emerging world power, needed to have its own dominating 'high culture', the imperative to be the best in the world? What would you say if people started referring to you as the first *complete* capitalist artist?

The image America has reproduced of itself is that of exporting technology, a technology which is democratic because it is good, neutral and progressive, a technology which is equally available to everyone — the means for a better life, and free from ideological bias. The American artists of the 1960s and 1970s have reproduced this pattern, becoming the 'cultural engineers' of 'international art'. With the image of neutrality — selling art, not ideology. This has even been institutionalized by galleries and museums, bringing the artists to make work 'on the spot'. The impact of this is immeasurable, as a way of showing other artists the American way of doing things, of making art. This is the extent to which production itself during the 1960s came to embrace and internalize the 'internationalist' ideology. By contrast to the 1950s — can you imagine someone giving Barnett Newman a plane ticket to fly to Australia and make a painting? When Abstract Expressionism was sent to Europe, it had to be packaged, it had to be given a form in the media, a publicity wrapping of 'free expression in a free society'. The art of the 1960s and 1970s was media-conscious, the packaging

was a feature of the 'expression', internal to actual production.

Such a form of art can't carry much personalized baggage: the potentially frail, the quirky, the idiosyncratic, the unsure. That destroys the illusion of objectivity — because this sort of objectivity has to do with how things are packaged, how they exist in relation to public forms or institutions of culture. Is *this* what you meant by suggesting that while 'power isn't the only consideration ... the difference between it and expression can't be too great either'?[23]

Yes, there *was* a time when the forms of 'high art' were powerful media in society. But other, more potent and far-reaching forms emerged, and, for 'high art' to maintain itself, it became dependent on the power of other, 'external' forms of media. Existing institutions had to be transformed, while those emerging presupposed, even embodied, the new media and market relations. It was 'natural' that the internationalization of American art and the institutional forms of culture that emerged during the 1960s should follow the structure of internationalization of media. A world invaded by the vast US-controlled international communications network found itself 'wanting' those cultural commodities.[24] All corners of the 'free world' *had* to have a Don Judd. A media-conscious form of art reproduces cultural hegemony, recreates the world in America's image.

You've said 'it's a strange idea that other people's culture is your culture', and also 'the idea that imported history is culture is one of the great American mistakes'.[25] I wholeheartedly agree. But *why* don't you think it such a strange idea that *your* culture should be someone else's? Then there is an appalling remark you made suggesting that everything is 'international art in America and the best thing that could happen would be equal international art elsewhere.'[26] What a preposterous remark, surely you didn't mean it as it came out? Did you? That remark blatantly reproduces the ambitions of US hegemony and economic and cultural imperialism — where 'international values' are dictated by the US' 'national interests', or rather the US' 'national interests' are imposed as 'in the self-interests' of other nations. Put bluntly, the internationalism you're talking about is unilateral, is something which is *exported*, not a state mutually achieved. This is the form of art you've presupposed, and *imperialism* is fundamental to its way of life.

The 'power' of American art has been acclaimed in many countries. Of course such power has highly contentious value, its relation to knowledge, to concepts like 'progress', 'advanced art', etc. are treacherous. The acquisition of power by a particular form of art conforms to the relations it presupposes to prevailing institutions, the channels through which 'values' are transmitted. Power accrues through the ability to mediate what counts as significant cultural points of reference. No matter what your personal intentions were, these weren't what give your work its power ... it was its interaction and interdependence with the media of the magazines, the museums, the prestigious exhibitions, the market, *all* the institutionalized forms of our culture.

Against all this, how could you see your work as

political, as *subversive*! 'So my work didn't have anything to do with society, the institutions and grand theories. It was one person's work and interests; its main political conclusion, negative but basic, was that it, myself, anyone shouldn't serve any of these things, that they should be considered very sceptically and practically'. And 'I've always thought that my work had political implications, had attitudes that would permit, limit or prohibit some kinds of political behaviour and some kinds of institutions. Also, I've thought that the situation was pretty bad and that my work was all I could do.'²⁷ Do you still believe that? Do you still believe that the individual *qua* individual can be political or subversive? Haven't you realized that achieves nothing, that it is exactly what the interests dominating this society *want*, that it is its most insidious form of social control? In fact, it is self-control – because only through an *organizational* base can one achieve power enough to subvert anything. Perhaps you would reply that *because* your work is so well represented in the media, the museums, that you do have power enough to influence our cultural institutions, and to influence them in a subversive sense where you see fit. But do you? Aren't you merely reproducing *their* power, thus power to assent, not dissent?

Yes, in America, the individual is in so many ways (apparently) sovereign. This is masked in the rhetoric of duty of the individual towards himself, the glorification of personality and private ethics.²⁸ Ruling 'national interests' are well served by maintaining this dominant (ideological) concept of 'individual', since it maintains us in a socially unorganized state. You can't treat this as incidental or accidental ... wasn't that plain when you remarked 'it's difficult to moderate a police chief in a little town in Mississippi but easy to destroy a government in Guatemala'. A remark which surely suggests the link between privilegedness of individualism and imperialism [...]

What then do you mean by 'subversion'? Subversive to what? As reformist, or as revolutionary? How can an artist today be revolutionary when every revolution stops at the collector's or museum's door, stops in the pages of a glossy art magazine? Both the idea and practice of 'cultural revolution' in Western society have been successfully *confined* to high culture alone – everything is immune to its 'revolutionary' power. The only thing it may be subversive to is *prevailing art and art history* ... which, given the dynamic of that, makes it subsumable and a 'logical' extension of that history. Yes, your art is revolutionary, but meanwhile art criticism, art history, museums, *all* the institutions remain *stable* and unchallenged. Yes, in these terms your work and most of that of the 1960s is subversive – it is subversive to other forms of art, by presupposing a more alienated form, a form which has internalized an exchange value, a form saturated by political and economic interests. As far as being subversive to our cultural institutions, your form of art surrenders any independence of them, it acts in collusion with the way of life these institutions support. *You can't be subversive to institutions and at the same time presuppose a form of art which reproduces, thus increases, the power of those institutions.* If you really want your art to

be subversive, it must be a form of art which doesn't reproduce the Big Cultural Lie.

How do you see your work today? A lot has been realized during the past decade and this has changed the way many of us view the art around us. Our relation to your work has changed, too. By engaging your work and your writing, by trying to engage *you*, do we have anything to talk to each other about? Or have our actions precluded that possibility?

1 Donald Judd, 'Jackson Pollock', *Arts Magazine* (April 1967).

2 And it also became a historical point of reference for many of the so-called Conceptual artists, providing a model for how to assume a responsibility for the 'language context' of the art they produced. While the value of this context remained implicit in your writing, a number of Conceptual artists developed it as an 'end-in-itself' and 'integrated' a linguistically defined context into their actual artworks or presented it 'as' the work itself.

3 Donald Judd, *Art in America* (October-November 1965).

4 Donald Judd, 'Specific Objects', *Arts Yearbook*, 8 (1965); reprinted in *Donald Judd: Complete Writings 1959-1975* (Halifax: Nova Scotia College of Art and Design; New York University Press, 1975) 181-89. [See in this volume pp. 207-10.]

5 ' … I don't make a great thing of technology and all that. In the first place, I use an old-fashioned technique - basically a late nineteenth-century metal-working technique. I don't romanticize technology like Robert Smithson and others. I think generally you are forced into modern technologies, but the technology is merely to suit one's purpose.' 'Interview with Donald Judd', *Artforum* (June 1971). Of course this implies technology is ideologically neutral. It can be, but only if one first amputates it from its function in the *real* world.

6 'Portfolio: 4 Sculptors', *Perspecta* (New Haven, Connecticut: Yale University, 1967).

7 Donald Judd, 'Lee Bontecou', *Arts Magazine* (April 1965).

8 'Portfolio', *op. cit.*

9 'There are precedents for some of the characteristics of the new work … Duchamp's readymades and other Dada objects are also seen at once and not part-by-part … Part-by-part structure can't be too simple or too complicated. It has to seem orderly … Duchamp's bottle-drying rack is close to some of the new three-dimensional work.' Judd, 'Specific Objects', *op. cit.*

10 E.g. 'I wanted to get rid of all those extraneous meanings - connections to things that didn't mean anything to the art.' 'Interview', *op. cit.*

11 'The Artist and Politics: A Symposium', *Artforum* (September 1970).

12 Donald Judd, 'Complaints: Part I', *Studio International* (April 1969) 166-79; reprinted in *Donald Judd: Complete Writings 1959-1975* (Halifax: Nova Scotia College of Art and Design; New York University Press, 1975) 197-99. [See in this volume pp. 245-47.]

13 Isn't the rejection of associations an obvious mode of abstraction? But then aren't we left with your notion of specificity on the one hand and a mode of abstraction on the other as somehow identifying the *same*

characteristic!

14 Judd, 'Specific Objects', *op. cit.*

15 Tony Smith provided a virtual parody of just how loaded. He is talking about the impact of what he calls 'artificial landscapes' which had 'a reality there that had not had any expression in art'. He says 'I discovered some abandoned airstrips in Europe … something that had nothing to do with any function, created worlds without tradition. Artificial landscape without cultural precedent began to dawn on me. There is a drill ground in Nuremberg large enough to accommodate two million men. The entire field is enclosed with high embankments and towers. The concrete approach is three 41cm [16in] steps, one above the other, stretching for 1.6 km [1 mile] or so.' 'Talking with Tony Smith', *Artforum* (December 1966).

16 In retrospect, the characterization of European art by the device 'relational' appears fairly arbitrary … perhaps as inappropriate as the term 'minimal' is for your work. We could suggest any number of other equally 'fundamental' characteristics for European art. For instance, why wasn't *abstraction* seen as a characteristic of European art, and thus pragmatically un-American?

17 Judd, 'Lee Bontecou', *op. cit.*

18 Donald Judd, 'Local History', *Arts Yearbook*, 7 (1964).

19 A persistent problem is that any interpretation we can come up with for one part of your 'system' not infrequently contains contradictions of another part of your system. This becomes frustrating when you make few, if any, remarks about your aims, content or intentions. A possible resolution would be that adopted by some of your 'critics', like Barbara Rose and Rosalind Krauss, who allow all your terms ostensive definition by your work … however that sets up a situation in which it is *impossible to criticize* your work in any terms acceptable to you, a tactic guaranteeing your work immunity to criticism.

20 Bruce Glaser, 'New Nihilism or New Art: Interview with Stella, Judd and Flavin', originally broadcast on WBAI-FM, New York, February 1964, revised and published in *ARTnews* (September 1966); reprinted in *Minimal Art: A Critical Anthology*, ed. Gregory Battcock (New York: E.P. Dutton & Co., 1968) 148-64. [See in this volume pp. 197-201.]

21 *Ibid.*

22 This attitude was widely held by artists in the early 1960s. For example, Frank Stella said: 'One could stand in front of any Abstract Expressionist work for a long time, and walk back and forth, and inspect the depths of the pigment and the inflection and all the painterly brushwork for hours. But … I wouldn't ask anyone to do that in front of my paintings. To go further, I would like to prohibit them from doing that in front of my paintings. That's why I make the paintings the way they are, more or less.' Glaser, *op. cit.* We can also tie in Robert Morris' discussions about Gestalt to a hope of escaping from a contemplative mode of seeing.

23 Judd, 'Specific Objects', *op. cit.*

24 As President Kennedy described it, in 1963: 'Too little attention has been paid to the part which an early

exposure to American goods, skills and American ways of
doing things can play in forming the tastes and desires
of newly emerging countries - or to the fact that, even
when our aid ends, the desire and need for our products
continue, and trade relations last far beyond the
termination of our assistance.' Quoted *New York Times*.

25 Donald Judd, 'Complaints: Part II', *Studio
International* (1969); reprinted in *Donald Judd:
Complete Writings 1959-1975* (Halifax: Nova Scotia
College of Art and Design; New York University Press,
1975).

26 The full quote was: ' … I think American art is far better
than that anywhere else but I don't think that situation
is desirable. Actually, it's international art in
America and the best thing that could happen would be
equal international art elsewhere.' Judd, 'Complaints:
Part I', *op. cit*. To make a blunt point, compare this to
then Secretary of State Rusk's statement that the US is
'criticized not for sacrificing our national interests to
international interests but for endeavouring to impose
the international interest upon other nations.'
Moreover this criticism is not rejected by Rusk, but
rather is seen as a sign 'of our strength'.

27 Also: 'It's hard to generalize about all art and the US
but essentially the best art is opposed to the main kinds
of power and to many of the prevailing attitudes … the US
is still a hierarchical country, sort of a large
oligarchy, though apparently not as hierarchical as
Europe, which may be the difference between European and
American art; my work and that of most artists is opposed
to that hierarchy … My work has qualities which make it
impossible for it to be in agreement with all of this
[American foreign policy]. It couldn't exist, wouldn't
have been invented, in agreement or acceptance of this.'
'Donald Judd Answers Question: Can the Present Language
of Artistic Research in the US be said to Contest the
System?', *Metro*, 14 (1968).

28 Take for example, your remark: 'The explicit power which
displaces generalizations is a new and stronger form of
individuality'. Judd, 'Lee Bontecou', *op. cit*.

Karl Beveridge and Ian Burn, 'Donald Judd', *The Fox* (1975)
129-42.

Judy CHICAGO
Through the Flower: My Struggle as A Woman Artist
[1975]

[…] After I finished college, I decided to go to auto-body
school to learn to spray paint, something several of the
male artists had discussed doing. I was the only woman
among 250 men, all of whom lined up to see me do my
final project, which was spraying an old Ford truck with
metallic chartreuse paint. I learned quite a bit that was
actually beneficial to me as an artist, the most important
being an understanding of the role of craft. I had never
actually seen art-making in terms of 'making an object',

and learning this concept improved my work. The problem
was that I had gone there partly to prove something to the
male artists. Recently, a male artist told me that he had
held me up as an example to his female students, saying,
'You see, if you want to be taken seriously, you've really got
to dig in there, like Judy'. It may be true about digging in
there, but it is a shame that I was made to feel that 'digging
in' could be measured only in terms of 'tough talk', spray
paint and motorcycles.

What I have described is a voyage that I was forced to
make out of the female world and into the male world
where, I was told, 'real' art was made. I learned that if I
wanted my work to be taken seriously, the work should not
reveal its having been made by a woman. One of the best
compliments a woman artist could receive then was that
'her work looked like it was made by a man'. A sculpture
like *In My Mother's House*, done while I was in graduate
school, was smilingly referred to as 'one of Judy's cunts' by
male artists. (The imagery was obviously feminine and
vaginal.) In *Car Hood*, which I made at auto-body school,
the vaginal form, penetrated by a phallic arrow, was
mounted on the 'masculine' hood of a car, a very clear
symbol of my state of mind at this time […]

During the next five years, I was continually made to
feel by men in the art world that there was something
'wrong' with me. They'd say things like, 'Gee, Judy, I like
your work, but I just can't cut it that you're a woman'. Or
male artists who lived in the neighbourhood would come
over and be astonished that I wouldn't cook for them or
cater to their needs. I heard stories from people about how
someone said that I was a 'bitch' or a 'castrator', which
hurt me deeply. If I showed work and Lloyd didn't, then I
was held responsible for his not being shown, and I was
accused of having 'cut his balls off'. The same thing
applied if I did a good work and he did a work that wasn't
as good as his last piece. It seemed like I couldn't win. But I
wouldn't give up. I knew that what I was confronting came
out of the fact that I was a woman, but whenever I tried to
talk about that openly, I would be put down with
statements like, 'Come on, Judy, the suffrage movement is
over', and treated as if I were a leper.

All through this period, I worked and I showed my work
in galleries and museums. The two people who helped me
most were my dealer and Lloyd; they supported me and
stood up for me. My earlier naivete about my situation as a
woman artist was giving way to a clear understanding that
my career was going to be a long, hard struggle.
Fortunately, I knew that I was OK – that the problem was in
the culture and not in me, but it still hurt. And I still felt that
I had to hide my womanliness and be tough in both my
personality and my work. My imagery was becoming
increasingly more 'neutralized'. I began to work with
formal rather than symbolic issues. But I was never
interested in 'formal issues' as such. Rather, they were
something that my content had to be hidden behind in
order for my work to be taken seriously. Because of this
duplicity, there always appeared to be something 'not
quite right' about my pieces according to the prevailing
aesthetic. It was not that my work was false. It was rather
that I was caught in a bind. In order to be myself, I had to
express those things that were most real to me, and those

included the struggles I was having as a woman, both
personally and professionally. At the same time, if I wanted
to be taken seriously as an artist, I had to suppress
anything in my work that would mark it as having been
made by a woman. I was trying to find a way to be myself,
still function within the framework of the art community
and be recognized as an artist. This required focusing
upon issues that were essentially derived from what men
had designated as being important, while still trying to
make my own way. However, I certainly do not wish to
repudiate the work that I made in this period, because
much of it was good work within the confines of what was
permissible.

By 1966, I had had a one-woman show, had been in
several group and museum shows and had made a lot of
work that could be classified as 'Minimal', although
hidden behind that facade were a whole series of concerns
that I did not know how to deal with openly without
'blowing my cover', as it were, and revealing that I was, in
fact, a woman with a different point of view from my male
contemporaries. At that time, I firmly believed that if my
difference from men were exposed, I would be rejected,
just as I had been in school. It was only by being different
from women and like men that I seemed to stand a chance
of succeeding as an artist. There was beginning to be a lot
of rhetoric in the art world then to the effect that sex had
little to do with art, and if you were good, you could make it
[…]

My work itself reflected my struggles, albeit indirectly.
The hard materials (plastics and metals), perfect finishes
and minimal forms in my work of 1966 and 1967 were
'containers' for my hidden feelings, which flashed in the
polished surfaces, shone in the light reflections and
disappeared in the mirrored bases. I had stopped painting
entirely by 1965 and was making sculpture. My pieces were
either very small and rearrangeable, which made the
viewer huge in relation to them, or were large, simple
pieces that one walked through and was dwarfed by. This
duality paralleled my own experience: in my studio, I was
large and able to manipulate my own circumstances; in the
world, I was small and could get lost in values and
attitudes that were hostile and foreign to me. The small,
rearrangeable pieces had another dimension that was
directly related to the struggles Lloyd and I were going
through in trying to be independent while still maintaining
a close relationship […]

I dealt with most of these *through* my work. In going to
auto-body school, learning to use tools and machines,
facing and overcoming rejection and difficulties in the
world, working on large-scale pieces, I was moving out of
the limits of the female role, which was healthy. Although
aspects of my work process were shaped by male
pressure, my own desire to grow and be a whole and
functioning artist also motivated me. When I made the
small, re-arrangeable pieces and the large sculptures
through which one walked, I was trying to give voice to
my own feelings of 'moving through' and 'out into' an
unfamiliar world, trying to gain control over my life, trying
to expand my capacities. One might almost say that the
years 1965–67 were spent exploring those aspects of my
personality that this culture calls masculine: my strength,

both physical and mental, my assertiveness, my ability to conceptualize. It is interesting that it was during this period that I encountered hostile statements to the effect that I was trying to be a man and that I was 'castrating' Lloyd [...]

As I was still trying to 'slip by' in the male world and express myself without losing validation from men, I decided to use three dome shapes, the simplest forms that I could think of that had reference to my own body, breasts, fecundity, while maintaining the necessary neutrality for the art world. Each of the three domes were made of a transparent material and had layers inside that could not be clearly seen, an interesting metaphor for my own hidden depths. The layers were sprayed with softly changing colours, which overlapped and overlayed inside the forms. In order to make these pieces, I had to slowly and painstakingly develop technical skills. I had not sprayed since auto-body school, and now I wanted to spray on plastic, which was difficult to do and which no one on the West Coast had yet done, certainly not in the scale that I ultimately used. I began making some tests and working on colour systems that would make the forms feel as if they were dissolving. I was trying to invent a format for expressing what it was like to be female and to have a multi-orgasmic sexuality (this was before the Masters and Johnson studies were published). Along with trying to begin dealing with issues about the nature of my identity as a woman, I was involved with the final resolution of my family relationships. I still had an unresolved sense of loss and an unclear self-image. The dome shapes stood for the essential family unit of mother, father and child as well as my multiple sexuality. One could walk around the domes and see them from all sides, which allowed them to be examined for their constantly changing relationships. I often think now about the contained quality of the colour in the domes, the way it was trapped inside the swollen breast or belly form. Also, the fact that so much subject matter was hidden in such simple shapes is a testament to the gap that existed between my real concerns as a woman and the forms that the professional art community allowed a 'serious' artist to use.

Even though I neutralized the subject matter of this work, I was identified as revealing my femaleness when a woman artist from New York came to my studio with the director of a local museum. She looked at the domes and remarked scornfully, 'Ah, the Venus of Willendorf', a reference to early female fetishes. I was devastated. It was one thing to approach issues about my own femaleness, no matter how indirectly. It was quite another to be identified as doing so. Again, my femaleness was creeping into my work, as it had done in graduate school, and again it was being rejected, this time by a woman. After a while, I recovered from my distress and realized that whether my work would be accepted or not, I *had* to work through these issues. After all, on one level, I *was* the Venus of Willendorf and all that she symbolized. Rather than running away, I would have to find a way to affirm myself and my own identity as a woman artist [...]

Judy Chicago, *Through the Flower: My Struggle as A Woman Artist* (Garden City: Doubleday & Company, 1975) 36-53.

1980-present RECENT WRITINGS

In recent decades Minimalism has become a key point of reference in the critical debates around Postmodernism. For critic Hal Foster, Minimalism is a crux that both completes and ruptures the Modernist paradigm spelled out by Clement Greenberg and Michael Fried, whereas for the artist and writer Peter Halley the geometries and syntax of Minimal art reflect a simulacral logic of capitalist order and reproduction. More recently Anna C. Chave has associated Minimal style with the forms of patriarchal, even authoritarian, control, while Rosalind Krauss laments the spectacularization of Minimal art by the Postmodern museum. With the deaths of Donald Judd and Dan Flavin, Minimalism, however defined, has acquired the patina of a historical movement.

Donald JUDD
On Installation [1982]

The installation and context for the art being done now is poor and unsuitable. The correction is a permanent installation of a good portion of the work of each of the best artists. After the work itself, my effort for some eighteen years, beginning in a loft on Nineteenth Street in New York, has been to permanently install as much work as possible, as well as to install some by other artists. The main reason for this is to be able to live with the work and think about it, and also to see the work placed as it should be. The installations provide a considered, unhurried measure by which to judge hurried installations of my own and others in unfamiliar and often unsuitable places. This effort seems obvious to me, but few artists do it, though there is a tendency to keep earlier work, and the idea of a permanent installation is nearly unknown to the public for visual art.

There are four situations in which art is seen: the collector's home, the art gallery, the public space and the museum. The collector's home should be fairly harmless, but almost always the architecture is awful and the art extremely crowded. There are few collectors and even fewer persons who have only two or three things. Usually the art gallery doesn't look so bad, though trite, but it's the showroom of a business. Small portable work sells best, not large work that is nearly made in place. And the shows are temporary. Anyway, business shouldn't determined the way art is seen, although most of my work has been shown first in galleries, the best made and the best installed in Leo Castelli's three spaces. Art in a public space is a recent result of public money. At this point, art is art and is neither public nor private, so 'public art' is a misnomer. 'Public', practically, means the application of many extraneous worries to the art, which favours willing mediocrity. Some large good pieces by intractable artists have been made and they are among the public, which is desirable, but the locations are invariably appalling, leftover spaces among positive schmaltz. A bad location doesn't ruin a good work but it tends to reduce understanding to information: you know it's good but you can't stand standing there long enough to find out why. This is also true of art in some museums and of antiquities that have been overrun by industry or suburbia. These three categories, aside from the important economic activity of the gallery and a few large pieces in public, fail to produce serious results. If somewhere there were serious and permanent installations, the ephemeral exhibitions of the gallery and the awful environments of the work in public could be criticized and endured.

The gallery is fairly controllable, if limited, the public space slightly, the collector's glass ranch house not at all. Most owners of art install it badly; little can be expected. The museum should be serious and competent and much is expected but it's a disappointment and a failure. Ways of living, societies and grand institutions develop without much thought and so do some lesser institutions such as the museum. A museum of contemporary art, sometimes joined to a historical museum, itself debatable, has become a necessary symbol of the city and of the culture of the city all over the world. One result of the thoughtlessness of this expensive efflorescence is that no museum is able merely to physically exhibit the art of the last twenty years, barely and not well that of the last forty, and amply not that of the last hundred. Such an institution is no proof of culture.

The art museum was first the palace of a failed noble and then a bourgeois copy growing increasingly distant as the new rich grew distant from the disappearing aristocracy and as liberal functions developed, such as the obligations of the new rich to educate those they left behind. Right away it's clear that this has little to do with art. The new rich in the last century, the old rich in this and the new rich now, are basically middle class. Unlike some of the aristocracy, and of course like many, the present rich, the trustees of the museum, do not intend to know anything about art. Only business. The solution to the problem of having culture without having to think about it is to hire somebody. The rich middle class is bureaucratic, so there's an expert for everything. The result is that there's little pleasure in art and little seriousness for anyone anywhere. A museum is the collection of an institution and it's an anthology. A few anthologies are all right, but some hundred in the US alone is ridiculous. It's freshman English forever and never no more literature.

Art is only an excuse for the building housing it, which is the real symbol, precise as chalk screeching on a blackboard, of the culture of the new rich. The new National Gallery is a fine example. It's the apotheosis of the public space. The main exhibition area is leftover space within the solids of a few triangles and a parallelogram, containing offices and boutiques. The power of the central government, the status of the financiers and the mediocre taste of both are dignified by art, much of it done by artists very poor most of their lives. So much money spent on architecture in the name of art, much more than goes to

It takes a great deal of time and thought to install work carefully.

This should not always be thrown away.

Most art is fragile and some should be placed and never moved again.

Some work is too large, complex and expensive to move.

Somewhere, a portion of contemporary art has to exist as an example of what the art

and its context were meant to be.

Somewhere, just as the platinum-iridium metre guarantees the tape measure,

a strict measure must exist for the art of this time and place.

Otherwise, .art is only show & monkey buines.

Donald JUDD 'Statement for the Chinati Foundation', 1986

art, is wrong, even if the architecture were good, but it's bad.

The handling and preservation in a museum, which is expected to be careful, is often careless. Sometimes the staff seems to resent the art. Usually the view is that the damage doesn't matter and can be repaired. Even with the best intentions of a director or a curator the installation is seldom good because the rooms are not. Always of course the exhibitions are temporary. Finally, the artist lends work, accepts damage to it – insurance is a joke – gives time, and gets next to nothing: 'The work is out in public'. The artist should be paid for a public exhibition as everyone is for a public activity […]

A good installation is too much work and too expensive and, if the artist does it, too personal to then destroy. Paintings, sculptures and other three-dimensional work cannot withstand the constant installation and removal and shipping. The perpetual show business is beyond the museum's finances and capacities. The show business museum gets built but the art does not, nor even handled well, when the art is the reason for the building. And the architecture is well below and behind the best art. An example of something much better for less money is to have saved *Les Halles* in Paris, an important deed itself, and then to have given two hundred thousand dollars each, sufficient at the time, to a dozen of the world's best artists to make work to remain forever. This would have been the achievement of the century. Instead Beaubourg was built, an expensive, disproportionate monster, romanticizing the machinery of an oil refinery, not scarce. The building makes change the main characteristic of paintings and sculptures that don't change. The building and the change are just show business, visual comedy […]

Millions are spent by the central government for and in the name of art and the same by the semi-public museums. All that money does not produce more first-rate art; in fact there is less since the government became involved. And the government is too dangerous to be involved. Money will not make good art; ultimately art cannot be bought. The best artists living now are valuable and not replaceable and so the society should see that their work gets done while they're alive and that the work is protected now and later. If this society won't do this, at least it could revise some of its attitudes, laws and tax laws to make it easier for the artists to do so. Art has no legal autonomy.

I bought a building in New York in 1968, which contains my work and that of others, and two buildings in Texas in 1973, which contain my work. One building in Texas has two large rooms and the other has one. Each of the two took two years of thinking and moving pieces around. The one room took about a year. One of the two rooms was the basis for the installations in the exhibition of my work at The National Gallery of Canada in 1975, which occupies part of an office building and so has fairly plain, decent space. None of my work that's installed is lent nor is that by other artists. Permanent installations and careful maintenance are crucial to the autonomy and integrity of art and to its defence, especially now when so many people want to use it for something else. Permanent installations are also important for the development of

larger and more complex work. It's not so far from the time of easel painting, still the time of the museum, and the development of the new work is only in the middle of the beginning.

Donald Judd, 'On Installation', *Documenta 7* (Kassel: Documenta 7, 1982) 164-67; reprinted in *Donald Judd: Complete Writings 1975-1986* (Eindhoven: Stedelijk Van Abbemuseum, 1987). Originally published under the title 'The Importance of Permanence', *Journal: A Contemporary Art Magazine*, 32: 4 (Los Angeles: LAICA, Spring 1982) 18-21.

Donald JUDD

Statement for the Chinati Foundation [1986]

In November 1971 I came to Marfa, Texas, to make a home for the summers in the southwest of the US and the northwest of Mexico, which before the Conquest was called Chichimeca. In 1973 and 1974 I bought three buildings and the land surrounding them, comprising a city block, which is now a large complex containing a great deal of my work and some by other artists. In 1975 I became a resident of Texas. In 1979 I began work on what is now the Chinati Foundation, a name given in 1986, the name of a nearby mountain.

The Chinati Foundation is the successor in Marfa to the Dia Foundation, which in 1979 purchased most of Fort DA Russell, where the Chinati Foundation is primarily located, as well as a very large building in the centre of town which became the installation of John Chamberlain's work. Later, as I suggested, Dia purchased two sections on the Rio Grande, 96.5 km [60 miles] away, as a site for a very large work of mine to be made of adobe, which was never begun. Also, Dia paid for the construction and purchase of five groups of my work, two of which are installed and three which are not: fifteen pieces made of concrete and 100 pieces made of mill aluminium, three vertical pieces, thirteen horizontal pieces and two large works in stainless steel. Dia provided the work by Chamberlain.

The Chinati Foundation, Fundación Chinati, which is independent, is now one of the largest visible installations of contemporary art in the world, visible, not in storage. When it nears completion or even now, if my own complex is added, it is the largest, as befits Texas.

The enterprise in Marfa was meant to be constructive. The art was meant to be, and now will be, permanently installed and maintained in a space suitable to it. Most of the art was made for the existing buildings, which were dilapidated. The buildings were adjusted to the art as much as possible. New ones would have been better. Nevertheless, in reworking the old buildings, I've turned them into architecture.

It takes a great deal of time and thought to install work carefully. This should not always be thrown away. Most art is fragile and some should be placed and never moved again. Some work is too large, complex and expensive to move. Somewhere, a portion of contemporary art has to exist as an example of what the art and its context were

meant to be. Somewhere, just as the platinum-iridium metre guarantees the tape measure, a strict measure must exist for the art of this time and place. Otherwise, art is only show and monkey business.

The art and architecture of the past that we know is that which remains. The best is that which remains where it was painted, placed or built. Most of the art of the past that could be moved was taken by conquerors. Almost all recent art is conquered as soon as it's made, since it's first shown for sale and once sold is exhibited as foreign in the alien museums. The public has no idea of art other than that it is something portable that can be bought. There is no constructive effort; there is no co-operative effort. This situation is primitive in relation to a few earlier and better times.

Art and architecture – all the arts – do not have to exist in isolation, as they do now. This fault is very much a key to the present society. Architecture is nearly gone, but it, art, all of the arts, in fact all parts of society, have to be rejoined, and joined more than they have ever been. This would be democratic in a good sense, unlike the present increasing fragmentation into separate but equal categories, equal within the arts, but inferior to the powerful bureaucracies […]

Most of the activities which should support art, which claim to support art, which justify themselves so, are nearly irrelevant to it. These are the museums, the art bureaucrats, the critics and the educators. Only the galleries – commerce – are not irrelevant, and they furnish an ambiguous situation, providing money necessary to live and work, but also a mercenary attitude, beyond the necessary business, which younger artists and the public are now quick to assume is part of the nature of art. Most older artists know very well that they are prior and separate from the galleries and certainly from the museums, but many younger artists accept the scheme which has grown since World War II as the nature of things. This new social structure is not part of the reality of art, and is killing it. This has to be resisted. I've always defended my work. I've installed every public exhibition and have kept and installed work in my own spaces, most of which are in my place in Marfa.

The Chinati Foundation is an attempt to continue this on a greater scale and also to extend the consideration to Flavin's and Chamberlain's work. This is nearly the only attempt I know of to show completely and naturally the present reality of art. Art must be the only activity which its practitioners don't control. We, after all, the 'experts', and not so many, are told what to do by many upstart self-appointed experts […]

Donald Judd, 'Statement for the Chinati Foundation', 1986 in *Donald Judd: Complete Writings 1975-1986* (Eindhoven: Stedelijk Van Abbemuseum, 1987) 110-14.

Peter HALLEY

Frank Stella … and the Simulacrum [1986]

'Here comes the time of the great Culture of tactile communication, under the technico-luminous cinematic space of total spatio dynamic theatre.'
– Jean Baudrillard

There have consistently been two poles around which critical attitudes towards the work of Frank Stella have been located. On one hand, his work has been hailed as an apotheosis of rigorous Modernist painting. It is seen as material in its effects, unbending in its logic and hermetic in its outlook. On the other hand, it is viewed, derisively, as a dehumanized dead end of painting. Here it is judged that the complexity of painting has been eliminated and the images have become merely 'graphic'. Humanistic subtlety is seen to be lacking in his work, where only a 'bureaucratic' reshuffling and an 'administrative', managerial approach to making art remain.

Ironically, it is only by combining these two viewpoints that a cogent appreciation of Stella's work can emerge. We will find that Stella's art is both materialist and bureaucratic, that it is both hermetic and graphic. But in order to encompass these various qualities, a different critical overview is needed. We will find that Stella is neither a Modernist nor a bureaucrat, but that his work conforms closely to a model of Postmodernism that is dominated by ideas of hyper-realization, simulation, closure and fascination.

We must initially ask, how can Frank Stella's work be postmodern when Postmodernism is an idea that has emerged in criticism only in the 1980s? The answer is that the critical formulation and dissemination of the idea of Postmodernism has lagged far behind its appearance in art and in culture. It is in fact in the early 1960s, the time of Frank Stella's emergence as an artist, that the elements of the Postmodern and its kindred phenomenon, the post-industrial, began to fall into place.

The early 1960s produced the emergence of the informational culture of the computer and of electronics. It produced international jet travel on a commercial scale and the accompanying changes in spatio-temporal and cultural relationships that phenomenon precipitated. The 1960s produced the Interstate Highway System and the associated development of the de-centred Sun Belt cities that are based on the circulation of the automobile. It produced ICBMs, the space programme and satellite reconnaissance, all of which inscribed reality within their circular orbits and parabolic trajectories.

If the 1960s were the cusp between the worlds of the industrial and the post-industrial, and between the real and the simulated, the art of the 1960s was a response to this situation. On one side, in 1960s art there is an intense nostalgia for both traditional and industrial culture. Rock musicians were fascinated by the acoustic blues of the railroad culture of the 1920s and by sitar music from India. Fashion embraced Guatemalan textiles and the clothing of the nineteenth-century American West. But at the same time, there is a fascination for the technological, the simulated and the futuristic that is reflected in such phenomena as moulded plastic furniture, the electric guitar and the geodesic dome.

Stella, around 1960, can be seen as responding to this

same situation. In Stella's work, a crucial transition took place in the jump between the *Black Paintings*, which were still nostalgic for the industrial and the traditional, and the *Aluminum Paintings*, which clearly embodied elements of the hyper-real, post-industrial world.

The *Black Paintings* were still Modernist in inspiration. The paint application, while mechanical, is uneven – and it shimmers with the sensitivity to light that is present in, for example, a Rothko. The patterned bands are likewise repetitive, but their symmetrical, hieratic quality and the frequent use of diagonal motifs links the images to the use of patterning in traditional non-Western art. The configurations are reminiscent of Islamic tile-work or perhaps Kurdistani carpets. Finally, the ubiquitous brooding black colour links the paintings to 1950s nihilism and existentialism.

In the *Aluminum Paintings*, an entirely different consciousness is posited. The paint is now applied evenly, the bands separated by taped lines. The effect is cool, even, science-fictional. The paint is now not just shimmering – it is aluminium, which is a contemporary, technological metal linked with lightness, efficiency and commercial usefulness. Most importantly, however, the configurations have almost completely lost their traditional associations. Instead, the introduction of the 'jog' suddenly makes the bands appear to be moving: they are like lanes on a highway, emphasizing movement or circulation. In addition, the bands are unvarying and uninflected. They fill the space evenly and neutrally, becoming surrogates for activity in the painting and substitutes for painterly incident and imagery.

The cut-out areas of the *Aluminum Paintings* also have an important function. No longer are these lanes of movement, these conduits of circulation, seen against a background as they are in, say, a Mondrian. In Stella, the background and with it nature is cut out. Abstract circulation and movement becomes the only reality.

In the various series of stripe paintings during the following five years, the concerns of the *Aluminum Paintings* were furthered and expanded. The *Copper Paintings* are noteworthy in so far as their right-angle turns and intersections make more explicit Stella's circulatory concerns. The *Purple* series introduced a new level of simulated intensity with Stella's use of metallic purple pigment. Their configurations – triangles, parallelograms and pentagons in which the bands form a continuous circuit – also define a situation of closure and circularity where line flows into line without beginning or end.

In the *Running V* series, the bands seem to travel at a new velocity more akin to electricity moving through a microprocessor than mere automobiles travelling on a highway. In the *Moroccan* series, Day-Glo paint is introduced. Colour itself is now replaced by its hyper-realized, simulated equivalent. In addition, in the *Moroccan* series, the theme of 'non-Western culture' re-emerges in a postmodern way. There is no longer any possibility of actual influence by a non-Western sensibility in this art. Rather, in these paintings, as in the phenomenon of 'Super Graphics', Moroccan culture is deracinated and reduced to its most easily reproduced signs. A whole culture is reproduced by the simple devices

of bright colour and diagonal, repeating patterns. The enclosure by the hyper-real of all other realities is complete.

Stella's development during these years is of interest not just for the visual themes that appear in his pictures, but for the way he went about ordering the production of his paintings as well. During this period, Stella hyper-realized the means he employed. He used only man-made, high-tech pigments and paints. His deep stretchers, shaped formats and extra-human scale also seem to hyper-realize the painting as an object: they are pushed further from the wall than a 'real' painting; they are bigger and more aggressive in shape.

At the same time, Stella's use of the series in moving from one group of paintings to the next is important. Artists have often worked in series, but in Stella's work there is no gradual evolution from painting to painting as one series emerges from the next. Rather, series follows series in almost yearly intervals like car models from Detroit. Further, within the series, there is no Modernist original upon which the other works are based. Instead, the configurations for the whole series were decided on beforehand. The identity of each painting was based on its being a part of the group.

The exhibition of these paintings as complete series hyper-realized the Modernist idea of the art exhibit. In a Stella exhibition during these years, no evolution was visible. There were no large important paintings and smaller intimate ones. Rather, there was just the display of the series, which, combined with the other simulated and hyper-real means Stella had employed, gave these exhibitions a distinctly science-fictional quality.

In 1967, with the *Protractor* series, Stella's work moved even further into the world of simulation. Until 1967 Stella's paintings could still be read literally, as flat areas of paint on canvas, without illusion or ambiguity. But in the *Protractor Paintings*, the way space is made becomes three-fold and contradictory. First, there is the physical space of the painting-as-object, which is dramatized by the work's massive dimensions, unusual shapes and deep relief. It is further emphasized by the inelegant physical way the canvas is stretched over the huge stretchers, the casual pencil-lines and the alternating areas of evenly applied paint and raw canvas. Secondly, there is the space of the design, which emphasizes either the overlap of the interlacing bands or the interlocking relationships between fanning and framing bands. Thirdly, there is the space made by combining Day-Glo and bright acrylic colours. Together they pulsate with an eerie push-pull effect that creates a colouristic space. Thus, three independent spatial systems combine to achieve a space of theatricality and fascination. There is no attempt at a unity of spatial clues. Rather, the spatial signs are additive – they combine to give as intense an effect as possible. Here, we have left the unified modern space of reason and have entered a postmodern space whose purpose is to seduce.

In the *Protractor* series, Stella also furthered his relationship with the issues of multiplicity and the model. The *Protractor Paintings* are not only based on a series of pre-existing patterns, but each variant is now treated in

three different ways, as 'interlaces', 'rainbows' and 'fans'. The choice of the protractor as the basis for this series is also significant. Stella's previous configurations had been based on simple geometric shapes – squares, triangles, pentagons and so on – shapes which still had some link with the classical, idealist tradition of geometry. With the protractor, Stella chose instead a tool of the designer and engineer. The protractor is itself both a model and a tool for making models. With the *Protractor* series, Stella takes the final step from the modern world of the ideal into the postmodern world, where the model precedes all.

In Stella's work, the *Protractor* series was at the same time an end and a beginning. It was the end of his making paintings simply with paint on canvas, while it was the beginning of his use of additive, colouristic and spatial effects to create visual overload that has characterized his work in metal relief up to the present time.

The various series of metal-relief paintings represent an intensification of the approach taken in the *Protractor* series. Seemingly massive cut-out shapes of high-tech honeycomb aluminium are lifted and tilted with mystifying ease. They are layered one over another with such complexity that any idea of their actual spatial relationships is confused. Figure and ground are also obscured as holes created by negative spaces are filled by shapes peeking out from behind. Then, each plane is covered with a profusion of texture, colour and brushwork that further complicates the space and creates a sense of scintillating spectacle. In this work, we are in a world where space is dramatic but no longer makes sense, where everything is arranged to maximize effect. Here, like at Disneyworld, Las Vegas or the shopping mall, everything is arranged to entice, seduce and amaze.

This is also a world in which any sign is admissible but all are severed from any vestigial real meaning. In these works, the Abstract Expressionist brushstroke is reduced to an empty, neutral sign. The brilliant, complex colour serves no other purpose than to establish the colour-effect. Likewise, composition serves only to establish the ideas of movement and attraction. The works as a whole become a hyper-real, neutral simulation of painting.

The only references out of the work are into the world of the Simulacrum. Honeycomb aluminium and etched magnesium remind us of the post-industrial world of ultra-light metals and printed circuits. The illusionistic 'cones and pillars' of the newest work are reminiscent of the spatial simulations of computer graphics. And, of course, everything refers to the universe of the model – multiply produced parts with repeating imagery are bolted together into paintings that are themselves also multiples.

If we have established a case for Frank Stella's work as postmodern, we must finally ask: how can this be so when Stella himself articulates such a different set of concerns for his own work? It is possible because in the postmodern situation the artist does not necessarily have the same degree of self-consciousness that was the ideal of Modernism. In fact, in the case of Stella, we may see him acting out the role of Modernist artist for a postmodern audience, and we can see his work as a hyper-realization of Modernism. We may also see him so firmly encased within the Simulacrum that he has no awareness of its existence

(unlike Warhol, who during the 1960s constantly alluded to his consciousness of this issue – although this was perhaps why he was unable to sustain his critique). For example, Stella has recently discussed his desire to give his work the same intense reality that is present in the work of an artist like Caravaggio. But if we translate Stella's desire for intense reality into desire for intense hyper-reality, we can get an idea of Stella's position vis-à-vis the Simulacrum.

Finally, Stella's Modernist credentials are often supported by reference to his education: as a product of the prep school and the distinguished university, he is thought undoubtedly to be a worthy standard-bearer of the Modernist tradition. Yet it is exactly this training that explains why we may locate Stella within the Simulacrum. For the Simulacrum was not invented by the masses, by the drinkers of Pepsi and the watchers of Super Bowls. It was invented by corporations, brokerage houses, advertising firms and broadcasting companies, precisely those institutions that draw their leaders from those machines for turning Modernist knowledge into postmodern information, the elite universities.

Peter Halley, 'Frank Stella … and the Simulacrum', *Flash Art* (January 1986); reprinted in *Peter Halley: Collected Essays 1981-1987* (Zurich: Bruno Bischofberger Gallery, 1988) 137-50.

Hal FOSTER
The Crux of Minimalism
[1986/96]

ABC art, primary structures, literalist art, Minimalism: most of the terms for the relevant work of Carl Andre, Larry Bell, Dan Flavin, Donald Judd, Sol LeWitt, Robert Morris, Richard Serra and others suggest that this art is not only inexpressive but almost infantile. Often dismissed in the 1960s as reductive, Minimalism was often regarded in the 1980s as irrelevant, and both trashings are too vehement to be only a matter of art world polemics. Beyond the vested interests of artists and critics pledged to humanist ideals and/or iconographic images in art, these trashings of Minimalism were conditioned by two related events: in the 1960s by a specific sense that Minimalism consummated one formalist model of Modernism, completed and broke with it at once; and in the 1980s by a general reaction that used a trashing of the 1960s to justify a return to tradition in art and elsewhere. For just as rightists in the 1950s sought to bury the radicalism of the 1930s, so rightists in the 1980s sought to cancel the cultural claims and to reverse the political gains of the 1960s, so traumatic were they to these neo-conservatives. Nothing much changed for the Gingrich radicals of the early 1990s, and political passion against the 1960s runs as high as ever today.[1]

So what is at stake in this trashing is history, in which Minimalism is hardly a dead issue, least of all to those who would make it so. It is, however, a perjured one, for in the 1980s Minimalism was represented as reductive and

retardataire in order to make neo-Expression appear expansive and vanguard, and in this way the different cultural politics of the Minimalist 1960s and the neo-Expressionist 1980s were misconstrued. For all its apparent freedoms, neo-Expressionism participated in the cultural regressions of the Reagan–Bush era, while for all its apparent restrictions, Minimalism opened up a new field of art, one that advanced work of the present continues to explore – or so it will be the burden of this chapter to prove. To do so, the reception of Minimalism must first be set in place, then a counter-memory posed via a reading of its fundamental texts. Next this counter-memory will be used to define the dialectical involvements of Minimalism with both late-Modernist and neo-avant-garde art, which in turn will suggest a genealogy of art from the 1960s to the present. In this genealogy Minimalism will figure not as a distant dead end but as a contemporary crux, a paradigm shift towards postmodernist practices that continue to be elaborated today. Finally, this genealogy will lead back to the 1960s, that is, to the place of Minimalism in this critical conjuncture of post-war culture, politics and economics.[2]

RECEPTION: 'I OBJECT TO THE WHOLE REDUCTION IDEA'
On first glance it all looks so simple, yet in each body of work a perceptual ambiguity complicates things. At odds with the 'specific objects' of Judd is his nonspecific composition ('one thing after another').[3] And just as the given Gestalts of Morris are more contingent than ideal, so the blunt slabs of Serra are redefined by our perception of them in time. Meanwhile, the latticed logic of LeWitt can be obsessive, almost mad;[4] and even as the perfect cubes of Bell appear hermetically closed, they mirror the outside world. So what you see is what you see, as Frank Stella famously said,[5] but things are never as simple as they seem: the positivism of Minimalism notwithstanding, perception is made reflexive in these works and so rendered complex.

Although the experiential surprise of Minimalism is difficult to recapture, its conceptual provocation remains, for Minimalism breaks with the transcendental space of most Modernist art (if not with the immanent space of the Dadaist readymade or the Constructivist relief). Not only does Minimalism reject the anthropomorphic basis of most traditional sculpture (still residual in the gestures of Abstract Expressionist work), but it also refuses the siteless realm of most abstract sculpture. In short, with Minimalism sculpture no longer stands apart, on a pedestal or as pure art, but is repositioned among objects and redefined in terms of place. In this transformation the viewer, refused the safe, sovereign space of formal art, is cast back on the here and now; and rather than scan the surface of a work for a topographical mapping of the properties of its medium, he or she is prompted to explore the perceptual consequences of a particular intervention in a given site. This is the fundamental reorientation that Minimalism inaugurates.

Made explicit by later artists, this reorientation was sensed by early critics, most of whom lamented it as a loss for art. Yet in the moralistic charge that Minimalism was

reductive lay the critical perception that it pushed art towards the quotidian, the utilitarian, the nonartistic. For Clement Greenberg, the Minimalists confused the innovative with the outlandish and so pursued extraneous effects rather than essential qualities of art. This was why they worked in three dimensions (note that he does not call this work 'sculpture'), a zone in which what is specific for Judd is arbitrary for Greenberg: 'Minimalist works are readable as art, as almost anything is today – including a door, a table or a blank sheet of paper.'[16] Greenberg intended this remark as a scourge, but to the likes of John Cage it was an avant-gardist challenge: 'We must bring about a music which is like furniture'.[7] And this challenge was indeed taken up, via Robert Rauschenberg, Jasper Johns, John Cage and Merce Cunningham, in Minimalist art (e.g. Judd and Morris), music (e.g. Philip Glass), dance (e.g. Yvonne Rainer) and theatre (e.g. Robert Wilson), if rarely in the interests of a restored use value for culture.[8] In this reorientation Greenberg smelled a rat: the arbitrary, the avant-gardist, in a word, Marcel Duchamp. This intuition of the return of the readymade paradigm in particular and the avant-gardist attack on the institution of art in general was common among both advocates and detractors of Minimalism, and it is one I want to develop here.

For Richard Wollheim, too, the art content of Minimalism was minimal; indeed, it was he who introduced the term, by which he meant that the work of art was to be considered in terms less of execution or construction than 'of decision or dismantling'.[9] This aesthetic possibility is still taken as a threat in the guild of high art; here Greenberg defends against it: 'Minimal art remains too much a feat of ideation'. If the first great misreading is that Minimalism is reductive, the second is that it is idealist. This was no less a misreading, made by some Conceptual artists too, when it was meant positively: that Minimalism captures pure forms, maps logical structures or depicts abstract thought. For it is precisely such metaphysical dualisms of subject and object that Minimalism seeks to overcome in phenomenological experience. Thus, far from idealist, Minimalist work complicates the purity of conception with the contingency of perception, of the body in a particular space and time. (Consider how Serra pressures the Platonic idea of the cube in *House of Cards* [1969], a massively fragile propping of lead slabs.) And far from conceptual, Minimalism is not 'based on systems built beforehand, a priori systems', or so Judd argued in 1966.[10] However, more important to Minimalism than this perceptual positivism is its avant-gardist comprehension of art in terms of its conventionality.[11] In short, Minimalism is as self-critical as any late Modernist art, but its analysis tends towards the epistemological more than the ontological, for it focuses on the perceptual conditions and conventional limits of art more than on its formal essence and categorical being. It is this orientation that is so often mistaken as 'conceptual'.

In this way the stake of Minimalism is the nature of meaning and the status of the subject, both of which are held to be public, not private, produced in a physical interface with the actual world, not in a mental space of idealist conception.[12] Minimalism thus contradicts the two

dominant models of the Abstract Expressionist, the artist as existential creator (advanced by Harold Rosenberg) and the artist as formal critic (advanced by Greenberg). In so doing it also challenges the two central positions in modern aesthetics that these two models of the artist represent, the first expressionist, the second formalist. More importantly, with its stress on the temporality of perception, Minimalism threatens the disciplinary order of modern aesthetics in which visual art is held to be strictly spatial. It is for this category mistake that Michael Fried condemned Minimalism – and rightly so from his position, for Minimalism did prompt a concern with time as well as an interest in reception in process art, body art, performance, site-specific work and so on. Indeed, it is difficult to see the work that follows Minimalism as entirely present, to be grasped in a single glance, a transcendental moment of grace, as Fried demands of Modernist art at the end of his famous attack on Minimalism, 'Art and Objecthood'.[13]

As Minimalism challenges this order of modern aesthetics, it also contradicts its idealist model of consciousness. For Rosalind Krauss this is the central import of the Minimalist attack on anthropomorphism and illusionism, for in her account these categories constitute not only an outmoded paradigm of art but an ideological model of meaning. In 'Specific Objects'[14] (1965) Judd had already associated relational composition with a 'discredited' rationalism. In 'Sense and Sensibility: Reflections on Post '60s Sculpture'[15] (1973), Krauss poses a further analogy between illusionism and intentionality. For an intention to become an idea, she argues, an illusionist space of consciousness must be posited, and this space is idealist. Thus, to avoid the relational and the illusionist, as Minimalism sought to do through its insistence on non-hierarchical orderings and literal readings, is in principle to avoid the aesthetic correlates of this ideological idealism as well.

This reading of Minimalism warrants a digression. In her phenomenological account of Minimalism, of Minimalism *as* a phenomenology, Krauss insists on the inseparability of the temporal and the spatial in our reading of this art. Indeed, in *Passages in Modern Sculpture*[16] (1977) she rethinks the Modernist history of the medium through this inseparability (which her very title advances). In effect Krauss gives us a Minimalist history of Modernist sculpture in which Minimalism emerges as the penultimate move in its long passage 'from a static, idealized medium to a temporal and material one'.[17] Here, rather than posit Minimalism as a break with Modernist practice (the conclusion to which her subsequent criticism tends),[18] she projects a Minimalist recognition back on to Modernism so that she can then read Minimalism as a Modernist epitome. Yet it is no less a break with it.

Of special interest here is the anachronism of this Minimalist reading of Modernist sculpture, which Krauss justifies in this way:
'*The history of modern sculpture coincides with the development of two bodies of thought, phenomenology and structural linguistics, in which meaning is understood to depend on the way that any form of being contains the latent experience of its opposite: simultaneity always*

containing an implicit experience of sequence'.[19]
It is true that, as represented by Edmund Husserl and Ferdinand de Saussure, phenomenology and structural linguistics did emerge with high Modernism. Yet neither discourse was current among artists until the 1960s, that is, until the time of Minimalism, and when they did re-emerge they were in tension.[20] For example, structuralism was more critical of idealist consciousness and humanist history than was phenomenology; phenomenology was questioned because such notions were held to be residual in it. Now if this is so, and if Minimalism is phenomenological at base, one might question how radical *its* critique of these notions is. For instance, just as phenomenology undercuts the idealism of the Cartesian 'I think', so Minimalism undercuts the existentialism of the Abstract Expressionist 'I express', but both substitute an 'I perceive' that leaves meaning lodged in the subject. One way to ease this bind is to stress the structuralist dimension of the Minimalist conjuncture, and to argue that Minimalism is also involved in a structural analysis of pictorial and sculptural signifiers. Thus, while some artists (like Robert Irwin) develop the phenomenological dimension of Minimalism, others (like Michael Asher) develop its structural analysis of these signifiers.

Minimalism does announce a new interest in the body – again, not in the form of an anthropomorphic image or in the suggestion of an illusionist space of consciousness, but rather in the *presence* of its objects, unitary and symmetrical as they often are (as Fried saw), just like people. And this implication of presence does lead to a new concern with perception, that is, to a new concern with the subject. Yet a problem emerges here too, for Minimalism considers perception in phenomenological terms, as somehow before or outside history, language, sexuality and power. In other words, it does not regard the subject as a sexed body positioned in a symbolic order any more than it regards the gallery or the museum as an ideological apparatus. To ask Minimalism for a full critique of the subject may be anachronistic as well: it may be to read it too much in terms of subsequent art and theory. Yet this question also points to the historical and ideological limits of Minimalism – limits tested by its critical followers. For if Minimalism does initiate a critique of the subject, it does so in abstract terms, and as subsequent art and theory develop this critique, they also come to question Minimalism (this is especially true of some feminist art). Such is the difficulty of a genealogical tracing of its legacy, which here must await an analysis of the discourse of Minimalism in its own time.

DISCOURSE: 'THERE IS NO WAY YOU CAN FRAME IT'
In its own time the discourse of Minimalism was dominated by three texts: 'Specific Objects' by Donald Judd (1965), 'Notes on Sculpture: Parts I and II' by Robert Morris (1966) and 'Art and Objecthood' by Michael Fried (1967).[21] Although well known, they manifest both the claims and the contradictions of Minimalism in ways that are not well understood.

The year of 'Specific Objects', 1965, was also the year that Greenberg revised his position paper, 'Modernist Painting', which followed by four years his landmark

collection of essays *Art and Culture*. In this context the first two claims made by Judd – that Minimalism is neither 'painting nor sculpture' and that 'linear history has unravelled somewhat' – defy both categorical imperatives and historicist tendencies in Greenbergian Modernism. Yet this extreme defiance developed as excessive devotion. For example, the reservation voiced by Greenberg about *some* painting after Cubism – that its content is too governed by its edge – is elaborated by Judd into a brief against *all* Modernist painting – that its flat, rectangular format 'determines and limits the arrangement of whatever is on and inside it'.[22] Here, as Judd extends Greenberg, he breaks with him, for what Greenberg regards as a definitional essence of painting Judd takes as a conventional limit, literally a frame to exceed. This break is attempted through a turn to 'Specific Objects', which he positions in relation to late Modernist *painting* (again, as represented by David Smith and Mark di Suvero, late Modernist sculpture remains too mired in anthropomorphic composition and/or gesture). In short, *Judd reads the putatively Greenbergian call for an objective painting so literally as to exceed painting altogether in the creation of objects.* For what can be more objective, more specific, than an object in actual space? Moved to fulfil the late Modernist project, Judd breaks with it, as is clear from his list of prototypes: Duchamp readymades, Johns cast objects, Rauschenberg combines, John Chamberlain scrap-metal sculptures, Stella shaped canvases, and so on – all rejects from the Greenbergian canon.

This list suggests another consequence of the Minimalist super-session of late Modernist art. According to Judd, some of these precursors assumed that 'painting and sculpture have become set forms', that is, forms whose conventionality could not be elaborated further. 'The use of three dimensions', he claims (note that Judd too does not term Minimalism 'sculpture'), 'isn't the use of a given form' in this reified sense. In this other realm of objects, he suggests, *any* form, material or process can be used. This expansion opens up criticism, too, as Judd is led by his own logic to this infamous avant-gardist position: 'A work of art needs only to be interesting'. Here, consciously or not, *interest* is posed against the great Greenbergian shibboleth *quality*. Whereas quality is judged by reference to the standards not only of the Old Masters but of the Great Moderns, interest is provoked through the testing of aesthetic categories and the transgressing of set forms. In short, quality is a criterion of normative criticism, an encomium bestowed upon aesthetic refinement; interest is an avant-gardist term, often measured in terms of epistemological disruption. It too can become normative, but it can also license critical enquiry and aesthetic play.[23]

In 'Specific Objects', then, the mandate that late Modernist art pursue objectivity is completed only to be exceeded, as Judd and company come out the other side of the objecthood of painting into the realm of objects. In 'Notes on Sculpture: Parts I and II' Robert Morris presents a different scenario in which Minimalism is again set in a complicated relation to late Modernist discourse.

As Morris retains the category of sculpture, he implicitly disagrees with Judd on the genesis of Minimalism. Sculpture was never 'involved with illusionism', pictorial as this category is, and neither is Minimalism. Far from a break with sculpture, Minimalism realizes 'the autonomous and literal nature of sculpture ... that it have its own, equally literal space'. At first glance this statement seems contradictory, for its two adjectives conflate the positions held by Greenberg and Judd respectively: the demand for autonomy and the demand for literalism. Yet this is precisely how Morris sees Minimalism, as a provisional resolution of this contradiction, for he defines its unitary forms as *both* autonomous and literal. With Minimalist Gestalts, Morris writes, 'One sees and immediately "believes" that the pattern of one's mind corresponds to the existential fact of the object'. His is the most nuanced discussion of the quintessentially Minimalist tension between 'the known constant and the experienced variable'. Although Morris sometimes privileges the unitary form as prior to the Specific Object (in a way that the anti-idealism of Minimalism otherwise does not), he usually presents the two as bound *qua* Gestalt 'cohesively and indivisibly together'. This unity is necessary for Morris to retain the category of sculpture and to posit shape as its essential characteristic.

Yet this argument also appears circular. Morris first defines Modernist sculpture in terms of Minimalism (that it be literal) and then defines Minimalism in terms of Modernist sculpture (that it be autonomous). He then arrives at the very property, shape, that a year later Fried will pose as the essential value of *painting*. Part I of 'Notes on Sculpture' ends in this way: 'The magnification of this single most important sculptural value ... establishes both a new limit and a new freedom for sculpture'. The paradoxical nature of this statement suggests the tensions in Minimalist discourse as well as the instabilities of aesthetic categories at this time. *For Minimalism is both a contraction of sculpture to the Modernist pure object and an expansion of sculpture beyond recognition.*

In Part II of 'Notes on Sculpture', Morris addresses this paradoxical situation. First he defines the 'new limit' for sculpture by reference to a remark by Tony Smith that situates Minimalist work somewhere between the object and the monument, around the scale of the human body. Then in an incisive move Morris redefines this scale in terms of address (from private object to public monument), that is, in terms of *reception* – a shift in orientation from the object to the viewer that turns the 'new limit' for sculpture into its 'new freedom' [...]

In this way, as Judd exceeds Greenberg, so Morris exceeds both, for here, in 1966, a new space of 'object/subject terms' is acknowledged. The Minimalist suppression of anthropomorphic images and gestures is more than a reaction against the Abstract Expressionist model of art; it is a 'death of the author' (as Roland Barthes would call it in 1968) that is at the same time a birth of the viewer.

'The object is but one of the terms of the newer aesthetic ... One is more aware than before that he himself is establishing relationships as he apprehends the object from the various positions and under varying conditions of light

and spatial context.'
Here we are at the edge of 'sculpture in the expanded field' (as Krauss would call it in 1978) [...] It is this expanded field, foreseen by Morris, that Michael Fried in 'Art and Objecthood' is pledged to forestall.

More fully than Judd and Morris, Fried comprehends Minimalism in its threat to formalist Modernism, which is why he prosecutes it with such passion. First Fried details the Minimalist crime: an attempt to displace late Modernist art by means of a literal reading that confuses the transcendental 'presentness' of art with the mundane 'presence' of things. According to Fried, the essential difference is that Minimalist art seeks 'to discover and project objecthood as such', whereas late Modernist art aspires 'to defeat or suspend' this objecthood. Here, he contends, 'the critical factor is *shape*', which, far from an essential sculptural value (as Morris would have it), is an essential pictorial value. Indeed, only if it 'compels conviction as shape' can the late Modernist painting of Kenneth Noland, Jules Olitski and Frank Stella suspend objecthood, transcend the literalism of Minimalism, and so achieve presentness.[24]

Given this difference, Fried must next show why Minimalist literalism is 'antithetical to art'. To this end he argues that the presence of the Minimalist object is that of a personage in disguise, a presence that produces a *situation* that, however provocative, is extrinsic to visual art. Here Fried also cites Smith on the scale of Minimalism, but in order to recast it as an art of abstract statues, hardly as radically anti-anthropomorphic as its advocates claim. And yet his primary point is not to show up Minimalism as secretly anthropomorphic but to present it as 'incurably theatrical', for, according to the crucial hypothesis of 'Art and Objecthood', 'theatre is now the negation of art'.

In order to support this hypothesis, Fried makes a strange detour: a gloss on an anecdote, again told by Tony Smith, about a night-time ride on the unfinished New Jersey Turnpike in the early 1950s. For this proto-Minimalist artist and architect the experience was somehow aesthetic but not quite art [...] What was revealed to Smith, Fried argues, was the 'conventional nature of art'. 'And this Smith seems to have understood not as laying bare the essence of art, but as announcing its end.'

Here is marked the crux not only of the Friedian case against Minimalism but of the Minimalist break with late Modernism. For in this epiphany about the conventionality of art is foretold the heretical stake of Minimalism and its neo-avant-garde successors: not to discover the essence of art à la Greenberg but to transgress its institutional limits [...] to negate its formal autonomy [...] precisely to announce its end.[25] For Fried as for Greenberg such avant-gardism is infantile: hardly a dialectical sublation of art into life, Minimalist transgression obtains only the literalism of a frameless event or object 'as it *happens*, as it merely *is*'. Fried terms this Minimalist literalism 'theatrical' because it involves mundane time, a property that he deems improper to visual art. Thus, even if the institutional autonomy of art is not threatened by Minimalism, the old Enlightenment order of the arts (the temporal versus the spatial arts) is

endangered. This is why 'theatre is now the negation of art', and why Minimalism must be condemned [...]

GENEALOGIES: 'ROOT, HOG OR DIE'
Fried is an excellent critic of Minimalism not because he is right to condemn it but because in order to do so persuasively he has to understand it, and this is to understand its threat to late Modernism. Again, Fried sees Minimalism as a corruption of late Modernism 'by a sensibility *already* theatrical, already (to say the worst) corrupted or perverted by theatre'. In this reading Minimalism develops out of late Modernism, only to break it apart (the Latin *corrumpere*, the root of *corrupt*, means 'to break'), contaminated as Minimalism already is by theatre. But theatre here represents more than a concern with time alien to visual art; it is also, as 'the negation of art', a code word for avant-gardism. We arrive, then, at this equation: *Minimalism breaks with late Modernism through a partial reprise of the historical avant-garde, specifically its disruption of the formal categories of institutional art.* To understand Minimalism – that is, to understand its significance for advanced art since its time – both parts of this equation must be grasped at once.

First the Minimalist break: rhetorically at least, Minimalism is inaugurated when Judd reads late Modernism so literally that he answers its call for self-critical objectivity perversely with 'specific objects'. Morris seeks to reconcile this new Minimalist literalism with the old Modernist autonomy by means of the Gestalt, only thereby to shift the focus from the object to its perception, to its *situation*. Fried then rises to condemn this theatrical move as a threat to artistic decorum and a corruption of artistic conviction; in so doing he exposes the disciplinary basis of his formalist aesthetics. In this general scenario, then, Minimalism emerges as a dialectic of a 'new limit and new freedom' for art, in which sculpture is reduced one moment to the status of a thing 'between an object and a monument' and expanded the next moment to an experience of sites 'mapped out' but 'not socially recognized' [...] In short, *Minimalism appears as a historical crux in which the formalist autonomy of art is at once achieved and broken up*, in which the ideal of pure art becomes the reality of one more specific object among others.

This last point leads to the other side of the Minimalist rupture, for if Minimalism breaks with late Modernist art, by the same token it prepares for the Postmodernist art to come.[26] Yet before this genealogy is sketched, the avant-gardist part of the Minimalist equation must be grasped [...] The return of the transgressive avant-garde (especially Duchampian Dada and Russian Constructivism) in art of the 1960s [...] poses the problem of its delay in the previous decades. To a great extent this avant-garde was suppressed by Nazism and Stalinism, but it was also detained in North America by a combination of old anti-Modernist forces and new Cold War politics, which tended to reduce the avant-garde to Bolshevism *tout court*.[27] This North American delay allowed the dominance of Greenbergian Formalism, which not only overbore the transgressive avant-garde institutionally but almost defined it out of existence [...] In effect, this formalist

avant-garde sought to *preserve* what the transgressive avant-garde sought to *transform*: the institutional autonomy of art. Faced with this account, the Minimalists looked to the transgressive avant-garde for alternative models of practice. Thus Andre turned to Aleksandr Rodchenko and Constantin Brancusi, Flavin to Vladimir Tatlin, many others to Duchamp and so on. In this way Minimalism became one site of the general return of this avant-garde – a return that, with the force of the repressed, opened up the disciplinary order of late Modernism [...]

For many critics the failure of the historical avant-garde to integrate art into life renders this avant-gardist project futile. 'Since now the protest of the historical avant-garde against art as an institution is accepted as *art*', Peter Bürger writes in *Theory of the Avant-Garde* (1974), 'the gesture of the neo-avant-garde becomes inauthentic'.[28] But this failure of the transgressive avant-garde in the 1910s and 1920s as well as of the first neo-avant-garde in the 1950s is not total; at a bare minimum it prompts a practical critique of the institution of art, the tradition of the avant-garde and other discourses in a *second* neo-avant-garde that emerges in the 1960s. In this second neo-avant-garde, in which Minimalism as well as Pop art figure prominently, the aim is twofold at least: on the one hand, to reflect on the contextual conditions of art, as in Minimalism, in order to expand its parameters, and on the other hand, to exploit the conventionality of the avant-garde, as in Pop, in order to comment on Modernist and mass-cultural formations alike. Both steps are important to the institutional critique that follows in art of the late 1960s and early 1970s [...]

None of this develops as smoothly or as completely as I imply here. Nevertheless, if Minimalism and Pop do mark a historical crux, then, again, they will suggest not only a perspective on Modernist art but also a genealogy of Postmodernist art. This genealogy cannot be a stylistic history of influence or evolution (in which Minimalism 'reduces' the art object, say, so that Conceptualism may then 'dematerialize' it altogether), nor can it be a psychological account of generational conflicts or periodic reactions (as with the trashings of the 1960s with which I began). Again, only an analysis that allows for both parts of the Minimalist equation – the break with late Modernism and the return of the avant-garde – can begin to account for the advanced art of the last thirty-five years or so.

A few readings of recent art approach Minimalism and Pop as such a crux, either as a break with the aesthetic order of late Modernism or as a reprise of the critical strategies of the readymade (but not both); they are significant for what they exclude as well as include. In two essays from 1979, Douglas Crimp and Craig Owens depart from the aesthetic order mapped out by Fried in 'Art and Objecthood'.[29] For Crimp it is theatrical presence, condemned by Fried and repressed in late Modernist art, that returns in the Performance and Video art of the early 1970s, to be recontained in the pictures of Cindy Sherman, Sherrie Levine and others in the late 1970s. For Owens it is linguistic temporality that returns to disrupt the visual spatiality of late Modernist art: the textual decentrings of the art object in the site/non-site works of Smithson, for example, or the allegorical collisions of aesthetic

categories in the performances of Laurie Anderson. Yet, however much they comprehend, both scenarios overlook crucial developments: the first neglects the institutional critique that emerges from Minimalism, and the second does not question the historical forces at work in the textual fragmentation of art after Minimalism. Moreover, both critics accept the terms offered by Fried, which are not deconstructed so much as reversed. In this way his negative terms, the theatrical and the temporal, are only revalued as positive, and his late Modernist schema remains in place, indeed in force.[30]

As an analysis of perception, Minimalism prepared a further analysis of the conditions of perception. This led to a critique of the spaces of art (as in the work of Michael Asher), of its exhibition conventions (as in Daniel Buren), of its commodity status (as in Hans Haacke) – in short, to a critique of the institution of art. For critics like Benjamin Buchloh this history is mostly a genealogy of the presentational strategies of the readymade. Yet, as we have seen, this narrative also leaves out a crucial concern: the sexual-linguistic constitution of the subject. For the most part this concern is left out of the art as well, for, again, even as Minimalism turned from the objective orientation of formalism to the subjective orientation of phenomenology, it tended to position artist and viewer alike not only as historically innocent but as sexually indifferent, and the same holds for much conceptual and institution-critical work that followed Minimalism. This omission is addressed in feminist art from the middle 1970s through the middle 1980s, and in this investigation such disparate artists as Mary Kelly and Sylvia Kolbowski, Barbara Kruger and Sherrie Levine, Louise Lawler and Martha Rosler turned to images and discourses adjacent to the art world, especially to representations of women in mass culture and to constructions of femininity in psycho-analytic theory. This is the most productive critique of Minimalism to date, and it is elaborated in practice.

Recently the status of Minimalism has changed once more. On the one hand, it recedes from us as an archival object as the 1960s becomes a historical period.[31] On the other hand, it rushes towards us as artists seek an alternative to practices of the 1970s and 1980s. This return is a mixed event: often rather than a working through of the problems left by Minimalism, it appears strategic and/or reactive. Thus there are strategic revisions of Minimalism that refashion it in iconographic, expressive and/or spectacular themes – as if to attack it with the very terms that it opposed. So, too, there are reactive versions of Minimalism that pit it against subsequent work – that pose its phenomenological intimation of the body, say, against the psychoanalytic definition of the subject in fem-inist art of the 1970s and 1980s (which here becomes the object of resentment). In this way, even as Minimalism became a set style long ago, its value is still not set, and this is further evidence of its crucial status in post-war art.[32]

A POP MINI-SERIES: 'A SCHIZOPHRENIC CLATTERING'
Finally, in order to understand the crux of Minimalism we must reposition it in its own time. One way to do so is to juxtapose Minimalism with Pop art, as related responses to the same moment in the dialectic of Modernism and

mass culture. In this account both Minimalism and Pop confront, on the one hand, the rarefied high art of late Modernism and, on the other hand, the spectacular culture of advanced capitalism, and both are soon overwhelmed by these forces. Thus Pop may seek to use mass culture in order to test high art, but its dominant effect is to recoup the low for the high, the categories of which remain mostly intact. And Minimalism may resist both high art and low culture in order to regain a transformative autonomy of aesthetic practice, but its dominant effect is to allow this autonomy to be dispersed across an expanded field of cultural activity. In the case of Pop, then, the fabled integration of high art and low culture is attained, but mostly in the interests of the culture industry, to which, with Warhol and others, the avant-garde becomes as much a subcontractor as an antagonist. In the case of Minimalism the fabled autonomy of art is achieved, but mostly to be corrupted, broken up, dispersed.

What forces effect this integration and that corruption? The best clues are the Pop embrace and the Minimalist refusal of low culture, both of which point to a new order of serial production and consumption. In this light the Minimalist stress on perceptual presence resists mass-mediated representations. Moreover, the Minimalist insistence on 'specific objects' counters simulacral images – even as Minimalism, like Pop, also employs serial forms and techniques. In short, the Minimalist emphasis on the physical here-and-now is not only an enthusiasm for phenomenology, nor is the Minimalist suspicion about artistic subjectivity only an embrace of structuralism. In part the first critiques, even as the second reflects, a reification of history and a fragmentation of the subject associated since Georg Lukács with the dynamic of capitalism [...] These historical processes reach a new intensive level in the 1960s – to the point, Frederic Jameson has claimed, where they effect an 'eclipse, finally, of all depth, especially *historicity* itself, with the subsequent appearance of pastiche and nostalgia art'.[33] Such an eclipse is projected by Minimalism and Pop alike, with each so insistent on the externality, indeed the superficiality, of contemporary representations, meanings, experiences. Certainly pastiche and nostalgia, the twin reactions to this putative eclipse of historical depth, dominate the cultural wares of the 1970s and 1980s.

Minimalism may resist the spectacular image and the disembodied subject of advanced capitalism, while Pop may embrace them. But in the end Minimalism may resist these effects only to advance them too.[34] This notion will remain conjectural, however, at the homological level of reflections or the mechanistic level of responses, unless a local link between artistic forms and socio-economic forces in the 1960s is found. One such link is provided by the readymade: both Minimalism and Pop use the readymade not only thematically but formally, even structurally – as a way à la Judd to put one thing after the other, to avoid the idealist rationalism of traditional composition.[35] But to what order do these Minimalist industrial objects and Pop art simulacra point? To work in a series, to serial production and consumption, to the socio-economic order of one-thing-after-another.

Of course seriality precedes Minimalism and Pop [...] *Yet not until Minimalism and Pop is serial production made consistently integral to the technical production of the work of art.* More than any mundane content, this integration makes such art 'signify in the same mode as objects in their everydayness, that is, in their latent *systematic*'.[36] And more than any cool sensibility, this integration severs such art not only from artistic subjectivity (perhaps the last transcendental order of art) but also from representational models. In this way Minimalism rids art of the anthropomorphic and the representational not through anti-illusionist ideology so much as through serial production. For abstraction tends only to *sublate* representation, to preserve it in cancellation, whereas repetition, the (re)production of simulacra, tends to *subvert* representation, to undercut its referential logic. (In future histories of artistic paradigms, repetition, not abstraction, may be seen to supersede representation – or at least to disrupt it most effectively.)

Since the Industrial Revolution a contradiction has existed between the craft basis of visual art and the industrial order of social life. Much sculpture since Rodin seeks to resolve this contradiction between 'individual aesthetic creation' and 'collective social production', especially in the turn to processes like welding and to paradigms like the readymade.[37] With Minimalism and Pop this contradiction is at once so attenuated (as in the Minimalist concern with nuances of perception) and so collapsed (as in the Warholian motto 'I want to be a machine') that it stands revealed as a principal dynamic of Modernist art. In this regard, too, the seriality of Minimalism and Pop is indicative of advanced-capitalist production and consumption, for both register the penetration of industrial modes into spheres (art, leisure, sport) that were once removed from them. As the economist Ernest Mandel has written:

'*Far from representing a "post-industrial society", late capitalism thus constitutes generalized universal industrialization for the first time in history. Mechanization, standardization, over-specialization and parcellization of labour, which in the past determined only the realm of commodity production in actual industry, now penetrate into all sectors of social life.*'[38]
Both Minimalism and Pop resist some aspects of this logic, exploit others (like mechanization and standardization) and foretell still others. For in serial production, a degree of difference between commodity-signs becomes necessary; this distinguishes it from mass production. Indeed, in our political economy of commodity-signs it is difference that we consume.[39]

This logic of difference and repetition is second nature to us today, but it was not so patent thirty-five years ago. Yet this logic structured Minimalism and Pop: in Minimalism it is evident in the tension between different 'specific objects' and repetitive serial ordering, and in Pop in the production of different images through repetitive procedures (like silk screening). Again, this serial structure integrates Minimalism and Pop, like no other art before them, into our systematic world of serial objects, images, people. Finally, more than any industrial technique in Minimalism or mass-cultural content in Pop, this logic, long since general to both high art and low culture, has redefined the lines between the two.

Although this logic qualifies the transgressive value of Minimalism and Pop, neither art merely reflects it. Both play with this logic too; that is, both release difference and repetition in sometimes subversive ways [...]

The artistic crux marked by Minimalism and Pop must be related to other ruptures of the 1960s – social and economic, theoretical and political. Somehow the new immanence of art with Minimalism and Pop is connected *not only* with the new immanence of critical theory (the post-Structuralism shift from transcendental causes to immanent effects), *but also* with the new immanence of North American capital in the 1960s. Somehow, too, the transgressions of institutional art with Minimalism and Pop are associated *not only* with the transgressions of sexist and racist institutions by women, African-Americans, students and others, *but also* with the transgressions of North American power in the 1960s [...]

1 Like 1848 for its subsequent generations, 1968 remains a prime cultural-political stake, and current interest in the art of the 1960s is part of its contestation.

2 The epigraphs of the four sections that follow are drawn from: Donald Judd in Bruce Glaser, 'New Nihilism or New Art? Interview with Stella, Judd and Flavin', originally broadcast on WBAI-FM, New York, February 1964, revised and published in *ARTnews* (September 1966); reprinted in *Minimal Art: A Critical Anthology*, ed. Gregory Battcock (New York: E.P. Dutton & Co., 1968) 148-64. [See in this volume pp. 197-201]; Tony Smith, 'Talking with Tony Smith', *Artforum* (December 1966); Gilles Deleuze, *Difference and Repetition*, 1968, trans. Paul Patton (New York: Columbia University Press, 1994) 293.

3 Donald Judd, 'Specific Objects', *Arts Yearbook*, 8 (1965); reprinted in *Donald Judd: Complete Writings 1959-1975* (Halifax: Nova Scotia College of Art and Design, 1975) 184. Unless otherwise stated, all subsequent Judd quotations are from this text, 181-89. [See in this volume pp. 207-10.]

4 See Rosalind Krauss, 'LeWitt in Progress', *The Originality of the Avant-Garde and Other Modernist Myths* (Cambridge, Massachusetts and London: MIT Press, 1985). Although few critics listened, LeWitt insisted on the illogic of his art in statements like 'Sentences on Conceptual Art', *Art-Language* (May 1969).

5 Frank Stella in Glaser, *op. cit.*, p. 158.

6 Clement Greenberg, 'Recentness of Sculpture', *American Sculpture of the Sixties*, ed. Maurice Tuchman (The Los Angeles County Museum of Art, 1967); reprinted in *Minimal Art: A Critical Anthology*, ed. Gregory Battcock (New York: E.P. Dutton & Co., 1968) 180-86. [See in this volume pp. 233-34.] All subsequent Greenberg quotations are from this text, 180-86.

7 John Cage, *Silence* (Middleton, Massachusetts: Wesleyan University Press, 1961) 76.

8 For example, Yvonne Rainer compared the factory fabrication, unitary forms and literal aspect of Minimalist art to the found movement, equal parts and task-like activity of Judson Church dance. 'A Quasi Survey of Some "Minimalist" Tendencies in the

Quantitatively Minimal Dance Activity Midst the Plethora, or an Analysis of Trio A', *Minimal Art*, *op. cit.*

9 Richard Wollheim, 'Minimal Art', *Arts Magazine* (January 1965); reprinted in *Minimal Art*, *op. cit.*, 399.

10 Judd in Glaser, *op. cit.* Judd ascribes this a priori quality to European Modern art as such, which is typical of the absolutist judgements of the time. This definition also opposes Minimal art to Conceptual art in which the system is often a priori. Whether the precedence of the concept devalues the authorial subjectivity of the artist (as LeWitt claims in 'Paragraphs on Conceptual Art', *Artforum* [Summer 1967]. 'The idea becomes the machine that makes the art') or inflates this subjectivity (as occurs in most idealist versions) is a crucial ambiguity in Conceptual art. How it is decided will determine its status in relation to Minimalism – whether Conceptual art elaborates 'the crux of Minimalism' or recoups it. But then this ambiguity may be undecidable, and this undecidability may be fundamental to Conceptual art.

11 Among the antecedents of Minimalism both positivist and avant-gardist tendencies appear in Johns (a case can be made for Ad Reinhardt as well).

12 See Rosalind Krauss, 'Sense and Sensibility: Reflection on Post '60s Sculpture', *Artforum* (November 1973) 43-53. [See in this volume pp. 275-57.]

13 See Michael Fried, 'Art and Objecthood', *Artforum* (June 1967); reprinted in *Minimal Art*, *op. cit.* [See in this volume pp.234-35.]

14 Judd, 'Specific Objects', *op. cit.*

15 Krauss, *op. cit.*

16 Rosalind Krauss, *Passages in Modern Sculpture* (Cambridge, Massachusetts: MIT Press, 1977) 292-93. The ultimate move comes with work that follows directly on Minimalism, such as Robert Smithson's *Spiral Jetty* (1970), Richard Serra's *Shift* (1970-72) and Bruce Nauman's video *Corridor* (1968-70). In this history Krauss favours sculpture that, like Minimalism, is materialist (its meaning opaque, carried on the surface) as opposed to idealist (its meaning transparent to its structure), but this very opposition is idealist.

17 See, for example, Rosalind Krauss, 'Sculpture in the Expanded Field', *October*, 13 (Spring 1979).

18 Krauss, *Passages*, *op. cit.*, 3-4.

19 The reception of phenomenology was mediated by Maurice Merleau-Ponty, especially his *Phenomenology of Perception*, which was translated in 1962. The reception of structural linguistics was mediated by Claude Lévi-Strauss, Roland Barthes and others, some of whose work was read by some North American artists in the mid 1960s.

20 Judd, 'Specific Objects', *op. cit.*

21 Robert Morris, 'Notes on Sculpture: Parts I and II', *Artforum* (February and October 1966); reprinted in *Minimal Art*, *op. cit.* Morris published 'Notes on Sculpture: Part 3' in *Artforum* in June 1967, the same issue in which Fried's 'Art and Objecthood' appeared. 'Notes on Sculpture: Part 4' appears in his collection *Continuous Project Altered Daily* (Cambridge, Massachusetts and London: MIT Press, 1993).

22 Fried, *op. cit.*

23 See Clement Greenberg, '"American-Type" Painting' (1955/1958), *Art and Culture* (Boston: Beacon Press, 1961).

24 Perhaps 'interest' does not displace 'quality' so much as provide the first term of its normative scheme. In this light Judd ascended to the pantheon of quality, which he defended passionately. (As Howard Singerman suggested to me, Judd implies as much in 'A long discussion not about masterpieces but why there are so few of them', *Art in America* [September- October 1984].) Moreover, it was his consistency that allowed Minimalism to become a style. Finally, in his obsession with (anti)illusionism he remained bound to painting.

25 Even late Modernist sculpture such as Anthony Caro's suspends its objecthood, Fried argues, by its emphasis on opticality and 'the efficacy of gesture'.

26 This is also the heretical stake of its avant-garde predecessors, with this difference: whereas avant-garde artists like Rodchenko mistook the conventionality of art for its end, neo-avant-garde artists like Smith imagined its end in the very limits of its conventionality.

27 For example, Minimalism pushes the 'empirico-transcendental' analytic of Modernist art, its double concern with the material and the spiritual, the immanent and the transcendental, to the point where this analytic is transformed – in the institutional critique central to Postmodernist art, its creative analysis of the discursive conditions of art. (On the 'empirico-transcendental' analytic see Michel Foucault, *The Order of Things* [New York: Vintage Books, 1970] 318-22.)

28 Peter Bürger, *Theory of the Avant-Garde* (Minneapolis: University of Minnesota Press, 1984) 53.

29 See Douglas Crimp, 'Pictures', *October*, 8 (Spring 1978); and Craig Owens, 'Earthwords', *October*, 10 (Fall 1979).

30 Fried suggests as much in *Discussions in Contemporary Culture* (Seattle: Bay Press, 1987) 56. The reversal of the opposition of presence and presentness was only one example of failed deconstruction. Another instance crucial to theories of Postmodernism was the reversal of the oppositions of aura and reproduction, originality and repetition, developed by Walter Benjamin in 'The Work of Art in the Age of Mechanical Reproduction' (1936). Too often this text was taken as a weapon to wither art suspected of aura; hence the attack on the original and the unique and the embrace of the photographic and the textual. Granted, this attack was provoked by a forced resurrection of aura – the various Frankenstein monsters, produced in the laboratory of market and academy, of neo-Expressionism, Postmodern architecture, art photography and the like. None the less, the Postmodernist reading of Benjamin tended to collapse his dialectic of mechanical reproduction and auratic experience. In so doing it also tended to void the critical potential of each term - as long as they are held in tension.

31 Especially as its signal artists like Judd begin to die. In an excellent new introduction to Battcock's *Minimal Art* (Berkeley: University of California Press, 1995), Anne M. Wagner draws on Foucault to define this status of Minimalism: 'privileged region of the archive is neither past nor present: at once close to us, and different from

our present existence, it is the border of time that surrounds our presence, which overhangs it and which indicates it in its otherness; it is that which, outside ourselves, delimits us'. (*The Archaeology of Knowledge and the Discourse on Language*, tr. A.M. Sheridan Smith [New York: Harper and Row, 1976] 130. This problematizes the objectivity of the Minimalist crux: is it liminal as such - or only for us now?

32 There are also thematic femmings and queerings of Minimalism. As represented by the exhibition 'Sense and Sensibility', curated by Lynn Zelevansky at The Museum of Modern Art, New York, in 1994, this femmed Minimalist art is posed against the psychoanalytic feminist art of the 1970s and 1980s, which it regards as oppressive. There is also a critical version of this position, as represented by Anna C. Chave in 'Minimalism and the Rhetoric of Power', *Arts Magazine* (January 1990) 44-63 [See in this volume pp. 276-85.], which attacks Minimalism for macho iconography. Minimalism worked to avoid the authority of iconographic meaning, it is thus counterproductive to reassert this authority when it is this authority that is in question. Moreover, both reactions - artistic and critical - condemn Minimalism in a way that forecloses a historical basis of feminist art. For again, however circumscribed, Minimalism did put the question of the subject in play, and in this respect feminist art begins where Minimalism ends.

33 Frederic Jameson, 'Periodizing the 60s', in *The Sixties without Apology* (Minneapolis: University of Minnesota Press, 1984) 195.

34 For an analysis of this ambiguous status of Minimalism (which draws on the original version of the present chapter), see Krauss, 'The Cultural Logic of the Late Capitalist Museum', *op. cit.*

35 See Krauss, *Passages in Modern Sculpture*, *op. cit.*, 250.

36 Jean Baudrillard, *For a Critique of the Political Economy of the Sign*, trans. Charles Levin (St. Louis: Telos Press, 1981) 109.

37 Benjamin Buchloh, 'Michael Asher and the Conclusion of Modernist Sculpture', in *Performance*, *Text(e)s & Documents*, ed. Chantal Pontbriand (Montreal: Parachute) 58.

38 Ernest Mandel, *Late Capital* (London: Verso, 1978) 387.

39 Baudrillard: 'The sign object is neither given nor exchanged: it is appropriated, withheld and manipulated by individual subjects as a sign, that is, as coded difference. Here lies the object of consumption.' Baudrillard, *op cit.*, 65.

Hal Foster, 'The Crux of Minimalism', *The Return of the Real*: *The Avant-Garde at the End of the Century* (Cambridge, Massachusetts and London: MIT Press, 1996). Originally published in *Individuals*: *A Selected History of Contemporary Art 1945-1986* (Los Angeles: Museum of Contemporary Art; New York: Abbeville Press, 1986) 162-83.

Anna C. CHAVE
Minimalism and the Rhetoric of Power [1990]

Let me begin with an anecdote: while I was looking at Donald Judd's gleaming brass floor box of 1968 from a distance in the galleries of The Museum of Modern Art last spring, two teenage girls strode over to this pristine work, kicked it and laughed. They then discovered its reflective surface and used it for a while to arrange their hair until, finally, they bent over to kiss their images on the top of the box. The guard nearby, watching all of this, said nothing. Why such an object might elicit both a kick and a kiss, and why a museum guard might do nothing about it are at issue in this essay. I will argue that the object's look of absolute, or 'plain power', as Judd described it, helps explain the perception that it did not need or merit protecting, that it could withstand or even deserved such an assault. What concerns me about Minimalist art is what Teresa de Lauretis describes as 'the relations of power involved in enunciation and reception', relations 'which sustain the hierarchies of communication ... the ideological construction of authorship and mastery; or more plainly, who speaks to whom, why and for whom'.[1] I want, further, to historicize those relations – to examine the rhetoric inscribed in Minimalism, and the discursive context of the movement, in relation to the socio-political climate of the time during which it emerged. Richard Serra remembers that in the 1960s, 'It was your job as an artist to redefine society by the values you were introducing, rather than the other way around'.[2] But did Minimalist art in any way propose, or effect, a re-valuation of values? And how are we to understand its cool displays of power in relation to a society that was experiencing a violent ambivalence towards authority, a society where many were looking for the means of transforming power relations?

By manufacturing objects with common industrial and commercial materials in a restricted vocabulary of geometric shapes, Judd and the other Minimalist artists availed themselves of the cultural authority of the markers of industry and technology. Though the specific qualities of their objects vary – from the corporate furniture-like elegance of Judd's polished floor box, to the harsh, steel mesh of Robert Morris' cage-like construction of 1967, to the industrial banality of Carl Andre's *Zinc-Zinc Plain* of 1969 – the authority implicit in the identity of the materials and shapes the artists used, as well as in the scale and often the weight of their objects, has been crucial to Minimalism's associative values from the outset.[3] In one of the first Minimalist group shows, 'Shape and Structure', at Tibor de Nagy Gallery in 1965, Andre submitted a timber piece so massive it almost caused the gallery's floor to collapse, and had to be removed. The unapologetic artist described his ambitions for that work in forceful and nakedly territorial terms: 'I wanted very much to seize and hold the space of that gallery – not simply fill it, but seize and hold that space'.[4] More recently, Richard Serra's mammoth, curving steel walls have required even the floors of the Leo Castelli Gallery's industrial loft space to be shored up – which did not prevent harrowing damage to both life and property.[5]

The Minimalists' domineering, sometimes brutal rhetoric was breached in this country in the 1960s, a decade of brutal displays of power by both the American military in Vietnam and the police at home in the streets and on university campuses across the country. Corporate power burgeoned in the US in the 1960s too, with the rise of the 'multinationals', due in part to the flourishing of the military-industrial complex. The exceptionally visible violence of the state's military and disciplinary establishments in this period met with a concerted response, of course. Vested power became embattled on every front with the eruption of the civil rights, alongside the feminist and gay rights, movements. In keeping with the time-honoured alignments of the avant-garde, the Minimalists were self-identified, but not especially clear-thinking, leftists. 'My art will reflect not necessarily conscious politics but the unanalysed politics of my life. Matter as matter rather than matter as symbol is a conscious political position, I think essentially Marxist', said Andre, contradictorily, in 1970.[6] 'A lot of people believed that there were really *changes* ... in the 1960s', Frank Stella recently observed, 'I believed it too. It did seem that way. A lot of the work seems ... strong to me. But it does seem that it didn't do what it was supposed to do.'[7] However, Stella didn't specify what the art of the 1960s was supposed to do, or why 'strength' was expected to accomplish its errands.

Now, as in the 1960s, the dominant accounts of Minimalism do not portray it as an instrument of social change but, on the contrary, as art that somehow generated and occupied a special sphere, aloof from politics and commerce and above personal feeling. The language typically used to describe Minimalism employs a rhetoric of purity, primacy and immediacy in focusing on the artists' means and on the objects' relations to the constitutive terms of their media. 'The demand has been for an honest, direct, unadulterated experience in art ... minus symbolism, minus messages and minus personal exhibitionism', wrote Eugene Goossen in 1966[8]; with Minimalism, 'the very means of art have been isolated and exposed', he stated two years later.[9] In the standard narratives, Minimalism forms the terse, but veracious, last word in a narrowly framed argument about what Modern art is or should be. As it happens, the person most responsible for framing that argument, Clement Greenberg, finally disliked seeing his logic carried to its extremes: 'Minimal works are readable as art, as almost anything is today', he complained in 1967:

Including a door, a table or a blank sheet of paper ... it would seem that a kind of art nearer the condition of non-art could not be envisaged or ideated at this moment. That, precisely, is the trouble. Minimal art remains too much a feat of ideation, and not enough anything else.[10]

But it was an account of the history of Modern art that Greenberg had inscribed as the true history that enabled these objects, which verged on being non-art, to be lionized instead as art of the first importance. Andre's metal plates and Morris' cage could only be regarded as works of art in the context of a discourse in which they stood as compelling proof of the unfolding of a certain historical inevitability. Lay spectators only recognize such objects as works of art (when or if they do so) because they are located in the legitimating contexts of the gallery and museum, installed by curators and dealers in thrall (as the artists themselves were) to a particular account of history.

Most of the artists and critics concerned would have agreed with Goossen that, with Minimalism, 'the spectator is not given symbols, but facts'[11]; that it offers no quarter to 'the romantic mentality, which fails to appreciate experience for its own intrinsic value and is forever trying to elevate it by complications and associations'.[12] The present account is concerned precisely with how such patently non-narrative art is 'complicated' by 'associations', however, and is bent on describing those associations. Morris' *Cock/Cunt* sculpture of 1963, with its schematic image of sexual difference and coitus, demonstrates plainly that highly simplified, abstract configurations may indeed be coded. A more characteristic example, however – one that is not literally, but metaphorically, 'inscribed' – is Dan Flavin's seminal and canonical work (I choose my adjectives advisedly), *the diagonal of May 25, 1963 (to Robert Rosenblum)*, his first work done entirely in fluorescent light. The type of power involved here is, in the first place, actual electrical power (with the requisite cords and connections hidden so that that power's contingency remains inapparent), but the rigid glass tube is also plainly phallic. This is, literally, a hot rod, and Flavin coyly referred to the specific angle he poised the fixture at as 'the diagonal of personal ecstasy',[13] alluding to the characteristic angle of an erect penis on a standing man.

Sympathetic critics have described Flavin's art as embodying 'the potential for transcendental experience that is inherent in ordinary experience and that has been recognized through light in virtually all spiritual traditions' (to take a representative phrase), while alluding to the artist's Roman Catholic upbringing.[14] Though he called some of the first works he created with light *icons*, Flavin knew that his commercial light fixtures 'differ from a Byzantine Christ held in majesty; they are dumb – anonymous and inglorious ... They bring a limited light.'[15] He invoked his religious upbringing in different terms, moreover, telling of the 'rank suppression' he experienced 'in the name of God the Father' at the hands of his own father, Daniel Senior, whom he described as 'an ascetic, remotely male, Irish Catholic truant officer'.[16] In Flavin's mind his *Diagonal* was less a reaffirmation of the possibility for spiritual experience in contemporary society, than 'a modern technological fetish'[17] – a fetish being, in Freudian terms, a talisman against castration and impotence, a symbolic surrogate for the female body's absent penis. From this perspective, Flavin's dependence on technological artefacts for his work may evince the sense of impotence visited on the sovereign universal (read: male) subject by the ascendancy of technology. 'Disenfranchised by an independently evolving technology, the subject raises its disenfranchisement to the level of consciousness, one might almost say to the level of a programme for artistic production', as Theodor Adorno observed.[18] Flavin's *Diagonal* not only looks technological and commercial – like Minimalism generally – it *is* an industrial product and, as such, it speaks of the extensive power exercised by the commodity in a society where virtually everything is for sale – where New York Telephone can advertise 'love', 'friendship' and 'comfort'

WHILE I WAS LOOKING AT DONALD JUDD'S GLEAMING BRASS FLOOR BOX OF 1968 FROM A DISTANCE IN THE GALLERIES OF THE MUSEUM OF MODERN ART LAST SPRING,

TWO TEENAGE GIRLS

STRODE OVER TO THIS PRISTINE WORK

KICKED IT

AND LAUGHED. THEY THEN DISCOVERED ITS REFLECTIVE SURFACE AND USED IT FOR A WHILE TO ARRANGE THEIR HAIR UNTIL, FINALLY,

THEY BENT OVER

TO KISS THEIR IMAGES ON THE TOP OF THE BOX.

THE GUARD

NEARBY, WATCHING ALL OF THIS,

SAID NOTHING.

Anna C. CHAVE 'Minimalism and the Rhetoric of Power', 1990

for 'as little as ten cents a call', for instance. Further, in its identity as object or commodity, Flavin's work may arouse our ambivalence towards those ever-proliferating commodities around us for which we have a hunger that is bound to be insatiable, as they will never fully gratify us.

Standard products, or commercially available materials, can also be seen to bear secondary meanings in Andre's famous *Lever* of 1966, done for the important 'Primary Structures' show at the Jewish Museum, New York, in 1966. 'Artworks at their best spring from physical, erotic propositions', Andre stated. And with its 137 firebricks set side by side in a row 1,051.5 cm [34.5 ft] long, *Lever* manifests his determination to put 'Brancusi's *Endless Column* on the ground instead of in the sky. Most sculpture is priapic with the male organ in the air. In my work, Priapus is down on the floor. The engaged position is to run along the earth.'[19] In terms of the artist's view of it, then, *Lever* is closer to Morris' *Cock/Cunt* than to Flavin's *Diagonal*, as it offers a schematic image of coitus with the floor serving as the (unarticulated) female element. Significantly too, of course, a 'lever' is a long, rigid tool used to pry or lift, while *lever* means to 'rise', 'raise' or 'lift' in French.

Though the critics have mostly ignored them, the suggestive titles of many of the objects now regarded as cornerstones of the Minimalist movement prove that the artists themselves were prone to 'complicating' their work by 'associations' […]

In 1966 Brian O'Doherty lauded the 'new object makers' for producing a kind of 'aesthetic furniture' that 'can be all things to all men while remaining totally unchanged', as well as for the smart marketing strategy demonstrated by their avoidance of those 'obsolescence cycles' to which avant-garde art was notoriously prone.[20] On the face of it, certainly, Minimalist objects are as interchangeable, as neutral and as neutered as standard consumer goods. That neutralization is crucial to capitalism, that 'differences must be neutralized to come globally under the law of the interchangeable', of exchange value, has been persuasively argued by Jean-François Lyotard.[21] From this perspective, Minimalism can be seen as replicating — and at times, perhaps, as implicating — 'those systems of mediation which have (over) determined our history: Money, the Phallus and the Concept as privileged operators of meaning'.[22] The perceived neutrality of Minimalist objects might also be explained, however, by the fact that the qualities or values they exemplify — unfeelingness and a will to control or dominate — are transparent by virtue of their very ubiquity. With closer scrutiny, in short, the blank face of Minimalism may come into focus as the face of capital, the face of authority, the face of the father.

Minimalism's partisans have all along insisted that it was wrongheaded to look for, let alone to interrogate, any found subject or author behind the art's patently object-like and de-subjectivized facade. Thus Douglas Crimp insists, for instance, that 'Characterization of Serra's work as macho, overbearing, oppressive, seeks to return the artist to the studio, to reconstitute him as the work's sole creator, and thereby to deny the role of industrial processes in his sculpture'.[23] We can be interested in Serra's use of industrial processes, however, and still hold him to account as the creator (not to say fabricator) of his work — work that plainly manifests certain personal ambitions and interests, its industrial facture notwith-standing.[24] That Serra's artistic gestures have less in common with the sculptor's conventional rituals than with the rituals of the industrial magnate who merely lifts the telephone to command labourers to shape tons of steel according to his specifications, and the rituals of the foreman or construction bosses who oversee the processes of fabrication and installation, does not render those gestures altogether impersonal: Serra's choice of a metal with a particular surface quality and density, and his decisions about the shape and proportions that metal takes, represent on their own terms a set of gestures hardly less individual that those of, say, Rodin.[25]

The materials used by Serra and the other Minimalists are indexed to, or have a value within, the political economy, however, in a way that Rodin's clay and bronze do not. In their ambition to make something that would be somehow more than or other than fine art (an ambition articulated most plainly in Judd's 'Specific Objects'[26]), the Minimalists found ways of using or commanding industry as another of the artist's tools. Working in heavy industry as a young man proved a deeply formative experience for Serra (as well as for Andre), contributing to his self-identity as a virile artist-worker.[27] A photograph of 1969, for instance, shows Serra standing in work clothes with his arms and legs spread wide, swinging a large metal ladle over his head as he flings hot molten lead. Though he is executing a work of art, he looks like a man about to mortally fell someone or something — or, as Rosalind Krauss puts it, 'Dressed as though for battle, he is helmeted, goggled, gas-masked. The field on which he stands is strewn with slag.'[28]

Isaac Balbus has perceptively suggested (in a critique of Foucault) that 'any True Discourse that relies on a *disembodied* founding subject does indeed both mask and justify the authoritarian process by means of which such a subject has (at least in part) been formed'. It follows that 'a True Discourse that posits an embodied founding subject is a prerequisite for any material appeal against this very process'.[29] What partisans of Minimalism have had to gain by denying the art's identity as a private statement is a masking of the mechanisms by which it has been elevated or empowered as a public statement of the first importance. To keep the public focus on the historical stage, where the work would appear most right or inevitable, the matter of the personal statement — who is speaking to whom, and by what authority — would have to be suppressed. As soon as anyone was permitted to ask — as soon, that is, as it was admitted to the level of a public discussion — why a grown man might fling lead at a wall, or order a big steel cube from a foundry, who such actions were addressed to and who they profited, the scaffolding of arguments holding that historic stage up to view as the centre stage, or the only stage, was bound to start becoming visible.

As for that big steel cube, Tony Smith's *Die*, a 183-cm [6-ft] black cube done in 1962, has emerged with Stella's pin-stripe paintings as another of the cornerstones and touchstones of Minimalism. Like *Die Fahne Hoch!*, *Die* was symmetrical, unitary and made of commercial materials. More than Stella's painting, however, *Die* set the stage for 'what followed in being an object with almost none of the standard signifiers of a work of fine art, except for a title. When Smith said of *Die* — which is patently lacking in formal complexities — 'This is a complicated piece. It has too many references to be coped with coherently', he must have been alluding in part to the multiple valences of the object's title. A die is one of a pair of dice, the small, sequentially marked cubes used for games of chance; but Smith's black cube offers only a fixed fate as all the sides are unmarked and identical and it is too big to roll. Die(!) is also a verb form, constituting a command — the cruellest command that the empowered can issue to the powerless: a murderer to his victim, a judge to a convicted criminal or a soldier to his enemy captive. The blackness, the sealed state and the human scale of Smith's cube help reinforce this reading of the title, which — considering that the command is directed at the viewer — renders the work a gruesome gesture: a bleak crypt presented to the viewer with succinct instructions to perish. 'Six feet has a suggestion of being cooked. Six foot box. Six foot under,' wrote Smith, who related *Die* also to a passage by Herodotus about a chapel found in the enclosure of a temple: a 'most wonderful thing … made of a single stone, the length and height of which were the same, each wall being forty cubits square, and the whole a single block!' — a description of a rather mausoleum-like structure.[30]

A die is also an industrial device that works by force, by pressure or by a blow, to cut blanks in or to mould an object or raw material. Though the making of *Die* did not involve such a device, as a standard form made of steel in a factory it might evince such means of facture. 'I didn't make a drawing; I just picked up the phone and ordered it', the artist boasted.[31] The 'death' at issue with this blank cube was not only that of the spectator, then, but also that of art, as *Die* effectively offers itself as the mould or die for the new non-art, as a machine that 'stamps out' art as we know it. A strange junket Smith organized in the early 1950s, a night-time car ride on an unfinished freeway with a group of students, had persuaded him that art as such was finished: 'Most painting looks pretty pictorial after that [the car ride]. There is no way you can frame it, you just have to experience it.' The experience of different spaces or 'artificial landscapes' was, in Smith's view, bound to take the place of art as we know it — the specific example he singled out admiringly being Albert Speer's Nuremberg Parade Ground:

'*A drill ground … large enough to accommodate two million men. The entire field is enclosed with high embankments and towers. The concrete approach is three 41 cm [16 in] steps, one above the other, stretching for a mile or so.*'

Like Andre, Smith was intoxicated by the prospect of 'seizing' or occupying space, and, without considering what constellations of social forces might lead to the erection of comparable sites in the US, he decried the dearth of art on such a scale in this country: 'I view art as something vast … Art today is an art of postage stamps.' In

his own work, he increasingly aimed to make 'citified monumental expression[s]' that would be not 'personal or subjective [but] ... as urbane and objective as possible'.[32]

Fascist architecture, especially 'the planning of Nazi Berlin' and 'Mussolini's constructions around Rome', also intrigued Frank Stella:

'The Fascist architects wanted to get on firm foundations. And the irony of their using what was considered to be classical art struck me ... as did the whole concept of public buildings in the US – which amount to much the same kind of thing.'[33]

For Western civilization, classicism is conventionally 'the art of authority, authoritative art'.[34] The architectural modes developed in Greece in the fifth century BC have, for evident symbolic reasons, long been a model for the buildings of democratic and liberal societies. Since the Roman Empire, however, certain often monumentalized and sharpened variations on the same structural language have served equally (as Stella noted) as a model for the architecture of autarchy – as in the Nuremberg parade ground. Because the Minimalists tended to work with completely regularized, geometric elements – not admitting anything like the subtle naturalistic swelling or tapering of the columns of Greek temples, for example – the relation of Stella's or Judd's work to Speer's is closer, finally, than their relation to the Temple of Hera at Paestum, for instance [...]

Judd continued to insist on the paramount importance of the 'plain power' of art in 'Specific Objects', the essay he published in 1965 that is often taken as a kind of keynote essay for the Minimalist movement.[35] Minimalism began to coalesce as a vision in 1964 and 1965 when the first group shows bringing together the artists now regarded as the Minimalists took place[36]. Historically, 1965 is also the year the first regular American combat troops entered Vietnam; the year the US started massive bombings of North Vietnam; the year Watts exploded in riots; and the year Malcolm X was assassinated. De Maria's *Death Wall* of 1965, a small stainless-steel plinth marked by a notch-like opening with the word DEATH engraved over it makes an exceedingly discreet, but evidently directed nod towards the violence of the time. Here, however, as with Minimalism generally, the art's political moment remains implicit largely in its acts of negation; it negated, that is, almost everything the public associated with or expected from works of art, including a sense of moral or spiritual uplift. Some female critics, especially, pointed (though not in a censorious way) to the violence implicit in the Minimalists' categorical refusal of the humanist mission of art: 'a negative art of denial and renunciation' and a 'rejective art', Barbara Rose and Lucy R. Lippard, respectively, dubbed it in 1965, while Annette Michelson suggested in 1967 that negation was the 'notion, philosophical in character ... animating [this] contemporary aesthetic'.[37]

The Minimalists effectually perpetrated violence through their work – violence against the conventions of art and against the viewer – rather than using their visual language to articulate a more pointed 'critique of particular kinds or instances of violence.[38] Judd insisted in 1970 that his work had not had 'anything to do with the

society, the institutions and grand theories. It was one person's work and interests; its main political conclusion, negative but basic, was that it, myself, anyone shouldn't serve any of these things ... Art may change things a little, but not much; I suspect one reason for the popularity of American art is that the museums and collectors didn't understand it enough to realize that it was against much in the society.[39]

But Judd's work was not, as he would have it, aloof from society. And given the geometric uniformity of his production, its slick surfaces, its commercial fabrication (often in multiples) and its stable, classic design, those prosperous collectors and institutions who were drawn to it could hardly be called obtuse if they perceived it not as 'against much in the society', but as continuous with their own ideals. Judd's work can easily be seen as reproducing some of the values most indelibly associated with the modern technocracy, in other words, even as it negated many of the qualities the public most fondly associated with the fine arts.

Though some of the Minimalists were alluding, by 1970, to a political moment implicit in their work, it was not at all plain from the way they represented their enterprise in the 1960s that they initially conceived it as a form of political resistance in keeping with the avant-garde mandate for oppositional artistic practices. Some critics now point to the Minimalists' interest in Russian Constructivism as a sign of their simmering political consciousness, but that interest revealed itself sporadically and not in politicized terms.[40] In 1966, on the other hand, Brian O'Doherty was congratulating the Minimalists for confronting 'what has become the illusion of avant-gardism', and developing 'a sort of intellectual connoisseurship of non-commitment'. This artist-critic went on to claim that the 'anti-avant-garde' object-makers were successfully establishing a new academy. Comparing the ambit of contemporary art to that of show jumping, he continued: the latest work 'sits blandly within the gates, announcing that it is not ahead of its time (therefore arousing no shock) and that the future is simply *now* ... This is going to be a tough academy to displace.'[41]

O'Doherty was prescient about the seamless assimilation of, at least the look of the new objects into the dominant culture: the clean, bold, precise, eminently classic and stable look of Minimalism soon permeated the design, the publicity, the products, the furnishings and the buildings of corporate and institutional America. Images like Noland's cropped up in commercial graphics, while Judd's gleaming boxes became, however indirectly, a model for the cabinets of advanced business machines and office furnishings. As assimilable, or readily colonized, as it proved in the corporate ambit, however, Minimalism met with a far less smooth reception from the general public. O'Doherty to the contrary, it did shock or anger people, and it does still, as eavesdropping in museums readily confirms. Minimalism dismays viewers by its obdurate blankness, by the extreme limitations of its means, by its harsh or antiseptic surfaces and quotidian materials, and by its pretentions, in spite of all this, to being fine art. Rather than soliciting the viewers' attention, as art objects customarily do, the Minimalist object is

perceived as exhibiting a cruel taciturnity and disinterest in the spectator, as its extreme simplicity and dearth of detail act to distance viewers and to repel the close scrutiny they expect to bring to works of art.

The viewer of a Minimalist art object necessarily takes cognizance of all that it lacks by comparison with other art: not only anthropomorphic or natural form, but traces of craftsmanship or touch, signs of inventiveness or uniqueness – qualities that help conjure the aura of a separate, specially inspired class of objects. Whether or not the Minimalists formed a self-conscious avant-garde, their work achieved what self-identified avant-gardists found increasingly difficult: it induced a sharp frisson, an intensely negative response. Whereas Pop art initially caused a collective shudder of distaste within the intelligentsia while being rapidly embraced by the public at large, Minimalism (in the same period) generally garnered toleration, at the least, from the cognoscenti, and either deep scepticism or unmitigated loathing from the public at large. That very loathing could be construed as a sign of this art at work, however, for what disturbs viewers most about Minimalist art may be what disturbs them about their own lives and times, as the face it projects is the society's blankest, steeliest face; the impersonal face of technology, industry and commerce; the unyielding face of the father: a face that is usually far more attractively masked.

In 'Specific Objects', Judd adduced what he plainly regarded as a positive vision: that the art of the future 'could be mass-produced, and possibilities otherwise unavailable, such as stamping, could be used. Dan Flavin, who uses fluorescent lights, has appropriated the results of industrial production.'[42] In the final event, however, neither Flavin nor Judd would sacrifice the cachet or the profits that mass-producing their work would likely have entailed. Artists like Flavin and Andre, who worked with commonly available products, took care to work in editions, limiting quantities so as to assure market value and, in Flavin's case, issuing certificates of authenticity upon the sale of their work. If Flavin appropriated commercial lighting fixtures and Andre used common building materials, it was not, in the end, with a view to standing the economy, or the valuations of the market, on its ear. Collectors were compelled to spend thousands of dollars to have one hundred and twenty sand-lime bricks purchased by Andre – to make *Equivalent VII*, for instance – rather than tens of dollars to buy the bricks for themselves. Though the artists depersonalized their modes of production to the furthest extent, they would not surrender the financial and other prerogatives of authorship, including those of establishing authenticity.

The rhetoric Judd mustered in 'Specific Objects' to promote the new (non-)art pointed to its attainment of 'plain power' through the deployment of 'strong' and 'aggressive' materials. At a time when the call was going out for a reformulation of the configurations of power, however, Judd's use of the term bore no inkling of its incipient volatility. For works of art to be powerful and aggressive was, from the Minimalists' standpoint, an unproblematic good, almost as it was once self-evident that art should be 'beautiful'. For an artist, 'power isn't the

only consideration', Judd grudgingly allowed, 'though the difference between it and expression can't be too great either'.[43] This equating of expression with power, rather than with feeling or communication, may or may not strike a reader as strange. Some kinds of art are routinely described as powerfully (read: intensely) expressive or emotional, but Judd's work is not of that sort: if his objects were persons (and I mean this strictly in a fanciful way) they would more likely be described as the proverbial 'strong, silent type'. In art-historical parlance, however, it has long been common approbatory language, even the highest level of praise, to describe works of art in terms of the exercise of power: as strong, forceful, authoritative, compelling, challenging or commanding; and the masculinist note becomes even more explicit with the use of terms like masterful, heroic, penetrating and rigorous. That what is rigorous and strong is valued while what is soft or flexible is comic or pathetic emerges again and again in the Minimalists' discourse, as it does in the everyday language of scholars. (Terms that might, but do not as readily, serve as high praise for art include, for instance: pregnant, nourishing, pleasurable.) The language used to esteem a work of art has come to coincide with the language used to describe a human figure of authority, in other words, whether or not the speaker holds that figure in esteem. As the male body is understood to be the strong body – with strength being measured not by tests of endurance, but by criteria of force, where it specially excels – so the dominant culture prizes strength and power to the extent that they have become the definitive or constitutive descriptive terms of value in every sphere: we are preoccupied not only with physical strength and military strength, but with fiscal, cultural, emotional and intellectual strength, as if actual force were the best index or barometer of success in any of those spheres.

Foucault has written at length about the power/knowledge paradigms that underwrite the master discourses, the 'True Discourses' of the successive regimes of modern history, and has pointed also to the 'will to power/knowledge' through which 'man' has historically been shaped and transformed. In Foucault's scheme, however (as de Lauretis has incisively observed), 'nothing exceeds the totalizing power of discourse [and] nothing escapes from the discourse of power'.[44] Foucault admits no possibility of a radical dismantling of systems of power and undertakes no theorizing or imagining of a society or world without domination. Balbus points perceptively to 'the blindness of a man [Foucault] who so takes for granted the persistence of patriarchy that he is unable even to see it. His gender-neutral assumption of a will to power (over others) that informs True Discourses and the technologies with which they are allied, transforms what has in fact been a disproportionately *male* into a generically human orientation, and obliterates in the process the distinctively female power' – my own word would have been capacity – 'of nurturance in the context of which masculine power is formed and against which it reacts'.[45] A persuasive case can be made, after all, that the patriarchal overvaluation of power and control – at the expense of mutuality, toleration or nurturance – can be held to account for almost all that is

politically reprehensible and morally lamentable in the world. The case can be made as well that what is most badly needed are, at least for a start, visions of something different, something else.

The Minimalists' valorization of power can readily be seen as a reinscribing of the True Discourses, the power discourses, found in art history as in the society at large. Received art-historical wisdom about what makes works of art 'powerful' is a quality of unity, with effects of dissonance or difference successfully effaced or overmastered such that an object's or image's composite parts are manoeuvred into a singular, coherent totality. Unity is associated with identity and a successful work of art is understood to require a whole identity no less than an integrated person does. Crudely speaking, the task that an artist is conventionally said to have undertaken is one of balancing the multifarious elements of a composition until they are harmonized and unified. The canny Minimalists started at the usual end of that task, however, by using configurations that were unified or balanced to begin with, such as squares and cubes, rather than engaging in the process of composing part by part. Thinking about what the society values most in art, Judd observed that, finally, no matter what you look at: '*The thing as a whole, its quality as a whole, is what is interesting. The main things are alone and are more intense, clear and powerful. They are not diluted by ... variations of a form, mild contrasts and connecting parts and areas.*'[46] In the best of the new art, Judd concluded (using Stella as his example), 'The shapes, the unity, projection, order and colour are specific, aggressive and powerful.'[47]

Returning to the anecdote I began with, a question that concerns me here – one I cannot presume to answer, admittedly, with any degree of specificity – is how the lay viewing public (as distinct from that specialized audience formed by critics) sees or responds to the powerfulness of work in the Minimalist idiom. Does Minimalist art strike viewers as exalting power? Or does it impress them as somehow indicting the overvaluation and the abuse of power? In either case, mightn't we anticipate that some viewers would be moved to endorse or embrace Minimalist objects while others would disparage or even assault them? Finally, might not the impulse to attack this art betray a perceived assault on the part of the objects themselves, be it a sense of their identity as instances or agents of authoritarianism perpetrating abuses of power against the hapless viewer or, from an opposing perspective, a sense of their implicating certain vital tenets of the True (or master) Discourse? Different answers are bound to pertain for different objects and viewers, and those answers will not likely be simple: the girls I observed with the Judd not only kicked, but also, however mockingly, kissed it (or kissed their images in it). The look of the objects Judd offers viewers tends to be commercial and corporate, as his structures and surfaces evoke shiny, expensive machinery done in this year's colours and materials, or the architectural and design fittings of modern airports and office buildings. As such (or but for their functionlessness), Judd's objects may well seem alluring to some viewers while others will deem them too

impersonal or banal, desiring other qualities from art. In either event, few viewers are likely to feel terribly abused by Judd's objects, as their surfaces are not harsh and their scale and presence remain comparatively unobtrusive.

Like Judd's boxes, Morris' cage-like construction of 1967 does not intrude aggressively on the viewers' space due to its moderate scale and its transparency. Unlike Judd's boxes, however, Morris' construction, with its steel materials reminiscent of chain-link fencing, evokes not corporate but carceral images of discipline and punishment that intrude aggressively on the viewers' sensibilities.[48] A fenced-in quadrangle surrounded by a fenced-in corridor evokes an animal pen and run, both without exits. Made during a year of African-American uprisings in Detroit and elsewhere, and the year of the siege of the Pentagon – a time when masses of ordinarily law-abiding citizens became subject to an exceptionally pervasive and overt meting out of discipline and punishment – Morris' sculpture succinctly images containment or repression. If it does not refer in any more pointed or pointedly critical way to the events of the day, by representing power in such an abrasive, terse and unapologetic way, the work none the less has a chilling effect: this is authority represented as authority does not usually like to represent itself; authority as authoritarian.

To judge by Morris' writings, his success at realizing such authoritative and oppressive images owed more to his infatuation with power than to his interest in finding strategies to counter the abuses of power rife and visible at the time. In terms befitting a military strategist, Morris wrote in his 'Notes on Sculpture' of seeking 'unitary' or 'strong Gestalt[s]' that would 'fail to present lines of fracture' and that would offer 'the maximum resistance to being confronted as objects with separate parts'.[49] Separate parts could become entangled in internal relationships that would render the objects vulnerable; because they lead to weak Gestalts, 'intimacy-producing relations have been gotten rid of in the new sculpture'. An elimination of detail is required in the new sculpture, further, because detail would 'pull it towards intimacy'; and the large scale of the work is important as 'one of the necessary conditions of avoiding intimacy'. There is plainly a psycho-sexual dimension to Morris' trenchant objections to relationships and intimacy, to his insistence on distancing the viewer, as well as to his fixation on keeping his objects discrete and intact.[50] In his pathbreaking study of male fantasies, for that (last) matter, Klaus Theweleit has described how the population of 'soldier males' whose writings he analysed: '*Freeze up, become icicles in the fact of erotic femininity. We saw that it isn't enough simply to view this as a defence against the threat of castration; by reacting in that way, in fact, the man holds himself together as an entity, a body with fixed boundaries. Contact with erotic women would make him cease to exist in that form. Now, when we ask how that man keeps the threat of the Red flood of revolution away from his body, we find the same movement of stiffening, of closing himself off to form a "discrete entity".*'[51]

Morris declared in 1966 that: 'The better new work takes relationships out of the work and makes them a

function of space, light and the viewer's field of vision'.[52] He referred not to a relationship between viewer and work, that is, but only to a relation between the work and the viewers' 'field of vision' – as if the viewers' sight were separable from their minds, bodies or feelings. The relation between art and spectator that interested Morris became clearer over the course of the 1960s and early 1970s as he made manifest an attitude towards the (embodied) viewer that was ambivalent at best, belligerent and malevolent at worst. The public, at times, returned the artist's animosity: his exhibition at the Tate Gallery in London in 1971 had to be closed after five days, allegedly to protect the public, but also to protect the work which the public was battering. Some of that work invited viewer participation – in simple tests of agility, for instance – but with work that engages the public, as the artist discovered, 'sometimes it's horrible. Sometimes you just can't get people to do what you want.' The following year Morris retaliated, as it were, against a different audience with a work called *Hearing*, a gallery installation that consisted of a copper chair, a zinc table and a lead bed (still executed in a Minimalist idiom). The chair contained water heated almost to the boiling point, and the bed and table were connected with thirty-six volts of electricity, while loudspeakers broadcast a (mock) interrogation lasting for three-and-a-half hours.[53] Later still, to tout another show of his work at the Castelli Gallery, Morris exposed his bare-chested body clad in sadomasochistic paraphernalia, thereby equating the force of art with corporeal force, where what prevails or dominates is generally the greatest violence.[54]

The increasing brutality of the Minimalist rhetoric may be charted also in the art of Walter De Maria. His *Cage* of 1965 [216 × 37 × 37 cm (85 × 14.5 × 14.5 in)] looked insidiously like a stainless steel standing cell, but its interior was inaccessible to the viewer. In 1966–67 De Maria made *Museum Piece*, the aluminium swastika that lies on the floor at the viewers' feet holding a metal ball that they can move around, engaging in an apparently meaningless, but sinister-seeming game. By 1968 De Maria's famous *Beds of Spikes*, large stainless steel platforms covered with rows of sharp, obelisk-shaped spikes, were completely and lethally accessible to viewers, who were obliged to sign an unconditional release to absolve the Dwan Gallery for responsibility in the event of accident or injury.

Less imminently harmful, but still effecting a kind of psychological aggression are Andre's bare, metal 'plains'. Working in the late 1960s with plates of various kinds of metal laid side by side on the floor, Andre built a unitary Gestalt, a square, by working repetitively with a simple, 30.5 cm² [1 ft²] module. Andre took this 'strong' form and brought it low, however, spreading it laterally over the ground like a carpet. So 'abased' are his sculptures that viewers are invited to walk on them, to enact a drama of humiliation that inverts the conventional relation of spectator and art work, evacuating the spirit of respect or reverence that customarily distances viewers from works of art. Andre challenges the viewers' cultural conditioning, their habit of 'looking up to' art as something ideal and untouchable, by putting it literally beneath them, forcing

14. Walter De Maria

them to look down on it. Walking on his work may make some viewers feel less triumphant than uncomfortable, however. As Stanley Cavell has observed, we are accustomed to regarding works of art as having identities, not unlike people; we are capable of having special feelings for them, almost as we have for people: to humiliate or abuse an other, even if that other is a very thing-like work of art, may feel like unworthy, even humiliating behaviour. As Andre manipulates viewers into performing a transgressive act that rebounds on themselves, he does it less as a gesture of humility, in a sense, than as an assertion of power. Consider, too, the expression to 'take the floor', which describes this work nicely and which means to claim the power to speak, to compel an audience to listen. What Andre achieved by spreading his materials out laterally was also the largest possible 'seizure' of territory, as he takes up far more area than sculptors typically do, except in realizing monuments.

That the Minimalist idiom could be used on a monumental scale was mainly the discovery of the youngest member of the Minimalist inner circle. Richard Serra (who first moved to New York in 1966) swiftly assimilated a visual rhetoric developed by others and shaped it to his own ends – ends in keeping with the more overtly aggressive tone of some of the Minimalist production of the later 1960s and 1970s. Serra's *Delineator* of 1974–76 is similar to Andre's plains in so far as it provides a rectangular metal carpet [3 × 8 m (10 × 26 ft)] for viewers to walk on. But unlike Andre's square, unitary planes, Serra's work revolves around a matrix of binary opposites: the 'delineated' opposition of floor and ceiling, the opposing orientation of one rectangle to the other and, not least, the oppositional relation set in play between the viewer and the work of art. For a viewer to tread on Serra's work is not to engage in a scenario of transgression and humiliation, however, but in one of transgression and (imminent) punishment. As no visible fastenings restrain the two-and-a-half-ton panel on the ceiling, viewers must wonder how long this Houdini-esque and Herculean feat of engineering will last – or how soon they are likely to be crushed to death.

The paradigmatic relation between work and spectator in Richard Serra's art is that between bully and victim, as his work tends to treat the viewer's welfare with contempt. This work not only looks dangerous, it *is* dangerous: the 'prop' pieces in museums are often roped off or alarmed and sometimes, especially in the process of installation and de-installation, they fall and injure or even (on one occasion) kill. Serra has long toyed with the brink between what is simply risky and what is outright lethal, as in his *Skullcracker Series: Stacked Steel Slabs* of 1969 which consisted of perilously imbalanced, 610 to 1,220-cm [20 to 40-ft]-tall stacks of dense metal plates. Rosalind Krauss insists that, 'It matters very little that the scale of this work … is vastly over life size', but Serra's ambitious expansion of the once-moderate scale of the Minimalist object was, together with his fascination with balance and imbalance, central to his work's concern with jeopardy and crucial to its menacing effect.[55] Judging by his own account, what impelled Serra to make ever bigger works in ever more public spaces was never an interest in the problems of

making art for audiences not fluent, let alone conversant, in the difficult languages of Modernist art, but rather a consuming personal ambition, a will to power. 'If you are conceiving a piece for a public place', he conceded (while avoiding the first-person pronoun), ' … one has to consider the traffic flow, but not necessarily worry about the indigenous community, and get caught up in the politics of the site'.[56] Serra's assurance that he could remain aloof from politics proved fallacious, of course, as the public returned his cool feelings, most notably in the case of the *Tilted Arc* of 1981.

It has been argued about the *Tilted Arc* that its oppressiveness could serve in a politically productive way to alert the public to its sense of oppression. Though an argument can be made for Serra similar to the ones I have made here for Judd, Morris and Stella – that the work succeeds in so far as it visualizes, in a suitably chilling way, a nakedly dehumanized and alienating expression of power – it is more often the case with Serra (as sometimes also with Morris) that his work doesn't simply exemplify aggression or domination, but acts it out. In its site on Federal Plaza in lower Manhattan, Serra's mammoth, perilously tilted steel arc formed a divisive barrier too tall (366 cm [12 ft]) to see over, and a protracted trip (3,660 cm [120 ft]) to walk around. In the severity of its material, the austerity of its form and in its gargantuan size, it served almost as a grotesque amplification of Minimalism's power rhetoric. Something about the public reaction to that rhetoric can be deduced from the graffiti and the urine that liberally covered the work almost from the first, as well as from the petitions demanding its removal (a demand met last year).

A predictable defence of Serra's work was mounted by critics, curators, dealers, collectors and some fellow artists. At the General Services Administration hearings over the petitions to have the work removed, the dealer Holly Solomon made what she evidently regarded as an inarguable case in its favour:

I can only tell you, gentlemen, that this is business, and to take down the piece is bad business … The bottom line is that this has financial value, and you really have to understand that you have a responsibility to the financial community. You cannot destroy property.'
But the principal arguments mustered on Serra's behalf were old ones concerning the nature and function of the avant-garde. Thus, The Museum of Modern Art's chief Curator of Painting and Sculpture, William Rubin, taught a hoary art history lesson:
About one hundred years ago the Impressionists and post-Impressionists … artists whose works are today prized universally, were being reviled as ridiculous by the public and the established press. At about the same time, the Eiffel Tower was constructed, only to be greeted by much the same ridicule … Truly challenging works of art require a period of time before their artistic language can be understood by the broader public.'[57]
What Rubin and Serra's other supporters declined to ask is whether the sculptor really is, in the most meaningful sense of the term, an avant-garde artist. Being avant-garde implies being ahead of, outside, or against the dominant culture; proffering a vision that implicitly stands

(at least when it is conceived) as a critique of entrenched forms and structures. 'Avant-garde research is functionally ... or ontologically ... located outside the system', as Lyotard put it, 'and by definition, its function is to deconstruct everything that belongs to order, to show that all this "order" conceals something else, that it represses'.[58] But Serra's work is securely embedded within the system: when the *brouhaha* over the *Tilted Arc* was at its height, he was enjoying a retrospective at The Museum of Modern Art (in the catalogue of which, by a special exception, he was allowed to have a critic of his choosing, Douglas Crimp, make a case for him).[59] The panel of luminaries who were empowered to award Serra the commission in the first place plainly found his vision congenial to their own. And his defence of the work rested precisely on this basis, that far from being an outsider, he was an eminent member of the establishment who, through some horrifying twist of fate, had become subject to harassment by the unwashed and uncouth who do not even recognize, let alone respect, authority when they see it.

Because his work was commissioned according to the regulations of a government agency, Serra reasoned that 'The selection of this sculpture was, therefore, made by, and on behalf of the public'. Stella expanded on this theme in his own remarks at the hearing:

'The government and the artist have acted as the body of society attempting to meet civilized, one might almost say civilizing goals ... To destroy the work of art and simultaneously incur greater public expense in that effort would disturb the status quo for no gain ... Finally, no public dispute should force the gratuitous destruction of any benign, civilizing effort.'[60]

These arguments locate Serra not with the vanguard but with the standing army or 'status quo', and as such represent a more acute view than Rubin's, though the rhetoric they depend on is no less hackneyed. More thoughtful, sensible and eloquent testimony at the hearing came instead from some of the uncouth:

'My name is Danny Katz and I work in this building as a clerk. My friend Vito told me this morning that I am a philistine. Despite that I am getting up to speak ... I don't think this issue should be elevated into a dispute between the forces of ignorance and art, or art versus government. I really blame government less because it has long ago outgrown its human dimension. But from the artists I expected a lot more. I didn't expect to hear them rely on the tired and dangerous reasoning that the government has made a deal, so let the rabble live with the steel because it's a deal. That kind of metality leads to wars. We had a deal with Vietnam. I didn't expect to hear the arrogant position that art justifies interference with the simple joys of human activity in a plaza. It's not a great plaza by international standards, but it is a small refuge and place of revival for people who ride to work in steel containers, work in sealed rooms and breathe recirculated air all day. Is the purpose of art in public places to seal off a route of escape, to stress the absence of joy and hope? I can't believe this was the artistic intention, yet to my sadness this for me has been the dominant effect of the work and it's all the fault of its position and location. I can accept anything in art, but I can't accept physical assault and complete destruction of

pathetic human activity. No work of art created with a contempt for ordinary humanity and without respect for the common element of human experience can be great. It will always lack a dimension.'[61]

The terms Katz associated with Serra's project include 'arrogance' and 'contempt', 'assault' and 'destruction'; he saw the Minimalist idiom, in other words, as continuous with the master discourse of our imperious and violent technocracy.

Though Serra has garnered public art commissions in this country and in Europe, the Minimalist work of the other artists discussed here has remained largely in private and museum spheres. Minimalist cubes stand outside corporate headquarters and in public plazas across the country, but – as a photograph of one such work, in New York's Cooper Square, helps to show – the artists chosen to make such public statements were those (such as Alexander Liberman, Beverly Pepper or in this case Bernard Rosenthal) who embellished, and thereby eased the implacable rhetoric of Judd, Morris, Andre and Smith.[62] The work in Cooper Square, *Alamo*, of 1966–67, is not a bare metal box set solidly on the ground, but a decoratively patterned cube poised coyly on a platform on one cut-off point; as the absolute geometry of the Minimalist cube has been abrogated, the effect is accordingly no longer absolutist. Corporate and government bodies generally proved receptive to Minimalism's fierce rhetoric only at a softened pitch or (less often, as in Serra's case) a heightened one. After all, a plain steel box looks more like a product than like art, and when a corporate or government agency pays for art it demands the work of an artist, the figure who serves as the living trace of the autonomous subject. In the case of *Alamo*, the unsystematic patterning on the black cube's surface gives the reassuring sense of an idiosyncratic and improvisational activity on the artist's part, whereas in a steel box by Judd all the decisions were plainly fixed at the start and there is nothing to signal the personal imprimatur of the maker. Finally, Minimalism's denial of subjectivity acts to distance and isolate viewers, rather than integrate them into the cultural (and so the economic) system, as more obliging work (such as Rosenthal's) would do.

It proves less of a strain to perceive Minimalist art as 'against much in the society' (as the artists themselves would generally have it) than when we compare it with art that harbours no such ambitions. But can Minimalism readily be seen as having that oppositional moment we demand of vanguard or Modernist art? The most defensible answer to this question is surely 'no', but a contrary answer can still be contrived given the at times disquieting effect of the most uningratiating Minimalist production – that bothersomeness that impels some viewers even to kick it. To construct the inobvious answer takes a recourse to the Modernist theory of Adorno, however. 'One cannot say in general whether somebody who excises all expression is a mouthpiece of reification. He may also be a spokesman for a genuine non-linguistic, expressionless expression, a kind of crying without tears', wrote Adorno.[63] If no general judgement of this kind can be made, I have proposed here that some local or specific

judgements might be; that in some of the Minimalists' most contained and expressionless works we might infer a denunciatory statement made in, and not against, the viewer's best interests. Adorno suggested that, 'The greatness of works of art lies solely in their power to let those things be heard which ideology conceals'.[64] Whether by the artists' conscious design or not, the best of Minimalist art does that well enough, through its lapidary reformulations of some especially telling phrases of the master discourse. Adorno championed Modernist art not only for its negative capability, however, but also for its utopian moment, its vision of something other or better than the present regime. Here we encounter Minimalism's departure: its refusal to picture something else; a refusal which finally returns the viewer – at best a more disillusioned viewer – to more of the same.

1 Teresa de Lauretis, *Alice Doesn't: Feminism, Semiotics, Cinema* (Bloomington: Indiana University Press, 1984) 179.

2 Harriet Senie, 'The Right Stuff', *ARTnews* (March 1984) 55.

3 Hal Foster alone has ventured in print (however tentatively): 'Is it too much to suggest that 'art for art's sake' returns here in its authoritative (authoritarian?) guise, a guise which reveals that, far from separate from power and religion (as Enlightenment philosophy would have it) bourgeois art is a displaced will to power … and ultimately *is* a religion?' Hal Foster, 'The Crux of Minimalism', *The Return of the Real: The Avant-Garde at the End of the Century* (Cambridge, Massachusetts and London: MIT Press, 1996), originally published in *Individuals: A Selected History of Contemporary Art 1945-1986* (Los Angeles: The Museum of Contemporary Art; New York: Abbeville Press, 1986) 174. [See in this volume pp. 270-75.]

4 Phyllis Tuchman, 'An Interview with Carl Andre', *Artforum* (June 1970) 61. In so far as space or voids are conventionally coded as feminine, a symbolic form of sexual domination is at issue here too.

5 See Don Terry, 'A 16-Ton Sculpture Falls, Injuring Two', *New York Times* (27 October 1988) B6; and Ruth Landa, 'Sculpture Crushes Two: Worker Loses Leg as 16-Ton Piece Falls', *Daily News* (27 October 1988) 1; 3. Douglas Crimp sees the outsized scale of Serra's work as proof that the artist uses the gallery as 'a site of struggle', but for an artist to overload a floor hardly amounts to a struggle; and there was no struggle with the dealer, who could not have been more accommodating.

6 Jeanne Siegel, 'Interview with Carl Andre: Artworker', *Studio International* (November 1970) 178; reprinted in *Artwords: Discourse on the 60s and 70s* (New York: Da Capo Press, 1992). [See in this volume pp. 250-53.] Andre and, to a lesser extent, Morris, were active in the Art Workers Coalition, an anarchic body formed in 1969 whose principal achievement was helping to organize the New York Art Strike against War, Racism and Repression, which closed numerous galleries and museums on 22 May 1970 (a sit-in on the steps of the Metropolitan Museum of Art, which did not close, drew about 500 participants). The AWC drew a distinction between the politicizing of artists, which it urged, and the politicizing of art,

which it did not.

It bears noting that that prime motivator of political action in the student population, the draft, did not threaten any of the men discussed here, as most of them had spent years in the military - in some cases by choice - prior to pursuing careers as artists. Kenneth Noland, born in 1924, served 1942-46 as a glider pilot and cryptographer in the air force, mainly in the US but also in Egypt and Turkey; he subsequently studied art at Black Mountain College and in Paris. Judd, born in 1928, served in the army in Korea in an engineer's unit, 1945-47 (before the outbreak of the war there); subsequently he studied at the Art Students League and at Columbia University, from which he graduated in 1953 with a BS in Philosophy, and where he pursued graduate studies in Art History, 1958-60. Sol LeWitt, born in 1928, earned a BFA from Syracuse University in 1949, and then served in the US Army in Japan and Korea, 1951-52. Morris, born in 1931, served time in Korea as an engineer towards the end of the Korean war; he attended numerous universities and art schools, including the California School of Fine Arts and Reed College, and did graduate work at Hunter College in New York in Art History. Dan Flavin, born in 1933, found himself, in 1955, by his own account, 'loitering in Korea with an army of occupation as an Air Weather Service Observer'; he subsequently attended Columbia University. Andre, born in 1935, studied at Phillips Andover Academy, 1951-53, and served in the army in North Carolina in 1955-56. Walter De Maria, born in 1935, earned a BA in History and an MA in Sculpture at the University of California at Berkeley, and was not in the military. Frank Stella, born in 1936, expected to be drafted on graduating from Princeton, but was exempted because of a childhood injury to his hand. Richard Serra, born in 1939, also did not see military service.

7 From an unpublished section of transcripts of interviews with Stella conducted in Cambridge, Massachusetts, in December 1983 or January 1984, primarily by Caroline Jones, in the Harvard University Art Museum archives.

8 Eugene C. Goossen, 'Distillation', 1966 (a text accompanying an exhibition held at the Tibor de Nagy and Stable galleries, New York, in September 1966); reprinted in *Minimal Art: A Critical Anthology*, ed. Gregory Battcock (New York: E.P. Dutton & Co., 1968) 169.

9 Eugene C. Goossen, *The Art of the Real: U.S.A. 1948-1969* (New York: The Museum of Modern Art, 1968) 11. This show represented the debut of Minimalism at The Museum of Modern Art, although it did not feature Minimalism exclusively.

10 Clement Greenberg, 'Recentness of Sculpture', *American Sculpture of the Sixties*, ed. Maurice Tuchman (Los Angeles County Museum of Art, 1967); reprinted in *Minimal Art, op. cit.*, 183. [See in this volume pp. 233-34.]

11 Goossen, *The Art of the Real, op. cit.*

12 Eugene C. Goossen, 'Eight Young Artists', 1964 (an essay accompanying an exhibition at the Hudson River Museum in Yonkers, New York, October 1964); reprinted in *Minimal Art, op. cit.*, 167.

13 Such was the title given to the drawing for the work in *fluorescent light etc. from Dan Flavin*, ed. Brydon Smith (Ottawa: National Gallery of Canada, 1969) 166; and Flavin reiterated the phrase when showing a slide of the work at a lecture at Harvard University in 1986.

14 Melinda Wortz, 'Dan Flavin: E.F. Hauserman Company Showroom, Pacific Design Center', *Artforum* (January 1983) 82.

16 From a venomous text in which he bemoans the religious training forced upon him as an adolescent sent to a junior seminary to fulfil his father's 'lost vocation'. The excesses of parental and religious authority visited upon Flavin as a child by his father, and a mother he calls 'a stupid, fleshly tyrant of a woman', propelled him, by his own oft-repeated account, into a fantasy life centred on exhibitions of power in other spheres; he 'dwelled in serious fantasies of war', doing 'pencil sketches of World War devastation as it progressed', and amassing 'hundreds of … drawings after the "Horrors of War" picture cards of Gum, Incorporated, and sundry other war-time illustrations', Dan Flavin, ' … in daylight or cool white', *Artforum* (December 1965) 21. [See in this volume pp. 204-206.]

17 Flavin, *ibid.*, 24.

18 Theodor Adorno, *Aesthetic Theory*, ed. Gretel Adorno and Rolf Tiedemann, trans. C. Lenhardt (London: Routledge & Kegan Paul, 1984) 35.

19 Siegel, *op. cit.*, 178; David Bourdon, *Carl Andre: Sculpture 1959-1977* (New York: Jaap Reitman, 1978) 27. A key work Andre conceived in 1960, but could not afford to execute until 1966, was *Herm*, consisting of a single rectangular timber standing on end. The title refers to ancient Greek road markers, simple, rectangular stone pillars often marked by an erect penis and surmounted by a bust of Hermes. In 1963 Andre made a wooden sculpture called *Cock* in evident homage to Brancusi (though 'cock' does not have the explicit slang connotation in French that it has in English).

20 Brian O'Doherty, 'Minus Plato', 1966, in *Minimal Art, op. cit.*, 252.

21 Jean-François Lyotard, 'Some of the Things at Stake in Women's Struggles', *Wedge*, 6 (Winter 1984) 27.

22 Alice Jardine, *Gynesis: Configurations of Woman and Modernity* (Ithaca: Cornell University Press, 1985) 101.

23 Douglas Crimp, 'Serra's Public Sculpture: Redefining Site Specificity', in Rosalind Krauss, *Richard Serra: Sculpture*, ed. Laura Rosenstock (New York: The Museum of Modern Art, 1986) 45.

24 Tellingly, Serra told one critic that he took a lot of art courses in college, 'partly to boost his grade-point average and partly because he found art "totally interesting and totally private"'. Senie, *op. cit.*, 57.

25 That Andre, for one, recognized this fact is evident in his response to Duchamp's readymades (which the artist himself insisted were chosen in a state of aesthetic 'anaesthesia'): 'Duchamp's taste is nothing short of exquisite, up to and including his taste in urinals'. Benjamin H.D. Buchloh (ed.), *Carl Andre, Hollis Frampton: Twelve Dialogues* (Halifax: Press of the Nova Scotia College of Art and Design; New York University Press, 1981) 25.

26 Donald Judd, 'Specific Objects', *Arts Yearbook*, 8 (1965); reprinted in *Donald Judd: Complete Writings 1959-1975* (Halifax: Nova Scotia College of Art and Design; New York University Press, 1975) 181-89. [See in this volume pp. 207-10.]

27 Before and during his college years, Serra worked numerous summers in steel mills, work that he sought not only because it paid more than other types of summer jobs, but because he found it 'actually, er … fun to do'. Interview with Bear, in *Serra: Interviews* (Yonkers: Hudson River Museum, 1980). After graduating from Phillips Academy and before a sojourn in Europe, Andre worked at the Boston Gear Works in Quincy, Massachusetts, his home town, and from 1960-64 he worked in New Jersey on the Pennsylvania Railroad as a freight brakeman and conductor. He said the (latter) experience made him a better sculptor, and his preferred materials initially included timbers like those used in laying railroad track.

28 Krauss, *Richard Serra: Sculpture, op. cit.*, 15; the photograph is reproduced on p. 14.

29 Isaac Balbus, 'Disciplining Women: Michel Foucault and the Power of Feminist Discourse', in *Feminism as Critique*, ed. Seyla Benhabib and Drucilla Cornell (Minneapolis: University of Minnesota Press, 1987) 125.

30 Samuel J. Wagstaff, Jr and Tony Smith, *Tony Smith: Two Exhibitions of Sculpture* (Hartford: Wadsworth Atheneum; Philadelphia: Institute of Contemporary Art, University of Pennsylvania, 1966).

31 *Ibid.*; Smith worked as a toolmaker and industrial draftsman in the 1930s.

32 Samuel J. Wagstaff, Jr, 'Talking with Tony Smith', *Artforum*, 5 (December 1966); reprinted in *Minimal Art, op. cit.*, 384-86.

33 Stella speculated also 'whether there is not some relationship between quality in art and architecture and the will to impose it - a kind of "totalitarianism of quality"' (Stella's phrase), according to William S. Rubin, *Frank Stella* (New York: The Museum of Modern Art, 1970) 45; 153. His self-identity as a kind of autocrat emerged also in his descriptions of his present mode of fabricating his work, in a factory context, as 'dictatorial proletarianism', Calvin, Tomkins, 'The Space Around Real Things', *New Yorker* (10 September 1984) 47.

34 Henri Zerner, 'Classicism and Power', *Art Journal*, 47: 1 (Spring 1988) 36.

35 While its rhetoric most plainly described Judd's own vision, this essay did not deal exclusively with the Minimalists, but included others such as Rauschenberg, Lucas Samaras and Claes Oldenburg, who were using non-fine-arts materials or objects in their work.

36 Samuel J. Wagstaff, Jr's 'Black, White, and Grey', an exhibition at the Wadsworth Atheneum in Hartford, Connecticut, in January-February of 1964, included Morris, Tony Smith, Flavin, Agnes Martin and Anne Truitt, for example, among other artists who would not become associated with Minimalism. Flavin organized an exhibition at the Kaymar Gallery in New York in March 1964 that included himself, Judd, LeWitt, Stella, Bannard, Robert Ryman and Jo Baer, among others. Goossen

organized 'Eight Young Artists' at the Hudson Rivers Museum in October 1964, including Andre and Bannard. The 'Shape and Structure' show at Tibor de Nagy in 1965 included Judd, Morris and Andre, among others. Michael Fried's 'Three American Painters', with Stella, Noland and Olitski took place at the Fogg Art Museum at Harvard in 1965. And Kynaston McShine's 'Primary Structures' exhibition occurred at the Jewish Museum, New York, in 1966.

37 Barbara Rose, 'ABC Art', *Art in America* (October-November 1965) 296 [See in this volume pp. 214-17]; Lucy R. Lippard, 'New York Letter: Rejective Art', *Art International* (1965); reprinted in Lucy R. Lippard, *Changing: Essays in Art Criticism* (New York: E.P. Dutton & Co., 1971) 141-53; Annette Michelson, '10 × 10 … ', *Artforum* (January 1967) 30-31.

38 That such a feat was possible was proved most recently by Maya Lin, designer of the Vietnam war memorial with its graduated V-shaped, Minimalist wall which makes a stark, symbolic cut in the landscape. The names of the war dead etched in the wall's polished, black stone surfaces mingle with the reflections of the spectators, many of whom have described feeling a deep emotional connection to the work antithetic to the sense of deprivation or of being defrauded more typical of the public's response to Minimalism. The question is (as Daniel Abramson observed in conversation) whether the sense of identification and healing viewers reportedly derive from Lin's work effectually undercuts the critical message and the image of violence she intended to convey.

39 'The Artist and Politics: A Symposium', *Artforum* (September 1970) 37.

40 Beginning in 1964-65, Flavin did a series of works entitled *Monument for Vladimir Tatlin*, which he later described as 'pseudo-monuments', noting that they are made of common fluorescent bulbs 'with a life of 2,100 hours of temporary illumination'. *fluorescent light etc. from Dan Flavin, op. cit.*, 218. Morris acknowledged Tatlin and Rodchenko, among others, as the progenitors of 'non-imagistic sculpture' in his 'Notes on Sculpture: Part I', *Artforum* (February 1966); reprinted in *Minimal Art, op. cit.*, 224. [See in this volume pp. 217-18] And Andre discussed Constructivism with Hollis Frampton in *Dialogues* written in 1962 and 1963, but not intended for publication; said the sculptor, Constructivism 'provides the suggestion of an aesthetic which could be the basis for a kind of plastic poetry which retained the qualities of both poetry and painting. I am experimenting towards that end, anyway. My Constructivism is the generation of overall designs by the multiplication of the qualities of the individual constituent elements.' Benjamin H.D. Buchloh (ed.), *Carl Andre, Hollis Frampton: Twelve Dialogues* (Halifax: Nova Scotia College of Art and Design; New York University Press, 1981) 34; 37. References to Duchamp or Brancusi generally occur more often than references to Tatlin and Rodchenko in these artists' discourse, however.

41 Brian O'Doherty, 'Minus Plato', *Art and Artists* (September 1966); reprinted in *Minimal Art, op. cit.*

42 Judd, 'Specific Objects', *op. cit.*, 187.

43 *Ibid.*, 181.

44 de Lauretis, *op. cit.*, 87.

45 Isaac Balbus, 'Disciplining Women: Michel Foucault and the Power of Feminist Discourse', in *Feminism as Critique*, ed. Seyla Benhabib and Drucilla Cornell (Minneapolis: University of Minnesota Press, 1987) 120.

46 Judd, 'Specific Objects', *op. cit.*, 187.

47 *Ibid.*, 184.

48 In 1978, Robert Morris would do a series of ink on paper drawings, called 'In the Realm of the Carceral'. See Stephen F. Eisenman, 'The Space of the Self: Robert Morris. "In the Realm of the Carceral"', *Arts Magazine* (September 1980) 104-109.

49 Morris, 'Notes on Sculpture: Part I', *op. cit.*, 226, 228.

50 Robert Morris, 'Notes on Sculpture: Part II', *Artforum*, 5:2 (October 1966); reprinted in *Minimal Art, op. cit.*, 232-33. Naomi Schor suggests that details have historically been coded feminine and viewed accordingly with suspicion, if not contempt, in *Reading in Detail: Aesthetics and the Feminine* (New York: Methuen, 1987). The psycho-sexual aspect to Morris' project became clearer in a performance piece of 1964 called *Site* in which the artist moved standard 122 × 244 cm [4 × 8 ft] construction materials around a stage while maintaining a studied indifference to the nude body of a woman (Carolee Schneemann) posed as the courtesan Olympia. When a critic suggested that the work 'implied that as the nude woman was to Manet, so the grey construction material was to him', the artist replied with a story about a woman being sexually aggressive toward him and so, as it seems, threatening the integrity of his work process: 'Morris' comment was that he had been approached several times by a dancer who wanted to work with him, unbuttoning her blouse as she spoke. His solution was *Site*'. William S. Wilson, 'Hard Question and Soft Answers', *ARTnews* (November 1969) 26.

51 Klaus Theweleit, *Male Fantasies*, 1: in *Women, Floods, Bodies, History* (Minneapolis: University of Minnesota Press, 1987) 244. The specific population Theweleit studied is the German Freikorps, 'the volunteer armies that fought, and to a large extent triumphed over, the revolutionary German working class in the years immediately after World War I', p. ix.

52 Morris, 'Notes on Sculpture: Part II', *op. cit.*, 232.

53 Jonathan Fineberg, 'Robert Morris Looking Back: An Interview', *Arts Magazine* (September 1975) 111-13.

54 Robert Morris' violence emerged most explicitly in some of the non-Minimalist work that forms the greater part of his production: he described a 'process piece' he conceived in the 1960s as follows, for example: 'I had them shoot a shotgun blast into the wall [of the gallery], and the pattern of the shot was photographed. That was a travelling show. At the next place the photograph was put up and the gun fired, and the result was photographed and enlarged. Each museum got a photograph of the shot photograph, and they shot that one so that you got a series of photographs of photographs that had been shot. Each photograph had to be bigger. I wanted it to get bigger and bigger'. Goossen, 'The Artist Speaks', *op. cit.*, 105.

55 Krauss, *Serra, op. cit.*, 24; see p. 25 for a reproduction

of one of the works from the *Skullcracker* series (which is no longer extant), a work made of hot-rolled steel, 610 × 244 × 305 cm [20 × 8 × 10 ft], at the Kaiser Steel Corporation, Fontana, California, Serra said the point of the exercise was to create a structure that would be just 'at the boundary of its tendency to overturn'. (The wall label for Serra's *Davidson Gate* of 1970, at the National Gallery of Canada, reads, in capital letters: 'Attention! Great weight and delicate balance are essential features of this work. Do not touch, nudge, push or otherwise test the steel plates. Children must be accompanied by an adult.') An insight into Serra's motivations emerged in an interview about his video work: 'I made an earlier videotape called *Surprise Attack*, which used a game theory that went: if you hear a burglar downstairs, should you pick up a gun? It was taken from Schilling's book *The Strategy of Conflict* … And then when I saw [Robert Bell] in New York recently he'd just finished a paper on Deterrents which mentioned this specific prisoner's dilemma. I read the paper, and in my trying to dope out the pros and cons of it … I found that my own thinking fascinated me, so much so that I thought it must have an awful lot to do with the way I think about anything.' 'Prisoner's Dilemma', interview with Liza Bear, 27 January 1974; reprinted in *Serra: Interviews, op. cit.*, 43.

56 Interview with Liza Bear, 30 March 1976, in *Serra: Interviews, op. cit.*, 73.

57 'Transcript: The Storm in the Plaza', excerpts from the General Services Administration hearing on the *Tilted Arc, Harper's* (July 1985) 30; 32.

58 Jean-François Lyotard, 'On Theory: An Interview', in *Driftworks*, ed. Roger McKeon (New York: Semiotext[e], 1984) 29.

59 William Rubin, 'Preface', in Krauss, *Serra, op. cit.*, 9-10. Serra announced sententiously at the hearing that the *Tilted Arc* would, *de facto*, be destroyed if it were moved as he does not make portable sculpture; but he had erected similar pieces on public sites on a temporary basis and he had no plans to dispose of the numerous works in his exhibition at The Museum of Modern Art once it was over.

60 'Transcript', *op. cit.*, 28; 32.

61 'Transcript', *op. cit.*, 33. Katz went on to give Serra and the work the benefit of the doubt: 'I don't believe the contempt is in the work. The work is strong enough to stand alone in a better place. I would suggest to Mr Serra that he take advantage of this opportunity to walk away from this fiasco and demand that the work be moved to a place where it will better reveal its beauty.'

62 A distinction is implied here between what might be called those fellow-travellers of Minimalism (i.e., Rosenthal, Pepper and Liberman), who simply embroidered on its plain cloth in an evident bid to make it more appealing, and those 'post-Minimalist' artists, such as Joel Shapiro and Jackie Winsor, whose work clearly inverted or critiqued some of the most deeply held tenets of Minimalism: in Shapiro's case, by his full return to an unambiguously referential art, and in Winsor's case, by her foregrounding of the complex processes and the labour involved in the facture of her

cubes (in contrast to Rosenthal's clearly machine-made box).

63 Theodor Adorno, *Aesthetic Theory* (London: Routledge & Kegan Paul, 1984) 171.

64 Theodor Adorno, 'Lyric Poetry and Society', *Telos*, 20 (Summer 1974) 58.

Anna C. Chave, 'Minimalism and the Rhetoric of Power', *Arts Magazine* (January 1990) 44-63.

Rosalind KRAUSS
The Cultural Logic of the Late Capitalist Museum [1990]

1 May 1983: I remember the drizzle and cold of that spring morning, as the feminist section of the May Day parade formed up at République. Once we started moving out, carrying our banners for the march towards the Place de la Bastille, we began our chant. '*Qui paie ses dettes s'enrichit*', it went, '*qui paie ses dettes s'enrichit*', in a reminder to Mitterrand's newly appointed Minister of Women's Affairs that the Socialists' campaign promises were still deeply in arrears. Looking back at that cry now, from a perspective firmly situated at the end of the 1980s, sometimes referred to as 'the roaring 1980s', the idea that paying your debts makes you rich seems pathetically naive. What makes you rich, we have been taught by a decade of casino capitalism, is precisely the opposite. What makes you rich, fabulously rich, beyond your wildest dreams, is leveraging.

17 July 1990: Coolly insulated from the heat wave outside, Suzanne Pagé and I are walking through her exhibition of works from the Panza Collection, an installation that, except for three or four small galleries, entirely fills the Musée d'Art Moderne de la Ville de Paris. At first I am extremely happy to encounter these objects – many of them old friends I have not seen since their early days of exhibition in the 1960s – as they triumphantly fill vast suites of galleries, having muscled everything else off the walls to create that experience of articulated spatial presence specific to Minimalism. The importance of this space as a vehicle for the works is something Suzanne Pagé is conscious of as she describes the desperate effort of remodelling vast tracts of the museum to give it the burnished neutrality necessary to function as background to these Flavins and Andres and Morrises. Indeed, it is her focus on the space – as a kind of reified and abstracted entity – that I finally find most arresting. This climaxes at the point when she positions me at the spot within the exhibition that she describes as being, for her, somehow the most riveting. It is in one of the newly stripped and smoothed and neutralized galleries, made whitely luminous by the serial progression of a recent work by Flavin. But we are not actually looking at the Flavin. At her direction we are scanning the two ends of the gallery through the large doorways of which we can see the disembodied glow produced by two other Flavins, each in an adjoining room: one of these an intense apple green light; the other an unearthly, chalky blue radiance. Both announce a kind of space-beyond which we are not yet in,

but for which the light functions as the intelligible sign. And from our point of view both these aureoles can be seen to frame – like strangely industrialized haloes – the way the gallery's own starkly cylindrical, International Style columns enter our point of view. We are having this experience, then, now in front of what could be called the art, but in the midst of an oddly emptied yet grandiloquent space of which the museum itself – as a building – is somehow the object.

Within this experience, it is the museum that emerges as powerful presence and yet as properly empty, the museum as a space from which the collection has withdrawn. For indeed, the effect of this experience is to render it impossible to look at the paintings hanging in those few galleries still displaying the permanent collection. Compared to the scale of the Minimalist works, the earlier paintings and sculpture look impossibly tiny and inconsequential, like postcards, and the galleries take on a fussy, crowded, culturally irrelevant look, like so many curio shops.

These are two scenes that nag at me as I think about the 'cultural logic of the late capitalist museum', because somehow it seems to me that if I can close the gap between their seeming disparateness, I can demonstrate the logic of what we see happening, now, in museums of Modern art.¹ Here are two possible bridges, flimsy perhaps, because fortuitous, but none the less suggestive.

1. In the July 1990 *Art in America*, there occurs the unanalysed but telling juxtaposition of two articles. One is the essay called 'Selling the Collection', which describes the massive change in attitude now in place according to which the objects in a museum's keeping can now be coolly referred to, by its director as well as its trustees, as 'assets'.² This bizarre Gestalt-switch from regarding the collection as a form of cultural patrimony or as specific and irreplaceable embodiments of cultural knowledge to one of eyeing the collection's contents as so much capital – as stocks or assets whose value is one of pure exchange and thus only truly realized when they are put in circulation – seems to be the invention not merely of dire financial necessity: a result, that is, of the American tax law of 1986 eliminating the deductibility of the market value of donated art objects. Rather, it appears the function of a more profound shift in the very context in which the museum operates – a context whose corporate nature is made specific not only by the major sources of funding for museum activities but also, closer to home, by the make-up of its boards of trustees. Thus the writer of 'Selling the Collection' can say:
'*To a great extent the museum community's crisis results from the free-market spirit of the 1980s. The notion of a museum as a guardian of the public patrimony has given way to the notion of a museum as a corporate entity with a highly marketable inventory and the desire for growth.*'

Over most of the course of the article, the market understood to be putting pressure on the museum is the art market. This is, for example, what Evan Maurer of the Minneapolis Institute of Art seems to be referring to when he says that in recent years museums have had to deal with a 'market-driven operation' or what George Goldner of the Getty Center means when he says that 'there will be some people who will want to turn the museum into a

dealership'. It is only at the end of the essay, when dealing with the Guggenheim Museum's recent sales, that some larger context than the art market's buying and selling is broached as the field within which de-accessioning might be discussed, although the writer does not really enter this context.

But 'Selling the Collection' comes back-to-back with quite another article, which, called 'Remaking Art History', raises the problems that have been spawned within the art market itself by one particular art movement, namely Minimalism.³ For Minimalism almost from the very beginning located itself, as one of its radical acts, within the technology of industrial production. That objects were fabricated from plans meant that these plans came to have a conceptual status within Minimalism, allowing for the possibility of replication of a given work that could cross the boundaries of what had always been considered the unreproducibility of the aesthetic original. In some cases these plans were sold to collectors along with or even in place of an original object, and from these plans the collector did indeed have certain pieces refabricated. In other cases it has been the artist himself or herself who has done the refabrication, either issuing various versions of a given object – multiple originals, so to speak – as is the case with the many Morris glass cubes, or replacing a deteriorated original with a contemporary remake as in the case of Alan Saret. This break with the aesthetic of the original is, the writer of this essay argues, part and parcel with Minimalism itself, and so she writes:
'*If, as viewers of contemporary art, we are unwilling to relinquish the conception of the unique original art object, if we insist that all refabrications are fraudulent, then we misunderstand the nature of many of the key works of the 1960s and 1970s ... If the original object can be replaced without compromising the original meaning, refabrications should raise no controversy.*'

However, as we know, it is not exactly viewers who are raising controversy in this matter, but artists themselves, as Donald Judd and Carl Andre have protested Count Panza's various decisions to act on the basis of the certificates they sold him and make duplicate versions of their works.⁴ And indeed, the fact that the group countenancing these refabrications is made up of the works' owners (both private collectors and museums) – that is, the group normally thought to have most interest in specifically protecting the status of their property *as* original – indicates how inverted this situation is. The writer of this essay also speaks of the market as playing some role in the story she has to tell. 'As the public's interest in the art of this period grows', she says, 'and the market pressures increase, the issues that arise when works are refabricated will no doubt gain prominence as well'. But what the nature of either 'the issues' or the 'market pressures' might really be, she leaves it to the future to decide.

In the bridge I am setting up here, then, we watch the activity of markets restructuring the aesthetic original, either to change it into an 'asset', as in the case outlined by the first article, or to normalize a once-radical practice of challenging the very idea of the original through a recourse to the technology of mass production. That this

normalization exploits a possibility *already* inscribed in the specific procedures of Minimalism will be important to the rest of my argument. But for now I simply point to the juxtaposition of a description of the financial crisis of the modern museum with an account of a shift in the nature of the original that is a function of one particular artistic movement, to wit, Minimalism.

2. The second bridge can be constructed more quickly. It consists merely of a peculiar rhyming between a famous remark of Tony Smith's from the opening phase of Minimalism and one by the Guggenheim's Director, Tom Krens, made last spring. Tony Smith is describing a ride he took in the early 1950s on the New Jersey Turnpike when it was still unfinished. He is speaking of the endlessness of the expanse, of its sense of being cultural but totally off the scale of culture. It was an experience, he said, that could not be framed, and thus, breaking through the very notion of frame, it was one that revealed to him the insignificance and 'pictorialism' of all painting. 'The experience on the road', he says, 'was something mapped out but not socially recognized. I thought to myself, it ought to be clear that's the end of art.' And what we now know with hindsight on this statement is that Tony Smith's 'end of art' coincided with – indeed, conceptually undergirded – the beginning of Minimalism.

The second remark, the one by Tom Krens, was made to me in an interview and also involves a revelation on a turnpike, the Autobahn just outside of Cologne.[5] It was a November day in 1985, and having just seen a spectacular gallery made from a converted factory building, he was driving by large numbers of other factories. Suddenly, he said, he thought of the huge abandoned factories in his own neighbourhood of North Adams, Massachusetts, and he had the revelation of MASS MoCA.[6] Significantly, he described this revelation as transcending anything like the mere availability of real estate. Rather, he said, it announced an entire change in – to use a word he seems extremely fond of – *discourse*. A profound and sweeping change, that is, within the very conditions within which art itself is understood. Thus, what was revealed to him was not only the tininess and inadequacy of most museums, but that the encyclopaedic nature of the museum was 'over'. What museums must now do, he said he realized, was to select a very few artists from the vast array of Modernist aesthetic production and to collect and show these few in depth over the full amount of space it might take to really experience the cumulative impact of a given oeuvre. The discursive change he was imagining is, we might say, one that switches from diachrony to synchrony. The encyclopaedic museum is intent on telling a story, by arraying before its visitor a particular version of the history of art. The synchronic museum – if we can call it that – would forego history in the name of a kind of intensity of experience, an aesthetic charge that is not so much temporal (historical) as it is now radically spatial, the model for which, in Krens' own account, was, in fact, Minimalism. It is Minimalism, Krens says in relation to his revelation, that has reshaped the way we, as late twentieth-century viewers, look at art: the demands we now put on it; our need to experience it along with its interaction with the space in which it exists; our need to

have a cumulative, serial, crescendo towards the intensity of this experience; our need to have more and at larger scale. It was Minimalism, then, that was part of the revelation that only at the scale of something like MASS MoCA could this radical revision of the very nature of the museum take place.

Within the logic of this second bridge, there is something that connects Minimalism – and at a very deep level – to a certain kind of analysis of the modern museum, one that announces its radical revision.

Now, even from the few things I've sketched about Minimalism, there emerges an internal contradiction. For on the one hand there is Krens' acknowledgement of what could be called the phenomenological ambitions of Minimalism, and on the other, underscored by the dilemma of contemporary refabrication, Minimalism's participation in a culture of seriality, of multiples without originals – a culture, that is, of commodity production.

That first side, it could be argued, is the aesthetic base of Minimalism, its conceptual bedrock, what the writer of the *Art in America* article called its 'original meaning'. This is the side of Minimalism that denies that the work of art is an encounter between two previously fixed and complete entities: on the one hand, the work as a repository of known forms – the cube or prism, for example, as a kind of geometric a priori, the embodiment of a Platonic solid; and on the other, the viewer as an integral, biographically elaborated subject, a subject who cognitively grasps these forms because he or she knows them in advance. Far from being a cube, Richard Serra's *House of Cards* is a shape in the process of forming against the resistance, but also with the help of the ongoing conditions of gravity; far from being a simple prism, Robert Morris' *L-Beams* are three different insertions within the viewer's perceptual field such that each new disposition of the form sets up an encounter between the viewer and the object which redefines the shape. As Morris himself wrote in his 'Notes on Sculpture', Minimalism's ambition was to leave the domain of what he called 'relational aesthetics' and to 'take relationships out of the work and make them a function of space, light and the viewer's field of vision'.[7]

To make the work happen, then, on this very perceptual knife-edge – the interface between the work and its beholder – is on the one hand to withdraw privilege both from the formal wholeness of the object prior to this encounter and from the artist as a kind of authorial absolute who has set the terms for the nature of the encounter in advance. Indeed, the turn towards industrial fabrication of the works was consciously connected to this part of Minimalism's logic, namely, the desire to erode the old idealist notions about creative authority. But on the other hand, it is to restructure the very notion of the viewing subject.

It is possible to misread a description of Minimalism's drive to produce a kind of 'death of the author' as one of creating a now all-powerful reader/interpreter, as when Morris writes:

'*The object is but one of the terms of the newer aesthetic ... One is more aware than before that he himself is establishing relationships as he apprehends the object from various positions and under varying conditions of light and*

spatial context.'

But, in fact, the nature of this 'he himself [who] is establishing relationships' is also what Minimalism works to put in suspension. Neither the old Cartesian subject nor the traditional biographical subject, the Minimalist subject – this 'he himself establishing relationships' – is a subject radically contingent on the conditions of the spatial field, a subject who coheres, but only provisionally and moment-by-moment, in the act of perception. It is the subject that, for instance, Maurice Merleau-Ponty describes when he writes:

'*But the system of experience is not arrayed before me as if I were God, it is lived by me from a certain point of view; I am not the spectator, I am involved, and it is my involvement in a point of view which makes possible both the finiteness of my perception and its opening out upon the complete world as a horizon of every perception.*'[8]

In Merleau-Ponty's conception of this radically contingent subject, caught up within the horizon of every perception, there is, as we know, an important further condition. For Merleau-Ponty is not merely directing us towards what could be called a 'lived perspective'; he is calling on us to acknowledge the primacy of the 'lived *bodily* perspective'. For it is the immersion of the body in the world, the fact that it has a front and a back, a left and a right side, that establishes at what Merleau-Ponty calls a level of 'pre-objective experience' a kind of internal horizon which serves as the precondition of the meaningfulness of the perceptual world. It is thus the body as the pre-objective ground of all experience of the relatedness of object that was the primary 'world' explored by the *Phenomenology of Perception*.

Minimalism was indeed committed to this notion of 'lived *bodily* perspective', this idea of a perception that would break with what it saw as the decorporealized and therefore bloodless, algebraicized condition of abstract painting in which a visuality cut loose from the rest of the bodily sensorium and now remade in the model of Modernism's drive towards absolute autonomy had become the very picture of an entirely rationalized, instrumentalized, serialized subject. Its insistence on the immediacy of the experience, understood as a bodily immediacy, was intended as a kind of release from the forward march of Modernist painting towards an increasingly positivist abstraction.

In this sense, Minimalism's reformulation of the subject as radically contingent is, even though it attacks older idealist notions of the subject, a kind of Utopian gesture. This is because the Minimalist subject is in this very displacement returned to its body, regrounded in a kind of richer, denser subsoil of experience than the paper-thin layer of an autonomous visuality that had been the goal of optical painting. And thus this move is, we could say, compensatory, an act of reparations to a subject whose everyday experience is one of increasing isolation, reification, specialization, a subject who lives under the conditions of advanced industrial culture as an increasingly instrumentalized being. It is to this subject that Minimalism, in an act of resistance to the serializing, stereotyping and banalizing of commodity production, holds out a promise of some instant of bodily plenitude in

a gesture of compensation that we recognize as deeply aesthetic.

But even if Minimalism seems to have been conceived in *specific* resistance to the fallen world of mass culture – with its disembodied media images – and of consumer culture – with its banalized, commodified objects – in an attempt to restore the immediacy of experience, the door it opened on to 'refabrication' none the less was one that had the potential to let that whole world of late capitalist production right back in.[9] Not only was the factory fabrication of the objects from plans a switch from artisanal to industrial technology, but the very choice of materials and of shapes range with the overtones of industry. No matter that Plexiglas and aluminium and polystyrene were meant to destroy the interiority signalled by the old materials of sculpture like wood or stone. These were none the less the signifiers of late twentieth-century commodity production, cheap and expendable. No matter that the simple geometries were meant to serve as the vehicles of perceptual immediacy. These were as well the operators of those rationalized forms susceptible to mass production and the generalized ones adaptable as corporate logos.[10] And most crucially, the Minimalist resistance to traditional composition which meant the adoption of a repetitive, additive aggregation of form – Donald Judd's 'one thing after another' – partakes very deeply of that formal condition that can be seen to structure consumer capitalism: the condition, that is, of seriality. For the serial principle seals the object away from any condition that could possibly be thought to be original and consigns it to a world of simulacra, of multiples without originals, just as the serial form also structures the object within a system in which it makes sense only in relation to other objects, objects which are themselves structured by relations of artificially produced difference. Indeed, in the world of commodities it is this difference that is consumed.[11]

Now how, we might ask, is it possible that a movement that wished to attack commodification and technologization somehow always already carried the codes of those very conditions? How is it that immediacy was always potentially undermined – infected, we could say – with its opposite? For it is this always already that is being tapped in the current controversy about refabrication. So, we could ask, how is it that an art that insisted so hard on specificity could have already programmed within it the logic of its violation?

But this kind of paradox is not only common in the history of Modernism, which is to say the history of art in the era of capital; it could be said to be of the very nature of Modernist art's relation to capital, a relation in which, in its very resistance to a particular manifestation of capital – to technology, say, or commodification, or the reification of the subject of mass production – the artist produces an alternative to that phenomenon which can also be read as a function of it, another version, although possibly more ideated or rarified, of the very thing against which he or she was reacting. Fredric Jameson, who is intent on tracing this capital-logic as it works itself out in Modernist art, describes it, for example, in Van Gogh's clothing of the drab peasant world around him in a hallucinatory surface

of colour. This violent transformation, he says: '*Is to be seen as a Utopian gesture: as an act of compensation which ends up producing a whole new Utopian realm of the senses, or at least of that supreme sense – sight, the visual, the eye – which it now reconstitutes for us as a semi-autonomous space in its own right*'.[12] But even as it does this, it in fact imitates the very division of labour that it performed in the body of capital, thereby 'becoming some new fragmentation of the emergent sensorium which replicates the specializations and divisions of capitalist life at the same time that it seeks in precisely such fragmentation a desperate Utopian compensation for them'.[13]

What is exposed in this analysis is then the logic of what could be called cultural reprogramming or what Jameson himself calls 'cultural revolution'. And this is to say that while the artist might be creating a Utopian alternative to, or compensation for, a certain nightmare induced by industrialization or commodification, he is at the very same time projecting an imaginary space which, if it is shaped somehow by the structural features of that same nightmare, works to produce the possibility for its receiver fictively to occupy the territory of what will be a next, more advanced level of capital. Indeed, it is the theory of cultural revolution that the imaginary space projected by the artist will not only emerge from the formal conditions of the contradictions of a given moment of capital, but will prepare its subjects – its readers or viewers – to occupy a future real world which the work of art has already brought them to imagine, a world restructured not through the present but through the next moment in the history of capital.

An example of this, we could say, would be the great *unités d'habitation* of the International Style and Le Corbusier, which rose above an older, fallen city fabric to project a powerful, futuristic alternative to it, an alternative celebrating the potential creative energy stored within the individual designer. But in so far as those projects simultaneously destroyed the older urban network of neighbourhoods with their heterogeneous cultural patterns, they prepared the ground precisely for that anonymous culture of suburban sprawl and shopping-centre homogeneity that they were specifically working to counter.

So, with Minimalism, the potential was always there that not only would the *object* be caught up in the logic of commodity production, a logic that would overwhelm its specificity, but that the *subject* projected by Minimalism also would be reprogrammed. Which is to say that the Minimalist subject of 'lived bodily experience' – unballasted by past knowledge and coalescing in the very moment of its encounter with the object – could, if pushed just a little farther, break up entirely into the utterly fragmented, Postmodern subject of contemporary mass culture. It could even be suggested that by prizing loose the old ego-centred subject of traditional art, Minimalism unintentionally – albeit logically – prepares for that fragmentation.

And it was that fragmented subject, I would submit, that lay in wait for the viewer to the Panza Exhibition in Paris – not the subject of lived bodily immediacy of 1960s

Minimalism, but the dispersed subject awash in a maze of signs and simulacra of late 1980s Postmodernism. This was not just a function of the way the objects tended to be eclipsed by the emanations from themselves that seemed to stand apart from their corporeal beings like so many blinking signs – the shimmering waves of the floor pieces punctuating the groundplan, the luminous exhalations of the light pieces washing the corners of rooms one had not yet entered. It was also a function of the new centrality given to James Turrell, an extremely minor figure for Minimalism in the late 1960s and early 1970s, but one who plays an important role in the reprogrammation of Minimalism for the late 1980s. The Turrell piece, itself an exercise in sensory reprogramming, is a function of the way a barely perceptible luminous field in front of one appears gradually to thicken and solidify, not by revealing or bringing into focus the surface which projects this colour, a surface which we as viewers might be said to perceive, but rather by concealing the vehicle of the colour and thereby producing the illusion that it is the field itself which is focusing, that it is the very object facing one that is doing the perceiving *for* one.

Now it is this de-realized subject – a subject that no longer does its own perceiving but is involved in a dizzying effort to decode signs that emerge from within a no longer mappable or knowable depth – that has become the focus of many analyses of Postmodernism. And this space, which is grandiloquent but somehow no longer masterable by the subject, seeming to surpass the reach of understanding like an inscrutable emblem of the multinational infrastructures of information technology or of capital transfer, is often referred to in such analyses as 'hyperspace'. It, in turn, is a space that supports an experience that Jameson calls 'the hysterical sublime'. Which is to say that precisely in relation to the suppression of the older subjectivity – in what could be called the waning of affect – there is 'a strange compensatory decorative exhilaration'.[14] In place of the older emotions there is now an experience that must properly be termed an 'intensity' – a free-floating and impersonal feeling dominated by a peculiar kind of euphoria.

The revision of Minimalism such that it addresses or even works to produce that new fragmented and technologized subject, such that it constructs not an experience of itself but some other euphorically dizzy sense of the museum as hyperspace, this revisionary construction of Minimalism exploits, as we have seen, what was always potential within Minimalism.[15] But it is a revision that is, as well, happening at a specific moment in history. It is happening in 1990 in tandem with powerful changes in how the museum itself is now being reprogrammed or reconceptualized.

The writer of 'Selling the Collection' acknowledged that the Guggenheim's de-accessioning was part of a larger strategy to reconceive the museum and that Krens himself has described this strategy as somehow motivated or justified by the way Minimalism restructures the aesthetic 'discourse'. What, we might now ask, is the nature of that larger strategy, and how is Minimalism being used to serve as its emblem?

One of the arguments made by analysts of Postmodern

culture is that in its switch from what could be called an era of industrial production to one of commodity production – an era, that is, of the consumer society, or the information society, or the media society – capital has not somehow been magically transcended. Which is to say, we are not in either a 'post-industrial society' or a 'post-ideological era'. Indeed, they would argue, we are in an even purer form of capital in which industrial modes can be seen to reach into spheres (such as leisure, sport and art) previously somewhat separated from them. In the words of the Marxist economist Ernest Mandel:

'*Far from representing a "post-industrial society", late capitalism thus constitutes generalized universal industrialization for the first time in history. Mechanization, standardization, over-specialization and parcellization of labour, which in the past determined only the realm of commodity production in actual industry, now penetrate into all sectors of social life.*'[16]

As just one example of this he gives the Green Revolution, or the massive industrialization of agriculture through the introduction of machines and chemicals. Just as in any other industrialization, the old productive units are broken up – the farm family no longer makes its own tools, food and clothing – to be replaced by specialized labour in which each function is now independent and must be connected through the mediating link of trade. The infrastructure needed to support this connection will now be an international system both of trade and of credit. What makes this expanded industrialization possible, he adds, is the overcapitalization (or noninvested surplus capital) that is the hallmark of late capitalism. It is this surplus that is unlocked and set in motion by the falling rate of profit. And it in turn accelerates the process of transition to monopoly capitalism.

Now noninvested surplus capital is exactly one way of describing the holdings – both in land and in art – of museums. It is the way, as we have seen, that many museum figures (directors and trustees) are now, in fact, describing their collections. But the market they see themselves responding to is the art market and not the mass market; and the model of capitalization they have in mind is the 'dealership' and not industry.

Writers about the Guggenheim have already become suspicious that it is the one exception in all this – an exception, most would agree, that will be an extremely seductive pattern for others to follow once its logic becomes clear. The *New York Times Magazine* writer of the profile on MASS MoCA was, indeed, struck by the way Tom Krens constantly spoke not of the museum but of the 'museum industry', describing it as 'overcapitalized', in need of 'mergers and acquisitions' and of 'asset management'. And further, invoking the language of industry, he spoke of the museum's activities – its exhibitions and catalogues – as 'product'.

Now from what we know from other industrializations, we can say that to produce this 'product' efficiently will require not only the break-up of older productive units – as the curator no longer operates as combined researcher, writer, director and producer of an exhibition but will be increasingly specialized into filling only one of these functions – but will entail the increased technologization (through computer-based data systems) and centralization of operations at every level. It will also demand the increased control of resources in the form of art objects that can be cheaply and efficiently entered into circulation. Further, in relation to the problem of the effective marketing of this product, there will be the requirement of a larger and larger surface over which to sell the product in order to increase what Krens himself speaks of as 'market share'. It takes no genius to realize that the three immediate requisites of this expansion are 1) larger inventory (the Guggenheim's acquisition of three hundred works from the Panza collection is a first step in this direction); 2) more physical outlets through which to sell the product (the Salzburg and Venice/Dogana projects are potential ways of realizing this, as would be MASS MoCA);[17] and 3) leveraging the collection (which in this case most specifically does not mean selling it, but rather moving it into the credit sector, or the circulation of capital;[18] the collection will thus be pressed to travel as one form of indebtedness; classically, mortgaging the collection would be the more direct form of leveraging).[19] And it also does not stretch the imagination too much to realize that this industrialized museum will have much more in common with other industrialized areas of leisure – Disneyland say – than it will with the older, pre-industrial museum. Thus it will be dealing with mass markets, rather than art markets, and with simulacral experience rather than aesthetic immediacy.

Which brings us back to Minimalism and the way it is being used as the aesthetic rationale for the transformation I am describing. The industrialized museum has a need for the technologized subject, the subject in search not of affect but of intensities, the subject who experiences its fragmentation as euphoria, the subject whose field of experience is no longer history, but space itself: that hyperspace which a revisionist understanding of Minimalism will use it to unlock.

This text, written as a lecture for the 10 September 1990 meeting of the International Association of Museums of Modern Art (CIMAM) in Los Angeles, is being published here considerably before I have been able to deliver, as fully as I would have liked, on the promise of its title. The timeliness of the issues, however, suggested that it was more important to open them to immediate discussion than to wait to refine either the theoretical level of the argument or the rhetoric within which it is framed.

1 Throughout, my debt to Fredric Jameson's 'Postmodernism, or The Cultural Logic of Late Capitalism', *New Left Review*, 146 (July–August 1984) 53–93, will be obvious.

2 Philip Weiss, 'Selling the Collection', *Art in America*, 78 (July 1990) 124–31.

3 Susan Hapgood, 'Remaking Art History', *Art in America*, 78 (July 1990) 114–23.

4 See *Art in America* (March–April 1990).

5 The interview took place 7 May 1990.

6 MASS MoCA (Massachusetts Museum of Contemporary Art), a project to transform the 69,677.5 m² [750,000 ft²] of factory space formerly occupied by Sprague Technologies, Inc., into a museum complex (that would not only consist of gargantuan exhibition galleries, but also a hotel and retail shops), proposed to the Massachusetts Legislature by Krens and granted funding in a special bill potentially underwriting half its costs with a $35 million bond issue, is now nearing the end of a feasibility study, funded out of the same bill, and being conducted by a committee chaired by Krens. See Deborah Weisgall, 'A Megamuseum in a Mill Town, The Guggenheim in Massachusetts?' *New York Times Magazine* (3 March 1989).

7 Robert Morris, 'Notes on Sculpture: Parts I and II', *Artforum* (February/October 1966); reprinted in *Minimal Art: A Critical Anthology*, ed. Gregory Battcock (New York: E.P. Dutton & Co., 1968).

8 Maurice Merleau-Ponty, *Phenomenology of Perception*, trans. Colin Smith (London: Routledge & Kegan Paul, 1962) 304, originally published as *Phénoménologie de la perception* (Paris: Gallimard, 1945). [See in this volume pp. 196–97.]

9 This analysis of the contradictions internal to Minimalism has already been brilliantly argued by Hal Foster in his genealogical study of Minimalism. See Hal Foster, 'The Crux of Minimalism', *The Return of the Real: The Avant-Garde at the End of the Century* (Cambridge, Massachusetts and London: MIT Press, 1996). Originally published in *Individuals: A Selected History of Contemporary Art 1945–1986* (Los Angeles: The Museum of Contemporary Art; New York: Abbeville Press, 1986) 162–83. [See in this volume pp. 270–75.] His argument, that Minimalism simultaneously completes *and* breaks with Modernism, announcing its end, and his discussion of the way much of Postmodernism in both its critical modes (the critique of institutions, the critique of the representation of the subject) and its collaborative ones (the trans-avant-garde, simulation) is nascent within the Minimalist syntax, both spatial and productive, is a complex articulation of the logic of Minimalism and anticipates much of what I am saying about its history.

10 This argument was already suggested by Art & Language's critique of Minimalism. See Karl Beveridge and Ian Burn, 'Donald Judd', *The Fox* (1975). That Minimalism should have been welcomed into corporate collections came full circle in the 1980s when its forms served as the, perhaps unwilling, basis of much of Postmodern architecture.

11 Foster, *op. cit.*, 180.

12 Jameson, *op. cit.*, 59.

13 *Ibid.*

14 *Ibid.*, 61.

15 The various 1970s projects organized by Heiner Friedrich and sponsored by the Dia Foundation, which set up permanent installations – like de Maria's *Earth Room* or his *Broken Kilometer* – had the effect of reconsecrating certain urban spaces to a detached contemplation of their own 'empty' presence. Which is to say that in the relationship between the work and its context, these spaces themselves increasingly emerge as the focus of the experience, one of an inscrutable but suggestive sense of impersonal, corporate-like power to penetrate artworld locales and to rededicate them to another kind of nexus of control. Significantly, it was Friedrich who began, in the mid 1970s, to promote the work of James

Turrell (he is also the manager, for the Dia Foundation, of Turrell's mammoth *Roden Crater*).

16 Ernest Mandel, *Late Capitalism* (London: Verso, 1978) 387, as cited in Foster, *op. cit.*, 179; and in Jameson, 'Periodizing the '60s', *The Ideologies of Theory*, II (Minneapolis: University of Minnesota Press, 1988) 207.

17 Projects at different stages of realization include a Salzburg Guggenheim, in which the Austrian Government would presumably pay for the new museum (designed by Hans Holein) and endow its operating expenses in return for a New York Guggenheim-managed programme, part of which would entail the circulation of the Guggenheim collection into Salzburg. In addition, there are negotiations for a Venice Guggenheim in the quarters of the former Customs House (the Dogana).

18 That as part of its industrialization the Guggenheim is willing to de-accession not just minor objects but masterpieces is a point made by 'Selling the Collection', where Professor Gert Schiff is quoted as saying of the de-accessioned Kandinsky, 'It really was a centrepiece of the collection - they could have sold almost anything but not that', and former director, now trustee, Tom Messer, is described as 'uncomfortable with the transaction' (130). Another detail in this report is the extraordinary spread between Sotheby's estimate on this Kandinsky ($10-15 million) and its actual sale price ($20.9 million). In fact, on the three works auctioned by the Guggenheim, Sotheby's underestimated the sales by more than 40 per cent. This raises some questions about 'asset management' in a domain, like the Guggenheim's, of increasing specialization of professional roles. For it is clear that neither the museum's staff nor its director had a grip on the realities of the market, and relying on Sotheby's 'expertise' (not, of course disinterested), they probably de-accessioned one more work than they needed to in order to accomplish their target, which was the purchase of the Panza collection. It is also clear - not only from Schiff's comment but also from one by William Rubin to the effect that in thirty years of experience he had never seen a comparable Kandinsky for sale, and that chances are that in the next thirty years there will not be another - that the separation of curatorial from managerial skills is wildly skewing the museum's judgement in the favour to those who stand to profit - in the form of fees and percentages of sales - from any 'deal' that takes place: auctioneers, dealers, etc.

19 In August 1990 the Guggenheim Museum, through the agency of The Trust for Cultural Resources of The City of New York (about which more later), issued $55 million of tax-exempt bonds to J.P. Morgan Securities (who will presumably remarket them to the public). This money is to be used for the museum's physical expansion in New York City: the annex to the present building, the restoration and underground expansion of the present building, and the purchase of the warehouse in midtown Manhattan. Counting interest on these bonds, the museum will, in the course of fifteen years, have to pay out $115 million to service and retire this debt.

The collateral for these bonds is curious, since the issuing document reads: 'None of the assets of the [Guggenheim] Foundation are pledged for payment of the Bonds'. It goes on to specify that the museum's endowment is legally unavailable to be used to meet the obligations of the debt and that 'certain works in the Foundation's collection are subject to express sale prohibitions or other restrictions pursuant to the applicable gift instruments or purchase contracts'. That such restrictions apply only to 'certain works' and not to all works is also something to which I will return.

In light of the fact that no collateral is pledged in case of the museum's inability to meet its obligations on this debt, one might well wonder about the basis on which Morgan Securities (as well as its partner in this transaction, the Swiss Bank Corporation) agreed to purchase these bonds. This basis is clearly threefold. First, the Guggenheim is projecting its ability to raise the money it needs (roughly $7 million per year over and above its current [the date in the bond issuance document is for financial year 1988] annual expenses of $11.5 million [on which it was running a deficit of about 9 per cent, which is *extremely* high for this kind of institution]) through, on the one hand, a $30 million fund drive and, on the other, added revenue streams due to its expansion of plant, programme, markets, etc. Since its obligation is $115 million, the fund drive, even if successful, will leave over $86 million to raise. Second, if the Guggenheim's plans for increasing revenue (added gate, retail sales, memberships, corporate funding, gifts, plus 'renting' its collection to its satellite museums, among others) by the above amount (or 70 per cent above its current annual income) do not work out as projected, the next line of defence the bankers can fall back on will be the ability of members of the Guggenheim's board of trustees to cover the debt. This would involve a personal willingness to pay that no trustee, individually, is legally required to do. Third, if the first two possibilities fail and default is threatened, the collection (minus, of course, 'certain works'), though it is not pledged, is clearly available as an 'asset' to be used for debt repayment.

In asking financial officers of various tax-exempt institutions to evaluate this undertaking, I have been advised that it is, indeed, a 'high-risk' venture. And I have also gleaned something of the role of The Trust for Cultural Resources of The City for New York.

Many states have agencies set up to lend money to tax-exempt institutions, or to serve as the medium through which monies from bond drives are delivered to such institutions, as is the case with The Trust for Cultural Resources. But unlike The Trust for Cultural Resources, these agencies are required to review the bond proposals in order to assess their viability. The review carried out by agency employees is clearly made by people not associated with the institutions themselves. The Trust for Cultural Resources, although it brokers the money at the behest of the government like the state agencies, has no staff to review proposals and therefore has no role in vetting the bond requests. What it seems to do instead is to give the proposal its bona fides. Given the fact that the members of the trust are also major figures of other cultural institutions (Donald Marron, for example, is president of the board of trustees of The Museum of Modern Art), the trust's own trustees are, in fact, potential borrowers.

Rosalind Krauss, 'The Cultural Logic of the Late Capitalist Museum', *October*, 54 (Fall 1990) 3-17.

Richard SERRA
Donald Judd [1994]

What I have been experiencing in the past several weeks is fear, a fear without an object, an empty feeling, a disconnected anxiety which makes me shudder, take a deep breath, sigh involuntarily. I have been trying to understand Judd's death, trying to deal with my incomprehension of this unexpected loss. A great sculptor has died. As an artist you measure yourself against other artists; as you grow older, you measure yourself against the people you have known who have died.

Some inventions are more important than others, more thoughtful, more conscious, more serious, more resolute, more radical, more influential, more articulate. By the time I arrived in New York, in the late 1960s, Judd's invention had already transformed the historical context. Judd's break had been so startling and abrupt that within three years Abstract Expressionism was out, Minimalism was in. Most sculptors of my generation spoke openly of their admiration for Judd's work. We all acknowledged his importance by either coming up against him, going around him, or using his work in ways he could not have imagined or intended.

Most of us treated him with respectful disrespect. Very early on, Eva Hesse built *Accessions*, a series of boxes made of galvanized steel frames with rubber tubing dangling inside. Eva added subjectivity, obsession, metaphor, psychology and sexuality to Judd's exquisitely tooled rarefied container. Bruce Nauman sarcastically undermined Judd's logic in a fibreglass work entitled *Platform Made Up of the Space between Two Rectilinear Boxes on the Floor*. Michael Heizer took Judd head-on. You want volumes, I'll give you volumes: *Double Negative*, two enormous cubic trenches dug out in the Nevada desert. Robert Smithson turned Judd's 'Specific Objects' into spray-painted specimen bins filled with rocks from everywhere, labelling them 'Non-sites'. Judd's boxes were pervasive – Andy Warhol was silk-screening Brillo logos on them; Richard Artschwager was making them out of suburban-counter-top Formica. I paid reverence with sagging lead plates propped up like a house of cards. Two decades later, Haim Steinbach's shelves and Robert Gober's serial sinks continue to tip their hat to Don. As irony would have it, there is probably more than a little Judd in Jeff Koons' industrial products deluxe. Individually and collectively, we all put our head into Judd's box.

In retrospect, one realizes that his influence was ubiquitous. The forms it took were diverse and often critical. It was never a question of whether you liked Judd's work or not; you could not get over it. It would not leave you alone. It gnawed on you. It made you drop dearly held

beliefs. It was not 'obvious' art; it didn't look like art. Nevertheless, it insisted on being taken seriously. I remember having fierce arguments with Smithson over Judd's preference for materials – I was taken aback by what I considered to be Don's fetishizing attitude, his hedonism, by the slickness and glitz of fluorescent Plexiglas, anodized aluminium, stainless steel, polished brass, metallic paints and honey-lacquered finishes. I was inclined to dismiss all this as sterile, high-tech positivism, I was leery of the content it implied and yet, when I stood in front of a Harley Davidson – red-lacquered, galvanized-iron, bull-nosed progression – and uttered 'Goddammit' under my breath, I completely embraced his aesthetic on his terms; or when I walked into the Dwan Gallery and saw a series of blunt, hot-dipped galvanized-iron boxes cantilevered off the wall that pushed the space and displaced the room, I had to admire his courage, his rudeness, his audacity. His objects were executed to millimetre perfection. Every aspect of their making was revealed and considered down to the detail of the detail. They could be unnerving in their absoluteness, their remoteness.

Judd's work is to be looked at, first and foremost. The experience is always rooted in perception, always physical, always kinaesthetic. I never considered the work to be an end in itself, a mere visual representation of theoretical propositions, intentions or concepts. Sure it makes visual common sense: one thing after another, a progression, a stack, a whole divided into so many equally interesting specific parts. But that's not all there is; at least that's not where I locate the meaning of Judd's sculpture. His empiricist prescriptions exclude too much, leave too many questions unanswered. I especially admire the big, open steel, concrete and plywood sculptures. They convey a public space, an expanse, a vastness derived from openness but not contained by a closed solution. Judd was one of the first to deal with the contained interior space and surrounding space simultaneously by emphasizing the continuity from the inside out. I think of Don Judd as an essential American, American as defined by Charles Olson in the first lines of *Call Me Ishmael*:
'*I take SPACE to be the central fact to man born in America, from Folsom cave to now. I spell it large because it comes large here. Large and without mercy.*'

Richard Serra, 'Donald Judd', *Artforum*, XXXII: 10 (Summer 1994) 70; 113-14.

Robert ROSENBLUM
Name in Lights [1997]

The death of Daniel Nicholas Flavin, Jr., on 29 November 1996, sent my memory rushing back to the early 1960s, now a mythic moment in the history of art. Born on 1 April 1933, Flavin was part of my own generation, for which the complementary austerities of an iconic soup can and a perfect rectangle appeared to launch a visual order in which industrial uniformity and pure cerebration would be the reigning muses. Worshipping early at New York's shrines of Modern art (he once worked as a guard at The

Museum of Modern Art, and attended Meyer Schapiro's lectures at Columbia University), by 1963 Flavin had become a pillar of the fiercely intelligent young art establishment whose spirit was nurtured monthly by the then year-old *Artforum*. I can't remember exactly how or when we first met, but it must have been somewhere in those rigorous precincts where the likes of Carl Andre, Frank Stella and Barbara Rose were drafting new aesthetic constitutions. Yet even within this group of the sharpest cutting edges, Flavin stood out, his toweringly intractable presence always cushioned from reality by his devoted wife, Sonia Severdija.

Teaching then at Princeton, I was only a weekender in this freshly minted world; but in the spring of 1963 my weekend extended through Mondays, when I gave a guest course at Columbia University on Neo-classical painting. Always keen on art history, and assuming, I think, that I was a student of Schapiro's (which I was not), Flavin asked to audit my lectures, especially those on Ingres, and then thanked me for the favour in the most generous ways. First there was a drawing dated 25 April 1963, which he offered to me with an inscribed dedication. Titled *icon IV (the pure land)*, it copied an earlier construction (now lost), a Formica square topped horizontally by a single fluorescent tube. In 1962, when Flavin was first working on this piece, his twin brother, David John, died, and in my drawing the shrine-like object was turned into a memorial by a tombstone-type inscription that recorded his brother's birth and death dates. (There is a telling parallel here to Barnett Newman's *Shining Forth [to George]* of 1961, the painter's abstract altarpiece commemorating his own brother's death in February of that year.)

One month after he executed this drawing, Flavin, echoing Newman's *Onement I* (1948), took a quantum leap, creating his first work made from nothing but a single standard 244-cm [8-ft] yellow fluorescent tube. He originally called it *the diagonal of May 25, 1963 (to Constantin Brancusi)*, but in 1964, in a second version shown at the Kaymar Gallery, New York, he replaced Brancusi's name with mine, an apotheosis that still has me reeling. Perhaps he was impressed by my youthfully rash remark that his work had destroyed painting for me, a comment he quoted in Bruce Glaser's radio interview of 15 February 1964, with him, Stella and Donald Judd (though he subsequently withdrew his own remarks from the publication of this early document of Minimalism).

The next year, our professional paths crossed in a different way that I'll also never forget. Applying for a Guggenheim Fellowship in 1965, Flavin respectfully asked me to write a recommendation. Believing ardently in his genius potential, I of course agreed to do so. But I was dumbfounded when he almost demanded to read my letter before I sent it off, lest I in some way misrepresent his mission. I wrote back that although I could assure him that the letter would be utterly positive, I could not send him a copy, since this violated protocol, and then added, much too breezily for his always furrowed brow, 'Who do you think you are? Barnett Newman?' I got back a passionately argued, lengthy, handwritten letter explaining how totally different he was from Newman. This might have been my first awareness that the AbEx

fervour for a heroic individuality of cosmic dimensions, a species presumably extinguished by early 1960s cool, had been inherited by at least one member of the next generation. (PS He didn't get the fellowship.)

All this was more than three decades ago, and at the time, if memory is to be trusted, Flavin's astonishingly familiar-yet-unfamiliar objects – mass-produced cylinders of artificial light – at first seemed to have everything to do with the *tabula rasa* of Minimalism and little to do with anything else. At home with the rock-bottom geometries portentously unveiled by other artists of his generation – Andre, Stella, Robert Morris, Judd – and, when lit, ethereally defiant of gravity and corporeal presence, his early work appeared to inhabit a pristine world of disembodied intellect, re-examining elementary principles of mensuration or, as in *a primary picture* (1964), rediscovering, via a hardware store's fluorescent spectrum, the three primary colours once sanctified by Piet Mondrian (and reinvented in the 1960s by Newman and Roy Lichtenstein). Moreover, the tonic cerebration that allied Flavin to Minimalism was further underlined by a growing awareness of his connection to Marcel Duchamp, for what was a store-bought fluorescent tube if not a readymade that could be declared, by intellectual fiat, a work of art?

By the time of Flavin's death, however, the narrow boundaries that constrained the original perception of his work had vanished. For one thing, his evolution, like Stella's, moved relentlessly from minimal to maximal, creating what in the early 1960s would have been unimaginable complexities of exquisitely reflected colours, of intricately circular and lattice-like patterns that could expand into sumptuously engulfing environments. And the associative power of Flavin's art, at first repressed by the chill of Minimalist polemics, has kept growing too, recalling, for one, the intensity of his Irish Catholic background. Hoping to have a priest for a son, his father had consigned him to a Brooklyn seminary, where he was drawn to the drama of the liturgy and its often luminous artefacts. Perhaps that is why the sometimes funereal or mystical quality of his work, with its fluorescent gloom or triumph, redolent of Machine Age populist spirituality, has become ever more potent [...]

Now that the light of Flavin's own life has gone out, we may begin to grasp the astonishing range of his art. From a single cylinder of light, the bone-dry attribute of a Minimalist monk of the 1960s, he went on to create a teeming infinity of shapes, colours and phantom spaces, and an equally rich domain of associations, both public and private, sacred and secular. Who could forget his recent triumph in New York, when, in 1992, vastly amplifying a Solomon R. Guggenheim Museum installation of 1971, he transformed Frank Lloyd Wright's rotunda into a neo-Gothic chapel in which a sky-bound column of immaterial pink light was surrounded by a spiralling refulgence splendid enough to provide a setting for his wedding, on 25 June? Magician that he was, he could make a fluorescent tube encompass everything from dirge to jubilation.

1 Anna C. Chave, 'Minimalism and the Rhetoric of Power', *Arts Magazine* (January 1990).

15. Piet Mondrian

Robert Rosenblum, 'Name in Lights', *Artforum*, 36: 7 (March 1997) 11-12.

John MCCRACKEN
Artist's statement [1999]

Art – real art – is, widely speaking, constructive activity that involves and has positive consideration for everything. That's the platform I jump from and the approach I try to take with my work.

In relation to 'minimal' art, I think of essences – trying to get at the soul of things, trying to pare down to just what's needed. And I think of speaking through the medium of pure form.

I make material objects that can at times appear to be non-material – physical, yet imaginative, virtual – so that they can be perceived as physically real and at the same time as if they were images formed by visual thought – i.e., mentally real. The point is, again, both dimensions are real – and the more they are perceived to be so, the more complete our grasp of actuality becomes. One thing I mean to imply is that thoughts are objects.

I also simply work in three-dimensional (sometimes two-dimensional) form. I conceive of form as comprising a language of its own that speaks with gesture and geometry. This is separate from the colours I use; in this regard, colour and surface are the body, the stuff, that the form is manifested through. Pure form by itself would have no substance and therefore be invisible. So it's got to be made out of something, and I choose colour (sometimes metal) as a means of embodying it. In a significant way, form is the central feature of my work – though it's hard not to say that colour and surface are just about as important.

The 'plank' form I've made symbolically connects the 'two worlds'. It touches the floor – the world of sculpture; the physical world we walk around in – and it touches the wall – the world of painting; the visionary world we look into. All my works tend to do that same thing, whether with gesture, form or the characteristics of colour and surface.

Colour is the main 'material' I use. Since it's really a quality and not a material, it has – besides being emotionally evocative – an abstract character at the outset. Then the polished finish brings clarity, transparency, shifting appearances, beauty.

The main historical art I've found interesting is ancient Egyptian work. Some of those works convey through form alone (whether two- or three-dimensional) information and spirit. (Which, I believe, is exactly what 'formalism' is about.) They don't impart information so much by referring or pointing as by simply speaking through the nature of their own being.

I try to make my works 'perfect', yet I'm not a 'perfectionist'. Crafting, I think, should only be aimed at getting the job done.

Part of the idea is this: you can see more than what you get.

The real challenge in art – in creative activity of all kinds – is to encourage everyone to become, further become, 'artists of life', and to endeavour to make art out of – 'up the quality of' – life, the world, everything. Everyone can in their own ways become fine creators, and everything, even the universe, can become high art – higher than it already is. Our concept of 'heaven' is only a glimmer, as if seen through wavy, misty glass, of the colossal, amazing 'symphony' that our existence actually touches on and can evolve – adventurously – towards becoming. The real artworks are ourselves and everything that exists.

John McCracken, 'Artist's statement' (New Mexico, May 1999).

ARTISTS' BIOGRAPHIES

Carl ANDRE [b. 1935, Quincy, Massachusetts] is a New York-based sculptor and poet and one of the leading figures associated with Minimalism. In 1959 he produced his first signature works of repeated identical units, developing a sculpture characterized by strict attention to the physical properties of materials. Andre's famous horizontal floor planes, including *Equivalents I-VIII* (1966) and *Cuts* (1966-67), blurred the distinction between sculpture and installation. His work has appeared in innumerable exhibitions including 'Primary Structures', the Jewish Museum, New York (1966), 'When Attitudes Become Form', Kunsthalle, Bern (1969), and 'Blurring the Boundaries: Installation Art 1969-1996' (1996). Retrospective exhibitions have been held at the Gemeentemuseum, The Hague (1969), Solomon R. Guggenheim Museum, New York (1970), Museum of Modern Art, Oxford (1975), Kunstmuseum Wolfsburg, Krefeld (1996), and Royal Botanic Garden, Edinburgh (1998). Andre has written catalogue texts for his contemporaries, including Frank Stella (with whom Andre studied) and Bernd and Hilla Becher. He has also contributed to *Artforum*, *Arts Magazine* and *Art in America* on aspects of Modernism and the relation between art, culture and politics.

Jo BAER [b. 1929, Seattle] lives and works in Amsterdam. Her austere, white canvases with coloured bands around their borders were archetypal examples of Minimal-type painting during the 1960s. Baer was included in such important group shows as 'Systemic Painting', Solomon R. Guggenheim Museum, New York (1966), 'Art in Series', Finch College Museum of Art, New York (1967), and '10', Dwan Gallery, New York (1966). Baer has had retrospective exhibitions at the Whitney Museum of American Art, New York (1975), Stedelijk Van Abbemuseum, Eindhoven (1978; 1986), and Stedelijk Museum, Amsterdam (1999).

Larry BELL [b. 1939, Chicago] lives and works in Taos, New Mexico. A central figure of the Los Angeles Finish Fetish 'Light and Space' movement, he developed a method for vacuum-coating glass in 1962, which he then fabricated into cubic solids with highly reflective surfaces. By the late 1960s he had begun producing environmental sculptures of sheets of tinted plate glass. His more recent works have departed from a strictly Minimal idiom. Bell's work has appeared in such group exhibitions as 'The Responsive Eye', The Museum of Modern Art, New York (1965), 'Primary Structures', the Jewish Museum, New York (1966), and Documenta 4, Kassel (1968). His numerous shows include the Stedelijk Museum, Amsterdam (1967), Pasadena Art Museum, California (1972), Fort Worth Art Museum (1975), Detroit Institute of Arts (1982), Museum of Contemporary Art, Los Angeles (1984), Denver Museum of Art (1995) and Museum Moderner Kunst Landkreis Cuxhaven, Germany (1999).

Ronald BLADEN [b. 1918, Vancouver; d. 1988, New York] was an artist and professor at Parsons School of Design, New York. During the 1960s Bladen developed dynamic, monumental shapes which differed dramatically from the static, human-scaled works being done by the Minimalists. His famous *Elements* (1966) was included in 'Primary Structures', the Jewish Museum, New York (1966). Bladen exhibited in such group exhibitions as 'Concrete Expressionism', Loeb Student Center, New York University (1965), and 'Scale as Content', Corcoran Gallery of Art, Washington, DC (1968). His solo shows include the Green (1962) and Fischbach Galleries, New York (1972). A retrospective was held at P.S. 1, New York (1999).

Mel BOCHNER [b. 1940, Pittsburgh] is an artist and critic currently residing in New York. One of the most incisive critics of Minimal art during the 1960s, he became an innovator of Conceptual art in the late 1960s and early 1970s. Bochner's early projects made use of serial methods derived from Minimalism, such as *36 Photographs and 12 Diagrams* (1966), and *Working Drawings and Other Visible Things on Paper Not Necessarily Meant to be Viewed as Art* (1966). Group shows include 'When Attitudes Become Form', Kunsthalle, Bern (1969), 'Information', The Museum of Modern Art, New York (1970), 'L'Art Conceptuel, Une Perspective', Musée d'Art Moderne de la Ville de Paris (1989-90), and '1965-1995: Reconsidering the Object of Art', Museum of Contemporary Art, Los Angeles (1995). Retrospective exhibitions have been held at the Baltimore Museum of Art (1976), Palais de Beaux-Arts, Brussels, and Städtische Galerie im Lenbachhaus, Munich (both 1995-96).

Judy CHICAGO [Judy Cohen Gerowitz] [b. 1939, Chicago] is one of the leading figures of the feminist art movement. Working in a Minimal style in the 1960s under the name Judy Gerowitz, she participated in early Minimal shows including the important 'Primary Structures', the Jewish Museum, New York (1966). A founder of the Feminist Art Program at the California Institute of Arts, and of Womanhouse, Los Angeles (1971), she was instrumental in developing an art based on a female-specific content and iconography. Chicago's best known work is the collaborative *The Dinner Party* (1974-79), a homage to famous women of history and legend. Her solo exhibitions include Rolf Nelson Gallery, Los Angeles (1966), and a retrospective of her work was held at Florida State University Art Museum (1999). She is the author of *Through the Flower: My Struggle as a Woman Artist* (1975), and *The Dinner Party: A Symbol of Our Heritage* (1979).

Walter DE MARIA [b. 1935, Albany, California] has been associated with Minimalism, Conceptualism, Fluxus, Land art and installation art since the 1960s. His Minimal-type sculpture is distinguished by its metaphorical allusions. De Maria participated in 'Primary Structures', the Jewish Museum, New York (1966), and Documenta 5, Kassel (1972); his *Lightning Field* (1977), *New York Earth Room* (1977) and *Broken Kilometer* (1977) are permanent installations housed by the Dia Foundation, New York. Solo exhibitions include the Kunstmuseum, Basel (1972), Moderna Museet, Stockholm (1989), Fondazione Prada, Milan (1999), and Kunsthaus, Zurich (1992; 1999).

Dan FLAVIN [b. 1933, New York; d. 1996, Long Island] developed an installational art of fluorescent lights in 1963 that revealed the physical and perceptual parameters of the gallery environment. His works *the nominal three (to William of Ockham)* (1964-69) and *the diagonal of May 25, 1963 (to Robert Rosenblum)* (1963) are classic works of 1960s Minimalism. Flavin participated in such group shows as 'Black, White, and Gray', Wadsworth Atheneum, Hartford (1964), 'Primary Structures', the Jewish Museum, New York (1966), and 'The Art of the Real: USA, 1948-1968', The Museum of Modern Art, New York (1968). Solo exhibitions include the National Gallery of Art, Ontario (1969), Fort Worth Art Museum (1976-77), Art Institute of Chicago (1976-77), Staatliche Kunsthalle, Baden-Baden (1989), Dia Center for the Arts, New York (1995), Solomon R. Guggenheim Museum, SoHo, New York (1995), and Fondazione Prada, Milan (1999).

Eva HESSE [b. 1936, Hamburg; d. 1970, New York] was a leading figure of post-Minimal sculpture whose soft, hand-made works broke down the rigidity of Minimal shape and syntax through the use of pliable materials and 'absurd' repetition. Hesse exhibited in numerous group shows including 'Eccentric Abstraction', Fischbach Gallery, New York (1966), 'Art in Series', Finch College Museum of Art, New York (1967), and 'Live in Your Head: When Attitudes Become Form', Kunsthalle, Bern (1969). Her solo exhibitions include Allan Stone (1963) and Fischbach Galleries (1968; 1970), New York. Retrospective exhibitions include the Solomon R. Guggenheim Museum, New York (1972), Whitechapel Art Gallery, London (1979), Yale University Art Gallery, New Haven (1992), IVAM Centre Julio Gonzàlez, Valencia (1993), and Ulmer Museum, Ulm, Germany (1994).

Ralph [Robert] HUMPHREY [b. 1932, Youngstown, Ohio; d. 1990, New York] developed a pared-down Minimal-type painting in the late 1950s. In the mid 1960s he made a series of eleven *Frame Paintings* with a painted border that contrasts sharply with the painted central panel. Group exhibitions include 'Abstract Expressionists and Imagists' (1961) and 'Systemic Painting' (1966), both Solomon R. Guggenheim Museum, New York. Humphrey has had many solo exhibitions at the Tibor de Nagy and Bykert Galleries in the 1960s, and Mary Boone Gallery, New York (1990).

Donald JUDD [b. 1928, Excelsior Springs, Missouri; d. 1994, New York] was an artist and critic and one of the central figures associated with the development of Minimal art. He began writing reviews for *Arts Magazine* in 1959, soon emerging as a leading polemicist of this new work with the publication of 'Specific Objects' (1965). His first show, of cadmium red works, was held at the Green Gallery, New York, in 1963. During the mid 1960s he began creating the serial, industrially produced works in metal and Plexiglas for which he is most

well known. Relocating to Marfa, Texas, in the 1970s, he established a number of permanent installations of his own and other artists' work. Judd appeared in countless exhibitions, including 'Shape and Structure', Tibor de Nagy Gallery, New York (1965), 'Primary Structures', the Jewish Museum, New York (1966), and 'The Art of the Real: USA, 1948-1968', The Museum of Modern Art, New York (1968). Retrospectives include the Whitney Museum of American Art, New York (1968; 1988), Stedelijk Van Abbemuseum, Eindhoven (1970; 1987), National Gallery of Canada, Ottawa (1975), Museum of Modern Art, Oxford (1976; 1994), Kunsthalle, Bern (1976), Staatliche Kunsthalle, Baden-Baden (1989), Museum Wiesbaden (1993), Museum Boymans-van Beuningen, Rotterdam (1993), Gemeentemuseum, The Hague (1993-94), and Sprengel Museum, Hannover (2000).

Sol LEWITT [b. 1928, Hartford] currently lives in Chester, Connecticut and Spoleto, Italy. An innovator of both Minimal and Conceptual art, he began producing Minimalist structures and reliefs in 1962 and developed his well-known series of factory-made, white lattice works by the mid 1960s. His *Serial Project No. 1 (ABCD)* (1966) bridged the gap between formal abstraction and Conceptualism. This was followed by his essay 'Paragraphs on Conceptual Art' (1967) and the development of his Conceptual wall drawings in the late 1960s. LeWitt has participated in numerous group exhibitions including 'Primary Structures', the Jewish Museum, New York (1966), 'Minimal Art', Gemeentemuseum, The Hague (1968), Documentas 4, 6 and 7, Kassel (1968; 1977; 1982), International Biennial of São Paulo (1996), and Skulptur Projekte in Münster and Venice Biennale XLVII (1997). Retrospective exhibitions include the Gemeentemuseum, The Hague (1970; 1992), Palais des Beaux-Arts, Brussels (1974), Rijksmuseum Kröller-Muller, Otterlo (1974), The Museum of Modern Art, New York (1978; 1996), Museum of Modern Art, Oxford (1993), and The San Francisco Museum of Modern Art, Museum of Contemporary Art, Chicago, and Whitney Museum of American Art, New York (2000).

John MCCRACKEN [b. 1934, Berkeley] currently lives and works in New Mexico. In the mid 1960s, in Los Angeles, he began to use geometric forms with richly coloured, lacquered surfaces. In 1966 he developed his well-known leaning planks. McCracken has participated in such group exhibitions as 'Primary Structures', the Jewish Museum,

New York (1966), 'The Art of the Real: USA, 1948-1968', The Museum of Modern Art, New York (1968), the Carnegie International, Pittsburgh (1991), and 'Sunshine and Noir: Art in LA 1960-1997' (1997). Solo shows include Nicholas Wilder Gallery, Los Angeles (1965; 1967; 1968), Sonnabend (1970) and David Zwirner (1997; 2000) Galleries, New York , and Galerie Hauser and Wirth, Zurich (1999). Retrospective exhibitions have been held at the Newport Harbor Art Museum (1987), Contemporary Arts Museum, Houston (1987), and the Kunsthalle, Basel (1995).

Robert MANGOLD [b. 1937, North Tonawanda, New York] currently lives and works in Washingtonville, New York. Mangold developed a pared-down abstract painting in the mid 1960s, exploring the potential of the shaped canvas in his *Wall* and *Area Series*. His inscription of perceptual uncertainty within the monochrome using drawn line and the literal edge between adjacent supports eventually led to the *X* and polychrome *Frame* works of the 1980s. Mangold's group shows include 'Systemic Painting', Solomon R. Guggenheim Museum, New York (1966), and Documentas 5, 6 and 7, Kassel (1972; 1977; 1982). Solo exhibitions include the Solomon R. Guggenheim Museum, New York (1971), La Jolla Museum of Contemporary Art (1974), Stedelijk Museum, Amsterdam (1982), and travelling exhibitions organized by the Akron Art Museum, Ohio (1984), and Museum Wiesbaden, Germany (1998-99).

Brice MARDEN [b. 1938, Bronxville, New York] developed a monochromatic painting style in the mid 1960s. Characterized by thick encaustic surfaces in shades of grey, black, green, blue and brown, and arranged into diptychs and triptychs, his early works are classic examples of Minimalist painting, a manner he left behind in his gestural *Cold Mountain* series of the late 1980s. Marden's work has appeared in numerous group exhibitions including Documenta 5, Kassel (1972), and the Whitney Biennial, Whitney Museum of American Art, New York (1972). Retrospectives include the Stedelijk Museum, Amsterdam (1981), Whitechapel Art Gallery, London (1981), Dia Center for the Arts, New York (1991), Kunsthalle, Bern (1993), Wiener Secession, Vienna (1993), Dallas Museum of Art (1999) and the Hirshhorn Museum and Sculpture Garden, Washington, DC (1999).

Agnes MARTIN [b. 1912, Saskatchewan, Canada] lives and works in Lamy, New Mexico. She developed her signature abstract

painting style in the late 1950s. Often executed in acrylic and graphite, in pale shades of off-white, pastel and grey, Martin's canvases are noted for their delicacy and austerity, and allusions to nature and transcendental experience. She has participated in numerous group exhibitions including 'Black, White, and Gray', Wadsworth Atheneum, Hartford (1964), 'The Responsive Eye', The Museum of Modern Art, New York (1965), and 'Systemic Painting', Solomon R. Guggenheim Museum, New York (1966), as well as Documenta 5, Kassel (1972). Retrospectives include the Institute of Contemporary Art, University of Pennsylvania, Philadelphia (1973), Hayward Gallery, London (1977), Stedelijk Museum, Amsterdam (1977; 1991), and a travelling exhibition was organized by the Whitney Museum of American Art, New York (1993-94).

Paul MOGENSEN [b. 1941, Los Angeles] lives and works in New York. During the 1960s and 1970s Mogensen developed a style of modular painting using richly saturated colours, black and white. Frequently the dimensions of the different sized panels of his work were governed by mathematical rules, as in his Golden Section works exhibited at the Bykert Gallery, New York (1968). Solo shows include the Weinberg Gallery, San Francisco (1974; 1976), and numerous shows at the Bykert Gallery, New York, beginning in 1965. Retrospectives include the Houston Museum of Fine Arts (1978) and Wiener Secession, Vienna (1994).

Robert MORRIS [b. 1931, Kansas City] has worked in a variety of media including sculpture and painting, and was involved in the Judson Church dance and performance group. His show of grey, geometric works at the Green Gallery, New York (1964), established him as a key figure in the development of Minimal art. Morris was also a leading theorist of Minimalism, publishing the influential 'Notes on Sculpture: Parts I and II' (1966), only to later reject Minimalism in favour of post-Minimal or 'anti-form' work in the late 1960s. Group exhibitions include 'Primary Structures', the Jewish Museum, New York (1966), 'The Art of the Real: USA, 1948-1968', The Museum of Modern Art, New York (1968), and 'Minimal Art', the Gemeentemuseum, The Hague (1968). Solo shows include the Whitney Museum of American Art, New York (1970), Tate Gallery, London (1971), Corcoran Gallery of Art, Washington, DC (1969; 1990), Solomon R. Guggenheim Museum, New York (1994), and Cabinet des Estampes, Geneva (1999).

David NOVROS [b. 1941, Los Angeles] currently lives and works in New York. One of the painters associated with Minimalism, Novros developed a style characterized by a sequence of shaped canvases made of unconventional materials such as vinyl and acrylic lacquer, and Dacron and fibreglass, during the 1960s; he began to produce wall frescoes of geometric design during the 1970s. Solo shows include 'Projects', The Museum of Modern Art, New York (1972), and the Sperone Westwater (1976; 1978) and Mary Boone (1983) Galleries, New York. Group shows include 'Systemic Painting', Solomon R. Guggenheim Museum, New York (1966), Documenta 5, Kassel (1972), and 'Rothko, Marden, Novros', Institute for the Arts, Rice University, Houston (1977).

Robert RYMAN [b. 1930, Nashville] emerged as one of the most rigorous Minimal painters during the 1960s. He began painting white, monochromatic canvases in the late 1950s, a format he has developed ever since. Ryman has exhibited internationally in such shows as 'Systemic Painting', the Solomon R. Guggenheim Museum, New York (1966), 'Live in Your Head: When Attitudes Become Form', Kunsthalle, Bern (1969), and Documenta 5, Kassel (1972). Ryman's retrospective exhibitions include Stedelijk Museum, Amsterdam (1974), Kunsthalle, Basel (1975), The Museum of Modern Art, New York (1993), and the Tate Gallery, London (1993).

Tony SMITH [b. 1912, South Orange, New Jersey; d. 1980, New York] was a sculptor, painter and architect. An assistant to the architect Frank Lloyd Wright and younger contemporary of the Abstract Expressionists, Smith developed a systemic, geometric sculpture contemporaneously with the emergence of Minimalism. His black Minimal-type work is extremely varied in shape, ranging from the simple cube to complex polyhedron constructions. Group shows include 'Primary Structures', the Jewish Museum, New York (1966), 'The Art of the Real: USA, 1948-1968', The Museum of Modern Art, New York (1968), and 'Minimal Art', Gemeentemuseum, The Hague (1968). Retrospectives include the Wadsworth Atheneum, Hartford (1964), Westfälischer Landesmuseum, Munster (1988), and The Museum of Modern Art, New York (1971; 1998).

Robert SMITHSON [b. 1938, Rutherford, New Jersey; d. 1973, Amarillo, Texas] was an innovator of Land art as well as a prolific artist-writer during the 1960s and 1970s. A generation younger than the Minimalists

294

Andre, Judd and LeWitt, Smithson's early abstract sculptures are based on crystalline forms. His later Non-sites transformed the Minimal object into a container bringing the site into the gallery, anticipating his later *Spiral Jetty* (1970). Smithson's essays of the late 1960s, such as 'Entropy and the New Monuments' (1966), announce a post-Minimal destruction of the Minimal object. Group exhibitions include 'Primary Structures', the Jewish Museum, New York (1966), and 'Minimal Art', Gemeentemuseum, The Hague (1968). Retrospectives include Cornell University Art Gallery, Ithaca (1980), Wallach Gallery, Columbia University, New York (1991), Los Angeles County Museum (1993) and the National Museum of Contemporary Art, Oslo (1999).

Frank STELLA [b. 1936, Malden, Massachusetts] lives and works in New York. The exhibition of Stella's *Black Paintings* (1958-59) at 'Sixteen Americans', The Museum of Modern Art, New York (1959), heralded the emergence of Minimalism in the visual arts. Based on a deductive format of painted stripes that follow the shape and edge of the canvas, they pointed towards the development of the Minimal object. Stella's restoration of a compositional method in his *Irregular Polygons* (1966) marked a rupture with Minimalism. Group exhibitions include 'New York Painting and Sculpture 1940-70', The Museum of Modern Art, New York (1969), and the Venice Biennale (1964; 1970). Retrospectives include The Museum of Modern Art, New York (1987), Museo Nacional Centro de Arte Reina Sofia, Madrid (1995), and the Walker Art Center, Minneapolis (1997). Stella delivered the Charles Eliot Norton Lectures at Harvard University in 1983-84, subsequently published as *Working Space* (1986).

Anne TRUITT [b. 1921, Baltimore] lives and works in Washington, DC. She was one of the first artists to develop a Minimal sculpture of whole geometric shapes, and had the first solo exhibition of Minimalist work at the Andre Emmerich Gallery, New York (1963). Group exhibitions include 'Primary Structures', the Jewish Museum, New York (1966), and 'The Art of the Real: USA, 1948-1968', The Museum of Modern Art, New York (1968). Retrospectives include the Whitney Museum of American Art, New York (1973), Corcoran Gallery of Art, Washington, DC (1974), and the Baltimore Museum of Art (1974; 1992).

AUTHORS' BIOGRAPHIES

Gregory BATTCOCK was a painter and lecturer and New York visual arts correspondent for *Arts Magazine*. As editor of a series of important volumes of art writing published by E.P. Dutton & Co. during the 1960s and 1970s he is renowned for the seminal books *The New Art: A Critical Anthology* (1966), *Minimal Art: A Critical Anthology* (1968) and *Idea Art: A Critical Anthology* (1973). Battcock also wrote criticism for a number of journals including *Art and Literature*, *College Art Journal* and *Film Culture*.

Karl BEVERIDGE [b. 1945, Ottawa] is a visual artist and occasional writer. He lives and works in Toronto. His writing has been published in *Leonardo*, *Fuse* and *Left Curve*. He is currently working on a book on the history of labour arts in Canada. Together with Carole Condé, he has exhibited his staged photographic work internationally, including exhibitions at the Photographers' Gallery, London, the Museum Folkswang, Essen, and the Primavera Fotográfica, Barcelona.

David BOURDON [b. 1934, Los Angeles; d. 1998, New York] was a writer and critic. A reporter on the New York art scene for the *Village Voice* during the early 1960s, Bourdon wrote the first close analysis of Andre's work, 'The Razed Sites of Carl Andre', in *Artforum* (1966). His publications include *Carl Andre Sculpture 1959-1977* (1978), *Warhol* (1989) and *Designing the Earth: The Human Impulse to Shape Nature* (1995).

Ian BURN [b. 1939, Geelong, Australia; d. 1993] was a founder of The Society for Theoretical Art and Analyses and one of the early participants in the British-based artists' group Art and Language, which he joined in 1969. Burn was involved in organizing the famous Art and Language *Index* for Documenta 5 (1972), and worked on the New York-based Conceptual journal *The Fox*. He published regularly, including his noteworthy article 'Conceptual Art as Art', *Art and Australia* (1970). His published writings include *Dialogue: Writings in Art History* (1991)

Anna C. CHAVE teaches art history at Queens College, The City University of New York. She has developed a feminist reading of

Modernism in a variety of essays on such artists as Picasso, Agnes Martin and Eva Hesse. Her publications include *Mark Rothko: Subjects in Abstraction* (1989) and *Constantin Brancusi: Shifting the Bases of Art* (1993).

John COPLANS [b. 1920, London] lives and works in New York. In 1962 he co-founded *Artforum*, and *Dialogue* in 1971. John Coplans reported on contemporary art in Los Angeles and New York. He curated 'Roy Lichtenstein' (1967), 'Serial Imagery' (1968) and 'Donald Judd' (1971) while he was a curator and director of the Pasadena Art Museum (1967-71). During 1971-77 he was Editor-in-chief of *Artforum*. He is the author of studies on major figures such as *Roy Lichtenstein* (1972) and *Ellsworth Kelly* (1972). Since 1980 he has pursued a career in photography and has had retrospective exhibitions at the Museum of Modern Art, San Francisco (1988) and the Wadsworth Atheneum, Hartford (1991).

Douglas CRIMP [b. 1944, Coeur d'Alene, Idaho] currently teaches in the Visual and Cultural Studies Program at the University of Rochester. He began writing art criticism for *ARTnews* in 1970 and received the first of two NEA Art Critics Fellowships in 1973. Formerly editor of *October* from 1977 to 1990, he is the author of *On the Museum's Ruins* (1993) and *AIDS Demographics* (1990), and the editor of *AIDS: Cultural Analysis/Cultural Activism* (1988). A central figure in the theorization of Postmodernism in the visual arts, Crimp has authored such essays as 'Pictures' and 'The Photographic Activity of Postmodernism', as well as studies on Mary Kelly and Richard Serra.

Mark DI SUVERO [b. 1933, Shanghai] lives in Long Island City, New York. His family moved to California in 1941, and he studied at the University of California. In 1957 he moved to New York and in 1962 founded the SoHo Co-operative Gallery. His large-scale outdoor works include the well-known *Tower of Peace*, *Los Angeles* (1966), a protest against the Vietnam war. Solo shows include Dwan Gallery, Los Angeles (1965), and the Whitney Museum of American Art, New York (1975). His group exhibitions include Documenta 4, Kassel (1968), and the Venice Biennale (1992).

Hal FOSTER [b. 1955, Seattle] is a scholar of twentieth-century art and an authority on historical and neo-avant-garde movements, including Surrealism and Minimalism, as well as contemporary art. Currently Professor of Modern Art at Princeton University, he is a co-editor of the journal *October*. His publications include *Recodings - Art, Spectacle, Cultural Politics* (1985), *Compulsive Beauty* (1993) and *The Return of the Real: The Avant-Garde at the End of the Century* (1996). Foster also edited the influential anthology *The Anti-Aesthetic* (1982).

Michael FRIED [b. 1939, New York] is the J.R. Herbert Boone Professor of Humanities at the Johns Hopkins University, Baltimore. He is the author of numerous books including *Absorption and Theatricality: Painting and Beholder in the Age of Diderot* (1980), *Courbet's Realism* (1990), *Manet's Modernism, of the Face of Painting in the 1860s* (1996), and *Art and Objecthood: Essays and Reviews* (1998).

Bruce GLASER [b. 1933, Brooklyn] lives and works in Fairfield, Connecticut. He is an art critic and curator and his interviews with artists during the 1960s, which were broadcast on the Pacifica Radio Network, include the famous 'New Nihilism or New Art?' with Donald Judd, Frank Stella and Dan Flavin, broadcast on WBAI-FM, New York (1964). He studied Art History at Columbia University and went on to serve as Director of Art Galleries in New York. His articles, interviews and discussions have been published in *ARTnews*, *Art in America* and *Artforum*.

Clement GREENBERG [b. 1909, New York; d. 1994, New York] was the most influential art critic of the later twentieth century. The author of such essays as 'Avant-Garde and Kitsch' and 'Modernist Painting', he emerged as a principal champion of Abstract Expressionism during the 1940s and 1950s, and leading theorist of Modernism in the visual arts. His essays have been anthologized in *Art and Culture* (1961) and *Clement Greenberg: The Collected Essays and Criticism* (1986-93).

Harold GREGOR [b. 1929, Detroit] is an artist who, since 1971, has painted panoramic depictions of the Midwest

farmlands, including his 'Flatscapes', colourful aerial perspectives of the Midwestern agriscene. Prior to 1970, he produced installations and site works. Educated at Wayne (1951), Michigan (1953) and Ohio State Universities (1960), Gregor has taught at a number of institutions including Chapman College, Orange, California (1966-70) and Illinois State University (1970-95).

Peter **HALLEY** [b. 1953, New York] is an artist and writer who lives and works in New York. He is best known for his large-scale geometric, abstract paintings and critical writings. Solo exhibitions of his work have been held at the Institute of Contemporary Arts, London (1989), the Musée d'art contemporain, Bordeaux (1991), and The Museum of Modern Art, New York (1997). Halley's writing has been compiled in *Collected Essays 1981-1987* (1988). Since 1996 he has been publisher of the culture magazine *Index*.

Hilton **KRAMER** [b. 1928, Gloucester, Massachusetts] is a writer and critic. Kramer was art critic and editor for the *New York Times* (1965-82), *Arts Magazine* (1955-58) and other publications. He studied at Columbia University (1950-51), Harvard (1951) and Indiana University (1951-52). His published writing includes *The Age of the Avant-Garde: An Art Chronicle of 1956-1972* (1973). In 1982 he co-founded the journal *New Criterion*.

Rosalind **KRAUSS** [b. 1940, Washington, DC] is a leading historian of twentieth-century art, whose studies of sculpture, painting and photography include *Passages in Modern Sculpture* (1977), *The Originality of the Avant-Garde and Other Modernist Myths* (1985) and *The Picasso Papers* (1998). During the 1960s she was an editor at *Artforum*, and left to found the journal *October* with Annette Michelson in 1975. Krauss is currently the Meyer Schapiro Professor of Modern Art at Columbia University.

Philip **LEIDER** is a writer and editor. As editor of *Artforum* during the 1960s, he published such texts as Robert Morris' 'Notes on Sculpture' and 'Anti-Form', Robert Smithson's 'Entropy and the New Monuments', Sol LeWitt's 'Paragraphs on Conceptual Art', and Michael Fried's 'Art and Objecthood'. Leider's publications include an essay for the Fort Worth Art Museum's catalogue *Stella Since 1970* (1978).

Lucy R. **LIPPARD** [b. 1937, New York] is a freelance writer, curator and activist currently based in New Mexico. One of the first critics to write on Minimal and Pop art during the 1960s, she has also written the monographs *Ad Reinhardt* (1981), *Tony Smith* (1972), *Sol LeWitt* (1978) and *Eva Hesse* (1992). Her other publications include *Changing: Essays in Art Criticism* (1971), *Mixed Blessings: New Art in a Multicultural America* (1990) and *The Pink Glass Swan: Selected Feminist Essays on Art* (1995). She has curated numerous exhibitions including 'Issue: Social Strategies by Women Artists', Institute of Contemporary Arts, London (1980).

Kynaston **MCSHINE** [b. 1935, Port of Spain, Trinidad] is Senior Curator of Painting and Sculpture at The Museum of Modern Art, New York. He was educated at Dartmouth College and the Institute of Fine Arts, University of New York. His influential exhibitions include 'Primary Structures', the Jewish Museum, New York (1966), 'Information', The Museum of Modern Art, New York (1970), and the touring exhibition 'Andy Warhol', The Museum of Modern Art, New York (1989). His publications include *Joseph Cornell* (1981).

Maurice **MERLEAU-PONTY** [b. 1908, Rochefort-sur-mer, France; d. 1961] was a leading phenomenological philosopher and professor at the Collège de France. Sometimes described as 'the philosopher of Minimalism', Merleau-Ponty developed a powerful account of bodily experience and gesture that had a considerable impact on discussions of sculpture during the 1960s. His most notable studies include *Phénoménologie de la Perception* (1945), *Signes* (1960) and *Le Visible et l'invisible* (1964), and the essay 'Cézanne's Doubt'. Merleau-Ponty was co-editor of the journal *Les temps modernes* with Jean-Paul Sartre.

Ursula **MEYER** [b. 1915, Hannover] is an artist and critic. The editor of *Conceptual Art* (1972), she has written articles for *ARTnews*, *Arts Magazine*, *Women in Art* and *The Print Collectors' Newsletter*. She has been Associate Professor of Sculpture at Lehman College, City University of New York, since 1968. Group shows include 'Listening to Pictures', Brooklyn Museum (1968) and 'Cool Art: Abstraction Today', Newark Museum (1968).

Annette **MICHELSON** is an eminent scholar of film and Professor of Film Studies at New York University. She has written influential essays on Duchamp, Surrealism and Minimal art. A founding editor of the journal *October*, Michelson has also edited *Kino-Eye: The Writings of Dziga Vertov* (1984) and *Cinema, Censorship, and the State: The Writings of Nagisa Oshima, 1956-1978* (1992).

Yvonne **RAINER** [b. 1934, San Francisco] is a dancer, choreographer and film maker. She was involved with the Judson Dance Theater in New York during the 1960s as principal dancer and choreographer. Her films include *Lives of Performers* (1972), *The Man Who Envied Women* (1985) and *Privilege* (1990). The recipient of a McArthur Foundation Achievement Grant, she has published *Works 1961-1973* (1974) and *The Films of Yvonne Rainer* (1989).

Barbara **ROSE** [b. 1937, Washington, DC], an art critic and historian based in New York and Todi, Italy, was one of the earliest supporters of Minimal work. She has been a contributing editor to *Artforum* and *Art in America*. Her most influential text on the subject of Minimalism was 'ABC Art', *Art in America* (1965), among the first essays that attempted to define Minimal style and its characteristics. Other principal texts by Rose include 'The Politics of Art, Part I', *Artforum* (1968) and a catalogue essay on Claes Oldenburg for The Museum of Modern Art, New York (1970). In 1990 she founded the short-lived *Journal of Art*. Her publications include *American Art Since 1900: A Critical History* (1967) and *Magdalena Abakanowicz* (1994).

Robert **ROSENBLUM** [b. 1927, New York] is Professor of Fine Arts at New York University and a curator at the Solomon R. Guggenheim Museum, New York. His interests range from art of the late eighteenth century to the present, with particular interest in French Neoclassical painting, Picasso and late twentieth-century art. His many publications include *Cubism and Twentieth Century Art* (1961), *Nineteenth Century Art* (1964) and *Transformations in Late Eighteenth Century Art* (1969). He has also authored a monograph on Frank Stella (1971) and a catalogue essay for the exhibition 'Sol LeWitt' at The Museum of Modern Art, New York (1978).

Jeanne **SIEGEL** currently chairs the Fine Arts and Art History Departments at the School of Visual Arts, New York, where she has taught the seminar 'Jackson Pollock: The Man and the Myth' since 1994. She is a former associate editor of *Arts Magazine*

and former President of the American Section of the International Association of Art Critics. She has published a number of artist interviews in volumes including *Artwords: Discourse on the 60s and 70s* (1985) and *Art Talk: The Early 1980s* (1990).

Susan **SONTAG** [b. 1933, New York] emerged as a leading cultural critic during the 1960s. She is the author of the essays 'Notes on "Camp"' and 'Against Interpretation', and her influential work has examined avant-garde film, photography and representations of popular culture. Sontag has also explored representations of illness and AIDS, edited the writings of Roland Barthes, Antonin Artaud and Walter Benjamin, and published several novels including *The Volcano Lover* (1992) and *In America* (2000). Her collected criticism has appeared in *Against Interpretation and other essays* (1966), *Styles of Radical Will* (1969) and *Under the Sign of Saturn* (1980).

Sidney **TILLIM** [b. 1925, Brooklyn] is an artist and critic who resides in New York. A contributing editor to *Arts Magazine* and *Artforum*, he also curated 'The Work of Art After the Age of Mechanical Reproduction' (1992). In 1996 he co-curated 'Photographs in Ink', an exhibition which surveyed the history and aesthetics of the photochemical processes of reproduction. A collection of his writings is forthcoming.

Samuel J. **WAGSTAFF** Jr. [b. 1921, New York; d. 1989, New York] was a curator and organized one of the early Minimal art exhibitions, 'Black, White, and Gray' (1964) at the Wadsworth Atheneum, Hartford, Connecticut. He also worked as a curator at the Detroit Institute for the Arts. Wagstaff sold his large photographic collection to the J. Paul Getty Museum in 1984.

BIBLIOGRAPHY

Agee, William, *Don Judd* (New York: Whitney Museum of American Art, 1968)

Alloway, Lawrence, *The Shaped Canvas* (New York: Solomon R. Guggenheim Museum, 1965)

_____, *Systemic Painting* (New York: Solomon R. Guggenheim Museum, 1966)

_____, 'Agnes Martin', *Artforum*, 11 (April 1973) 32-37

Andre, Carl, *Carl Andre: Sculpture 1958-1974* (Bern: Kunsthalle, 1975)

_____, *Carl Andre: Wood* (Eindhoven: Stedelijk Van Abbemuseum, 1978)

_____, *Carl Andre* (The Hague: Gemeentemuseum; Eindhoven: Stedelijk Van Abbemuseum, 1987)

_____; Frampton, Hollis, *12 Dialogues 1962-1963*, ed. Benjamin H.D. Buchloh (Halifax: Nova Scotia College of Art and Design, 1981)

Antin, David, 'Art and Information I: Grey Paint, Robert Morris', *ARTnews*, 65 (April 1966) 23-24; 56-58

Artstudio, 'Art Minimal: Carl Andre, Dan Flavin, Donald Judd, Sol LeWitt, Robert Morris, Tony Smith', *Artstudio*, 6 (Autumn 1987)

Ashton, Dore, 'The Anti-Compositional Attitude in Sculpture', *Studio International*, 172 (July 1966) 44-47

_____, 'New York: "The Art of the Real" at The Museum of Modern Art', *Studio International*, 176 (September 1968) 92-93

Baer, Jo, 'Art and Politics/On Painting', *Flash Art*, 37 (November 1972) 6-7

_____, 'I am no longer an abstract artist', *Art in America*, 71 (October 1983) 136-37

_____, *Jo Baer: Paintings from the 1960s and early 1970s* (New York: Paula Cooper Gallery, 1995)

Baker, Amy, 'Painterly Edge: A Conversation with Ralph Humphrey', *Artforum*, 8 (April 1982) 38-43

Baker, Elizabeth C., 'Judd the Obscure', *ARTnews*, 67 (April 1968) 44-45; 60-62

Baker, Kenneth, 'Ronald Bladen', *Artforum*, 10 (April 1972) 79-80

_____, 'Material Feelings: Ralph Humphrey', *Art in America*, 72 (October 1984) 162-67

_____, *Minimalism: Art of Circumstance* (New York: Abbeville, 1988)

Banes, Sally, *Greenwich Village 1963: Avant-Garde Performance and the Effervescent Body* (Durham: Duke University Press, 1993)

Bann, Stephen, *Brice Marden: Paintings, Drawings, Etchings 1975-1980* (Amsterdam: Stedelijk Museum, 1981)

Bannard, Darby, 'Present-Day Art and Ready-Made Styles', *Artforum*, 5 (December 1966) 30-35

Barette, Bill, *Eva Hesse: Sculpture* (New York: Timken, 1989)

Batchelor, David, 'Within and Between', *Sol LeWitt: Structures 1962-1993* (Oxford: Museum of Modern Art, 1993)

_____, *Minimalism* (London: Tate Gallery, 1997)

Battcock, Gregory (ed.), *Minimal Art: A Critical Anthology* (New York: E.P. Dutton & Co., 1968)

Bell, Larry, *Larry Bell: The 1960s* (Santa Fe: Museum of Fine Arts, 1982)

_____, *Zones of Experience: The Art of Larry Bell* (Albuquerque Museum, 1997)

Belloli, Jay, *Dan Flavin: installations in fluorescent light 1972-1975* (Texas: Fort Worth Art Museum, 1977)

_____; Rauh, Emily S., *Dan Flavin: drawings, diagrams and prints 1972-1975* (Texas: Fort Worth Art Museum, 1977)

Berger, Maurice, *Labyrinths: Robert Morris, Minimalism, and the 1960s* (New York: Harper and Row, 1989)

Berkson, Bill, 'Ronald Bladen: Sculpture and Where We Stand', *Art and Literature*, 12 (Spring 1967) 139-50

_____, *Ronald Bladen: Early and Late* (San Francisco: Museum of Modern Art, 1991)

_____; Blok, Cor, 'Minimal Art at the Hague', *Art International*, 12 (May 1968) 18-24

Blok, Cor [see Berkson, Bill]

Bochner, Mel, 'Art in Process - Structures', *Arts Magazine*, 40 (September-October 1966) 38-39

_____, 'Systemic', *Arts Magazine*, 41 (November 1966) 40

_____, 'Serial Art, Systems: Solipsism', *Arts Magazine*, 41 (Summer 1967) 39-43

_____, *Working Drawings and Other Visible Things on Paper Not Necessarily Meant to be Viewed as Art* (Geneva: Cabinet des estampes du Musée d'Art et d'Histoire, 1997)

Bois, Yve Alain, 'Ryman's Tact', *Painting as Model* (Cambridge, Massachusetts and London: MIT Press, 1990)

_____, 'Surprise and Equanimity', *Robert Ryman: New Paintings* (New York: Pace Gallery, 1990)

_____, 'The Inflection', *Donald Judd: New Sculpture* (New York: Pace Gallery, 1991)

Bourdon, David, *Carl Andre Sculpture 1959-1977* (New York: J. Rietman, 1978)

Chicago, Judy, *Through the Flower: My Struggle as a Woman Artist* (Garden City: Doubleday & Company, 1975)

Clarke, David, 'The Gaze and the Glance: Competing Understandings of Visuality in the Theory and Practice of Late Modernist Art', *Art History*, 15 (March 1992) 80-98

Clay, Jean, 'La Peinture en charpie', *Macula*, 3-4 (September 1978) 167-85

Colpitt, Frances, *Finish Fetish: LA's Cool School* (Los Angeles: Fisher Gallery, University of Southern California, 1991)

_____, *Minimal Art: The Critical Perspective* (Ann Arbor: UMI Research Press, 1990)

Compton, Michael; Sylvester, David, *Robert Morris* (London: Tate Gallery, 1971)

Cooper, Helen, *Eva Hesse: A Retrospective* (New Haven: Yale University Art Gallery, 1992)

Coplans, John, 'Three Los Angeles Artists', *Artforum*, 1 (April 1963) 29-31

_____, 'Serial Imagery', *Artforum*, 7 (October 1968) 34-43

_____, 'An Interview with Don Judd: "I am interested in static visual art and hate imitation of movement."' *Artforum*, 9 (June 1971) 44

Crow, Thomas, *The Rise of the Sixties* (New York: Abrams, 1996)

Danieli, Fidel, 'Bell's Progress', *Artforum*, 5 (Summer 1967) 68-71

De Duve, Thierry, 'Ryman irreproductible: nonreproductible Ryman', *Parachute*, 20 (Fall 1980) 18-27

_____, 'The Monochrome and the Blank Canvas', *Reconstructing Modernism: Art in New York, Paris, and Montreal 1945-1964*, ed. Serge Guilbaut (Cambridge, Massachusetts, and London: MIT Press, 1990)

Develing, Enno, *Minimal Art* (The Hague: Gemeentmuseum, 1968)

Didi-Huberman, Georges, *Ceci que nous voyons, ce qui nous regarde* (Paris: Editions Minuit, 1992)

Dreishpoon, Douglas, *Ronald Bladen: Drawings and Sculptural Models* (Greensboro: Weatherspoon Art Gallery, University of North Carolina, 1995)

Droll, Donald; Necol, Jane, *Abstract Painting 1960-1969* (New York: P.S. 1, 1983)

Dwan Gallery, *Ten* (New York: Dwan Gallery, 1966)

_____, *Virginia Dwan: Art Minimal - Art Conceptuel - Earthworks* (Paris: Galerie Montaigne, 1991)

Elliott, David; Fuchs, Rudi, *Jo Baer: Paintings 1962-1975* (Oxford: Museum of Modern Art, 1977)

Fer, Briony, 'Bordering on Blank: Eva Hesse and Minimalism', *On Abstract Art* (New Haven: Yale University Press, 1997)

Field, Richard, *Mel Bochner: Thought Made Visible 1966-1973* (New Haven) Yale University Art Gallery, 1995)

Flavin, Dan, *'monuments' for V. Tatlin from Dan Flavin, 1964-1982* (Los Angeles: Museum of Contemporary Art; Chicago: Donald Young Gallery, 1989)

_____, 'some remarks ... excerpts from a spleenish journal', *Artforum*, 5 (December 1966) 27-29

_____, 'some other comments ... more pages from a spleenish journal', *Artforum*, 6 (December 1967) 20-25

_____, 'several more remarks', *Studio International*, 177 (April 1969) 173-75

Foster, Hal, 'Some Uses and Abuses of Russian Constructivism', *Art into Life: Russian Constructivism 1914-1932* (Seattle) Henry Art Gallery, University of Washington, 1990)

_____ (ed.), 'The Reception of the Sixties', *October*, 69 (Summer 1994) 3-21

Frampton, Hollis [see Andre, Carl]

Fried, Michael, *Three American Painters* (Cambridge, Massachusetts: Fogg Art Museum, Harvard University, 1965)

_____, 'Shape as Form: Frank Stella's New Paintings', *Artforum*, 5 (November 1966) 18-27

_____, *Art and Objecthood* (Chicago: University of Chicago Press, 1998)

Friedman, Martin, 'Robert Morris: Polemics and Cubes', *Art International*, 10 (December 1966) 23-27

Fuchs, Rudi [see Elliott, David]

Gibson, Eric, 'Was Minimalist Art a Political Movement?', *The New Criterion*, 5 (May 1987) 59-64

Goossen, Eugene C., *Eight Young Artists* (Yonkers: Hudson River Museum, 1964)

_____, *The Art of the Real: USA 1948-1968* (New York: The Museum of Modern Art, 1968)

_____, 'The Artist Speaks: Robert Morris', *Art in America*, 58 (May-June 1970) 102-11

_____, *Eight Young Artists: Then and Now, 1964-1991* (New York: Hunter College, 1991)

Graham, Dan, 'Carl Andre', *Arts Magazine*, 42 (December 1967-January 1968) 34

_____, *Rock My Religion: Writings and Art*

Projects 1965-1990, ed. Brian Wallis (Cambridge, Massachusetts, and London: MIT Press, 1993)

Green, Eleanor, *Scale as Content: Ronald Bladen, Barnett Newman, Tony Smith* (Washington, DC: Corcoran Gallery of Art, 1968)

Greenberg, Clement, *The Collected Essays and Criticism, 1986-1993*, ed. John O'Brian (vols. I-IV, Chicago: University of Chicago Press, 1993)

Hanhardt, John; Haskell, Barbara, *Blam! The Explosion of Pop, Minimalism, and Performance 1958-64* (New York: Whitney Museum of American Art, 1984)

Harrison, Charles, *Essays on Art and Language* (Oxford: Basil Blackwell, 1991)

Haskell, Barbara, *Larry Bell* (Pasadena Art Museum, 1972)

_____, *Jo Baer* (New York: Whitney Museum of American Art, 1975)

_____, *Donald Judd* (New York: Whitney Museum of American Art, 1988)

_____, *Agnes Martin* (New York: Whitney Museum of American Art, 1992)

_____ [see Hanhardt, John]

Held, Jutta, 'Minimal Art: eine amerikanische Ideologie', *Neue Rundschau*, 83 (1972) 660-77

Hobbs, Robert, *Robert Smithson: Sculpture* (Ithaca: Cornell University Press, 1981)

Hopps, Walter, 'Boxes', *Art International*, 8 (March 1964) 38-41

_____, *Anne Truitt: Sculptures and Drawings 1961-1973* (Washington, DC: Corcoran Gallery of Art, 1974)

Insley, Will, 'Jo Baer', *Art International*, 13 (February 1969) 26-28

Jones, Caroline, *Machine in the Studio: Constructing the Postwar American Artist* (University of Chicago Press, 1996)

Judd, Donald, 'Aspects of Flavin's Work', *fluorescent light, etc. from Dan Flavin* (Ottawa: National Gallery of Canada, 1969)

_____, *Donald Judd: Complete Writings 1959-1975* (Halifax: Nova Scotia College of Art and Design; New York University Press, 1975)

_____, *Donald Judd Furniture: Retrospective* (Rotterdam: Boymans van Beuningen Museum, 1993)

_____, *Zeichnungen/Drawings 1956-1976* (Basel: Kunstmuseum, 1976)

_____, *Donald Judd: Complete Writings 1975-1986* (Eindhoven: Stedelijk Van Abbemuseum, 1987)

_____, *Architektur* (Munich: Westfälischen Kunstverein, 1989)

_____, *Räume: Kunst + Design* (Stuttgart: Cantz, 1993)

_____, 'Some Aspects of Color in General

and Red and Black in Particular', *Artforum*, 32 (Summer 1994) 70-79; 110; 113

Karmel, Pepe, *Robert Morris: The Felt Works* (New York University, Grey Art Gallery, 1989)

Kellein, Thomas, *Walter De Maria* (Stuttgart: Staatsgalerie, 1987)

_____, *McCracken* (Basel: Kunsthalle, 1995)

Kertess, Klaus, *Brice Marden: Paintings and Drawings* (New York: Abrams, 1992)

Kingsley, April, 'Ronald Bladen: Romantic Formalist', *Art International*, 18 (September 1974) 42-44

Kosuth, Joseph, *Art After Philosophy and After: Collected Writings, 1966-1990*, ed. Gabriele Guercio (Cambridge, Massachusetts, and London: MIT Press, 1991)

Kramer, Hilton, 'Art: Constructed to Donald Judd's Specifications', *The New York Times* (19 February 1966)

_____, '"Primary Structures" - The New Anonymity', *The New York Times* (1 May 1966)

_____, 'An Art of Boredom?', *The New York Times* (5 June 1966)

Krauss, Rosalind, 'Robert Mangold: An Interview', *Artforum*, 12 (March 1974) 36-38

_____, *Passages in Modern Sculpture* (Cambridge, Massachusetts, and London: MIT Press, 1977)

_____, *The Originality of the Avant-Garde and Other Modernist Myths* (Cambridge, Massachusetts and London: MIT Press, 1985)

_____, 'Overcoming the Limits of Matter: On Revising Minimalism', *American Art of the 1960s*, ed. John Elderfield (New York: The Museum of Modern Art, 1991)

_____, 'The LeWitt Matrix', *Sol Le Witt: Structures 1962-1993* (Oxford: Museum of Modern Art, 1993)

_____, 'The Mind/Body Problem: Robert Morris in Series', *Robert Morris: The Mind/Body Problem* (New York: Solomon R. Guggenheim Museum, 1994)

_____, 'The Material Uncanny', *Donald Judd: Early Fabricated Work* (New York: Pace Wildenstein Gallery, 1998)

Leen, Frederik, ' … Notes for an Electric Light Art [Dan Flavin]', *Forum International*, 15 (November- December 1992) 71-81

Leffingwell, Edward, *Heroic Stance: The Sculpture of John McCracken 1985-1986* (New York: P.S. 1; Newport Harbor Museum, 1986)

Legg, Alicia (ed.), *Sol LeWitt* (New York: The Museum of Modern Art, 1978)

Leider, Philip, 'Literalism and Abstraction: Frank Stella's Retrospective at the Modern', *Artforum*, 8 (April 1970) 44-51

LeWitt, Sol, 'The Cube', 1966; reprinted in Legg (ed.), *Sol LeWitt, op. cit.*, 172

_____, 'Paragraphs on Conceptual Art', *Artforum*, 5 (June 1967) 79-83

_____, 'Sentences on Conceptual Art', *Art-Language*, 1 (May 1969) 11-13

_____, *Sol LeWitt* (The Hague: Gemeentemuseum, 1970)

_____, 'Doing Wall Drawings', *Art Now*, 3 (June 1971)

_____, *Sol LeWitt: Drawings 1958-1992*, ed. Susanna Singer (The Hague: Gemeentemuseum, 1992)

_____, *Sol LeWitt: Wall Drawings 1984-1992*, ed. Susanna Singer (Bern: Kunsthalle, 1992)

_____, *Sol LeWitt: Structures 1962-1993* (Oxford: Museum of Modern Art, 1993)

_____, *Sol LeWitt: Twenty-Five Years of Wall Drawings 1968-1993* (Seattle: University of Washington Press, 1993)

_____, *Sol LeWitt: Critical Texts*, ed. Adachiara Zevi, *AEIOU* (1994)

Lippard, Lucy R., '10 Structurists in 20 Paragraphs', in Enno Develing, *Minimal Art* (The Hague: Gemeentemuseum, 1968)

_____, *Eva Hesse* (New York: E.P. Dutton & Co., 1968); reprinted New York University, 1976

_____, *Changing: Essays in Art Criticism* (New York: E.P. Dutton & Co., 1971)

_____, 'Color at the Edge: Jo Baer', *ARTnews* (May 1972) 24-25; 64-66

_____, *Tony Smith* (New York: Abrams, 1972)

_____, *Six Years: The Dematerialization of the Art Object from 1966 to 1972* (New York: Praeger, 1973)

McCracken, John, *John McCracken* (Paris: Galerie Ileana Sonnabend, 1969)

_____, *John McCracken* (Vienna: Hochschule für Angewandte Kunst, 1995)

McEvilley, Thomas, 'Grey Geese Descending: The Art of Agnes Martin', *Artforum*, 25 (Summer 1987) 94-99

McShine, Kynaston, *Primary Structures* (New York: Jewish Museum, 1966)

Marden, Brice, *Suicide Notes* (Lausanne: Editions des Massons, 1974)

Martin, Agnes, *Agnes Martin* (Philadelphia: Institute of Contemporary Art, University of Pennsylvania, 1973)

_____, *Agnes Martin* (Munich: Kunstraum, 1973)

_____, *Agnes Martin: Paintings and Drawings 1957-1975* (London: Arts Council of Great Britain, 1977)

_____, *Agnes Martin: Paintings and Drawings 1974-1990* (Amsterdam: Stedelijk Museum, 1991)

Melville, Robert, 'Planks in a Minimal

Program', *New Statesman* (18 April 1969)

_____, 'Minimalism', *Architectural Review*, 146 (August 1969) 146-48

Merleau-Ponty, Maurice, *Phenomenology of Perception* (London: Routledge & Kegan Paul, 1962)

Meyer, Franz, *Walter De Maria* (Frankfurt: Museum für Moderne Kunst, 1991)

Meyer-Hermann, Eva, *Carl Andre: Sculptor 1996* (Cologne: Oktagon, 1996)

Michelson, Annette, 'Agnes Martin: Recent Paintings', *Artforum*, 5 (January 1967) 46-47

_____, '10 x 10: "Concrete Reasonableness"', *Artforum*, 5 (January 1967) 30-31

_____, *Robert Morris: An Aesthetics of Transgression* (Washington, DC: Corcoran Gallery of Art, 1970)

Monte, James; Young, Dennis, *John McCracken: Sculpture 1965-1969* (Toronto: Art Gallery of Ontario, 1969)

Morris, Robert, 'Notes on Sculpture, Part 3: Notes and Nonsequiturs', *Artforum*, 5 (June 1967) 24-29

_____, 'Notes on Sculpture, Part 4', *Artforum*, 7 (April 1969) 50-54

_____, *Continuous Project Altered Daily: The Writings of Robert Morris* (Cambridge, Massachusetts, and London: MIT Press, 1993)

Necol, Jane [see Droll, Donald]

Nodelman, Sheldon, *Marden, Novros, Rothko: Painting in the Age of Actuality* (Houston: Institute for the Arts, Rice University, 1978)

O'Doherty, Brian, 'Frank Stella and a Crisis of Nothingness', *The New York Times* (19 January 1964)

_____, *Inside the White Cube: The Ideology of the Gallery Space* (Santa Monica and San Francisco: Lapis Press, 1976)

Oliva, Achille Bonito (ed.), *Ubi Fluxus ibi motus 1990-1962* (Venice: Mazzotta, 1990)

Owens, Craig, 'Earthwords', *October*, 10 (Autumn 1979) 120-30

Pagé, Suzanne (ed.), *Un choix d'art minimal dans la collection Panza* (Paris: Musée d'Art Moderne de la Ville de Paris, 1990)

Parsy, Paul-Hervé, *Art minimal* (Paris: Musée national d'Art Moderne, Centre Georges Pompidou, 1992)

Perreault, John, 'Union-Made: Report on a Phenomenon', *Arts Magazine*, 41 (March 1967) 26-31

Perrone, Jeff, 'Carl Andre: Art Versus Talk', *Artforum*, 14 (May 1976) 32-33

Phillips, Michael, *Ronald Bladen: Sculpture*, (Hempstead: Hofstra University, 1967)

Pincus-Witten, Robert, '"Systemic" Painting', *Artforum*, 5 (November 1966) 43

_____, 'Sol LeWitt: Word = Object', *Artforum*, 11 (February 1973) 69-72

_____, *Eye to Eye: Twenty Years of Art Criticism* (Ann Arbor: UMI Research Press, 1984)

_____, *Postminimalism into Maximalism: American Art, 1966-1986* (Ann Arbor: UMI Research Press, 1987)

Ratcliff, Carter, 'Jo Baer: Notes on 5 Recent Paintings', *Artforum* (May 1972) 28-32

Rauh, Emily S., *diagrams from Dan Flavin 1963-1972* (Missouri: St Louis Art Museum, 1973)

_____, [see Belloli, Jay]

Reise, Barbara, '"Untitled 1969": A Footnote on Art and Minimal Stylehood', *Studio International*, 177 (April 1969) 166-72

_____, 'Robert Ryman: Unfinished I [Materials]/Unfinished II [Procedures]', *Studio International*, 197 (February-March 1984) 76-80; 122-28

Richardson, Brenda, *Frank Stella: The Black Paintings* (Baltimore Museum of Art, 1976)

Robbe-Grillet, Alain, *For a New Novel* (New York: Grove Press, 1965)

Robins, Corinne, 'Object, Structure or Sculpture: Where Are We?', *Arts Magazine*, 40 (September-October 1966) 33-37

_____, 'The Artist Speaks: Ronald Bladen', *Art in America*, 57 (September-October 1969) 76-81

Rose, Barbara, 'Looking at American Sculpture', *Artforum*, 3 (February 1965) 29-36

_____, 'Los Angeles: The Second City', *Art in America*, 54 (January- February 1966) 110-15

_____, *A New Aesthetic* (Washington, DC: Washington Gallery of Modern Art, 1967)

_____, 'Blow Up: The Problem of Scale in American Sculpture', *Art in America*, 56 (July-August 1968) 80-91

_____, *Autocritique* (New York: Weidenfeld and Nicholson, 1988)

Rosenblum, Robert, 'Pop Art and Non-Pop Art', *Art and Literature*, 5 (Summer 1965) 80-93

_____, *Frank Stella* (Harmondsworth: Penguin, 1971)

Rubin, Lawrence, *Frank Stella Paintings 1958-1965* (New York: Stewart, Tabori and Chang Publishers, 1986)

Rubin, William, *Frank Stella* (New York: The Museum of Modern Art, 1970)

_____, *Frank Stella 1970-1987* (New York: The Museum of Modern Art, 1987)

Ruda, Edwin, 'Park Place 1963-1967: Some Informal Notes in Retrospect', *Arts Magazine*, 42 (November 1967) 30-33

Ryman, Robert, 'Dossier Robert Ryman', *Macula*, 3-4 (September 1978) 113-85

_____, *Robert Ryman: Exhibition of Works* (New York: Solomon R. Guggenheim Museum, 1972)

_____, *Robert Ryman* (Amsterdam: Stedelijk Museum, 1974)

_____, *Robert Ryman* (London: Whitechapel Art Gallery, 1977)

_____, *Robert Morris: Mirror Works 1961-1978* (New York: Leo Castelli Gallery, 1979)

_____, *Robert Ryman: Paintings and Reliefs* (Zurich: Hallen für Neue Kunst, 1980)

_____, *Robert Ryman* (Paris: Musée national d'Art Moderne, Centre Georges Pompidou, 1981)

_____, *Robert Ryman* (New York: DIA Foundation, 1988)

_____, *Robert Morris: The Mind/Body Problem* (New York: Solomon R. Guggenheim Museum, 1994)

Sandler, Irving, 'The New Cool-Art', *Art in America*, 53 (February 1965) 96-101

_____, *American Art of the 1960s* (New York: Harper and Row, 1988)

Schjeldahl, Peter, *Ralph Humphrey - Frame Paintings: 1964 to 1965* (New York: Mary Boone Gallery, 1990)

Schwarz, Dieter (ed.), *Agnes Martin: Writings/ Schriften* (Winterthur: Kunstmuseum, 1992)

Serota, Nicholas, *Carl Andre Sculpture 1959-1977* (London: Whitechapel Art Gallery, 1978)

_____ (ed.), *Eva Hesse: Sculpture* (London: Whitechapel Art Gallery, 1979)

_____ (ed.), *Brice Marden: Paintings, Drawings and Prints 1975-80* (London: Whitechapel Art Gallery, 1981)

Shapiro, Gary, *Earthwards: Robert Smithson and Art After Babel* (Berkeley: University of California Press, 1995)

Sharp, Willoughby, 'Points of View: A Taped Conversation with Four Painters', *Arts Magazine* (December 1970-January 1971) 41-42

Shearer, Linda, *Brice Marden* (New York: Solomon R. Guggenheim Museum, 1975)

Smith, Brydon, *fluorescent light, etc. from Dan Flavin* (Ottawa: National Gallery of Canada, 1969)

_____, *Donald Judd* (Ottawa: National Gallery of Canada, 1975)

Smith, Roberta, 'Brice Marden's Painting', *Arts Magazine*, 47 (May-June 1973) 36-41

_____, 'Jo Baer: Whitney Museum of American Art', *Artforum*, 1 (September 1975) 73-77

Smith, Tony, 'Statement on *Die*', *Art Now*, 1 (November 1969)

Smithson, Robert, *The Writings of Robert Smithson*, ed. Nancy Holt (New York University Press, 1979)

_____, *Robert Smithson: The Collected Writings*, ed. Jack Flam (Berkeley, Los Angeles and London: University of California Press, 1996)

Sontag, Susan, *Against interpretation and other essays* (New York: Farrar, Straus, Giroux, 1966; reprinted New York: Anchor Books/Doubleday, 1990)

_____, *A Susan Sontag Reader* (New York: Farrar, Straus, Giroux, 1982)

Spector, Buzz, *Objects and Logotypes: Relationships Between Minimal Art and Corporate Design* (The Renaissance Society, University of Chicago, 1980)

Stemmrich, Gregor (ed.), *Minimal Art: Eine kritische Retrospektive* (Dresden and Basel: Verlag der Kunst, 1995)

Stich, Sidra, *Made in USA: An Americanization in Modern Art, the 1950s and 1960s* (Berkeley: University Art Museum, University of California, 1987)

Storr, Robert, *Robert Ryman* (London: Tate Gallery; New York: The Museum of Modern Art, 1993)

_____, *Tony Smith: Architect, Painter, Sculptor* (New York: The Museum of Modern Art, 1998)

Strickland, Edward, *Minimalism: Origins* (Bloomington: Indiana University, 1993)

Sylvester, David [see Compton, Michael]

Truitt, Anne, *Anne Truitt: Sculpture 1961-1991* (New York: André Emmerich Gallery, 1991)

_____, *Daybook: The Journal of an Artist* (London and New York: Penguin, 1984)

_____, *Turn: The Journal of an Artist* (New York: Viking Penguin, 1986)

_____, *Prospect: The Journal of an Artist* (London and New York: Scribner, 1996)

Tuchman, Maurice (ed.), *American Sculpture of the 1960s* (Los Angeles County Museum of Art, 1967)

_____ (ed.), *Art in Los Angeles: Seventeen Artists in the Sixties* (Los Angeles County Museum of Art, 1981)

Tuchman, Phyllis, 'An Interview with Carl Andre', *Artforum*, 8 (June 1970) 55-61

_____, 'An Interview with Robert Ryman', *Artforum* (9 May 1971) 46-53

Tucker, Marcia, *Robert Morris* (New York: Whitney Museum of American Art, 1970)

Varian, Elayne, *Art in Process: The Visual Development of a Structure* (New York: Finch College Museum of Art, 1966)

Wagstaff, Samuel J., Jr, 'Talking with Tony Smith', *Artforum*, 5 (December 1966) 14-19

_____, *Tony Smith: Two Exhibitions of Sculpture* (Hartford: Wadsworth Atheneum; Philadelphia: Institute of Contemporary Art, University of Pennsylvania, 1966)

Waldman, Diane, 'Finch College Museum's "Art in Process"', *ARTnews*, 65 (September 1966) 72

Wallis, Brian, 'Notes on [Re]Viewing Donald Judd's Work', *Donald Judd: Eight Works in Three Dimensions* (Charlotte: Knight Gallery, 1983)

Wilson, Ann, 'Linear Webs: Agnes Martin', *Art & Artists*, 1 (October 1966) 46-49

Wilson, William S., 'Ralph Humphrey: An Apology for Painting', *Artforum* 3 (November 1977) 54-59

Wollheim, Richard, 'Minimal Art', *Arts Magazine*, 39 (January 1965) 26-32

Young, Dennis [see Monte, James]

INDEX

Entries in italics refer to images. Entries in inverted commas refer to titles of documents.

PUBLISHER'S ACKNOWLEDGEMENTS

We would like to thank all those who gave their kind permission to reproduce the listed material. Every effort has been made to secure all reprint permissions prior to publication. However, in a small number of instances this has not been possible. The editors and publisher apologize for any inadvertent errors or omissions. If notified, the publisher will endeavour to correct these at the earliest opportunity.

We would like to thank the following for their help in providing images:
Ace Gallery, New York; AKG, London; Albright-Knox Art Gallery, Buffalo; Art Gallery of Ontario, Toronto; Art Resource, New York; Jo Baer, Amsterdam; Baltimore Museum of Art, Maryland; Galerie Beaubourg, Vence; Larry Bell, Taos, New Mexico; Estate of Ronald Bladen, New York; Mel Bochner, New York; Bridgeman Art Library, London; C&M Arts, New York; Leo Castelli Archives, New York; Walter De Maria, New York; Paula Cooper Gallery, New York; The Chinati Foundation, Marfa, Texas; Christie's Images, London; Cunningham Dance Foundation Inc., New York; The Denver Art Museum, Colorado; Des Moines Art Center, Iowa; Detroit Institute of Arts, Michigan; Dia Center for the Arts, New York; Catherine Docter Consulting, Santa Barbara; Documenta Archiv, Kassel; Virginia Dwan Collection, New York; Konrad Fischer Galerie, Dusseldorf; Estate of Dan Flavin, New York; Estate of Hollis Frampton, New York; Gagosian Gallery, New York; Marian Goodman Gallery, New York; Ronald Grant Archive, London; Solomon R. Guggenheim Museum, New York; Donald Judd Estate, Marfa, Texas; Krefelder Kunstmuseen, Karlsplatz; Jeff Koons, New York; Kosuth Studio, New York; Kröller-Müller Museum, Otterlo; Kunstmuseum, Wolfsburg; LA Louver Gallery, Venice, California; Fisher Landau Center, New York; Lenbachhaus, Munich; Lisson Gallery, London; John McCracken, Medanales, New Mexico; Matthew Marks Gallery, New York; Metro Pictures, New York; Modern Art Museum of Fort Worth, Texas; Paul Mogensen, New York; Musée de Grenoble; Museum Ludwig, Cologne; Robert Miller Gallery, New York; The Museum of Modern Art, New York; Museum of Modern Art, Oxford; National Gallery of Art, Washington, DC; National Gallery of Canada, Ottowa; Norton Simon Museum, Pasadena; Kenneth Noland, North Bennington, Vermont; David Novros, New York; PaceWildenstein, New York; PA News Photolibrary, London; Philadelphia Museum of Art, Pennsylvania; Raussmüller Collection, Basel; Statens Konstmuseer, Stockholm; Haim Steinbach, New York; Tate Gallery of Art, London; Through the Flower, Belen, New Mexico; Alexandra Truitt and Jerry Marshall, New York; Galerie Tschudi, Glarus; Diane Upright Fine Arts, New York; Wadsworth Atheneum, Hartford, Connecticut; Walker Art Center, Minneapolis; John Weber Gallery, New York; Daniel Weinberg Contemporary Art, San Francisco; Westfälischer Kunstverein, Munster; Whitney Museum of American Art, New York.

PHOTOGRAPHERS

J. Gordon Adams: p. 70 (top and bottom); Eric Baudouin: p. 141; Bernd and Hilla Becher: p. 158 (top); Rudolf Burckhardt: pp. 49 (left), 50, 65 (bottom), 80 (middle), 121; Cathy Carver: pp. 77 (bottom), 145; Gordon R. Christmas: p. 53 (bottom); Geoffrey Clements: pp. 74, 89, 136 (top), 150 (top); Giorgio Columbo: pp. 131, 132–33, 141, 142, 143; James Dee: p. 177; Dan De Wilde: p. 147 (top); Todd Eberle: pp. 2–3, 188–89; Sarah Harper Gifford: p. 53 (top); Tom Haartsen: p. 152; David Heald: p. 184; Hickey-Robertson: p. 93 (bottom); Martin Lauffer: p. 187 (top); Erich Lessing: p. 192 (right, third from top); David Lubarsky: p. 39 (second to left); Mancia/Bodmer: p. 178 (top, middle and bottom); Douglas M. Parker Studio: pp. 124 (bottom), 158 (bottom); Eric Pollitzer: p. 77 (top); Nathan Rabin: p. 136 (bottom); Walter Russell: p. 153 (top); P. Mussat Sartor: pp. 93 (top), 159; Tom Scott: p. 150 (bottom); Fred Scruton: pp. 14, 179 (top); Marvin Silver: p. 191 (right bottom); David Stansbury: p. 116; Joseph Szaszfai: p. 106; Frank J. Thomas: pp. 71, 88; Michael Tropea: p. 160; Ellen Page Wilson: pp. 126, 128, 171 (top and bottom); Gareth Winters: p. 180 (bottom); Wolfgang Woessner: p. 137; Donald Woodman: p. 36 (right)

AUTHOR'S ACKNOWLEDGEMENTS

This book reflects the contributions of many individuals. I am indebted to Iwona Blazwick, who was the commissioning editor, and Gilda Williams, who oversaw the project with judicious care and unflagging counsel and support. Audrey Walen, the project editor, stewarded the project to completion with great professionalism and provided helpful advice. Clair Joy, John Stack, Clare Stent and Zoe Stollery provided meticulous research, and Catherine Caesar authored the pellucid photo captions. Stuart Smith conceived the book's elegant design. Adam Hooper provided expert assistance, and production controller Veronica Price brought it through to the highest standards.

My thanks as well to Jon Ippolito, Alexandra Truitt and Patrick Paul Garlinger, and above all to the many artists and writers who generously contributed images and texts. This book is a tribute to their work.